THE INDEFINITE DUCHAMP

POIESIS II

Schriftenreihe des Duchamp-Forschungszentrums
am Staatlichen Museum Schwerin
herausgegeben von **edited by** Gerhard Graulich
und **and** Kornelia Röder

Diese Publikation wurde ermöglicht durch
This publication of the proceedings was supported by

Freunde des Staatlichen
Museums Schwerin e.V.

Thomas Girst

THE INDEFINITE
DUCHAMP

Hrsg. **Ed.** Katharina Uhl

HATJE
CANTZ

INHALT

CONTENTS

GRUSSWORT

ANNE LEIBOLD

Die Freunde des Staatlichen Museums Schwerin e. V. haben bereits mit der Förderung des ersten Bandes der neuen Schriftenreihe *Poiesis: Impuls Marcel Duchamp // Where do we go from here?* einen wesentlichen Beitrag zur Profilierung und Internationalisierung des Duchamp-Forschungszentrums geleistet. Mit der Initiierung und Ausschreibung eines Forschungsstipendiums wurde eine weitere wichtige Voraussetzung geschaffen, um die wissenschaftliche Forschung zum Werk von Marcel Duchamp in Schwerin zu intensivieren.

Der Erfolg sowohl des ersten Bandes der Schriftenreihe als auch die inspirierenden Forschungsergebnisse der Stipendiatin Sarah Kolb aus Wien zum Thema *Malerei im Dienste der Metaphysik. Marcel Duchamps Werk im Spiegel der Philosophie von Henri Bergson*, vorgestellt in einer von den Freunden ausgerichteten Rendezvous-Veranstaltung im Staatlichen Museum Schwerin, bestärken uns, die Schriftenreihe und die junge Forschung auch zukünftig zu unterstützen.

Die europaweit größte Sammlung von Duchamps Werken am Schweriner Museum erfährt weiterhin große Aufmerksamkeit. Mit vier bedeutenden Leihgaben — u. a. mit *Die Braut von ihren Junggesellen entblößt, sogar / Die Grüne Schachtel* (1934) — unterstützte das Staatliche Museum Schwerin die erfolgreiche Ausstellung *Marcel Duchamp in München*, 2012, die von Thomas Girst initiiert und ko-kuratiert wurde. Zudem konnte Kornelia Berswordt-Wallrabe hier ihre im *The Getty Research Institute*, Los Angeles, begonnene Forschung zum Thema Duchamp in München in einem Beitrag des sehr gelungenen, die Ausstellung begleitenden Katalogs weiter vertiefen.

Mit dem nun vorliegenden zweiten Band der Schriftenreihe *The Indefinite Duchamp* von Thomas Girst erweist sich *Poiesis* bereits als ein sowohl von der Fachwelt als auch von einem interessierten Publikum wahrgenommenes Forschungs-, Austausch- und Kommunikationsmedium zum Werk dieses wegweisenden Künstlers des 20. Jahrhunderts.

PREFACE

ANNE LEIBOLD

With the support of the first volume of the new scholarly series *Poiesis: Impuls Marcel Duchamp // Where do we go from here?*, the Friends of the Staatliches Museum Schwerin had already made a significant contribution to the recognition and internationalization of the Duchamp Research Center. With the initiation and announcement of a research scholarship, a further important condition has been created for stepping up scientific research on the work of Marcel Duchamp in Schwerin.

The success of both the first volume of the scholarly series as well as the inspiring research results of the grantee Sarah Kolb from Vienna on the topic *Malerei im Dienste der Metaphysik. Marcel Duchamps Werk im Spiegel der Philosophie von Henri Bergson* (*Painting at the Service of Metaphsyics: The Work of Marcel Duchamp as reflected in Henri Bergson's Philosophy*), first presented at a small-circle gathering which has been organized by the Friends of the Staatliches Museum Schwerin, reinforced our quest to further support the scholarly publication series as well as research by younger academics.

In addition, Europe's largest collection of works by Marcel Duchamp, on permanent display at the Museum Schwerin still attracts a great deal of attention. With four significant loans, with *The Bride Stripped Bare by her Bachelors, even / The Green Box* (1934) among them, the Museum Schwerin supported the critically acclaimed exhibition *Marcel Duchamp in München 1912* (*Marcel Duchamp in Munich 1912*), 2012, which had been initiated and co-curated by Thomas Girst. Moreover, Kornelia Berswordt-Wallrabe could further explore her research on Duchamp's time in Munich, initially begun at The Getty Research Institute, Los Angeles, with a contribution to the exhaustive catalogue that accompanied the exhibition.

With the present second volume of the scholarly series, *The Indefinite Duchamp* by Thomas Girst, *Poiesis* again proves to be a medium of research, exchange and communication pertaining to the work of this

Aus diesem Grund ist es uns ein besonderes Anliegen und eine Ehre zugleich, das Erscheinen des zweiten Bandes ebenfalls zu unterstützen. Wir danken Thomas Girst, der mit seinen Beiträgen den Wissenschaftsdiskurs aus der Betrachterperspektive erweiterte und die inspirierenden Impulse aufzeigt, die von Marcel Duchamps Werk auf zeitgenössische Künstler bis heute ausgehen. Gerhard Graulich, stellvertretender Direktor und Leiter der Gemäldesammlung, und Kornelia Röder, Kuratorin und wissenschaftliche Mitarbeiterin, danken wir für ihr Engagement zur Weiterentwicklung des Duchamp-Forschungszentrums und für das Konzept des zweiten Bandes von *Poiesis*. Auch bei Direktor Dirk Blübaum möchten wir uns für seine engagierte Unterstützung der wissenschaftlichen Projekte am Duchamp-Forschungszentrum herzlich bedanken. Unser besonderer Dank gilt Katharina Uhl, wissenschaftliche Volontärin, sowohl für ihre konzeptionelle Arbeit als auch für die wissenschaftliche Aufbereitung der zweisprachigen Duchamp-Publikation.

Anne Leibold ist Vorsitzende der Freunde des Staatlichen Museums Schwerin e. V.

seminal artist of the twentieth century, a series well-received both in professional circles and by an interested public.

For this reason, it is a special concern and, at the same time, an honor for us to support the publication of this second volume. We thank Thomas Girst who broadens the scholarly discourse with his contributions from the onlooker's perspective and who highlights inspiring stimuli devolving from Marcel Duchamp's work to contemporary artists. We also thank Gerhard Graulich, deputy director and head of the painting collection, as well as Kornelia Röder, curator and research assistant, for their engagement concerning the further development of the Duchamp Research Center and for introducing to us the concept for the second volume of *Poiesis*. We are grateful to museum director Dirk Blübaum for his committed support of the scientific projects at the Duchamp Research Center. We owe our special thanks to Katharina Uhl, scientific trainee, both for her conceptual work as well as for the academic processing of the bilingual Duchamp publication.

Transl. Janina Wildfeuer

Anne Leibold is the president of the Society of the Friends of the Museum Schwerin.

NEUE KRITERIEN ZUR ARBEIT AM DUCHAMP-FORSCHUNGS- ZENTRUM SCHWERIN

GERHARD GRAULICH UND KORNELIA RÖDER

Das Marcel Duchamp-Forschungszentrum am Staatlichen Museum Schwerin besteht seit nunmehr vier Jahren. Mit der Schriftenreihe *Poiesis* und dem Duchamp-Forschungsstipendium, das 2012 zum zweiten Mal ausgeschrieben wird, konnten, mit der freundlichen Unterstützung der Freunde des Staatlichen Museums Schwerin e. V. und dank der wertvollen Anregungen von Dirk Blübaum, dem Direktor unseres Museums, zwei tragende Säulen für die weitere Forschungsarbeit und zugleich für die Förderung von Nachwuchswissenschaftlerinnen und -wissenschaftler etabliert werden. Mit diesen beiden Wissenschaftsforen gelang es, das Duchamp-Forschungszentrum ins Blickfeld sowohl der internationalen Fachwelt als auch der am Werk Duchamps interessierten Öffentlichkeit zu rücken. Der bereits bestehende Austausch mit Duchamp-Forschern und Museen mit eigenen Duchamp-Sammlungen konnte intensiviert werden, neue, interessante Kontakte entstanden. Dieses wertvolle Netzwerk gilt es weiter auszubauen, um daraus neue gemeinsame Forschungsvorhaben zu entwickeln und die Schweriner Duchamp-Forschung weiter zu etablieren.

Die Aktivitäten des Duchamp-Forschungszentrums konzentrierten sich bisher auf Fragen zur Schweriner Sammlung, die sich unter anderem im Katalog zur Ausstellung *Duchamp in München* und hier speziell im Aufsatz »Von der Bewegung zur Bewegtheit. Marcel Duchamp — Flug-Gasolin aus München« von Prof. Dr. Kornelia von Berswordt-Wallrabe, der Gründerin des Forschungszentrums, und in Textbeiträgen von wissenschaftlichen Mitarbeiterinnen des Schweriner Museums widerspiegeln. Die Bedeutung des Aufenthaltes in München war bisher ein weißer Fleck in der Biografie und der Werkgenese des Künstlers. Bedeutende Leihgaben für diese international mit großer Aufmerksamkeit wahrgenommene Ausstellung kamen aus Schwerin.

Forschungen zum Bestand sind auch für andere Museen von großem Wert, wie die neue Publikation des Philadelphia Museum of Art zu *Étant donnés* deutlich macht. Auch das Moderna Museet in Stock-

NEW CRITERIA
CONCERNING THE WORK AT THE
DUCHAMP RESEARCH CENTER SCHWERIN

GERHARD GRAULICH AND KORNELIA RÖDER

The Duchamp Research Center at the Staatliches Museum Schwerin came into being four years ago. With the series *Poiesis* and the Duchamp scholarship, which has been announced for the second time in 2012—with the kind support of the Friends of the Staatliches Museum Schwerin and with great gratitude to Dirk Blübaum, director of our museum, for his valuable suggestions—, two cornerstones for further research and especially for the promotion of young scholars have been established. With both of these scientific forums, the Duchamp Research Center managed to raise eyebrows both with international experts in the field as well as with the general public interested in Duchamp's work. The already existing exchange with Duchamp researchers and museums with Duchamp collections of their own has been intensified as new and fruitful contacts have been established. It is essential to further strengthen this valuable network in order to develop new and joint research projects and to further deepen Duchamp research in Schwerin.

The activities of the Duchamp Research Center have so far mainly concentrated on questions concerning the Schwerin collection, which are, amongst others, reflected in exhibition catalogue *Duchamp in München 1912* (*Duchamp in Munich 1912*) and in particular in the article "Von der Bewegung zur Bewegtheit. Marcel Duchamp—Flug-Gasolin in München" ("From Movement to Movens: Marcel Duchamp—Aviation-Gasoline from Munich") by Kornelia von Berswordt-Wallrabe, founder of the Duchamp Research Center, as well as in further contributions of research assistants at the Museum Schwerin. The significance of Duchamp's stay in Munich has so far been a blank area in the artist's biography and his work's genesis. Important loans for this internationally acclaimed exhibition, which has attracted much attention, came from Schwerin.

Research on the inventory is also of high value for other museums, as has been made clear by, for example, the new publication of the

holm setzt den Schwerpunkt mit der Ausstellung *Picasso / Duchamp He Was Wrong* auf die eigene Sammlung und untersucht die Verbindungen zwischen den beiden Künstlern, die die Kunst des 20. Jahrhunderts mit ihren Neuerungen revolutionierten.

Ein weiterer Fokus der internationalen Forschung liegt derzeit auf der Frage von Original und Kopie, von Reproduktion und Multiple. Diese Phänomene der Kunst können insbesondere am Werk von Marcel Duchamp untersucht, diskutiert und neu betrachtet werden. Im Katalog der Schweriner Ausstellung *Kopie, Replik und Massenware*, insbesondere im Aufsatz »Das Image der Mona Lisa – Über Duchamps Konzept graphischer Reproduktion« wird dieser Diskurs am Beispiel von Duchamps Auseinandersetzung mit der Reproduktion der *Mona Lisa* von Leonardo da Vinci weiter spezifiziert. Ausstellungen wie *Déjà-vu – Von Dürer bis YouTube* in Karlsruhe oder *The Small Utopia. Aufstieg und Fall des Multiple* in der Fondazione Prada in Venedig diskutierten ihrerseits das sich verändernde Verständnis von Reproduktion und Original, das gleichsam zu einer neuen Sicht auf das Readymade führt. Es ist zu fragen, ob angesichts des Readymade überhaupt noch von einem Werk im traditionellen Sinne gesprochen werden kann, denn worin besteht der Anteil des Künstlers, des Herstellers und des Rezipienten bei der Konstituierung des Kunstwerks? Duchamp bemerkt zum Readymade, dass die jeweilige Wahl des Gegenstandes das Entscheidende sei. Aber wann, wo und wie liefen die Entscheidungen ab? Und gehört nicht die Reflexion oder vielleicht auch der Ort der Wahl dazu? Wie und wo soll man die Werke studieren? Braucht man noch das Original und gibt es dieses überhaupt?

Mit den Werken Marcel Duchamps veränderte sich die Kunst wie auch die Reflexionspraxis nachhaltig. Zweifelsohne hat sich die klassische Kunstgeschichte mit den Werken Duchamps schwer getan, weil die überkommenen Systeme der Beschreibung und ihre Begrifflichkeit kaum brauchbar waren, um seine »offenen« Werke zu diskutieren. Mit den Veränderungen des Werkbegriffs ging die Entwicklung der »New Art History« einher. So wurden Ende der 1960er-Jahre Versuche unternommen, poststrukturalistische Theorien einzubeziehen, wobei man über die kunstimmanente Objektebene, deren Deskription wie auch kategoriale, mediale, historisch-soziale Bestimmung hinausging. Kunst und Realität lassen sich seit Duchamp nicht mehr auf ein einfaches Referenzverhältnis reduzieren, vielmehr werden durch die Realisationen selbst neue Realitäten erzeugt. »Andere Kriterien« (Leo Steinberg) in

Philadelphia Museum of Art on *Étant donnés*. The Moderna Museet in Stockholm also puts an emphasis on its own collection with the exhibition *Picasso / Duchamp He Was Wrong* and examines the connection between both artists who revolutionized the art of the twentieth century with their innovations.

A further focus of international research now evolves around the question of original and copy, of reproduction and multiple. These phenomena of art can be examined, discussed and newly considered in particular in regard to the work of Marcel Duchamp. Within the catalogue of the Schwerin exhibition *Kopie, Replik und Massenware* (*Copy, Replica and Commodity Products*), in particular within the article "Das Image der Mona Lisa – Über Duchamps Konzept graphischer Reproduktion," ("The Image of the Mona Lisa: On Duchamp's Concept of Graphical Reproduction") this discourse is further specified through Duchamp's discussion of the reproduction of the *Mona Lisa* by Leonardo da Vinci. Exhibitions like *Déjà-vu–Von Dürer bis You Tube* (*Déjà-vu–From Dürer to YouTube*) in Karlsruhe or *The Small Utopia. Aufstieg und Fall des Multiple* (*The Small Utopia. The Rise and Fall of the Multiple*) at the Fondazione Prada in Venice discussed the changing understanding of reproduction and original, which itself leads to a new perspective on the Readymade. In light of the Readymade, it has to be asked whether it can be referred to at all as a work in its traditional meaning, for wherein lies the participation of the artist, the producer and the recipient in the constitution of the artwork? Duchamp comments on the Readymade that choice of the object is essential. But when, where and how did these decisions proceed? And does the reflection or perhaps also the place of the choice belong to it? How and where shall we study these works? Are we in need of the original and does it even exist?

With the works of Marcel Duchamp, art itself as well as modes of contemplation changed significantly. Traditional art history doubtlessly had difficulties with the works of Duchamp, since outdated systems of description and their terminology were barely useful to discuss his "open" works. Alongside these changes, "New Art History" came into being. Thus, at the end of the 1960s, attempts were undertaken to integrate poststructuralist theories, whereby these transcended the object level immanent to art, its description as well as the categorical, medial and historical and social definition. Since Duchamp, art and perception cannot be reduced to a simple relation of reference; rather new reali-

einem erweiterten Sinn sind entwickelt worden, um sich jenseits von Ikonografie und Ikonologie mit Duchamps Werken auseinanderzusetzen. Vor diesem Hintergrund meint *Poiesis*, dass sowohl ein innovatives Eingehen auf Duchamps Realisationen als auch die produktive Reflexion notwendig sind, um neue Diskurse zu entwickeln.

Diesem spannenden Aspekt widmet sich auch der zweite Band der Schriftenreihe *Poiesis* von Thomas Girst. Seit 2001 ist der Autor mit dem Schweriner Museum verbunden. Zu dieser Zeit leitete er die Forschungsabteilung am New Yorker Art Science Research Laboratory, das von Rhonda Roland Shearer und ihrem Mann Stephen Jay Gould gegründet wurde und sich vor allem der Auseinandersetzung mit Duchamp widmete. Insbesondere die systematische Analyse der Readymades wie das Heranziehen realer Vergleichsobjekte gaben damals neue Impulse zur historischen Verortung der Readymades, aber auch zu deren alltäglichen Bedeutung und Funktion. Thomas Girst widmet sich in seinen aktuellen Texten den künstlerischen Ambivalenzen, die den Objekten und Schriften Duchamps inhärent sind. In dem einführenden Gespräch mit Molly Nesbit und Hans Ulrich Obrist weist Thomas Girst darauf hin, dass es ihm nicht um einen weiteren Kommentar zu Duchamp gehe, sondern darum, dessen abgewandte, zwischen Konsequenz und Widerspruch oszillierende Seite zu beleuchten. Im Kapitel »Duchamp für Alle« thematisiert der Autor programmatisch die Zusammenhänge von Readymade und Warenwelt, aber auch deren gegenwärtige Rezeption. In dem Beitrag »Belle Haleine« geht es Duchamp, wie Girst es formuliert, »mitnichten um eine rein visuelle Lesart des Assisted Readymade als Duftwasser-Imitat, sondern vielmehr um zentrale Ideen seiner Auseinandersetzung mit Erotik und männlicher wie weiblicher Geschlechtlichkeit«. Darüber hinaus wird die Suggestion des Duftwassers derart thematisiert, dass die Verweigerung des Duftes – der Flakon von *Belle Haleine* enthält keine Flüssigkeit – gleichsam darauf hinweist, dass Duchamp das Olfaktorische der Malerei überwunden habe.

Besondere Einsichten in Duchamps Persönlichkeit bieten die Interviews, die Thomas Girst mit Zeitzeugen wie Timothy Phillips, Charles Henri Ford und Robert Barnes geführt hat. Sie vermitteln uns auf ihre ganz eigene Weise die Person Duchamp und unbekannte Facetten seiner Werke. Sicherlich mag hier ein Stück »oral history« vorliegen, gleichzeitig zeichnen sich die Interviews durch ihren Esprit und ihre Spontaneität aus.

ties are created by these realizations. "Other criteria" (Leo Steinberg), in a larger sense, have been developed in order to deal with Duchamp's works beyond the level of iconography and iconology. Against this background, *Poiesis* thinks that both an innovative response to Duchamp's realizations as well as the productive reflection are necessary to develop new discourses.

The second volume of the scholarly series *Poiesis*, written by Thomas Girst, attends to this fascinating aspect. Since 2001, the author has established contact with the Staatliches Museum Schwerin. At that time, he was research manager at the New York-based Art Science Research Laboratory, which has been founded by Rhonda Roland Shearer and her husband Stephen Jay Gould and which was to a large part devoted to the examination of Duchamp. In particular the systematic analysis of the Readymades as well as the consultation of real objects of comparison gave new stimuli to the historical positioning of the Readymades, but also to their ordinary meaning and function. Throughout his essays and contributions Thomas Girst addresses the artistical ambivalences inherent to the objects and writings of Duchamp. Within the introductory trialogue with Molly Nesbit and Hans Ulrich Obrist, Thomas Girst points to the fact that he is not interested in commenting further on Duchamp, but rather in elucidating averted aspects oscillating between consequence and contradiction. Within the chapter "Duchamp für Alle" ("Duchamp for Everyone"), the author programmatically addresses the connections between Readymade and consumer world, but also its actual reception. With *Belle Haleine* for example Duchamp is, as Girst writes, "by no means interested in a mere visual interpretation of his Assisted Readymade as an elaborate imitation of a perfume bottle, but is instead much more concerned with central ideas of his thoughts on eroticism and male as well as female sexuality." Furthermore, the suggestion of the perfume is made a subject of discussion in such a way that the denial of the fragrance—*Belle Haleine*'s vial does not contain any fluid—points to the fact that Duchamp had overcome the olfactory of painting.

Specific insights into Duchamp's personality are offered by the interviews which Thomas Girst conducted with contemporary witnesses: Timothy Phillips, Charles Henri Ford and Robert Barnes. They convey in their own way the character of Duchamp and unknown facets of his works. Surely, this is a piece of oral history yet at the same time, these interviews stand out due to their esprit and their spontaneity.

Wie die Forschungsergebnisse der ersten Stipendiatin, Sarah Kolb, zu Duchamp und dem französischen Philosophen Henri Bergson gibt auch *The Indefinite Duchamp* wertvolle Impulse für den Aspekt der Künstlerforschung zum Werk Duchamps. Dieser zeigt sich auch eindrucksvoll in der Installation *Marcel Duchamp – Le mystère de Munich* von Rudolf Herz. Auch der Ankauf von Pierre Granoux' *Flaschentrockner* für die Sammlung und die Intervention des Künstlers, eine Straße in Schwerin in *Rue Marcel Duchamps* umzubenennen – zurückgehend auf einen Fehler in einem französischen Reiseführer – ist ein Beleg für die lebendige Rezeption Duchamps in der zeitgenössischen Kunst.

Das Duchamp-Forschungszentrum versteht sich als Brücke zwischen Kunstgeschichte und aktuellem Kunstschaffen. Um die Forschung in Schwerin weiter zu qualifizieren, bildet der Aufbau einer Bibliothek und eines Archivs einen Schwerpunkt. Zudem werden am Caspar-David-Friedrich-Institut der Universität Greifswald neue Aspekte der Duchamp-Forschung vermittelt. Neben der initiierten Artists Talk-Reihe fand 2009 zudem erstmals ein Kolloquium statt, bei dem es um die Zukunft der Duchamp-Forschung ging: »Where do we go from here?«, lautete der Titel. Für 2013 ist eine weitere Tagung geplant, die insbesondere dem wissenschaftlichen Nachwuchs gewidmet sein wird.

Das Duchamp-Forschungszentrum wird sich in seiner Bezugnahme auf Fluxus, Konzept-Kunst und Mail Art auch zukünftig im Kontext der Schweriner Sammlung zur Moderne positionieren. Der dritte Band der Schriftenreihe *Poiesis*, der 2014 erscheinen wird, nimmt den Titel der Arbeit *Not Wanting to Say Anything About Marcel* von John Cage auf und wird den Verbindungen, Bezügen, Divergenzen zwischen Marcel Duchamp, John Cage und Marcel Broodthaers nachgehen.

Similar to the research results of the first Duchamp scholarship grantee, Sarah Kolb, on Duchamp and the French philosopher Henri Bergson, *The Indefinite Duchamp* also gives valuable impulses to the aspect of research on artists within the Research Center. This aspect also shows itself impressively in the installation *Marcel Duchamp—Le mystère de Munich* by Rudolf Herz. The acquisition of Pierre Granoux's *Bottle Dryer* for the collection and the intervention of the artist to rename a street in Schwerin as *Rue Marcel Duchamps*—based on a mistake in a French tourist guide—is also a proof for the vivid reception of Duchamp in contemporary art.

The Duchamp Research Center sees itself as a bridge between art history and the art which comes into being today. In order to further qualify research in Schwerin, the construction of a library and an archive is a main concern. Furthermore, new aspects of Duchamp research are taught at the Caspar David Friedrich Institute of the University of Greifswald. Besides the initiation of an Artist Talk series, a colloquium was held in 2009, which examined the future of Duchamp research. Its title was "Where do we go from here?" For 2013, a further conference is scheduled which will be devoted in particular to young researchers.

The Duchamp Research Center will position itself in its relation to modern art, specifically taking into account the focus on fluxus, conceptual art and mail art within the context of the Schwerin collection. The third volume of the scholarly publication series *Poiesis*, which will appear in 2014, will take up the title of the work *Not Wanting To Say Anything About Marcel* by John Cage and will examine relations, references and divergencies between Marcel Duchamp, John Cage, and Marcel Broodthaers.

Transl. Janina Wildfeuer

TRIALOG ZU ODER ÜBER MARCEL DUCHAMP

THOMAS GIRST, MOLLY NESBIT, HANS ULRICH OBRIST

THOMAS GIRST Ich wollte das Buch zunächst *The Definitive Duchamp* nennen, weil ich dachte, dass die Hybris und der anmaßende Witz darin leicht zu erkennen seien. Außerdem mochte ich die Alliteration, genau wie in Marcel Duchamps Gemälde *Jeune homme triste dans un train* (1911). In einer Notiz aus der *Grünen Schachtel* über die Jura-Paris-Route sagt Duchamp, dass er das Wort »indefinit« dem Wort »infinit« wegen dessen Genauigkeit vorzieht.[1] *The Indefinite Duchamp* ergab ohnehin sehr viel mehr Sinn.

HANS ULRICH OBRIST *The Definitive Duchamp*: Die Andeutung der Möglichkeit einer Unmöglichkeit. Dieser ganze Gedanke eines Rätsels oder einer Lösung ist aussichtslos. Die Superstringtheorie in den Naturwissenschaften hat elf Dimensionen. Neue Generationen werden immer neue Dimensionen entdecken. Alle großen Künstler machen so etwas möglich, so reist Kunst durch die Zeit. Das ist auch der Grund, warum sie nach 200, 300, 400 Jahren immer noch inspirierend sind.

Erst gerade habe ich das Studio von Fangzhi besucht, der Albrecht Dürer neue Geheimnisse entlockt. Hier sind wir also, Jahrhunderte nach Dürer entdeckt ein chinesischer Maler des 21. Jahrhunderts neue Geheimnisse in dessen Arbeit. Das ist es, was einen Künstler am Leben hält. Dürer, Goya, Duchamp, sie sind alle unerschöpflich. In den nächsten hundert Jahren werden wir in den Arbeiten von Gerhard Richter viele neue Dimensionen erkennen. Duchamps Œuvre ist unerschöpflich.

THOMAS GIRST Duchamp Gesamtwerk ist gewissermaßen nicht nur unerschöpflich, sondern scheint auch immer noch auf eine Weise unverdaulich zu sein — zumindest für die Kunstgeschichte. Ein wichtiger Aspekt bei Duchamp generell, den ich herauszuarbeiten versuche, ist, dass alles, was er gemacht hat und was heute hoch geschätzt wird, beispielsweise die Readymades, dass dies alles die Kunst wirklich verändert hat — er ist einer der bedeutendsten Wegbereiter moderner Kunst.

1 *The Writings of Marcel Duchamp*, hrsg. von Michel Sanouillet und Elmer Peterson, New York 1989, S. 27.

TRIALOGUE ON OR ABOUT MARCEL DUCHAMP

THOMAS GIRST, MOLLY NESBIT, HANS ULRICH OBRIST

THOMAS GIRST I first wanted to call the book *The Definitive Duchamp* thinking the hubris and the preposterous joke would be easily detected. Plus I liked the alliteration, just like in Marcel Duchamp's painting *Jeune homme triste dans un train* (1911). In his *Green Box* note about the Jura-Paris road, Duchamp says he prefers the word "indefinite" over "infinite" in terms of accuracy.[1] In any case, *The Indefinite Duchamp* made much more sense.

HANS ULRICH OBRIST *The Definitive Duchamp*: that would be to suggest the possibility of an impossibility. This whole idea of one enigma or one solution is futile. Superstring theory in science, for example, has discovered eleven dimensions. New generations will always discover new dimensions. This is what all great artists have done, and this is how art travels through time. It's why it can still inspire 200, 300, 400 years later.

Only recently, I visited the studio of Fangzhi and he'd just discovered some new secrets about Albrecht Dürer. So here we are, centuries after Dürer's time, and there's a Chinese twenty-first-century painter who discovers unsolved riddles in his work. This is what keeps the artist alive. Dürer, Goya, Duchamp, they're inexhaustible. For the next hundreds of years we'll still be seeing many new dimensions in the works of Gerhard Richter. Duchamp's oeuvre is inexhaustible.

THOMAS GIRST Duchamp's complete works to some degree is not only inexhaustible but still seems somewhat indigestible—at least for art history itself. The larger point that I am trying to make with Duchamp in general is that with all the things he has done which are highly appreciated today, like the Readymades, he has changed the course of art. He is one of the major forces of modern art. What I find important is that also art history needed to rewrite itself a little bit. Most references regarding Duchamp's work lie outside the realm of art history.

1 Michel Sanouillet and Elmer Peterson, eds., *The Writings of Marcel Duchamp* (New York, 1989), p. 27.

Es ist wichtig hervorzuheben, dass sich auch die Kunstgeschichte ein klein wenig selbst neu schreiben musste. Vielleicht vermag es Duchamp im zweiten Jahrhundert seiner Wirkungsgeschichte, die Art und Weise, wie Kunsthistoriker über Kunst schreiben zu verändern, so wie er im ersten die Kunst selbst verändert hat.

HANS ULRICH OBRIST Ganz bestimmt. Und ich glaube, dass er auf eine Weise viele Brücken bildete, zum Beispiel die Brücke zwischen Kunst und Wissenschaft, wir könnten über den Bezug zu Henri Poincaré sprechen. Er baute auch Brücken zwischen Kunst und eher industriell inspirierten Darstellungsformen in Ausstellungen. Duchamp hat Kunst, Wissenschaft, Literatur und Musik verbunden. Eines meiner faszinierendsten Gespräche über Duchamp war das mit dem inzwischen verstorbenen Philip Johnson, als wir uns zur Geschichte der Architektur austauschten. Wir haben den Einfluss der Readymades im Design diskutiert sowie den Einfluss von Gewerbekunstschauen auf Duchamp. Wie Du und Molly habe auch ich verschiedene Menschen getroffen, die Duchamp mit ihren eigenen Augen gesehen haben, was wirklich etwas ganz besonderes ist. Ich war also einmal mit Rem Koolhaas bei Philip und der sagte: »Rem, weißt du, die intelligentesten Menschen, die ich in meinem Leben je getroffen habe, das sind Marcel Duchamp und du«. Eines der Dinge, die ich am meisten an Deiner Ausstellung über Marcel Duchamp in München[2] mochte, ist das dokumentarische Filmmaterial über alltägliche Ereignisse in den Straßen von München 1912, das ihr in einem Archiv aufgestöbert habt. Das zeigt uns München, wie Duchamp die Stadt gesehen hat.

THOMAS GIRST Angenommen man würde im Jahre 2112 eine Ausstellung über einen Künstler, der sich im Jahr 1912 eine zeitlang in München aufgehalten hat, genau so kuratieren wie wir das zum Anlass des hundertsten Jahrestages von Duchamps dreimonatigen Aufenthalt in der bayrischen Hauptstadt gemacht haben: es würde keinen Sinn mehr ergeben. Es gibt keinerlei Einheit von Raum und Zeit mehr. In einer Zeit ohne Telefon, E-Mail, Radio oder TV können wir die Dinge, die Duchamp in seiner unmittelbaren Umgebung interessierten, die ihn aus bestimmten Gründen inspiriert haben könnten, wen er getroffen haben mag, zumindest als auf Fakten basierende Behauptung formulieren. Hundert Jahre später in München 2012 könnte man sich aber auch einfach in einem kleinen Zimmer aufhalten, das man nie verlässt, während

2 *Marcel Duchamp in München 1912*, 31. März – 15. Juli 2012, Lenbachhaus München, kuratiert von Helmut Friedel, Thomas Girst, Matthias Mühling, Felicia Rappe; s. *Marcel Duchamp in München 1912*, hrsg. von Helmut Friedel, Thomas Girst, Matthias Mühling, Felicia Rappe, Ausst.-Kat. Lenbachhaus München, München 2012.

So my take would be that Duchamp should change the way that art historians write about art and not only about Duchamp.

HANS ULRICH OBRIST Definitely. And I think he built many bridges: the bridge between art and science, for example. We could talk about the link to Henri Poincaré. He also built bridges between art and more industrial displays. He connected art, science, literature, music. One of my most fascinating conversations about Duchamp was with the late Philip Johnson on the history of architecture. We discussed the influence of the Readymade in design as well as the influence of trade fairs on Duchamp. Like both of you, I met several people whose eyes actually saw Duchamp, which is an extraordinary thing. I was with Philip and with Rem Koolhaas and Philip says: "Rem, you know, I've met two people in my life who are the most intelligent people I ever spoke to—Marcel Duchamp and you." One of the things that I liked the most about your exhibition of Marcel Duchamp in Munich,[2] is the archive footage you unearthed of ordinary things happening on the streets of Munich in 1912. It shows us the Munich as Duchamp saw it.

THOMAS GIRST Let's say you did a show of an artist in 2112 who spent some time in Munich in 2012, the way we did the show in 1912 about the hundred year anniversary of Duchamp's three-month stay in the Bavarian Capital in 1912: it would not make sense anymore. There is no more unity of time and space. With no telephone, no e-mail, no radio, no TV, we can look at the things that could have been of interest to Duchamp in his immediate environs, what could have inspired him and why, whom he met, etc. One hundred years later in Munich in 2012 you could just be in a little room which you never leave, be in constant touch with your friends in Daressalam and be inspired by a billboard in Kuala Lumpur. One would have no way of knowing.

HANS ULRICH OBRIST With the footage in the show, all of a sudden you see Munich through Duchamp's very own eyes. It was fascinating to learn in your exhibition that he saw industrial displays at the Bavarian Trade Fair and the Deutsches Museum. That's something that Philip Johnson picked up on with his *Machine Art* exhibition in New York in 1934,[3] and it's another thing I learned from Duchamp's writings: his idea of not confining himself to the art world. A lot of things can happen when we go beyond the fear of pooling knowledge.

2 *Marcel Duchamp in Munich 1912*, March 31–July 15, 2012, curated by Helmut Friedel, Thomas Girst, Matthias Mühling, Felicia Rappe, Lenbachhaus, Munich; see Helmut Friedel, Thomas Girst, Matthias Mühling, Felicia Rappe, eds., *Marcel Duchamp in Munich 1912*, exh. cat. Lenbachhaus Munich, (Munich, 2012).
3 *Machine Art*, March 7–April 16, 1934, curated by Philip Johnson, then MoMA's Chairman of the Department of Architecture, at the Museum of Modern Art, New York.

man ständig in Kontakt mit Freunden in Daressalam ist oder sich von einem Billboard in Kuala Lumpur inspirieren lässt. Es gäbe keinerlei Möglichkeit mehr, das zu wissen.

HANS ULRICH OBRIST Mit dem Filmmaterial in der Duchamp-Ausstellung sieht man München plötzlich mit den Augen Duchamps, mit dessen eigenen Augen. Es war in der Ausstellung auch faszinierend zu sehen, dass er offensichtlich Ausstellungen industriell gefertigter Objekte auf der Bayrischen Gewerbeschau und im Deutschen Museum sah. Das ist etwas, was Philip Johnson in seiner Ausstellung zur Maschinenkunst in New York 1934 herausarbeitete.[3] Und das ist etwas anderes, was ich aus Duchamps Schriften gelernt habe, sein Gedanke, sich nicht allein auf die Kunstwelt zu beschränken; es kann viel passieren, wenn wir die Furcht überwinden, unser Wissen untereinander in Verbindung zu setzen.

MOLLY NESBIT Duchamp ist ein durchtriebener Reiseführer. Sich eine Zeit lang mit seiner Arbeitsweise zu beschäftigen, wenn man den Mut dazu aufbringt, bahnt den Weg zu einer Ausbildung, die weit über Systeme und Logik hinausführt. Das ist der Punkt, an dem die meisten Akademiker innehalten müssen, weil man einen Bereich betritt, den Wittgenstein liebte und Nietzsche verehrte. Das ist nicht für jeden was, das ist unsicheres Terrain, wo sich eine Art von Wissen findet, das von der Vernunft entkoppelt scheint.

THOMAS GIRST Glaubst Du auch, dass Duchamp den gleichen Einfluss auf die Kunstgeschichte, auf das Schreiben über Kunst haben kann, wie er ihn auf die Kunst selbst hatte?

MOLLY NESBIT Nein, noch nicht. Sich wirklich mit seiner Arbeit beschäftigen und über Unsicherheiten zu schreiben bedeutet nämlich, dass man ein anderes Buch schreiben muss, als es die Universitäten befürworten — einige haben das getan. Ecke Bonks Buch über die *Boîte-en-valise* ist eins davon.[4] Duchamps Arbeit und seine eigenen Schriften dazu bieten zahlreiche Herausforderungen und eine davon ist es, etwas zu schreiben, das eben nicht nur Kommentar ist. Duchamp machte sein Desinteresse an dem, was man über ihn zu sagen hatte, was man an Erklärungen zu seinem Werk aufbot, sehr deutlich. Aber gleichzeitig ist seine Arbeit für Künstler ebenso kompliziert, weil man sie nicht ein-

3 *Machine Art*, 7. März–16. April 1934, kuratiert von Philip Johnson, dem späteren Vorsitzenden des Instituts für Architektur im Museum of Modern Art, New York.
4 Ecke Bonk, *Marcel Duchamp: The Box-in-a-valise. De ou par Marcel Duchamp ou Rrose Sélavy*. Bestandsaufnahme einer Edition durch Ecke Bonk, München/New York 1989.

MOLLY NESBIT Duchamp is a really tricky travel guide. To spend time with his way of working, if one has the stomach for it, produces the way to an education going beyond systems and logic. That is the point where most academics have to stop—you enter a zone that Wittgenstein loved and Nietzsche adored. It is not for everybody, it is very insecure, there is a kind of knowledge there that is not always reasonable.

THOMAS GIRST Do you also think that Duchamp could have the same impact on art history, on the writing about art, as he had on art itself?

MOLLY NESBIT No, not yet. Precisely because to really deal with the work, to write about the insecurities, means you have to write a different kind of book than the one the university prefers. Some people certainly have done that. Ecke Bonk's book on the *Boîte-en-valise* is one of them.[4] Duchamp's work and his own writing about it offers many challenges and one of them is the challenge to write something which is not commentary. Duchamp was pretty clear about his disinterest in what people had to say about his work, producing their own explanations. But, at the same time, for artists his work is an equally complicated matter because you can't repeat it and have the same surge of liberation, it is not possible. You have to find your own points of liberation. I do not have the answer for the problem of how to respond to Marcel Duchamp.

THOMAS GIRST Did you find him handsome?

MOLLY NESBIT Well I never met him. The thing to remember is that he had a kind of an irresistible charm when he wasn't off taking a break from everyone for yet another two weeks. He had this odd sense of humor which was surprising yet charming. Those who knew him, and in the 1990s I spoke to many of those that were part of Teeny's [Duchamp's wife] and Marcel's New York social circle, all they talk about is how natural he was. Which is not the way we normally think about him, and so this is worth stressing. Part of our responsibility, certainly my responsibility when I am teaching at Vassar, is to pass that knowledge of Duchamp forward.

4 Ecke Bonk, *Duchamp, Marcel: The Box-in-a-valise: De ou par Marcel Duchamp ou Rrose Sélavy.* Inventory of an Edition by Ecke Bonk (Munich/ New York, 1989).

THOMAS GIRST Duchamp surely has many facets. Besides doing what he did, he was a chess player, a cheese merchant, an inventor, an art

fach wiederholen und die gleiche Woge an Befreiung erleben kann, das ist nicht möglich. Man muss seine ureigenen Ansätze zur Befreiung finden. Ich habe keine Antwort auf das Problem, wie man Marcel Duchamp begegnen sollte.

THOMAS GIRST Sah er gut aus?

MOLLY NESBIT Nun ja, ich habe ihn nie getroffen. Woran man sich erinnern sollte, ist, dass er einen unwiderstehlichen Charme hatte, wenn er nicht gerade wieder für zwei Wochen fort war, um sich von allem und jedem zu erholen. Er hatte diesen eigenwilligen Sinn für Humor, der überraschte und charmant war. Diejenigen, die ihn kannten – in den 1990er-Jahren sprach ich mit vielen, die Teil von Teenys [Duchamps Frau] und Marcels gesellschaftlichem Umfeld in New York waren – bemerkten stets, wie natürlich er war. Was nicht dem entspricht, wie wir gewöhnlich über ihn denken, weswegen das durchaus erwähnt werden sollte. Ein Teil unserer Verantwortung und ganz besonders meine Verantwortung, wenn ich am Vassar College lehre, ist es, eben auch dieses Wissen über Duchamp weiterzugeben.

THOMAS GIRST Duchamp hat gewiss viele Facetten. Nebenbei war er auch ein Schachspieler, ein Käsehändler, ein Erfinder, ein Kunsthändler, ein Theoretiker, er sprach von sich selbst als »Atmender«, als »Bricoleur« oder als der berüchtigte »An-Artist«. Diese Liste geht noch weiter. Wie Sartre einmal sagte, ergibt das Leben nur in der Retrospektive Sinn, zumindest denken wir, dass es das tut. Mit Duchamp kann man diese Punkte auf so vielfältige Weise verbinden, mir fallen dabei immer die Zeilen von Walt Whitman ein: »Widerspreche ich mir? Nun gut, dann widerspreche ich mir. Ich bin groß, in mir sind Welten«.[5] Was zeitgenössische Künstler betrifft, finden Sie es ungewöhnlich, dass einige von ihnen immer noch glauben, es sei ikonoklastisch, die Readymades zu benutzen? Ich glaube, man kann so viel mehr von Duchamp lernen: wie man seine eigenen Werke in Museen und Ausstellungen unterbringt, den Kunstmarkt umgeht, ein Kurator wird. Warum, glauben Sie, beziehen sich so viele Künstler auf Duchamp als den Großvater ihrer Ideen?

HANS ULRICH OBRIST Er ist ein Künstler mit immensem Einfluss. Dennoch wäre es außerordentlich reduzierend zu sagen, »dieses oder jenes ist der Grund, warum junge Künstler an Duchamp interessiert

5 Walt Whitman, *The Complete Poems*, London 1996, S. 123 [Übersetzung des Autors].

dealer, a theoretician, referring to himself as a "breather," a "bricoleur," or as the infamous "an-artist." The list goes on. As Sartre once pointed out, life only makes sense in retrospect, at least we think it does. With Duchamp you can connect the dots in so many different ways, it always brings to my mind Walt Whitman's lines "Do I contradict myself? Very well then I contradict myself. I am large, I contain multitudes."[5] When it comes to contemporary artists, do you find it strange how some of them still believe it to be iconoclastic to make use of a Readymade? I think one can learn so much more from Duchamp: How to position your own works in museums and exhibitions, short-circuiting the art market, being a curator. Why do you think so many artists refer to Duchamp as their grandfather of ideas?

HANS ULRICH OBRIST He's an artist of immense influence. Yet it would be incredibly reductive to say that this or that is why young artists are interested in him, because they're interested for so many different reasons. I can answer with just one aspect that's particularly pertinent or relevant now. It's something that was emphasized by Bruce Nauman, who was himself very inspired by Duchamp. Nauman early on understood that overexposure can be a problem. We live in an epoch of extreme overexposure.

THOMAS GIRST "The great artist of tomorrow will go underground."[6]

HANS ULRICH OBRIST It's an idea that many artists talk to me about. It's only a relatively recent development—this extraordinarily large number of exhibitions and exhibition venues that have proliferated since the 1980s. This is something that Nauman had already understood by the early 70s. He resisted overexposure in many different ways. As Gilles Deleuze once said, "Be in the middle of things, but be in the center of nothing." Slowness is of importance as well. With Shumon Basar and Joseph Grima, I've just written what we call a "Posthastist Manifesto," a text where we appeal for a rediscovery of moments of slowness. And Duchamp, I'm sure, can be of help here. Art is often fast, if you compare it with an epic novel like Vikram Seth's *A Suitable Boy* (1993), which he worked on for ten years. Vikram told me recently that his new book, *A Suitable Girl*, again grows over many years, it's a marathon not a sprint. With the acceleration all around him, Duchamp also seemed to have taken his time. He worked for nine years on his *Large*

5 Walt Whitman, *The Complete Poems* (London, 1996), p. 123.
6 Last sentence of a lecture by Marcel Duchamp, "Where do we go from here?" held at the Philadelphia Museum College of Art, March 1961; reproduced in Anthony Hill, ed., *Duchamp: Passim. A Marcel Duchamp Anthology* (East Roseville, 1994), p. 89.

sind«, weil sie aus so unterschiedlichen Gründen an ihm interessiert sind. Ich kann diese Frage mit lediglich einem Aspekt beantworten, der heute besonders angemessen oder relevant ist, etwas, das Bruce Nauman hervorhob, der selbst sehr von Duchamp inspiriert wurde. Nauman hat früh verstanden, das vermehrte Visibilität für den Künstler ein Problem darstellen könnte. Wir leben in einer Zeit oder eher in einer Epoche der extremen Zurschaustellung und Künstlerpräsenz.

THOMAS GIRST »The great artist of tomorrow will go underground.«[6]

HANS ULRICH OBRIST Das ist ein Gedanke, über den viele Künstler heute mit mir reden, eine sehr junge Entwicklung seit den 1980er-Jahren, diese außergewöhnlich hohe Zahl an Ausstellungen und Ausstellungsorten. Das ist etwas, was Bruce Nauman in den frühen 1970er-Jahren noch gar nicht verstanden hatte, aber bereits lebte. Er widerstand dieser Zurschaustellung in vielerlei Hinsicht. Wie Gilles Deleuze einmal sagte: »In allem mittendrin sein, aber im Zentrum von nichts«. Langsamkeit ist ein weiterer wichtiger Aspekt. Mit Shumon Basar und Joseph Grimal habe ich verfasst, was wir ein »Posthastist Manifesto« nennen, einen Text, in dem wir zu einer Wiederentdeckung der Langsamkeit aufrufen. Und Duchamp, da bin ich mir sicher, kann hier hilfreich sein. Kunst ist oft schnell, wenn man diese mit einem epischen Roman wie zum Beispiel Vikram Seths *A Suitable Boy* (1993) vergleicht, an dem er über zehn Jahre lang arbeitete. Vikram hat mir kürzlich erzählt, das sein neues Buch, *A Suitable Girl,* gleichfalls über viele Jahre hinweg langsam Gestalt annimmt, es ist ein Marathon, kein Sprint. Inmitten der Beschleunigung um ihn herum schien Duchamp sich gleichfalls stets die Zeit zu nehmen, die er benötigte. Er arbeitete neun Jahre lang an seinem *Großen Glas* (1915-1923) und über zwanzig Jahre an *Étant donnés* (1946-1966). Wie ein Autor, der an einem Roman schreibt.

THOMAS GIRST Diese ganzen jungen Künstler, die sich nach ihrerersten Einzelausstellung sehnen. Arthur C. Danto erzählte mir einmal, dass er das Gefühl hat, dass die meisten von ihnen aus dem falschen Grund Künstler seien: Ruhm und Geld. Wann immer ich die Möglichkeit habe, lasse ich junge Künstler wissen, was Nietzsche einmal in einem seiner Gedichte schrieb: »Wer viel einst zu verkünden hat / Schweigt viel in sich hinein / Wer einst den Blitz zu zünden hat / Muss lange Wolke sein!«[7]

6 Letzter Satz eines Vortrags von Marcel Duchamp, »Where do we go from here?«, gehalten im Philadelphia Museum College of Art im März 1961; abgedruckt in: *Duchamp: Passim. A Marcel Duchamp Anthology*, hrsg. von Anthony Hill, East Roseville 1994, S. 89.
7 Friedrich Nietzsche, *Briefwechsel. Kritische Gesamtausgabe* III 7/1, Berlin 2003, S. 995.

Glass (1915–1923) and for over twenty years on *Étant donnés* (1946–1966), just like a writer working on a novel.

THOMAS GIRST All those young artists craving for that first solo show. Arthur C. Danto once told me he has the feeling that most of them are artists for the wrong reason now: fame and money. Whenever I have the chance I let young artists know what Nietzsche once wrote in a poem of his: "who one day will proclaim a lot / remains silent more often than not / who one day sets off a lightning / for a long time a cloud must be."[7]

MOLLY NESBIT If you really take Duchamp seriously as an artist, you have to walk the gangplank. That takes a certain courage. It is not the thing any artist can do regularly, the timing has to be right; and not everybody has the strength to live with their art like that, completely independent, in an almost structureless condition. Duchamp had a very special kind of stamina. He really did not need the support of others for his work. He got it, but did not particularly want it, which was part of his independence. I think only a few people would be capable of living that independently, even geniuses.

HANS ULRICH OBRIST I think another aspect we can learn from Duchamp—another one of at least eleven dimensions—is his idea that the viewer is just as important as the artist within the creative process.[8] And yet another dimension of Duchamp for me would be as an inventor of display features. In my interviews with Richard Hamilton, we talked about this extensively. These talks with Richard were really a masterclass in which he taught me that the only memorable exhibition is one that invents new display features. Just like García Lorca's analogy of a corkscrew that taps right into the memory of the audience, display features are the corkscrew of every exhibition. And Duchamp was a master curator not only in this regard. Think of the *Twelve Hundred Coal Bags*; think of the *Sixteen Miles of String!*[9] Through studying Duchamp's writings, I became very interested in this idea, which is key for so many of my shows today: the effort to develop and experiment with display features.

MOLLY NESBIT Yes, yes, certainly, and we should note here that the corkscrew was to be an unrealized Readymade. The door to the work of Marcel Duchamp opens in many ways and in many places. It opens

7 Friedrich Nietzsche, *Briefwechsel, Kritische Gesamtausgabe* III 7/1 (Berlin, 2003), p. 995 [author's translation].
8 See Marcel Duchamp, "The Creative Act," a lecture held in April 1957 during the convention of the American Federation of Arts, Houston, Texas, reprinted in Anthony Hill 1994 (see note 6), pp. 87–88.
9 As a curator for the *Exposition Internationale du Surréalisme* at the Galerie Beaux-Arts, Paris, January 17–February 24, 1938, Marcel Duchamp, among other things suspended 1,200 coal bags from the ceiling of the central exhibition room; *First Papers of Surrealism*, October 14–November 7, 1942, 451 Madison Avenue, Coordinating Council of French Relief Societies, Inc., New York. He also stretched miles of twine all over the room between the displays, like unruly cobwebs.

MOLLY NESBIT Wenn man Duchamp als Künstler wirklich ernst nimmt, dann muss man den Sprung ins kalte Wasser wagen. Dazu braucht es einen gewissen Mut. Es ist nicht etwas, was jeder Künstler regelmäßig zu tun vermag, das Timing muss stimmen und nicht jeder hat die Kraft, mit seiner Kunst dergestalt zu leben, vollkommen unabhängig, in einem fast strukturlosen Zustand. Duchamp hatte eine ganz besondere Art von Ausdauer. Er brauchte die Unterstützung anderer für seine Arbeiten nicht. Er bekam sie, aber er war nicht zwingend darauf aus, das war ein Teil seiner Unabhängigkeit. Ich glaube, nur sehr wenige Menschen sind in der Lage, so unabhängig zu leben, sogar Genies können das nicht.

HANS ULRICH OBRIST Ich glaube, ein Aspekt, den wir ebenfalls von Duchamp lernen können und der nur eine weitere von bestimmt elf Dimensionen ist, ist Duchamps Idee des Betrachters, der im kreativen Prozess genauso wichtig ist wie der Künstler.[8] Eine ganz andere Dimension bei Duchamp wäre für mich die, ihn als Erfinder von neuen Möglichkeiten der Ausstellung von Kunst zu sehen. In meinen Interviews mit Richard Hamilton sprach ich darüber sehr ausführlich. Für mich waren diese Gespräche mit Richard wirklich eine Meisterklasse, in der er mich lehrte, dass der einzige Weg, eine Ausstellung in Erinnerung zu behalten, der sei, auch neue Kriterien der Darstellung zu finden. Ähnlich wie García Lorcas Analogie eines Korkenziehers, der direkt in das Gedächtnis des Publikums hineindreht. Darstellungskriterien sind der Korkenzieher einer jeden Ausstellung, und Duchamp war ein Meisterkurator, nicht nur in diesem Sinne. Denken Sie an die *Twelve Hundred Coal Bags*, denken Sie an die *Sixteen Miles of String*![9] Während ich Duchamps Schriften studierte, begann mich eine Idee zu interessieren, die noch heute der Schlüssel zu vielen meiner Ausstellungen ist: das Bestreben, neue Formen der Ausstellung zu entwickeln und damit zu experimentieren.

MOLLY NESBIT Ja, ganz bestimmt — und wir sollten hier nicht unerwähnt lassen, dass der Korkenzieher tatsächlich ein nicht realisiertes Readymade ist. Die Tür zum Werk von Marcel Duchamp öffnet sich auf unterschiedliche Weise und an vielen Orten. Überall auf der Welt, wie wir wissen. Duchamps Erbe wird an und durch jene Menschen vermittelt, die durch eine dieser Türen gehen — und jeder einzelne von ihnen hat dabei seine ganz eigene Geschichte zu erzählen. So weit ich das

8 S. Marcel Duchamp, »The Creative Act«, Vorlesung gehalten im April 1957 während der Versammlung der American Federation of Arts in Houston, Texas; abgedruckt in: Anthony Hill 1994 (wie Anm. 6), S. 87–88.
9 Als Kurator für die *Exposition Internationale du Surréalisme* in der Galerie Beaux-Arts in Paris vom 17. Januar bis zum 24. Februar 1938 hing Marcel Duchamp unter anderem zwölfhundert Kohlesäcke von der Decke des zentralen Ausstellungsraums; *First Papers of Surrealism*, 14. Oktober bis 7. November 1942, 451 Madison Avenue, Coordinating Council of French Relief Societes, Inc., New York. Für die Installation nutzte Duchamp hunderte Meter Faden, die er durch den ganzen Raum sowie zwischen den Ausstellungsobjekten wie widerspenstige Spinnennetze spannte.

around the world, as we know. Duchamp's legacy is transmitted by different people walking through one of these doors—and every one of them has their own tale to tell. As I understand the door for you both was the door for many of the German speakers that opened thanks to Serge Stauffer. Maybe we could begin by talking about the door that Stauffer built. When you were still a teenager, did you get his books?

HANS ULRICH OBRIST Everything I've learned about art, I've learned from artists, and obviously Duchamp has always been what we would call an artist's artist. Of course, early on I made the pilgrimage to Philadelphia, where all his major works are. But yes, I remember the big book by Serge Stauffer with Duchamp's writings and notes in German, rendered typographically, beautiful and elegant.[10] My frequent visits to the studio of Fischli and Weiss as a teenager were my art education. David Weiss had told me to buy this book and somehow it was also related to André Thomkins, since Stauffer was close friends with him. Thomkins is also a very Duchampian artist; he made these amazing bachelor machine-like drawings. As a student I bought a print of his, which I kept on my bedroom wall, an incredibly dense print with a lot of constellations and movements, which were reminiscent to me of the drawings that Duchamp had done in Munich in 1912, and which again came to my mind while walking through Thomas's Duchamp exhibition. But Weiss told me to buy that book by Stauffer.

THOMAS GIRST Unfortunately Stauffer's book was very expensive, heavy and huge. He also had published a more affordable book with Duchamp's aphorisms.[11] But it was the big book that got me into Duchamp more. You just knew Duchamp must be interesting when you witness someone like Stauffer being that obsessed with him, being so interested in this man. You opened the book and you entered a great mind, another presence. The Duchamp universe through Stauffer's typographical rendering of the notes published in his lifetime was at once hilarious and highly sophisticated, a universe entirely of its own. Probably something every teenager needs.

HANS ULRICH OBRIST It was like entering a world.

THOMAS GIRST It felt the same way in Stauffer's Duchamp archives that are now kept in Stuttgart. The level of obsession was breathtaking.

10 Serge Stauffer, ed., *Marcel Duchamp. Die Schriften* (Zurich, 1981).
11 Serge Stauffer, ed., *Marcel Duchamp Readymade: 180 Aussprüche aus Interviews mit Marcel Duchamp* (Zurich, 1973).

sehe, war eure Tür jene, die Serge Stauffer geöffnet hat, wie für viele deutschsprachige, an Duchamp Interessierte. Vielleicht können wir über diese Tür sprechen, die Stauffer aufbaute. Als Du noch ein Teenager warst, wie kamst Du da an seine Bücher heran?

HANS ULRICH OBRIST Alles, was ich über Kunst gelernt habe, habe ich von Künstlern gelernt, und offensichtlich war Duchamp immer jemand, den wir eines Künstlers Künstler nennen. Natürlich begab ich mich sehr früh auf Pilgerreise nach Philadelphia, wo der Großteil seines Werks zu sehen ist. Ich erinnere mich auch an das dicke Buch von Serge Stauffer mit den Schriften und Notizen Duchamps auf Deutsch, in der Typographie angepasst, wunderschön und elegant.[10] Meine häufigen Besuche bei Fischli und Weiss waren meine Kunsterziehung. David Weiss hatte mir empfohlen, dieses Buch zu kaufen, und irgendwie war es auch mit André Thomkins verbunden, weil Stauffer ein enger Freund von ihm war. Thomkins ist auch ein großer Duchamp-Künstler, er hatte diese tollen Zeichnungen, die der »Junggesellenmaschine« glichen. Als Student kaufte ich einen seiner Drucke, den ich an meiner Schlafzimmerwand aufhing und an den ich mich erinnerte, als ich durch Thomas' Duchamp-Ausstellung ging. Ein unheimlich dichter Druck mit vielen Konstellationen und Bewegungen, die mich an die Zeichnungen erinnerten, die Duchamp in München 1912 gefertigt hatte. Und Weiss sagte mir, dass ich das Buch von Serge Stauffer kaufen sollte.

THOMAS GIRST Leider war Stauffers Buch sehr teuer, schwer und groß. Er hat aber auch ein günstigeres Buch mit Aphorismen Duchamps veröffentlicht.[11] Aber es war mehr das dicke Buch, das mich zu Duchamp brachte. Man wusste einfach, dass Duchamp interessant sein musste, wenn man jemanden wie Stauffer erlebte, der so besessen von ihm, so interessiert an diesem Mann war. Man öffnete das Buch und trat ein in diesen großen Geist, eine andere Präsenz. Das Duchamp-Universum trat durch Stauffers typografische Anpassung der Notizen, die zu seinen Lebzeiten veröffentlicht wurden, gleichzeitig hochraffiniert und vergnügt zutage, ein Universum ganz für sich. Vermutlich etwas, das jeder Teenager braucht.

HANS ULRICH OBRIST Es war, als würde man eine neue Welt betreten.

10 *Marcel Duchamp. Die Schriften*, hrsg. von Serge Stauffer, Zürich 1981.
11 *Marcel Duchamp Readymade: 180 Aussprüche aus Interviews mit Marcel Duchamp*, hrsg. von Serge Stauffer, Zürich 1973.

The dozens of letters he had sent to track down one minor detail of one work by Duchamp. His own correspondence with Duchamp and the one hundred very specific, very focused questions he had sent to him once. I saw the meticulousness and also realized how important it was to have a life outside your infatuation with Marcel. The sheets of tracing paper and measurements undertaken just to come to grips with the functionality of the *Boîte*!

MOLLY NESBIT He was on some level a classically trained scholar and scholars were trained to measure like that. It is not a character defect, it is a sign of seriousness. Apart from Stauffer and a few others, though, there seemed to be a silence in German-speaking Europe in regard to Marcel Duchamp. Joseph Beuys said "The Silence of Marcel Duchamp is Overrated" (1964) and it is quite a bon mot! Did this have a reality? There was not much of Duchamp's work to see in Germany, right?

THOMAS GIRST You are quite right. There are barely any works by Duchamp in German collections, even today. Nothing in Munich, a *boîte* at the Kunsthalle Hamburg, a few later versions of the Readymades at the Neue Nationalgalerie Berlin or the Museum Ludwig in Cologne, *Bagarre d'Austerlitz* (1921) and *Pollyperruque* (1967) at the Staatsgalerie Stuttgart. Only in 1997, the Staatliche Museum Schwerin acquired the Duchamp collection of Belgian dealer Ronny van de Velde with almost one hundred works. It is interesting you bring up Joseph Beuys. I just love that sentence, especially the "overrated" always makes me question my motives while working away on Duchamp, even early on it held my hagiographical ways on Duchamp in check. With Polke, Kippenberger, Richter, Oehlen, many German artists in post-war Germany were actually very interested in Duchamp's work. Richter's *Ema, (Nude on a Staircase, 1966)* is at the Museum Ludwig in Cologne and could also be thought of as a placeholder for the absence of Duchamp's works throughout German collections.

MOLLY NESBIT Even the French had problems actually seeing the work by Duchamp until recently whereas the collections in the US, in Philadelphia, Yale and MoMA are brimming with works of his. People in the US can come to Duchamp through different routes—the Philadelphia route, the New Haven route, the New York route. In Germany, his work was difficult to access, and the conditions of that obscurity are

THOMAS GIRST In Stauffers Duchamp-Archiv, das jetzt in Stuttgart ist, fühlte es sich genauso an. Der Grad der Besessenheit war atemberaubend. Die unzähligen Briefe, die er verschickt hatte, um ein einziges kleines Detail einer Arbeit von Duchamp aufzustöbern. Seine eigene Korrespondenz mit Duchamp und die hundert sehr spezifischen, sehr fokussierten Fragen, die er ihm einst geschickt hatte. Das Ausmaß der Akribie war bemerkenswert, und gleichzeitig erkannte ich, wie wichtig es ist, ein Leben außerhalb dieser Hingabe zu Marcel zu führen. Die vielen Pauspapierblätter und die Abmessungen, die er unternahm, nur um die Funktionsweise der *Boîte* zu ergründen!

MOLLY NESBIT Bis zu einem gewissen Grad war er ein klassisch ausgebildeter Wissenschaftler und Wissenschaftler waren darin geübt, dergestalt vorzugehen. Das ist keine Charakterschwäche, das ist ein Zeichen von Ernsthaftigkeit. Abgesehen von Stauffer und einigen wenigen anderen scheint es aber im deutschsprachigen Raum ein generelles Schweigen über Marcel Duchamp gegeben zu haben. Joseph Beuys sagte: »Das Schweigen des Marcel Duchamp wird überbewertet« (1964), und das ist ein ziemliches Bonmot! Entsprach das der Realität? Es gab nicht viele von Duchamps Arbeiten in Deutschland zu sehen?

THOMAS GIRST Ja, richtig. Es gibt kaum Arbeiten von Duchamp in deutschen Sammlungen, bis heute nicht. Nichts in München, eine *Boîte* in der Kunsthalle Hamburg, ein paar späte Editionen der Readymades in der Neuen Nationalgalerie Berlin oder im Museum Ludwig in Köln, *Bagarre d'Austerlitz* (1921) und *Pollyperruque* (1967) in der Staatsgalerie Stuttgart. Erst 1997 erwarb das Staatliche Museum Schwerin von dem belgischen Händler Ronny van de Velde einen Großteil von dessen Duchamp-Sammlung mit knapp 100 Arbeiten. Es ist interessant, dass Du Joseph Beuys erwähnst. Ich liebe diesen Satz einfach, besonders das »überbewertet« lässt mich stets meine Motive hinterfragen, wenn ich über Duchamp drauflosarbeite, es hielt sogar meine hagiografische Begeisterung in Schach. Mit Polke, Kippenberger, Richter und Oehlen waren zahlreiche deutsche Künstler im Nachkriegsdeutschland sehr interessiert an Duchamps Arbeit. Richters *Ema (Akt auf einer Treppe)* (1966) ist im Museum Ludwig in Köln ausgestellt und ist eine Art Platzhalter für das Fehlen von Arbeiten Duchamps in deutschen Sammlungen.

very particular. This means there was a whole landscape that needed to be drawn for someone like Hans Ulrich or you. Let's take this as an occasion to remap. The conditions of silence and obscurity are different. How did Stauffer get to Stuttgart?

THOMAS GIRST I was lucky to archive his Duchamp library and estate at the Staatsgalerie Stuttgart while I was in my mid-20s in 1997. Stauffer passed away in 1989. Ulrike Gauss, then the director of the Prints and Drawing department there, knew him well and had gotten everything to Germany in a small truck she herself drove up from Zürich to Stuttgart. In 1992 she published all of the interviews and statements by Duchamp which had been painstakingly collected by Stauffer,[12] something that is still not available in English today.

HANS ULRICH OBRIST His first book, the huge one, was also the beginning of my interest in artist's writings. Duchamp's collected writings, which Stauffer so meticulously put together, were for me the most fascinating thing about Duchamp. I read and reread and reread them and then, as a teenager, I thought, "Why not do something similar with Gerhard Richter?" whom I'd befriended. So it was actually this book by Stauffer on Duchamp that gave me the idea to edit Richter's writings. And obviously, there's a link between the two that we could talk about for hours. What Stauffer also did for me was that he made me want more. And I then found a little publication, the German edition of Pierre Cabanne's *Dialogues With Marcel Duchamp*.[13] Now, these conversations were the second long interviews with an artist that I'd read, the first one being David Sylvester's interviews with Francis Bacon from the 1960s and 1970s. I read Cabanne's book until it literally fell apart. I read it for a year, every day for an hour on my way to and from school on the train. It became my bible. And this was the moment that I thought I should start to begin to record interviews with artists. Because I read that these interviews were based on three afternoons with Marcel Duchamp. So I decided to buy a tape recorder and document my conversations with artists.

THOMAS GIRST Those interviews with Pierre Cabanne were done two years before he passed away. Reading Duchamp in his own words, how he contradicted himself—all that is always indefinitely more interesting than what any Duchamp scholar could ever write about him.

12 Serge Stauffer, *Marcel Duchamp. Interviews und Statements* (Ostfildern, 1992).
13 Pierre Cabanne, *Gespräche mit Marcel Duchamp* (Köln, 1972).

MOLLY NESBIT Sogar die Franzosen hatten bis vor kurzem ihre Probleme damit, Duchamps Arbeiten in ihrem eigenen Land zu sehen, während die Sammlungen in den Vereinigten Staaten, in Philadelphia, Yale und im MoMA zahlreiche Werke von ihm vereinen. In den USA kann man sich Duchamp auf den verschiedensten Routen nähern. Über die Philadelphia-Route, die New Haven-Route, die New York-Route. In Deutschland war es schwieriger, sich seine Arbeiten zu erschließen, die Rahmenbedingungen für seine Obskurität waren sehr speziell. Das heißt, dass es eine ganze Landschaft gab, die es für jemand wie Dich oder Hans Ulrich erst einmal zu erschaffen galt. Das erscheint mir eine Möglichkeit, alles neu zu kartieren. Die Rahmenbedingungen für Schweigen und Obskurität sind verschiedene. Wie kam Stauffer nach Stuttgart?

THOMAS GIRST Ich hatte das Glück 1997 seine Duchamp-Bibliothek sowie seinen Nachlass in der Staatsgalerie Stuttgart archivieren zu dürfen, als ich gerade Mitte 20 war. Stauffer starb 1989. Ulrike Gauss, damals Leiterin der Graphischen Sammlung dort, kannte ihn sehr gut und hatte alles in einem kleinen LKW, den sie selbst von Zürich nach Stuttgart gefahren hatte, nach Deutschland gebracht. 1992 veröffentlichte sie die Interviews und Statements Duchamps, die von Stauffer sorgfältig gesammelt worden waren,[12] sie sind bis heute nicht auf Englisch verfügbar.

HANS ULRICH OBRIST Sein erstes Buch, das dicke, war gleichsam der Beginn meines Interesses an Schriften von Künstlern. Duchamps gesammelte Schriften, die Stauffer so akribisch zusammengestellt hatte, waren für mich letztlich das Faszinierendste überhaupt an Duchamp. Ich las sie wieder und wieder und wieder, und dann dachte ich — als Teenager: warum nicht so etwas Ähnliches für Gerhard Richter machen, mit dem ich befreundet war? Es war also tatsächlich das Buch von Stauffer über Marcel Duchamp, das mich auf den Gedanken brachte, Gerhard Richters Schriften zu editieren. Und offenbar gibt es eine Verbindung zwischen den beiden, über die wir stundenlang reden könnten. Was Stauffer ebenfalls mit mir machte, war, dass ich mehr wollte. Und dann fand ich eine kleine Publikation, die deutsche Ausgabe von Pierre Cabannes *Gespräche mit Marcel Duchamp*.[13] Diese Gespräche waren die zweitlängsten Interviews mit einem Künstler, die ich je gelesen hatte, die ersten waren David Sylvesters Interviews mit

12 Serge Stauffer, *Marcel Duchamp. Interviews und Statements*, Ostfildern 1992.
13 Pierre Cabanne, *Gespräche mit Marcel Duchamp*, Köln 1972.

MOLLY NESBIT Let's take one more step here. When you began to map a landscape for yourself, where did you want to start after the door was opened and you passed through it? Sometimes it is luck, sometimes it is fate.

THOMAS GIRST It all started out with Salvador Dalí, of course, as a young teenager. A fan-like infatuation which made me read everything by or about him I could get my hands on—I then wrote art reviews for a school newspaper I had founded. Vermeer, Joyce, and Proust I spent entire summers with. And then there was Duchamp and he never went away. When I was sixteen, I wanted to go to Cologne and see the Duchamp show at the Museum Ludwig. My parents didn't let me, they thought I could see everything exhibited there in the stores of my hometown as well. A year later, in 1989, I went to high-school in the US, producing one linocut after the other of the *Chocolate Grinder* (1913) in art class and went straight down to the Philadelphia Museum of Art as soon as I had the possibility. Back in Germany me and a friend, Jens Kiefer, would call up the German Duchamp scholars Ecke Bonk, Dieter Daniels and Herbert Molderings to inquire about how to get in touch with Duchamp's wife Teeny. Also, Serge Stauffer had just died and besides his big book I had been greatly inspired by photos from a road trip he had taken to Duchamp's birthplace in Blainville-Crevon which had been published in the 1988 Cologne catalogue.[14] So the moment I had a car at age eighteen I went there as well. At that time, Teeny Duchamp had invited me and my friend to her house near Fontainebleau. Jacqueline Matisse Monnier and her son Antoine, Sophie Matisse and her husband Alain Jacquet, were all there and what I thought would be the ultimate climax of my obsession with Duchamp was actually just the beginning—on another level, as I then started to write about him in more depth, though certainly with a juvenile passion![15] We had also built a miniature "Étant donnés-en-boîte" as a present for Teeny which Jackie and Antoine were sweet enough to keep. I saw it again after over twenty years while discussing the Munich exhibition with them in Villiers-sous-Grez. When studying at New York University in my early twenties I did a lot of research for Duchamp scholar Francis M. Naumann, running off to libraries, looking at microfiche records for days on end. The years I later spent at Harvard professor Stephen Jay Gould's and Rhonda Roland Shearer's Art Science Research Laboratory between 1999 and 2003 were mostly devoted to working on Duchamp

14 Serge Stauffer, "Weg zu/weg von Marcel Duchamp," in Alfred M. Fischer und Dieter Daniels, eds., *Übrigens sterben immer die anderen. Marcel Duchamp und die Avantgarde seit 1950*, exh. cat. Museum Ludwig (Köln, 1988), pp. 11–15.

15 "Chez Marcel," a collage photo-essay written in 1991 at the age of nineteen and published in Thomas Girst, Jens Kiefer, eds., *Die Aussenseite des Elementes* 1 (Hamburg, 1992).

Francis Bacon aus den 1960er- und 1970er-Jahren. Ich las Cabannes Buch, bis es buchstäblich auseinanderfiel, ich nahm es im Zug mit zur Schule, ich las es ein ganzes Jahr lang, jeden Tag für eine Stunde auf dem Weg zur und von der Schule, es wurde meine Bibel. Und das war dann wirklich der Moment, in dem ich dachte, ich sollte damit beginnen, Interviews mit Künstlern aufzuzeichnen. Ich hatte gelesen, das Cabannes Interviews auf Gesprächen mit Duchamp an nur drei Nachmittagen beruhen. Ich entschied mich also, ein Aufnahmegerät zu kaufen und meine Gespräche mit Künstlern zu dokumentieren.

THOMAS GIRST Diese Interviews mit Pierre Cabanne wurden zwei Jahre, bevor er starb, geführt. Duchamp in seinen eigenen Worten zu lesen, wie er sich oft selbst widersprach — das ist alles immer unendlich viel interessanter als irgendein Duchamp-Forscher je über ihn schreiben könnte.

MOLLY NESBIT Gehen wir hier noch einen Schritt weiter. Als du damit angefangen hast, dir eine Landschaft zu erschließen, wo wolltest Du beginnen, nachdem die Tür offen stand und Du hindurch geschritten warst? Manchmal ist es Glück, manchmal Schicksal.

THOMAS GIRST Es begann natürlich alles mit Salvador Dalí, als ich ein Teenager war. Eine Vernarrtheit, die mich alles von und über ihn, das ich bekommen konnte, lesen ließ — ich schrieb damals Kunstkritiken für eine Schülerzeitung, die ich gegründet hatte. Vermeer, Joyce und Proust folgten ihm alle während langer Sommer. Und dann gab es da Duchamp und er ließ mich nicht mehr los. Als ich 16 Jahre alt war, wollte ich nach Köln fahren und die Duchamp-Ausstellung im Museum Ludwig sehen. Meine Eltern ließen mich nicht, sie dachten, ich könnte genau so gut alles dort Ausgestellte in den Läden meiner Heimatstadt anschauen. Ein Jahr später, 1989, ging ich auf die High School in den Vereinigten Staaten und fertigte an der Kunstschule von *Schokoladenreibe* (1913) einen Linolschnitt nach dem anderen an und ging so oft ich konnte ins Philadephia Museum of Art. Zurück in Deutschland wollten Jens Kiefer, ein Freund von mir, und ich von den deutschen Duchamp-Forschern Ecke Bonk, Dieter Daniels und Herbert Moldeerings wissen, wie wir Kontakt zu Duchamps Frau Teeny herstellen könnten. Serge Stauffer war gerade gestorben und neben seinem großen Buch war ich auch besonders von den Fotos einer Reise fasziniert, die

and the online journal about him. But how about you Molly? I remember reading your essay on Duchamp's early exposure to everyday objects through geometric drawing taught at schools in a 1993 essay collection published by MIT.[16]

MOLLY NESBIT An earlier version had been published years before in *October*.[17] That was actually my very first writing on Duchamp. You, Thomas, took Duchamp as someone who presented you with a set of coordinates with which you could proceed in life. There's joy in it but also insanity as one person's life cannot become another person's life. But you were lucky and so was I because we were both introduced to Duchamp by someone who knew him as a person, namely Teeny. I went to Yale as a student, and there of course was the collection of the Société Anonyme, collected, as we all know, in part by Duchamp, with many of his works on display there as well. Robert Herbert was teaching the modern art that emerged fundamentally with machine aesthetics at its core and Duchamp's work was part of this. Forces of industrialization had overcome everybody. Artists had to think about of how to proceed and become increasingly modern.

Through the back door of my own research I realized the importance of the mechanical drawing instruction everyone was getting in the public school system at the turn of the last century, how it featured the everyday object in a very prominent way, geometrically. That is what led me to write my first little article about the Readymades. Then I was told by people in the field, Jacques Caumont and Jennifer Gough-Cooper, that I absolutely had to write to Teeny. So, I did this very shyly as I wasn't used to being in touch with the living, that is, with living history. It was one of the best things that ever happened to me because for one thing Teeny Duchamp had you understand all of Marcel Duchamp's existence as being human first and foremost, as a person—all the things he did were a result of his having lived on earth like everybody else. That gave me a way to ground the work of Marcel Duchamp. That was very different from anything I would have gotten at school. And I now see that for many people who have ended up working for years on Duchamp, long after he himself had passed away, that they had been introduced to Duchamp by someone who knew him as a person—whether it was Teeny or Richard Hamilton as in the case of Sarat Maharaj. Or Walter Hopps, you name it. Many people have showed others where the doors were. This did not involve alchemical mystery;

16 Molly Nesbit, "The Language of Industry," in Thierry de Duve, ed., *The Definitely Unfinished Marcel Duchamp* (Cambridge, 1993), pp. 351–384.
17 Molly Nesbit, "Ready-Made Originals," *October* 37 (Summer 1986), pp. 53–64.

er zu Duchamps Geburtshaus in Blainville-Crevon gemacht hatte und die in dem Katalog aus dem Jahr 1988 in Köln veröffentlicht worden waren.[14] Und dann kam auch der Moment, in dem ich mit 18 endlich ein Auto bekam. Zu der Zeit hatte Teeny Duchamp mich und meinen Freund in ihr Haus in der Nähe von Fontainebleau eingeladen. Jacqueline Matisse-Monnier und ihr Sohn Antoine, Sophie Matisse und ihr Mann Alain Jacquet, sie waren alle dort, und ich dachte, es würde der ultimative Höhepunkt meiner Leidenschaft für Duchamp sein, dabei war es tatsächlich nur der Anfang — auf einer anderen Ebene, weil ich dann begann, tiefgründiger über ihn zu schreiben, aber natürlich mit einer jugendlichen Leidenschaft![15] Wir hatten außerdem eine Miniatur »Étant donnés-en-Boîte« als Geschenk für Teeny gebaut, die Jackie und Antoine liebenswerterweise aufbewahrten. Ich sah sie über 20 Jahre später wieder, als ich mit ihnen die Münchner Ausstellung in Villiers-sous-Grez besprach. Als ich mit Anfang 20 an der New York University studierte, recherchierte ich sehr viel für den Duchamp-Forscher Francis M. Naumann, ich rannte in Bibliotheken, las tagelang Mikrofiche-Filme alter Zeitungen. Die Jahre zwischen 1999 und 2003, die ich im Art Science Research Laboratory von Harvardprofessor Stephen Jay Gould und Rhonda Roland Shearer verbrachte, waren vor allem der Arbeit zu Duchamp und dem Online-Journal gewidmet, das sich mit dem Künstler ausführlich befasst. Aber was ist mit Molly? Ich erinnere mich, Deinen Beitrag über Duchamps frühe Kenntnis alltäglicher Objekte durch geometrische Zeichnungen, die er in der Schule erlernte, gelesen zu haben, veröffentlicht vom MIT in einer Essay-Sammlung von 1993.[16]

MOLLY NESBIT Eine frühere Version war Jahre zuvor in *October*[17] veröffentlicht worden. Das war tatsächlich mein erster Text über Duchamp. Thomas, Du hast Duchamp als jemanden wahrgenommen, der dir einen Satz von Koordinaten präsentierte, mit denen Du im Leben weitergehen konntest. Das birgt Freude, aber auch Wahnsinn, weil jemandes Leben nicht das einer anderen Person werden kann. Aber wir hatten Glück, weil wir beide von jemandem mit Duchamp bekannt gemacht wurden, der ihn als Person kannte, nämlich Teeny. Ich war Studentin in Yale, und dort gab es natürlich die Sammlung der Société Anonyme, die, wie wir alle wissen, in Teilen von Duchamp selbst zusammengestellt war — mit vielen seiner eigenen Arbeiten. Robert Herbert unterrichtete moderne Kunst, deren Kern sich aus der Maschinenästhetik entwickelte, und

14 Serge Stauffer, »Weg zu/weg von Marcel Duchamp«, in: *Übrigens sterben immer die anderen. Marcel Duchamp und die Avantgarde seit 1950*, hrsg. von Alfred M. Fischer und Dieter Daniels, Ausst.-Kat., Köln 1988, S. 11 ff.
15 »Chez Marcel« eine Photo-Essay-Collage, geschrieben 1991 im Alter von 19 Jahren, veröffentlicht in: *Die Außenseite des Elementes* 1, hrsg. von Thomas Girst und Jens Kiefer, Hamburg 1992.
16 Molly Nesbit, »The Language of Industry«, in: *The Definitely Unfinished Marcel Duchamp*, hrsg. von Thierry de Duve, Cambridge 1993, S. 351 ff.
17 Molly Nesbit, »Ready-Made Originals« in: *October*, 37, Sommer 1986, S. 53 ff.

these were responses to life. They do not make the mysteries evaporate. Duchamp's responses to life were very complex. The longer one stays with his work, the more one sees further layers, further complexities, deep dreams.

HANS ULRICH OBRIST Leonora Carrington was also a great person to talk to, who knew Duchamp. I visited her with Pedro Reyes in 2003 in Mexico. She helped him to install the *Sixteen Miles of String* for the 1942 Surrealist exhibition in New York.[18] I really do believe that Duchamp is a superstring artist—even in a literal sense, if we think about his use of string within his oeuvre. I also talked to Walter Hopps about Duchamp, who organized his first retrospective in Pasadena, when Duchamp was already in his late seventies.[19] Which brings us back to overexposure. If you think about this Pasadena show, Duchamp still had something to be amused by late in his life—he hadn't fired all his guns, he'd kept his powder dry. That's something a lot of young artists are interested in right now. I'll never forget that when I went to Germany as a young man to work with Kasper König, one evening Thomas Bayrle took me aside and said, "Hans Ulrich, you go very very very fast. You need to have a secret garden and you need to cultivate this garden, otherwise you're going to burn out within a nano-second." That was the most important message anyone had ever given to me. And it's a very Duchampian advice. For Duchamp's last twenty-five years, *Étant donnés* was his secret garden.

This conversation is an edited blend of e-mail exchanges, recorded dialogues, Skype interviews and one actual face-to-face meeting which all took place in late spring / early summer of 2012.

18 "Marcel and I arranged an exhibition. I was a good friend of Marcel's. We got very bored putting up all these strings." Leonora Carrington, quoted from the transcript of an unpublished interview between the artist and Hans Ulrich Obrist, 2003.
19 *By or of Marcel Duchamp or Rrose Sélavy*, October 8–November 3, 1963, curated by Walter Hopps at the Pasadena Art Museum (now Norton Simon Museum), Pasadena, California.

Duchamps Arbeit war ein Teil davon. Die Kräfte der Industrialisierung hatten jeden überwältigt, und die Künstler mussten darüber nachdenken, wie es weitergeht, sie wurden zunehmend moderner.

Durch eine Hintertür in meiner damaligen Forschung bemerkte ich, wie wichtig mechanische Lehrzeichnungen in diesem Kontext waren, die jeder im öffentlichen Schulsystem zur Jahrhundertwende erlernen musste, und wie Alltagsgegenstände rein geometrisch dargestellt wurden. Das war es, was mich den ersten kleinen Beitrag über die Readymades schreiben ließ. Von den Duchamp-Kennern Jacques Caumont und Jennifer Cough-Cooper wurde ich daraufhin aufgefordert, unbedingt Teeny zu schreiben. Das tat ich, schüchtern wie ich war, weil ich nicht wusste, wie man Kontakt mit den Lebenden, mit der lebenden Geschichte, knüpft. Es war eines der besten Dinge, die mir je passiert sind, weil Teeny Duchamp mir verständlich machte, dass Marcel Duchamps gesamte Existenz zunächst und vor allem die eines Menschen, einer Person, war: all die Dinge, die er tat, ein Ergebnis davon waren, wie eben jeder andere auch auf dieser Welt gelebt zu haben. Das gab mir die Möglichkeit, die Arbeit Marcel Duchamps zu erden. Es war ganz anders als alles, was ich in der Schule gelernt hatte. Und ich bemerke das bei vielen, die jahrelang über Duchamp gearbeitet haben, nachdem er selbst gestorben war, dass sie durch jemanden an ihn herangeführt worden waren, der ihn als Person selbst gekannte hatte, ob es nun Teeny war oder Richard Hamilton wie im Falle von Sarat Maharaj. Oder Walter Hopps oder wer auch immer. Viele wiesen dorthin, wo die Türen waren. Dazu brauchte es keine alchemistischen Geheimnisse, sondern es waren Reaktionen auf das Leben. Das lässt die Geheimnisse nicht verfliegen. Duchamps Reaktionen auf das Leben waren hochkomplex. Je mehr man sich mit ihm auseinandersetzt, umso mehr bemerkt man weitere Ebenen und Komplexitäten, tiefere Träume.

HANS ULRICH OBRIST Mit Leonora Carrington konnte man sich wunderbar unterhalten und sie kannte Duchamp. Ich habe sie 2003 in Mexiko zusammen mit Pedro Reyes besucht. Sie half ihm die Schnüre für die Surrealisten-Ausstellung in New York 1942 zu installieren, seine *Sixteen Miles of String*.[18] Ich glaube tatsächlich, dass Duchamp ein Superstring-Künstler ist — sogar im buchstäblichen Sinn, wenn wir an die zahlreiche Verwendung von Fäden in seinem Werk denken. Ich habe auch mit Walter Hopps über Duchamp gesprochen, der dessen erste Retrospektive in Pasadena kuratierte, als Duchamp schon in den

18 »Marcel und ich arbeiteten an der Ausstellung. Wir waren miteinander befreundet. All diese Schnüre zu installieren wurde uns sehr langweilig.« Leonore Carrington, zitiert aus der Transkription eines Interviews zwischen der Künstlerin und Hans Ulrich Obrist, 2003 [Übersetzung des Autors].

späten 70ern war.[19] Was uns zur übertriebenen Präsenz, zur Zurschau-stellung zurückbringt. Duchamp hatte auch spät in seinem Leben noch viel, über das er sich amüsieren konnte. Und wenn man an diese Pasa-dena-Ausstellung denkt, dann hatte Duchamp noch längst nicht all sein Pulver verschossen, er war auf der Hut. Das treibt derzeit viele zeit-genössische Künstler um. Ich vergesse nie, wie ich als junger Mann nach Deutschland kam, um mit Kasper König zusammen zu arbeiten, und mich Thomas Bayrle eines Abends beiseite nahm und sagte: »Hans Ulrich, du bist sehr schnell, sehr, sehr, sehr schnell. Du brauchst einen geheimen Garten, und du musst diesen Garten hegen und pflegen, sonst brennst du in der nächsten Nanosekunde aus«. Das war die wich-tigste Botschaft, die mir jemals jemand mit auf den Weg gegeben hat. Und das ist ein sehr duchampscher Rat. In Duchamps letzten 25 Jah-ren war *Étant donnés* sein geheimer Garten.

Aus dem Englischen von Janina Wildfeuer

Das Gespräch ist eine editierte Zusammenfassung aus einem E-Mail-Austausch, auf-gezeichneten Unterhaltungen, Skype-Interviews und einem Treffen, die alle im Spät-frühling/Frühsommer 2012 stattgefunden haben.

19 *By or of Marcel Duchamp or Rrose Sélavy*, 8. Oktober–3. November 1963, kuratiert von Walter Hopps im Pasa-dena Art Museum (heute Norton Simon Museum), Pasadena, Kalifornien.

I
DUCHAMP FÜR ALLE
DUCHAMP FOR EVERYONE

Marcel Duchamp, *Flatternde Herzen*, 1936/1961, Siebdruck, 32,4 × 51 cm,
Staatliches Museum Schwerin – Kunstsammlungen, Schlösser und Gärten

Marcel Duchamp, *Fluttering Hearts*, 1936/1961, serigraph, 32.4 × 51 cm,
Staatliches Museum Schwerin – Kunstsammlungen, Schlösser und Gärten

DUCHAMP FÜR ALLE

Wer damit beginnt, sich intensiver mit einem Künstler von gewisser Bekanntheit auseinanderzusetzen, wird recht bald feststellen, dass der Großteil des geistigen wie materiellen Erbes und damit auch der Bedeutung, die diesem zukommt, selten mehr als von einem halben Dutzend Menschen verwaltet wird: das für den Nachlass verantwortliche Familienmitglied; der Galerist, der über die meisten Werke des Künstlers verfügt; der Sammler, der die kostbarsten Werke des Künstlers besitzt; das Museum, das über die wichtigste Sammlung von Werken eines Künstlers verfügt; der Kurator, der wichtige Ausstellungen über den Künstler ermöglicht; schließlich der Kunsthistoriker oder -kritiker, der über einen Künstler am umfangreichsten publiziert, wobei hier die Königsdisziplin das Werkverzeichnis bleibt. Oft sind sich diese Menschen untereinander spinnefeind — was nicht selten etwas mit Streitereien um Geld zu tun hat, wie mit einer unterschiedlichen Auffassung über den Künstler selbst. Was nicht weiter schlimm wäre, würden diese Zwistigkeiten nicht allzu häufig dazu führen, dass dadurch signifikante Forschungsarbeiten blockiert werden und der allgemeine Zugang zum Künstler das Bauernopfer interner Grabenkämpfe zwischen verfeindeten Lagern wird.

Bei Marcel Duchamp verhält es sich dergestalt, dass er noch zu Lebzeiten selber dafür Sorge trug, die meisten seiner Werke in kaum mehr als drei Museen zu platzieren, weswegen er für den Kunstmarkt, also Galeristen, Auktionshäuser und Privatsammler, keine besondere Rolle spielt — es fehlen schlichtweg die wichtigen Arbeiten dazu. Der Nachlass selber wird von den Kindern und Nachfahren von Duchamps zweiter Frau Alexina »Teeny« Duchamp verwaltet, die — ein weiterer Glücksfall — gemäß Duchamps Diktum der Meta-Indifferenz nur in den abstrusesten Fällen von Appropriationskunst eingreifen und ansonsten Forschung, Ausstellungsgestaltung und Nutzung des visuellen Vokabulars Duchamps durch andere Künstler vergleichsweise freien Lauf lassen. Bei idealen Grundvoraussetzungen wie diesen ist es umso be-

DUCHAMP FOR EVERYONE

Whoever begins to focus more intensively on a well-known artist will soon discover that a large part of his or her intellectual and material heritage as well as the overall significance attributed to him or her is usually overseen by no more than half a dozen people: the family member responsible for the estate; the gallery owner in possession of the greatest number of works; the collector who owns the most valuable works by the artist; the museum with the most important collection of works by the artist; the curator who has enabled important exhibitions about the artist; finally the art historian or art critic who has published most extensively on the artist, with the highest achievement in this category being defined by writing the catalogue raisonné. More often than not, the people involved are feuding with one another—most frequently due to conflicts based on monetary matters but also generated by differences of opinion pertaining to the perception and reception of the artist in question. This would be of little concern if these conflicts did not ultimately hinder and even render impossible significant research or altogether block the publication of scholarly findings and impede the general accessibility of the artist to the public by rendering him a pawn offered up in the internal battles within the trenches of opposing camps.

In the case of Marcel Duchamp, one finds an artist who, already during his own lifetime, saw to it that the majority of his most important works be placed in no more than three museums, which means that he now plays no major role within the speculative art market comprised of gallery owners, auction houses and private collectors. The estate itself is overseen by the children of Duchamp's second wife Alexina "Teeny" Duchamp and their families, all of whom, another stroke of luck and fortunately in harmony with Duchamp's own dictum of meta-indifference—solely veto the most abstruse examples of appropriationist art. When it comes to research, exhibitions, or the use of Duchamp's visual vocabulary by other artists, the estate is generous, caring and genuinely interested—all of which should not be taken for granted. In

fremdlicher, dass Duchamp, den mehr zeitgenössische Künstler als ein Quell ihrer Inspiration angeben als irgendjemand sonst, in der öffentlichen Wahrnehmung über das Wissen um seinen Namen und eine diffuse Ahnung von dessen Wirkung hinaus meistens ohne Bedeutung bleibt. In der kulturellen Berichterstattung und Fachliteratur wird dessen Name zwar gerne und häufig aufgeführt, meistens jedoch, um lediglich verkürzt auf ein sich wandelndes künstlerisches Bezugssystem — Veränderung des Kunstbegriffs durch die Verwendung von Gebrauchsgegenständen, Ikonoklasmus der Avantgarde, et cetera — zu verweisen.[1] Auch gereicht es zum Vorteil, wenn Feuilletonisten, Kunsthistoriker, Künstler, Museumsmenschen in ihren Texten hier und da Duchamp erwähnen, gilt er doch vielen, wenn auch vage, als einer der intelligentesten Künstler des 20. Jahrhunderts. Allein die Geste bleibt von innen hohl und wird dem Facettenreichtum dieses Mannes kaum gerecht. Dabei beschied ihm schon 1912 Guillaume Apollinaire, seine Kunst könne »Werke von unvorstellbarer Kraft hervorbringen. Möglicherweise spielt sie sogar eine soziale Rolle«.[2] Abschließend formuliert der Dichter und Freund Duchamps: »Vielleicht wird es einem derart von ästhetischen Vorurteilen befreiten, derart um Energie bemühten Künstler wie Marcel Duchamp vorbehalten bleiben, Kunst und Volk wieder miteinander zu versöhnen«.[3] Selbst wenn Duchamp Apollinaires Worte später dankbar als wohlgemeinte Lobhudelei abtat, so formulieren sie doch einen Anspruch, dem die Literatur über Duchamp heute kaum gerecht zu werden vermag. Die Forschung zu Duchamp sollte es daher ebenso zum Ziel haben, die Primärliteratur — Schriften, Briefe, Interviews — wissenschaftlich zu erschließen und deren Lektüre allen Interessierten zu ermöglichen, auch und gerade unter Einbeziehung der neuen Medien. Würde etwa ein wissenschaftliches Projekt die zu Lebzeiten wie posthum veröffentlichten und mitunter heute noch zum Teil schwer zugänglichen Notizen Duchamps mehrsprachig und online mit Querverweisen interaktiv zur Verfügung stellen, man könnte gleichsam viele hundert größtenteils ab- bzw. durchgetrennte und sowohl vorder- als auch rückseitig beschriebene Zettel und Schreibvorlagen einem Puzzle oder den Qumran-Rollen ähnlich wieder zusammenfügen. Nicht nur für die konkrete Duchamp-Forschung täte sich ein neues, erkenntnisreiches Feld auf. Ein weiteres Anliegen sollte es sein, über die Vermittlung wissenschaftlicher Erkenntnisse zur Wertschätzung Duchamps unter Künstlern ebenso wie in der Populärkultur beizutragen. Der Anspruch wird nicht verwässert, die Rigidität und Kohärenz der Forschung nicht

1 Vincenzo Latronico, »Statistics«, in: *Frieze*, September 2011, S. 16.
2 »Marcel Duchamp«, in: Guillaume Apollinaire, *Die Maler des Kubismus*, Zürich 1956, S. 105 ff., S. 107.
3 Ebd., S. 108.

the light of such ideal prerequisites, it is all the more perplexing that Duchamp, whom more artists name than any other as their source of inspiration, still remains obscure in the general public perception—beyond a recognition of his name and a vague sense of his influence. In cultural and scholarly writing he is often referred to, but for the most part cursorily, reduced to signifying paradigmatic shifts within art historical coordinates—the transformation of the concept of art itself through the incorporation of mass-produced objects, the iconoclasm of the avant-garde, etc.[1] It can also be of advantage for critics, for art historians, artists and museum directors to mention Duchamp here and there as for the most part he is acknowledged, even if only vaguely, as one of the most intelligent artists of the twentieth century. But the reference on the whole remains empty and fails to take into account the multifaceted layers of Duchamp. Already in 1912, it was Guillaume Apollinaire who declared that his art could "bring forth works of unimaginable power and that potentially it could even assume a social role."[2] In conclusion, the poet summarized the characterization of his friend Duchamp, "Perhaps it will be the role of someone so free of aesthetic prejudices to bring about the reconciliation of art and the common man."[3] Even if Duchamp later gratefully downplayed Apollinaire's words as well-meaning yet naïve praise, this prediction established a standard which the literature devoted to Duchamp today can scarcely achieve. Research on Duchamp should therefore have as its goal a close scholarly examination of the primary literature—writings, correspondence, interviews—but also a concentrated effort to make the results accessible to all those interested, in particular through the use of new media. Were a research project to make all notes of Duchamp available—those published during his lifetime as well as posthumously, many of which remain hard to come by—in many languages and online with cross-referencing and possibilities for interaction, then one could assemble all these hundreds of notes, often written on the front and back sides of scraps of paper, not unlike a puzzle or the Dead Sea Qumran rolls. Rich, new fields of inquiry would open up, and not only those restricted to Duchamp research. A further objective should be scholarly contributions to the understanding of Duchamp's significance that would enrich popular knowledge as well as the understanding of Duchamp by other artists.

The standards would not be watered down, nor the rigidity and coherence of existing research reduced were one to make Duchamp's life and work more universally understandable and thereby seek for words

1 Vincenzo Latronico, "Statistics," *Frieze* (September 2011).
2 Guillaume Apollinaire, *The Cubist Painters: Aesthetic Meditations* (New York, 1970), p. 48.
3 Guillaume Apollinaire 1970, p. 48.

beeinträchtigt, würde man Duchamps Leben und Werk allgemeinverständlicher, fernab des selbstreferentiellen akademischen Vokabulars, weit außerhalb des Elfenbeinturms zu formulieren suchen. Duchamp als Zersetzer, Individualist und Bilderstürmer inmitten eines westlich geprägten Kunstkanons – der allen gut gemeinten Bemühungen der letzten Jahrzehnte zum Trotz noch allzu oft als hegemoniale Bedeutungshudelei wahrgenommen wird – ist gerade in Asien wie im Mittleren Osten und Südamerika als befreiende Kraft willkommen und hoch angesehen.[4] Die in diesem Buch versammelten Texte wollen Interesse an Duchamp selber wecken und letztlich nichts anderes aufzeigen als das Potenzial, welches Duchamp für eine offene Kunstgeschichtsschreibung uneingeschränkt birgt, sowohl inhaltlich als auch formal.

4 Bedri Baykam, *Monkey's Right to Paint and the Post-Duchamp Crisis. The Fight of a Cultural Guerilla for the Rights of Non-Western Artists and the Empty World of the Neo-Ready-Mades*, Istanbul 1994, S. 212, S. 303.

beyond the realm of self-referential academic vocabulary and outside the ivory tower in which academic research is often conducted. Duchamp as a dis-locater, individualist and iconoclast in the midst of an art canon established with a primarily Western bias which, regardless of all well-meaning efforts of the last decades, nevertheless continues to be perceived all too often as a hegemonical hodge-podge of self-importance. For it is Duchamp as a liberating figure who is welcomed, in particular in Asia as well as in the Middle East and South America, all regions in which he is held in high esteem.[4] The texts collected in this book wish to awaken interest for Duchamp himself and, in the end, to demonstrate nothing more than the potential end even the guidance that Duchamp offers for an open history of art, in terms of content as well as of form.

Transl. Harriett Watts

4 Bedri Baykam, *Monkey's Right to Paint and the Post-Duchamp Crisis: The Fight of a Cultural Guerrilla for the Rights of Non-Western Artists and the Empty World of the Neo-Ready-Mades* (Istanbul, 1994), see p. 212, p. 303.

DER TROJANISCHE FLAKON
MARCEL DUCHAMPS *BELLE HALEINE*

Als junger Mann gab Marcel Duchamp 1918 die Malerei komplett auf, nachdem er ab 1912 ohnehin nur noch wenige Studien in Öl und eine Auftragsarbeit auf Leinwand schuf. Die revolutionäre Geste der Verweigerung ähnelt der seines Landsmannes Arthur Rimbaud, der Lyrik und Prosa bereits mit 21 Jahren den Rücken kehrt. Während die Zäsur des Dichters einen kompletten Lebenswandel markierte, rümpfte Duchamp vor allem über die »olfaktorische Masturbation«[1] seiner Künstlerkollegen die Nase. Im Rausch der Gerüche von Farbpasten und Tuben, vom Kunstwollen im Atelier ganz und gar durchdrungen Meisterwerke schaffen: Mit alldem wollte der rigorose Avantgardist trotz der Skandalerfolge als Maler rein gar nichts mehr zu schaffen haben.

Drei Jahre nach diesem Bruch rekurriert Duchamp erneut auf den Geruchssinn. Von seinem Freund Man Ray als Frau abgelichtet, wirbt Marcel Duchamp mit dem Alter Ego *Rrose Sélavy* – »Eros, c'est la vie« (»Eros ist das Leben«) – auf dem Label eines Parfumfläschchens wortspielreich für *Belle Haleine: Eau de Voilette* (1921, Abb. 1), in etwa: »Schöner Atem: Schleierwasser«.[2] Da Duchamp einen Flakon des Duftfabrikanten Rigaud für seine in New York entstandene Arbeit verwendet, zählt *Belle Haleine* zur Reihe seiner Readymades, die als industriell gefertigte Objekte in der verkürzt gängigen Lesart allein durch ihre Kontextualisierung im Kulturbetrieb zu Kunstgegenständen werden. Mit seinen Experimenten zu Duftwasser und Geschlechterrollen befindet sich Duchamp 1921 ausnahmsweise in bester Gesellschaft. Auf der anderen Seite des Atlantik kreiert Coco Chanel in Paris, ihrerseits nicht selten in Männerkleidung gesehen, zeitgleich das legendäre Parfum *Chanel No. 5*. Im gleichen Jahr in der gleichen Stadt schreibt James Joyce aus Frauenperspektive am inneren Monolog Molly Blooms, dem letztem Kapitel seines Jahrhundertromans *Ulysses*. In der bildenden Kunst bleibt Duchamp hier allerdings unangefochtener Pionier – ohne ihn keine Cahun, keine Sherman, kein Morimura – neben den Frauen-

1 Marcel Duchamp in einem Interview mit Georges Charbonnier; zit. n. Jennifer Gough-Cooper und Jacques Caumont, »Ephemerides on and about Marcel Duchamp and Rrose Sélavy, 1887–1968«, in: *Marcel Duchamp*, hrsg. von Pontus Hulten, Mailand 1993, o. S. [9.12.1960; Übersetzung des Autors].
2 »[A]llein auf dem Etikett stehen mehr Sprachspiele als ein Feuilleton Überschriften hat«, bemerkte zu Recht Peter Richter (»Das Clownsparfüm der Avantgarde«, in: *Frankfurter Allgemeine Zeitung*, 29.1.2011, S. 36). Neben »eau de voilette« (auch: »violette«) für »eau de toilette« können die Initialen »RS« (das »R« ist in Spiegelschrift wiedergegeben) im Englischen auch als »Arse« (»Arsch«) gelesen werden, »Haleine« ist gleichlautend mit »Hélène« (auf die »Schöne Helena« wird im Text noch eingegangen), und das zweite »R« in »Rrose« verweist neben Eros laut Duchamp auch auf »arroser« (»erregen«; Francis M. Naumann, *Marcel Duchamp: The Art of Making Art in the Age of Mechanical Reproduction*, New York 1999, S. 86 sowie Anm. 49, S. 94). Als *Voilette de Madame* hatte Guerlain bereits Anfang des 20. Jahrhunderts erfolgreich ein Parfum eingeführt. Zur Homo- und Polyphonie in *Belle Haleine* als Parodie und strategische Verschleierung, siehe Sherin Najjar, *Die unsichtbare Farbe: Der Gebrauch und die Funktion der Titel im frühen Werk Marcel Duchamps*, Weimar 2008, S. 59 ff.

THE TROJAN VIAL
MARCEL DUCHAMP'S *BELLE HALEINE*

As a young man, in 1918, Marcel Duchamp abandoned painting. Within the six years prior he had only completed a couple of studies in oil as well as one work on canvas that had been specifically commissioned. The revolutionary gesture of his denial is not unlike that of his compatriot Rimbaud, who at age twenty-one, had turned his back on writing. To the poet this juncture marked a complete break with his former way of life while Duchamp mostly looked down his nose at the "olfactory masturbation"[1] of his contemporaries. The emotional rush brought about by the smell of paints and tubes, the intertwined desire to create masterpieces in the studio: despite his success as a painter, the rigorous avantgardiste wanted nothing more to do with it.

Three years after this break, Duchamp began to reconsider the sense of smell in a whole new way. Photographed as a woman by his friend Man Ray, Marcel Duchamp dressed up as his alter ego *Rrose Sélavy*—"Eros, C'est la vie" ("Eros is life")—and thus depicted on the label of a perfume bottle, advertises *Belle Haleine: Eau de Voilette* (1921, fig. 1), or "Beautiful Breath: Veil Water," a work rich on wordplays.[2] Since Duchamp made use of a vial by the perfume manufacturer Rigaud for his New York work, *Belle Haleine* counts among his Readymades, which as industrial objects came to be considered works of art by the change of context from a store to an artistic setting. With his experiments with perfume and gender roles, in 1921 Duchamp found himself in rather good company. On the other side of the Atlantic, Coco Chanel, who was often seen dressed in men's clothing, was simultaneously creating the legendary perfume *Chanel No. 5* in Paris. In the same year and the same city, James Joyce was writing the interior monologue of Molly Bloom from a female perspective for the last chapter of his novel *Ulysses*. In the realm of visual art, from as early as the start of the 1910s, Duchamp remained an undisputed pioneer (without whom we would have no Cahun, no Sherman or Morimura)—alongside female represen-

1 Marcel Duchamp in an interview with George Charbonnier, quoted in Jennifer Gough-Cooper and Jacques Caumont, "Ephemerides on and about Marcel Duchamp and Rrose Sélavy, 1887–1968," in Pontus Hulten, ed., *Marcel Duchamp* (Milano, 1993), n. p. [December 9, 1960].
2 "On the label there are more word plays than an art review section has titles" as Peter Richter rightly remarked. See "Das Clownsparfüm der Avantgarde," *Frankfurter Allgemeine Zeitung* January 29, 2011, p. 36. Besides "eau de voilette" (also "violette") for "eau de toilette," the initials "RS" (the "R" in mirror-reverse on the label) can be read in English as "arse," "Haleine" sounds like "Hélène" (also discussed in the text) and the second "R" in "Rrose" means not only "Eros" but also hints at the French verb "arroser" ("to arouse"); see Francis M. Naumann, *Marcel Duchamp. The Art of Making Art in the Age of Mechanical Reproduction* (New York, 1999), p. 86 as well as fn. 49, p. 94. Guerlain had already successfully introduced a perfume, *Voilette de Madame*, at the start of the twentieth century. For homophony and polyphony in *Belle Haleine* as a parody and strategic veiling process, see Sherin Najjar, *Die unsichtbare Farbe: Der Gebrauch und die Funktion der Titel im frühen Werk Marcel Duchamps* (Weimar, 2008), pp. 59–61.

darstellungen durch Karl Valentin bis Charlie Chaplin im Theater- und Filmbereich bereits ab Anfang der 1910er-Jahre.

1921 ließ sich Duchamp von Man Ray sowohl in New York als auch später in Paris als *Rrose Sélavy* fotografieren, im April desselben Jahres wurde der etwa sechzehn Zentimeter hohe Flakon erstmalig auf dem von Duchamp gestalteten Cover der einzigen mit Man Ray herausgegebenen Ausgabe von *New York Dada* abgebildet (Abb. 2). Das Titelblatt ist komplett rosafarben, sicher ganz im Sinne von *Rrose*. *Belle Haleine* ist das einzige im Original erhaltene Assisted Readymade Duchamps. »Assisted«, da Duchamp keinen industriell gefertigten Gegenstand signiert, sondern durch den aufwendigen Entwurf des Labels auf einem massenproduzierten Flakon einen solchen nur vorgibt. Das Etikett ist eine Collage, die zuvor arrangiert und anschließend fotografiert wurde. Hierzu wurde das Porträtfoto in eine abgewandelte, vergrößerte Nachzeichnung des Etiketts eingeklebt. Abgezogen wurde die aufgenommene Collage auf in Form getrimmtes Barytpapier. Die Besonderheit des zu dieser Zeit üblichen Materials ist eine Schicht aus weißem Pigment (das Baryt genannte Bariumsulfat) zwischen dem Papierträger und der lichtempfindlichen, abschließenden Bindemittelschicht. Dadurch ähnelt es stark einem weiß gestrichenen Papier für Druckzwecke, wie es für den Etikettdruck in der Lithografie beziehungsweise im Chromo- und später Offsetlithografieverfahren damals angewandt wurde. Vor allem erhielt Duchamp durch den Umweg über die Fotografie eine homogene Oberfläche ohne im Streiflicht sichtbare Montagespuren, die seine Collage schnell verraten hätte.[3] Durch Duchamps vermutlich erst nach 1945 vorgenommene Überschreibung — mit »Rrose Sélavy« und dem Datum »1921« — der außen auf dem Karton angebrachten, goldenen Plakette, die den Namen des Parfums »Un Air Embaumé«, den Hersteller »Rigaud« und den Entstehungsort »Paris« trägt (Abb. 3), schafft dieser gleichsam ein Palimpsest, das als künstlerisches Verfahren auf das Spiel von Autorschaft, Identität und wortspielerischer Bedeutungsvielfalt innerhalb des Kartons verweist.

PROVENIENZ UND AUSSTELLUNGSKONTEXT, ZAHLENMYSTIK UND MARKENFLASCHE

Die erste Besitzerin von *Belle Haleine* nach der Entstehung des Readymade im April 1921 war Yvonne Chastel, die frühere Frau des Künstlers Jean Crotti, der nach der Trennung Duchamps Schwester Suzanne hei-

3 Die Angaben zur Herstellung basieren auf einer Untersuchung via Stereoauflichtmikroskop, die Georg Josef Dietz, Leiter des Kupferstichkabinetts der Staatlichen Museen zu Berlin, vornahm und in einer E-Mail vom 28.1.2011 an Hanna Streicher und Udo Kittelmann dokumentierte.

tations in the works of Karl Valentin and Charlie Chaplin within the worlds of theatre and film.

In 1921, Duchamp had his friend Man Ray photograph him as *Rrose Sélavy*, first in New York and later in Paris. In April that same year, the perfume bottle remodelled by Duchamp and Man Ray, some sixteen centimetres of height, was depicted on the cover of the initial and only issue of *New York Dada* (fig. 2). The title page was printed on pink paper, most likely as a nod to *Rrose*. *Belle Haleine* is itself the only surviving "Assisted Readymade" by Duchamp. "Assisted," because Duchamp did not sign a mass-produced industrial object but rather made us believe that we are looking at one. The label itself turns out to be a pre-arranged and re-photographed collage. The portrait photo was pasted onto a hand-drawn, modified version of the original label, while the collage thus created was produced on trimmed barite paper. At the time, the distinctiveness of the quite common barite paper was a layer of white pigment (barium sulphate) which was placed between the object and the light-sensitive gluing agent. As a result, it bore a strong resemblance to a piece of primed white paper used for printing purposes, as was common for the printing of labels in lithographical, chromo- and, later, offset-lithography processes. Through this procedural detour, Duchamp achieved a homogenous surface without any montage traces being visible in bright light, which would have quickly betrayed his self-manufactured label.[3] To our knowledge the box itself was signed only after 1945. Both "Rrose Sélavy" and the date, "1921," were written across the name of the perfume "Un Air Embaumé," the manufacturer "Rigaud" and the place of origin "Paris" initially listed on the golden label attached to the outside of the carton holding the vial (fig. 3). Duchamp thus created a palimpsest of sorts, which, as an artistic practice already hints at the game of authorship, identity and the multi-layered wordplays we are confronted with upon opening the box.

PROVENANCE AND EXHIBITION CONTEXT, NUMEROLOGY AND BRANDED BOTTLES

3 All information about the production are based on microscopic examinations, see the e-mail of the Director of Restoration at the Staatliche Museen in Berlin, Georg Josef Dietz, to Hanna Streicher and Udo Kittelmann from January 28, 2011.

The first owner of *Belle Haleine* in April 1921 was Yvonne Chastel, who had previously been married to the artist Jean Crotti. After the separation, Crotti married Duchamp's sister Suzanne, for whom the marriage would also be her second one. At the start of 1918 in New York, both Duchamp and his best friend Henri-Pierre Roché were in love with

ratete, für die es sich gleichfalls um die zweite Ehe handelte. In New York Anfang 1918 war Chastel sowohl Duchamps Geliebte als auch die seines engsten Freundes Henri-Pierre Roché, der allerdings heillos in Lou Arensberg, die Frau des Sammlers und Mäzens Walter Arensberg verliebt war, in deren Salon sich derweil alle trafen – bis Duchamp im September desselben Jahres spontan mit Chastel für knapp neun Monate nach Buenos Aires zog.[4] Über vierzig Jahre bleibt *Belle Haleine* in ihrem Besitz, bis sie 1964 – längst wieder verheiratet und nun als Yvonne Lyon in London wohnhaft – ihr Readymade über den britischen Künstler Richard Hamilton veräußern möchte, der zu dieser Zeit eine autorisierte Replik von Duchamps Hauptwerk *Die Braut von ihren Junggesellen entblößt, sogar / Das Große Glas (La Mariée mise à nu par ses célibataires, même / Le Grand verre*, 1915–1923, Abb. 4) anfertigt und eine große Retrospektive zum Werk Duchamps in der Tate Britain plant. In einem Brief an Hamilton vom 12.7.1964 schlägt Duchamp einen Preis von 500 US-Dollar vor, für den Lyon *Belle Haleine* an den New Yorker Kunsthändler Arne Ekstrom verkaufen solle.[5] Von dort geht die Arbeit in die Sammlung von Mary Sisler über,[6] um schließlich am 23.5.2009 auf der Aktion des Modedesigners Yves Saint Laurent und dessen Lebensgefährten Pierre Bergé, in deren Besitz sich der Flakon zuletzt befand, im Pariser Grand Palais von Christie's als Los Nummer 37 für knapp neun Millionen Euro an Unbekannt versteigert zu werden.[6a] Im Grand Palais endete Duchamps letzter großer Taschenspielertrick, der darin bestand, dass die ihm zugesprochene Bedeutung in der Kunst zwar stetig zunahm, dies aber kaum Auswirkung auf die erzielten Preise seiner Arbeiten im Kunstmarkt hatte. Wurde 2004 sein Pissoir *Fountain* (1917, Abb. 5) in einer Umfrage der BBC von 500 Kunstexperten zum einflussreichsten Kunstwerk der Moderne erklärt, so war die Edition von 1964 Anfang des Jahrtausends in New York noch für knapp über eine Million Dollar zu ersteigern. Bereits Zeit seines Lebens hatte es Duchamp vermocht, nahezu gänzlich an Galeristen und Auktionshäusern vorbei seine wichtigsten Werke bei wenigen Sammlern zu platzieren, die sie auf seine Anregung hin wenigen großen Museen vermachten, allen voran dem Philadelphia Museum of Art.[7] Duchamp war es gelungen, sich dem verhassten Kunstmarkt weitestgehend zu entziehen, indem er geschickt den Zugriff auf beinahe alle seine Hauptwerke und Originale verweigerte. Im Jahr der Versteigerung von *Belle Haleine* in Paris stellte Udo Kittelmann, als neuer Direktor der Nationalgalerien zu Berlin kaum in der Hauptstadt angekommen, eine spätere Edition

4 Calvin Tomins, *Marcel Duchamp: A Biography*, New York 1996, S. 201 f.
5 Jennifer Gough-Cooper und Jacques Caumont, »Ephemerides on and about Marcel Duchamp and Rrose Sélavy«, in: Hulten 1993 (wie Anm. 1), o. S. [12.7.1964].
6 Der Ausstellungskatalog *NOT SEEN and/or LESS SEEN of/by MARCEL DUCHAMP/RROSE SELAVY 1904–1964* der Mary Sisler Collection, wie diese vom 14.1.–13.2.1965 von der New Yorker Galerie Cordier & Ekstrom gezeigt wird, führt *Belle Haleine* ganzseitig als Nr. 71 (o. S.) auf.
6a Am 5. November 2012 wurde bei Sotheby's in New York die Label-Collage für »Belle Haleine« für $ 2,4 Millionen – und damit für über eine halbe Millionen Dollar mehr als der obere Schätzwert – versteigert, ein Rekord für eine Arbeit auf Papier von Duchamp.
7 Francis M. Naumann, »Marcel Duchamp. Money is no Object: The Art of Defying the Art Market«, in *Tout Fait: The Marcel Duchamp Studies Online Journal*, 2003. <www.toutfait.com/online_journal_details.php?postid=1501> (12.6.2012).

Chastel. Roché however, was also hopelessly in love with Lou Arensberg, the wife of collector and patron Walter Arensberg, in whose salon they all met—until Duchamp suddenly left for Buenos Aires with Chastel in September of the same year.[4] For over forty years, *Belle Haleine* belonged to Chastel—who was, by this time, long married and living in London as Yvonne Lyon—until 1964, when she decided to sell the Readymade via the British artist Richard Hamilton, who was creating an authorised replica of Duchamp's main work, *The Bride stripped Bare by Her Bachelors, Even / The Large Glass (La Mariée mise à nu par ses célibataires, même / Le Grand verre*, 1915–1923, fig. 4). Hamilton at that time was planning a large retrospective of Duchamp's work for the Tate Gallery in London, and in a letter to him of July 12, 1964, Duchamp suggested a price of $500, for which Lyon should sell *Belle Haleine* to New York Art Dealer Arne Ekstrom.[5] From there, it enters the collection of Mary Sisler[6] until eventually, on May 23, 2009, during a Christie's auction of the belongings of fashion designer Yves Saint Laurent and his partner Pierre Bergé, who last owned the vial, it sold as lot number 37 to an unknown bidder for almost €9 million.[6a] At the Grand Palais in Paris, where the auction took place, Duchamp's last trick came to an end, according to which his significance within the arts was steadily on the rise while this development had almost no impact on the art market. In 2004, his urinal, *Fountain* (1917, fig. 5) was voted as the most influential piece of modern art by 500 art experts in a BBC survey, yet at the start of the twenty-first century its 1964 edition sold at auction for just above $1 million. During his lifetime, Duchamp had managed to place his most important works almost entirely in the hands of a few collectors, who, at his suggestion, would bequeath them to a few large museums, amongst which the Philadelphia Museum of Art would be the one benefiting the most.[7] By skilfully refusing access to his main works and originals, Duchamp was largely successful in his efforts to withdraw from the art market he so despised—at least when it came to his own works. In the year in which *Belle Haleine* was auctioned in Paris, Udo Kittelmann, the then newly appointed director of the National Galerie Berlin, placed a later edition of Duchamp's *Bicycle Wheel* (1913, fig. 6) in the dead centre of the emptied-out, huge main hall of the Hamburger Bahnhof. The ultimate test, as if, based on a curious curator's experiment, the Readymade had to now prove once and for all that it had arrived within the cold heart of its very own apotheosis. Its ability to stand its ground in the eyes of visitors and not to burst under the

4 Calvin Tomkins, *Marcel Duchamp. A Biography* (New York, 1996), p. 201.
5 Jennifer Gough-Cooper und Jacques Caumont, "Ephemerides," in Pontus Hulten 1993 (see note 1), n. p. [July 12, 1964].
6 The exhibition *NOT SEEN and/or LESS SEEN of/by MARCEL DUCHAMP / RROSE SELAVY 1904-1964* of the *Mary Sisler Collection* which was shown between the January 14 and February 13, 1965, by the New York Cordier&Ekstrom Gallery. The catalogue cited the *Belle Haleine* as nr. 71 [n. p.].
6a On Novermber 5, 2012, Sotheby's New York auctioned off the label-collage "Belle Haleine" for $ 2.4 million, over half a million dollars above its high estimate and a record for a work on paper by Duchamp.
7 See Francis M. Naumann, "Marcel Duchamp. Money is no Object: The Art of Defying the Art Market," *Tout Fait: The Marcel Duchamp Studies Online Journal*, 2003 <www.toutfait.com/online-journal_details.php?postid=1501&keyword=> (June 12, 2012).

von Duchamps *Fahrrad-Rad* (1913, Abb. 6) mitten ins einsame Zentrum der turmhohen Haupthalle des Hamburger Bahnhofs. Der ultimative Härtetest. Ganz so, als müsse sich das Objekt in einer grausamen Versuchsanordnung des Kurators beweisen, als Readymade nun tatsächlich im kalten Herzen seiner eigenen Musealisierung angekommen zu sein. Um im Ergebnisprotokoll dem Blick der Besucher als Kunstwerk ein für allemal standhalten zu können, um eben nicht zu zerbersten unter dem enormen Druck des leeren, riesenhaften Ausstellungsraums. Duchamp wurde bislang noch nie derartig vorgeführt. Folgerichtig wurde wenig später und damit knapp hundert Jahre nach dem ersten Readymade mit der Präsentation der Ausstellung *Marcel Duchamp. Belle Haleine: Eau de Voilette* (27.–30.1.2011) in der oberen Halle der Neuen National-galerie (Abb. 7) noch eins draufgesetzt. Konsequent wurde hier für 3 Tage rund um die Uhr, das hagiografische wie komplexe Endspiel der Apotheose Duchamps als Nullpunkt des Koordinatensystems fast aller nach ihm entstandenen Konzeptkunst inszeniert. Es wäre fahrlässig einzuwenden, der ursprünglichen Idee der Readymades am ehesten noch dadurch gerecht zu werden, diese im Kontext des Museums möglichst unauffällig als Gebrauchsgegenstände zu platzieren. Duchamp selbst hatte das bereits 1916 durchexerziert, als er in der New Yorker Bourgeois Gallery nach eigenen Angaben zwei seiner Readymades an einen Kleiderständer im Eingangsbereich hing, ohne dass sie jemand bemerkte. Als der Künstler knapp ein halbes Jahrhundert später der Edition vieler im Original zumeist verloren gegangener Readymades zustimmte, war ihm allzu bewusst, dass diese seit Neo-Dada und Pop-Art ihren revolutionären Impetus weitgehend eingebüßt und im Zentrum des Kunstdiskurses ihren Platz eingenommen hatten. Es überrascht indes kaum, dass die Faszination der Readymades in zeitgenössischer künstlerischer Praxis anhält. Erst Anfang 2009 eröffnete die Gagosian Gallery Rome die Ausstellung *Greed. A New Fragrance by Francesco Vezzoli*, die wie das Launch-Event eines neuen Parfumlabels inszeniert wurde, mitsamt Werbeclip von Roman Polanski, der die beiden Schauspielerinnen Michelle Williams und Natalie Portman im Streit um den begehrten Flakon zeigt. Der wiederum ist identisch mit dem Fläschchen Duchamps. Das Label ist *Belle Haleine* exakt nachempfunden, wobei hier der Markenname *Greed* auf dem Etikett prangt und Vezzoli sich für das Etikett von Modefotograf Francesco Scavullo als Frau fotografieren ließ.

Nun wissen wir spätestens seit David Foster Wallace' Essay *E Unibus Pluram*,[8] dass die Haltung ironischer Brechung als Kritik bestehen-

8 David Foster Wallace, »E Unibus Pluram: Television and U.S. Fiction«, in: *Review of Contemporary Fiction*, 13, 2, Sommer 1993.

enormous pressure of the vacant exhibition space was a test indeed. Duchamp's work had never, up until this point, been exposed in such a way. Consequently, only a little later, and just under a hundred years after the first Readymade came into being, the exhibition entitled *Marcel Duchamp. Belle Haleine, Eau de Voilette* went even one step further in the upper hall of the Neue Nationalgalerie in Berlin, from January 27–30, 2011 (fig. 7). For three days, twenty-four hours a day, the hagiographical as well as complex end-game of Duchamp's significance was staged as a ground zero from which almost all concept art originated and followed. It would be negligent to argue, that considering the original idea of the Readymades here, the ideal way to show those works would mean to place them as everyday objects in the least conspicuous manner within the museum context so that visitors would not mistake them for art. Already in 1916 he had, by his own account, hung two of his Readymades from a clothing rack in the New York Bourgeois Gallery, without anyone noticing. When, almost fifty years after Duchamp agreed to the production of editions of many of the original, lost Readymades, he knew all too well that since the time of Neo-Dada and Pop Art, they had broadly forfeited their revolutionary impetus and had already taken their place at the centre of much of the discourse evolving around modern art. It's hardly surprising therefore, that the fascination with Readymades in contemporary art practice still continues. At the start of 2009, the Gagosian Gallery in Rome opened an exhibition entitled *Greed. A New Fragrance by Francesco Vezzoli.* Staged like the launch-event of a new perfume label, an advertising clip by Roman Polanski showed actresses Michelle Williams and Natalie Portman fighting over the coveted vial identical to that of the Duchamp bottle. Even the label is modelled on *Belle Haleine.* The brand name *Greed* is emblazoned across the label and Vezzoli himself was depicted as a woman by fashion photographer Francesco Scavullo.

We already know from David Foster Wallace's essay, "E Unibus Pluram"[8] that irony itself has long been incorporated by the marketplace. Peter Bürger also showed that genuine iconoclasm, the questioning of the status quo by Duchamp's Readymades at the start of the twentieth century had, since the 1960s, enjoyed an increasingly affirmative application. It's thus hardly surprising that Vezzoli—and indeed countless other contemporary artists—would endeavour to scrutinize the "Ambiguity of the concept of truth,"[9] as the press release for the *Greed* exhibition has it. In the inflationary use of Readymades in con-

8 David Foster Wallace, "E Unibus Pluram: Television and U.S. Fiction," *Review of Contemporary Fiction*, 13, 2 (Summer 1993), pp. 151–194.
9 Francesco Vezzoli Exhibition *Greed* at the Gagosian Gallery, Rome, from February 6 to March 21, 2009, from the press release of January 7, 2009.

der Zustände längst schon vom Markt selber inkorporiert ist. Peter Bürger verwies gleichsam schon früh darauf, dass der genuine Ikonoklasmus, die Infragestellung des Status quo durch Duchamps Readymades zu Beginn des 20. Jahrhunderts, sich schon seit den 1960er-Jahren einer zunehmend affirmativen Verwendung erfreut. Es überrascht also kaum, dass Vezzoli wie unzählige andere zeitgenössische Künstler zwar noch immer Duchamp bemüht, um, wie es etwa der Pressetext zu *Greed* verlautbart, die »Ambiguität des Wahrheitsbegriffs« zu hinterfragen.[9] Bei der inflationären Nutzung von Readymades in der zeitgenössischen Kunst übersehen allerdings die Meisten, dass diese bei Duchamp als sehr private Souvenirs im kontemplativen Mittelpunkt umfassender Gedankenprozesse stehen. Seine Überlegungen zu »grauer Materie«, zu Vierdimensionalität und Schattenwurf, zu nicht-euklidischer Geometrie und Nominalismus berücksichtigen die Readymades ebenso wie dessen Abneigung rein retinaler Kunst und die stete Inbezugnahme jener hochkomplexer, rigoros individualistischer wie autonomer Ideensysteme, die Duchamp Zeit seines Lebens in hunderten von Notizen festgehalten hat. Vezzoli dagegen, wie so viele andere auch, bedient sich einer simplifizierten Idee des zur hohlen Geste der Auflehnung verkommenen Readymades.[10]

Dass *Belle Haleine* 3 ganze Tage lang, insgesamt 72 Stunden, in der Nationalgalerie gezeigt wurde, unter dem grandiosen Schutzschild einer Replik der Glasvitrine der Büste von Nofretete, die ähnlich enigmatisch lächelnd von der Stiftung Preußischer Kulturbesitz in der Ägyptischen Sammlung auf der Berliner Museumsinsel gezeigt wird, fügt sich zudem wunderbar ein in die private Zahlenmythologie Duchamps, der über sein gesamtes Schaffen hinweg der Nummer Drei stets eine besondere Bedeutung beimaß. Ein Gedankenspiel, mit dem er inmitten seiner Surrealistenfreunde und Numerologen von André Breton bis Kurt Seligmann nicht allein war. Als Duchamp 1913/1914 mit den *Drei Massnorm-Stoppagen* den Zufall für die Kunst entdeckte und der Welt ganz nebenbei ein neues Längenmaß bescherte, waren es 3 ein Meter lange Bindfäden, die er horizontal aus einem Meter Höhe fallen ließ und in ihrer dadurch entstandenen Form auf Leinwandstreifen fixierte. »Die Zahl Drei ist für mich wichtig. Eins steht für Einheit, zwei ist das Doppelte, die Dualität, und Drei ist der Rest.« Oder anders ausgedrückt: »1 ist Einheit / 2 Opposition / 3 eine Serie«.[11] Dementsprechend wollte Duchamp, der sich oftmals schlichtweg als »Individuum« oder als »Atmender« bezeichnete, weder als Künstler noch als Anti-Künstler,

9 Ausstellung Francesco Vezzoli, *Greed*, Gagosian Gallery, Rom, 6.2.–21.3.2009, aus der Pressemitteilung vom 7.1.2009.
10 Zu Duchamp und zeitgenössischer Kunst siehe Thomas Girst, »Marcel Duchamp. Eine Hagiographie«, in: *Impuls Marcel Duchamp. Where do we go from here?*, hrsg. von Antonia Napp und Kornelia Röder, Ostfildern-Ruit 2011, S. 44 f.
11 Zit. n. Francis M. Naumann, »Marcel Duchamp: A Reconciliation of Opposites«, in: *Marcel Duchamp: Artist of the Century*, hrsg. von Rudolf Kuenzli und Francis M. Naumann. Cambridge 1989, S. 20 ff., S. 30, [Übersetzung des Autors].

temporary art, however, most overlook the fact that Duchamp took them to be extremely private souvenirs from the contemplative center of a complex thought process. His thoughts on "grey matter," four-dimensionality, the casting of shadows, non-Euclidean geometry and nominalism are all incorporated into his Readymades. His aversion to mere retinal art and the constant reference to the highly sophisticated, rigorously individualistic as well as autonomous idea systems that Duchamp spelled out in hundreds of notes he wrote during his lifetime is also present throughout his work. Vezzoli however, like so many others, offers us only hollow gestures of rebellion that oversimplify and degrade the idea of Readymades as mere objects of dissent.[10]

That *Belle Haleine* was shown for exactly three days, seventy-two hours in total (under the protective shield of a replica of the glass casing of the bust of Nofretete, who is shown smiling enigmatically within the Egyptian Museum in Berlin), fits in perfectly with Duchamp's private number-mythology. Throughout his oeuvre, one finds many examples of the importance Duchamp attached to the number three. An exercise in which, among his Surrealist and numerologist friends from André Breton to Kurt Seligmann, he was not alone. At the time he introduced the concept of chance to art in 1913/14 with the *Three Standard Stoppages* and offered the world a new unit of length, it was three one metre long pieces of thread which he let fall from the height of one metre to attach them to three strips of canvas. "The number 3 is important to me. 1 stands for unity, 2 is the double, duality, and 3 is the rest." Or, more simply, "1 is unity / 2 opposition / 3 a series."[11] In that same vein Duchamp, who often referred to himself simply as an "individual" or a "breather," never called himself "artist" or "anti-artist," but rather "an-artist," in onomatopoetic proximity to anarchist[12]—placing himself squarely in the realm of the series or the rest, without ever claiming what should constitute art. Within his first biography, *Belle Haleine* is depicted three times on one page as part of a catalogue raisonné[13]: on the cover of the only issue of *New York Dada*, the box with the signature of *Rrose Sélavy* containing the vial and finally the vial itself (figs. 1–3). It is exactly this seriality which *Belle Haleine*—completed at age 33—aims for as a prototype for the potentially mass-producable perfume brand. Not just the brand, but also the merchandising was a process in which Duchamp was very interested. To Alexander Archipenko, whom Duchamp in 1943 would call a "pioneer"[14] for his Sculpto-Peintures and his technique of "direct cutting" using plaster, wood and

10 For Duchamp and contemporary art, see Thomas Girst, "Marcel Duchamp: A Hagiography," in Antonia Napp and Kornelia Röder, eds., *Impuls Marcel Duchamp. Where do we go from here?* (Ostfildern, 2011), pp. 40–58.
11 Quoted in Francis M. Naumann, "Marcel Duchamp: A Reconciliation of Opposites," in Rudolf Kuenzli and Francis M. Naumann, eds., *Marcel Duchamp: Artist of the Century* (Cambridge 1989), pp. 20–40, p. 30.
12 Walter Hopps, "Marcel Duchamp: A System of Paradox in Resistance," in *By or of Marcel Duchamp or Rrose Sélavy: A Retrospective Exhibition*, exh. cat. Pasadena Art Museum (Pasadena, 1963), n. p.
13 Robert Lebel, *Marcel Duchamp* (New York, 1959), Plates 96 a–c, p. 140.
14 Serge Stauffer, *Marcel Duchamp. Die Schriften* (Zurich, 1981), p. 219.

sondern vielmehr als »an-artist«[12] gelten — dem Anarchisten lautmalerisch nicht unähnlich — und damit eben genau auf die Serie, den gesamten Rest verweisen, ohne Alleinanspruch auf das, was ein Kunstwerk konstituieren mag. Im Werkverzeichnis der ersten Biografie über Duchamp wird *Belle Haleine* auf einer Seite 3-mal abgebildet:[13] zu sehen ist das Cover der einzigen Ausgabe von *New York Dada*, die Schachtel mit der Signatur von *Rrose Sélavy* und schließlich der Flakon selbst (Abb. 1–3). Es ist genau diese Serialität, auf die *Belle Haleine*, von Duchamp im Alter von 33 Jahren geschaffen, als Prototyp einer potentiell massenproduzierbaren Parfummarke abzielt. Nicht nur der Marke, auch der Vermarktung kommt Bedeutung zu, ein Prozess, an dem Duchamp außerordentlich interessiert war. Alexander Archipenko, den Marcel Duchamp 1943 vor allem wegen seiner Sculpto-Peintures und seiner Technik des »›direct cutting‹ aus Gips, Holz und anderen Materialien« als »Pionier« bezeichnete,[14] widmet letzterer im Entstehungsjahr von *Belle Haleine* eine ganzseitige Anzeige. Diese anonyme Persiflage damals gängiger Zeitschriftenwerbung bietet den *ARCHIE PEN* an, einen Füllfederhalter, der über den Schreibwarenhandel oder Duchamps, Man Rays und Katherine Dreiers Société Anonyme, New York, zu beziehen sei. Das Schreibutensil »denkt für Sie« und ist »ohnegleichen in Qualität und Wert der künstlerischen Formgebung« — so der Werbetext.[15] Im unmittelbaren Zusammenhang von *Belle Haleine* ist das allemal von Interesse, das Cover von *New York Dada* ist eben auch eine Anzeige für *Belle Haleine*. Gleichfalls ist nicht zu vergessen, dass Duchamp zur Zeit von *Belle Haleine* mit seinem Hauptwerk *Die Braut von ihren Junggesellen entblößt, sogar / Das Große Glas* beschäftigt ist, an dem er zwischen 1915 und 1923 9 Jahre arbeiten sollte, bevor er es für immer in unvollendetem Zustand belässt. Auch hier kommt Duchamps privater Zahlenmythos voll zum Tragen. Von den neun »männischen Gussformen«, den drei »Schokoladenreiberollen« und den drei »Okkulisten-Zeugen« in der unteren Region der Junggesellen zu den drei »Durchzugskolben« und »Neun Einschüssen« im oberen Bereich der Braut, ist auch hier die Zahl Drei (beziehungsweise 3 mal 3) stets präsent. Zudem begegnet uns in seinem *Großen Glas* mit dem Behältnis für den Kräuterlikör Bénédictine eine weitere Flasche, die in der Junggesellenmaschine als Gewichte die onanistischen Bewegungen des Schienengleiters zu regulieren helfen. Explizit hat Duchamp diese Flaschen bei der Übersetzung seiner Notizen für das *Große Glas* vom Französischen ins Englische als »branded bottles«, als »Markenflaschen« bezeichnet.[16]

12 Walter Hopps, »Marcel Duchamp: A System of Paradox in Resistance«, in: *By or of Marcel Duchamp or Rrose Sélavy. A Retrospective Exhibition*, Ausst.-Kat. Pasadena Art Museum, o. O. 1963, o. S.
13 Robert Lebel, *Marcel Duchamp*, New York 1959, Plates 96 a–c, S. 140.
14 Serge Stauffer, *Marcel Duchamp. Die Schriften*, Zürich 1981, S. 219.
15 Ebd., S. 227. Die Anzeige wurde 1921 in der Februar / März Ausgabe von *The Arts*, 1, 3, S. 64 geschaltet.
16 Sarat Maharaj, »Typotranslating the Green Box«, in: *The Duchamp Effect*, hrsg. von Martha Buskirk und Mignon Nixon, Cambrige 1996, S. 61 ff., S. 72; Jennifer Gough-Cooper und Jacques Caumont, »Ephemerides on and about Marcel Duchamp and Rrose Sélavy«, in: Hulten 1993 (wie Anm. 1), o. S. [29.1.1959].

other materials, he devoted an entire page of fake advertising in the same year that *Belle Haleine* was produced. The anonymous spoof of a contemporary newspaper ad offered the *ARCHIE PEN*, a fountain pen which could be bought in stores selling stationary or ordered through Duchamp's, Man Ray's and Katherine Dreier's Société Anonyme. The writing utensil "thinks for you" and is "unique in its quality and value of artistic form" according to the copy.[15] Its direct link with *Belle Haleine* is of interest here, as the cover of *New York Dada* also constitutes a front-page ad for *Belle Haleine*. It should not be forgotten, that at the time of *Belle Haleine*, Duchamp was also busy with his major oeuvre *The Large Glass* on which between 1915 and 1923 he would work for nine years, before leaving it unfinished. In this work, Duchamp's number-mythology also becomes apparent. From the nine "malic moulds," the three "draft pistons" and the "nine shots" in the upper part of the bride, the number three is present throughout (three times three). Moreover, we encounter another bottle in his notes on the *Large Glass*, the herbal liquor Bénédictine helps to regulate the onanist movement of the gliders in the bachelor apparatus. Duchamp explicitly referred to these bottles as "branded bottles" when assisting the translation of his notes from French into English.[16]

15 Serge Stauffer 1981 (see note 14), p. 227. The ad is from the February/March 1921 issue of *The Arts* (vol. 1, nr. 3, p. 64).
16 Sarat Maharaj, "Typotranslating the Green Box," in Martha Buskirk und Mignon Nixon, eds., *The Duchamp Effect* (Cambridge, 1996), pp. 61–92, p. 72; Jennifer Gough-Cooper und Jacques Caumont, "Ephemerides," in Pontus Hulten 1993 (see note 1), n. p. [January 29, 1959].

DREI TAGE IM JANUAR 2011

Birgt die Tages- (3) wie Stundenanzahl (72: Quersumme 7+2 = 9 = 3 × 3) der Ausstellung von *Belle Haleine* in der Neuen Nationalgalerie gewisse Korrelationen zum Œuvre Duchamps, so mag es gleichfalls von Interesse sein zu erfahren, was genau Duchamp an diesen Tagen, vom 28. bis 30. Januar, in seinem Leben unternahm. Für einige Jahre wissen wir dies ziemlich genau, dank Jennifer Gough-Coopers und Jacques Caumonts *Ephemerides on and about Marcel Duchamp and Rrose Sélavy 1887–1968*, die anlässlich seiner Retrospektive von 1993 im Palazzo Grassi in Venedig erstmals gesamthaft publiziert wurden.[17] Am 28. Januar 1922 etwa schifft sich Duchamp nach siebenmonatigem Aufenthalt in Frankreich zurück nach New York ein. André Breton wird zu dieser Überfahrt einmal bemerken: »Ich sah Duchamp etwas Außergewöhnliches ausführen, als er eine Münze in die Luft warf mit der Bemerkung: ›Kopf — ich fahre heute abend nach Amerika; Zahl — ich bleibe in Paris‹. Es war keine Indifferenz dabei im Spiele: er wäre zweifelsohne lieber abgereist als geblieben«.[18] Fünf Jahre später zeigt sich Duchamp in einem Brief an Alice Roullier vom Arts Club of Chicago über den Kauf einer Skulptur (*L'Oiseau d'Or* für 1,00 US-Dollar) und zweier Zeichnungen von Constantin Brâncuși zufrieden, und 1961, also genau 50 Jahre vor der Ausstellungseröffnung von *Belle Haleine* in Berlin gratulieren er und seine Frau Teeny ihrer Tochter Jacqueline Monnier zur Geburt ihres Sohnes Antoine Blaise. Am gleichen Tag sendet er zwei weitere Briefe an das Ehepaar Lou und Walter Arensberg sowie an seinen Künstlerfreund Pierre de Massot. In beiden Schreiben freut er sich über die bevorstehende Überlassung vieler seiner Werke aus der Sammlung der Arensbergs an das Philadelphia Museum of Art.[19] Am 29. Januar 1917 diskutiert Duchamp die Organisation der Ausstellung der Society of Independent Artists mit Lou Arensberg, Beatrice Wood und John Covert. Etwa zwei Monate später wird Duchamp mit dem anonym eingereichten Pissoir *Fountain* einen Skandal auslösen. Im Jahr der Entstehung von *Belle Haleine* erscheint im *New York Evening Journal* ein Beitrag von Margery Rex mit der Überschrift: »Dada will get you if you don't watch out; it is on the way here«. Darin definiert Duchamp Dada als »nothing«. Vier Jahre später verstirbt Duchamps Mutter Lucie. Am 30. Januar 1953 eröffnet im Pariser Musée d'Art Moderne die Ausstellung *Le Cubisme 1907–1914*, die den ganzen Zorn André Bretons auf sich zieht, der sich auch über den »ungewollten Humor« der Hängung dreier Gemälde Duchamps aufregt, die in einem engen Gang an Wänden oberhalb der Feuerschutzgerätschaften versteckt sind. Zur gleichen Zeit verstirbt 1959 Duchamps Schwager Jean Crotti achtzigjährig in Paris. Am selben Tag stirbt auch Crottis älterer Bruder André.

17 Jennifer Gough-Cooper und Jacques Caumont, »Ephemerides on and about Marcel Duchamp and Rrose Sélavy« in: ebd., o. S. [Auswahl aus den Einträgen zum 28., 29. und 30.1.].

18 André Breton, »Marcel Duchamp«, in: *Litterature* 5, 1.10.1922, S. 7 ff., S. 9; zit. n. Serge Stauffer, *Marcel Duchamp: Interviews und Statements*, Ostfildern-Ruit 1992, S. 24.

19 Francis M. Naumann und Hector Obalk, *Affectt. Marcel: The Selected Correspondence of Marcel Duchamp*, London 2000, S. 298 f. Die Publikation enthält auch den Brief Duchamps an Ettie und Carrie Stettheimer vom 11.8.1922, in dem er von »Rrose Sélavy dans le vert bouteille« (»Rrose Sélavy in der grünen Flasche«, S. 122) spricht, siehe dazu u. a. Bonnie Jean Garner, »Duchamp Bottles Belle Greene: Just Desserts for his Canning« in: *Tout-Fait: The Marcel Duchamp Studies Online Journal*, ‹www.toutfait.com/issues/issue_2/News/garner.html› (1.5.2012). Garner begründet allerdings ihr gesamtes Argument auf der Annahme, der Flakon von *Belle Haleine* sei eine grüne bzw. grün gefärbte Flasche, was nicht der Fall ist. *Belle Haleine* besteht aus farblosem Glas, die Rigaud-Flasche war in den Einfurchungen ähnlich dem Cover von *New York Dada* zartrosa.

THREE DAYS IN JANUARY, 2011

As a certain correlation with Duchamp's oeuvre is contained in the number of days (3) as well as the number of hours (72 with the cross sum 7+2=9=3×3) of the exhibition of *Belle Haleine* in Berlin's Neue Nationalgalerie, it might be of interest to consider exactly what Duchamp was up to between the 28th and 30th January throughout his life. For a number of years we know this precisely, thanks to the *Ephemerides on and about Marcel Duchamp and Rrose Sélavy 1887-1968* by Jennifer Gough-Cooper and Jacques Caumont, first published on the occasion of his retrospective in 1993 in the Palazzo Grassi in Venice.[17] For example, on January 28, 1922, after a seven month stay in France, Duchamp embarked on his return journey to New York. André Breton would later remark, "I saw Duchamp do something extraordinary: he threw a coin in the air and remarked, 'heads, I return to America this evening, tails—I stay in Paris.' There was no indifference in that game—without a doubt he would have preferred to leave rather than stay."[18] Five years later, in a letter to Alice Roullier of the Arts Club of Chicago about the sale of a sculpture (*L'Oiseau d'Or* for $1.00) and two drawings by Constantin Brâncuşi, Duchamp showed himself to be content with the deal. And in 1961, exactly fifty years before the Berlin opening of the *Belle Haleine* exhibition, he and his wife wife Teeny congratulate her daughter Jacqueline Monnier on the birth of her son Antoine Blaise. On that same day, he sent two further letters to Lou and Walter Arensberg and to his artist friend Pierre de Massot. In the letter addressed to the Arensbergs, he rejoiced in the permanent transfer of a number of his works from their collection to the Philadelphia Museum of Art.[19] On January 29, 1917, Duchamp discussed the organisation of the exhibition of the Society of Independent Artists with Lou Arensberg, Beatrice Wood and John Covert. Almost two months later, Duchamp would trigger a scandal with his anonymously presented urinal *Fountain*. In the year *Belle Haleine* is made, an article in the *New York Evening Journal* by Margery Rex appeared with the headline "Dada will get you if you don't watch out; it is on the way here." Within, Duchamp defined Dada as "nothing." Four years later that day, Duchamp's mother Lucie would pass away. On January 30, 1953, an exhibition entitled *Le Cubisme 1907-1914* at the Musée d'Art Moderne in Paris enraged André Breton: the "unwanted humour" of hiding three of Duchamp's paintings in a narrow corridor above fire protection equipment was too much for him. At the same time in 1959, Duchamp's brother-in-law Jean Crotti died in Paris, aged 80. That very day, Crotti's older brother André also passed away.

17 Jennifer Gough-Cooper und Jacques Caumont, "Ephemerides" in Pontus Hulten 1993 (see note 1), n. p. [Selection of entries from 28, 29, and 30, January].

18 André Breton, "Marcel Duchamp," *Litterature* 5 (October 1922), pp. 7–10, p. 9; quoted in Serge Stauffer, *Marcel Duchamp: Interviews und Statements* (Ostfildern-Ruit, 1992), p. 24.

19 Francis M. Naumann and Hector Obalk, *Affectt. Marcel: The Selected Correspondence of Marcel Duchamp* (London, 2000), pp. 298–299. The publication also includes the letter Duchamp sent to Ettie and Carrie Stettheimer from August 11, 1922, in which he speaks of "Rrose Sélavy dans le vert bouteille" ("Rrose Sélavy in the green bottle") (p. 122). See also, amongst others, Bonnie Jean Garner, "Duchamp Bottles Belle Greene: Just Desserts for his Canning," *Tout-Fait: The Marcel Duchamp Studies Online Journal* <www.toutfait.com/issues/issue_2/News/garner.html> (May 1, 2012). Garner based her entire argument on the the presumption that the *Belle Haleine* bottle was a green, or green coloured bottle, which was not the case. *Belle Haleine* was made from transparent glass, the Rigaud bottle, like the cover of *New York Dada*, had a soft pink hue.

VEILCHENWASSER, READYMADE UND *RROSE SÉLAVY*

Der für Duchamps Werk essentielle Aufenthalt in München im Som-
mer 1912 birgt avant la lettre für *Belle Haleine* bereits aufschlussreiche
Verweismöglichkeiten. Nicht nur boten dort — die olfaktorische Verbin-
dung von Ölfarbe und Duftwasser bekräftigend — Parfumerieläden
Gemälde zum Verkauf an,[20] allein Jacques Offenbachs *Die Schöne
Helena (La belle Hélène,* 1864) wurde zwischen Juni und September in
der bayrischen Hauptstadt 23-mal aufgeführt, wobei das Lustspielhaus
zudem den die opéra bouffe parodierenden Weiberstreich *Wem gehört
Helene?* präsentierte.[21] Duchamps Parfum bezieht sich im Titel lautma-
lerisch auf Offenbachs Operette, das Spiel mit »Rrose« und »Voilette«
verweist zudem auf die Duftnoten von Rose und Veilchen (französisch:
»violette«), was wiederum mit dem dunkellila Karton der Parfumflasche
korrespondiert. Bereits 1912 verfasst ein französischer Parfumfabrikant
eine auch zu Duchamps Zeit in Deutschland in den dortigen Tageszei-
tungen besprochene Abhandlung über den Zusammenhang des Cha-
rakters einer Frau und dem von ihr bevorzugten Parfum. Darin wird
Rosenduft, der »eine Stimmung von Luxus und Verschwendungssucht«
erzeugt, der »eleganten Dame von Welt« zugeordnet, jenen Damen, die
»ihr kostbares Spitzentaschentuch auf der Treppe verlieren und beim
Juwelier Einkäufe machen, über die dem Gatten die Haare zu Berge
stehen«. Veilchenduft indes ist das »Lieblingsparfum der exzentrischen
und launenhaften Frau. Diese bescheidene Blume wird von den Damen
bevorzugt, die flatterhaft, extravagant und frivol sind«.[22] Es scheint, als
hätte Duchamp als *Rrose Sélavy,* so wie sie uns schmallippig, schmuck-
behangen auf Man Rays Fotos erscheint, keine besseren Duftnoten
setzen können. Die Überlegungen des Pariser Parfumeurs zu Beginn
des 20. Jahrhunderts entfalten auch in weiterer Hinsicht ihre Wirkung,
denn, wie dieser schreibt, ist »oft ja das erste, was uns auf die Nähe ei-
nes weiblichen (manchmal auch männlichen) Wesens aufmerksam
macht, die Wahrnehmung eines Parfums«.[23] Wichtig ist hier der Text in
der Klammer. Denn war der alltägliche Gebrauch von Eau de Toilette
in der Historie der Verwendung von Duftwasser lange Zeit der Frau
vorbehalten, die darauf aus wahr, stets wohl zu riechen, so gesellte
sich im vergangenen Jahrhundert nach Gleichem trachtend auch im-
mer mehr der Mann hinzu.

Dass der nach Parfum duftende Mensch zu Duchamps Zeit nicht
mehr geschlechterspezifisch zuzuordnen war, dürfte dessen androgy-

20 Thomas Girst, »Marcel Duchamp,
München 1912: Miszellaneen«, in:
Marcel Duchamp in München 1912,
hrsg. von Helmut Friedel, Thomas
Girst, Matthias Mühling und Felicia
Rappe, München 2012, S. 87 ff., S. 95,
Abb. 9.
21 *Münchner Neueste Nachrichten,*
1.8.1912, S. 3; *Münchner Neueste
Nachrichten,* 8.7.1912, S. 2; *Münchner
Neueste Nachrichten,* 19.8.1912, S. 2.;
Generalanzeiger, 13.10.1912, S. 1.
22 *Münchner Neueste Nachrichten,*
12.9.1912, S. 2.
23 Ebd.

VIOLET WATER, READYMADE AND *RROSE SÉLAVY*

A stay in Munich in the summer of 1912 proved essential for Duchamp's work and contains, avant la lettre, some insightful references in regard to *Belle Haleine* that would come later. Not only were paintings offered for sale in perfume shops, underlining the olfactory connection between oil paints and fragranced water.[20] Meanwhile, Jacques Offenbach's *La belle Hélène* (1864) was performed twenty-three times between June and September in the Bavarian capital, while a comedy entitled *Who owns Helena?*[21] parodied the opéra bouffe. Duchamp's perfume onomatopoetically refers to Offenbach's operette in its title while the wordplay on "Rrose" and "Voilette" directly correlates to the fragrances of roses and violets (in French: "violette,") and the colour violet in turn corresponds to the dark purple colour of the packaging. Already in 1912, in a daily newspaper while Duchamp was in Germany, a French perfume maker had contributed to the discussion about the connection between the character of a woman and her preferred perfume. In it, he claimed, the smell of roses generated an "atmosphere of luxury and exuberance" assigned to the "elegant woman of the world"— to women, who "would lose their precious handkerchiefs on the stairs, and go on shopping sprees with jewellers that would make their husbands' hair stand up."[22] The smell of violets on the other hand is the "favourite perfume of the eccentric and moody woman. This humble flower is preferred by women who are flighty, extravagant and frivolous." It seems that as the thin-lipped and bejewelled *Rrose Sélavy* of Man Ray's photograph, Duchamp could hardly have engaged better fragrances. The reflections of a Parisian parfumeur at the start of the twentieth century also allow, at closer look, another observation pertaining to the use of perfume, for, as he writes, "often the first thing which makes us aware of a female (and sometimes a male) being, is to perceive the scent of a perfume."[23] The text in brackets is important here. According to the history of the use of fragrance, at the time, the daily use of perfume had largely been reserved for women, while men, out of the same desire to smell good, only slowly began to join in towards the start of the last century.

From this time onward, the scent of a perfume on a person could no longer determine the gender, something that must have appealed to Duchamp's game of androgyny. Furthermore, his *Eau de Voilette* ("Veil Water") only half-heartedly veils the obvious connection between

20 Thomas Girst, "Marcel Duchamp, Munich 1912: Miscellanea," in Helmut Friedel, Thomas Girst, Matthias Mühling, Felicia Rappe, eds., *Marcel Duchamp in München 1912* (Munich, 2012), pp. 87–108, p. 95 [fig. 9].
21 *Münchner Neueste Nachrichten*, August 1, 1912, p. 3; *Münchner Neueste Nachrichten*, July 8, 1912, p. 2; *Münchner Neueste Nachrichten*, August 19, 1912, p. 2.; *Generalanzeiger*, October 13, 1912, p. 1.
22 *Münchner Neueste Nachrichten*, September 9, 1912, p. 2.
23 *Münchner Neueste Nachrichten*, September 9, 1912, p. 2.

nem Spiel entgegen gekommen sein. Verschleiert Duchamps *Eau de Voilette* (»Schleierwasser«) nur halbherzig die offensichtliche Verbindung zur *Belle Hélène* als schönster Frau ihrer Zeit, deren Entführung durch den ebenfalls auf dem Etikett vermerkten Paris (New York–Paris) bekanntlich der Auslöser des Trojanischen Krieges war, so entpuppt sich die von *Rrose Sélavy* signierte Parfumschachtel, wie wir sehen werden, als Trojanisches Pferd. Das meiste was wir über den Trojanischen Krieg um 1200 vor Christus wissen, wissen wir aus Homers *Ilias*. Allerdings hat Duchamp genau hierzu eine sehr dezidierte Meinung: »Wir verstehen kein Wort von Aristophanes oder Homer, selbst wenn eine Interpretation des Homer sehr, sehr 20. Jahrhundert ist. Sie sehen was ich meine, die Verzerrung, die alle fünfzig Jahre eine neue Generation den alten Kunstwerken zufügt und auch den neuen, ist nicht zu rechtfertigen. Mit anderen Worten, vor fünfzig Jahren liebten wir dieses, vor hundert Jahren liebten wir das, folglich ist das Urteil der Menschheit über Kunstwerke zweifelhaft«. Dabei sind Kunstwerke »nach zwanzig Jahren erledigt«, »der Tod dauert länger bei Ideen, weil die Sprache zumindest für ein paar Jahrhunderte fortlebt«.[24] Ein Brief an seinen Schwager Jean Crotti ist im Zusammenhang mit dem Parfum *Belle Haleine* sicher von Interesse, denn Duchamp vergleicht darin, die sich zügig ins Nichts auflösende, tatsächliche Absicht eines Kunstwerks sowie dessen originelle Bedeutung mit einem ersten, unverfälschten Aroma. »Ich glaube an den ursprünglichen Duft, aber wie jeder Duft verfliegt er sehr schnell (ein paar Wochen, ein paar Jahre höchstens). Was zurückbleibt ist eine vertrocknete Nuss, von den Historikern eingeordnet in die ›Geschichte der Kunst‹.«[25] Die »chemische Zusammensetzung« mag man vermitteln können, allerdings führt dies zu einer »Vulgarisation und zum kompletten Verschwinden des ursprünglichen Duftes«.[26] Wobei Duchamp unmissverständlich klarstellt: »Kunstgeschichte ist nicht Kunst«.[27] Für Duchamp ist es daher die Kunst selber und nicht die Kunstgeschichte, die einzig dazu in der Lage ist, Ideen noch am Leben zu halten, auch wenn diese sich eben darin wiederholt: »Natürlich ist der Abstrakte Expressionismus nur eine Art ›zweiter Wind‹ von Kandinsky, Mondrian und Kupka um 1910. Und Pop-Art ist ein ›zweiter Wind‹ von Dada. Ich war nie ein echter Dadaist. Ich war nicht in Zürich, als Tzara und die Anderen damit anfingen im Jahre 1916. Aber Picabia und ich machten etwas Ähnliches wie er. Nichts Neues, natürlich. Der Geist von Jarry und lange vor ihm Aristophanes«.[28]

24 Marcel Duchamp im Interview mit George Heard Hamilton und Richard Hamilton (ca. Oktober 1959), in: Stauffer 1992 (wie Anm. 18), S. 74 ff., S. 82.
25 Aus einem Brief von Marcel Duchamp an Jean Crotti und seine Schwester Suzanne, dessen Frau, vom 17. August 1952, in: Naumann und Obalk 2000 (wie Anm. 19), S. 320, [Übersetzung des Autors].
26 Ebd.
27 Stauffer 1992 (wie Anm. 18), S. 82.
28 Marcel Duchamp im Interview mit François Stegmuller (1963), ebd., S. 137 ff., S. 140.

Belle Haleine and *Belle Hélène* as the most beautiful woman of antiquity, whose abduction by the Trojan king's son Paris—mentioned on the label as well: "New York–Paris"—is said to have been the reason for the start of Trojan War. So the perfume's box signed by *Rrose Sélavy* turns into a Trojan Horse of its own. Most of what we know of the Trojan War around 1200 BC we know from Homer's *Ilias*. And Duchamp had a very distinct opinion on this particular matter: "We have no idea of what Aristophanes or Homer said, even when the interpretation is very, very 20th century. You see, the distortion that a new age inflicts on old and new art every 50 years, is not justified. In other words, 50 years ago we loved this, 100 years ago we loved that, thus human judgement is doubtful." In the same vein, an "artwork is finished every twenty years, only the death of ideas takes longer" as "the language continues for at least a few hundred years."[24] A letter by Duchamp to his brother-in-law Jean Crotti is of interest to the context of *Belle Haleine*, as within, Duchamp compared the swiftly fleeting true intention of an artwork and its original meaning with the first, genuine aroma. "I believe in the original fragrance, but, like every fragrance, it evaporates very quickly (a few weeks, a few years at most). What remains is a dried up nut, classified by the historians in the chapter 'History of Art'."[25] The "chemical formula" can be conveyed, but that only "breeds vulgarization and total disappearance of the original fragrance."[26] Thus he clarifies: "Art history is not art."[27] For Duchamp, only art and not art history is capable to keep ideas alive, even when those ideas are repeated: "Obviously, Abstract Expressionism is a kind of 'second wind' of Kadinsky, Mondrian and Kupka in 1910. And Pop-Art is a 'second wind' of Dada. I was never a real Dadaist. I was not in Zurich when Tzara and the others started it in 1916. But Picabia and I made something similar to him. Nothing new, of course. In the spirit of Jarry, and long before him, Aristophanes."[28]

The repeated recourse to Aristophanes is striking here. A Greek poet like Homer, he is known to us mainly for his comedies, but also through his particpation in Plato's *Symposium*, within the eulogy of Eros. Plato is also mentioned by Duchamp, in an interview as well as in his writing. In his thoughts on the publication of his notes for his key work, *The Bride stripped Bare by Her Bachelors, Even / The Large Glass* Duchamp had envisaged Plato as a possible author for the preface to the book which was originally conceived as a catalogue without beginning or end, held together by spiral binding. Eventually, Duchamp set-

24 Marcel Duchamp in an interview with George Heard Hamilton and Richard Hamilton, circa October 1959, in Serge Stauffer 1992 (see note 18), pp. 74–84, p. 82. [author's translation].
25 From a letter of Marcel Duchamp to Jean Crotti and his sister Suzanne, Crotti's wife, from August 17, 1952, in Francis M. Naumann und Hector Obalk 2000 (see note 19), p. 320.
26 Francis M. Naumann und Hector Obalk 2000 (see note 19), p. 320.
27 Stauffer 1992 (see note 18), p. 82.
28 Marcel Duchamp in an interview with François Stegmuller (1963), in Stauffer 1992 (see note 18), pp. 137–141, p. 140 [author's translation].

Der wiederholte Rekurs auf Aristophanes fällt in diesem Zusammenhang auf. Ein griechischer Dichter wie Homer, er ist uns vor allem durch seine Komödien bekannt sowie durch seinen posthumen Auftritt in Platons *Symposium* während der Lobreden auf den Eros. Auch Platon wird von Duchamp erwähnt, sowohl in einem Interview als auch in seinen Notizen. In seinen Gedanken zur Publikation der Notizen zu seinem Hauptwerk *Die Braut von ihren Junggesellen entblößt, sogar* wird Platon als möglicher Autor für das Vorwort des als Katalog konzipierten Buchs angedacht, das letztlich ohne Anfang und Ende mit Spiralbindung gedruckt werden sollte, bevor sich Duchamp entschied, die Texte einzeln faksimiliert in einer Schachtel mit gleichnamigem Titel herauszugeben (Abb. 8).[29] Platon als Verfasser der Einleitung eines Buches von Marcel Duchamp, weit über zweitausend Jahre nach dem Ableben des antiken Philosophen, wo doch selbst Ideen nur für ein paar Jahrhunderte fortzuleben vermochten? Duchamp schränkt in diesem Fall selber ein, widerspricht sich gar, wie so oft: »Es ist trotzdem merkwürdig, dass die zu Lebzeiten ausgegebenen Ideen den Charakter von permanenter Wirklichkeit bewahren, selbst nach dem Tod: Wir kennen die Ideen von Sokrates, von Platon, zum Beispiel, und wir sehen sie diskutieren, als wären sie ewig«.[30] Es ist die Idee, das Konzept, das auch für Duchamp zählt, spätestens nachdem er sich angewidert von einer Malerei abgewendet hatte, die auf rein visueller Ebene ihre Wirkung anstrebt. Was Duchamp indes interessierte, war die »graue Materie«, fernab von Pinselschwung und Ölfarbengeruch und genau deshalb ist auch sein Parfumflakon leer,[31] enthält keinerlei Duft mehr. Mit *Belle Haleine* geht es Duchamp mitnichten um eine rein visuelle Lesart des Assisted Readymade als Duftwasser-Imitat, sondern vielmehr um zentrale Ideen seiner Auseinandersetzung mit Erotik und männlicher wie weiblicher Geschlechtlichkeit, die sein trojanischer Flakon gerade in seiner bewussten Bezugsetzung zur Antike birgt. Für *Rrose Sélavy* bedeutet Eros bekanntlich das Leben selbst und Duchamp hat als ihr Alter Ego beständig auf die essentielle Bedeutung des Eros für sein gesamtes Werk hingewiesen.

ARISTOPHANES, DAS DRITTE GESCHLECHT UND INFRAMINCE

In Platons *Symposion* wird nicht weniger verhandelt als die Geburt des Eros und dessen Bezug zum menschlichen Schaffen. Unter dem Begriff der téchne wurde seinerzeit das Können sowohl in Wissenschaft und

29 Marcel Duchamp, *Notes*, Nr. 71, hrsg. von Paul Matisse, Paris 1980, o. S.
30 Marcel Duchamp im Interview mit Georges Herbiet (1968), in: Stauffer 1992 (wie Anm. 18), S. 237 ff.
31 Hierauf verwies erstmalig Dalia Judovitz in ihrem Buch *Unpacking Duchamp. Art in Transit*, Berkeley 1998, S. 131.

tled on the idea of printing facsimiles of his individual notes, loosely collected in a green box bearing the same title as the artwork (fig. 8).[29] Plato as the author of the introduction of a book by Duchamp, more than two thousand years after the death of the ancient philosopher, even if ideas only have a shelf life of a maximum of a couple of hundred years? Curiously enough, Duchamp holds a different view here, even contradicting himself, as every so often: "It remains odd, that ideas expressed during one's lifetime preserve a character of permanent reality, even after death: We know the ideas of Socrates, of Plato, for example, and we see them argue as if they were eternal."[30] It's the idea, the concept that matters to Duchamp, especially after he had turned away from painting that only meant to please visually. What interested Duchamp, on the other hand, was the "grey matter," far from the dabbling with brushes, far away from the smell of oil paints, and for exactly that reason his perfume bottle is empty, containing absolutely no fragrance.[31] With *Belle Haleine*, Duchamp is by no means interested in a mere visual interpretation of his Assisted Readymades as an elaborate imitation of a perfume bottle, but is instead much more concerned with central ideas of his thoughts on eroticism and male as well as female gender—which is why his Trojan vial contains conscious references to antiquity. To *Rrose Sélavy*, Eros meant life itself—and thus as his alter ego, Duchamp pointed out the essential significance of Eros in his work.

ARISTOPHANES, THE THIRD SEX AND INFRATHIN

Plato's eulogy of Eros within his *Symposium* is about nothing less than the birth of this God and his relations to human creativity. At the time, within the term *techné*, scientific, technical and artistic abilities were all subsumed—there were no differences between the disciplines then— and also not for Theodor W. Adorno over two thousand years later, when he denoted "the separation of the so-called artistic quality from the technical," as "something completely dogmatic,"—since "authoritative, objectively valid artistic quality only exists insofar as the artwork is executed consistently in technological terms."[32] In Plato's *Symposium*, it would be the comedy writer Aristophanes who would defend the sovereignty of Eros over *techné* and thus carry off the rhetorical victory over the previous speakers. Among them the doctor Eryximachos, who claimed exactly the opposite. With his narrow-minded pride in the power of science, he would "fall short to recognize the earnest-

29 Paul Matisse, ed., *Marcel Duchamp, Notes* (Boston, 1980),, n. p. [note 71].
30 Marcel Duchamp in an interview with François Stegmuller (1963), in Stauffer 1992 (see note 18), pp. 237 ff [author's translation].
31 First referenced by Dalia Judovitz in her book *Unpacking Duchamp: Art in Transit* (Berkeley 1998), p. 131.
32 Theodor W. Adorno, *Nachgelassene Schriften*, Abteilung IV: *Vorlesungen*, (Posthumous Writings, IV: Lectures) vol. 3: *Ästhetik* (Frankfurt am Main, 2009), p. 19 [author's translation].

Technik als auch in der Kunst subsumiert, Unterschiede zwischen den Disziplinen gab es keine – auch über zwei Jahrtausende später bei Adorno nicht, der »die Trennung des sogenannten künstlerischen Gehalts von der Technik« als »etwas vollkommen Dogmatisches« bezeichnete, »das heißt, dass es einen verbindlichen, objektiv gültigen künstlerischen Gehalt überhaupt nur soweit gibt, wie das Kunstwerk eben in sich technisch konsequent durchgeführt ist«.[32] In Platons *Symposion* wird es der griechische Komödiendichter Aristophanes sein, der am Ende des Gesprächs die Herrschaft des Eros über die téchne verteidigt und damit rhetorisch den Sieg davonträgt, ganz im Gegensatz zu seinen Vorrednern, unter anderem dem aufgeklärten Arzt Eryximachos, der genau das Gegenteil behauptet. Mit dessen borniertem Stolz auf die Macht der Wissenschaft wird er »dem Ernst der Seele in der erotischen Leidenschaft nicht gerecht«,[33] die so viel mehr ist als eine Naturkraft, als eine allzu menschliche, rein körperliche Begierde, als nur profaner Geschlechtstrieb. Auch spricht Aristophanes von den drei Geschlechtern, den mannweiblichen Kugelmenschen, die es neben Mann und Frau gab, bevor sie Zeus in zwei Hälften trennte, um der Stärke und dem Übermut der Menschen Einhalt zu gebieten.[34] Das transsexuelle Geschlechterspiel weicht im von Aristophanes beschriebenen Urzustand dem Hermaphroditen und entzieht sich damit dem binären Geschlechtssystem. Das dritte Geschlecht muss auch für Duchamp nicht zuletzt aufgrund der Zahl Drei von Interesse gewesen sein. Mit Aristophanes verbindet ihn noch mehr, hat er doch mit *Belle Haleine* ein vom handwerklichen Können, von der Technik der Ausführung her nahezu vollkommenes Werk geschaffen. Sein Leitsatz »Eros, c'est la vie« hat Duchamp Zeit seines Lebens gleichsam von der Ernsthaftigkeit der Erotik sprechen lassen, Erotik als Grundlage von Allem und Jedem, ohne dass man darüber Worte verliert. Anspielungen darauf versteckt er in seinen Werken, keineswegs aus Scham, vielmehr als Spiel.

Noch eine weitere Bedeutung tut sich hier auf. Als nächstes Werk unmittelbar nach *Belle Haleine* entsteht mit *Why not Sneeze Rrose Sélavy?* (1921, Abb. 9) ein weiteres Readymade. Für den kleinen, mit 152 Marmorwürfeln, einem Thermometer und einem Schulp gefüllten Vogelkäfig zeichnet gleichfalls *Rrose Sélavy* verantwortlich. Das Niesen oder vielmehr der Umgang damit findet in allen geistigen und religiösen Bewegungen des Abendlandes seine Beschreibung, wie ein keine zehn Jahre vor Entstehung von *Why Not Sneeze?* öffentlich geführter Diskurs nahe legt.[35] Bereits im genannten Disput zwischen Aristophanes

32 Theodor W. Adorno, *Nachgelassene Schriften*, Abteilung IV: Vorlesungen, Bd. 3, Frankfurt 2009, S. 19.
33 Gerhard Krüger, *Einsicht und Leidenschaft: Das Wesen des platonischen Denkens*, Frankfurt 1983, S. 122.
34 Platon, *Sämtliche Werke, Symposion*, Bd. 2, Hamburg 2011, S. 37 ff.
35 *Münchner Neueste Nachrichten*, 4.9.1912, S. 2.

ness of the soul within erotic passion,"[33] which is defined by so much more than mere carnal lust or sheer sex drive. Aristophanes also talks of the third sex, the male-female spherical human existing in addition to the male and the female before Zeus split them in two to curb the arrogance and strength of the species.[34] The transsexual gender play is rendered futile by Aristophanes who introduces the hermaphrodite and thus eludes the binary gender system. The third gender must also have been of interest to Duchamp not least because of his delight of the number three and his constant attempts at reconciling opposites. He connects with Aristophanes on even more levels as with *Belle Haleine* he created a work almost perfect when it comes to its technical execution. His maxim "Eros, c'est la vie" shows us how seriously Duchamp took eroticism, which was for him, to put it plainly, the foundation of everyone and everything. Allusions are to be found throughout his works, not hidden out of shame but rather as part of a game.

Yet another layer of meaning comes into focus here. The Readymade to follow *Belle Haleine* as the very next work was *Why not sneeze Rrose Sélavy? Rrose Sélavy* is also responsible for the small birdcage, filled with 152 marble cubes, a thermometer and a cuttlebone (1921, fig. 9). Sneezing, or rather dealing with it, is described in all of Western spiritual and religious movements, as discussed not even a decade prior to the creation of *Why not sneeze?*[35] In the dispute between Aristophanes and Eryximachos over the status of Eros, the sneeze is also of great importance—in ancient literature, the urge to sneeze is only mentioned in Plato's *Symposium*. Before Aristophanes' eulogy of Eros as the best God for humankind, Eryximachos suggests curing the hiccups by sneezing. Aristophanes turns the doctor's recommendation against him, in that he wonders how a perfectly organised body could possibly be in need of the convulsions of a sneeze. Within the humoristic, ironic and oftentimes snappy dispute about eros, the sneezing itself becomes an allegory for the sensual God as seen by Aristophanes. When Eryximachos prescribes the sneeze, Aristophanes as a comical poet attempts to persuade him of the value of his own point of view and at the same time render the doctor's assertions futile. Thus, when Duchamp as *Rrose Sélavy* has *Belle Haleine* followed directly by *Why not sneeze?* we may assume his knowledge of the dispute about Eros in Plato's *Symposium*.

A final observation: for the first time in 1980, 289 of Duchamp's notes were posthumously published, forty-six of which concerned the concept of Inframince (or Infrathin), thoughts rich with Duchamp's very

33 Gerhard Krüger, *Einsicht und Leidenschaft: Das Wesen des platonischen Denkens* (Frankfurt, 1983), p. 122 [author's translation].
34 Plato, *Collected Works*, vol. 2: *Symposium* (Hamburg, 2011), pp. 37–101, pp. 60–63.
35 *Münchner Neueste Nachrichten*, September 4, 1912, p. 2.

und Eryximachos über den Stellenwert des Eros ist das Niesen gleichfalls von großer Bedeutung – in der antiken Literatur findet der Niesreiz einzig in Platons *Symposion* Erwähnung. Vor Aristophanes eigener Lobeshymne auf den Eros als menschenfreundlichster aller Götter heilt Eryximachos diesen vom Schluckauf, indem er ihn Niesen macht. Aristophanes nutzt die Empfehlung des Arztes, um sie gegen ihn zu kehren, indem er sich darüber wundert, wie denn ein wohlgeordneter Körper einer Erschütterung wie dem Niesen bedürfe. Das Niesen ist im teils forschen, teils humorvoll-ironischen Disput ein Sinnbild für den Eros, wie Aristophanes ihn sieht – dadurch, dass Eryximachos ihm den Niesreiz verschreibt, versucht der Komödiendichter den Arzt von der Wertigkeit seines Standpunkts zu überzeugen und zugleich dessen eigene Behauptungen in Abrede zu stellen. Wenn also Duchamp auf *Rrose Sélavys* Readymade *Belle Haleine* sogleich deren Readymade *Why not Sneeze?* folgen lässt, so dürfen wir fest von dessen genauer Kenntnis über den Eros-Wettstreit in Platons *Symposion* ausgehen.

Und noch eines: Erst im Jahre 1980 werden 289 Notizen Duchamps posthum veröffentlicht, 46 davon befassen sich mit Inframince (»Infradünn«), ein Gedankenkomplex reich an Poesie und Humor, der sich von infinitesimalen Unterschieden zwischen massenproduzierten Gegenständen über die rückseitige Ansicht von Gemälden auf Glas bis hin zur Vergegenwärtigung von U-Bahngästen erstreckt, die in letzter Sekunde durch die sich schließende Tür in den Waggon eintreten. Für eine weitere Deutung von *Belle Haleine* sind zwei Notizen von Interesse: in einer werden »Gerüche infradünner als Farben«[36] bezeichnet, während eine bereits im März 1945 publizierte Notiz – das einzige Mal übrigens, dass das Wort Inframince zu seinen Lebzeiten überhaupt Erwähnung findet – auf der Umschlagrückseite der Duchamp gewidmeten Nummer des New Yorker Avantgardemagazins *View* (Abb. 10) steht: »Wenn der Tabakrauch auch nach dem Mund riecht, der ihn ausatmet, dann sind die beiden Gerüche durch Inframince verheiratet«.[37] Verweist der Originaltitel des Parfums *Un Air Embaumé* auf wohlriechende Luft, so macht Duchamp mit seinem »schönen Atem« *Belle Haleine* auch ein Mundwasser daraus. Wie wir festgestellt haben, ist Duchamps Parfumflasche allerdings leer, so wie bereits seine Ampulle *Air de Paris* (1919)[38] von Flüssigkeit geleert war – was bei Duchamp wenig verwundern muss, war doch eines seiner ersten Readymades der *Flaschentrockner* (1914, Abb. 11). In seinem bereits zitierten Brief an Jean Crotti glaubte Duchamp bekanntlich ohnehin nicht an die Möglichkeit des Erhalts des

36 Duchamp 1980, Nr. 37 (wie Anm. 29), o. S. [Übersetzung des Autors].
37 Ebd., Nr. 11 (verso).
38 S. Thomas Girst und Rhonda Roland Shearer, »»Paris Air‹ or ›Holy Ampule‹«, in: *Tout-Fait: The Marcel Duchamp Studies Online Journal*, vol 1, issue 1 (1999), ›www.toutfait. com/online_journal_details.php? postid=744‹ (28. September 2012).

own poetics and humour, in which he examines the infinitesimal differences between mass produced objects and contemplates the sight of the backsides of paintings on glass, or visualises Metro train travellers, who climb on board at the last moment when the doors are sliding shut. For a further reading of *Belle Haleine*, two notes are of interest here: "Smells more infrathin than colours,"[36] while another one published in French in March 1945—the only time, incidentally, that the word "infrathin" is mentioned in Duchamp's lifetime—is to be found on the back-cover of an issue of New York avant garde magazine *View* (fig. 10) dedicated to Duchamp: "When the tobacco smoke smells also of the mouth which exhales it, the two odors are married by Infrathin."[37] As the original title of the perfume *Un air embaumé* refers to pleasant-smelling air, so Duchamp also turns it into mouthwash with his "beautiful breath" *Belle Haleine*. As we have seen, Duchamp's bottle was altogether empty, just as his ampoule *Air de Paris* (1919)[38] was completely emptied of liquid—something hardly surprising with Duchamp, taking into account that one of his first Readymades was a *Bottle Dryer* (1914, fig. 11). In his letter to Jean Crotti quoted earlier, Duchamp did not believe in the possibility of preserving the original fragrance. And while early on he rid himself of the "olfactory masturbation" of his painter colleagues, within his notes and ruminations Duchamp nevertheless grants the sense of smell an intellectual and mental component unfurling far away from the scent of oil paints. Barely two years prior to his death the beautiful breath *Belle Haleine* appears in yet another extended context: "My art would be that of living: each second, each breath is a work which is inscribed nowhere, which is neither visual nor cerebral. It's a sort of constant euphoria."[39]

Transl. Amy Fulconbridge

36 Marcel Duchamp 1980 (see note 29), n. p. [note 37].
37 Marcel Duchamp 1980 (see note 29), n. p. [note 11, verso].
38 See Thomas Girst and Rhonda Roland Shearer, "'Paris Air' or 'Holy Ampule,'" *Tout-Fait: The Marcel Duchamp Studies Online Journal*, vol 1, issue 1 (1999), <www.toutfait.com/ online_journal_details.php?postid= 744> (September 28, 2012).
39 Pierre Cabanne, *Dialogues with Marcel Duchamp* (New York, 1987), p. 72.

This essay is based on a talk of October 29, 2011, held at the Kunstverein Schwerin, "Die Nase voll von Belle Haleine. Von Duchamps Readymades und dem Duft der Rrose Sélavy," as part of *Redefine Readymade* (16 March – 29 October 2011). The title of the talk refers to the author's published review (*Die Welt*, 28 January, 2011, p. 23) of the exhibition *Marcel Duchamp. Belle Haleine, Eau de Voilette* at the Neue Nationalgalerie, Berlin, 27–30 January, 2011.

ursprünglichen Dufts. Und auch wenn er gegen die »olfaktorische Masturbation« seiner Malerkollegen anstank, so spricht Duchamp in seinen Notizen fernab der Ölfarbendüfte dem Geruchssinn letztlich eine immateriell geistige Komponente zu, die sich weit weg von Farben und visuellem Wohlgefallen zu entfalten vermag. Kaum zwei Jahre vor seinem Tod erscheint uns der schöne Atem *Belle Haleine* in einem erweiterten Sinnzusammenhang: »Meine Kunst wäre es, zu leben: jede Sekunde, jeder Atemzug, ist ein Werk, das keinen Titel trägt, das weder visuell noch geistig ist. Eine Art fortwährende Euphorie.«[39]

39 Pierre Cabanne, *Dialogues with Marcel Duchamp*, New York 1987, S. 72 [Übersetzung des Autors].

Der vorliegende Beitrag wurde zuerst am 29.10.2011 im Kunstverein Schwerin als Vortrag mit dem Titel »Die Nase voll von Belle Haleine. Von Duchamps Readymades und dem Duft der Rrose Sélavy« im Rahmen der Ausstellungs- und Veranstaltungsreihe *Redefine: Readymade* (16.3.–29.10.2011) gehalten. Der Titel bezieht sich auf die gleichnamige Rezension des Autors *(Die Welt,* 28.1.2011, S. 23) zur Ausstellung *Marcel Duchamp. Belle Haleine: Eau de Voilette,* Neue Nationalgalerie, Berlin, 27.–30.1.2011.

VOM MISS- UND GEBRAUCH MARCEL DUCHAMPS
DAS KONZEPT DES READYMADE IN DER NACHKRIEGS- UND ZEITGENÖSSISCHEN AMERIKANISCHEN KUNST

In einem Interview mit Katherine Kuh aus dem Jahre 1961 lässt Marcel Duchamp auf die Frage nach seinen Readymades wissen, dass das Konzept dieser Objekte wohl »die wichtigste einzelne Idee ist, die aus meinem Werk kommt«.[1] Im Juni 1967 führt der selbsternannte »an-artist«[2] dazu aus: »Es muss eigentlich nicht angeschaut werden, es ist einfach da. [...] nicht die visuelle Frage des Ready-made zählt, sondern die Tatsache, dass es existiert [...] Es gibt keine Frage der Visualität mehr. Das Ready-made ist sozusagen nicht mehr sichtbar. Es ist vollständig graue Substanz. Es ist nicht mehr retinal«. Als Duchamp von seinem Interviewpartner nach dem Paradox der Readymades befragt wird, die einerseits »›konsumiert‹ werden in Museen, in Ausstellungen« und andererseits »als Kunstobjekte verkauft werden« — dies besonders im Lichte der Editionen der Galleria Schwarz in Mailand im Jahre 1964 —, antwortet er außerdem:

»Es gibt einen absoluten Widerspruch, aber genau das ist angenehm, nicht wahr, die Idee des Widerspruchs, den Begriff des Widerspruchs hineinzubringen, der eben etwas ist, was nie genügend ausgebeutet wurde, verstehen Sie? Und umso mehr, als diese Ausbeutung [...] nicht sehr weit geht. Wenn man von den Readymades eine Edition von acht macht, wie eine Skulptur — wie ein Bourdelle oder sonst wer, verstehen Sie —, so ist das nicht übertrieben! Es gibt etwas, dass man Multiples nennt, das in die 150, 200 Exemplare geht. Hier erhebe ich Einspruch, weil das wirklich zu vulgär wird, wenn Sie so wollen [...] Das vulgarisiert auf eine unnötige Art Dinge, die interessant sein könnten, wenn sie von weniger Leuten gesehen würden. Es gibt zu viele Leute auf der Welt, die anschauen. Man muss die Zahl der Leute, die anschauen, reduzieren! Aber das ist ein anderes Problem, verstehen Sie?«[3]

1 Katherine Kuh, *The Artist's Voice: Talks with Seventeen Artists*, New York 1962, S. 92; für die deutsche Übersetzung siehe Serge Stauffer, *Marcel Duchamp: Interviews und Statements*, Graphische Sammlung Staatsgalerie Stuttgart, Ostfildern-Ruit 1992, S. 120 ff.
2 In einem Interview aus dem Jahre 1959 prägt Duchamp den Begriff des »an-artist«, ein Wortspiel mit »Anarchist«, das gleichzeitig den Begriff »Anti-Christ« abtut als etwas, das so sehr von seinem Gegenteil abhängt, um zu existieren (und was dadurch genauso viel von einem Künstler hätte wie der Begriff ohne das Präfix »anti-«); aus einem Interview mit Georg Heard Hamilton und Richard Hamilton, »Marcel Duchamp Speaks«, BBC — Third Program (in der Serie: *Art, Anti-Art*, ca. Oktober 1959); veröffentlicht als Audioband bei *Audio Arts Magazine*, hrsg. von William Furlong, 2, 4, 1976. Ich danke André Gervais für die Bereitstellung dieser Quelle, in der zum ersten Mal der Begriff »an-artist« durch Duchamp verwendet wird.
3 »Marcel Duchamp spricht über Readymades«, Interview mit Phillipe Collin, 21. Juni 1967, in: *Marcel Duchamp*, Ausst.-Kat., Museum Jean Tinguely, Basel, Ostfildern 2002, S. 37 ff.

(AB)USING MARCEL DUCHAMP: THE CONCEPT OF THE READYMADE IN POST-WAR AND CONTEMPORARY AMERICAN ART

In a 1961 interview with Katherine Kuh, Marcel Duchamp, when asked about his Readymades, let it be known that the concept behind those objects might be "the most important single idea to come out of my work."[1] In June 1967, the self-proclaimed "an-artist"[2] elaborated on his concept of the Readymade: "Ultimately, it should not be looked at... It's not the visual aspect of the Readymade that matters, it's simply the fact that it exists... Visuality is no longer a question: the Readymade is no longer visible, so to speak. It is completely gray matter. It is no longer retinal." When pressed by his interviewer about the paradox of the Readymades having "ended up being 'consumed' in museums and exhibitions, and sold as art objects" (particularly in light of the editions produced by the Galleria Schwarz in Milan in 1964), Duchamp replied:

> There is an absolute contradiction, but that is what is enjoyable, isn't it? Bringing in the idea of contradiction, the notion of contradiction, which is something that has never really been used, you see? And all the more since this use doesn't go very far. If you make an edition of eight Readymades, like a sculpture, like a Bourdelle or you name it, that is not overdoing it. There is something called "multiples," that go up to hundred and fifty, two hundred copies. Now there I do object because that's getting really too vulgar in a useless way, with things that could be interesting if they were seen by fewer people. There are too many people in this world looking. We have to reduce the number of people looking! But that's another matter.[3]

To "reduce the number of people looking" echoes an early note by Marcel Duchamp, "Limit the no. of rdymades yearly (?)."[4] This comment,

1 Katharine Kuh, *The Artist's Voice: Talks with Seventeen Artists* (New York, 1962), p. 92.
2 In a 1959 interview, Duchamp coined the sobriquet "an-artist" for himself, a pun on *anarchist*—while dismissing the term "anti-artist" as someone who would depend on his opposite too much in order to exist (and would thus still be as much of an artist as the one without the prefix "anti-"); from an interview with George Heard Hamilton and Richard Hamilton, "Marcel Duchamp Speaks," BBC-Third Program (series: *Art, Anti-Art*, ca. October 1959); issued as an audio tape by William Furlong, ed., *Audio Arts Magazine* 2, 4 (London, 1976). I thank André Gervais for providing me with the source of Duchamp's first mention of "an-artist."
3 "Marcel Duchamp Talking about Readymades" (Interview by Phillipe Collin, June 21, 1967), in *Marcel Duchamp*, exh. cat. Museum Jean Tinguely Basel (Ostfildern, 2002) pp. 37–40, p. 38.
4 Michel Sanouillet and Elmer Peterson, eds., *The Writings of Marcel Duchamp* (New York, 1989), p. 33.

»Die Zahl der Menschen, die anschauen, reduzieren« erinnert an eine frühe Notiz Marcel Duchamps, »Die Zahl der Rdymades pro Jahr einschränken(?)«.[4] Dieser Kommentar, der zuerst in *Die Braut von ihren Junggesellen entblößt, sogar / Die Grüne Schachtel (La Mariée mise à nu par ses célibataires, même / La Boîte verte,* Abb. 8) von 1934 veröffentlicht wurde, wurde sehr wahrscheinlich zwischen den Jahren 1911 bis 1915 geschrieben — in der Zeit der ersten Readymades, wie dem *Fahrrad-Rad* (1913, Abb. 6) und dem *Flaschentrockner* (1914, Abb. 11).[5] Da Duchamp nie Interesse daran hatte, diese öffentlich zu zeigen, dienten sie zunächst allein der privaten Kontemplation — nicht unähnlich dem berühmten Wachsbeispiel von Descartes oder Ockhams Rasiermesser —, möglicherweise auch als Antworten auf seine Notizen aus dem Jahre 1913: »Kann man Werke machen, die nicht ›Kunst‹ sind?«[6] Dementsprechend galten die Readymades außerhalb des kleinen Kreises von Freunden und Familie bis in die 1940er-Jahre als relativ unbekannt, mit Ausnahme der einzigen Ausstellung in New York im Jahre 1916, in der sie zu sehen waren. Wir sollten außerdem berücksichtigen, dass sogar das Urinal mit dem Titel *Fountain* (Abb. 5), das nicht einmal unter Duchamps Namen, sondern unter dem Pseudonym »R. Mutt« eingereicht wurde, im Jahre 1917 von der Society of Independent Artists nicht zur ersten Ausstellung zugelassen wurde. Häufig in seinem Leben lehnte es Duchamp ab, an Ausstellungen teilzunehmen, besonders wenn seine Readymades gezeigt werden sollten. Das *Fahrrad-Rad* zum Beispiel wurde erstmals im Jahre 1951 ausgestellt und auch dann nur als eine Replik des verloren gegangenen Originals. Man kann Duchamp also durchaus Glauben schenken, wenn er behauptet, dass die Readymades »ein persönliches Experiment waren, das ich nie der Öffentlichkeit zu zeigen intendiert hatte«.[7]

Was ihre tatsächliche Anzahl betrifft, so spricht Duchamp einmal von dreißig bis fünfunddreißig Werken, obwohl davon heute nur ungefähr ein Drittel bekannt ist.[8] Viele Objekte, die als Readymades bezeichnet wurden — beispielsweise in seinen Notizen oder in frühen Berichten von Charles Sheeler, William Carlos Williams und Edgar Varèse —, wurden nie verwirklicht oder sind spurlos verschwunden. Jedenfalls deuten diese limitierte Anzahl sowie die Tatsache, dass zumindest ein paar dieser Objekte nicht vermisst werden, stark darauf hin, dass sie tatsächlich »das persönliche Experiment« sind, das der »an-artist« beschreibt. Duchamp war seit jeher bemüht zu betonen, dass die Wahl seiner Objekte begrenzt sei, um Redundanzen zu ver-

4 *Marcel Duchamp. Die Schriften,* hrsg. von Serge Stauffer, Zürich 1981, S. 100.
5 In seinem Werk *Marcel Duchamp. The Art of Making Art in the Age of Mechanical Reproduction,* New York 1999, differenziert Francis M. Naumann zwischen »assisted readymade«, »imitated rectified readymade«, »printed readymade«, »Ready-made« (»readymade oder ready-made«), »rectified readymade« und »semi-readymade« (S. 308 f.), nicht zu vergessen das »reciprocal readymade«, wie es in Duchamps Notizen zur Grünen Schachtel erwähnt wird: »Einen Rembrandt als Bügelbrett benützen« (Stauffer 1981, S. 100) — eine Notiz, die Robert Rauschenberg dazu inspiriert haben muss, seinen *Erased de Kooning* (1953) zu schaffen, und Jasper Johns, Duchamps kleines bronzenes *Female Fig Leaf* für einen oberflächlichen Abdruck — obgleich kaum erkennbar — auf seiner Malerei *No* (1961) zu nutzen. Innerhalb dieses Essays befasse ich mich mit dem »unassisted Ready-made«.
6 Stauffer 1981 (wie Anm. 4), S. 125.
7 Autor unbekannt, »Artist Marcel Duchamp Visits U-classes, Exhibits at Walker«, in: *Minnesota Daily,* 22. Oktober 1965.
8 Dieter Daniels, *Duchamp und die Anderen. Der Modelfall einer künstlerischen Wirkungsgeschichte in der Moderne,* Köln 1992, S. 205.

first published in *Die Braut von ihren Junggesellen entblößt, sogar / Die Grüne Schachtel* (*La Mariée mise à nu par ses célibataires, même / La Boîte-en-Valise*, fig. 8) of 1934, was most likely written between 1911 and 1915, during the period of the first Readymades, such as the *Bicycle Wheel* (1913, fig. 6) and the *Bottle Dryer* (1914, fig. 11).[5] As he was never keen on showing them publicly, early on they may have functioned as works of private contemplation (not unlike Descartes' famous piece of wax or William of Occam's razor), responses, perhaps, to his note of 1913: "Can one make works which are not works of 'art'?"[6] Accordingly, with the exception of one single New York exhibition in 1916, the Readymades were unknown outside his small circle of friends and family until the 1940s. We should bear in mind that even the urinal entitled *Fountain* (fig. 5)—submitted not under Duchamp's name, but under the pseudonym "R. Mutt"—was rejected for display at the first exhibition of the Society of Independent Artists in 1917. Throughout his life Duchamp often declined to participate in exhibitions, especially when his Readymades were involved. The *Bicycle Wheel*, for example, was not shown until 1951, and even then only as a replica of the lost original. Duchamp is thus to be believed when he says that the Readymades "were a very personal experiment that I had never intended to show to the public."[7]

As for their actual number, Duchamp once spoke of thirty to thirty-five, though today only about a third of them are known.[8] Many objects qualifying as Readymades—mentioned in his notes and in early accounts by Charles Sheeler, William Carlos Williams, and Edgar Varèse—were never realized or are lost without a trace. In any case, their limited number, and the fact that at least a few of them are unaccounted for, strongly suggest that they were indeed the "personal experiment" that the "an-artist" described. Duchamp sought from the beginning to assure that his choice of objects would be limited in order to avoid redundancy, an inevitable consequence if a larger number of original Readymades had been produced. In the 1930s Duchamp declined a proposal from the Knoedler Gallery in New York, whose director offered him a substantial sum if he would continue to produce the works for which he was most famous (such as the *Nude Descending a Staircase* of 1912, fig. 12). "It would force me to repeat myself. I will not even envisage this possibility. I value my independence too much."[9] Despite the temptation, Duchamp kept the Readymades out of the fray and, accordingly, they remained virtually unknown.

5 In his *Marcel Duchamp: The Art of Making Art in the Age of Mechanical Reproduction* (New York, 1999) Francis M. Naumann differentiates between "assisted readymade," "imitated rectified readymade," "printed readymade," "readymade (or readymade)," "rectified readymade," and "semi-readymade" (pp. 308–309), not to mention the "reciprocal readymade," as discussed in one of Duchamp's notes in his *Green Box*: "Use a Rembrandt as an Ironing Board," (in *The Writings of Marcel Duchamp*, p. 32), a remark that may well have inspired Robert Rauschenberg to do his *Erased de Kooning* (1953) and Jasper Johns to use Duchamp's small bronze *Female Fig Leaf* for a surface imprint (albeit almost undetectable) on his painting *No* (1961). Throughout this essay, I concern myself with the "unassisted readymade."
6 Naumann 1999 (see note 5), p. 74.
7 Anonymous, "Artist Marcel Duchamp Visits U-classes, Exhibits at Walker," *Minnesota Daily*, October 22, 1965.
8 Dieter Daniels, *Duchamp und die Anderen. Der Modelfall einer künstlerischen Wirkungsgeschichte in der Moderne* (Cologne, 1992), p. 205.
9 Duchamp, cited in Arturo Schwarz, *The Complete Works of Marcel Duchamp* (New York, 2000), p. 68.

meiden, die eine unvermeidbare Folge der Produktion einer größeren Anzahl von Readymades gewesen wären. In den 1930er-Jahren lehnt Duchamp ein Angebot des Direktors der Knoedler Galerie in New York ab, der ihm eine beträchtliche Summe dafür bot, dass er weiterhin diejenigen Werke produziert, für die er so berühmt war, wie zum Beispiel für den *Akt, eine Treppe herabsteigend* aus dem Jahre 1912 (Abb. 12). »Es würde mich zwingen, mich selbst zu wiederholen. Ich will diese Möglichkeit nicht einmal ins Auge fassen. Dafür schätze ich meine Unabhängigkeit zu sehr.«[9] Trotz dieser Versuchung entzieht Duchamp die Readymades jeglicher Auseinandersetzung, sie bleiben dementsprechend nahezu unbekannt.

Duchamps Weigerung, die Readymades als Kunstwerke zu behandeln, lassen ihn behaupten, dass »während einer Periode von 30 Jahren [...] niemand von ihnen gesprochen (hat), ich auch nicht«.[10] Seine oft geäußerte ästhetische Gleichgültigkeit gegenüber diesen Objekten klammerte auch die Möglichkeit aus, sie in hoher Auflage erscheinen zu lassen, was wiederum sein »Experiment« unterwandert hätte. Um seine Gleichgültigkeit auch trotz allem neu erworbenen Ruhms weiterhin aufrecht zu erhalten, denkt Duchamp, der stets in Sorge über die unvermeidliche Ästhetik der Patina ist, darüber nach, sie gegen neuere, massenproduzierte Objekte auszutauschen und beispielsweise den *Flaschentrockner* durch einen Plastikeimer zu ersetzen.[11]

Abgesehen von seinen Notizen in der *Grünen Schachtel*, seiner privaten Korrespondenz und den Miniaturen und fotografischen Reproduktionen in *Von oder durch Marcel Duchamp oder Rrose Sélavy / Die Schachtel im Koffer (De ou par Marcel Duchamp ou Rrose Sélavy / La Boîte-en-Valise, 1941, Abb. 13)*[12] erwähnt Duchamp die Readymades öffentlich nicht vor 1945.[13] Tatsächlich erweist sich die einzige Definition, die unter Duchamps Namen 1938 veröffentlicht wird — »ein gewöhnliches Objekt, das einzig durch die Wahl des Künstlers zu einem Kunstwerk erhoben wird« — als nicht von Duchamp, sondern von André Breton verfasst.[14]

Das bis hierher Besprochene kann die Feinheiten des frühen Konzepts der Readymades nach Duchamp und seine vielen Fehldeutungen lediglich skizzieren. Von der unmittelbaren Nachkriegszeit an bis heute wurden und werden Duchamps Readymades zu oft als Blankovollmacht für ein »anything goes«, als schiere nihilistische oder ikonoklastische Gesten gesehen, die auf dem durch die Wahl des Künstlers hervorgerufenen Glauben gründen, dass es lediglich der Kontext ist, durch den

9 Duchamp, zitiert nach Arturo Schwarz, *The Complete Works of Marcel Duchamp*, New York 2000, S. 68 [Übersetzung des Autors].
10 »Marcel Duchamp spricht über Readymades« (wie Anm. 3), S. 37 ff.
11 Werner Spies, *Max Ernst, Collagen*, Köln 1988, S. 23.
12 Es wurde argumentiert, dass Duchamp lediglich über die Dokumentation der Readymades in der *Schachtel im Koffer* den bedeutenden Schritt ging, sowohl die Readymades und klar bestimmte Gruppen von Arbeiten — die er mit aufnehmen wollte, als er 1936 an der Schachtel zu arbeiten begann — sowohl zu definieren als sie auch in den jeweiligen Kunstkontext einzuordnen. S. Daniels 1992 (wie Anm. 8), S. 217.
13 Hector Obalk, »The Unfindable Readymade«, in: *Tout-Fait: The Marcel Duchamp Studies Online Journal*, 1, 2, ‹www.toutfait.com / issues / issue_2 / Articles / obalk.html›.
14 Ebd., durch André Gervais bestätigt.

Duchamp's refusal to have the Readymades treated as works of art led him to claim that "for a period of thirty years nobody talked about them and neither did I."[10] His often pronounced aesthetic indifference towards these objects also excluded the possibility of their appearance in large numbers, as that would have allowed for taste to infiltrate his "experiment." In later years, to maintain this indifference despite their newly acquired fame, Duchamp—always concerned about the unavoidable aesthetics of patina—even thought of swapping them for newer mass-produced objects, replacing, for example, the *Bottle Dryer* with a plastic bucket.[11]

Apart from his notes in the *Green Box,* his private correspondence, and the miniatures and photographic reproductions in *From or by Marcel Duchamp or Rrose Sélavy / The Box in a Valise (De ou par Marcel Duchamp ou Rrose Sélavy / La Boîte-en-Valise,* 1941, fig. 13),[12] Duchamp did not publicly mention the Readymades until 1945.[13] In fact, the sole definition of the Readymade published under Duchamp's name, in 1938—"an ordinary object elevated to the dignity of a work of art by the mere choice of an artist"—turns out not to have been written by Duchamp but by André Breton.[14]

All of the above can only hint at the intricacies of Duchamp's early concept of the Readymade and the many misreadings that followed. From the immediate post-war period until today, Duchamp's Readymades have been all too often taken as carte blanche for "anything goes," mere nihilistic or iconoclastic gestures based on the belief that, generated by the choice of the artist, it is only the changing of the context (i. e. a urinal at a plumbing-fixture store vs. *Fountain* at an art exhibition) through which an ordinary object is transformed into a work of art.[15] Misreading Duchamp of course, is what the ambivalent "an-artist" himself must have anticipated and, to a certain extent, encouraged, as Dieter Daniels observed:

Whenever other artists embrace the principle of the Readymade, the idea becomes completely detached from the historical objects and begins a life of its own. In so doing, it illustrates in the best way possible Duchamp's dictum that it is the viewer who makes the pictures. The continued artistic influence of the Readymade may therefore be understood only as a permanent redefinition of its meaning.[16]

10 "Marcel Duchamp Talking about Readymades," 1967 (see note 3), p. 40.

11 Werner Spies, *Max Ernst, Collagen* (Cologne, 1988), p. 23.

12 It has been argued that only with their documentation within the *Boîte-en-valise* did Duchamp take the significant step of both defining the Readymades as a clearly defined group of works (deciding which ones he would include when starting to work on the *Boîte* around 1936) and placing them within the context of art. See Dieter Daniels 1992 (see note 8).

13 Hector Obalk, "The Unfindable Readymade,"*Tout-Fait: The Marcel Duchamp Studies Online Journal,* vol. 1, no. 2, (Articles) <www.toutfait. com/issues/issue_2/Articles/obalk. html>.

14 Hector Obalk, "The Unfindable Readymade," (as confirmed by André Gervais).

15 George Dickie, *Art and the Aesthetic. An Institutional Analysis* (Ithaca and London, 1974), pp. 38–39.

16 Dieter Daniels, "Marcel Duchamp: The Most Influential Artist of the 20th Century?" in *Marcel Duchamp,* exh. cat. Museum Jean Tinguely, Basel (Ostfildern, 2002), p. 29.

das gewöhnliche Objekt in ein Kunstwerk verwandelt wird – das Urinal aus einem Sanitärgeschäft wird zum *Fountain* in einer Kunstgalerie.[15] Gewiss hat der ambivalente »an-artist« die Fehleinschätzungen seiner Readymades bereits antizipiert und er musste sich durch sie zu einem gewissen Maße sogar angespornt gefühlt haben, wie Dieter Daniels beobachtet: »Indem andere Künstler nur das Prinzip der Ready-mades aufgreifen, löst sich die Idee völlig von den historischen Objekten und beginnt ein Eigenleben, das auf die beste Weise Duchamps Dictum illustriert, dass die Betrachter die Bilder machen. Die künstlerische Fortführung des Ready-made-Prinzips kann nur als eine permanente Re-Definition seiner Bedeutung verstanden werden«.[16]

Duchamps anhaltende Bekanntheit und sein Einfluss auf eine jüngere Generation von Künstlern kam zunächst unerwartet: es dauerte eine Zeit, bis anerkannt wurde, dass »dieses ganze verdammte revolutionäre und widerspruchsvolle Jahrhundert im Grunde eine große Duchamp-Beckett-Burleske war«.[17] Seine eigene Haltung gegenüber seinen Erben schien bestenfalls durch Zurückhaltung – derselben Art, wie er sie früher gegenüber Dada und Surrealismus erklärt hatte – und schlimmstenfalls durch Frustration gekennzeichnet zu sein, wie sie von dem Dadaisten Hans Richter folgendermaßen überliefert wurde: »Dieses Neo-Dada, das sich jetzt neuer Realismus, Pop-Art, Assemblage etc. nennt, ist ein billiges Vergnügen und lebt von dem, was Dada tat. Als ich die Readymades entdeckte, gedachte ich den ästhetischen Rummel zu entmutigen. Im Neo-Dada benutzten sie aber die Readymades, um an ihnen ›ästhetischen Wert‹ zu entdecken!! Ich warf ihnen den Flaschentrockner und das Urinoir ins Gesicht als eine Herausforderung, und jetzt bewundern sie es als das ästhetisch Schöne«.[18]

Es gibt allerdings ein Problem mit diesem berüchtigten Zitat. Hans Richter behauptete zunächst, dass es einem Brief Duchamps an ihn aus dem Jahre 1961 entstammt. Wenige Jahre später räumt er allerdings ein, dass diese Worte nicht jene Duchamps sind. Stattdessen hat Richter den obigen Abschnitt an Duchamp mit der Bitte um Kommentierung gesandt: »Du warfst Ihnen den Flaschentrockner und das Pissoir ins Gesicht…«. Duchamp notierte lediglich am Rand: »Ok, ça va trés bien« (»Ok, einverstanden«).[19] Tatsächlich war des An-Artisten Einschätzung der neuen künstlerischen Bewegungen, die um ihn herum entstanden und denen er zu einem gewissen Grad seine Renaissance als Künstler verdankte, deutlich teilnahmsvoller als Richters irreführendes Zitat es suggeriert – obwohl sich Duchamp weiter aus allen Ent-

15 George Dickie, *Art and the Aesthetic. An Institutional Analysis*, Ithaca and London 1974, S. 38 f.

16 Dieter Daniels, »Marcel Duchamp: The Most Influential Artist of the 20th Century?«, (wie Anm. 3), S. 29.

17 Brooks Adams »Like Smoke: A Duchampian Legacy«, in: *The Age of Modernism. Art in the 20th Century*, hrsg. von Christos M. Joachemides and Norman Rosenthal, Ausst.-Kat., Ostfildern 1997, S. 321 [Übersetzung des Autors]. Vgl. diesbezüglich auch Pontus Hultens Anmerkung in *Marcel Duchamp*, hrsg. von Pontus Hulten, Ausst.-Kat., Milano 1993, S. 19: »Wenn jemand im Jahre 1953 gesagt hätte, dass Duchamps Arbeit 40 Jahre später als wichtiger angesehen werde als die von Picasso, hätte man diese Person wohl als Verrückten bezeichnet. Und dennoch…« [Übersetzung des Autors].

18 Marcel Duchamp, zit. n. Hans Richter, *Dada: Kunst und Anti-Kunst*, Köln 1978 (1964), S. 211 f.

19 Hans Richter, *Begegnungen von Dada bis Heute*, Köln 1982, S. 155 ff.

Duchamp's continuing fame, and his influence on a younger generation of artists, were unexpected: it took some time before it was established that "this whole bloody, revolutionary, contradictory century has basically been a big Duchampian-Beckettian burlesque."[17] His own attitude towards his heirs seemed to be, at best, one of aloofness (of the same sort he had earlier professed towards Dada and Surrealism), and, at worst, frustration, as was articulated to the Dadaist Hans Richter:

> This Neo-Dada, which they call New Realism, Pop Art, Assemblage, etc., is an easy way out, and lives on what Dada did. When I discovered the Readymades I sought to discourage aesthetics. In Neo-Dada they have taken my Readymades and found aesthetic beauty in them, I threw the bottle-rack and the urinal into their faces as a challenge and now they admire them for their aesthetic beauty.[18]

There is a problem with this infamous quote, however. Hans Richter asserted that it came straight from a letter written to him by Duchamp in 1961. Only years later did he admit that those words were not Duchamp's. Richter had sent Duchamp this paragraph for comment, writing: "You threw the bottle rack and the urinal into their face...," et cetera Duchamp simply scrawled: "Ok, ça va très bien" into the margins.[19]

In fact, the "an-artist's" overall assessment of the new movements spreading all around him (and to which, to a certain degree, he owed his enormous renaissance) was, though disengaged, much more sympathetic than Richter's misleading quote would suggest. In 1964, Duchamp, though unmoved by the Pop Art artist's sense of humor and choice of material, made the following favorable comments:

> Pop Art is a return to "conceptual" painting, virtually abandoned, except by the Surrealists, since Courbet, in favor of retinal painting... If you take a Campbell soup can and repeat it 50 times, you are not interested in the retinal image. What interests you is the concept that wants to put 50 Campbell soup cans on a canvas.[20]

From the 1950s on, Duchamp's influence on the American art scene has grown precipitously. Beginning in 1942 he lived permanently in New York, and his presence was undoubtedly a factor in the numerous exhibitions that were held in this country in succeeding years.[21] In 1952 *Life* magazine honored his continuing presence as "Dada's Daddy" in a ten-

17 Brooks Adams "Like Smoke: A Duchampian Legacy," in Christos M. Joachemides and Norman Rosenthal, eds., *The Age of Modernism: Art in the 20th Century*, exh. cat. (Ostfildern, 1997), p. 321. In this regard, see also Pontus Hulten's remark in Pontus Hulten, ed., *Marcel Duchamp*, exh. cat. (Milano, 1993), p. 19: "If, in 1953, somebody had said that forty years later [Duchamp's] work would be considered more important than Picasso's, that person would have been looked on as a madman. *Et pourtant...*"
18 Duchamp, in Hans Richter, *Dada: Art and Anti-Art* (New York, 1965), pp. 207–208.
19 Hans Richter, *Begegnungen von Dada bis Heute* (Cologne, 1982) pp. 155 ff.
20 Rosalind Constable, "New York's Avant-Garde, and How It Got There," cited in Jennifer Gough-Cooper and Jacques Caumont, "Ephemerides on and about Marcel Duchamp and Rrose Sélavy, 1887–1968," May 17, 1964, in Pontus Hulten, ed., *Marcel Duchamp* (Cambridge, 1993).
21 Among the important shows of Duchamp's work in the late 1940s and early 1950s were those at the Sidney Janis Gallery, the Rose Fried Gallery, and the Julien Levy Gallery, New York, as well as various exhibitions at the Yale University Art Gallery. Peggy Guggenheim's Art of this Century was already displaying his works in the early 1940s, and in 1957, the Guggenheim Museum launched a major travel exhibition of the three Duchamp brothers, entitled "Jacques Villon, Raymond Duchamp-Villon, Marcel Duchamp."

wicklungen heraus hielt. Wenngleich er vom Sinn für Humor einiger Pop-Art Künstler und ihrer Materialauswahl ungerührt bleibt, kommentiert er im Jahre 1964 wohlwollend: »Pop Art ist die Rückkehr zur Konzept-Malerei, die mit Ausnahme der Surrealisten seit Courbet zugunsten retinaler Malerei so gut wie aufgegeben war [...] Wenn man eine Campbell-Suppendose nimmt und sie fünfzigmal wiederholt, ist man nicht interessiert an dem retinalen Bild. Was wirklich interessiert, ist das Konzept, das vorsieht, fünfzig Campbell-Suppendosen auf eine Leinwand zu packen«.[20]

Duchamps Einfluss auf die amerikanische Kunstszene nimmt seit den 1950er-Jahren stetig zu. Seit 1942 lebt er dauerhaft in New York und seine dortige Präsenz hatte zweifelsohne Auswirkung auf zahlreiche Ausstellungen, die hier in den folgenden Jahren gezeigt werden.[21] 1952 ehrt das *Life* Magazine ihn im Hinblick auf seine andauernde Präsenz in einer 10-seitigen Fotoserie als »Dada's Daddy«.[22] Mitte der 1950er-Jahre werden bereits einige seiner Readymades dauerhaft in amerikanischen Museen ausgestellt. Mit der Veröffentlichung des Sammelbands *The Dada Painters and Poets* im Jahre 1951 leistet Robert Motherwell einen bedeutenden Beitrag zu Duchamps Wiederentdeckung, indem er den *Flaschentrockner* gleichzeitig als »Skulptur« und »Anti-Kunst« und folglich als »dadaistische Geste« bezeichnet und schlussfolgert: »es ist 35 Jahre später offensichtlich, dass der Flaschenständer, den er ausgewählt hat, als Skulptur eine schönere Form hat als alles andere 1914 je Geschaffene«.[23] Damit war die Partie eröffnet, was sicherlich nicht jedem gefiel, am wenigsten den Abstrakten Expressionisten.

Im Jahr 1957 bringt Barnett Newman sein Unbehagen über das Whitney Museum of American Art, besonders über Robert Motherwells Beitrag in einem Ausstellungskatalog zum Gedenken an Bradley Walker Tomlin zum Ausdruck. In einem Brief an John I. H. Baur, den Direktor des Whitney Museums, beschuldigt Newman Motherwell der Beleidigung und Verleumdung und verdeutlicht »dass für den Fall, dass Motherwell Marcel Duchamp zu einem Vater machen möchte, Duchamp sein Vater ist und nicht meiner oder der irgend eines anderen amerikanischen Malers, den ich respektiere«.[24] Vier Jahre zuvor hatte er in einer ähnlichen Tirade gegen das Museum of Modern Art bereits zu verstehen gegeben, dass Duchamps Werke in dieser Institution lediglich zu deren »popularisierender Unterhaltungsrolle« beitrugen, und außerdem behauptet, »dass das amerikanische Publikum [...] mehr begehrt

20 Rosalind Constable, »New York's Avant-Garde, and How It Got There«, zit. n. Jennifer Gough-Cooper und Jacques Caumont, »Ephemerides on and about Marcel Duchamp and Rrose Sélavy, 1887–1968«, 17. Mai 1964, in: *Marcel Duchamp*, hrsg. von Pontus Hulten, Cambridge 1993, o. S. [Übersetzung des Autors].
21 Unter den wichtigen Ausstellungen, die Duchamps Arbeit in den späten 1940er- und frühen 1950er-Jahren zeigten, waren auch die in der Sidney Janis Galerie, der Rose Fried Galerie und der Julien Levy Galerie in New York sowie verschiedene Ausstellungen an der Yale University Kunstgalerie. Peggy Guggenheim's *Art of this Century* hat seine Arbeiten bereits in den frühen 1940ern ausgestellt und im Jahre 1957 zeigte das Guggenheim Museum eine größere Wanderausstellung der drei Duchamp-Brüder mit dem Titel: *Jacques Villon, Raymond Duchamp-Villon, Marcel Duchamp*.
22 Sargeant Winthrop, »Dada's Daddy: A New Tribute is Paid to Duchamp, Pioneer of Nonsense and Nihilism«, in: *Life*, 32, 17, 28. März 1952, S. 100 f. [Übersetzung des Autors].
23 *The Dada Painters and Poets. An Anthology*, hrsg von Robert Motherwell, Cambridge 1989, xxiii [Übersetzung des Autors]. Weitere bedeutende englischsprachige Publikationen zu Duchamp vor 1960 sind *Marcel Duchamp: From the Green Box*, New Haven 1957; 25 Notizen, die von George Heard Hamilton übersetzt und in einer Auflage von 400 veröffentlicht wurden, Robert Lebels weit verbreitete Monographie *Marcel Duchamp*, New York 1959 und Richard Hamiltons typografische Version aller Notizen in der *Grünen Schachtel: The Bride Stripped Bare by her Bachelors, even*, London und Bradford, New York 1960.
24 Newman, in: *Barnett Newman: Selected Writings and Interviews*, hrsg. von John P. O'Neill, New York 1990, S. 208 [Übersetzung des Autors].

page photo spread,[22] and by the mid-1950s some of his Readymades were permanently installed in American museums. Robert Motherwell made a significant contribution toward a Duchamp renaissance with the publication of the anthology *The Dada Painters and Poets* (1951), in which he characterized the *Bottle Dryer* as at once a "sculpture" and an "anti-art and consequently Dada gesture," concluding, "it is evident, thirty-five years later, that the bottle rack he chose has a more beautiful form than almost anything made, in 1914, as sculpture."[23] The game was on, and it certainly didn't please everyone, least of all the Abstract Expressionists.

In 1957, Barnett Newman voiced his displeasure with the Whitney Museum of American Art, particularly with Robert Motherwell's contribution to a catalogue for the memorial exhibition of Bradley Walker Tomlin. In a letter to John I. H. Baur, the Whitney's director, Newman accused Motherwell of "smear and slander," stating that he wanted to "make clear that if Motherwell wishes to make Marcel Duchamp a father, Duchamp is his father and not mine nor that of any American painter that I respect."[24] Four years earlier, in a similar tirade against the Museum of Modern Art, he had insinuated that Duchamp's works in that institution merely added to its "popularizing role of entertainment," and asserted "that the American public... seeks more from art than just gadgets."[25] In 1952, he confirmed that the "gadgets" of his scorn were indeed the Readymades: "Marcel Duchamp tried to destroy art by pointing to the *Fountain*, and we now have museums that show screwdrivers and automobiles and paintings. [The museums] have accepted this aesthetic position that there's no way of knowing what is what."[26]

This was precisely the view of Clement Greenberg, the preeminent art critic of America's post-war era. Greenberg attacked the tendency to produce art without the guidance of aesthetic judgment, a factor many artists wanted to do away with "in the hope, periodically renewed since Marcel Duchamp first acted on it fifty-odd years ago, that by dint of evading the reach of taste while yet remaining in the context of art, certain kinds of contrivances will achieve unique existence and value. So far, this hope has proved illusory."[27] With the advent of "Assemblage, Pop, Environment, Op, Kinetic, Erotic, and all the other varieties of Novelty Art"[28]—all movements, that is, which were more or less indebted to Duchamp—Greenberg bemoaned not only the passing of Abstract Expressionism but of "authentic art values."[29] These movements were fulfillments of "Duchamp's dream of going 'beyond' the issue of artistic

22 Sargeant Winthrop, "Dada's Daddy: A New Tribute is Paid to Duchamp, Pioneer of Nonsense and Nihilism," *Life* 32, 17 (March 28, 1952), pp. 100–110.

23 Robert Motherwell, ed., *The Dada Painters and Poets. An Anthology* (Cambridge, 1989), xxiii. Other significant English-language publications on Duchamp before 1960 include *Marcel Duchamp: From the Green Box* (New Haven, 1957) [25 notes translated by George Heard Hamilton and published in an edition of 400], Robert Lebel's widely available monograph *Marcel Duchamp* (New York, 1959), and Richard Hamilton's typographic version of all of the *Green Box* notes in *The Bride Stripped Bare by Her Bachelors, Even* (London and Bradford, New York, 1960).

24 Newman, in John P. O'Neill, ed., *Barnett Newman: Selected Writings and Interviews* (New York, 1990), p. 208.

25 Newman, in O'Neill 1990 (see note 24), p. 39.

26 Newman, in O'Neill 1990 (see note 24), p. 247. Newman went on to suggest that MoMA should "put on an exhibition of machine guns." It bears notice that in September 1999, when the New York gallery owner Mary Boone presented Tom Sach's *Haute Bricolage*, in which firearm paraphernalia were displayed and 9-millimeter bullets were placed in a bowl for visitors to take home, she was briefly arrested by the police for the illegal distribution of live ammunition.

27 Clement Greenberg, "Avant-Garde Attitudes: New Art in the Sixties," in John O'Brian, ed., *Clement Greenberg: The Collected Essays and Criticism*, vol. 4 (Chicago and London, 1993), p. 293.

28 Clement Greenberg, "Recentness of Sculpture," in O'Brian 1993 (see note 27), p. 252.

29 Donald B. Kuspit, *Clement Greenberg: Art Critic* (Madison, 1979), p. 114.

von der Kunst als nur Apparaturen«.[25] Im Jahre 1952 bestätigt er dann, dass es sich bei den von ihm verhöhnten »Spielereien« tatsächlich um die Readymades handelt: »Marcel Duchamp versuchte, die Kunst zu zerstören, indem er auf *Fountain* verwies, und wir haben heute Museen, die Schraubenzieher, Automobile und Malereien zeigen. [Die Museen] haben die ästhetische Haltung akzeptiert, dass es gar nicht mehr möglich ist zu wissen, was was ist«.[26]

Dies ist genau die Sicht, die auch Clement Greenberg, herausragender Kunstkritiker der amerikanischen Nachkriegszeit, vertritt. Greenberg bemängelt den Trend, Kunst ohne ein ästhetisches Urteil zu produzieren – ein Umstand, den viele Künstler aus dem Weg schaffen wollen – »in jener Hoffnung, die regelmäßig wieder aufflammt, seitdem Marcel Duchamp mehr als 50 Jahre zuvor als erster versuchte, durch das Ausweichen vor dem Geschmack beim gleichzeitigen Verbleib im Kunstkontext bestimmten Erfindungen einen besonderen Status und Wert beizumessen. Bislang hat sich diese Hoffnung als illusorisch herausgestellt«.[27] Greenberg beklagt nicht nur das Verschwinden des Abstrakten Expressionismus mit dem Aufkommen von »Assemblage, Pop, Environment, Op-Art, Kinetischer Kunst, Erotik und all den anderen Spielarten moderner Kunst«[28] – alles Bewegungen, die Duchamp mehr oder weniger verpflichtet sind –, sondern auch das »authentischer Kunstwerte«.[29] Diese Bewegungen seien Erfüllungen des »Traum[s] Duchamps, über den Wert der künstlerischen Qualität hinauszugehen«. »Das eigentliche Versagen der Pop Art«, noch über ihre »Unbekümmertheit« hinausgehend, ist ihre »Angreifbarkeit in qualitativen Vergleichen«, etwas, was Duchamp vermutlich mit seiner Aussage anregte, »den Unterschied zwischen gut und schlecht im Allgemeinen zu überwinden«.[30] Daraus folgt, dass im Zentrum dieser Irritation die Readymades in ihrer Dreidimensionalität stehen, als eine räumliche »Koordinate, die die Kunst mit Nicht-Kunst zu teilen hat«.[31] Aus diesen Beobachtungen ist deutlich erkennbar, dass Greenberg das Readymade eher als zur Geschichte der Malerei zugehörig ansieht als zur Skulptur.[32]

Am anderen Ende des Spektrums ist es Duchamp selbst, der sich lebhaft gegen die Kunstströmung ausspricht, die vor allem von Greenberg propagiert wurde: »Innerhalb eines Jahrhunderts moderner Kunst betrachtet, zeigen die allerneuesten Erzeugnisse des ›Abstrakten Expressionismus‹ deutlich den Höhepunkt der retinalen Annäherung, die mit dem Impressionismus einsetzte. Mit ›retinal‹ meine ich, dass der ästhetische Genuss fast ausschließlich vom Eindruck auf die Netzhaut

25 Ebd. S. 39 [Übersetzung des Autors].

26 Ebd. S. 247 [Übersetzung des Autors]. Newman schlug außerdem vor, dass das MoMA eine »Ausstellung von Maschinengewehren« ermöglichen sollte. Erwähnt werden sollte, dass die New Yorker Galerie-Besitzerin Mary Boone, als sie im September 1999 Tom Sachs *Haute Bricolage* präsentierte – eine Ausstellung in welcher Feuerwaffenutensilien ausgestellt und 9-Millimeter-Patronen für die Besucher bereit gestellt wurden, um sie mit nach Hause zu nehmen –, kurzzeitig von der Polizei für die illegale Verbreitung von scharfer Munition verhaftet wurde.

27 Clement Greenberg, »Avant-Garde Attitudes: New Art in the Sixties«, in: *Clement Greenberg: The Collected Essays and Criticism*, hrsg. von John O'Brian, 4, Chicago und London 1993, S. 293 [Übersetzung des Autors].

28 Clement Greenberg, »Recentness of Sculpture«, in: O'Brian 1993 (wie Anm. 27), S. 252 [Übersetzung des Autors].

29 Donald B. Kuspit, *Clement Greenberg: Art Critic*, Madison 1979, S. 114 [Übersetzung des Autors].

30 Clement Greenberg, »Avant-Garde Attitudes: New Art in the Sixties«, in: O' Brien 1993 (wie Anm. 27), S. 301 f. [Übersetzung des Autors].

31 Clement Greenberg, »Recentness of Sculpture«, in: O'Brian 1993 (wie Anm. 27), S. 254 [Übersetzung des Autors].

32 Thierry de Duve, *Clement Greenberg: Between the Lines*, Paris 1996, sowie seine *Résonances du Readymade*, Nîmes 1989, S. 132, zit. n. Dieter Daniels, »Marcel Duchamp: The Most Influential Artist of the 20th Century?«, (wie Anm. 3), S. 31.

30 Clement Greenberg, "Avant-Garde Attitudes: New Art in the Sixties," in O'Brian 1993 (see note 27), pp. 301–302.

31 Clement Greenberg, "Recentness of Sculpture," in O'Brian 1993 (see note 27), p. 254.

32 See Thierry de Duve, Clement Greenberg: Between the Lines (Paris, 1996) as well as his Résonances du Readymade (Nîmes 1989), p. 132 (referred to in Dieter Daniels 2002 [see note 16], p. 31).

33 Marcel Duchamp, "Where Do We Go From Here?," address to a symposium at the Philadelphia Museum College of Art, March 1961, in Anthony Hill, ed., Duchamp: Passim. A Marcel Duchamp Anthology (East Roseville, 1994), p. 89. Duchamp seems to have had an unfavorable opinion of Abstract Expressionism's major player, Jackson Pollock. According to Thomas B. Hess, Duchamp "complained" to him that Pollock "still uses paint, and we finished that... [Pollock] never will enter the Pantheon!" (Hess, "J'accuse Marcel Duchamp," in Joseph Masheck, ed., Marcel Duchamp in Perspective [Englewood Cliffs, 1975], p. 120). Duchamp had declared painting dead with his last oil on canvas, Tu m' from 1918. In regard to Pollock, there is yet another anecdote worth telling: in 1945, Peggy Guggenheim called in Duchamp and David Hare to deal with a crisis involving a twenty-foot-long mural by Pollock. The mural was too long for the space it had been commissioned to fill, in the entrance hall of Guggenheim's apartment. Duchamp coolly advised cutting eight inches off one end. According to Hare, "Duchamp said that in this type of painting it wasn't needed" (Calvin Tomkins, Duchamp: A Biography [New York, 1996], p. 362).

34 Scott Rothkopf, "Banned and Determined," Artforum 40, 10 (Summer 2002), p. 144.

35 John Tancock, "The Influence of Marcel Duchamp," in Anne d'Harnoncourt and Kynaston McShine, eds., Marcel Duchamp: A Retrospective Exhibition, exh. cat. Philadelphia Museum of Art, (Philadelphia, 1973), p. 174.

quality." The "real failure of Pop art," on top of its "easiness," was its "vulnerability to qualitative comparisons," something Duchamp had supposedly initiated in his "'transcending' the difference between good and bad in general."[30] It follows that at the heart of this confusion are the Readymades in their three-dimensionality, a spatial "coordinate that art has to share with non-art."[31] That Greenberg saw the Readymade as belonging to the history of painting rather than to that of sculpture clearly evolved from these observations.[32]

On the other end of the spectrum, it was Duchamp himself who spoke out vividly against the movement heralded most by Greenberg:

> The recent examples of Abstract Expressionism clearly show the ultimate in the retinal approach begun by Impressionism. By "retinal" I mean that the aesthetic pleasure depends almost entirely on the impression on the retina, without appealing to any auxiliary interpretation ... The young artist of tomorrow will refuse to base his work on a philosophy as over-simplified as that of the "representative or non-representative" dilemma.[33]

In the field of art theory, similar opposing voices made themselves heard. To give but one example: early on, New York's young and infamous art critic Gene Swenson rejected the tradition that linked everything from Cubism to Color Field painting and instead proposed a different trajectory declaring Dada and Surrealism the ancestors of Pop. In 1966, he curated the exhibition The Other Tradition at the Philadelphia Institute of Contemporary Art. According to the catalogue, the show's declared goal was "1) seeing certain twentieth-century works of art which have been overlooked or neglected by art historians, and 2) suggesting alternative 'intellectual' rather than formal ways of dealing with this art." Swenson's checklist is topped off by four contributions from Duchamp, leading him to ask: "How much longer will we rest content with our defective and infectious critical tools and our academic standards? How many more times can we see the words 'picture plane,' 'modernism,' 'crisis,' new,' and 'literary' without flushing?"[34]

Swenson was reacting to a paradigmatic shift in American art, and many young artists were enthralled to find out that Duchamp's newly discovered oeuvre spoke to their own strategies of subverting what came before them. He was simply "in the air,"[35] as Bruce Nauman put it. John Cage began lecturing on Duchamp at Black Mountain College (starting

abhängig ist, ohne eine andere Hilfsinterpretation zu beanspruchen«. Duchamp ist zu »glauben geneigt, dass der junge Künstler von morgen sich weigern wird, sein Werk auf eine so einseitige Philosophie wie die des Dilemmas von ›gegenständlich oder ungegenständlich‹ abzustützen«.[33]

Im Bereich der Kunsttheorie meldeten sich ähnlich gegensätzliche Stimmen zu Wort. Um nur ein Beispiel zu geben, sei der junge wie berüchtigte New Yorker Kunstkritiker Gene Swenson genannt, der schon früh die Tradition, die alles vom Kubismus bis zur Farbfeldmalerei miteinander verbindet, zurückweist und stattdessen eine andere Linie vorschlägt, die Dadaismus und Surrealismus zu den Ahnen des Pop erklärt. Er kuratiert im Jahre 1966 die Ausstellung *The Other Tradition* im Philadelphia Institute of Contemporary Art. Gemäß dem Katalog war das erklärte Ziel dieser Ausstellung, »1. bestimmte Kunstwerke des 20. Jahrhunderts zu zeigen, die bisher von den Kunsthistorikern übersehen oder vernachlässigt worden waren, und 2. alternative, eher ›intellektuelle‹ als formale Wege aufzuzeigen, mit Kunst umzugehen«. Swensons Liste ausgestellter Werke beginnt mit vier Arbeiten von Duchamp, die ihn zu der Frage veranlassten: »Wie viel länger werden wir uns noch zufrieden geben mit unseren fehlerhaften und anfälligen kritischen Werkzeugen und unseren akademischen Standards? Wie viel öfter können wir uns noch die Worte ›Bildoberfläche‹, ›Moderne‹, ›Krise‹, ›neu‹ und ›literarisch‹ antun, ohne nachzuspülen?«[34]

Swenson reagiert damit auf einen Paradigmenwechsel in der amerikanischen Kunst und viele junge Künstler finden begeistert heraus, dass das neu entdeckte Werk Duchamps ihre eigenen Strategien anspricht, nämlich das zu unterwandern, was vor ihnen kam. Er ist sozusagen »in the air«,[35] wie Bruce Nauman es formuliert. John Cage beginnt damit, Vorträge über Duchamp am Black Mountain College, erstmals 1952, sowie an der New School of Social Research (1956–1958) zu halten, die vor allem an eine neue Generation von Künstlern gerichtet sind, zu denen auch Robert Rauschenberg, George Brecht, Allan Kaprow, Al Hansen, Dick Higgings und Jackson Mac Low gehören. Georg Segal bemerkt dazu, dass »Marcel Duchamp durch John Cage wiederbelebt wurde«.[36] Im Jahre 1958 sehen Rauschenberg und Japser Johns die Duchamp-Sammlung im Philadelphia Museum of Art. Jahre zuvor, zu Kriegszeiten, war Joseph Cornell Duchamp bei der Arbeit an dessen *Schachtel im Koffer* behilflich gewesen. Um den vollen Umfang der hohen Wertschätzung Duchamps durch die Nachkriegsgeneration und

33 Marcel Duchamp, »Where Do We Go From Here?«, Vortrag auf einem Symposium am Philadelphia Museum College of Art im März 1961, in: Stauffer 1981 (wie Anm. 4), S. 241 ff. Duchamp schien eine nachteilige Meinung über den Vorreiter des Abstrakten Expressionismus, Jackson Pollock, zu haben. Thomas B. Hess zufolge »beschwerte« sich Duchamp bei ihm, dass Pollock »immer noch Farbe benutzt und wir längst damit aufgehört haben […] [Pollock] wird nie ins Pantheon einkehren!«. Thomas B. Hess, »J'accuse Marcel Duchamp«, in: *Marcel Duchamp in Perspective*, hrsg. von Joseph Masheck, Englewood Cliffs 1975, S. 120 [Übersetzung des Autors]. Duchamp hatte die Malerei mit seinem letzten Ölbild auf Leinwand, *Tu'm* (1918), für tot erklärt. In Bezug auf Pollock gibt es noch eine andere erzählenswerte Anekdote: 1945 rief Peggy Guggenheim Marcel Duchamp und David Hare zu sich, um ein Problem zu lösen, dass ein sechs Meter langes Wandbild von Pollock betraf. Dieses Wandbild war zu groß für den Platz, den es in der Eingangshalle des Guggenheim Museums hätte einnehmen sollen. Duchamp riet gelassen dazu, 20 Zentimeter von seinem Ende abzuschneiden. Hare zufolge »sagte Duchamp, dass dies in dieser Art von Malerei nicht gebraucht würde«. Calvin Tomkins, *Duchamp: A Biography*, New York 1996, S. 362 [Übersetzung des Autors].
34 Scott Rothkopf, »Banned and Determined«, in: *Artforum*, 40, 10, Sommer 2002, S. 144.
35 John Tancock, »The Influence of Marcel Duchamp«, in: *Marcel Duchamp. A Retrospective Exhibition*, hrsg. von Anne d'Harnoncourt und Kynaston McShine, Ausst.-Kat., Philadelphia Museum of Art 1973, S. 174.
36 Segal, zit. n. Wouter Kotte, *Marcel Duchamp als Zeitmaschine / Marcel Duchamp als Tijdmachine*, Köln 1987, S. 86.

36 Segal, cited in Wouter Kotte, *Marcel Duchamp als Zeitmaschine / Marcel Duchamp als Tijdmachine* (Cologne, 1987), p. 86, fn. 236.
37 Marcel Duchamp's influence was not limited to the acknowledgment of his Readymades alone. His *The Bride stripped Bare by Her Bachelors, Even / The Large Glass (La Mariée mise à nu par ses célibataires, même / Le Grand verre, 1915–1923)* proved equally inspiring to many artists. As this exhibition for this contribution was written focuses on the impact of the Readymades on the post-war and contemporary American art scene, his influence on European artists since the 1940s is not discussed (from Arman, Gianfranco Baruchello, Joseph Beuys, Guillaume Bijl, Marcel Broodthaers, Hans Haacke, Richard Hamilton, Thomas Hirschhorn, Ilya Kabakov, Martin Kippenberger, Piero Manzoni, Sigmar Polke, Gerhard Richter, Daniel Spoerri, André Thomkins, Jean Tinguely and Ben Vautier to the "Young British Artists," many artists come to mind—and those, of course, of other parts of the world). A more complete list of quotations by post-war American artists would also include statements from Bill Anastasi, Michael Asher, John Armleder, Richard Artschwager, Matthew Barney, Jim Dine, Mark Dion, Brian O'Doherty, Robert Gober, Al Henson, Eva Hesse, Dick Higgins, Ray Johnson, Mike Kelley, Ellsworth Kelly, Edward Kienholz, Alison Knowles, Barbara Kruger, Les Levine, Roy Lichtenstein, Glenn Ligon, George Maciunas, Walter de Maria, Allan McCollum, Paul McCarthy, Tony Oursler, Richard Prince, Charles Ray, Larry Rivers, James Rosenquist, Andres Serrano, Cindy Sherman, Kiki Smith, Haim Steinbach, Paul Thek, Wayne Thiebaud, Robert Watts, Tom Wesselman, Emmett Williams, Fred Wilson, and Christopher Wool. In a recent statement, Lawrence Weiner—believing that his answer would come to late to be acknowledged in the survey—denied any influence Duchamp might have had on his work: "I seemed to have missed the deadline, which is as close to being Duchampian as I hope I'll ever be" (fax to the author, February 3, 2003). Jeanne-Claude, speaking for Christo, also saw no connection between her husband's work and Duchamp: "When he showed his

in 1952) as well as at the New School of Social Research (1956–58), to a new generation of artists that included Robert Rauschenberg, George Brecht, Allan Kaprow, Al Hansen, Dick Higgins, and Jackson Mac Low. George Segal remarked that "Marcel Duchamp had a revived life through John Cage."[36] In 1958 Rauschenberg and Jasper Johns went to see the Duchamp collection at the Philadelphia Museum of Art. Years before, during the War, Joseph Cornell had befriended Duchamp in the course of his collaboration on the latter's *Box in a Valise*. Yet to comprehend fully the scope of Duchamp's deep appreciation by post-war generation and contemporary American artists as well as the influence he wielded over them—especially with his Readymades—nothing serves the purpose better than to hear it in their own words[37]:

ROBERT MOTHERWELL

"I would say that one of the most astonishing things in my lifetime as an artist is his prominence. Thirty years ago, if somebody had said to me, 'he may become the major the major influence on the art scene,' I'd have said: 'You're out of your mind,' and most of my judgments were quite accurate then."

Vivien Raynor, "A Talk with Robert Motherwell," *Art News*, 73, 4 (April 1974). p. 51, quoted in: Dieter Daniels, "Marcel Duchamp: The Most Influential Artist of the 20th Century?," in *Marcel Duchamp*, exh. cat. Museum Jean Tinguely Basel (Ostfildern, 2002) p. 25.

BARNETT NEWMAN

"I want particularly to make clear that if Motherwell wishes to make Marcel Duchamp a father, Duchamp is his father and not mine nor that of any American painter that I respect."

In a letter to John I. H. Baur, October 20, 1957, quoted in John P. O'Neill, ed., *Barnett Newman: Selected Writings and Interviews* (New York, 1990), p. 208.

GEORGE SEGAL

"Marcel Duchamp had a revived life through John Cage."

Cited by Wouter Kotte, *Marcel Duchamp als Zeitmaschine / Marcel Duchamp als Tijdmachine* (Cologne, 1987), p. 86.

RONI HORN

"The images produced by Marcel Duchamp (photographed by Man Ray) made a strong impression on me when I was young, especially: *Rrose Sélavy* (1921), *Belle Haleine* (Beautiful Breath, 1921) and *Dust*

durch zeitgenössische amerikanische Künstler zu verstehen sowie den Einfluss, den er auf sie — besonders durch seine Readymades — ausübte, erfüllt nichts anderes besser den Zweck, als diese in ihren eigenen Worten zu erfassen:[37]

ROBERT MOTHERWELL

»Ich würde sagen, dass eines der erstaunlichsten Dinge in meinem Leben als Künstler seine Bekanntheit war. Wenn mir jemand 30 Jahre zuvor gesagt hätte, ›er werde einmal den größten Einfluss auf die Kunstszene ausüben‹, hätte ich geantwortet: ›Du bist nicht ganz bei Sinnen‹, und die meisten meiner Einschätzungen waren zu der Zeit relativ genau.«
Vivien Raynor, »A Talk with Robert Motherwell«, *Art News*, 73, 4, April 1974, S. 51, zitiert nach: Dieter Daniels, »Marcel Duchamp: The Most Influential Artist of the 20th Century?«, in: *Marcel Duchamp*, Ausst.-Kat., Museum Jean Tinguely, Basel, Ostfildern 2002, S. 25.

BARNETT NEWMAN

»Ich will eindeutig klarstellen, dass für den Fall, dass Motherwell Marcel Duchamp zu einem Vater machen möchte, Duchamp sein Vater ist und nicht meiner oder der irgend eines anderen amerikanischen Malers, den ich respektiere.«
In einem Brief an John I. H. Baur vom 20. Oktober 1957, zitiert nach: *Barnett Newman: Selected Writings and Interviews*, hrsg. von John P. O'Neill, New York 1990, S. 208.

GEORGE SEGAL

»Marcel Duchamp wurde durch John Cage wiederbelebt.«
Zitiert nach: Wouter Kotte, *Marcel Duchamp als Zeitmaschine/Marcel Duchamp als Tijdmachine*, Köln 1987, S. 86.

RONI HORN

»Die von Duchamp geschaffenen Images haben bei mir seit ich jung war einen bleibenden Eindruck hinterlassen: *Rrose Sélavy* (1921), *Belle Haleine* (Schöner Atem, 1921) und *Staubzucht* (1920), Man Rays Fotografie von Duchamps *Das Grosse Glas* (1915–1923).«
»Questionnare: Roni Horn«, in: *Frieze*, April 2012, S. 156.

JOHN CAGE

»Es ist erstaunlich, wie sehr Marcel Duchamp andere kreativ macht.«
Zitiert nach Serge Stauffer in: Thomas Zaunschirm, *Bereites Mädchen Ready-made*, Klagenfurt 1983, S. 10., zitiert nach: »Marcel Duchamp: The Most Influential Artist of the 20th Century?«, in: *Marcel Duchamp*, Ausst.-Kat., Museum Jean Tinguely, Basel, Ostfildern 2002, S. 27.

37 Marcel Duchamps Einfluss war nicht begrenzt auf die Anerkennung seiner Readymades. Etwa sein *Die Braut von ihren Junggesellen entblößt, sogar / Das Große Glas (La Mariée mise à nu par ses célibataires, même / Le Grand verre*, 1915–1923) erwies sich als ebenso inspirierend für viele Künstler. Sein Einfluss auf europäische Künstler seit den 1940er-Jahren wird hier nicht diskutiert, beispielsweise auf Arman, Gianfranco Baruchello, Joseph Beuys, Guillaume Bijl, Marcel Broodthaers, Hans Haacke, Richard Hamilton, Thomas Hirschhorn, Ilya Kabakov, Martin Kippenberger, Piero Manzoni, Sigmar Polke, Gerhard Richter, Daniel Spoerri, André Thomkins, Jean Tinguely und Ben Vautier, auch unter den »Young British Artists«; sind viele Künstler nennenswert — natürlich gleichfalls solche aus anderen Teilen der Welt. Eine umfassendere Liste mit Zitaten von Nachkriegskünstlern aus Amerika würde auch Kommentare von Bill Anastasi, Michael Asher, John Armleder, Richard Artschwager, Matthew Barney, Jim Dine, Mark Dion, Brian O'Doherty, Robert Gober, Al Henson, Eva Hesse, Dick Higgins, Ray Johnson, Mike Kelley, Ellsworth Kelly, Edward Kienholz, Alison Knowles, Barbara Kruger, Les Levine, Roy Lichtenstein, Glenn Ligon, George Maciunas, Walter de Maria, Allan McCollum, Paul McCarthy, Tony Oursler, Richard Prince, Charles Ray, Larry Rivers, James Rosenquist, Andres Serrano, Cindy Sherman, Kiki Smith, Haim Steinbach, Paul Thek, Wayne Thiebaud, Robert Watts, Tom Wesselman, Emmett Williams, Fred Wilson und Christopher Wool mit einschließen. In einem Kommentar bestreitet Lawrence Weiner jede Art von Einfluss, die Duchamp auf seine Arbeit gehabt haben könnte — vermutlich dachte er, dass seine Antwort zu spät kommen würde, um noch in die Umfrage mit aufgenommen zu werden: »Ich habe wohl die Deadline verpasst, was mich so nah an einen Duchampianer heranbringt, wie ich es näher nie sein werde.« Fax an den Autor vom 3. Februar 2003. Jeanne-Claude, für Christo sprechend, sah ebenfalls keine Verbindung zwischen der Arbeit ihres Ehemannes und Duchamp: »Als er sein Fahrrad-Rad zeigte, tat er nichts dazu. Christo ist das genaue Gegenteil, wenn man mit seinen frühen Arbeiten aus den 50ern

Breeding (1920), Man Ray's photograph of Duchamp's *The Large Glass* (1915–1923)."
"Questionnare: Roni Horn," *Frieze* (April 2012), p. 156.

JOHN CAGE

"It is astonishing how very much Marcel Duchamp makes others creative."
Cited by Serge Stauffer in Thomas Zaunschirm, *Bereites Mädchen Ready-made* (Klagenfurt, 1983), p. 10, quoted in Dieter Daniels, "Marcel Duchamp: The Most Influential Artist of the 20th Century?," in *Marcel Duchamp*, exh. cat. Museum Jean Tinguely Basel (Ostfildern, 2002), p. 27.

"Say it's not a Duchamp. Turn it over and it is."
"26 statements Re Duchamp," (1969) in Susan Hapgood, *Neo-Dada: Redefining Art 1958–62*, exh. cat. (New York, 1994), p. 137.

NAM JUNE PAIK

"Marcel Duchamp has already done everything there is to do—except video…only through video art can we get ahead of Marcel Duchamp."
Interview with Irmeline Lebeer, *Chroniques de l'art vivant* 55 (February 1974), p. 35, quoted in Dieter Daniels, "Marcel Duchamp: The Most Influential Artist of the 20th Century?," in *Marcel Duchamp*, exh. cat. Museum Jean Tinguely Basel (Ostfildern, 2002)

CHRISTIAN MARCLAY

"Duchamp's invention of the readymade, taking something and signing it and saying, ,It's mine'—that's what the DJ does today, takes someone's music and remixes it."
Ben Neill, "Christian Marclay," *Bomb* 84 (Summer 2003).

ROBERT MORRIS

"The Readymades are traditionally iconic art objects."
"Notes on Sculpture 4: Beyond Objects" (1969), in Charles Harrison and Paul Wood, eds., *Art in Theory: 1900–1990. An Anthology of Changing Ideas*, vol. 2 (Oxford and Cambridge, 1992), p. 872, quoted in Dieter Daniels, "Marcel Duchamp: The Most Influential Artist of the 20th Century?," in *Marcel Duchamp*, exh. cat. Museum Jean Tinguely Basel (Ostfildern, 2002), p. 30.

JOSEPH KOSUTH

"The event that made conceivable the realization that it was possible to 'speak another language' and still make sense in art was Marcel Duchamp's first unassisted Readymade. With the unassisted Readymade, art changed its focus from the form of the language to what was

Bicycle Wheel, he did not do anything to it. With Christo it is the opposite, starting with his early works in the 1950s" (telephone conversation with the author, February 1, 2003). One should keep in mind that the Duchamp effect is not only limited to the visual arts. He has inspired many works of literature, and—starting with John Cage—many minds of the music world (among them Merce Cunningham, David Bowie, Bryan Ferry, Grant Hart, REM, Beck, and Björk).

»Sagen, dass es kein Duchamp ist. Drehen Sie es herum, dann ist es einer.«

»26 statements Re Duchamp« (1969), in: *Neo-Dada: Redefining Art 1958–62*, hrsg. von Susan Hapgood, Ausst.-Kat., New York 1994, S. 137.

NAM JUNE PAIK

»Marcel Duchamp hat schon alles gemacht, was gemacht werden kann — außer Video [...] nur durch Videokunst können wir Marcel Duchamp voraus sein.«

Interview mit Irmeline Lebeer, in: *Chroniques de l'art vivant*, 55, Februar 1974, S. 35, zitiert nach: »Marcel Duchamp: The Most Influential Artist of the 20th Century?«, in: *Marcel Duchamp*, Ausst.-Kat., Museum Jean Tinguely, Basel, Ostfildern 2002, S. 27.

CHRISTIAN MARCLAY

»Duchamps Erfindung des Readymade, etwas nehmen und signieren und zu sagen ›Das ist meins‹ — genau das macht heute der DJ, er nimmt die Musik eines anderen und mischt diese neu.«

Ben Neill, »Christian Marclay«, in: *Bomb 84*, Sommer 2003.

ROBERT MORRIS

»Die Ready-mades sind tradierte ikonische Kunstobjekte.«

»Notes on Sculpture 4: Beyond Objects« (1969), in: *Art in Theory: 1900–1990. An Anthology of Changing Ideas*, hrsg. von Charles Harrison and Paul Wood, Oxford and Cambridge, 2, MA 1992, S. 872, zitiert nach: »Marcel Duchamp: The Most Influential Artist of the 20th Century?«, in: *Marcel Duchamp*, Ausst.-Kat., Museum Jean Tinguely, Basel, Ostfildern 2002, S. 30.

JOSEPH KOSUTH

»Das Ereignis, das die Erkenntnis ermöglichte, eine ›andere Sprache sprechen‹ zu können und dabei immer noch einen Sinn zu ergeben, war jenes erste, ›unassisted‹ Readymade von Marcel Duchamp. Durch dieses Readymade wechselte der Fokus der Kunst von der Form der Sprache zu dem, was gesagt wurde [...] Dieser Wandel — jener von der ›Erscheinung‹ hin zur ›Konzeption‹ — war der Beginn sowohl der ›modernen‹ Kunst als auch der Konzeptkunst. Jede Kunst (nach Duchamp) ist (von Natur aus) konzeptuell, weil Kunst nur konzeptuell existiert.«

»Art after Philosophy« (1969), in: *Art in Theory: 1900–1990. An Anthology of Changing Ideas*, S. 844, zitiert nach: »Marcel Duchamp: The Most Influential Artist of the 20th Century?«, in: *Marcel Duchamp*, Ausst.-Kat., Museum Jean Tinguely, Basel, Ostfildern 2002, S. 30.

beginnt« (Telefongespräch mit dem Autor vom 1. Februar 2003). Man sollte bedenken, dass der Duchamp-Effekt nicht auf die visuellen Künste beschränkt ist. Er hat viele Arbeiten in der Literatur und — beginnend mit John Cage — viele Köpfe der Tanz- und Musikwelt, unter ihnen Merce Cunningham, David Bowie, Bryan Ferry, Grant Hart, REM, Beck und Björk, inspiriert.

being said...This change—one from 'appearance' to 'conception'—was the beginning of 'modern' art and the beginning of conceptual art. All art (after Duchamp) is conceptual (in nature) because art only exists conceptually."

"Art after Philosophy" (1969), in Charles Harrison and Paul Wood, eds., *Art in Theory: 1900-1990. An Anthology of Changing Ideas*, vol. 2 (Oxford and Cambridge, 1992), p. 844, quoted in Dieter Daniels, "Marcel Duchamp: The Most Influential Artist of the 20th Century?," in *Marcel Duchamp*, exh. cat. Museum Jean Tinguely Basel (Ostfildern, 2002), p. 30.

ALLAN KAPROW

"[Duchamp] deliberately stopped making art objects in favor of little (ready-made) hints to the effect that you could pick up art anywhere you wanted. In other words, he implied that the whole business of art is quite arbitrary."

"Interview with Allan Kaprow," in *Allan Kaprow*, exh. cat. Pasadena Art Museum (Pasadena, 1967), p. 8, quoted in John Tancock, "The Influence of Marcel Duchamp," in Anne d'Harnoncourt and Kynaston McShine, eds., *Marcel Duchamp: A Retrospective Exhibition*, exh. cat. Philadelphia Museum of Art (Philadelphia, 1973), p. 171.

"His Readymades... are radically useful contributions to the current art scene. If a snow shovel becomes a work of art by simply calling it that, so is all of New York, so is the Vietnam war, so is a pedantic article on Marcel Duchamp ... The Readymade is a paradigm of the way humans make and unmake culture. Better than 'straight' philosophy and social science, a good Readymade can 'embody' the ironic limits of the traditional theory that says reality is nothing but a projection of mind or minds."

"Doctor MD" in "A Collective Portrait of Marcel Duchamp," in Anne d'Harnoncourt and Kynaston McShine, eds., *Marcel Duchamp: A Retrospective Exhibition*, exh. cat. Philadelphia Museum of Art (Philadelphia, 1973), p. 205.

"I think we all learned from ... Duchamp. A key feature was discreetness, a timing and a restraint that many of us didn't learn well enough. Duchamp was personally very helpful to us, no question... both practically and intellectually."

Interview with Susan Hapgood, in Susan Hapgood, *Neo-Dada: Redefining Art 1958-62*, exh. cat. (New York, 1994), p. 116.

ALLAN KAPROW

»[Duchamp] hörte bewusst damit auf Kunstobjekte zu produzieren, zugunsten kleiner (Readymade-)Andeutungen – mit dem Effekt, dass man Kunst überall finden konnte, wo man wollte. Mit anderen Worten: er wies darauf hin, dass das gesamte Kunstgeschehen ziemlich willkürlich ist.«

»Interview mit Allan Kaprow«, in: *Allan Kaprow*, Ausst.-Kat., Pasadena Art Museum, Pasadena 1967, S. 8, zitiert nach: John Tancock, »The Influence of Marcel Duchamp«, in: *Marcel Duchamp. A Retrospective Exhibition*, hrsg. von Anne d'Harnoncourt and Kynaston McShine, Ausst.-Kat., Philadelphia 1973, S. 171.

»Seine Readymades […] sind grundlegend nützliche Beiträge zur aktuellen Kunstszene. Wenn eine Schneeschippe zu einem Kunstwerk erhoben wird nur dadurch, dass man sie als ein solches bezeichnet, gilt das für ganz New York, für den Vietnam-Krieg, für einen pedantischen Beitrag über Marcel Duchamp […] Das Readymade ist ein Musterbeispiel wie Menschen Kultur machen und zunichtemachen. Ein gutes Readymade kann besser als die reine Philosophie oder die Sozialwissenschaft auf ironische Weise die Grenzen der traditionellen Theorie zum Ausdruck bringen, die besagt, dass Realität nichts ist außer einer Projektion des Geistes und der Gedanken.«

»Doctor MD«, in: *A Collective Portrait of Marcel Duchamp*, zitiert nach: *Marcel Duchamp. A Retrospective Exhibition*, hrsg. von Anne d'Harnoncourt und Kynaston McShine, Ausst.-Kat., Philadelphia 1973, S. 205.

»Ich glaube, wir haben alle von […] Duchamp gelernt. Ein Hauptmerkmal ist Verschwiegenheit, eine Haltung und eine Selbst-Beschränkung, die viele von uns nicht gut genug erlernt haben. Persönlich war uns Duchamp sehr hilfreich, keine Frage […] sowohl auf praktischer als auch auf intellektueller Ebene.«

Interview mit Susan Hapgood, zitiert nach: *Neo-Dada: Redefining Art 1958–62*, hrsg. von Susan Hapgood, Ausst.-Kat., New York 1994, S. 116.

VITO ACCONCI

»Nahm dieser Film [›Conversions‹ aus dem Jahre 1971] einen Prozess auf, der parallel zur Multivalenz zwischen Marcel Duchamp und Rrose Sélavy verläuft?« – »Ja.«

Interview mit Robert Pincus Witten, »Vito Acconci and the Conceptual Performance«, in: *Artforum*, 10, 8, April 1972, S. 49, zitiert nach: John Tancock, »The Influence of Marcel Duchamp«, in: *Marcel Duchamp. A Retrospective Exhibition*, hrsg. von Anne d'Harnoncourt and Kynaston McShine, Ausst.-Kat., Philadelphia 1973, S. 178.

VITO ACCONCI

"Did this film [Conversions of 1971] record a process parallel to the mul-
tivalence between Marcel Duchamp and Rrose Sélavy?"
"Yes."

Interview with Robert Pincus Witten, "Vito Acconci and the Conceptual Perform-
ance," in Artforum, 10, 8 (April 1972), p. 49, quoted in: John Tancock, "The Influence
of Marcel Duchamp," in Anne d'Harnoncourt and Kynaston McShine, eds., Marcel
Duchamp. A Retrospective Exhibition, exh. cat. Philadelphia Museum of Art (Phila-
delphia, 1973), p. 178.

WILLIAM T. WILEY

"What we can learn from Marcel Duchamp is the same message from
any artist who has made his presence manifest in the form of personal
achievement: is essentially that we do not have to follow his example.
Yet should we find in his example a path that interests us we should
trust ourselves enough to follow that path as long as it is possible with-
out an overabundance of human misery."

"Thoughts on Marcel Duchamp," in Brenda Richardson, ed., Wizdumb: William T. Wiley
(Berkeley, 1971), p. 42, quoted in John Tancock, "The Influence of Marcel Duchamp,"
in Anne d'Harnoncourt and Kynaston McShine, eds., Marcel Duchamp. A Retrospec-
tive Exhibition, exh. cat. Philadelphia Museum of Art (Philadelphia, 1973), p. 173.

PAUL PFEIFFER

"Somewhere I read a statement by Duchamp to the effect that his art
was intended as a destroyer, specifically of identity. I find that really in-
spiring. Putting a mustache on Mona Lisa makes a pretty basic point
about the fluidity of identity and the depths to which gender, race and
nationality are encoded into vision. I'm interested in multiple meanings
and a kind of ambiguity that frustrates any attempt to pin it down."

Linda Yablonsky, "Making Microart that can Suggest Macrotruths," The New York
Times, December 9, 2001, p. 39.

RICHARD PETTIBONE

"My response to Duchamp hasn't changed at all in the last 34 years. His
work is just as beautiful. Being a visual artist I feel that it's very impor-
tant what things look like & in spite of all that talk about chance & giv-
ing up taste, etc. Duchamp's work is still drop dead gorgeous."

Letter to Francis M. Naumann, August 1997, quoted in Francis M. Naumann, "Apropos
of Marcel," in The Art of Making Art after Duchamp in the Age of Mechanical Repro-
duction (New York, 1999) p. 13.

WILLIAM T. WILEY

»Was wir von Marcel Duchamp lernen können, ist die Botschaft jedes anderen Künstlers, der uns seine Präsenz durch persönliche Errungenschaft zu spüren lassen vermochte: nämlich grundsätzlich, dass wir seinem Beispiel nicht zu folgen haben. Allerdings sollten wir in seinem Beispiel einen Weg finden, der uns interessiert; wir sollten uns selbst genügend vertrauen, diesem Weg so lange zu folgen, wie das ohne übergroße Fülle menschlichen Leidens möglich sein wird.«

»Thoughts on Marcel Duchamp«, in: *Wizdumb: William T. Wiley*, hrsg. von Brenda Richardson, Berkeley 1971, S. 42, zitiert nach: John Tancock, »The Influence of Marcel Duchamp«, in: *Marcel Duchamp. A Retrospective Exhibition*, hrsg. von Anne d'Harnoncourt and Kynaston McShine, Ausst.-Kat., Philadelphia 1973, S. 173.

PAUL PFEIFFER

»Ich habe irgendwo ein Statement von Duchamp gelesen über die Wirkung, die das zerstörerische seiner Kunst besonders auf die Frage von Identität haben soll. Ich fand das wirklich inspirierend. Der Mona Lisa einen Schnäuzer zu verpassen verweist gezielt auf die Instabilität von Identitäten und darauf wie stark sich bestimmte Vorstellungen von Gender, Rasse und Nationalität einschreiben. Mich interessieren multiple Bedeutungen und eine Art der Ambiguität, die jeden Versuch, diese näher zu bestimmen vereitelt.«

Linda Yablonsky, »Making Microart that can Suggest Macrotruths«, in: *The New York Times*, 9. Dezember 2001, S. 39.

RICHARD PETTIBONE

»Meine Antwort auf Duchamp hat sich in den letzten 34 Jahren überhaupt nicht geändert. Seine Arbeiten sind einfach schön. Als visueller Künstler weiß ich, dass es sehr wichtig ist, wie Dinge aussehen und trotz all dem Gerede über Zufall und die Absage an den guten Geschmack usw. ist Duchamps Arbeit einfach verdammt gut.«

Brief an Francis M. Naumann, August 1997, zitiert nach: Francis M. Naumann, »Apropos of Marcel«, in: *The Art of Making Art after Duchamp in the Age of Mechanical Reproduction*, Ausst.-Kat., New York 1999, S. 13.

SANFORD BIGGERS

»Duchamps Readymades gefallen heute ästhetisch und formal, obwohl sie für eine gewisse Zeit kontrovers waren und mit Konventionen brachen [...] Ich glaube auch, dass eines der wichtigsten Elemente die Bewahrung der Form ist, glaube aber ebenso stark an die Herausforderung vorgefasster kunsttheoretischer Ideen. Die Tatsache, dass ich der

SANFORD BIGGERS

"Duchamp's Readymades are now aesthetically and formally pleasing, though they were controversial for their time and opposed the conventions ... I also follow the idea of keeping the form as one of the most important elements but also feel strongly about challenging prescribed notions in art theory. The fact that I am the creator or author of these pieces also adds to how these pieces are interpreted by art theory."

Lauren Wilcox, "Transformation and Tradition: Interview with Sanford Biggers," *Tout-Fait: The Marcel Duchamp Studies Online Journal*, 2, 4, Art & Literature (January 2002), <www.toutfait.com/online_journal_details.php?postid=1298> (August 18, 2012).

ELAINE STURTEVANT

"[Duchamp's] concern with trying to redefine what we consider art was a very big factor in terms of my own work."

Francis M. Naumann, "Apropos of Marcel," in *The Art of Making Art after Duchamp in the Age of Mechanical Reproduction* (New York, 1999), p. 22.

CLAES OLDENBURG

"[Duchamp] was certainly on the scene. But I believe that the sort of thing I was into, which really was about the very gritty aspects of the Lower East Side, was very remote from Duchamp."

Interview with Susan Hapgood, in Susan Hapgood, *Neo-Dada: Redefining Art 1958–62*, exh. cat. (New York, 1994) p. 124.

"Yes, he was a historical figure."

Interview with Benjamin H. D. Buchloh (1985), quoted in Martha Buskirk and Mignon Nixon, eds., *The Duchamp Effect. Essays, Interviews, Round Table* (Cambridge, 1996), p. 33. [originally published as "Three Conversations in 1985: Claes Oldenburg, Andy Warhol, Robert Morris," *October* 70 (Fall 1994)].

GEORGE BRECHT

"The difference between a chair by Duchamp and one of my chairs could be that Duchamp's chair is on a pedestal and mine can still be used."

Henry Martin, *An Introduction to George Brecht's Book on the Tumbler on Fire* (Milan, 1978), p. 71, quoted in Susan Hapgood, *Neo-Dada: Redefining Art 1958–62*, exh. cat. (New York, 1994) p. 27.

"I read somewhere, quite a while ago, that an interviewer asked: 'How does it feel now, Mr. Duchamp, hat everyone knows your name?' And Duchamp answered, 'My grocer doesn't.'"

"Notes on the Inevitable Relationship GB-MD (If there is one)" (1973), quoted in Anthony Hill, ed., *Duchamp: Passim. A Marcel Duchamp Anthology* (East Roseville, 1994), p. 167.

Schöpfer und Autor dieser Dinge bin, trägt auch dazu bei, wie diese Dinge durch die Kunsttheorie interpretiert werden.«

Lauren Wilcox, »Transformation and Tradition: Interview with Sanford Biggers« in: *Tout-Fait: The Marcel Duchamp Studies Online Journal*, 2, 4, Art & Literature, Januar 2002, <www.toutfait.com/online_journal_details.php?postid=1298> (18. August 2012).

ELAINE STURTEVANT

»[Duchamps] Anliegen, das, was wir als Kunst betrachten, neu zu definieren hat einen großen Stellenwert in meiner eigenen Arbeit eingenommen.«

Francis M. Naumann, »Apropos of Marcel«, in: *The Art of Making Art after Duchamp in the Age of Mechanical Reproduction*, Ausst-Kat., New York 1999, S. 22.

CLAES OLDENBURG

»[Duchamp] war sicherlich präsent. Aber ich glaube, dass die Dinge, an denen ich interessiert war und die die sehr düsteren Seiten der Lower East Side betrafen, sehr weit entfernt von Duchamp waren.«

Interview mit Susan Hapgood, in: *Neo-Dada: Redefining Art 1958-62*, hrsg. von Susan Hapgood, Ausst.-Kat., New York 1994, S. 124.

»Ja, er war eine historische Figur.«

Interview mit Benjamin H. D. Buchloh (1985), zitiert nach: *The Duchamp Effect. Essays, Interviews, Round Table*, hrsg. von Martha Buskirk und Mignon Nixon, Cambridge 1996, S. 33 [ursprünglich veröffentlicht als »Three Conversations in 1985: Claes Oldenburg, Andy Warhol, Robert Morris«, in: *October*, 70, Herbst 1994].

GEORGE BRECHT

»Der Unterschied zwischen einem Stuhl von Duchamp und einem meiner Stühle könnte sein, dass Duchamps Stuhl auf einem Podest steht und meiner immer noch benutzt werden kann.«

Henry Martin, *An Introduction to George Brecht's Book on the Tumbler on Fire*, Milan 1978, S. 71, zitiert nach: *Neo-Dada: Redefining Art 1958-62*, hrsg. von Susan Hapgood, Ausst.-Kat., New York 1994, S. 27.

»Vor einiger Zeit las ich irgendwo, dass ein Interviewer fragte: ›Wie fühlt sich das jetzt an, Herr Duchamp, wenn jeder Ihren Namen kennt?‹ Und Duchamp antwortete: ›Mein Lebensmittelhändler kennt ihn nicht‹.«

»Notes on the Inevitable Relationship GB-MD (If there is one)« (1973), zit. n.: *Duchamp: Passim. A Marcel Duchamp Anthology*, hrsg. v. Anthony Hill, Langhorne, PA 1994, S. 167.

ANDY WARHOL

»Ehm ja, wir haben ihn oft gesehen, ab und zu. Er war da. Ich wusste nicht, dass er so berühmt oder so war.«

ANDY WARHOL

"Well, yeah, we saw him a lot, a little bit. He was around. I didn't know he was that famous or anything."

Interview with Benjamin H. D. Buchloh (1985), in Martha Buskirk and Mignon Nixon, eds., *The Duchamp Effect. Essays, Interviews, Round Table* (Cambridge, 1996), p. 37.

JASPER JOHNS

"Duchamp's wit and high common sense ('Limit the no. of rdymades yearly'), the mind slapping at thoughtless values ('Use a Rembrandt as an ironing board'), his brilliantly inventive questioning of visual, mental and verbal focus and order (the beautiful Wilson-Lincoln system, which was never added to the glass; 'lose the possibility of identifying ... 2 colors, 2 laces, 2 hats, 2 forms'; the vision of an alphabet 'only suitable for the description of this picture') inform and brighten the whole of [the Green Box]."

"The Green Box," *Scrap* (December 1960), p. 4, in Joseph Mascheck, ed., *Marcel Duchamp in Perspective* (Englewood Cliffs, 1975), p. 111.

"Marcel Duchamp, one of this century's pioneer artists, moved his work through the retinal boundaries which had been established with Impressionism into a field where language, thought and vision act upon another ... The art community feels Duchamp's presence and his absence. He has changed the condition of being here."

"Marcel Duchamp (1887–1968)," *Artforum*, VII, 3 (November 1968), p. 6, in Joseph Mascheck, ed., *Marcel Duchamp in Perspective* (Englewood Cliffs, 1975), p. 147.

"The ready-made was moved mentally and, later, physically into a place previously occupied by the work of art."

Quoted in Wouter Kotte, *Marcel Duchamp als Zeitmaschine / Marcel Duchamp als Tijdmachine* (Cologne, 1987), p. 84.

DONALD JUDD

"Duchamp invented several fires but unfortunately didn't bother with them ... The work of Duchamp is of course highly interesting, but it's a mistake not to have developed it. His work and his historical importance are different things. It's to other people's credit to have developed his or related ideas ... The roto-reliefs and the ready-mades and assisted ready-mades are fine."

"Marcel Duchamp and/or Rrose Sélavy," *Arts Magazine* XXXIX, 6 (March 1965), pp. 53–54, in Joseph Mascheck, ed., *Marcel Duchamp in Perspective* (Englewood Cliffs, 1975), p. 121.

Interview mit Benjamin H. D. Buchloh (1985), in: *The Duchamp Effect. Essays, Interviews, Round Table*, hrsg. von Martha Buskirk und Mignon Nixon, Cambridge 1996, S. 37 ff.

JASPER JOHNS

»Duchamps Scharfsinn und Menschenverstand (›Die Zahl der Readymades pro Jahr beschränken‹), der Verstand, der sich mit gedankenlosen Werten herumschlug (›Einen Rembrandt als Bügelbrett benutzen‹), sein brillant einfallsreiches Infragestellen zentraler visueller, mentaler und verbaler Fokussierung und Ordnung (das herrliche Wilson-Lincoln-System, das niemals dem Großen Glas hinzugefügt wurde; ›die Möglichkeit der Unterscheidung verlieren [...] 2 Farben, 2 Riemen, 2 Hüte, 2 Formen‹; die Vorstellung eines Alphabets, das ›nur für die Beschreibung dieses Bildes angemessen ist‹) machen die [Grüne Schachtel] aus.«

»The Green Box«, *Scrap*, 23. Dezember 1960, S. 4, zitiert nach: *Marcel Duchamp in Perspective*, hrsg. von Joseph Masheck, Englewood Cliffs 1975, S. 111.

»Marcel Duchamp, einer der wegbereitenden Künstler dieses Jahrhunderts, führte seine Arbeit über die Grenzen der retinalen Kunst hinweg, die sich im Impressionismus etabliert hatte, in einen Bereich, in dem Sprache, Gedanken und Ideen einander befruchten [...] Die Kunstwelt fühlt Duchamps Präsenz ebenso wie seine Abwesenheit. Er hat die Bedingungen, hier zu sein, verändert.«

»Marcel Duchamp (1887–1968)«, in: *Artforum*, 7, 3, November 1968, S. 6, zitiert nach: *Marcel Duchamp in Perspective*, 1975, S. 147.

»Das Readymade nahm geistig und später auch physikalisch eine Stellung ein, die zuvor durch das Kunstwerk besetzt war.«

Zitiert nach Wouter Kotte, *Marcel Duchamp als Zeitmaschine / Marcel Duchamp als Tijdmachine*, Köln 1987, S. 84.

DONALD JUDD

»Duchamp entzündete mehrere Brände, hielt sich aber leider damit nicht auf [...] Das Werk Duchamps ist natürlich hoch interessant, aber es ist ein Fehler, es nicht weiterentwickelt zu haben. Seine Arbeit und seine historische Bedeutung sind zwei verschiedene Dinge. Es ist der Verdienst anderer Leute, seine oder verwandte Ideen ausgearbeitet zu haben. Die Rotoreliefs und die Readymades und die Assisted Readymades sind ausgezeichnet.«

»Marcel Duchamp and/or Rrose Sélavy«, *Arts Magazine*, 39, 6, März 1965, S. 53–54, in: *Marcel Duchamp in Perspective*, hrsg. v. Joseph Masheck, Englewood Cliffs 1975, S. 121.

ROBERT SMITHSON

"I see Duchamp as a kind of priest of a certain sort. He was turning a urinal into a baptismal front … In other words, a Readymade doesn't offer any kind of engagement. Once again it is the alienated relic of our modern postindustrial society. But he is just using manufactured goods, transforming them into gold and mystifying them."

Moira Roth, "Robert Smithson, an Interview," *Artforum* XII, 2 (October 1973), p. 47, in Joseph Mashek, ed., *Marcel Duchamp in Perspective* (Englewood Cliffs, 1975), p. 136.

WILLIAM N. COPLEY

"If Marcel Duchamp ever died, his phoenix Rrose Sélavy lifted herself from the remains of the past that the former had desecrated by putting an ink-moustache on the Mona Lisa, thus creating a present for himself and all of us in which nouns like 'art' and 'poetry' melt into a single word."

"Art is not Furniture," in Alfred M. Fischer and Dieter Daniels, eds., *Übrigens Sterben Immer die Anderen. Marcel Duchamp und die Avantgarde seit 1950*, exh. cat. Museum Ludwig (Cologne, 1988), p. 283 [author's translation].

MIKE BIDLO

"Many artists have spent significant energies exploring his legacy."

The Fountain Drawings, exh. cat. (Zurich/New York, 1998), p. 54.

JOSEPH CORNELL

"I believe that Surrealism has healthier possibilities than have been developed. The constructions of Marcel Duchamp who the surrealists themselves acknowledge bear out this thought, I believe."

Letter to Alfred Barr, November 13, 1936, quoted in Anne Temkin, "Habitat for a Dossier," in Polly Koch, ed., *Joseph Cornell/Marcel Duchamp…in resonance*, exh. cat. (Ostfildern, 1999), p. 87.

ROBERT RAUSCHENBERG

"[Duchamp's] recognition of the lack of art in art and the artfulness of everything, I think, is probably his most important contribution."

Transcribed from the film *Rebel Ready-Made: Marcel Duchamp* (BBC, June 23, 1966), quoted in Francis M. Naumann, *Marcel Duchamp: The Art of Making Art in the Age of Mechanical Reproduction* (New York, 1999), p. 294.

"Marcel Duchamp is all but impossible to write about. Anything you may say about him is at the same time untrue, but when I think of him I get a sweet taste in my body."

ROBERT SMITHSON

»Ich sehe Duchamp als Priester der besonderen Art. Er hat ein Urinal in ein Taufbecken gewandelt [...] Mit anderen Worten: ein Readymade bietet keine Möglichkeit der Auseinandersetzung. Erneut ist es schlicht-weg das entfremdete Relikt unserer modernen post-industriellen Ge-sellschaft. Aber er nutzt lediglich industriell gefertigte Waren dafür, transformiert sie zu Gold und mystifiziert sie.«

Moira Roth, »Robert Smithson, an Interview«, in: *Artforum*, 12, 2, Oktober 1973, S. 47, in: *Marcel Duchamp in Perspective*, hrsg. v. Joseph Masheck, Englewood Cliffs 1975, S. 134 ff.

WILLIAM N. COPLEY

»Falls Marcel Duchamp überhaupt gestorben ist, dann erhob sich sein Phönix Rrose Sélavy aus den Resten der Vergangenheit, die er ent-weiht hatte, als er der Mona Lisa mit Tinte einen Schnurrbart gab und so für sich und für uns alle eine Gegenwart schuf, in der die Substan-tive ›Kunst‹ und ›Poesie‹ zu einem Wort verschmelzen.«

»Art is not Furniture«, in: *Übrigens Sterben Immer die Anderen. Marcel Duchamp und die Avantgarde seit 1950*, hrsg. von Alfred M. Fischer und Dieter Daniels, Ausst.-Kat., Köln 1988, S. 283.

MIKE BIDLO

»Viele Künstler haben enorme Energie aufgewandt, um seine Hinterlas-senschaft zu erforschen.«

The Fountain Drawings, Ausst.-Kat., Zürich, New York 1998, S. 54.

JOSEPH CORNELL

»Ich glaube, dass der Surrealismus gesündere Möglichkeiten hat als jene, die bisher entwickelt wurden. Die Konstruktionen Marcel Du-champs, die die Surrealisten selbst anerkennen, bekräftigen diesen Ge-danken, glaube ich.«

Brief an Alfred Barr, 13. November 1936, zitiert nach: Anne Temkin, »Habitat for a Dossier«, in: *Joseph Cornell/Marcel Duchamp...in resonance*, hrsg. von Polly Koch, Ausst.-Kat., Ostfildern 1999, S. 87.

ROBERT RAUSCHENBERG

»[Duchamps] Erkenntnis des Mangels an Kunst in der Kunst und der Kunsthaftigkeit aller Dinge ist vermutlich, so glaube ich, sein wichtigs-ter Beitrag.«

Transkribiert aus dem Film *Rebel Ready-Made: Marcel Duchamp*, BBC, 23. Juni 1966, zitiert nach: Francis M. Naumann, *Marcel Duchamp. The Art of Making Art in the Age of Mechanical Reproduction*, New York 1999, S. 294.

"A Collective Portrait of Marcel Duchamp" quoted in Anne d'Harnoncourt and Kynaston McShine, eds., *Marcel Duchamp: A Retrospective Exhibition*, exh. cat. Philadelphia Museum of Art (Philadelphia, 1973), p. 217.

YOKO ONO

"drink an orange juice laced with sunshine and spring and you'll see Duchamp."

"A Collective Portrait of Marcel Duchamp" quoted in Anne d'Harnoncourt and Kynaston McShine, eds., *Marcel Duchamp: A Retrospective Exhibition*, exh. cat. Philadelphia Museum of Art (Philadelphia, 1973), p. 215.

JASON RHOADES

"Duchamp for me is like L. Ron Hubbard. He's a slippery figure who keeps popping up."

Russell Ferguson, "Given: 1. The Caprice, 2. The Ferrari," *Parkett* 58 (2000), p. 123.

HANNAH WILKE

"To honor Duchamp is to oppose him ... The issue that remains, was Duchamp trying to control his own death by killing art while he was still alive—aesthetic impotence for the sake of survival ... Objecting to art as commodity is an honorable occupation that most women find it impossible to afford. Is this ready maid, having collected many of the readymades now in Oldenburg's Ray Gun Wing owned by Peter Ludwig, owed an equal share for her part in the collaboration? Could commodities but speak, they would say; Our use, value may be a thing that interests men ... In the eyes of each other we are nothing but exchange values."

"I Object. Memoirs of a Sugar Giver," in Alfred M. Fischer and Dieter Daniels, eds., *Übrigens Sterben Immer die Anderen. Marcel Duchamp und die Avantgarde seit 1950*, exh. cat. Museum Ludwig (Cologne, 1988), p. 270.

ARAKAWA & MADELINE GINS

"Managing to position objects to hold their own in relation to that which ubiquitously happens along and even to redirect it, using very-adjusted and less-adjusted ready-made insertions into symbolizing power, an inchoate emanating-out ready-made in its own right, to convey and express enough and more than enough, M. D. changed the history of expression (read symbolizing) and redefined (artistic) purpose two remarkable achievements."

E-mail to the author, February 7, 2003.

»Es ist unmöglich, über Marcel Duchamp zu schreiben. Alles, was man über ihn sagen möchte, ist gleichzeitig unwahr, aber wenn ich an ihn denke, bekomme ich einen süßen Geschmack in meinem Körper.«
A Collective Portrait of Marcel Duchamp, zitiert nach: *Marcel Duchamp. A Retrospective Exhibition*, hrsg. von Anne d'Harnoncourt und Kynaston McShine, Ausst.-Kat., Philadelphia 1973, S. 217.

YOKO ONO
»Trink einen Orangensaft gewürzt mit Sonnenschein und Frühling und du wirst Duchamp sehen.«
»A Collective Portrait of Marcel Duchamp«, S. 215.

JASON RHOADES
»Duchamp ist für mich wie L. Ron Hubbard. Er ist eine gerissene Gestalt, die immer wieder auftaucht.«
Russell Ferguson, »Given: 1. The Caprice, 2. The Ferrari«, in: *Parkett*, 58, 2000, S. 123.

HANNAH WILKE
»Duchamp zu ehren heißt, sich ihm zu widersetzen [...] Der Gedanke, der bleibt, ist der, dass Duchamp seinen eigenen Tod zu kontrollieren versucht, indem er die Kunst tötet, während er selbst noch lebt – ästhetisches Unvermögen ums Überleben willen [...] Den Warencharakter der Kunst zu beanstanden ist eine ehrenvolle Beschäftigung, von der die meisten Frauen denken, sie sich nicht leisten zu können. Ist diesem bereiten Mädchen (ready maid), nachdem es viele der Readymades in Oldenburgs Ray Gun Win, das Peter Ludwig gehörte, gesammelt hatte, ein gleicher Anteil für ihren Teil des Beitrags geschuldet? Wenn Waren nur sprechen könnten, würden sie sagen: Unser Nutzen, unser Wert mag etwas sein, was Menschen interessiert [...] In unserer gegenseitiger Augen sind wir nichts als austauschbare Werte.«
»I Object. Memoirs of a Sugar Giver«, in: *Übrigens Sterben Immer die Anderen. Marcel Duchamp und die Avantgarde seit 1950*, hrsg. von Alfred M. Fischer und Dieter Daniels, Ausst.-Kat., Köln 1988, S. 270.

ARAKAWA & MADELINE GINS
»Indem er es vermochte, Objekte so zu positionieren, dass sie sich selbst in Beziehung setzten zu dem, was allgegenwärtig drumherum geschah, und das Ganze durch den Gebrauch von äußerst angepassten und weniger angepassten Readymades sogar in eine symbolisierende Kraft umzuleiten, ein unvollständiges, ausstrahlendes Readymade in seiner Eigenständigkeit, um genug und mehr als genug zu vermitteln

ED RUSCHA

"If [Duchamp] hadn't come along, we would have needed to invent him."

Interview with Robert L. Pincus, October 30, 1990, in Robert L. Pincus, "'Quality Material...': Duchamp Disseminated in the Sixties and Seventies," in Bonnie Clearwater, ed., *West Coast Duchamp* (Miami Beach, 1991), p. 100.

"What do you think is Duchamp's most significant contribution?"
"That he discovered common objects and showed you could make art out of them."

Interview with Elizabeth Armstrong, June 17, 1994, in Martha Buskirk and Mignon Nixon, eds., *The Duchamp Effect: Essays, Interviews, Round Table* (Cambridge, 1996), p. 55.

BRUCE CONNOR

"I still feel that he dealt with enigmas and arbitrariness in the world with a sharp analytical mind."

Interview with Elizabeth Armstrong, June 9, 1994, in Martha Buskirk and Mignon Nixon, eds., *The Duchamp Effect: Essays, Interviews, Round Table* (Cambridge, 1996), p. 57.

VIJA CELMINS

"I was greatly influenced by Duchamp, if only indirectly, by questioning what painting is—and should be."

Interview with Robert L. Pincus, March 26, 1991, in Robert L. Pincus, "'Quality Material...': Duchamp Disseminated in the Sixties and Seventies," in Bonnie Clearwater, ed., *West Coast Duchamp* (Miami Beach, 1991), p. 88.

SHERRIE LEVINE

"I was very surprised when I saw my first Fountain. When I made the decision to cast the urinal, I was thinking primarily about Duchamp, but the finished high polish bronze sculpture more readily evoked Brâncusi."

Interview with Martha Buskirk, May 13, 1994, in Martha Buskirk and Mignon Nixon, eds., *The Duchamp Effect: Essays, Interviews, Round Table* (Cambridge, 1996), p. 179.

LOUISE LAWLER

"[T]o me, Duchamp signaled a 'bottle rack' (who uses that?), a weird looking urinal, and a lot of pictures of him smoking and enjoying the sun with other people ... in fact, all the readymades are interesting-looking things now, and their normalcy is gone. ... This discussion of Duchamp seems a good opportunity to express my discomfort with too

und auszudrücken, veränderte Marcel Duchamp die Geschichte des Ausdrucks (lies: der Symbolisierung) und definierte den (künstlerischen) Zweck neu – zwei bemerkenswerte Errungenschaften.«
E-Mail an den Autor, 7. Februar 2003.

ED RUSCHA

»Wäre [Duchamp] nicht aufgekreuzt, hätten wir ihn erfinden müssen.«
Interview mit Robert L. Pincus, 30. Oktober 1990, in: Robert L. Pincus, »›Quality Material…‹: Duchamp Disseminated in the Sixties and Seventies«, in: *West Coast Duchamp*, hrsg. von Bonnie Clearwater, Miami Beach 1991, S. 100.

»Was, glauben Sie, ist Duchamps wichtigster Beitrag?« – »Dass er gewöhnliche Objekte entdeckte und zeigte, dass man aus ihnen Kunst machen kann.«
Interview mit Elizabeth Armstrong, 17. Juni 1994, in: *The Duchamp Effect. Essays, Interviews, Round Table*, S. 55.

BRUCE CONNOR

»Ich denke immer noch, dass er Rätseln und Willkürlichkeiten in der Welt mit einem scharfen analytischen Verstand begegnete.«
Interview mit Elizabeth Armstrong, 9. Juni 1994, in: *The Duchamp Effect. Essays, Interviews, Round Table*, hrsg. von Martha Buskirk und Mignon Nixon, Cambridge 1996, S. 57.

VIJA CELMINS

»Ich bin sehr stark beeinflusst worden von Duchamp, wenn auch nur indirekt, indem ich fragte, was Malerei ist – und sein sollte.«
Interview mit Robert L. Pincus, 26. März 1991, in: Robert L. Pincus, »›Quality Material…‹: Duchamp Disseminated in the Sixties and Seventies«, in: *West Coast Duchamp*, hrsg. von Bonnie Clearwater, Miami Beach 1991, S. 88.

SHERRIE LEVINE

»Ich war sehr überrascht, als ich zum ersten Mal Fountain sah. Als ich die Entscheidung traf, das Urinal zu gießen, dachte ich zunächst auch an Duchamp, aber die fertige Hochglanz-Bronzeskulptur erinnerte mich viel eher an Brâncuși.«
Interview mit Martha Buskirk, 13. Mai 1994, in: *The Duchamp Effect. Essays, Interviews, Round Table*, hrsg. von Martha Buskirk und Mignon Nixon, Cambridge 1996, S. 179.

LOUISE LAWLER

»Mir vermittelt Duchamp einen ›Flaschentrockner‹ (wer benutzt so etwas?), ein merkwürdig aussehendes Urinal, und viele Bilder von ihm rauchend und mit anderen Menschen die Sonne genießend […] Tat-

much referencing of authority that is restrictive, rather than enjoying the work's 'kindling' effect and use."

Interview with Martha Buskirk, May 20, 1994, in Martha Buskirk and Mignon Nixon, eds., *The Duchamp Effect: Essays, Interviews, Round Table* (Cambridge, 1996), p. 186.

"Duchamp's fetishization gets on my nerves."

E-mail to the author, February 2, 2003

CHRIS BURDEN

"He was definitely a formative figure for me ... In an age of Cal Arts and Jeff Koons, Duchamp is a different role model."

Interview with Robert L. Pincus, September 26, 1990, in Robert L. Pincus, "'Quality Material...': Duchamp Disseminated in the Sixties and Seventies," in Bonnie Clearwater, ed., *West Coast Duchamp* (Miami Beach, 1991) p. 98.

JOHN BALDESSARI

"There is a serious unseriousness going on ... I see a kinship there, I feel I understand what [Duchamp's] about."

Interview with Moira Roth, January 6, 1973, in Robert L. Pincus, "'Quality Material...': Duchamp Disseminated in the Sixties and Seventies," in Bonnie Clearwater, ed., *West Coast Duchamp* (Miami Beach, 1991), p. 88.

CLYFFORD STILL

"Few men could better exemplify the antithesis of my work than Marcel Duchamp."

"Letter to the Editor," *Artforum* (February 1964), quoted in Calvin Tomkins, *Duchamp. A Biography* (New York, 1996), p. 438.

WILLIAM DE KOONING

"And then there is that one-man movement, Marcel Duchamp—for me a truly modern movement because it implies that each artist can do what he thinks he ought to—a movement for each person and open for everybody."

"What Abstract Art Means to Me," *Museum of Modern Art Bulletin* 18, 3 (June 1951), p. 7.

SHIGEKO KUBOTA

"Are we dancing still on the gigantic palm of Duchamp, thinking it is a big continent and ocean?"

"Twenty Questions About My Work," quoted in Zdenek Felix, ed., *Shigeko Kubota. Video Sculptures*, exh. cat. (1981), p. 51.

sächlich sind heute alle Readymades interessant aussehende Dinge und sie haben ihre Normalität verloren [...] Diese Diskussion um Duchamp scheint mir eine gute Möglichkeit zu sein, mein Unbehagen über jene Verweise auszudrücken, die sich einer einengenden Autorität bemühen, anstatt einfach den ›zündenden‹ Effekt und Nutzen des Werks zu genießen.«

Interview mit Martha Buskirk, 20. Mai 1994, in: *The Duchamp Effect. Essays, Interviews, Round Table,* hrsg. von Martha Buskirk und Mignon Nixon, Cambridge 1996, S. 186.

»Duchamps Fetischisierung geht mir auf die Nerven.«

E-Mail an den Autor, 2. Februar 2003

CHRIS BURDEN

»Er war definitiv eine prägende Gestalt für mich [...] In einem Zeitalter von Cal Arts und Jeff Koons ist Duchamp ein abweichendes Vorbild.«

Interview mit Robert L. Pincus, 26. September 1990, in: Robert L. Pincus, »›Quality Material...‹: Duchamp Disseminated in the Sixties and Seventies«, in: *West Coast Duchamp,* hrsg. von Bonnie Clearwater, Miami Beach 1991, S. 98.

JOHN BALDESSARI

»Da ist eine ernste Unernsthaftigkeit im Umlauf. Ich sehe eine Seelenverwandtschaft, ich glaube, ich verstehe, worum es bei Duchamp geht.«

Interview mit Moira Roth, 6. Januar 1973, in: »›Quality Material...‹: Duchamp Disseminated in the Sixties and Seventies«, S. 88.

CLYFFORD STILL

»Nur wenige Menschen könnten besser die Antithese zu meiner Arbeit personifizieren als Marcel Duchamp.«

»Letter to the Editor«, (Leserbrief), in: *Artforum,* Februar 1964, zitiert nach: Calvin Tomkins, *Duchamp. A Biography,* New York 1996, S. 438.

WILLIAM DE KOONING

»Und dann gibt es da diese Ein-Mann-Bewegung, Marcel Duchamp — für mich eine wahrhaft moderne Bewegung, weil sie impliziert, dass jeder Künstler tun kann, was er glaubt, tun zu müssen — eine Bewegung für jeden und offen für jedermann.«

»What Abstract Art Means to Me«, in: *Museum of Modern Art Bulletin,* 18, 3, Juni 1951, S. 7.

SHIGEKO KUBOTA

»Tanzen wir immer noch auf der gigantischen Handfläche Duchamps und glauben, dass das ein großer Kontinent und Ozean ist?«

JEFF KOONS

"You can look at Marcel Duchamp ... Everything comes back to the ability of the artist to be able to communicate, to focus."

"Jeff Koons. I have my finger on the eternal," interview with Andrew Renton, in *Flash Art XXIII*, 153 (Summer 1990), pp. 110–115, quoted in: Thomas Zaunschirm, *Kunst als Sündenfall. Die Tabuverletzungen des Jeff Koons* (Freiburg, 1996), p. 16.

"My process of distancing myself from subjective art continued through the late '70's, which included exposure to Marcel Duchamp. He seemed the total opposite of the subjective art I had been immersed in. It was the most objective statement possible, the readymade. I loved that aspect and started doing my first inflatables."

Interview with Alan Jones, in *Temaceleste 88* (November/December 2001), p. 36.

„In the 20th century there was Picasso and Duchamp. Now I'm taking us out of the twentieth century."

Jeff Koons, *The Jeff Koons Handbook* (New York, 1992), p. 31.

„Duchamp is great. So are Picasso and Picabia. I believe that Duchamp and Picasso together provided us with the greatest possibilities for art in the 20th century."

Holger Liebs, „Interview with Jeff Koons," *Monopol*, special on Jeff Koons (Summer 2012), p. 42 [author's translation]

BRUCE NAUMAN

"The kind of questions Duchamp was interested in were being looked at again and were being circulated. A large number of people were looking at that information and thinking about it, and I think maybe…well…so anyway he is an influence in that sense."

Interview with Lorraine Sciarra (1972), quoted in: Janet Kraynak and Bruce Nauman, eds., *Pay Attention Please: Bruce Naumann's Words: Writings and Interviews*, (Cambridge, 2003), p. 157.

"He leads to everybody and nobody"

"A Collective Portrait of Marcel Duchamp," in Anne d'Harnoncourt and Kynaston McShine, eds., *Marcel Duchamp: A Retrospective Exhibition*, exh. cat. Philadelphia Museum of Art (Philadelphia, 1973), p. 211.

»Twenty Questions About My Work« zitiert nach: *Shigeko Kubota. Video Sculptures*, hrsg. von Zdenek Felix, Ausst.-Kat., 1981, S. 51.

JEFF KOONS

»Sehen Sie sich Marcel Duchamp an [...] Alles läuft auf die Fähigkeit des Künstlers hinaus, zu kommunizieren, zu fokussieren.«
»Jeff Koons. I have my finger on the eternal«, Interview mit Andrew Renton, in: *Flash Art*, 23, 153, Sommer 1990, S. 110 ff., zitiert nach: Thomas Zaunschirm, *Kunst als Sündenfall. Die Tabuverletzungen des Jeff Koons*, Freiburg 1996, S. 16.

»Mein Prozess des mich-Distanzierens von der subjektiven Kunst dauerte bis in die späten 70er an, was auch meine Hinwendung zu Marcel Duchamp miteinschloss. Er schien das totale Gegenteil zur subjektiven Kunst zu sein, in die ich vertieft war. Da war die objektivste Aussage überhaupt, das Readymade. Ich liebte diesen Aspekt und begann meine ersten aufblasbaren Werke zu produzieren.«
Interview mit Alan Jones, in: *Temaceleste*, 88, November/Dezember 2001, S. 36.

»Im 20. Jahrhundert gab es Picasso und Duchamp. Jetzt führe ich uns aus dem 20. Jahrhundert heraus.«
Jeff Koons, *The Jeff Koons Handbook*, New York 1992, S. 31.

»Duchamp ist großartig. Picasso und Picabia sind es auch. Ich denke schon, dass uns Duchamp und Picasso gemeinsam die größten Möglichkeiten für die Kunst des 20. Jahrhunderts geschenkt haben.«
Holger Liebs, »Interview mit Jeff Koons«, in: *Monopol*, Spezial zu Jeff Koons, Sommer 2012, S. 42.

BRUCE NAUMANN

»Die Art von Fragen, die für Duchamp wichtig waren, wurden sich wieder angeschaut und in Umlauf gebracht. Viele Leute beschäftigen sich damit und dachten darüber nach und ich denke vielleicht ... nun ... in diesem Sinne war er sicherlich ein Einfluss.«
Interview mit Lorraine Sciarra (1972), zitiert nach: *Pay Attention Please. Bruce Naumann's Words: Writings and Interviews*, hrsg. von Janet Kraynak und Bruce Nauman, Cambridge 2003, S. 157, siehe auch: *Bruce Nauman. Interviews 1967–1988*, hrsg. von Christine Hoffmann, Amsterdam 1966, S. 66.

»Er führt zu jedem und niemandem.«
A Collective Portrait of Marcel Duchamp, zitiert nach: *Marcel Duchamp. A Retrospective Exhibition*, hrsg. von Anne d'Harnoncourt und Kynaston McShine, Ausst.-Kat., Philadelphia 1973, S. 211.

38 Schwabsky, in "Coffee Table: Barry Schwabsky and Andy Grundberg on Art and Photography," Bookforum 8, 2 (Winter 2001), p. 42.
39 Regarding Duchamp's overpowering influence, three examples come to mind: Joseph Beuys's 1964 performance Das Schweigen des Marcel Duchamp wird überbewertet (The Silence of Duchamp is Overrated) and Vivre et laisser mourir ou la mort tragique de Marcel Duchamp (To Live and Let Die or the Tragic Death of Marcel Duchamp), also of 1964, a series of eight canvases by Gilles Aillaud, Eduardo Arroyo, and Antonin Recalati. More recently, Peter Saul painted Pooping on Duchamp (1996).
40 Amelia Jones, Postmodernism and the En-gendering of Marcel Duchamp (Cambridge, 1994), p. 8, p 14.
41 On the issue of Duchamp and concepts of taste and disgust, see the argument between Jean Clair, "Duchamp at the Turn of the Centuries" (a translated excerpt from his Marcel Duchamp et la fin de l'art, Paris, 2000), in Tout-Fait: The Marcel Duchamp Studies Online Journal, vol. 1, no. 3 (Winter 2000), News, <www.toutfait.com/issues/issue-3/News/clair/clair.html>, and Arthur C. Danto, "Marcel Duchamp and the End of Taste: A Defense of Contemporary Art," in Tout-Fait: The Marcel Duchamp Studies Online Journal, vol. 1, nr. 3 (Winter 2000), News, <www.toutfaitcom/issues/issue-3/News/Danto/danto.html>
42 I have borrowed the phrase from the title of an article by Peter Bürger, "Der Konformismus der Verweigerung. Anmerkungen zur Neo-Neo-Avantgarde," in Texte zur Kunst 12, 48 (December 2002), p. 165.
43 Since 1997, the artist Rhonda Roland Shearer and her husband, the late Stephen Jay Gould, have raised havoc, at least within the discipline of art history, by arguing that Duchamp did not select his objects, but fabricated them himself, or altered early studio photographs depicting the original Readymades, now mostly lost, see the transcriptions of their conference Methods of Understanding in Art and Science: The Case of Duchamp and Poincaré, November 5–7, 1999 and Rhonda Roland Shearer, "Why the Hatrack is and/or is not Readymade," Tout-Fait: The Marcel Duchamp Studies Online Journal, vol. 1, no. 3, Multi-

It is obvious what Barry Schwabsky meant when he reviewed Arturo Schwarz's revised edition of The Complete Works of Marcel Duchamp in 2001: "Duchamp's work is so deeply encoded in the fabric of contemporary art that I'm tempted to keep this book not with other art monographs, but on the ready-reference shelf next to Roget, Bartlett, and Merriam-Webster: Duchamp is to a great extent, our vocabulary."[38] The an-artist quickly had become the Über-father par excellence, creating an anxiety of influence some felt was too overpowering.[39] Particularly within the American context "Duchamp's significance as originating father is generally seen to be identical to the significance of the Readymades in relation to postmodernism.... As paternal, theological origin, Duchamp is the Readymades and the 'Readymades Duchamp' comes to signify postmodernism.... Duchamp has become a powerful authorizing function by which works produced by contemporary artists claim nepotistic validation as begotten by the Duchampian seed."[40]

Today, with the concept of irony co-opted and empty gestures of shocking for shock's sake[41] held in high regard (with no one within the art world ever offended), many artistic strategies add up to nothing more than a "conformity of refusal."[42] Could it be that the Readymade is finally losing its disruptive potential?[43] Maybe so, if its concept is only interpreted as an excuse for "anything goes" or the mere provocative gesture declaring anything to be art via a change of context. Duchamp himself had already noticed as much when he allowed his Readymades to be turned into an edition precisely at that moment in the early 1960s when they had become celebrated icons and art-world commodities. Nowadays, it is not enough simply to appropriate formally the "an-artist's" work. Every artist borrowing Duchamp's highly charged visual vocabulary walks a fine line between creating a token pastiche (an art-world inside joke based solely on recognizing affinities) and intellectually engaging the ideas surrounding the work.

Duchamp—except for his fleeting fame at the Armory Show of 1913—, had the luxury of being unrecognized as a major artistic force until he had reached his sixties. Left to himself, far away from the spotlight and thus from any system's intricacies of interdependence, he could proclaim himself to be nothing but a "breather," being mostly (and somewhat wrongfully) known for having abandoned all artistic activity from the mid-1920s on. Besides his many artist friends and a few wealthy patrons, Duchamp lived completely detached from the art world as we know it. He carefully kept himself independent, see-

Es ist offensichtlich, was Barry Schwabsky meint, wenn er Arturo Schwarz' überarbeitetes Werkverzeichnis *The Complete Works of Marcel Duchamp* im Jahre 2001 folgendermaßen kommentiert: »Duchamps Werk hat sich so sehr in die Struktur der zeitgenössischen Kunst eingeschrieben, dass ich versucht bin, dieses Buch nicht zu den anderen Kunstmonographien, sondern in das Regal der Nachschlagewerke, direkt neben Roget, Bartlett und Merriam-Webster zu stellen: Duchamp ist in hohem Maße unser Vokabular«.[38] Der »an-artist« war sehr schnell zum Übervater schlechthin geworden, eine Einflussangst bewirkend, die viele als zu überwältigend empfanden.[39] Vor allem im amerikanischen Kontext wird »Duchamps Bedeutung als Gründungsvater gemeinhin mit der Bedeutung der Readymades im Kontext der Postmoderne gleichgesetzt. [...] Als väterlicher, theologischer Ursprung ist Duchamp mit den Readymades gleichzusetzen, während die ›Readymades gleich Duchamp‹ die Postmoderne kennzeichnen. [...] Duchamp ist zu einer mächtigen Autorisierungsfunktion geworden, über die Kunstwerke, die durch den duchampschen Keim in die Welt gesetzt wurden, nepotistische Gültigkeit für sich in Anspruch nehmen.«[40]

Durch Ironie, die ins Leere läuft und leere Schock-Gesten einzig um des Schockes willen vereinnahmt[41] – die hoch geschätzt werden und von niemandem innerhalb der Kunstwelt je angegriffen würden –, tragen heute viele künstlerische Strategien lediglich zur mittlerweile konform gewordenen »allgemeinen Verweigerungshaltung« bei.[42] Kann es also sein, dass das Readymade sein disruptives Potential verliert?[43] Vielleicht ist dies so, wenn sein Konzept nur als eine Entschuldigung für das »anything goes« oder als bloße provokative Geste interpretiert wird, die alles über die Veränderung des Kontextes zu Kunst erklärt. Duchamp selbst hatte dies bereits erkannt, als er zu jenem Zeitpunkt in den früher 1960er-Jahren gestattete, die Readymades, als sie bereits zu berühmten Ikonen und Kunstgütern geworden waren, als Edition zu produzieren. Heutzutage ist nichts einfacher, als sich die Arbeit des »an-artist« formal anzueignen. Jeder Künstler, der sich des stark aufgeladenen Vokabulars Duchamps bedient, bewegt sich auf dem schmalen Grat zwischen selbstgefälliger Nachahmung – ein Insider-Witz der Kunstwelt, der lediglich auf dem Erkennen von Ähnlichkeiten beruht – und der intellektuellen Übernahme der Ideen, die seine Arbeit ausmachen.

Mit Ausnahme des flüchtigen Ruhms durch die *Armory Show* im Jahre 1913 ist es Duchamps Luxus, als große künstlerische Kraft unerkannt zu bleiben, bis er älter als sechzig war. Sich selbst überlassen,

38 Schwabsky, »Coffee Table: Barry Schwabsky and Andy Grundberg on Art and Photography«, in: *Bookforum*, 8, 2, Winter 2001, S. 42.

39 Den überwältigenden Einfluss Duchamps betrachtend fallen einem drei Beispiele ein: Joseph Beuys' *Das Schweigen des Marcel Duchamp wird überbewertet* und *Vivre et laisser mourir ou la mort tragique de Marcel Duchamp*, auch aus dem Jahre 1964, es handelt sich um eine Serie von acht Leinwänden von Gilles Aillaud, Eduardo Arroyo und Antonin Recalati. Unlängst malte Peter Saul *Pooping on Duchamp* (1996).

40 Amelia Jones, *Postmodernism and the En-gendering of Marcel Duchamp*, Cambridge, UK 1994, S. 8, 14 [Übersetzung des Autors].

41 Was Duchamp und Konzepte von Geschmack und Ekel betrifft, vgl. die Auseinandersetzung zwischen Jean Clair, »Duchamp at the Turn of the Centuries« (ein übersetzter Auszug aus seinem Marcel Duchamp et la fin de l'art, Paris 2000), in: *Tout-Fait: The Marcel Duchamp Studies Online Journal*, 1, 3, Winter 2000, News, <www.toutfait.com/issues/issue_3/News/clair/clair.html>, und Arthur C. Danto, »Marcel Duchamp and the End of Taste: A Defense of Contemporary Art«, in: *Tout-Fait: The Marcel Duchamp Studies Online Journal*, 1, 3, Winter 2000, News, <www.toutfait.com/issues/issue_3/News/Danto/danto.html>.

42 Der Begriff ist einem Artikel von Peter Bürger entnommen, »Der Konformismus der Verweigerung. Anmerkungen zur Neo-Neo-Avantgarde«, in: *Texte zur Kunst*, 12, 48, Dezember 2002, S. 165.

43 Seit 1997 argumentieren die Künstlerin Rhonda Roland Shearer und ihr Ehemann, der kürzlich verstorbene Stephen Jay Gould, dass Duchamp seine Objekte, die heute größtenteils verloren sind, nicht einfach ausgewählt, sondern selbst hergestellt hat, oder frühe Studiofotografien, die die originalen Readymades zeigen, entsprechend verändert hat; vgl. die Transkriptionen ihrer Konferenz »Methods of Understanding in Art and Science: The Case of Duchamp and Poincaré«, 5.–7. November 1999 sowie Rhonda Roland Shearer, »Why the Hatrack is and/or is not Readymade«, in: *Tout-Fait: The Marcel Duchamp Studies Online Journal*, 1, 3, Multimedia,

ing to it personally that his works would end up grouped together with a few collectors and museums. Later in life, Duchamp thought the contemporary art market responsible for the impossibility of young artists truly to concentrate on what they were doing. He came to lament the perpetually increasing tide of attention, of dealers, galleries, collectors, critics, and exhibitions, turning art into an "over-developed exoteric":

> By that I mean that the general public accepts and demands too much from art, far too much from art; that the general public today seeks aesthetic satisfaction wrapped up in a set of material and speculative values and is drawing artistic output towards an enormous dilution. This enormous dilution, losing in quality what it gains in quantity, is accompanied by a leveling down of present taste and Its immediate result will be to shroud the near future in mediocrity. In conclusion, I hope that this mediocrity, conditioned by too many factors foreign to art per se, will this time bring a revolution on the ascetic level, of which the general public will not even be aware and which only a few initiates will develop on the fringe of a world blinded by economic fireworks. The great artist of tomorrow will go underground.[44]

Underground, the artist would examine whole new ways of expression to subvert the overall status quo of the art world in all of its wide-ranging aspects. In a 1922 survey by Alfred Stieglitz regarding the status of photography as a form of art, Duchamp had answered: "You know exactly how I feel about photography. I would like to see it make people despise painting until something else will make photography unbearable. There we are."[45] Today, installation and video art are ever on the rise, figurative painting yet again en vogue (with often surprising results), and the idea of a single work of art often substituted for the impact of a whole group of them or an environment. More than ever, artists "on the fringe" (geographically and ethnically) make themselves heard.[46] As a critique of biotechnology, some artists are using new materials such as DNA, treating the body as a Readymade.

It remains to be seen how these strategies will eventually play out. An interesting aspect pertaining to Duchamp's oeuvre is a renewed interest in his last major work, *Étant donnés: 1° la chute d'eau, / 2° le gaz d'éclairage* (Given: 1. The Waterfall, 2. The Illuminating Gas, 1946–1966,

media (December 2000), <www.tout-fait.com/issues/issue_3/Multimedia/Shearer/Shearer01.html>. Their hypotheses seem to revive some of the Readymade's upsetting possibilities.
44 "Where Do We Go From Here?" (1961), in Anthony Hill 1994 (see note 33), p. 89.
45 Michel Sanouillet and Elmer Peterson 1989 (see note 4), p. 165; originally published in *Manuscripts* 4 (December, 1922).
46 For a scathing examination of the contemporary art world's mechanisms (while holding up the figure of Duchamp as an important predecessor), see Bedri Baykam, *Monkeys' Right to Paint and the Post-Duchamp Crisis: The Fight of a Cultural Guerilla for the Rights of Non-Western Artists and the Empty World of the Neo-Ready-Mades* (Istanbul, 1994). An excerpt follows: "The West, which is moving anyway more and more into the 'multi-cultural art world,' behaves as if it was doing a favor to the East and South. This is definitely wrong and no 'favor' is needed. In fact they are only starting to pay the interest of years of constipation and prejudiced block-headedness. They are also trying to bring a fresh breath to their once again bored art world, which is sinking in an unspoken crisis generated paradoxically by the ever-growing importance of Marcel Duchamp, provoking lost generations working on *pastiche* ideas" (p. 212); "At this moment, Marcel Duchamp's timeless, a-national, ambiguous, ready-mades and concepts, interpretable in 1000 different ways, come as handy and as opportune as water in the desert, although in its new variations the humor and witty sarcasm of Marcel, of course, is not present" (p. 303).

ganz abseits des Scheinwerferlichts und somit auch fern jeglicher Abhängigkeiten vom System, kann er sich selbst als »Breather«, als »Atmender«, bezeichnen, der vor allem — und teilweise zu unrecht — bekannt dafür war, jegliche künstlerische Produktion seit Mitte der 1920er-Jahre aufgegeben zu haben. Neben seinen vielen Künstlerfreunden und ein paar wohlhabenden Förderern lebt Duchamp völlig abgesondert von der Kunstwelt, wie wir sie kennen. Er bewahrte sehr achtsam seine Unabhängigkeit, persönlich dafür sorgend, dass seine Arbeiten immer möglichst geschlossen bei Sammlern und in Museen ihren Platz finden. Später in seinem Leben macht Duchamp den zeitgenössischen Kunstmarkt für die Unfähigkeit junger Künstler verantwortlich, sich auf das zu konzentrieren, worum es ihnen tatsächlich ging. Er bedauert die ständig steigende Aufmerksamkeitsflut durch Händler, Galerien, Sammler, Kritiker und Ausstellungen, die die Kunst in »hypertrophierte Exoterik« verwandeln: »Ich meine damit die Tatsache, dass das große Publikum viel Kunst, viel zu viel Kunst akzeptiert und verlangt; dass das große Publikum heute ästhetische Befriedigung sucht, die in einem Spiel von materiellen und spekulativen Werten verpackt sind, und dass es die künstlerische Produktion zu einer massiven Verwässerung treibt. Diese massive Verwässerung, die das an Qualität verliert, was sie an Quantität gewinnt, wird von einer Nivellierung von unten her des gegenwärtigen Geschmacks begleitet und wird in naher Zukunft einen Nebel von Mittelmäßigkeit zur Folge haben. Zum Schluss hoffe ich, dass diese Mittelmäßigkeit, die durch zu viele, der Kunst per se fremde Faktoren bedingt ist, eine Revolution, diesmal eine von asketischer Art, herbeiführen wird, über die sich das große Publikum nicht einmal bewusst werden wird und die bloß einige Eingeweihte entwickeln werden, — am Rande einer Welt, die durch das ökonomische Feuerwerk geblendet ist. The great artist of tomorrow will go underground.«[44]

Einmal untergetaucht werde der Künstler neue Ausdrucksweisen erarbeiten, den Status quo der Kunstwelt in all seinen weitreichenden Aspekten zu untergraben. In einer Umfrage von Alfred Stieglitz aus dem Jahre 1922, die den Status der Fotografie als Kunstform zu eruieren sucht, hatte Duchamp geantwortet: »Sie wissen genau, was ich von der Photographie halte. Ich möchte, dass sie die Leute dazu bringt, die Malerei zu verachten, bis etwas anderes die Photographie unerträglich machen wird. Soweit wären wir«.[45] Heutzutage gibt es immer mehr Installationen und Videokunst, figurative Malerei ist ebenso wieder en vogue — mit oft erstaunlichen Ergebnissen — und der Gedanke eines

Dezember 2000, <www.toutfait.com/issues/issue_3/Multimedia/Shearer/Shearer01.html>. Ihre Hypothesen scheinen einige Aspekte des aufrührerischen Potentials der Readymades wiederzubeleben.
44 »Where Do We Go From Here?« (1961), in: Stauffer 1981 (wie Anm. 4), S. 242.
45 Stauffer 1981 (wie Anm. 4), S. 234; zuerst veröffentlicht in *Manuscripts*, 4, Dezember 1922.

47 Björk, from an interview with Thomas Venter, in "Der Look Passiert Nicht," *Süddeutsche Zeitung*, August 27, 2001 [author's translation].

48 Dodie Kazanjin, "Gregory Crewdson. Twilight Zone," *Vogue* (May 2002), p. 300.

49 John Canaday, reviewing the work for *The New York Times*, wrote that it was "very interesting, but nothing new," just "an entertaining invention that has arrived a bit late to make a sensation.... For the first time, this cleverest of 20th-century masters looks a bit retardaire. Edward Kienholz, as the major specific example, has gone so far beyond the spent and sterile slickness of this final Duchamp work that he makes Duchamp look like Bouguereau" ("Philadelphia Museum Shows Final Duchamp Work," *The New York Times*, July 7, 1969). Warhol, in 1971, is the first artist on record to be inspired by Duchamp's last work, while contemplating an idea for a gallery show consisting only of binoculars with which the visitors would have to find the actress/artist Brigid Berlin performing in the window of a faraway building: "It also has to do with the same thing Duchamp was doing [in *Etant Donnés*], looking through a box [sic]. Sex...in the window...Oh, that would be nutty. That's just the kind of thing you'd want to see with binoculars-some perversion, right? Somebody jerking off. Brigid could be the art. She could stand in the window." (David Bourdon, *Warhol* [New York, 1989], pp. 315–316; the quotation is from a telephone conversation between Bourdon and Andy Warhol in June 1971. I thank Ms. Yona Backer for drawing this source to my attention).

50 "I Object. Memoirs of a Sugar Giver", in Dieter Daniels 1992 (see note 8), p. 270.

51 "Marcel Duchamp Talking About Readymades," (Interview by Phillipe Collin, June 21, 1967), in *Marcel Duchamp*, exh. cat. Museum Jean Tinguely Basel (Ostfildern, 2002), p. 40.

figs. 14, 15), *Étant Donnés* for short. In a recent interview, Björk, Iceland's Queen of Pop, declaring Duchamp a "genius," expressing awe for *Étant donnés*: "And then he created an artwork, when he was already very old, when everyone thought he'd already be over with, and this artwork changed completely the 20th century."[47] For the New York photographer Gregory Crewdson, "it's extraordinarily photographic, to the point of looking through an aperture at a frozen moment in time. It's everything I want from an art piece. It's haunting, mysterious, troubling, beautiful, heightened, disturbing."[48] Looking through two peepholes drilled at eyelevel into a massive wooden door in a separate room at the Philadelphia Museum of Art, the viewer becomes aware of a 3-D multimedia assemblage depicting the partly hidden body of a nude woman (with a prominently displayed, shaved vulva) lying on a bed of twigs and clutching a gas burner in front of a *trompe-l'oeil* landscape with a running waterfall and clouds made of cotton. Duchamp had secretly worked on *Étant donnés* for twenty years. It was revealed only after his death in the summer of 1969.[49] After seeing the "an-artist's" last work, Hannah Wilke, another artist greatly inspired by him, asked: "Did Dr. Duchamp (MD) disguise with dignity or despair the destruction, degeneration, and denigration of the maimed model of mortality—Mother?"[50] Since Socrates, asking questions often proves more beneficial and generates more creative energy than trying to provide that one right answer. Duchamp himself was not always right, of course. In 1961, for example, he predicted that "in five or six years, no one would talk about [the Readymade] anymore."[51] Throughout his late interviews in the sixties, he often pointed out that he was mostly interested in an audience fifty or a hundred years hence. Thirty-five years after his death, that audience is ever-growing.

Parts of this essay were presented as a lecture entitled "Marcel Duchamp, Stephen Jay Gould and the End of 'Anything Goes'," on June 15, 2002, on the occasion of a symposium held during the run of a Duchamp exhibition curated by Harald Szeemann at the Museum Jean Tinguely, Basel, Switzerland. The article was first published in two parts within the exhibition catalogue for "Aftershock: The Legacy of the Readymade in Post-War and Contemporary American Art," Dickinson Roundell, Inc., New York, May–June 2003, pp. 18–25, pp. 112–119, pp. 121–123.

einzelnen Kunstwerks wird oft durch die Wirkung einer Reihe von Kunstwerken oder eines Environments ersetzt. Mehr denn je verschaffen sich auch Künstler »vom Rande der Gesellschaft« — sowohl geographisch als auch ethnisch — Gehör.[46] Um etwa Kritik an der Biotechnologie zu üben, nutzen einige Künstler neue Materialien wie die DNA und machen so den Körper zum Readymade.

Es bleibt abzuwarten, wohin diese Strategien führen werden. Ein interessanter Aspekt, der Duchamps Werk ebenso betrifft, ist das neuerliche Interesse an seiner letzten großen Arbeit, *Étant donnés: 1° la chute d'eau, 2° le gaz d'éclairage* (Gegeben Sei: 1. Der Wasserfall / 2. Das Leuchtgas, 1946–1966), kurz: *Étant donnés* (Abb. 14, 15). In einem kürzlich gegebenen Interview erklärt Islands »Queen of Pop« Björk Duchamp zu einem Genie und äußert ihre Ehrfurcht vor *Étant donnés*: »Und dann schuf er ein Kunstwerk, als er bereits sehr alt war, als jeder dachte, dass es bereits vorbei war mit ihm, und dieses Kunstwerk veränderte das 20. Jahrhundert total«.[47] Für den New Yorker Fotografen Gregory Crewdson ist die Arbeit »ungemein fotografisch, so als ob man durch eine Blende einen in der Zeit eingefrorenen Moment anschaut. Es ist alles, was ich von einem Kunstwerk will. Es ist packend, mysteriös, beunruhigend, schön, erhöhend, verstörend«.[48] Durch zwei Löcher auf Augenhöhe in einer massiven Holztür schaut der Besucher des Philadelphia Museum of Art in einen separaten Raum und sieht dort eine 3D-Multimedia-Assemblage, die den Körper einer nackten Frau — mit deutlich sichtbarer, rasierter Scham — zeigt, sie liegt auf einem Bett aus Reisig und hält einen Gasbrenner gegen eine Trompe-l'œil-Landschaft mit Wasserfall und aus Baumwolle geschaffenen Wolken. Duchamp hatte über zwanzig Jahre lang heimlich an *Étant donnés* gearbeitet. Das Werk wurde erst nach seinem Tod im Sommer 1969 öffentlich zugänglich gemacht.[49] Nachdem sie diese letzte Arbeit des »an-artist« gesehen hatte, fragte Hannah Wilke, eine weitere Künstlerin, die von ihm stark inspiriert worden war: »Hat Dr. Duchamp die Entblößung, Entartung und Verunglimpfung dieser entstellten Attrappe der Sterblichkeit mit Würde oder Verzweiflung verschleiert — Mutter?«[50]

Seit Sokrates erweist sich das Stellen von Fragen als nützlich und generiert mehr kreative Energie als der Versuch, die eine richtige Antwort zu finden. Duchamp selbst liegt natürlich auch nicht immer richtig. Im Jahre 1961 zum Beispiel sagt er voraus, dass »in fünf oder sechs Jahren niemand mehr über [das Ready-made] sprechen werde«.[51] In seinen späten Interviews in den 1960er-Jahren führt er oft aus, dass er am

46 Über eine vernichtende Auseinandersetzung mit zeitgenössischen Mechanismen der Kunstwelt, die aber zugleich Duchamp als einen wichtigen Vorgänger würdigt, vgl. Bedri Baykam, *Paint and the Post-Duchamp Crisis. The Fight of a Cultural Guerilla for the Rights of Non-Western Artists and the Empty World of the Neo-Ready-Mades*, Istanbul 1994. Es folgt ein Auszug: »Der Westen, der sich gerade mehr und mehr in eine ›multi-kulturelle Kunstwelt‹ verwandelt, verhält sich, als würde er dem Osten und dem Süden einen Gefallen tun. Das ist definitiv nicht richtig, es braucht diesen ›Gefallen‹ nicht. Tatsächlich beginnt man nur endlich, Zinsen für Jahre der Verstopfung und voreingenommener Sturköpfigkeit zu zahlen. Außerdem versucht man, frischen Atem in ihre eigene, wieder einmal gelangweilte Kunstwelt zu bringen, die in eine unausgesprochene, paradoxerweise durch das ständig wachsende Ansehen Marcel Duchamps verursachte Krise zu versinken droht, indem man verlorene Generationen dazu bringt, an Ideen der Nachahmung zu arbeiten.« (S. 212); »In diesem Moment erscheinen Marcel Duchamps zeitlose, a-nationale, doppeldeutige Readymades und Konzepte, die auf 1000 verschiedene Arten interpretiert werden können, so bequem und gelegen wie Wasser in der Wüste, obwohl der Humor und der geistreiche Sarkasmus von Marcel natürlich in seinen neuen Variationen gar nicht mehr vorhanden ist.« (S. 303 [Übersetzung des Autors]).
47 Björk in einem Interview mit Thomas Venter, in: »Der Look Passiert Nicht«, *Süddeutsche Zeitung*, 27. August 2001.
48 Dodie Kazanjin, »Gregory Crewdson. Twilight Zone«, *Vogue*, Mai 2002, S. 300.
49 Das Bekanntwerden von *Étant Donnés* nach Duchamps Tod war für die meisten eine vollkommene Überraschung, auch wenn spätere Berichte dies anders darstellen. John Canaday, der das Werk für die *New York Times* besprach, schrieb allerdings, dass es »sehr interessant, aber nichts Neues war«, nur »eine unterhaltsame Erfindung, die ein bisschen zu spät erschien, um noch eine Sensation zu werden. Zum ersten Mal kommt der gewandteste Meister des 20. Jahrhunderts ein bisschen verspätet daher. Edward

meisten an dem Publikum in fünfzig oder hundert Jahren interessiert sei. 35 Jahre nach seinem Tod wächst dieses Publikum beständig.

Aus dem Englischen von Janina Wildfeuer

Teile dieses Essays wurden am 15. Juni 2002 als Vortrag mit dem Titel »Marcel Duchamp, Stephen Jay Gould and The End of ›Anything Goes‹« auf einem Symposium gehalten, das während der von Harald Szeemann kuratierten Duchamp-Ausstellung im Museum Jean Tinguely, Basel, Schweiz, ausgerichtet wurde. In englischer Sprache wurde der Beitrag in zwei Teilen im Ausstellungskatalog zu *Aftershock: The Legacy of the Readymade in Post-War and Contemporary American Art*, Dickinson Roundell, Inc., New York, Mai–Juni 2003, S. 18–25, S. 112–119, S. 121–123, erstmals veröffentlicht.

Kienholz hat, als herausragendes Beispiel, ist bereits weit über die überholte und sterile Glätte dieses letzten Werks Duchamps hinausgegangen und lässt Duchamp auf diese Weise wie Bouguereau aussehen«. »Philadelphia Museum Shows Final Duchamp Work«, in: *The New York Times*, 7. Juli 1969.

Warhol ist 1971 der erste Künstler, der sich durch Duchamps letztes Werk inspiriert zeigt und gleichzeitig einen Idee für eine Ausstellung entwickelt, die darin besteht, dass die Besucher durch Ferngläsern nach der Schauspielerin/Künstlerin Brigid Berlin Ausschau halten sollen, die im Fenster eines fernen Gebäudes ihre Performance abhält: ›It also has to do with the same thing Duchamp was doing [in Etant Donnés], looking through a box. Sex...in the window ... Oh, that would be nutty. That's just the kind of thing you'd want to see with binoculars-some perversion, right? Somebody jerking off. Brigid could be the art. She could stand in the window.« (»Es hat mit den gleichen Dingen zu tun, mit denen Duchamp arbeitete [in Étant Donnés], nämlich in eine Schachtel zu sehen. Sex... im Fenster ... Oh, das wäre pikant. Das ist aber doch eigentlich genau das, was man durch ein Fernglas sehen will. Ein bisschen Perversion, oder? Jemanden, der sich einen runterholt. Brigid könnte diese Kunst sein. Sie könnte im Fenster stehen.« David Bourdon, *Warhol*, New York 1989, S. 315 ff.; das Zitat stammt aus einem Telefongespräch zwischen Bourdon und Warhol aus dem Juni 1971. Ich danke Frau Yona Backer dafür, mich auf diese Quelle aufmerksam gemacht zu haben.

50 »I Object. Memoirs of a Sugar Giver«, in: *Übrigens Sterben Immer die Anderen. Marcel Duchamp und die Avantgarde seit 1950*, hrsg. von Alfred M. Fischer und Dieter Daniels, Ausst.-Kat., Köln 1988, S. 270.

51 »Marcel Duchamp spricht über Readymades«, Interview mit Phillipe Collin, 21. Juni 1967, in: *Marcel Duchamp*, Ausst.-Kat., Museum Jean Tinguely, Basel, Ostfildern 2002, S. 40.

DUCHAMPS SCHAUFENSTER FÜR ANDRÉ BRETONS *LE SURRÉALISME ET LA PEINTURE*

»Vielleicht wird es einem derart von ästhetischen Vorurteilen befreiten, derart um Energie bemühten Künstler wie Marcel Duchamp vorbehalten bleiben, Kunst und Volk wieder miteinander zu versöhnen.« Guillaume Apollinaire, *Les Peintres Cubistes*, 1913[1]

»Hintergrund von Fußsohlen (von Zeit zu Zeit bewegen sich die Zehen) / fünf oder sechs Paar«.[2] Die in Duchamps Nachlass entdeckte Notiz findet sich gemeinsam auf einem Blatt Papier mit Bemerkungen zu anderen Projekten. Von zwei Spiegeln ist die Rede, die einander gegenübergestellt ein Objekt ins Unendliche projizieren. Von einem langsam aufgeblasenen Luftballon, der zerplatzt. Blenden aus Gummimaterial oder Leinwand, die von der Rückseite gedehnt und deformiert werden. Die meisten der auf insgesamt 41 Notizzettel vermerkten und in ihrer Kürze oft vage gehaltenen Projektideen hat Duchamp nie verwirklicht. Die Darstellung einer Fußsohle im Werk des selbsternannten An-Artisten ist indes aus dem Jahr 1959 bekannt. Seine *Torture-morte* ist ein lebensgroßer Fuß aus Gips, auf dessen Sohle mehrere Fliegen angebracht sind. Zwei weitere Werke Duchamps, die denselben Körperteil zeigen, wurden von der Forschung erst kürzlich wiederentdeckt. Das dem surrealistischen Malerfreund Enrico Donati 1946 gewidmete Werk *Von oder durch Marcel Duchamp oder Rrose Sélavy / Die Schachtel im Koffer (De ou par Marcel Duchamp ou Rrose Sélavy / La Boîte-en-Valise,* 1941, Abb. 13) kurz: Die *Schachtel im Koffer,* in der Duchamp seit Beginn der 1940er-Jahre in geringer Auflage Farbreproduktionen und Miniaturmodelle seiner wichtigsten Arbeiten aufbewahrte, enthält auf der Innenseite des Schachteldeckels als Originalbeigabe die Zeichnung einer Fußsohle — diese stammt womöglich von der Bildhauerin Maria Martins, Duchamps Geliebte zu dieser Zeit und Frau des brasilianischen Botschafters in den USA.[3] Aus dem Vorjahr ist zudem Duchamps Schaufensterdekoration für André Bretons Buch *Le Surréalisme et la peinture* (Abb. 16) bekannt, für die er unter anderem ein paar Füße gestaltete, deren Sohlen in der Mitte mit pyramidenförmig angeordneten Nägeln vernietet sind und statt der Ferse einen Schuhabsatz aufweisen.[4] Zudem scheinen die Enden der Zehen unterseitig

1 »Marcel Duchamp«, in: Guillaume Apollinaire, *Die Maler des Kubismus,* Zürich 1956, S. 105 ff., S. 108
2 Aus Marcel Duchamp, *Notes,* Nr. 196, hrsg. von Paul Matisse, Paris 1980, o.S. Die 289 enthaltenen Notizen sind zwischen 1912 und den 1960er-Jahren entstanden [Übersetzung des Autors].
3 Francis M. Naumann, »Marcel & Maria«, in: *Art in America,* 89, 4, April 2001, S. 98 ff., S. 157. In *Ödipus und Sphinx* von Ingres, einem Gemälde, das Duchamp zur Vorlage für ein anderes Werk diente, ist eben diese Fußsohle spiegelverkehrt abgebildet, s. Thomas Girst, »Marcel Duchamp. Eine Hagiographie«, in: *Impuls Marcel Duchamp. Where do we go from here?,* hrsg. von Antonia Napp und Kornelia Röder, Ostfildern-Ruit 2011, S. 40 ff., S. 54.

"Perhaps it will be the role of someone so free of aesthetic prejudices like Marcel Duchamp to bring about the reconciliation of art and the common man."
Guillaume Apollinaire, *Les Peintres Cubistes*, 1913[1]

"Background of soles of feet (from time to time / moving their toes) / 5 or 6 pair."[2] This note discovered in Duchamp's papers, is written on one piece of paper along with comments on other projects. One proposes two mirrors, which, when facing one another, can project an object into infinity; another a balloon which is slowly blown up and then bursts; screens of rubber or canvas, which can be stretched from the backside and deformed. Most of the projects contained within a total of forty-one notes, mostly vague and briefly formulated, were never realized by Duchamp. The use of the sole of a foot in the work of the self-designated "an-artist," however, is actually documented in the year 1959. Duchamp's *Torture-morte* consists of a life-sized plaster foot with numerous flies attached to its sole. Two further works by Duchamp which show the same part of the body have only recently been discovered by researchers. One was found inside a box dedicated to the Surrealist painter friend Enrico Donati in 1946—another example of the *From or by Marcel Duchamp or Rrose Sélavy / The Box in a Valise* (*De ou par Marcel Duchamp ou Rrose Sélavy / La Boîte-en-Valise*, 1941, fig. 13), in short: *The Box in a Valise,* in which Duchamp, since the beginning of the 1940s, had stored a small number of color reproductions and miniature models of his most important works. On the inside of the lid is an original drawing of the sole of a foot—possibly the foot of the sculptress Maria Martins, Duchamp's lover at the time and the wife of the Brazilian Ambassador to the USA.[3] From the previous year there is also Duchamp's shop window decoration for André Breton's book *Le Surréalisme et la peinture* (fig. 16), for which, among other things, he created two feet, whose soles are affixed in the middle with nails arranged in the form of a pyramid and which display, rather than the heel of a foot, the heel of a shoe.[4] In addition, the tips of the toes are painted from beneath in such a way that they seem to be colored with

1 Guillaume Apollinaire, *The Cubist Painters: Aesthetic Meditations* (New York, 1970), p. 48.
2 Marcel Duchamp, *Notes,* ed. Paul Matisse (Paris, 1980), n. p. [note 196]. The 289 notes included came to be between 1912 and the 1960s.
3 Francis M. Naumann, "Marcel & Maria," *Art in America,* 89, 4 (April 2001), pp. 98–110, 157. "In 'Sphinx and Oedipus' by Ingres, a painting which had inspired Duchamp for another work of his, the exact same sole of a foot is depicted in a mirror-image," see Thomas Girst, "Marcel Duchamp. A Hagiography," in Antonia Napp, Kornelia Röder, eds., *Impuls Marcel Duchamp. Where do we go from here?* (Ostfildern-Ruit, 2011), pp. 40–58, p. 54.
4 That a work by Duchamp is implied here can be derived only from a picture caption in the publication of *La Victoire 47,* November 24, 1945.

derart bemalt, dass diese wie mit einer um 180 Grad verschobenen Lackierung versehen wirken.

Schon 1936, in seiner Anthologie über den Surrealismus, hat der New Yorker Kunsthändler Julien Levy Duchamp als »idealen Schuster«[5] bezeichnet: »Ein Schuster stellt Schuhe her. Ein handwerklich begabter Schuster stellt ausgezeichnete Schuhe her. Ein idealer Schuster aber stellt keine Schuhe mehr her, sondern Ideen. Er ist von seinen materiellen Zielen getrennt, wie ein Verrückter mag er Leder schneiden und vernähen. Er mag das Leder wie eine tollgewordene Maschine auswählen. Aber er verfolgt eben eine Idee«.[6] Duchamp selbst mag 1918 aufgehört haben zu malen, aber unter dem Pseudonym Rrose Sélavy sei er zurückgekehrt, um Schuhe herzustellen. Levy zitiert Duchamp: »Wenn es Schuhe sind, die ihr wollt, dann gebe ich euch Schuhe, die ihr derart bewundern werdet, dass ihr zu lahmen beginnt, wenn ihr darin zu laufen versucht«.[7]

Neun Jahre später sind Duchamps Füße / Schuhe für Bretons Schaufenster ein ideales Beispiel für das, was Levy hier übermittelt. Denn in Duchamps Werk geht es weniger um das Entweder-oder als um das Sowohl-als-auch. Ab 1921 etwa tritt an seiner Seite das weibliche Alter Ego Rrose Sélavy auf, Duchamps Spiel mit den Geschlechtern beginnt. Seine Tür: 11, rue Larrey von 1927, mit einem Scharnier an der gemeinsamen Leiste zweier im rechten Winkel zueinander positionierten Türrahmen angebracht, ist gleichzeitig sowohl geschlossen als auch geöffnet.

Als Duchamp ausgerechnet Julien Levy 1950 eine kleine Skulptur aus galvanisiertem Gips mit dem Titel Not a Shoe schenkt (Abb. 17), verwundert es nicht, wenn sie es ist, die in einer Reihe von Objekten den Anfang macht, die erst nach dem posthum öffentlich bekannt gewordenen Spätwerk Étant donnés: 1° la chute d'eau, / 2° le gaz d'éclairage (Gegeben sei: 1. Der Wasserfall / 2. Das Leuchtgas, 1946–1966, Abb. 14, 15) als Nebenprodukte seiner heimlichen Arbeit erkannt werden.[8] Schließlich teilte Duchamp, mit zwei biegsamen Drähten spielend, schon bei seiner ersten Begegnung mit Levy an Deck eines Überseedampfers auf dem Weg von New York nach Le Havre 1927 mit, dass er einen »mechanischen, weiblichen Apparat bauen« wolle, eine »weiche anatomische Maschine«.[9] Das Ganze, so Duchamp weiter, solle »eine lebensgroße, bewegliche Schaufensterpuppe« sein, »eine mechanische Frau, deren Vagina [...] möglicherweise selbstbefeuchtend ist und von einer Fernbedienung angeschaltet wird, die sich vielleicht im Kopf befindet« – seine »machine-onaniste«.[10] Mit Not A Shoe hat Duchamp

4 Dass es sich hierbei um ein Werk Duchamps handelt, geht einzig aus einer Bildunterschrift der Zeitschrift La Victoire 47 (New York), 24. November 1945, hervor.
5 Julien Levy, Surrealism, New York 1995 (1936), S. 16 [Übersetzung des Autors; kursiv im Original].
6 Ebd.
7 Ebd., S. 17.
8 Zu diesen Objekten zählen Weibliches Feigenblatt (1950), Dart-Objekt (1951) und Keuschheitskeil (1954), zu Duchamps Lebzeiten u. a. als »bizarre Artefakte« bezeichnet. S. Stuart Preston, »Diverse Facets: Moderns in Wide Variety«, in: The New York Times, 20. Dezember 1953, Sektion 10, S. 12. Optisch ist Not a Shoe – übrigens die einzige derzeit bekannte Kleinplastik aus dieser Reihe, die Duchamp nicht in einer späteren Edition herausgab – nahezu identisch mit einem die Vertikallinie in der Mitte einschließenden Detail des Weiblichen Feigenblatts sowie dem in Dentalkunststoff steckenden Bronzekeil des Keuschheitskeils. Allgemein wird davon ausgegangen, dass es sich hierbei um den Abdruck eines weiblichen Geschlechts handelt. Forschungsergebnisse des ASRL belegen aber, dass man dabei vielmehr vom geschlechtsneutralen Abdruck eines Perineums ausgehen muss, also des zwischen unterem Vulva-Ansatz (bei der Frau) bzw. Skrotum (beim Mann) und After befindlichen Damms. S. Rhonda Roland Shearer, »This is Not a Vulva Mold (and Other Discoveries Regarding How and Why Duchamp's Readymades are Not Readymades«, Bard College, Annendale-on-Hudson, New York, 21. November 2000 sowie Thomas Girst »Von Readymades und ›Asstricks‹: Forschungsergebnisse des Art Science Research Laboratory zu drei Werken Marcel Duchamps«, in: Marcel Duchamp. Die Schweriner Sammlung, Ostfildern 2003.
9 Julien Levy, Memoirs of an Art Gallery, New York 1977, S. 20 [Übersetzung des Autors].
10 Ebd. [kursiv im Original].

nail polish rotated 180 degrees. In his anthology *Surrealism* (1936), Levy describes Duchamp as an *"ideal* shoemaker"[5] who no longer makes shoes but who is still steeped in the act of creation.

> A shoemaker makes shoes. A manually proficient shoemaker makes superb shoes. An *ideal* shoemaker no longer makes shoes, but ideas in his medium. He is divorced from his material objective and, like a madman, he would cut leather and sew leather and choose leathers like a runway engine, except that he has an idea.[6]

Duchamp had stopped painting in 1918, but under the pseudonym of *Rrose Sélavy* he has returned to make shoes, according to Levy quoting Duchamp: "If it is shoes that you want, I'll give you shoes that you will admire to such an extent that you will make yourselves lame trying to walk in them."[7]

It appears that with Duchamp's feet/shoes in the shop window nine years later, this is exactly what he has done. Duchamp's universe is not one of either/or or neither/nor but one of as-well-as or of one and the other. As of 1921, there emerged at his side the feminine alter ego *Rrose Sélavy,* and Duchamp's gender play begins. His *Door: 11, rue Larrey* of 1927 with a hinge on the shared border of two door frames positioned at a ninety degree angle to one another is a door simultaneously closed as well as opened.

When Duchamp presented to Julien Levy, of all people, a small sculpture of galvanized plaster in 1950 with the title of *Not a Shoe* (fig. 17), it is no surprise that this work is the first in a series of objects related to the late work that was only posthumously made public[8]: *Étant donnés: 1° la chute d'eau,/2° le gaz d'éclairage* (Given: 1. The Waterfall, 2. The Illuminating Gas, 1946–1966, figs. 14–15), offshoots of his secret production. After all, Duchamp had told Levy when they first met on the deck of a steam ship on the way to New York in 1927 that he was considering making a "mechanical female apparatus," a "soft anatomical machine."[9] He was playing with two flexible wires at the time and he said, jokingly, that his idea was to make "a life-sized dummy, a mechanical woman whose vagina, contrived of meshed springs and ball bearings, would be contractile, possibly self-lubricating, and activated from a remote control, perhaps located in the head and connected by the leverage of the two wires he was shaping. The apparatus might be used as a sort of *'machine-onaniste'* without hands."[10]

5 Julien Levy, *Surrealism* (New York, 1995 [1936]), p. 16 [italics in the original].
6 Julien Levy 1995 (see note 5).
7 Julien Levy 1995 (see note 5), p. 17.
8 To these objects belong *Female Fig Leaf* (1950), *Dart-Object* (1951) and *Wedge of Chastity* (1954), all characterized during Duchamp's life as "bizarre artifacts." See Stuart Preston, "Diverse Facets: Moderns in Wide Variety," *The New York Times*, December 20, 1953, section 10, p. 12. On a visual level *Not a Shoe*—the only small sculpture from this series that Duchamp did not reproduce in a later edition—is almost identical with the detail of the vertical line in the center of the *Female Fig Leaf* as well as the bronze wedge lodged in dental plastic that constitutes *Wedge of Chastity*. In general it is assumed that what is depicted is the triangle of the female sexual organ. Researchers at the Art Science Research Laboratory, New York, however, have found proof that one should interpret this area much more as the gender-neutral impression of a perineum, that is to say, the dam to be found between the lower vulva-opening (in the woman) or the scrotum (by the man) and the opening of the anus. See Rhonda Roland Shearer, "This is Not a Vulva Mold (and Other Discoveries Regarding How and Why Duchamp's Readymades are Not Readymades)," Bard College, Annendale-on-Hudson, New York, November 21, 2000 as well as Thomas Girst "Von Ready-mades und 'Asstricks'" in *Marcel Duchamp. Die Schweriner Sammlung* (Ostfildern, 2003).
9 Julien Levy, *Memoirs of an Art Gallery* (New York, 1977), p. 20.
10 Julien Levy 1977 [italics in the original].

Levy knapp ein Vierteljahrhundert später das Herzstück dieses Apparats vermacht, den vermeintlichen Abdruck des zur Schau gestellten Geschlechts in *Étant donnés*, die am meisten ausgeleuchtete Stelle dieser pornografischen Assemblage. Der Torso ist im Übrigen aus Leder geschaffen. Und Leder ist das Material des Schusters.

Schuhe und Füße. *Not a Shoe* ist kein Schuh, auch wenn die Form des keilartigen Objekts von der Seite betrachtet an einen abstrahierten Fuß und dessen Beinansatz erinnern mag. *Not a Shoe* ist vielmehr der Abdruck der enthaarten Geschlechtsöffnung von *Étant donnés*.[11] Zudem dreht Duchamp mit Man Ray bereits 1921 einen Film über die Dada-Künstlerin Baroness Elsa von Freytag Loringhoven. Die einzige Handlung darin besteht in der Rasur ihrer Scham.

Ein paar Jahre zuvor wird Duchamps rege Beteiligung an einem Tableau vivant im Hause des Sammlerehepaars Walter und Louise Arensberg beobachtet: »Eine junge Französin lag gleich einer jungfräulichen Olympia auf einem Diwan ausgestreckt, während die männlichen Gäste sich beim Streicheln einzelner Körperteile ablösten. Duchamp widmete sich ganz ihren Beinen, die er mit seinen Fingerspitzen liebkoste. [William Carlos] Williams sah der Veranstaltung ehrerbietig zu: ›So etwas hatte ich noch nie zuvor gesehen. Ihre Füße wurden geküsst, ihre Schienbeine, ihre Knie […]‹«.[12] Duchamp schenkte diesem Teil der weiblichen Anatomie also durchaus ebenso Beachtung.

Vielleicht wird ihm Balzacs Novelle *Das Ungekannte Meisterwerk* (1831) bekannt gewesen sein: Bevor er es endgültig dem Feuer anheim gibt, arbeitet der berühmte Maler Frenhofer über Jahre an einem einzigen Gemälde und bannt doch »nichts als Farben, die im wirren Durcheinander massiert sind und von einer Fülle bizarrer Linien zusammengehalten werden«,[13] auf die Leinwand. Was die Bekannten Frenhofers schließlich in einer Ecke des Bildes ausmachen können, ist »ein entzückende[r]« ein »lebende[r] Fuß«, ja »dieser Fuß erschien wie der Torso irgendeiner Venus aus parischem Marmelstein, der aus den Ruinen einer zu Asche gebrannten Stadt sich erhebt«.[14] Eine weitere Erzählung war Duchamp zweifelsfrei bekannt: Wilhelm Jensens *Gradiva* von 1903, ein wichtiger Quellentext der Surrealisten,[15] nach dessen Titel André Breton 1937 seine kurzlebige Pariser Galerie benennt, für die Duchamp die Eingangstür gestaltet (Abb. 18, 19).[16] Das kurze Prosastück erfreut sich nicht zuletzt deshalb großer Beliebtheit, weil der von den Surrealisten bewunderte Sigmund Freud es früh einer psychoanalytischen Lektüre unterzieht und dazu bereits 1907 einen Aufsatz

11 Hirnforscher Vilayanur S. Ramachandran, Professor für Neurowissenschaften und Psychologie an der University of California, San Diego, zufolge liegt das Areal, welches in der Hirnrinde den Füssen zugeordnet ist, direkt neben demjenigen für die Geschlechtsteile. S. *Süddeutsche Zeitung Magazin* 3, 19. Januar 2001, S. 19 ff. S. 21.

12 Carolyn Burke, *Becoming Modern: The Life of Mina Loy*, New York 1996, S. 218 [Übersetzung des Autors].

13 Honoré de Balzac, *Das Ungekannte Meisterwerk*, Zürich 1998, S. 95 ff., S. 131 f.

14 Ebd., S. 132.

15 Zur Diskussion der Bedeutung von *Gradiva* für die Surrealisten, u. a. Max Ernst, Salvador Dalí und André Masson, s. Antje von Graevenitz, »Duchamps Tür Gradiva. Eine literarische Figur und ihr Surrealistenkreis«, in: *Avantgarde* 2 (1989), hrsg. von Klaus Beckman und Antje von Graevenitz, S. 63 ff.

16 Als Duchamp 1968 die Einladungskarte für die *Doors*-Ausstellung der New Yorker Galerie Cordier& Ekstrom gestaltet (19. März – 20. April 1968) wählt er die für Bretons *Gradiva* entworfene Tür aus, um Miniaturen derselben auf Papier und Acetat anfertigen zu lassen. Zwei Jahre nach der Fertigstellung von *Étant donnés* muss es Duchamp in seinem letzten Lebensjahr amüsiert haben, dergestalt auf die spanische Holztür der Außenansicht seines posthumen Hauptwerks hinzuweisen, über das er verfügt hatte, es erst nach seinem Tod im Philadelphia Museum of Art öffentlich zugänglich zu machen.

With *Not a Shoe*, Duchamp had presented Levy a quarter of a century later the very heart of that apparatus, supposedly the cast of the female sex which is the center and spotlight of *Étant donnés*, the most illuminated location of his pornographic assemblage. The torso itself is made of leather. And leather is the material of the shoemaker.

Shoes and feet. *Not a Shoe* is indeed no shoe, even if the form of the wedge-shaped object if viewed from the side seems to resemble an abstracted foot and its connection to the leg.

Not a Shoe is much more the cast of the hairless vaginal opening of *Étant donnés*.[11] In addition, Duchamp had already produced with Man Ray in 1921 a film featuring Dada artist Baroness Elsa von Freytag Loringhoven. The sole action of the short movie, now lost, is that of the Baroness shaving off her pubic hair.

A few years before Duchamp's lively participation in a *tableau vivant* in the house of the collector Walter and Louise Arensberg had been observed and recorded:

A young Frenchwoman was reclining on a divan like a virginal Olympia while the male guest took turns stroking parts of her body. Duchamp was devoting himself to her legs, which he caressed with the tips of his fingers. [William Carlos] Williams watched the spectacle in awe: "It was something I had not seen before. Her feet were being kissed, her shins, her knees..."[12]

Duchamp was no stranger to this part of the female anatomy. Perhaps he knew Balzac's novella *The Unknown Masterpiece* (1831). Before he committed the work to the flames, the famous painter Frenhofer had worked for years on a single painting but created "nothing but confused masses of color and a multitude of fantastical lines" on the canvas.[13] All that an acquaintance of Frenhofer could distinguish in a corner of the painting was the "delicate beauty" of a bare foot, a "living" foot that "seemed like the Parian marble torso of some Venus emerging from the ashes of a ruined town."[14] Another story Duchamp was certainly familiar with was Wilhelm Jensen's *Gradiva* from 1903, an important source text for the Surrealists.[15] Its title was the name chosen by André Breton in 1937 for his short-lived Parisian gallery, whose entrance door was designed by Duchamp (figs. 18, 19).[16] It was none other than Sigmund Freud, admired by Breton and the Surrealists, who had written a long essay on Jensen's book[17] annotating his copy of *Gradiva* with short notes about the meaning of dreams and the delight taken in the female foot.[18] The contents are quickly told. The plot solely evolves

11 The brain researcher Vilayanur S. Ramachandran, Professor for Neuroscience und Psychology at the University of California, San Diego, has found that the region in the cortex of the brain which is devoted to the feet is to be found directly next to that for the sexual organs. See *Süddeutsche Zeitung Magazin* 3 (January 19, 2001), pp. 19–23, p. 21.

12 Carolyn Burke, *Becoming Modern: The Life of Mina Loy* (New York, 1996), p. 218.

13 Honoré de Balzac, *The Unknown Masterwork* (1832), <www.gutenberg.org/files/23060/23060-h/23060-h.htm> (September 27, 2012).

14 Honoré de Balzac 1832.

15 For a discussion of the significance of *Gradiva* for the Surrealists, including Max Ernst, Salvador Dalí and André Masson, see Antje von Graevenitz, "Duchamps Tür Gradiva. Eine literarische Figur und ihr Surrealistenkreis," in Klaus Beckman and Antje von Graevenitz, eds., *Avantgarde* 2 (1989), pp. 63–96.

16 When in 1968 Duchamp designed the invitation card to the *Doors*-Exhibition of the New York Gallery Cordier& Ekstrom (March 19–April 20, 1968), he chose the door designed for Breton's *Gradiva* in order to produce miniatures on paper and acetate. Two years after the completion of *Étant donnés* it must have amused Duchamp in the final year of his life that one could find a reference to the Spanish wooden door in his posthumous major work, which was made public at the Philadelphia Museum of Art only after his death.

17 Sigmund Freud, *Die Wahrheit und die Träume in W. Jensens Gradiva* (Frankfurt, 1998).

18 In André Bretons *Le Surréalisme, même* 1 (1956), René Alleau provided a detailed contribution pertaining to Jensen's hero with "Gradiva Redivia," (pp. 13–21). The cover design was provided by Duchamp and shows a photograph of the *Female Fig Leaf*.

veröffentlicht.[17] Am Rande seiner Ausgabe von *Gradiva* findet man zahlreiche Bemerkungen Freuds sowohl zur Traumdeutung als auch zur Liebhaberei des weiblichen Fußes.[18] Der Inhalt ist schnell erzählt, ist er doch nichts anderes als eine einzige Amour fou des Archäologen Dr. Norbert Hanold zu einer auf einem römischen Gipsrelief aus Pompeji dargestellten jungen Frau, auf deren leibhaftige Spuren sich der Protagonist ganz im Sinne des ewigen *cherchez la femme* in den Ruinen der zu Asche verbrannten Stadt begibt. Was Hanold an Gradiva übrigens mehr als alles andere fasziniert, ist deren Gang, der erotisch aufgeladene Raum zwischen Fußsohle und Sandale, der sich beim Schreiten unterhalb ihrer langen Tunika offenbart (Abb. 20).

Schuhe und Füße. 1945 gestaltet Duchamp das Schaufenster für Bretons Buch *Le Surréalisme et la peinture*, auf dessen Cover René Magrittes Gemälde *Das rote Modell* von 1935 zu sehen ist. Es zeigt ein paar schwarze Halbstiefel, die nahtlos in fleischfarbene Füße und Zehen übergehen. Enrico Donati hat sie für die Assemblage als Objekt nachgebaut. Duchamps eingangs erwähnte Fußsohlen mit Schuhabsatz sind gleichfalls von Magrittes Gemälde inspiriert. Vom 3. bis 20. Januar 1936 wurde *Das rote Modell* in Julien Levys Galerie im Rahmen seiner ersten New Yorker Einzelausstellung, *René Magritte, Paintings*, gezeigt. Alex Salkin, seit den späten 1930er-Jahren Besitzer des Gemäldes, übergibt es 1947 an die Hugo Gallery in New York, wo es Duchamps Geliebte Maria Martins auf Anraten Duchamps kauft.[19] Duchamp ist es auch, der Breton gegenüber darauf besteht, dass *Das rote Modell* auf dem Umschlag von *Le Surréalisme et la peinture* gezeigt wird (Abb. 21). Nachdem er am 2. Juli 1945 Robert Tenger, den Verleger von Brentano's, trifft, kabelt er an Elisa und André Breton in Reno, Nevada: »Nehme die bloßen Füße, Magrittes Schuhe. Statt schwarz, mache einen roten Aufdruck auf rosa Papier (oder weißem). Diese blutunterlaufene Reproduktion würde in der Mitte des Deckels angebracht, zusammen mit Deinem Namen, dem Titel des Buchs […] und Brentano's darunter«.[20]

Duchamp inszeniert, dem Zufall überlässt er dabei nichts. »Gestern morgen haben wir am Schaufenster für Brentano's ›Le Surréalisme et la peinture‹ gearbeitet«, schreibt die junge Schweizer Künstlerin Isabelle Waldberg am 10. November 1945 aus New York ihrem Ehemann in Paris und fügt eine Zeichnung bei (Abb. 22): »Natürlich hat Marcel alles gemacht, den gesamten Entwurf und die Ausführung«.[21]

Schon 1913 hat sich Duchamp in seinen Notizen eingehend mit Schaufenstern beschäftigt:

17 Sigmund Freud, *Der Wahrheit und die Träume in W. Jensens ›Gradiva‹*, Frankfurt 1998.
18 René Alleau hat in André Bretons *Le Surréalisme, même* 1 (1956) mit »Gradiva Rediviva« einen längeren Beitrag zu Jensens Heldin verfasst (S. 13 ff.). Den Umschlag dazu hat Duchamp gestaltet. Er zeigt eine Aufnahme des *Weiblichen Feigenblatts*.
19 *René Magritte: Catalogue Raisonné*, hrsg. von David Sylvester, Bd. 2, London 1993, S. 207.
20 Jennifer Gough-Cooper and Jacques Caumont, »Ephemerides on and about Marcel Duchamp and Rrose Sélavy, 1887–1968«, 2.7.1945, in: *Marcel Duchamp* hrsg. von Pontus Hulten, Ausst.-Kat., Cambridge 1993, o. S. Die zweite Auflage des 1928 bei Gallimard (Paris) erschienenen Buchs von 1945 enthält den zuvor einzig in der surrealistischen Zeitschrift *Minotaure*, (Paris, Nr. 2, 6, Winter 1935, S. 45 ff.) publizierten Essay Bretons zu Duchamps *Die Braut von ihren Junggesellen entblößt*, sogar / *Das Große Glas* (1915–1923), der im gleichen Jahr auf Englisch erstmals in Charles Henri Ford's *View* (New York, Nr. 5, 1, March 1945, S. 6 ff., 13) veröffentlicht wird. Es ist bemerkenswert, dass Duchamp für *Minotaure*, für *View* sowie für die zweite Auflage von *Le Surréalisme et la Peinture* die Umschlaggestaltung übernommen hat.
21 Patrick Waldberg, Isabelle Waldberg, *Un Amour Acéphale. Correspondance 1940–1949*, Paris 1992, S. 331 [Übersetzung des Autors]. Brentano's, der Name einer bekannten Buchhandlung und eines Verlags, befand sich in Manhattan auf der 586, Fifth Avenue.

around the *amour fou* of the archeologist Dr. Horbert Hanold for a young woman presented on a Roman plaster relief from Pompeii. The protagonist, in a heightened sensual state of *cherchez la femme*, commits himself to a search through the ashes of the ruined town. What fascinated Hanold most about Gradiva was what was revealed in her stride, the erotically charged space between the sole of her foot and the shoe, which could be glimpsed beneath her long tunic as she walked (fig. 20).

Shoes and Feet. In 1945 Duchamp designed the shop window for Breton's book *Le Surréalisme et la peinture,* on whose cover René Margritte's painting *The Red Model* from 1935 is to be seen. The painting contains a pair of black half-boots, which seamlessly go over into flesh-colored feet and toes. Enrico Donati constructed them for the assemblage as an object. Duchamp's foot soles with the shoe heel mentioned earlier were also inspired by Magritte's painting. In 1936, *The Red Model* was included in Magritte's first American solo show *René Magritte, Paintings* at Julien Levy's gallery (January 3–January 20). In 1947, it was sent by Alex Salkin—the painting's owner since the late 1930s—to the Hugo Gallery in New York, where, most importantly, it was bought by none other than Maria Martins, following the advice of Marcel Duchamp.[19] Moreover, it was Duchamp who insisted with Breton that *The Red Model* be included on the cover of *Le Surréalisme et la peinture* (fig. 21). On July 2, 1945, after meeting with Brentano's publisher Robert Tenger, Duchamp mailed a letter to Elisa and André Breton in Reno, Nevada, with suggestions for the cover: "Take the bare feet, Magritte's shoes. Instead of black, make a print in sanguine on pink paper (or just white). This bloodshot reproduction would be imprinted in the middle of the board and also imprinted with your name, the title of the book ... and Brentano's below."[20]

With Duchamp's concept for the cover, nothing was left to chance. On November 10, 1945, the Swiss artist Isabelle Walberg included a drawing (fig. 22) in one of her many letters to her husband Patrick, living in Paris at the time. "Marcel naturally did everything, all the design and execution," she writes to him.[21]

Since 1913, Duchamp had been occupied in his notes with the question of the shop window:

19 David Sylvester, ed., *René Magritte: Catalogue Raisonné,* vol. 2 (London, 1993), p. 207.

20 Jennifer Gough-Cooper and Jacques Caumont, "Ephemerides on and about Marcel Duchamp and Rrose Sélavy, 1887–1968", July 2, 1945, in Pontus Hulten, ed., *Marcel Duchamp* (Mailand, 1993), n. p. The second edition of the book from 1928, published by Gallimard (Paris) in 1945 contains the essay by Breton on Duchamp's *The Bride stripped Bare by Her Bachelors, Even / The Large Glass* (1915–1923) which had previously appeared only in the Surrealist Magazine *Minotaure* 2, 6 (December 1935) pp. 45–49. In the same year was published in English translation in Charles Henri Ford's *View* 5 (March 1945), pp. 6–9, p 13. It is noteworthy that Duchamp had assumed the design of the cover of *Minotaure* and of *View* as well as that of the second edition of *Le Surréalisme et la peinture.*

21 Patrick Waldberg and Isabelle Waldberg, *Un Amour Acéphale. Correspondance 1940–1949* (Paris 1992), p. 331 [author's translation]. Brentano's as the name of a famous bookstore and publishing house was to be found in Manhattan on 586 Fifth Avenue.

Die Frage der Schaufenster:.
über sich ergehen lassen
Das Verhör der Schaufenster:.

Die Forderung des Schaufensters:.
der Existenz
Das Schaufenster, Beweis der äusseren

Welt:. ——————

Wenn man das Verhör der Schaufenster über

sich ergehen lässt, spricht man auch sein

eigenes ~~Urteil~~ Verurteilung aus.

Die Wahl ist tatsächlich hin

und zurück. Aus dem Verlangen der

Schaufenster, aus der unvermeidlichen Antwort

auf die Schaufenster, beschliesst sich

die Fixierung der Wahl. Keine Versessen-

heit ad absurdum, : den Koitus

durch eine Glasscheibe hindurch mit einem

oder mehreren Objekten des Schaufensters

verbergen zu wollen. Die Strafe

besteht darin, die Scheiben zu durchschneiden
darüber
und Gewissensbisse zu haben, sobald

die Besitznahme erfolgt ist

q.e.d. ——————

Neuilly. 1913 [22]
——————

22 Notiz aus Marcel Duchamp, *À l'Infinitif (Die weiße Schachtel)*, New York 1967, o. S. Die Übersetzung aus dem Französischen entstammt Serge Stauffer, *Marcel Duchamp: Die Schriften*, Zürich 1994 (1981), S. 125.

The question of shop windows:.
 To undergo
The interrogation by shop windows:.

The necessity of the shop window:.
 of existence
The shop window proof of the world

outside:. ──────────

When undergoing the interrogation

by shop windows, you also pronounce

your own ~~judgment~~ condemnation.

In fact, the choice is a round trip. From

the demands of shop windows, from the

inevitable response to shop windows,

the conclusion is the making of a choice.

No obstinacy, ad absurdum, : in hiding

this coition through a sheet of glass

with one or more of the objects in the

shop window. The penalty consists in

cutting the glass and in kicking yourself

as soon as possession is consummated.

q.e.d. ──────────

 Neuilly. 1913 [22]

22 Richard Hamilton and Ecke Bonk, *Marcel Duchamp: In the Infinitive— A Typotranslation* by Richard Hamilton and Ecke Bonk of Marcel Duchamp's *White Box* (Northend, 1999), pp. 5–6 [translated from the French by Jacqueline Matisse Monnier, Richard Hamilton and Ecke Bonk].

Welches Verlangen bricht sich im Schaufenster vom November 1945 die Bahn? Die ausgeklügelte Dekoration zu Bretons Buch entsteht keine zwei Jahre vor der ersten Skizze zum Frauenkörper von *Étant donnés*, für den zunächst Maria Martins Modell gestanden hat. Duchamp selber datiert den Beginn der Arbeit zu seinem späten Hauptwerk auf 1946. Die Zeichnung einer Fußsohle für Donatis *Schachtel im Koffer* aus demselben Jahr, Levys *Not a Shoe* und später *Torture-morte* (ein makabres Wortspiel mit »Nature morte«, dem französischen Begriff für »Stilleben«) verweisen allesamt auf den Fuß / Schuh-Komplex von *Das rote Modell* sowie auf Duchamps frühe Ausführungen zu einer lebensgroßen »machine-onaniste« oder den gleichfalls gegenüber Levy gemachten Bemerkungen zum »*idealen* Schuster«. Es stellt sich zudem heraus, dass Duchamp mit Donatis Schuhen sehr viel mehr zu schaffen hatte, als ursprünglich vermutet. Neben dem bekannten Foto des Schaufensters existiert noch ein weiteres, von einem anderen Blickwinkel aus aufgenommen, das in der französischsprachigen Wochenzeitung *La Victoire* (Nr. 47) am 24. November 1945 publiziert wurde (Abb. 23). Das Foto hat die folgende Bildunterschrift: »Schaufensterdekoration von Marcel Duchamp und André Breton im New Yorker Buchladen Brentano's für ›Le Surréalisme et la peinture‹. ›Magritte Schuhe‹ von Enrico Donati, Maske von Isabelle Waldberg, Papierkaskade und genietete Füße von Marcel Duchamp«. Die Fotoreproduktion in *La Victoire* ist, zumal nach über einem halben Jahrhundert, in schlechtem Zustand. Was sich aber besser erkennen lässt als auf der einzigen anderen erhaltenen Fotografie, sind die Fußsohlen neben Donatis Schuhen. Sie sind schmaler als dessen große Schuhe und wirken daher weiblicher. Das Ensemble erinnert damit an Picabias Umschlaggestaltung für die siebte Ausgabe von Bretons *Littérature* vom Dezember 1922 (Abb. 24) – für die Duchamp mit dem Wortspiel *Lits et Ratures*, also *Betten und Streichungen*, beitrug – sowie an Duchamps enigmatischen Gipsfuß der Kleinskulptur *Torture-morte* von 1959. In diesem Zusammenhang ist sicher von Interesse, dass die ersten beiden Studien zu *Étant donnés* noch die Beine des nackten weiblichen Körpers unterhalb der Knie zeigen, Details der Anatomie, die in der endgültigen Ausführung der Assemblage nahezu vollends fehlen.

1947 arbeitet Duchamp erneut mit Donati zusammen, sie gestalten gemeinsam den Ausstellungskatalog für *Le Surréalisme en 1947* (Abb. 25). Die Deluxe-Ausgabe präsentiert auf dem Umschlag Frauenbrüste aus gehärtetem Schaumstoff, für deren Realisierung Duchamp

What demands lead to a breakthrough in the shop window of November 1945? The cleverly planned decoration for Breton's book came into being not even two years prior to the initial sketches of the woman's body in *Étant donnés*, for which, in the beginning, Maria Martins presumably served as a model. Duchamp himself dates the start for his late work with 1946. The drawing of the sole of a foot for Donati's *Box in a Valise* of the same year, Levy's *Not a Shoe* and later *Torture-morte* (a macabre play on words on *Nature morte*, the French expression for still life) all point to the foot/shoe-complex of *The Red Model* as well as to Duchamp's earlier versions of a life-sized "machine-onaniste" or to the remarks made to Levy in regards to the "*ideal* shoemaker." It turns out that he was deeply involved with Donati's shoes as well. Besides the known photograph of the window display, there is another shot from a different angle, reproduced in the French paper *La Victoire* (fig. 23). Underneath the photograph, the following caption appears: "Window display by Marcel Duchamp and André Breton at Brentano's bookstore in New York, for 'Surrealism and the Painting.' 'Magritte Shoes' by Enrico Donati, mask by Isabelle Waldberg, falling paper and studded feet by Marcel Duchamp." After more than half a century, the quality of the reproduced photograph in the remaining copies of *La Victoire* is very poor. What can be better discerned here than from the other photograph are the soles of the feet next to Donati's, a work by Duchamp mentioned only in *La Victoire*. They are considerably smaller and seem to be feminine in comparison to Donati's big shoes with protruding plaster toes. While the ensemble with Donati's shoes might resemble Picabia's cover for Breton's *Littérature* (fig. 24)—for which Duchamp came up with the play on words *Lits et Ratures*, or *Beds and Deletions*—it is reminiscent as well of Duchamp's *Torture-morte* of 1959, his enigmatic plaster foot. It is worth mentioning in this regard that both of the first two studies for *Étant donnés* also show the legs of a naked female body beneath the knee, details of the anatomy which are all but totally missing in the final version of the assemblage.

In the year 1947 Duchamp worked once again with Donati. Together they designed the exhibition catalog for *Le Surréalisme en 1947* (fig. 25). The deluxe-edition presents a bare artificial female breast made of hardened foam, for whose realization Duchamp initially employed the plaster cast of Maria Martins bosom before he decided to use an industrially produced model instead. This is not to say that plaster impressions of a woman's breast are anything new in the history of art.

zunächst Gipsabdrücke von Maria Martins Brüsten anfertigte, bevor er sich mit einem handelsüblichen Modell begnügte. Wobei Brustabgüsse in der Kunstgeschichte nichts Neues sind. In Gradivas Heimatstadt Pompeji fanden diese als Votivgaben häufig Verwendung (Abb. 26).[23]

In *Le Surréalisme en 1947* wird indes zum ersten Mal das bekannte Foto von Duchamps Installation für *Le Surréalisme et la peinture* veröffentlicht. Auf der gleichen Seite des Ausstellungskatalogs sind neben der Abbildung eines weiteren von Duchamp gestalteten Schaufensters auch Gemälde der Surrealisten Wilhelm Freddie und Jindrich Styrsky zu sehen, die beide halbverhüllte Frauenkörper zeigen. In Freddies Werk *Pro Patria* hängt die untere Hälfte einer leicht bekleideten Frau aus einer Maueröffnung, die dem Loch der durchbrochenen Backsteinwand von *Étant donnés* nicht unähnlich ist (Abb. 27).

Als Duchamp Maria Martins kennenlernt, ist sie für ihn die Fleischwerdung der »Braut« aus seinem Werk *Die Braut von ihren Junggesellen entblößt, sogar / Das Große Glas (La Mariée mise à nu par ses célibataires, même / Le Grand verre*, 1915–1923, Abb. 4), seinem ersten Hauptwerk — »enfin arrivée«[24], endlich angekommen, wie er sie leidenschaftlich wissen lässt. Verheiratet ist sie allerdings mit einem anderen. Wenn sich in der Schaufensterdekoration Duchamps, wie wir gesehen haben, zahlreiche Anspielungen auf *Étant donnés* finden, dann fehlt nur noch die »Braut«, um diese vollends als zunächst verschlüsselten, erst im Rückblick erkennbaren Hinweis auf all das zu deuten, woran Duchamp die folgenden zwanzig Jahre seines Lebens arbeiten wird. Der Wasserfall mag die alte Papierbahn aus Duchamps Atelier sein, die wie ein Zeltdach die Dekoration nach oben abschließt, »vieux papier de l'atelier de M. en chute«, wie Waldberg in ihrem Brief schreibt.[25] Und für das Leuchtgas sorgt allemal die schwere, mitten in der Auslage neben Bretons Büchern platzierte Lampe. Links davon befindet sich eine »Puppe aus Maschendraht, ready-made gekauft«.[26] Waldbergs Zeichnung markiert mit zwei kleinen Kreisen die hervorstehenden Brüste der Puppe. Auf den erhaltenen Fotos ist hingegen nicht zu erkennen, ob es sich um ein männliches oder ein weibliches Modell handelt. Der am Unterleib abgetrennte Körper entspricht in Hinblick auf seine fragmentierte Form und das verwendete Material dem ebenfalls in Maschendraht angefertigten, weiblichen Miniaturtorso, den Duchamp zwei Jahre zuvor für die Gestaltung der Rückseite des Magazins *VVV* verwendet (Abb. 28). Ähnlich wie der Leser von *Le Surréalisme en 1947* aufgefordert ist, die darauf angebrachte Frauenbrust zu berühren (auf

23 Siehe: Stefano de Caro, *Il Gabinetto Segreto del Museo Archeologico Nazionale di Napoli*, Neapel: Museo Archeologico Nazionale, 2000, S. 28. Als Glücksbringer, Dildos und Zeichen monetären Wohlstands wurden riesenhafte Phalli innerhalb und außerhalb von Wohnhäusern sowie bei Beerdigungen prominent platziert. Zudem dienten nachgebildete Körperteile wie Füße und Brüste über Jahrhunderte Künstlern, Wissenschaftlern und Medizinern als Studienmodelle S. *Theatrum Naturae et Artis: Wunderkammern des Wissens*, hrsg. von Horst Bredekamp, Jochen Brüning und Cornelia Weber, Ausst.-Kat., Berlin 2000, S. 197 ff. Während der späten 1910er- und frühen 1920er-Jahre war es in New York die von Duchamp besessene Dada-Baroness Elsa von Freytag-Loringhoven, die einige ihrer Gäste mit einem Gipsphallus begrüßte. S. Francis M. Naumann, *New York Dada 1915–23*, New York 1994, S. 173. Nur wenig später baumelten 1924 von der Decke des Pariser Surrealistenbüros Gipsfiguren nackter Frauen, wobei es Breton selber war, der hier die Dekoration übernommen hatte. S. Mark Polizzotti, »Revolution of the Mind: The Life of André Breton«, New York 1995, S. 220.
24 Naumann 2001, (wie Anm. 3), S. 103.
25 Patrick Waldberg, Isabelle Waldberg 1992 (wie Anm. 21), S. 331.
26 Ebd. [Übersetzung des Autors; Waldberg schreibt im franz. Original »acheté tout fait«].

In Gradiva's home city of Pompeii they were frequently used as votive offerings (fig. 26).[23]

Le Surréalisme en 1947 published for the first time a photograph of Duchamp's installation for Le Surréalisme et la peinture. In the catalogue, plate XLI depicts four images: to the lower left is a photograph of Duchamp's and Donati's window display of 1945. The upper right image shows another window design by Duchamp of the same year, while the pictures by Surrealist painters Wilhelm Freddie and Jindrich Styrsky both depict half-concealed women. In Freddie's painting, the lower half of what appears to be a clothed female who hangs outside of a wall opening not unlike the brick wall of Duchamp's Étant donnés interior (fig. 27).

When Duchamp became acquainted with Maria Martins, she was to become the incarnation of the bride from his work The Bride stripped Bare by Her Bachelors, Even / The Large Glass (La Mariée mise à nu par ses célibataires, même / Le Grand verre, 1915–1923, fig. 4), his first major work—enfin arrivée, finally arrived,[24] as he passionately let her know—despite the fact that she was married to someone else. When in the shop window decorations of Duchamp, as we have seen, numerous references to Étant donnés are to be found, what is still missing is the bride herself. She is the one element that can complete our assessment—in light of the manifold allusions to Étant donnés which could only to be understood when considered in retrospect—of what Duchamp would be working on for the next twenty years of his life. Thus, the waterfall may well be the old protective paper strip from Duchamp's atelier which encloses the decoration overhead like a tent—"vieux papier de l'atelier en chute," as Waldberg writes in her letter.[25] And as the lightning gas one finds the heavy lamp placed next to Breton's books. To the left stood a "doll of wire-mesh, bought ready-made."[26] Waldberg's drawing marks with two small circles the protruding breasts of the doll. On the photos which have been preserved, one is unable to distinguish if the model is female or male. The body, separated from the lower half of its anatomy, corresponds with its fragmented form and the material employed to the female miniature torso, likewise constructed of wire mesh, that Duchamp had used two years earlier in the creation of the back cover of the Magazine VVV (fig. 28). In a manner similar to that in which the reader of Le Surréalisme en 1947 is encouraged to stroke the woman's breast of the book cover (on the cover flap one can read the label "Prière de Toucher," that is to say "Please

23 See Stefano de Caro, Il Gabinetto Segreto del Museo Archeologico Nazionale di Napoli, exh. cat. Museo Archeologico Nazionale (Naples, 2000) p. 28. As symbols of good luck, dildos and indicators of monetary prosperity, giant phalli were placed inside and outside of dwellings as well as displayed at the funerals of prominent figures. In addition, imitations of body parts such as feet and breasts were used over the centuries by artists, scientists and doctors as models for study. See Horst Bredekamp, Jochen Brüning and Cornelia Weber, eds., Theatrum Naturae et Artis: Wunderkammern des Wissens, exh. cat., (Berlin, 2000), pp. 197–218. During the late 1910s and the early 1920s it was the Dada-Baroness Elsa von Freytag-Loringhoven, obsessed with Duchamp, who greeted certain of her guests with a plaster phallus. See Francis M. Naumann, New York Dada 1915–23 (New York, 1994), p. 173. Only shortly later there hung in 1924 from the ceiling of the Paris Surrealist-Bureau plaster figures of nude women. It was Breton himself who had taken over the decoration of the office. See Mark Polizzotti, Revolution of the Mind: The Life of André Breton (New York, 1995), p. 220.
24 Francis M. Naumann 2001 (see note 3), p. 103.
25 Patrick Waldberg and Isabelle Waldberg 1992 (see note 21), p. 331.
26 Patrick Waldberg and Isabelle Waldberg 1992 (see note 21) [translation of the author; Waldberg wrote in the French original "acheté tout fait"].

der Umschlagrückseite befindet sich das Etikett »Prière de toucher« bzw. »Bitte berühren«), so hält VVV seine Käufer an, für eine »ungewöhnliche Berührungserfahrung« mit den Händen an beiden Seiten des Maschendrahttorso entlang zu streichen, der so genannte »Twin-Touch-Test«.[27]

Zur Rechten der schweren Lampe finden wir Donatis und Duchamps Schuhe/Füße, auf die bereits im Detail eingegangen wurde. Nur bei genauem Hinsehen stellt man fest, dass zwischen Lampe, Füßen/Schuhen, Maschendrahttorso und dem Zeltdach aus Papier eine skelettartige Figur schwebt, die Isabelle Waldberg in ihrem Brief als »ein Objekt von mir unter dem Zelt«[28] beschreibt. Tatsächlich ist diese Skulptur dem Werkkomplex ihrer Constructions zuzuordnen, die während ihres New Yorker Aufenthalts zwischen 1941 und 1946 entstehen.[29] Und es ist diese Skulptur, die dem seltsam entstellten Torso von Étant donnés entspricht: Der Kopf bleibt versteckt, ebenso ein Arm, wobei der zweite ausgestreckt ist. Die Beine sind weit auseinandergespreizt, eines strebt gerade vom Körper weg, das andere ist im rechten Winkel am Knie gebogen. Die Scham wird durch ein Dreieck markiert.[30] Drehen wir Waldbergs Skulptur um 180 Grad und legen sie über eine Vorstudie zu Étant donnés, wird die visuelle Entsprechung am deutlichsten (Abb. 29–31). Der Schaufensternotiz von 1913 eingedenk hätte Duchamp keinen besseren Ort wählen können, um hier das Programm für seine Arbeit an Étant donnés darzulegen. Das unerfüllte Verlangen, der »Koitus/durch eine Glasscheibe hindurch«,[31] der »Junggeselle«, der auf ewig von seiner »Braut« getrennt bleibt.

27 S. die letzte Seite von VVV 2–3 (New York), März 1943.
28 Patrick Waldberg, Isabelle Waldberg 1992, (wie Anm. 21), S. 331.
29 In einem Telefonat vom 6. April 2000 bestätigt Michel Waldberg, Isabelle Waldbergs Sohn, dass die meisten Skulpturen aus der New Yorker Zeit verloren sind, so auch jene für das Schaufenster vom November 1945.
30 In einem Telefonat mit Michel Waldberg (s. Anm. 29), geht dieser davon aus, dass Duchamp die verloren gegangene Skulptur aufgrund ihrer Ähnlichkeit mit seiner Vorstellung für das zukünftige Aussehen des Torso von Étant donnés ausgewählt haben mag. Das Material von Waldbergs Construction kann nicht klar definiert werden, wahrscheinlich ist es aber biegsames Holz, da Waldberg erst nach ihrer Rückkehr nach Europa begann, Draht für die Herstellung ihrer Skulpturen zu benutzen. S. Hans Christoph von Tavel, Isabelle Waldberg: Skulpturen 1943–1980, Ausst.-Kat., Kunstmuseum Bern, Bern 1981.
31 Marcel Duchamp 1967 (wie Anm. 22), o. S.

Dieser Beitrag basiert in Teilen auf einem Vortrag im Rahmen eines dreitägigen Duchamp-Symposiums des Hessischen Landesmuseums Darmstadt, 23.–25. November 2001. Eine gekürzte Version des Essays erschien erstmals in deutscher und englischer Sprache in: Shopping. 100 Jahre Kunst und Konsum, hrsg. von Christoph Grunenberg, Max Hollein, Ausst.-Kat., Kunsthalle Schirn Frankfurt, Ostfildern 2002, S. 142 ff.

27 See the last page of *VVV* 2-3 (New York, March 1943).
28 Patrick Waldberg and Isabelle Waldberg 1992 (see note 21), p. 331.
29 In a telephone conversation with Michel Waldberg, Isabelle Waldberg's son, he confirmed that most of the sculptures from the New York period have been lost, including that for the shop window of November 1945.
30 In a telephone conversation with Michel Waldberg (see note 29), Waldberg assumes that Duchamp chose the lost sculpture because of its similarity with the future appearance of the torso for *Étant donnés*. The material of Waldberg's *Construction* cannot be clearly defined. Probably it is flexible wood, as Waldberg only began to use wire for her sculptures after her return from Europe. See Hans Christoph von Tavel, *Isabelle Waldberg: Skulpturen 1943-1980*, exh. cat. Kunstmuseum Bern (Bern, 1981).
31 Richard Hamilton and Ecke Bonk 1999 (see note 22).

Touch"), he reader of *VVV* is invited to stroke with his hands boths sides of the wire-mesh torso in order to have "an unusual tactile experience," the so-called "Twin-Touch Test."[27]

To the right of the heavy lamp, we find Donati's and Duchamp's Shoe/Feet, which we have already discussed in detail. Only by looking very closely can one discover that between the lamp, Feet/Shoes, wire-mesh torso and the paper roof of the tent, a skeleton-like figure, which Isabelle Waldberg in her letter describes as "an object from me under the tent."[28] In fact, this sculpture finds its place within the many works created as part of her Constructions-series which came into being during her stay in New York between 1941 and 1946.[29] Waldberg's skeletal wire sculpture bears a close resemblance to the strangely distorted body of *Étant donnés* the head and one arm hidden, the other outstretched, legs spread far apart, one straight and the other sharply bent at the knee, the triangle of genitalia exposed.[30] If we turn Waldberg's sculpture 180 degree and place it directly over a preliminary study for *Étant donnés*, the visual correspondence becomes most apparent (figs. 29–31). In light of his shop window note from 1913, Duchamp would have be unable to choose a more appropriate location to announce the underlying concept for *Étant donnés*: the unfullfilled longing for "this coition through a sheet of glass"[31] of the bachelor, who remains eternally separated from his bride.

Transl. Harriett Watts

This article is in part based on a lecture held during a three-day Duchamp symposium at the Hessisches Landesmuseum Darmstadt, November 23-25, 2001. A shortened version of this essay was first published in German and English in Christoph Grunenberg and Max Hollein, eds., *Shopping. A Century of Art and Consumer Culture*, exh. cat. Kunsthalle Schirn, (Ostfildern, 2002), pp. 142-147.

II
ART SCIENCE RESEARCH LABORATORY

Marcel Duchamp, *Ausgewählte Stücke nach Rodin*, 1968,
Radierung, erster Zustand, Druck auf Japan-Velum,
50,5 × 32,5 cm (Blatt), 34,5 × 23,7 cm (Druck),
Staatliches Museum Schwerin – Kunstsammlungen, Schlösser und Gärten

Marcel Duchamp, *Selected Details after Rodin*, 1968,
first state of etching, printed on Japan vellum,
50.5 × 32.5 cm (sheet), 34.5 × 23.7 cm (print),
Staatliches Museum Schwerin – Kunstsammlungen, Schlösser und Gärten

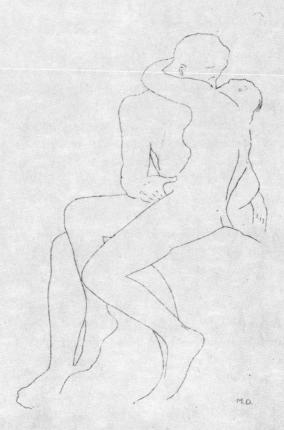

M.D.

13/30 marcel duchamp

ART SCIENCE RESEARCH LABORATORY

Seit seiner Gründung Ende der 1990er-Jahre stand das non-profit Art Science Research Laboratory (ASRL) unter der Leitung des Harvard-Professors Stephen Jay Gould und dessen Frau Rhonda Roland Shearer in regem Austausch mit dem Duchamp-Forschungszentrum des Staatlichen Museums Schwerin. Forschungsergebnisse beider Institutionen wurden in Schweriner Publikationen sowie in ASRLs *Tout-Fait: The Marcel Duchamp Studies Online Journal* veröffentlicht und auf Symposien vorgestellt.[1] Zeitweise verfügte das ASRL über die weltweit größte Privatsammlung der Werke Duchamps. Im New Yorker Stadtteil Soho fanden sich im dritten Stock der Greene Street Nr. 62 über viele Jahre Kunsthistoriker, 3D-Grafiker und Webdesigner, Physiker, Mathematiker, Dermatologen und Ex-Fotospezialisten des CIA zum Austausch über die Verbindung von Kunst und Wissenschaft im Allgemeinen sowie über Marcel Duchamp im Speziellen ein.[2] Der rein kunsttheoretische Ansatz wurde hier durch rigoros multidisziplinäre wie weltweit vernetzte Arbeit sowie durch die intensive Forschung am Objekt selber erweitert. Referenz- und Koordinatensysteme jedweder Auseinandersetzung mit Duchamps Werk berücksichtigten bewusst Kontextualisierungen fernab kunsthistorischer Bezüge — eine Öffnung, wie sie Duchamp in seiner künstlerischen Praxis selbst bereits mit seinen Arbeiten vorgemacht hatte. So bezog sich auch die Sammeltätigkeit des ASRL eben nicht nur auf Werke Duchamps, sondern gerade was die Erforschung der Readymades betraf — in der Darbietung der Exponate einer prämusealen Wunderkammer gleich — auch auf Firmen- und Versandhauskataloge, Zeugnisse der Populärkultur und Industrieobjekte. Gould und Shearer versuchten mit ihrem Ansatz — unter Einbeziehung von Duchamps Notizen, etwa zu seinem Konzept des Inframince, und seinen Interviews, seiner Lektüre des Mathematikers Henri Poincaré sowie der Wissenschaftstheorie zu Beginn des 20. Jahrhunderts über nicht-euklidische Geometrie und Überlegungen zur vierten Dimension — die Nicht-Existenz der verlorenen, meist nur noch auf alten Fotografien erhaltenen,

1 S. Kornelia Röder, »Zur Marcel Duchamp-Rezeption in Mittel- und Osteuropa im Kontext des Netzwerks der Mail Art: Ein Interview mit Serge Segay«, in: *Tout-Fait: The Marcel Duchamp Studies Online Journal* 2003 (Vol. 2, Nr. 5) <www.toutfait.com/online-journal_details.php?postid=1525> (6. August 2012); Thomas Girst, »Von Readymades und ›Asstricks‹«, in: *Marcel Duchamp. Die Schweriner Sammlung,* hrsg. von Kornelia von Berswordt-Wallrabe, Ostfildern 2003; Thomas Girst, »Marcel Duchamp. Eine Hagiographie«, in: *Impuls Marcel Duchamp. Where do we go from here?* hrsg. von Antonia Napp, Kornelia Röder, Ostfildern-Ruit 2011, S. 40 ff.
2 S. Thomas Girst, »Intrusion in the Enchanter's Domain: An Inside View of Rhonda Shearer's Duchamp-based Art Science Research Laboratory, Inc.«, in: *NY Arts* 4, April 1999.

ART SCIENCE RESEARCH LABORATORY

Since the end of the 1990s, the non-profit Art Science Research Laboratory (ASRL), founded at that time by the Harvard professor Stephen Jay Gould and his wife Rhonda Roland Shearer, has been engaged in an exchange with the Duchamp Research Center of the Staatliches Museum Schwerin. The resulting research at the two centers has been included in publications both in Schwerin and ASRL's *Tout-Fait: The Marcel Duchamp Studies Online Journal*, in addition to having been presented at symposiums.[1] For a period of time, ASRL held the most extensive private collection worldwide of Duchamp's works. In Soho in New York on the third floor of 62 Greene Street for a number of years, art historians, 3D graphic and website designers, physicists, mathematicians, dermatologists and ex-photo specialists of the CIA observed and reflected upon the connections between art and science in general, and in particular, in regards to Marcel Duchamp.[2] The purely art historical approach was enhanced and expanded through rigorous multidisciplinary investigations which involved world-wide networking as well as intensive research conducted on the objects themselves. Systems of cross-reference and coordinates resulting from these detailed observations and involvement with the original works, went far beyond the context of mere art-historical relevance—a practice that Duchamp himself had already manifested in his own work. In this regard, ASRL's collection went beyond information, data and original works, expanding—particularly in regard to the Readymades—beyond the works themselves, involving hardware catalogues and other literature that was able to provide necessary evidence in regard to popular culture and industrial objects. Thus, the collection came to resemble that of a pre-museum *wunderkammer*. Gould and Shearer developed their particular approach, taking Duchamp's notes into consideration, by examining his concept of Inframince and looking closely at his interviews, his reading of mathematician Henri Poincaré as well as scientific theories at the beginning of the twentieth century, in particular those regarding non-Euclidian

1 See Kornelia Röder, "Zur Marcel Duchamp-Rezeption in Mittel- und Osteuropa im Kontext des Netzwerks der Mail Art: An Interview with Serge Segay," *Tout-Fait: The Marcel Duchamp Studies Online Journal* 2003 (vol. 2, nr. 5) <www.toutfait.com/online_journal_details.php?postid=1525> (August 6, 2012), Thomas Girst, "Von Readymades und Asstricks," in Kornelia von Berswordt-Wallrabe, ed., *Marcel Duchamp. Die Schweriner Sammlung* (Ostfildern 2011), pp. 40–58; Thomas Girst, "Marcel Duchamp. Eine Hagiographie", in Antonia Napp and Kornelia Röder, eds., *Impuls Marcel Duchamp. Where do we go from here?* (Ostfildern-Ruit, 2011), pp. 40–58.
2 See Thomas Girst, "Intrusion in the Enchanter's Domain: An Inside View of Rhonda Scherer's Duchamp-based Art Science Research Laboratory, Inc.," *NY Arts* 4 (April 1999).

originalen Readymades als massenproduzierte Gegenstände nachzu-weisen,[3] eine Hypothese, die von Mitarbeitern des ASRL fasziniert wie kontrovers diskutiert wurde.

Seit Ende 1999 erschien hier das gemeinnützige *Tout-Fait: The Marcel Duchamp Studies Online Journal*, das der Autor in seiner Tätig-keit als Forschungsleiter des ASRL bis 2003 als Chefredakteur be-treuen durfte. Neben renommierten, internationalen Kunsthistorikern und -theoretikern wie Jean Clair, Arthur C. Danto und Sylvère Lotringer publizierten auch Duchamp-Experten wie André Gervais, Jean Suquet, Francis M. Naumann, Dieter Daniels, Robert Lebel, Hector Obalk, Tho-mas Zaunschirm, Craig Adcock, Kornelia Röder, Hans de Wolf, Timothy Shipe, Juan Antonio Ramirez und Lars Blunck zahlreiche Beiträge — zu-meist Erstveröffentlichungen in mehreren Sprachen. Vor allem Künstler wie William Anastasi, Ecke Bonk, Dove Bradshaw, Arakawa und Made-line Gins nutzten die multimediale Plattform für deren Gedanken zu Duchamp. Studierende konnten dort ebenso ihre Arbeiten publizieren, so diese den Redaktionsstandards hinsichtlich Inhalt und Form gerecht wurden. Hunderte von wertvollen Texten zu Marcel Duchamp sowie zahlreiche, schwer zugängliche Quellentexte wurden von *Tout-Fait* veröffentlicht. Wohlgemerkt zu einer Zeit, als wissenschaftliche Online-Artikel heftig kritisiert wurden, ganz zu schweigen von dem — Ende der 1990er-Jahre noch als Sakrileg empfundenen — Umstand, dass Beiträge führender Kunsthistoriker neben jenen von Studenten veröffentlicht wurden und man Texten, die per Mausklick auch Animationen und Filme zeigten, ohnehin jeden wissenschaftlichen Wert absprechen wollte. Die Redaktion ließ sich trotz anfänglich heftiger Kritik indes nicht von ihrem Glauben an die fortschrittliche partizipative Erscheinungsform von *Tout-Fait* abbringen. Es war schließlich Duchamp, der schon in sei-ner *Schachtel von 1914 (Boîte de 1914)* von »Elektrizität *en large*« als »einzig mögliche Verwendung von Elektrizität ›*dans les arts*‹«[4] sprach und bereits 1965 vollkommen richtig vorhersagte, man könne in der Zu-kunft »eine Kunstausstellung in Tokio sehen, indem man bloß auf einen Knopf drückt«.[5]

Der anfänglichen Querelen eingedenk, erreichte *Tout-Fait* in nur drei Jahren knapp 200.000 Leser weltweit — in der Frühzeit des Inter-nets eine beachtliche Leistung — und wurde von *BBC* wie *New York Times* empfohlen, von MITs Wissenschats- und Technologiemagazin *Leonardo* positiv besprochen sowie von der Internet Public Library der University of Michigan aufgenommen. Es war der 2005 verstorbene

3 Neben zahlreichen Publikationen zu diesem Thema in wissenschaftli-chen Magazinen wie *Nature*, *Science* und *Leonardo* fand 1999 ein seitens ASRL organisiertes, international re-nommiert besetztes Symposium an der Harvard Universität statt, das u. a. auch Goulds und Shearers Theorien untersuchte: »Methods of Understan-ding in Art and Science: The Case of Duchamp and Poincaré«, 5.–7.11.1999, Harvard University Science Center.
4 Serge Stauffer, *Marcel Duchamp. Die Schriften*, Zürich 1981, S. 22.
5 Interview mit Grace Glueck für die *New York Times* (14. Januar 1965), in: Serge Stauffer, *Marcel Duchamp: In-terviews und Statements*, Stuttgart 1992, S. 178.

geometry and speculations concerning the possibilities of the fourth dimension. These observations were then applied to a theory evolving around the possibility of the 'non-existence' of the Readymades as mass-produced objects[3]—most of them were lost and their originals can only be studied on photographs—a fascinating hypothesis leading to intensive debates and critique not only within ASRL.

From 1999 to 2003, as ASRL's research manager, this author also served as editor-in-chief of *Tout Fait: The Marcel Duchamp Studies Online Journal*. Along with renowned, international art historians and theoreticians such as Jean Clair, Arthur C. Danto and Sylvère Lotringer, major Duchamp scholars such as André Gervais, Jean Suquet, Francis M. Naumann, Dieter Daniels, Robert Lebel, Hector Obalk, Thomas Zaunschirm, Craig Adcock, Kornelia Röder, Hans de Wolf, Timothy Shipe, Juan Antonio Rameriz and Lars Blunk have contributed articles, which represent, for the most part, first-time publications in numerous languages. Many artists, amongst them William Anastasi, Ecke Bonk, Dove Bradshaw, Arakawa, and Madeline Gins have made use of this multimedia platform for their thoughts concerning Marcel Duchamp. Students studying Duchamp have also been able to publish their results as long as their thoughts and arguments proved coherent and original regarding both content and form. Hundreds of texts on and about Duchamp along with numerous otherwise hard-to-access original texts have been published in *Tout-Fait*. These publications came about at the end of the 1990s, at a time when systematic research initially put into circulation on the internet was still looked down upon. The fact that contributions by well-known art historians appeared side by side those by students was scorned, even more so that serious texts could be published which included the possibility of animations and films available via a single mouse-click. The editors refused to be intimidated by such criticism and persisted in their conviction that *Tout-Fait* remain open to public participation. It was Duchamp himself, after all, who had commented in his *Box of 1914 (Boîte de 1914)* on "electricity *en large*" as the "only possible means of utilizing electricity '*dans les arts*'"[4] and who rightly prophesied in 1965 that in the future one could "see an exhibition in Tokyo merely by pressing a button."[5]

Despite the initial furor, in a mere three years *Tout-Fait* had achieved a readership of 200,000—a considerable accomplishment in the early days of the internet—and was recommended by the *BBC* as well as the *New York Times*. It was reviewed positively by MIT's scien-

3 In addition to numerous publications on this theme in scientific magazines such as *Nature, Science* and *Leonardo*, a symposium organized by the ASRL with internationally recognized specialists was held at the Harvard University at which, amongst other themes, the theories of Gould and Shearer were investigated: *Methods of Understanding in Art and Science: The Case of Duchamp and Poincaré*, November 5–7, 1999, Harvard University Science Center.
4 Serge Stauffer, *Marcel Duchamp. Die Schriften* (Zurich, 1981), p. 22.
5 Interview with Grace Glueck for the *New York Times* (January 14, 1965) in Serge Stauffer, *Marcel Duchamp: Interviews and Statements* (Stuttgart, 1992), p. 178.

Kurator Harald Szeemann, der sich von seinen Mitarbeitern jede neue Online-Ausgabe von *Tout-Fait* komplett ausdrucken ließ, um diese zu Beginn des dritten Jahrtausends in seiner riesenhaften Bibliothek in Tegna im Tessiner Maggiatal ausgiebig studieren zu können.[6]

Die folgenden zwischen 1999 und 2007 entstandenen Texte wurden ausgewählt, um einen Eindruck von der Methodologie und der Forschungsansätze vieler von ganz unterschiedlichen Autoren in *Tout-Fait* veröffentlichter Beiträge zu vermitteln, die die Duchamp-Forschung bei aller Gravitas und Ernsthaftigkeit vor allem als fröhliche Wissenschaft vermitteln möchten. Neben unbändiger Neugier und einem unablässigen Hinterfragen vermeintlicher Fakten sind die Texte vom Wunsch unbedingter Zugänglichkeit getragen, die im Bestfall Duchamps komplexes Universum einem möglichst breiten Publikum eröffnet.

6 Besuch des Autors bei Harald Szeemann im Tessin am 1./2. Januar 2001.

tific and technological magazine *Leonardo* and was subscribed to by the Internet Public Library of the University of Michigan. The curator Harald Szeemann, who died in 2005, insisted that his colleagues print out each new online edition of *Tout-Fait*, so that the publication could be studied in depth at the beginning of this century in Szeemann's immense library in Tegna, in the Maggia Valley region of Tessin.[6]

The following texts, which were written between 1999 and 2007, have been selected so as to give an impression of the methodology and research approach of the various authors in *Tout-Fait*, all of whom were able to transmit their serious and in-depth research on Duchamp as a gay science, to speak in Nietzsche's terms, a philosopher Duchamp held in high esteem. Along with an unfettered curiosity and a relentless probing into facts that had been assumed axiomatic, these texts are characterized by their desire to be accessible to all who are interested, and at best will be able to open up Duchamp's complex universe to the widest public possible.

6 Visit of the author with Harald Szeemann in Tessin on January 1–2, 2001.

Transl. Harriett Watts

ELSIE ... VERZWEIFELT GESUCHT
AUTHENTIFIZIERUNG DER AUTHENTIZITÄT AUF DER RÜCKSEITE VON *L.H.O.O.Q.*

Jaques Caumont und Jennifer Gough-Cooper, Marcel Duchamps engagierteste Biografen, berichten uns, dass Duchamp am 22. Dezember 1944 in New York war und dort am Nachmittag dieses Tages Friedrich Kiesler zum Gespräch über eine in Kürze erscheinende Ausgabe des *View*-Magazins traf. Diese Ausgabe sollte ausschließlich Duchamp gewidmet sein. Nach diesem Treffen mit Kiesler telegrafierte Duchamp Walter Arensberg in Hollywood, um die Adresse eines Fotografen in Erfahrung zu bringen, der vor dem Zweiten Weltkrieg einige Aufnahmen von seinen Arbeiten gemacht hatte. Duchamp wollte in Zusammenarbeit mit *View* erneut Kontakt mit ihm aufnehmen.[1] In diesem Telegramm stand: »PLEASE WIRE ADDRESS OF MR LITTLE WHO PHOTOGRAPHED MY PICTURES SOME YEARS AGO STOP VIEW MAGAZINE PREPARDING [sic] DUCHAMP NUMBER WRITING=MARCEL DUCHAMP«.

Was von seinen Biografen nicht erwähnt wurde, sich aber am gleichen Tag zutrug: Duchamp hatte eine wichtige Erledigung zu machen.[2] Er bat Frau Elsie Jenriche darum, die Authentizität seines Rectified Readymade *L.H.O.O.Q.* zu bestätigen, das 1919, also 25 Jahre früher, entstanden war (Abb. 32). Wir kennen diese Bestätigung von einer Notiz auf der Rückseite des Readymades. Mit Tinte geschrieben heißt es (Abb. 33): »This is to certify / that this is the original / ›ready made‹ LHOOQ / Paris 1919 / Marcel Duchamp«. Darunter ebenfalls mit Tinte festgehalten: »Witnesseth: / This 22nd day of / December, 1944 / Elsie Jenriche«.

Ein Stempel rechts von Frau Jenriches Namen bestätigt, dass sie eine öffentliche Notarin war: »NOTARY PUBLIC, New York Co. / N.Y. Co. Clk. No. 63, Reg. No. 82J-3 / Commission expires March 30, 1945«. Doch können wir uns da wirklich sicher sein? Band A bis L des »Notaries Public N.Y. County Term Expires 1943« (archive #0394442) schließt alle Zweifel aus. Samt ihrem Berufstand »staatliche Gerichtsschreiberin« und ihrer Signatur ist Frau Jenriche dort eingetragen. Im Verzeich-

1 *Marcel Duchamp*, hrsg. von Pontus Hulten, Mailand 1993, o. S.
2 Ich bin Francis M. Naumann dankbar für den Hinweis, dass Duchamp vier Jahre, bevor er seinen ›Auftrag‹ erledigte, mit dem Gedanken spielte, *L.H.O.O.Q.* an Louise und Walter Arensberg zu verkaufen. In einem Brief vom 16. Juli 1940 schreibt Duchamp aus Arcachon in Frankreich: »Une autre chose dans la même genre est l'original de la Joconde aux moustaches (1919) / Pensez-vous que $100 soit trop pour la dite Joconde«. Es ist nicht bekannt, ob die Arensbergs die Arbeit tatsächlich erstanden haben. Arturo Schwarz führt in *The Complete Works of Marcel Duchamp*, Bd. 2, New York 1997, die Cordier & Ekstrom Galerie in New York und die Sammlerin Mary Sisler als Vorbesitzer von *L.H.O.O.Q.* an. Dem aktuellen Stand zufolge ist das Werk heute in einer privaten Sammlung in Paris. Bisher unbeachtet bleibt die Pierre Matisse Galerie in New York der, als »Matisse Gal.«, auf einem Etikett auf der Rückseite der Arbeit für die Leihgabe zur Wanderausstellung *The Art of Assemblage* des MoMA, die vom 10. Oktober bis 12. November 1961 in New York gezeigt wurde, gedankt wird.

DESPERATELY SEEKING ELSIE
AUTHENTICATING THE AUTHENTICITY
OF *L.H.O.O.Q.*'S BACK

Duchamp's most fervent biographers, Jacques Caumont and Jennifer Gough-Cooper, tell us that Marcel Duchamp was in New York City on December 22, 1944 and that, on this day, he met up with Frederick Kiesler in the afternoon for a discussion about a forthcoming issue of *View* magazine. This issue was going to be dedicated exclusively to Duchamp. After meeting with Kiesler, Duchamp cabled Walter Arensberg in Hollywood to inquire about the address of a photographer who had taken some pictures of Duchamp's work before World War II. Duchamp wanted to contact him again in connection with *View*.[1] The cable said, "PLEASE WIRE ADDRESS OF MR LITTLE WHO PHOTOGRAPHED MY PICTURES SOME YEARS AGO STOP VIEW MAGAZINE PREPARDING [sic] DUCHAMP NUMBER WRITING = MARCEL DUCHAMP."

Not noted by his biographers but also on that same day, Duchamp ran a very important errand.[2] He asked Ms. Elsie Jenriche to confirm the authenticity of his Rectified Readymade *L.H.O.O.Q.*, made twenty-five years earlier in 1919 (fig. 32). We know this from an inscription on the reverse side of the Readymade. It reads, in ink (fig. 33): "This is to certify / that this is the original / 'ready made' LHOOQ / Paris 1919 / Marcel Duchamp." Beneath this, also in ink, is a testimony: "Witnesseth: / This 22nd day of / December, 1944 / Elsie Jenriche."

A rubber stamp to the right of Ms. Jenriche's name declares that she was a notary: NOTARY PUBLIC, New York Co. / N. Y. Co. Clk. No. 63, Reg. No. 82J-3 / Commission expires March 30, 1945. But can we be sure of this? The 1943 A to L volume of Notaries Public N.Y. County Term Expires 1943 (archive #0394442), begins to eliminate doubt. Ms. Jenriche is listed, along with her profession 'public stenographer' and signature. Then, in the 1945 A to K volume of the Notaries Public N.Y. County Term Expires 1945 (archive #0394442), Elsie Jenriche is listed again, this time as a public stenographer at the Hotel St. Regis. The entry is dated March 17, 1943 with an expiration of March 30, 1945. This is precisely in accordance with the stamp on the back of *L.H.O.O.Q.*

1 Pontus Hulten, ed., *Marcel Duchamp*, (Mailand, 1993), n. p.
2 I am grateful to Francis M. Naumann for pointing out that four years prior to this 'errand,' Duchamp intended to sell *L.H.O.O.Q.* to Louise and Walter Arensberg. In a letter dated July 16, 1940, Duchamp writes from Arcachon, France: "Une autre chose dans la même genre est l'original de la Joconde aux moustaches (1919) / Pensez-vous que $100 soit trop pour la dite Joconde." The Arensbergs are not known to have acquired the work. Arturo Schwarz in his *The Complete Works of Marcel Duchamp*, vol. 2 (New York 1997) lists the Cordier & Ekstrom Gallery in New York and the collector Mary Sisler as previous owners of *L.H.O.O.Q.* As for its current status, it is now in a private collection in Paris. As yet unaccounted for is the Pierre Matisse Gallery, New York, which on a label on the work's verso is credited, as "Matisse Gal.," for loaning the work to the Museum of Modern Art's traveling exhibition, *The Art of Assemblage*, which was on display in New York from October 10 – November 12, 1961.

nis von 1945, Band A bis K des »Notaries Public N.Y. County Term Expires 1945« (archive #0394442), ist Elsie Jenriche dann als offizielle Stenografin des Hotels St. Regis aufgeführt. Datiert ist der Eintrag vom 17. März 1943 mit einer Gültigkeit bis zum 30. März 1945. Das stimmt exakt mit den Angaben des Stempels auf der Rückseite von *L.H.O.O.Q.* überein.

Fünfzig Jahre später. Am Donnerstag, den 29. April 1999, bestätigt der Archivar der Division of Old Records at New Yorks County's Surrogate Court Hall of Records Herr Jonathan van Nostren, dass Elsie Jenriches Unterschrift auf der Rückseite von *L.H.O.O.Q.* »authentic« ist, und fügt hinzu, dass »kein Zweifel besteht, dass das Werk ordnungsgemäß notariell beglaubigt wurde«.

Aus dem Englischen von Janina Wildfeuer

Der Beitrag wurde in englischer Sprache erstmals in: *Tout-Fait: The Marcel Duchamp Studies Online Journal,* Vol. 1, Ausgabe 1, 1999, veröffentlicht <www.toutfait.com/online_journal_details.php?postid=767> (20. August 2012).

Fast forward some fifty years. On Thursday, April 29, 1999, Mr. Jonathan van Nostren, archivist of the Division of Old Records at New York County's Surrogate Court Hall of Records, declared that Elsie Jenriche's signature on *L.H.O.O.Q.*'s verso is "authentic," adding that "there's no doubt that the work was properly notarized."

This article was first published in English in: *Tout-Fait: The Marcel Duchamp Studies Online Journal,* vol 1, issue 1, 1999, <www.toutfait.com/online_journal_details.php? postid=767> (August 20, 2012).

SCHÜSSE AUF DIE SCHEUNE

1942 soll Marcel Duchamp fünf Schüsse auf die Scheune seines Künstlerfreundes Kurt Seligmann in Sugar Loaf, New York, abgefeuert haben (Abb. 34). Kurz darauf wurde das Titelbild des Katalogs für die New Yorker Ausstellung *First Papers of Surrealism*, die von dem im Exil lebenden Gründer des Surrealismus André Breton organisiert wurde, genau an den Stellen durchlöchert, an denen Duchamps Kugeln die Steinmauer aus dem 19. Jahrhundert getroffen hatten (Abb. 35). Andere Löcher auf dem Cover sehen ähnlich aus, wurden aber nicht perforiert.

Man vermutet, dass Duchamp mit diesen Einschüssen auf die »Neun Schüsse der Junggesellen« im Bereich der »Braut« in *Die Braut von ihren Junggesellen entblößt, sogar / Das Große Glas (La Mariée mise à nu par ses célibataires, même / Le Grand verre,* 1915–1923) verweist, deren Position sich wiederum einer seiner zwischen 1911 und 1915 verfassten und in *Die Braut von ihren Junggesellen entblößt, sogar / Die Grüne Schachtel* (La Mariée mise à nu par ses célibataires, même / La Boîte verte, 1934) veröffentlichten Notizen zufolge zufällig ergab, indem er in frische Farbe getunkte Streichhölzer aus einer Spielzeugkanone abgefeuert hatte (Abb. 36).[1]

Fast sechzig Jahre später kann auch bei näherer Untersuchung die exakte Lage jenes Ausschnitts der Scheunenwand, der auf dem Titel von *First Papers of Surrealism* dargestellt ist, nicht länger auf der Oberfläche der verwitterten Mauer ausgemacht werden. Was den auf der Rückseite des Umschlages abgebildeten Käse betrifft (Abb. 37), so dauert die Diskussion an. Es handelt sich ganz sicher um einen Schweizer Käse[2] aus Seligmanns Geburtsland, aber ist es tatsächlich ein feiner Gruyère, wie Francis M. Naumann und Arturo Schwarz behaupten, oder einfach ein Emmentaler,[3] wie Stephan E. Hauser mutmaßt?

Eine letzte Begebenheit noch: Charles Shaughnessy zufolge, einem langjährigen Freund der Familie und Nachbar, wird das Kaliber .22-Gewehr, das Duchamp benutzte, als identisch mit jener Waffe angese-

1 Francis M. Naumann, *The Art of Making Art in the Age of Mechanical Reproduction*, Ghent, Amsterdam 1999, S. 151 (s. S. 150, 153).
2 Martica Sawin, *Surrealism in Exile and the Beginning of the New York School*, Cambridge 1995, S. 224 ff.
3 Stephan E. Hauser, *Kurt Seligmann (1900–1962): Leben und Werk*. Basel 1997, S. 221 ff.

SHOOTING BULLETS AT THE BARN

In 1942 Marcel Duchamp is said to have fired five shots at the base of artist-friend Kurt Seligmann's barn in Sugar Loaf, New York (fig. 34). Shortly thereafter, for the 1942 New York exhibition *First Papers of Surrealism*, organized by the exiled Surrealist leader André Breton, the cover of the catalogue was perforated where Duchamp's bullets hit the nineteenth century stone wall (fig. 35). Other holes on the cover look similar but remain without cut-through circles.

It has been suggested that by firing the bullets, Duchamp was referring to the "Nine Shots of the Bachelors" in the "Bride's" domain of *The Bride stripped Bare by Her Bachelors, Even / The Large Glass* (*La Mariée mise à nu par ses célibataires, même / Le Grand verre*, 1915–1923), whose location, according to one of his notes, written between 1911–15 and published in *The Bride stripped Bare by her Bachelors, Even / The Green Box* (*La Mariée mise à nu par ses célibataires, même / La Boîte verte*, 1934) was to be achieved by randomly firing matches dipped in fresh paint from a toy cannon (fig. 36).[1]

On close examination almost sixty years later, the exact location of the barn's detail depicted on the cover of *First Papers of Surrealism* can no longer be made out on the surface of the crumbling and weather-beaten wall. As for the cheese on the back of the cover, the debate still continues (fig. 37). It is definitely Swiss cheese,[2] from Seligmann's native country, but is it a refined Gruyère as Francis M. Naumann and Arturo Schwarz maintain or just Emmentaler, as Stephan E. Hauser[3] claims?

One final incidental: According to Charles Shaughnessy, a longtime family friend and neighbor, the .22 rifle Duchamp used is considered the same one that accidentally killed Seligmann twenty years later.

Addendum: On Wednesday, April 26, 2000, Bonnie Garner, Lester Lockwood and the author drove to the Seligmann homestead, 26 Oak Drive, Sugar Loaf, New York, to examine the barn. We'd like to thank Ms. Patricia Gilchrest, Executive Director of the Orange County Citizens

1 Francis M. Naumann, *The Art of Making Art in the Age of Mechanical Reproduction* (Ghent, Amsterdam 1999), p. 151. See also: p. 150, p 153.
2 Martica Sawin, *Surrealism in Exile and the Beginning of the New York School* (Cambridge, 1995), pp. 224–226.
3 Stephan E. Hauser, *Kurt Seligmann (1900–1962): Leben und Werk* (Basel, 1997), pp. 221–222.

hen, mit der Seligmann auf seiner Farm in Sugar Loaf bei einem Unfalltod zwanzig Jahre später verstarb.

Nachtrag: Am 26. April 2000 fuhren Bonnie Garner, Lester Lockwood und der Autor zu Seligmanns Gehöft in der Oak Drive 26, Sugar Loaf, New York, um die Scheune zu untersuchen. Wir möchten uns bei Frau Patricia Gilchrest, Geschäftsführerin der Orange County Citizens Foundation, und Herrn Charles ›Chuck‹ Shaughnessy für Ihre Gastfreundschaft bedanken. Außerdem danken wir Stephan E. Hauser für die Kontaktaufnahme.

Kurz nach dem Mitte 2000 erschienenen Beitrag *Schüsse auf die Scheune* publizierte Stephan E. Hauser gleichfalls in *Tout-Fait* den Text *Marcel Duchamp Chose Emmentaler Cheese*, in dem er den Käse auf der Umschlagseite von *First Papers of Surrealism* zweifelsfrei als Emmentaler definieren konnte. Der Schweizer Seligmann mag diesen seinen Gästen zudem auf seiner Farm serviert haben. Die Löcher des Emmentaler werden offiziell als Augen bezeichnet, was mit den »Okkulisten-Zeugen« in der unteren Hälfte des *Großen Glases* als auch mit den Gucklöchern in der Holztür seines Spätwerks *Étant donnés: 1° la chute d'eau, / 2. le gaz d'éclairage* (Gegeben sei: 1. Der Wasserfall / 2. Das Leuchtgas, 1946–1966) korrelieren mag.

Aus dem Englischen von Janina Wildfeuer

Der Beitrag wurde in englischer Sprache erstmals in: *Tout-Fait: The Marcel Duchamp Studies Online Journal*, Vol. 1, Ausgabe 2, 2000, veröffentlicht <www.toutfait.com/online_journal_details.php?postid=1194> (20. August 2012).

Foundation, and Mr. Charles "Chuck" Shaughnessy for their hospitality. We'd also like to thank Stephan E. Hauser for establishing the contact.

In his "Marcel Duchamp Chose Emmentaler Cheese," published within *Tout-Fait* shortly after "Shooting Bullets at the Barn" had appeared in mid-2000, Stephan E. Hauser could establish beyond a doubt that the cheese depicted on the cover of *First Papers of Surrealism* was indeed Emmentaler cheese. As a native of Switzerland, Seligmann might have served Emmentaler to guests visiting his farm. The holes of the Emmentaler are officially referred to as "eyes" which may correlate with the "Oculist Witnesses" in the lower half of Duchamps *Large Glass* as well as with the peepholes in the wooden door of his final work *Étant donnés: 1° la chute d'eau, / 2° le gaz d'éclairage* (Given: 1. The Waterfall, 2. The Illuminating Gas, 1946–1966).

This article was first published in English in: *Tout-Fait: The Marcel Duchamp Studies Online Journal* vol 1, issue 2, 2000 <www.toutfait.com/online_journal_details.php?postid=1194> (August 20, 2013).

Art Science Research Laboratory

NATURWISSENSCHAFT TRIFFT KUNST
THIS QUARTER UND JACOB BRONOWSKI

This Quarter wurde im September 1932 von Edward W. Titus heraus-
gegeben und veröffentlicht (Abb. 38). In seinem dritten Jahr als He-
rausgeber für The Black Manickin Press publizierte er außerdem die
Memoiren von Kiki de Montparnasse und Bücher von Anaïs Nin. Die
Surrealist Number von *This Quarter* umfasst Artikel, Prosa und Gedich-
te von berühmten Künstlern und Schriftstellern der Bewegung — unter
Ihnen Salvador Dalí, Paul Éluard, Max Ernst, René Crevel und Tristan
Tzara. Des Weiteren übersetzte Samuel Beckett einige Gedichte. In sei-
ner Herausgebernotiz beschreibt Edward W. Titus den gewaltigen Ein-
fluss des Surrealismus, stimmt aber beschämt der Unzufriedenheit des
Gastherausgebers André Breton zu, der gebeten wurde, »Politisches
und andere Dinge, die nicht in erklärtem Einklang mit den anglo-ameri-
kanischen Zensurmaßnahmen stünden«, zu unterlassen. Zwei Jahre vor
der Herausgabe von *Die Braut von ihren Junggesellen entblößt, sogar /
Die Grüne Schachtel (La Mariée mise à nu par ses célibataires, même /
La Boîte verte*, Abb. 8) im Jahre 1934 tauchen in dieser Ausgabe erst-
mals einige unveröffentlichte Notizen Duchamps auf. Interessanter-
weise wird in diesen ausgewählten Notizen bereits mehrfach der Titel
von Duchamps posthum veröffentlichten Werk erwähnt: *Étant donnés:
1° la chute d'eau, / 2° le gaz d'éclairage* (Gegeben sei: 1. Der Wasserfall /
2. Das Leuchtgas, 1946–1966, Abb. 14, 15).

 This Quarter veröffentlichte diese von J. Bronowski ins Englische
übersetzten Notizen mit einem Vorwort von André Breton (Abb. 39).
Neben der längeren Notiz »Preface« und »Algebraic Comparison« ent-
hielt *This Quarter* Duchamps Überlegungen zu den »Malic Moulds«
(»männische Gussformen«) und den »Draft Pistons« (»Durchzugskol-
ben«). Erstere sind ein wesentlicher Bestandteil der unteren Hälfte von
*Die Braut von ihren Junggesellen entblößt, sogar / Das Große Glas (La
Mariée mise à nu par ses célibataires, même / Le Grand verre*, 1915–1923,
Abb. 4), dem Bereich der »Junggesellen«, letztere sind Teil der oberen
Hälfte, dem Bereich der »Braut«.

This Quarter of September 1932 was published and edited by Edward W. Titus (fig. 38). In his third year as editor for the The Black Manickin Press, he also published the memoirs of Kiki de Montparnasse and books by Anaïs Nin. *This Quarter's Surrealist Number* contains articles, prose and poems by important artists and writers of the movement, among them Salvador Dalí, Paul Éluard, Max Ernst, René Crevel and Tristan Tzara. Samuel Beckett also translated some of the poems. In his editorial note, Edward W. Titus describes the tremendous impact of Surrealism, however acknowledging with embarrassment the unhappiness of guest editor André Breton at having been asked to leave out "politics and such other issues not be[ing] in honeyed accord with Anglo-American censorship usages." It is in this issue that for the first time ever, various unpublished notes by Duchamp appear, two years prior to the publication of *The Bride stripped Bare by her Bachelors, Even / The Green Box (La Mariée mise à nu par ses célibataires, même / La Boîte verte*, fig. 8) in 1934. Curiously enough, the chosen notes include various mentions of the title of Duchamp's posthumously revealed work *Étant donnés: 1° la chute d'eau, / 2° le gaz d'éclairage* (Given: 1. The Waterfall, 2. The Illuminating Gas, 1946–1966, figs. 14, 15).

With a preface by André Breton, *This Quarter* published these notes in English, translated by J. Bronowski (fig. 39). Besides a longer note titled "Preface" and an "Algebraic Comparison," *This Quarter* contained Duchamp's thoughts on the "Malic Moulds" and the "Draft Pistons," the former being an integral part of the lower half of *The Bride stripped Bare by Her Bachelors, Even / The Large Glass (La Mariée mise à nu par ses célibataires, même / Le Grand verre*, 1915–1923), the domain of the "Bachelors," and the latter being essential components of the upper half, the domain of the "Bride."

In his preface, André Breton (who published three of the same notes in the fifth issue of *Surréalisme au Service de la Révolution*, May 1933)[1] calls the notes an abstract "from a large, unpublished collection

1 Francis M. Naumann, *The Art of Making Art in the Age of Mechanical Reproduction* (Ghent, Amsterdam, 1999), p. 112.

In seinem Vorwort bezeichnete André Breton – der drei dieser Notizen im Mai 1933 in der fünften Ausgabe der *Surréalisme au Service de la Révolution*[1] veröffentlichte – Duchamps Aufzeichnungen als einen Auszug »aus einer umfangreichen, unveröffentlichten Sammlung […] vorgesehen als erklärender Begleittext (wie es sich für einen vorbildlichen Ausstellungskatalog gehört) für das ›verre‹ (Malerei auf durchsichtigem Glas), bekannt als ›Die Braut von ihren Junggesellen entblößt, sogar‹«. Darüber hinaus erklärt er, dass dieser Auszug »von beachtlichem dokumentarischen Wert für die Surrealisten ist«.

Richard Hamilton, der 1960 eine typografische Version der *Grünen Schachtel* veröffentlichte (Abb. 40, 41), war in mehrfacher Hinsicht unzufrieden mit J. Bronowskis Übersetzung und der grafischen Gestaltung der Aufzeichnungen: »Im Layout wird nicht deutlich, dass ›This Quarter‹ Übertragungen ins Englische von vier einzelnen Notizen darstellt. So hatte der Übersetzer Schwierigkeiten, die visuelle Komplexität des Manuskriptes umzusetzen«. Auf gedruckten Text begrenzt, »muss Bronowskis Ausschnitt […] selektiv sein«.[2]

WER WAR J. BRONOWSKI?[3]

Jacob Bronowski wurde 1908 in Lodz, Polen, geboren. Im Ersten Weltkrieg flüchtete seine Familie nach London. Dort wurde Bronowski, der auf einem speziellen Gebiet der algebraischen Geometrie forschte, mit einem Mathematikstipendium in Cambridge ausgezeichnet. Zwischen 1929 und 1942 veröffentlichte er seine Arbeiten mit Titeln wie *The Figure of Six Points in Space of Four Dimensions* (1942) in den *Cambridge Philosophical Society Proceedings* und in anderen Fachzeitschriften. Während des Zweiten Weltkriegs leitete er aufgrund seiner Ausbildung als Mathematiker die Entwicklung der Operational Research Units für das British Ministry of Home Security und die Joint Target Group in Washington. Als Leiter der Chiefs of Staff Mission wurde er als einer der Ersten zur Überwachung der durch die Atombombe verursachten Schäden nach Nagasaki versetzt. Das war seiner Ehefrau Rita Bronowski zufolge »der große Wendepunkt in Brunos [gemeint ist ihr Ehemann] Leben«.[4] In seinen drei Vorlesungen, die er 1953 am Massachusetts Institute of Technology hielt, forderte er eine verantwortungsvolle Kombination aus humanistischen Werten und wissenschaftlicher Forschung. Anstatt nach dem Zweiten Weltkrieg wieder an

1 Francis M. Naumann *The Art of Making Art in the Age of Mechanical Reproduction*, Ghent, Amsterdam 1999, S. 112.
2 Richard Hamilton, *Collected Words*, London 1982, S. 184 ff.
3 Die Informationen und Zitate in den folgenden Absätzen sind entnommen aus: Rita Bronowski, »Bruno: A Personal View,« in: *Leonardo* 18, 4, 1985, S. 223 ff., und aus einem Telefongespräch mit Rita Bronowski vom 4. April 2000.
4 Alle Zitate von Rita Bronowski aus der Aufzeichnung eines Telefongesprächs vom 4. April 2000.

... intended to accompany and explain (as might an ideal exhibition catalogue) the 'verre' (painting on clear glass) known as 'The Bride Stripped Bare By Her Own Bachelors.'" He goes on to maintain that the extract "is of considerable documentary value to Surrealists."

Richard Hamilton, who in 1960 published a typographic version of *The Green Box* (figs. 40, 41) was somewhat dissatisfied with J. Bronowski's first translation of and graphic attempt at the notes. "'This Quarter' gives translations of four separate notes though the layout does not make this clear. The translator has been at some pains to transpose the visual complication of the manuscript." Limited to printed text, "Bronowski's extract ... must be selective."[2]

BUT WHO WAS J. BRONOWSKI?[3]

Jacob Bronowski was born in Lodz, Poland, in 1908. Fleeing World War I, his family moved to London, where Bronowski eventually won a math scholarship to Cambridge, working in a specialized area of algebraic geometry. Between 1929 and 1942 he published his papers, bearing titles like "The Figure of Six Points in Space of Four Dimensions" (1942), in the Cambridge Philosophical Society Proceedings and other learned journals. During World War II, due to his mathematical training, he led the development of the Operational Research Units for both the British Ministry of Home Security and the Joint Target Group in Washington. As head of the Chiefs of Staff Mission, he was among the first to be sent to Nagasaki to survey the damage of the atomic bomb. According to his wife, Rita Bronowski, "this was the great turning point in Bruno's [as she refers to her late husband] life."[4] His three lectures given at the Massachusetts Institute of Technology in 1953 called for a responsible combination of humanistic values and scientific endeavors. After World War II he did not return to his university job but started a research laboratory for the British National Coal Board. "An early environmentalist and ecologist, he invented and developed a new kind of smokeless fuel from coal," his wife noted. In 1963 Bronowski returned to teaching, at the Salk Institute of Biological Studies in California. His lifetime interest in cultural and anthropological evolution culminated in a highly popular thirteen-hour television series called "The Ascent of Man."

Bronowski died in 1974, leaving behind numerous popular books like *Science and Human Values* (1956) and a groundbreaking study of

2 Richard Hamilton, *Collected Words* (London 1982), pp. 184–186.
3 The information and quotations of this and the following paragraphs come from Rita Bronowski, "Bruno: A Personal View," *Leonardo* 18 (April 4, 1985), pp. 223–225, and a telephone conversation with Ms. Bronowski, April 4, 2000.
4 All quotes from Rita Bronowski from the transcript of a telephone conversation of April 4, 2000.

die Universität zurückzukehren, richtete er ein Forschungslabor für das British National Coal Board ein. »Frühzeitiger Umweltschützer und Ökologe, der er war, erfand und entwickelte er eine Art rauchfreien Kohlebrennstoff«, merkte seine Frau an. 1963 nimmt Bronowski seine Lehrtätigkeit wieder auf und beginnt, am Salk Institute of Biological Studies in Kalifornien zu unterrichten. Sein lebenslanges Interesse an der kulturellen und anthropologischen Entwicklungsgeschichte erreichte ihren Höhepunkt in der Mitwirkung an der berühmten 13-stündigen Fernsehserie *The Ascent of Man*.

Als Bronowski im Jahre 1974 starb, hinterließ er eine große Anzahl bekannter Bücher. Darunter *Science and Human Values* (1956) sowie eine bahnbrechende Studie über William Blake: *William Blake: A Man Without a Mask* (1944). Sein Leben lang hegte Jacob Bronowski großes Interesse für Literatur und noch bevor er seinen akademischen Grad erworben hatte, begründete er das Avantgarde-Magazin *Experiment*. Hier kann man die frühesten Schriften von William Empson, Paul Eluard, W. H. Auden und vieler anderer finden. Rita Bronowski erinnert sich: »Nachdem er seinen Doktortitel erworben und drei Jahre Forschungstätigkeit hinter sich hatte, wurde ziemlich schnell klar, dass Bruno sich als Jude keine Hoffnungen zu machen brauchte, je als Mitarbeiter an seinem College (Jesus College, Cambridge) angestellt zu werden. So entschied er sich ›aufzugeben‹, um wie viele junge Studenten — bärtig und mittellos (wie 30 Jahre später die Hippies) — zum Schreiben nach Paris zu gehen. Dort lernte er unter anderem Samuel Beckett kennen, und gemeinsam veröffentlichten sie 1931 die Anthologie ›European Caravan‹«. In Paris stieß er dann auf die Surrealisten und zusammen mit Beckett half er die *Surrealismus-Ausgabe* von *This Quarter* zu übersetzen. Rita Bronowski zufolge hatte man ihren Ehemann für die Übersetzung von Duchamps Notizen ausgewählt, weil er nicht nur Dichter, sondern vor allem auch ausgebildeter Wissenschaftler war.

Bronowski, sein ganzes Leben lang ein Lyriker, schrieb einst: »Das große Gedicht und das tiefgründige Theorem sind neu für jeden Leser und sind, weil er sie selbst wiedererschafft, dennoch seine eigenen Erfahrungen. Sie markieren die Einheit der Vielfalt und in jenem Moment, da der Verstand sie als Kunst oder Wissenschaft begreift, beginnt das Herz höher zu schlagen«.[5]

1939 schrieb Bronowski das bisher unveröffentlichte und im Folgenden abgedruckte Gedicht über den Tod des österreichischen Satirikers Karl Kraus:[6]

5 Jacob Bronowski, *Science and Human Values (bound with the Abacus and the Rose: a New Dialogue on Two World Systems)*, New York 1960, S. 32.
6 Karl Kraus (1874–1936), war in einer Zeit ökonomischer, sozialer und politischer Umbrüche in Österreich Satiriker, Herausgeber, Dichter, Essayist und Theaterautor aus Wien. Als Mitglied des Café Bohème richtete er seinen bitteren Sarkasmus auf Menschen (einschließlich seines eigenen sozialen Umfelds), Ereignisse und Täuschungen der politischen und sozialen Grundlagen Wiens um die Jahrhundertwende. Als Sohn eines erfolgreichen Geschäftsmannes war er finanziell abgesichert durch seine Familie, was es ihm ermöglichte, sechs Jahre an der Universität Wien (ab 1892) zu studieren. Nach zwei Jahren Jurastudium wechselte er ins Philosophie- und Germanistikstudium. Kurz nachdem er die Universität im April 1899 (ohne einen Abschluss) verließ, begann er mit der scharfzüngigen Zeitschrift *Die Fackel*, die bis vier Monate vor seinem Tod Bestand hatte. Kraus renommiertestes Stück war *Die letzten Tage der Menschheit*, geschrieben zwischen 1915 und 1917. Unter seinen zahlreichen Essays sind *Die Demolierte Literatur* sowie *Sittlichkeit und Kriminalität* zu finden.

William Blake (*William Blake: A Man Without a Mask*, 1944). Jacob Bronowski had a lifelong interest in literature. While still an undergraduate he started a small avant-garde magazine called *Experiment*. There one can find the earliest writings of William Empson, Paul Éluard, W. H. Auden and many more. Rita Bronowski remembers that after receiving his Ph.D. and conducting three years of research, it became clear that being a Jew, Bruno would not be made a Fellow at his college (Jesus College, Cambridge). He decided to 'drop out.' Like so many young students (hippies, thirty years later), bearded and down-at-heel, he went to Paris to write. There he met, among others, Samuel Beckett, and they jointly edited an anthology called *European Caravan* (1931).

It was in Paris that Bronowski bumped into the Surrealists and together with Beckett, he helped translate the *Surrealist Number* of *This Quarter*. According to Rita Bronowski, her husband was picked to translate Duchamp's notes since he was not only a poet but, most of all, a trained scientist.

A poet all his life, Bronowski once wrote: "The great poem and the deep theorem are new to every reader and yet are his own experience because he recreates them. They are the marks of unity in variety and in the instant when the mind seizes this for itself in art or science, the heart misses a beat."[5] In 1939, Jacob Bronowski wrote the following and previously unpublished poem on the death of the Austrian satirist Karl Kraus[6]:

The Death of Karl Kraus

Kraus died in time: before the God
he honored as his equal, who shot
Lorca, and brutally smashed
Mühsam's delicate ears, washed
Vienna with his cleaning squads.
Now becomes God the anger which
Kraus spilled upon the dunged and rich
ferment Vienna. God also saw
the Danube spawn this medlar culture,
and plunged to drain it like a ditch.
Would Kraus to-night think it given
him as a grace, if he were driven
by boors to clean latrines? Or would

5 Jacob Bronowski, *Science and Human Values* (bound with *The Abacus and the Rose: A New Dialogue on Two World Systems*) (New York, 1960), p. 32.

6 Karl Kraus (1874–1936) was a satirist, publisher, poet, essayist, and playwright in Vienna during a time of economic, social and political change in Austria. A member of the café bohemia, Kraus focused his acerbic sarcasm on people (including his own social set), events, and the fallacies of political and social elements of turn-of-the-century Vienna. The son of a successful businessman, Kraus was financially supported by his family, which allowed him to spend six years at the University of Vienna (starting in 1892), studying law for two years before switching to philosophy and German studies. In April 1899, shortly after he left the University (without attaining a degree), he started the stinging journal *Die Fackel (The Torch)*, which remained in existence until four months before his death. Kraus's most noted play was Die *letzten Tage der Menschheit (The Last Days of Mankind)*, written between 1915 and 1917, and among his many essays are "Die Demolierte Literatur" ("The Demolished Literature") and "Sittlichkeit und Kriminalität" ("Morality and Criminality").

The Death of Karl Kraus

Kraus died in time: before the God
he honored as his equal, who shot
Lorca, and brutally smashed
Mühsam's delicate ears, washed
Vienna with his cleaning squads.
Now becomes God the anger which
Kraus spilled upon the dunged and rich
ferment Vienna. God also saw
the Danube spawn this medlar culture,
and plunged to drain it like a ditch.
Would Kraus to-night think it given
him as a grace, if he were driven
by boors to clean latrines? Or would
that bitter Jew pray for his God's
forgiveness, but would not forgive?
O yes, the age which he disowned
was easy, ageing, overblown.
Kraus prayed an age sharp as day
might etch his eyes: who, had he stayed,
would see an age like night come down,
and sharp and savagely blind
the poet's eyes, and splash his mind
bloody from a knacker's wall.
Hate and terror walk the malls.
Below the city, torture mines
the cellars. O Mühsam, Lorca,
I call to you across the dark
age, ere my voice too is dumb.
Give courage when the headsmen come.
Give to the desecrated God
who Kraus unleashed, once more his manhood.
Give light where only ghosts, your ghosts are.

Der Beitrag wurde in englischer Sprache erstmals in: *Tout-Fait: The Marcel Duchamp Studies Online Journal* Vol. 1, Ausgabe 2, 2000, veröffentlicht <www.toutfait.com/online_journal_details.php?postid=1143> (20.8.2012) und war Teil eines Vortrags anlässlich des »Study Day at the Tate Gallery on Duchamp's Large Glass«, London, 24.5.2003. Aus dem Englischen von Janina Wildfeuer

that bitter Jew pray for his God's
forgiveness, but would not forgive?
O yes, the age which he disowned
was easy, ageing, overblown.
Kraus prayed an age sharp as day
might etch his eyes: who, had he stayed,
would see an age like night come down,
and sharp and savagely blind
the poet's eyes, and splash his mind
bloody from a knacker's wall.
Hate and terror walk the malls.
Below the city, torture mines
the cellars. O Mühsam, Lorca,
I call to you across the dark
age, ere my voice too is dumb.
Give courage when the headsmen come.
Give to the desecrated God
who Kraus unleashed, once more his manhood.
Give light where only ghosts, your ghosts are.

This article was first published in English in: *Tout-Fait: The Marcel Duchamp Studies Online Journal* vol 1, issue 2, 2000, <www.toutfait.com/online_journal_details.php? postid=1143> (August 20, 2013) and was part of a lecture held on the occasion of the "Study Day at the Tate Gallery on Duchamp's Large Glass," London, May 24, 2003.

FOUNTAIN AVANT LA LETTRE

In seinem bisher unveröffentlichten Artikel »Duchamp's New Leap« über Duchamps *Étant donnés: 1° la chute d'eau, / 2° le gaz d'éclairage* (Gegeben sei: 1. Der Wasserfall / 2. Das Leuchtgas, 1946–1966), sein Konzept des Inframince und seine Readymades lenkt Juan José Gurrola unsere Aufmerksamkeit auf ein Zitat aus einem Brief vom 9. Mai 1768 von Madame du Deffand an die Duchesse de Choiseul, das auch von Norbert Elias in dessen 1939 erschienenen Werk *Über den Prozess der Zivilisation* erwähnt wird.[1] Wir erachten es in Bezug auf Duchamps Urinal *Fountain* (1917) als derart unterhaltsam, das wir es unseren Lesern nicht vorenthalten wollen (Abb. 5, 42):

»Je voudrais, chère grand'maman, venir peindre, ainsi qu'au grand-abbé, quelle fut ma surprise, quand hier matin on m'apporta, sur mon lit, un grand sac de votre part. Je me hâte de l'ouvrir, j'y fourre la main, j'y trouve des petits pois […] et puis un vase. […] je le tire bien vite: c'est un pot de chambre! […] mais d'une beauté, d'une magnificence […] que mes gens, tout d'une voix, disent qu'il en fallait faire une saucière. […] Le pot de chambre a été en représentation hier toute la soirée, et fit l'admiration de tout le monde. Les pois […] furent mangés sans qu'il en restât un seul.«

»Mit Vergnügen sollte ich Dir, liebe Großmutter, so wie schon dem Abt, berichten, wie groß meine Überraschung war, als mir gestern Morgen eine große Tasche von Dir ans Bett gebracht wurde. Ich eilte diese zu öffnen, steckte meine Hand hinein und fand einige grüne Erbsen und dann eine Vase, die ich schnell herausholte: ein Nachttopf! Aber von solcher Schönheit und Pracht, dass meine Leute übereinstimmend sagten, dass sie als Soßenschüssel gedacht sein müsse. Der Nachttopf war den ganzen gestrigen Abend im Gespräch und wurde von jedermann bewundert. Die Erbsen aufgegessen […] bis keine mehr übrig war.«

Der Beitrag wurde in englischer Sprache erstmals in: *Tout-Fait: The Marcel Duchamp Studies Online Journal* Vol. 1, Ausg. 1, 1999, veröffentlicht <www.toutfait.com/online_journal_details.php?postid=775> (20.8.2012). Aus dem Englischen v. Janina Wildfeuer

1 *Correspondence complète de Mme. du Defand avec la Duchesse de Choiseul, l'Abbé Barthélemy et M. Craufurt*, hrsg. von M. le Mis. de Saint-Aulaire, Paris 1866, S. 160 f.; s. Norbert Elias, *Über den Prozess der Zivilisation*, Bd. 1, Frankfurt 1997, S. 272. Der Brief dient Elias als Beispiel für den *Wandel in der Einstellung zu den natürlichen Bedürfnissen.*

FOUNTAIN AVANT LA LETTRE

In his as yet unpublished article "Duchamp's New Leap," on Duchamp's *Étant donnés: 1° la chute d'eau, / 2° le gaz d'éclairage* (Given: 1. The Waterfall, 2. The Illuminating Gas, 1946–1966), the Inframince (infrathin) and the Readymades, Juan José Gurrola draws our attention to the following quotation in a letter of May 9, 1768 from Madame du Deffan to the Duchess de Choiseul which was also cited in Norbert Elias's *The Civilizing Process* of 1939.[1] In regard to Duchamp's urinal *Fountain* (1917) we thought it too amusing not to share with our readers (figs. 5, 42):

> Je voudrais, chère grand'maman, venir peindre, ainsi qu'au grand-abbé, quelle fut ma surprise, quand hier matin on m'apporta, sur mon lit, un grand sac de votre part. Je me hâte de l'ouvrir, j'y fourre la main, j'y trouve des petits pois ... et puis un vase..... je le tire bien vite: c'est un pot de chambre!.... mais d'une beauté, d'une magnificence ... que mes gens, tout d'une voix, disent qu'il en fallait faire une saucière.... Le pot de chambre a été en représentation hier toute la soirée, et fit l'admiration de tout le monde. Les pois ... furent mangés sans qu'il en restât un seul.

> I should like to tell you, dear grandmother, as I already told the Grand Abbé, how great was my surprise when a large bag from you was brought to me at my bed yesterday morning. I hastened to open it, put it in my hand and found some green peas and then a vase that I quickly pulled out: it is a chamber pot! But of such beauty and magnificence, that my people said in unison that it ought to be used as a gravy boat. The chamber pot was on display the whole of yesterday evening and was admired by everyone. The peas were eaten till not one was left.

1 M. le Mis. de Saint-Aulaire, ed., *Correspondence complète de Mme. du Defand avec la Duchesse de Choiseul, l'Abbé Barthélemy et M. Craufurt* (Paris, 1866), pp. 160–161; also see Norbert Elias, *The Civilizing Process* (New York, 1978), pp. 133–134, p. 279. The letter serves as an example for our changes in attitude toward the natural functions.

This article was first published in English in: *Tout-Fait: The Marcel Duchamp Studies Online Journal* vol 1, issue 1, 1999, <www.toutfait.com/online_journal_details.php?postid=775> (August 20, 2012).

DADADADADA

Das Werkverzeichnis von Marcel Duchamp (1887–1968) führt unter der Nummer 543 den Titel *Design für »Dada: 1916–1923«* (Abb. 43) auf.[1] Gemeint ist der Posterentwurf von 1953 für die umfassende Dada-Ausstellung der Sidney Janis Gallery, New York. Seit langem gilt das Plakat (96,5 cm × 63,5 cm) als Meilenstein typografischer Gestaltung, das gerne in Designbüchern reproduziert und dessen Bedeutung von Ikonen des Fachs wie Milton Glaser hervorgehoben wird. Als Sidney Janis — Buchautor, Geschäftsmann, Berater des Museum of Modern Art — eine Dada-Ausstellung mit 212 Exponaten organisiert, ist diese Werkschau knapp 30 Jahre nach dem Ende Dadas der Beginn der Rezeption dieser Kunstbewegung, die bis dato nahezu keinerlei Niederschlag in der Öffentlichkeit oder der Kunstgeschichtsschreibung gefunden hatte. Gibt es 2006 in New York knapp 1 000 Galerien, die sich auf zeitgenössische Kunst konzentrierten, so waren es Anfang der 1950er-Jahre nur eine Handvoll. Und mit Künstlern wie Mark Rothko, Clyfford Still und Jackson Pollock vertrat Janis sehr früh eine amerikanische Avantgarde, die über die Jahrzehnte immer mehr an Bedeutung gewinnen sollte. Sidney Janis bewunderte Marcel Duchamp und holte oft dessen Rat ein, wenn es um Ausstellungen oder Künstler ging. Als die Dadaisten Richard Huelsenbeck und Hans Richter vor der Eröffnung von *Dada 1916–1923* die Exponate neu arrangierten, ficht das Duchamp nicht an: »Marcel hatte eine Art innerer Selbstsicherheit, die ich nur von Mondrian her kannte. Marcel und Mondrian schätzten Dinge, die verschieden von dem waren, was sie selber taten. Sie mussten nicht die ganze Zeit ihren eigenen Standpunkt verteidigen«.[2] Für Duchamp gab es ohnehin keine Lösungen, weil es keine Probleme gab — um eines seiner Bonmots zu paraphrasieren. Als Kurator stellte sich Duchamp nicht zwischen Werk und Betrachter, sondern ließ die Künstler selbst sprechen. Der Kunsthistoriker und Dada-Experte Francis M. Naumann nennt das Poster »eines der gelungensten und optisch ansprechendsten ›Images‹ in der Geschichte der Grafikkunst des 20. Jahrhunderts«.[3]

1 Arturo Schwarz, *The Complete Works of Marcel Duchamp*, New York 2000, S. 801.
2 Calvin Tomkins, *Duchamp. A Biography*, New York 1996, S. 378.
3 Francis M. Naumann, *The Art of Making Art in the Age of Mechanical Reproduction*, New York 1999, S. 179.

DADADADADA

In the catalogue raisonné of Marcel Duchamp (1887-1968), *Design for 'Dada: 1918-1923'* (fig. 43) is listed under number 543.[1] It is the design for a poster created in 1953 for the Dada exhibition of the Sidney Janis Gallery, New York. For years the poster (96.5 × 63.5 cm) has been regarded as a milestone of typographical design, often reproduced in books on the subject. Its significance has been emphasized by icons of the discipline such as Milton Glaser. When Sidney Janis—author businessman and advisor to the Museum of Modern Art—organized a Dada exhibition of 212 objects, this show marked the beginning of the reception of this art movement roughly thirty years after its end, a movement which up to this point had been accorded little significance in public reception or in the written accounts of art history. With approximately 1.000 galleries focused on contemporary art in New York in 2006, it was only a handful of galleries at the beginning of the 1950s. With artists such as Mark Rothko, Clyfford Still and Jackson Pollock, Janis represented part of the American avant garde which was to gain ever more importance over the following decades. He was also an admirer of Marcel Duchamp and often asked for his advice in matters concerning artists or exhibitions. When the Dadaists Richard Huelsenbeck and Hans Richter rearranged the exhibition objects before the opening of *Dada 1916-1923*, Duchamp raised no protest. "Marcel had that inner confidence that I have observed in only one other painter, Mondrian. Both Marcel and Mondrian liked things that were different from what they were doing. They didn't have to protect their own point of view all the time."[2] In any case, for Duchamp there were no problems to begin with, as there were no solutions—to paraphrase one of his favorite sayings. As a curator, Duchamp did not place himself between the work and the observer, but rather allowed the artist to speak for himself. The art historian and Dada expert Francis M. Naumann has called the poster "one of the most efficient and visually arresting images created in the entire history of 20th-century graphic design."[3]

1 Arturo Schwarz, *The Complete Works of Marcel Duchamp* (New York, 2000), p. 801.
2 Calvin Tomkins, *Duchamp: A Biography* (New York, 1996), p. 378.
3 Francis M. Naumann, *The Art of Making Art in the Age of Mechanical Reproduction* (New York, 1999), p. 179.

ADADADADADADADADADADADADADADADADADADADA

ZURICH

1 JEAN ARP Formes Terrestres, Forêt, 1916-17, embroidery, 21×22

2 JEAN ARP Formes Terrestres, 1916, wood relief, 26×20"

3 JEAN ARP Construction Elementaire selon les Droits du Hasard, 1918, collage, 16×13

4 JEAN ARP Composition Horizontale-Verticale, 1917, embroidery, 23×17

5 JEAN ARP Etamines et Courbes, 1915, collage, 16×11

6 JEAN ARP Formes Terrestres, Forêt, 1917, relief, 34×24

7 VIKING EGGELING Principle to the Problem of Counterpoint, 1917, 2-sided drawing, 40×28

8 VIKING EGGELING Diagonal Symphony, 1920, series of drawings, 9×8

9 RICHARD HUELSENBECK Phantastische Gebete, ...

10 RICHARD HUELSENBECK Phantastische Gebete, 1921, poems illustrated by Grosz (Berlin)

11 RICHARD HUELSENBECK Dadaco, 1922, manifesto, layout by Heartfield (Berlin)

12 RICHARD HUELSENBECK En Avant Dada, 1920, pamphlet.

13 RICHARD HUELSENBECK Schalaban, Schalomai, Schalamezomai, ... poems (Steegemann Hannover) 1920.

14 MARCEL JANCO Mann sur ..., Paris, ...

15 MARCEL JANCO Balance, 1917, plaster on burlap.

16 MARCEL JANCO Soleil Jardin Caté..., ...

17 HANS RICHTER Figure, 1917, drawing on scroll, 38×112

18 HANS RICHTER Head, 1917, oil, 18×14"

19 HANS RICHTER Variations, 1918-19, series of drawings.

20 HANS RICHTER Rhythm, 1921, photostat of film strip, 24×3

21 SOPHIE TAEUBER-ARP Horizontale-Verticale, No. 1, 1916, crayon, 13½×11½

22 SOPHIE TAEUBER-ARP Horizontale-Verticale, No. 2, 1916, crayon, 13½×11½

23 SOPHIE TAEUBER-ARP Triptyche, No. 2, 1918, oil, 44×20

24 SOPHIE TAEUBER-ARP König Hirsch, 1917-18, 4 scenes from ... play, photos.

25 Der Zeltweg, 1919, magazine photostat.

26 Cabaret Voltaire, 1916, magazine.

27 Dada 2, 1917, magazine.

28 Dada 3, 1918, ed. de luxe. No. 6.

29 391 No. 8, 1919, magazine.

30 Anthologie Dada, 1919, ed. de luxe No. 20, publication.

31 Couverture La Première Aventure, Céleste de M' Antipyrine, 1916, book jacket.

32 Dada Soirée 8, 1919, poster.

33 Première Exposition Dada, Galerie Corray, 1917, throwaway.

34 CHRISTIAN SCHAD 7 Schadographs, 1918.

35 Photos of original Zurich Dadaists Arp, Ball, Eggeling, Hennings, Huelsenbeck, Janco, Richter, Serner, Taeuber-Arp, Tzara.

HANNOVER

63 KURT SCHWITTERS Das Fruehlingsbild, Merz 208, 1920, oil and collage, 37×30

64 KURT SCHWITTERS Bild mit Roten Kreuz, Merz 1B, 1919, oil and collage, 26×21

65 KURT SCHWITTERS Oval Painting, Merz 13, 1919, oil and collage, 16½×12

66 KURT SCHWITTERS Merz 30b, 1921, collage.

67 KURT SCHWITTERS Grosses S, Merz 265, 1921, collage, 7×6

68 KURT SCHWITTERS Zeichnung Campendonk, Merz 259, 1921, collage, 7×6"

69 KURT SCHWITTERS Anna Blume Dichtungen, 1919, book.

70 KURT SCHWITTERS Memoiren Anna Blume, 1922, booklet.

71 KURT SCHWITTERS Anna Blume, 1922, stories.

72 KURT SCHWITTERS Die Blume Anna eine Gedichtsammlung, 1918-22, booklet.

73 KURT SCHWITTERS Auguste Bolte, 1923, book.

74 KURT SCHWITTERS Mers, Nos. 1, 2, 4, 6, 8, 1920-23, magazines.

75 KURT SCHWITTERS Einladung Mersmatinee, 1923, throwaway.

76 CRISTOF SPENGEMANN Die Warheit über Anna Blume, 1920-23, magazines.

77 STEEGEMANN En Avant Dada, Geschichte des Dadaismus, 1920, magazine.

78 Der Zweeman, 1919, magazine.

79 TRISTAN TZARA La Première aventure celeste de M. Antipyrine, Collection Dada, 1916, book.

COLOGNE

80 J. T. BAARGELD The Red King, 1920, ink on drawing, 19×15"

81 J. T. BAARGELD Guillaume Apollinaire, 1920, drawing, 9×12"

82 J. T. BAARGELD #64 and #65, 2 photocollages.

83 J. T. BAARGELD and MAX ERNST collage with typewriting, 3 pages.

84 MAX ERNST La Bicyclette Graminée Garnie de Grelots les Grisons Grivelés et les Echinodermes Courbants l'Echine pdür Quêter des Caresses, 1920, botanical chart and gouache, 29×39"

85 MAX ERNST Paysage en Ferraille erreur de ceux qui Preferent la Navigation sur l'Herbe a une buste de Femme, 1920, oil on canvas, 29½×26"

86 MAX ERNST Etamines et Marsellaise, 1919, watercolor and pencil, 17½×14"

87 MAX ERNST Le Massacre des Innocents, 1919, collage, 12×15½

88 MAX ERNST Amy Louise, 1921, fotomontage.

89 MAX ERNST Jimmy, 1921, fotomontage.

90 MAX ERNST Chinese Nightingale, 1920, fotomontage, 5x4"

91 MAX ERNST Buddha, 1920, drawing and collage.

92 MAX ERNST Dadamax (Ernst and Caesar Buonarutti), c.1920, photo.

93 MAX ERNST Two Heads, collage.

94 MAX ERNST 2 collage drawings Dada, 1920.

95 MAX ERNST 6 collage on steel engravings.

96 MAX ERNST Fiat Modes, 1919-20, portfolio.

97 MAX ERNST Au dessus des Nuages Marche la Minuit. Au dessus de la Minuit Plane l'Oiseau Invisible du Jour. Un peu plus Haut que l'Oiseau l'Éther Pousse et les Murs et les Toits Flottent, 1920, collage.

98 Dada Ausstellung, 1920, catalogue.

99 Die Schammade, 1920, magazine.

100 Bulletin D, 1919-20, magazines (2)

101 Dada Siegt, 1920, poster.

137 Dadaistisches Manifest, 1920.

138 Deutschland muss untergehen, 1920, book (Hausmann)

139 Der Dada (Huelsenbeck) magazine, 1922.

140 Der neue Mensch, (Freiland) 1918-19.

141 Club Dada, 1920-21, magazine.

142 Dada Messe Berlin, 1920, poster.

143 Was ist der Dadaismus, 1920, ...

144 Serée Dada, 1917-1920, throw...

ADADADADADADADADADADADADADADADADADADA

Marcel Duchamp, *Dada 1916–1923*, 1953, Druck auf Zellstoffpapier, 96,5 × 63,5 cm
Design for Dada 1916–1923, print on tissue paper, 96.5 × 63.5 cm,
Staatliches Museum Schwerin – Kunstsammlungen, Schlösser und Gärten

1 Mit brauner Tinte hat Sidney Janis eines dieser Poster signiert und mit »Greetings to André Breton« beschrieben. Als unter Protesten der Öffentlichkeit alle Habseligkeiten André Bretons, dem Begründer des Surrealismus, bei einer großen Auktion über sieben Tage in Paris im April 2003 unter den Hammer kommen, wird unter der Losnummer 520 am 8.4.2003 genau diese signierte Version von Duchamps Poster versteigert. Von New York nach Paris versandt, vierfach gefaltet in einem eigens dafür entworfenen Umschlag, an die Rue Fontaine Nummer 42, ist das Poster auch ein Gruß von der neuen Kunstmetropole der Welt an die vergangene. Zugleich verbindet die persönliche Widmung an André Breton konsequent die Umtriebe Dadas mit der daraus erwachsenen Folgebewegung des Surrealismus.

2 Das Poster selbst fungiert als Ausstellungskatalog, gleichfalls ein revolutionärer Einfall. Es enthält zum Anlass der Ausstellung verfasste Texte von Hans Arp, Richard Huelsenbeck, Jacques-Henri Lévesque und Tristan Tzara – wichtige Vertreter Dadas. Die über 200 Werke Dutzender Künstler von Kurt Schwitters und Max Ernst bis zu Francis Picabia und Man Ray sind nach den Städten der Bewegung (u. a. Zürich, Berlin, Paris und New York), mit Titel, Datum und Medium bezeichnet. »Dada is cheap and dear, like life. Dada gives itself for nothing, for Dada is priceless«, schreibt Arp. »Dada was a spiritual and psychological revolution [...]. It wanted to change the world by magic«, schreibt Huelsenbeck. Und Tzara bemerkt auf dem Poster: »Dada tried to destroy, not so much art, as the idea one had of art, breaking down its rigid borders«.

3 Die schwarz-orangerote Farbgebung auf weißem Grund, die großen diagonal und zum Teil einzeln eingesetzten Lettern knüpfen an die Plakat- und Kataloggestaltung der Futuristen und Dadaisten aus den 1910er- und 1920er-Jahren an. Duchamp selber verwendet mindestens sechs verschiedene Schriftarten. Ist die Auflistung der Exponate in der Längsausrichtung des Posters von unten nach oben vertikal gesetzt, dann ergeben die vier Texte zu Dada die kleingedruckte diagonale Kaskade von oben links nach unten rechts – die wiederum der von größerer Distanz lesbaren orangeroten Diagonale aus Lettern und Worten entgegenläuft, welche die Information zu Ausstellungstitel, Ort und Zeit enthält. Francis M. Naumann hat argumentiert, dass sich die Texte der Dadaisten in ihrer typografischen Abwärtsbewegung mit Duchamps Skandal-Gemälde *Akt, eine Treppe herabsteigend* von 1912 assoziieren lassen. Das Poster umrahmt das Mantra »DADADADADADADA« gleichfalls in orangeroten Lettern, wobei die Redundanz des Wortes sowohl auf die spielerische Komponente der Bewegung wie auf die Vieldeutigkeit des Wortes (französisch »Steckenpferd«, russisch »Jaja«, etc.) verweisen mag.

4 Auf hauchdünnem Papier gedruckt, erfüllte das Poster vor allem einen Zweck: Es konnte zu kleinen Kugeln zusammengeknüllt werden. Duchamps Ausstellungskonzept sah vor, dass das Poster in eben dieser Form aus einem Mülleimer nahe des Eingangs von den Besuchern herausgefischt und entfaltet werden sollte, um so eine entsprechende Orientierung zu geben. Eine Dada-Geste par excellence.

Der Beitrag wurde in deutscher Sprache erstmals in: *Aviso. Zeitschrift für Wissenschaft und Künste*, 1, 2007 (München), S. 26 f., veröffentlicht und war zunächst Teil eines Vortrags anlässlich des Duchamp-Symposiums zur Ausstellungseröffnung von *Marcel Duchamp. Druckgraphik der Sammlung Hummel*, Wien, 10. Mai 2003.

1 In one particular instance, Sidney Janis signed one of the posters with "Greetings to André Breton" in brown ink. In 2003 in Paris, when most of the belongings and collection of André Breton (under great public protest) were put up for sale at auction for seven days in a row, Duchamp's poster was auctioned off as well on April 4, listed as lot number 520. From New York to Paris, folded four times in an envelope especially designed for the purpose, the poster not only announces a particular exhibition but serves as a greeting from the new art metropolis to the old center of art in Europe. At the same time, Janis's personal dedication to André Breton links the activities of Dada with the movement of Surrealism, which it engendered.

2 The poster itself functioned as a catalogue for the exhibition, a revolutionary concept in itself. It contains texts prepared for the exhibition by Hans Arp, Richard Huelsenbeck, Jacques-Henri Lévesque and Tristan Tzara—important figures in Dada. Over 200 works of dozens of artists from Kurt Schwitters and Max Ernst to Francis Picabia and Man Ray are listed in conjunction with cities that were centers of the movement (Zurich, Berlin, Paris and New York, amongst others) with indication of the work's title, date and medium. "Dada is cheap and dear, like life. Dada gives itself for nothing, for Dada is priceless," writes Arp. "Dada was a spiritual and psychological revolution ... It wanted to change the world by magic," writes Huelsenbeck. And Tzara remarks on the poster: "Dada tried to destroy, not so much art, as the idea one had of art, breaking down its rigid borders."

3 The Black-Orange-Red coloration on a white background, the large diagonal and in part individually set letters recall the poster and catalog designs of the Futurists and the Dadaists of the 1910s and 1920s. Duchamp himself uses at least six different typefaces. The listing of the objects is set vertically from bottom to top along the length of the poster. The four texts on Dada are set in diagonal cascades in small print falling from the upper left to the lower right against the orange-red diagonals of letters and words—discernible from a distance and containing information about the title of the exhibition and where and when it is taking place. Francis M. Naumann has argued that the texts of the Dadaists in their typographical downward movement are associated with Duchamp's scandalous painting of the *Nude Descending a Staircase* of 1912. The poster frames the mantra "DADADADADA" in orange-red letters, whereby the redundancy of the word may indicate the playful component of the art movement as well as the multiplicity of its meanings (French, "hobby horse;" Russian, "yes, yes;" etc.)

4 Printed on very thin paper, the poster fulfilled yet another important purpose. It could be squashed together into little balls. According to Duchamp's concept for the exhibition, the grumpled-up poster could be fished out of trash cans at the entrance to the exhibit and then unfolded and flattened out in order to provide the orientation desired. A Dada gesture par excellence.

Transl. Harriett Watts

This article was first published in German, in *Aviso. Zeitschrift für Wissenschaft und Künste* (1, 2007) and was initially part of a lecture held at a Duchamp-symposium on the occasion of the opening of the exhibition *Marcel Duchamp. Printed Matter* of the Collection Hummel, Vienna, May 10, 2003.

III
ANSICHTEN UND DURCHSICHTEN
VIEWS AND REVIEWS

Marcel Duchamp, *Rotorelief Nr. 9, Mongolfière*, 1935,
Kartonscheibe, beidseitig farbig gedruckt als
Offset-Lithografie, Durchmesser 20 cm, Originaledition,
Staatliches Museum Schwerin – Kunstsammlungen,
Schlösser und Gärten

Marcel Duchamp, *Rotorelief No. 9, Mongolfière*, 1935,
cardboard disk, printed on both sides in color offset lithograph,
20 cm in diameter, original edition, Staatliches Museum
Schwerin – Kunstsammlungen, Schlösser und Gärten

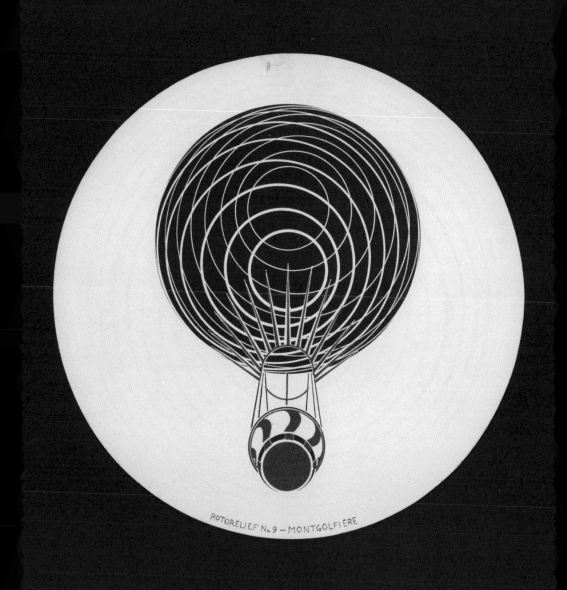

ROTORELIEF N. 9 — MONTGOLFIÈRE

ANSICHTEN UND DURCHSICHTEN

Dem Anspruch, Duchamp nicht nur einem eng abgesteckten Adressatenkreis der Kunstgeschichtsschreibung zu überlassen, die in Teilen nicht zuletzt durch schwer verständliches Diskursvokabular die Tür zu einem notwendigen Zugang zu Duchamp von innen zustemmt, sollte vor allem dadurch entsprochen werden, mit den eigenen Beiträgen in Online-Zeitschriften oder in Printmedien eine möglichst breite Leserschaft zu erreichen — dabei stets Thoreaus »Simplify, Simplify!« als Leitgedanken im Kopf, ohne dabei Duchamps Komplexität zu verwässern. Auch gilt es, sowohl Quellentexte neu zu erschließen wie jene Künstler vorzustellen, die intelligent und inspiriert mit dessen Erbe umzugehen verstehen, anstatt den längst nicht mehr vorhandenen Ikonoklasmus seiner Readymades stets aufs Neue als vermeintliche Provokation aufzuwärmen. »Vom Übertrumpfen des Trompe l'œil« erschien 2009 in der englischsprachigen Ausgabe des *Frieze* Magazin anlässlich der umfassenden Ausstellung zu *Étant donnés* im Philadelphia Museum of Art und ist hier erstmals ungekürzt abgedruckt.[1] Mit »Rarität von 1944« wurde in *Tout-Fait: The Marcel Duchamp Studies Online Journal* bereits 2002 der komplette Text der schwer erhältlichen, frühen Publikation *Duchamp's Glass* als Faksimile im Internet veröffentlicht. Der Einleitungstext ist hier wiedergegeben. Katherine S. Dreier ist als Ko-Autorin des schmalen Büchleins übrigens eine von zahlreichen Künstlerinnen, die sich über Jahrzehnte von Marcel Duchamp haben inspirieren lassen. Elsa von Freytag Loringhoven, Hannah Wilke, Carolee Schneemann, Alison Knowles, Sherri Levine, Elaine Sturtevant oder Elena del Rivero.[2] Sie alle haben Duchamps Abkehr vom männlichen Blick, dessen Geschlechterspiele und Aufwertung der Frau etwa im *Großen Glas* zum Ausgangspunkt verschiedener Überlegungen für ihr eigenes Werk genommen.

1 Thomas Girst, »The Importance of Being Marcel Duchamp«, in: *Very*, Oktober 2001, S. 32 f.; Thomas Girst, »Ahead of the Game«, in: *The Art Newspaper* Online-Ausgabe 1. Oktober 2008, erschienen anlässlich des 40. Todestages von Duchamp <www.theartnewspaper.com/articles/ Ahead%20of%20the%20game/16126> (8. August 2012); auch falsche Informationen in den Mainstream-Medien gilt es gegebenenfalls durch Leserbriefe zu korrigieren, etwa wenn es heißt, Duchamp habe 1913 ein Pissoir auf der *Armory Show* ausgestellt, s. Thomas Girst, »Right Artist, Wrong Show«, in: *International Herald Tribune*, 15. Oktober 1993.
2 Thomas Girst, »Elena del Rivero and Marcel Duchamp: Les Amoureuses«, in: *Tout-Fait: The Marcel Duchamp Studies Online Journal* Vol. 2, Issue 4, 2002 <www.toutfait.com/ online_journal_details.php?postid= 1305> (20. August 2012).

The legacy of Marcel Duchamp should not be left exclusively to a narrow circle of the addressees of art historical writing which in part employs discourse vocabulary that is hard to penetrate. Some of art history seems to slam the door shut from within so as not to allow for a broader access to the understanding of Duchamp and others. Instead, Thoreau's "Simplify, Simplify!" should be the guiding idea of any writing on artists without ever compromising the complexity of the subject at hand. Every scholar should aim for a broad distribution and readership of his writings, both in print and online. In addition, original texts should be made available as much as possible while those contemporary artists deserve visibility, who, in an intelligent and inspiring manner, comprehend and carry forth the legacy of Duchamp rather than rehashing once again the no longer existing iconoclasm of his Readymades in futile attempts of mindless provocation. "Trumping the Trompe-l'œil" appeared in 2009 in the English language edition of *Frieze* magazine on the occasion of the major exhibition evolving around *Étant donnés* in the Philadelphia Museum of Art, republished here for the first time in its entirety.[1] "Rarity from 1944" made available online the complete text of the early and difficult to obtain publication of *Duchamp's Glass*, published in facsimile in 2002 within *Tout-Fait: The Marcel Duchamp Studies Online Journal*. The introductory text is included here. Katherine S. Dreier was not only the co-author of this small booklet but one of the numerous women artists who have been inspired by Marcel Duchamp over the decades. Elsa von Freytag Loringhoven, Hannah Wilke, Carolee Schneemann, Alison Knowles, Sherri Levine, Elaine Sturtevant and Elena del Rivero[2]—all these artist have taken Duchamp's rejection of the male gaze, his play with the sexes and his elevation of the woman in, for example, the *Large Glass*, as a point of departure for new considerations concerning their own work.

Transl. Harriett Watts

1 Thomas Girst, "The Importance of Being Marcel Duchamp," *Very* (October 2001), pp. 32–33. Thomas Girst, "Ahead of the Game," *The Art Newspaper* Online-Edition 1.10.2008, which appeared on the occasion of fortieth anniversary of Duchamp's death www.theartnewspaper.com/articles/Ahead%20of%20the%20game/16126 (August 8, 2012). Mistakes in the mainstream media are also corrected, such as when it is declared that Duchamp exhibited a urinal in 1913 at the *Armory Show*, see Thomas Girst, "Right Artist. Wrong Show," *International Herald Tribune*, October 15, 1993.
2 Thomas Girst, "Elena del Rivero and Marcel Duchamp: Les amoureuses," *Tout-Fait: The Marcel Duchamp Studies Online Journal* vol. 2, issue 4, 2002, <www.toutfait.com/online_journal_details.php?postid=1305> (August 20, 2012).

VOM ÜBERTRUMPFEN DES TROMPE-L'ŒIL

Im Sommer 1968, so erfährt man aus Michael Taylors Ausstellungs-
katalog *Étant donnés*,[1] nur wenige Monate vor seinem Tod, will Marcel
Duchamp im spanischen Cadaqués für sein posthum im Jahr 1969 erst-
mals öffentlich gezeigtes Hauptwerk *Étant donnés: 1° la chute d'eau, /
2° le gaz d'éclairage* (Gegeben sei: 1. Der Wasserfall / 2. Das Leuchtgas,
1946–1966, Abb. 14, 15) 150 handverlesene Ziegelsteine zur Errichtung
des äußeren Torbogens einer massiven Holztür nach New York liefern
lassen. Durch deren beiden Gucklöcher erblickt der Betrachter eine
weitere gemauerte Ziegelsteinwand, hinter welcher auf Herbstzweigen
und Laub der Torso einer nackten Frau mit gespreizten Beinen liegt —
ihre rasierte Scham zur Schau gestellt und mit ihrer ausgestreckten lin-
ken Hand eine erleuchtete Gaslampe umklammernd. Im Hintergrund
erblickt der Betrachter die täuschend echt aussehende Collage einer
Waldlandschaft mit Wolken aus Watte, zu der ein Wasserfall aus meh-
reren Schichten Klebstoff gehört, von hinten beleuchtet mit einer Glüh-
lampe und offenbar durch den trickreichen Einsatz eines rotierenden
Motors in Bewegung gesetzt. Aufgrund von Duchamps Tod kamen diese
150 Steine zunächst nicht in New York an, erst nach einer Zahlung von
32.500 Peseten — zur damaligen Zeit ungefähr 468 US-Dollar — des
Museumspersonals aus Philadelphia an den spanischen Lieferanten,
erreichten schließlich 149 davon ihren Bestimmungsort. Durch den Um-
stand, dass 28 Steine bei der Überfahrt zu Bruch gingen, wurden die
Pläne des Restaurators, den Torbogen aus 119 Steinen aufzubauen,
durchkreuzt, da in diesem Fall kaum Steine als Reserve für eventuelle
Reparaturen übrig geblieben wären. Darüber hinaus erfährt man, dass
es Paul Matisse, der Sohn von Duchamps Witwe Teeny war, der die Idee
zu einer Lösung mit nur 107 Steinen einbrachte — 50 ganze und 114 hal-
be Ziegelsteine —, um eine möglichst große Ähnlichkeit mit den Tor-
bögen der alten Dörfer, wie sie an der spanischen Nordküste zu finden
sind, zu erzielen. Das ist noch lange nicht alles: die Größe der Steine,
weitere Zeichnungen zur Installation, der Name des Lieferanten, die

1 *Marcel Duchamp: Étant donnés*,
hrsg. von Michael R. Taylor, Ausst.-
Kat. Philadelphia Museum of Art, Yale
2009, S. 163 f. Der Katalog erschien
anlässlich der Ausstellung des Phila-
delphia Museum of Art, *Marcel Du-
champ: Étant donnés* (15.8.–29.11.2009).

TRUMPING THE TROMPE-L'OEIL

In the summer of 1968, we learn from Michael Taylor's publication *Étant donnés*, that a few months prior to his death, Duchamp hand-selected 150 bricks for *Étant donnés: 1° la chute d'eau, / 2° le gaz d'éclairage* (Given: 1. The Waterfall, 2. The Illuminating Gas, 1946–1966, figs. 14, 15) in Cadaqués, Spain, to be shipped to New York to create the outer archway for a massive wooden door through whose two peepholes the onlooker views a brickwall behind which the torso of a naked woman lies spread-legged on autumn branches and leaves—her shaved genitalia exposed—clasping a lit gas lamp with her erect left hand.[1] In the background a faux forest landscape with actual cotton clouds can be seen including a glistening waterfall consisting of layers of transparent glue, lit up by a lightbulb from behind and seemingly set in motion through the trickery of a rotating motor. The 150 bricks never made it to New York and only 149 of them arrived when the payment of an outstanding invoice of 32,500 pesetas (roughly $468 at the time) was finally made to the Spanish contractor by the Philadelphia museum. As twenty-eight were broken in transit, the plans of the conservator to create the archway with 119 bricks fell through since almost none would be left for replacement. We learn that Paul Matisse, the son of Duchamp's widow Teeny, came up with a solution involving only 107 bricks—50 full bricks and 114 half bricks—to best resemble similar archways of ancient villages along the Northern coast of Spain. It does not stop here: the size of the bricks, drawings, the name of the contractor, the shipping company and its location, the correspondence and conversations evolving around the installation are all provided here in great detail. For the initiated, all of this reads like a spellbinding page-turner. And the above, mind you, is only a rough outline of the least important of all the newly revealed facts pertaining to Duchamp's last installation.

The exhibition itself contains dozens of heretofore unknown works by Marcel Duchamp all closely related to his final oeuvre, variant parts of the nude figure of *Étant donnés*, landscape studies for the back-

1 Michael R. Taylor, *Étant donnés*, exh. cat. Philadelphia Museum of Art (Yale 2009)—published on the occasion of his exhibition on Duchamp's posthumously revealed assemblage of the same name from August 15 – November 29, 2009.

Transportgesellschaft und ihr Firmensitz, die Korrespondenz ebenso wie Gespräche, die sich um die Installation von *Étant donnés* drehen, werden im Katalog detailliert beschrieben. Für den Interessierten liest sich dies alles wie ein fesselnder Roman. Und die obigen Ausführungen sind wohlgemerkt nur ein sehr kleiner Ausschnitt der unbedeutendsten Einzelheiten all der neu aufgedeckten Fakten, die Duchamps letztes Werk betreffen.

Die Ausstellung selbst zeigt Dutzende bisher unbekannte Arbeiten Marcel Duchamps, die alle nah verwandt mit seinem finalen Werk sind: verschiedene Fragmente des nackten Körpers in *Étant donnés*, Landschaftsstudien für den Hintergrund, an denen er zusammen mit Salvador Dalí gearbeitet hat, viele Bilder und Stereo-Fotografien, mit denen Duchamp seine Arbeit im Atelier dokumentierte, sowie fünf »erotische Objekte«, bei denen es sich größtenteils um kupfer-galvanisierte Gipskörper handelt. Die letztgenannten Werke vervollständigen eine Serie von Gipsabdrücken und Bronzen, zu denen *Feuille de Vigne Femelle* (*Weibliches Feigenblatt*, 1950, Abb. 44), *Not a Shoe* (1950, Abb. 17), *Coin de chasteté* (*Keuschheitskeil*, 1954, Abb. 45) oder *Objet-Dard* (*Dart-Objekt*, 1951, Abb. 46) zählen. Duchamp präsentierte sie in den 1950er- und 1960er-Jahren meistens als Editionen. Im Rückblick gehören diese Arbeiten zum Entstehungsprozess von *Étant donnés*, auch wenn das zu jener Zeit ganz sicher noch niemand wissen konnte. Ergänzend befasst sich der Ausstellungskatalog in allen Einzelheiten mit dem verwendeten Material und der technischen Umsetzung der Installation. Auf diese Weise erfahren wir, dass sich drei dieser Objekte zwar an den Genitalbereich des Körpers und an den Schamhügel anpassen, *Not a Shoe* sich aber ebenso gut in die Lücke zwischen Arm und rechter Brust einer früheren Version der nackten Figur einfügt.

Der Katalog ist reich an neuen Details und wird im Verlauf der nächsten Jahre zu den bedeutendsten Standardwerken zählen dürfen, in denen es um unser Verständnis von Duchamps letztem Werk geht. Zudem macht er erstmalig die komplette Korrespondenz zwischen Marcel Duchamp und Maria Martins, der brasilianischen Bildhauerin, zugänglich. Zwischen 1943 und den frühen 1950er-Jahren geriet Duchamp in den Bann dieser willensstarken und freigeistigen Ehefrau des in New York ansässigen brasilianischen Botschafters. Die etwa zehn Jahre während Affäre inspirierte ihn dazu, Maria Martins Körper als Vorlage für seine Arbeit an *Étant donnes* zu verwenden. »Küsse überall zur gleichen Zeit«, »Ich denke so oft an Deine Hand [...] die mir so viel mehr Freude ge-

ground of the assemblage on which he collaborated with Salvador Dalí, many pictures and stereoscopic photo studies Duchamp took of the work in his studio as well as five "erotic objects" mostly made of copper-electroplated plaster. The last works complete a series of plasters and bronzes titled *Feuille de Vigne Femelle (Female Fig Leaf,* 1950, fig. 44), *Not a Shoe* (1950, fig. 17), *Coin de chasteté (Wedge of Chastity,* 1954, fig. 45) or *Objet-Dard (Dart-Object,* 1951, fig. 46) which Duchamp for the most part presented as editions in the 1950s and 1960s. Retrospectively, these works relate to the casting process of *Étant donnés* but certainly noone knew at the time. With its technical essays the catalogue of the exhibition goes through great lengths to examine the material used and processes applied in the making of *Étant donnés* and it is here where we learn that while three of these objects fit snugly to the torso's genital area and pubic mount, *Not a Shoe* also fits into the gap between the arm and the right breast of an early version of the nude figure.

While the catalogue contains new and rich details on every single page and will surely be the major reference book on Duchamp's final work for many years to come it also makes available for the first time the entire surviving correspondence between Marcel Duchamp and Maria Martins, the Brazilian sculptor. Between 1943 and the early 1950s Duchamp came under the spell of this strong-willed and free spirited wife of the Brazilian ambassador to New York. His decade long affair made Duchamp base the torso of his final work on her body. "Kisses everywhere at the same time," "I often think about your hand ... which has given me more joy than any lover could wish for," "I am within you and you only have to knead me to make us happy," "How I would like to breathe with you."[2] The letters provide a rare and unknown glimpse into Duchamp as lover, albeit already in his 60s. Yet they also reveal his sadness in being unable to convince Martins to live with him. He often is in "a state of great laziness and disgust."[3] He feels as if "life is empty, the city is empty" and that "isolation hurts," experiencing "a feeling of great emptiness."[4] Duchamp at his most vulnerable—and almost a relief from the notion of indifference displayed publicly through almost his entire life. Getting back to the subject *Étant donnés*, he writes to Martins in great detail about the process of working on "our lady of desire."[5] While he and Maria "both need physical love ... these long interruptions of chastity only serve to sharpen a new razor blade"—ultimately "work is a sexual stimulant" and working on plaster casts of Maria's body makes him feel as if she were with him.[6]

2 Michael R. Taylor 2009 (see note 1), p. 415, p. 411 (twice), p. 409.
3 Michael R. Taylor 2009 (see note 1), p. 425.
4 Michael R. Taylor 2009 (see note 1), p. 407, p. 417, p. 419.
5 Michael R. Taylor 2009 (see note 1), p. 419.
6 Michael R. Taylor 2009 (see note 1), p. 412.

geben hat, als jeder Liebhaber sich wünschen kann«, »Ich bin in Dir und Du musst mich nur formen, um uns glücklich zu machen«, »Wie gerne würde ich mit Dir atmen.«[2] Die Briefe vermitteln einen seltenen, flüchtigen Blick auf den damals über 60-jährigen Liebhaber Duchamp. Gleichzeitig zeugen sie von seiner Traurigkeit darüber, dass er Martins nicht davon überzeugen konnte, gemeinsam mit ihm zu leben. Oft befindet er sich in einem Zustand der »Trägheit und Abscheu«.[3] Er beklagt, dass »das Leben leer ist, die Stadt leer«, und dass »die Einsamkeit schmerzt«, in ihm »ein Gefühl großer Leere« ist.[4] Duchamp zeigt sich hier von seiner empfindlichsten Seite – und beinahe wirkt dies wie eine Befreiung von dem Bild, das er in seiner Rolle des gleichgültigen, über den Dingen stehenden Künstlers öffentlich stets vermittelte. Zudem berichtet er in seinen Briefen an Martins, um wieder auf *Étant donnés* zurückzukommen, detailliert über die Entwicklung seiner Arbeit an »unserer Lieben Frau des Begehrens«.[5] Da er und Maria »beide körperlicher Liebe bedürfen […], dienen die langen Unterbrechungen nur dazu, das Feuer weiter anzufachen« – letztlich sei »die Arbeit sexuell stimulierend«, und die Arbeit an dem Gipsabdruck von Marias Körper würde ihm das Gefühl geben, dass sie bei ihm wäre.[6]

Lassen Sie uns noch etwas näher auf das Thema Sexualität eingehen. Zu Beginn seiner Karriere machte Duchamp deutlich, dass er nicht an retinaler Kunst, also an Kunst, die nur für das Auge bestimmt ist, interessiert sei. Stattdessen wollte er die »graue Materie« des Betrachters ansprechen, die Verstandesleistung über den Eindruck des Visuellen setzen. Erotik spielt in diesem Zusammenhang eine entscheidende Rolle. »Ich möchte die Dinge mit dem Geist so erfassen, wie der Penis von der Vagina umfasst wird«,[7] gab Duchamp einmal bekannt, überzeugt davon, dass Sexualität und Erotik »die Grundlage von allem sei«, aber »niemand spricht darüber«.[8] In Briefen aus den 1950er- und frühen 1960er-Jahren an den Schweizer Duchampianer Serge Stauffer, die bis heute nicht in englischer Sprache vorliegen, beschreibt der Künstler den Liebesakt als eine »vierdimensionale Situation par excellence«.[9] Von allen Sinnen macht es wahrscheinlich nur der Tastsinn als unerlässlicher Bestandteil des Liebesaktes möglich, einen flüchtigen Eindruck oder im besten Fall eine physikalische Interpretation der vierten Dimension zu vermitteln. Und das von einem Künstler, der behauptet, dass ein dreidimensionales Objekt auf die vierte Dimension dergestalt verweise, wie es der Schattenwurf etwa seiner Readymades auf das dreidimensionale Objekt tue.

2 Ebd., S. 409, 411, 415 [Übersetzung des Autors, wie in Folge].
3 Ebd., S. 425.
4 Ebd., S. 407, 417, 419.
5 Ebd., S. 419.
6 Ebd., S. 412.
7 Marcel Duchamp im Gespräch mit Laurence D. Steefel, Jr., September 1956, in: Serge Stauffer, *Marcel Duchamp: Interviews und Statements*, Graphische Sammlung Staatsgalerie Stuttgart, Ostfildern-Ruit 1992, S. 62.
8 Pierre Cabanne, *Dialogues with Marcel Duchamp*, New York 1987, S. 88 (Pierre Cabanne, *Gespräche mit Marcel Duchamp*, Köln 1972).
9 *Marcel Duchamp. Die Schriften*, Brief vom 28.5.1961, hrsg. von Serge Stauffer, Zürich 1981, S. 276.

Let us dwell on the subject of sexuality a little further. Duchamp early on in his career made it clear not to be interested in mere "retinal art." Instead he wanted to engage the "grey matter" of the onlooker, putting brain before the eyes, thought before the pleasures of the purely visual. In this context, eroticism plays a crucial part. "I would like to grasp an idea as the vagina grasps the penis,"[7] Duchamp once remarked, believing that sexuality and eroticism were at "the basis of everything and no one talks about it."[8] In letters to the Swiss Duchampian Serge Stauffer of the late 1950s and early 1960s, unavailable in English to this day, the artist compares the act of love to a "four dimensional situation par excellence."[9] Of all senses only the sense of touch as a crucial part of lovemaking could possibly provide a rare glimpse or at the most a physical interpretation of the fourth dimension. This from an artist who maintained that a three-dimensional object relates to the fourth dimension in the same way the shadow of his Readymades related to the object itself.

In this context it does become apparent that *Étant donnés* is not or rather much more than what meets the eye. Getting back to the archway, does it really surround a door as the catalogue proclaims without questioning. What constitutes a door? The wooden planks put together from a massive Spanish gate contain no hinges, no key hole, no handle, no knob, no door lock, no door frame—and there is no way to open the construction. Duchamp created many doors and passageways throughout his career, most importantly *Door: 11, rue Larrey* (1927) in his tiny Paris apartment, a door hinged between the studio and the bedroom which to the pleasure of Duchamp solved the old paradox of a door that heretofore could not be open and closed at the same time. Nothing with Duchamp is as simple as it may seem.

Michael Taylor again does an extraordinary job to show the ever-growing impact of *Étant donnés* on contemporary art, a work that even Björk once referred to as "an artwork which completely changed the 20th century."[10] Nevertheless, his thoughts prove most disappointing as many artists from Francesco Vezzoli to Marcel Dzama only seem to appropriate the mere visual content of Duchamp's final oeuvre for their own ends—just as for almost a hundred years now, artists simply make use of Readymade objects in their work and still deem the gesture provocative and in tune with the spirit of Duchamp, as if this once iconoclastic gesture had not already become standard artistic practice since the 1950s. In general, I have almost no issues with Taylor's truly enlight-

7 Quoted in Katrina Martin, "Anémic-Cinéma," *Studio International* (January–February 1975).
8 Pierre Cabanne, *Dialogues with Marcel Duchamp* (New York, 1987), p. 88
9 Serge Stauffer, ed., *Marcel Duchamp. Die Schriften* (Zurich, 1981), p. 276 [letter of May 28, 1961].
10 Björk in an interview with Thomas Venter, in "Der Look Passiert Nicht," *Süddeutsche Zeitung*, August 27, 2001 [author's translation].

In diesem Zusammenhang wird deutlich, dass *Étant donnés* nicht das ist oder genauer gesagt noch viel mehr ist als das, was das Auge zu erfassen vermag. Zurück zum Torbogen — umrahmt dieser tatsächlich eine Tür, wie der Katalog das ohne zu hinterfragen kundtut? Was definiert eine Tür? Die von einem massiven spanischen Tor stammenden Holzplanken verfügen über keine Scharniere, kein Schlüsselloch, keinen Griff, keinen Knauf, kein Türschloss, keinen Türrahmen — und es gibt keine Möglichkeit, die Tür zu öffnen. Duchamp hat viele Türen und Durchgänge geschaffen, zu den bedeutendsten zählt *Tür: 11, rue Larrey* (1927). Diese in seiner winzigen Pariser Wohnung zwischen Atelier und Schlafzimmer über Eck in Scharniere gehängte Tür löste zu Duchamps Vergnügen das bekannte Paradox auf, dass eine Tür vordem nicht im selben Moment offen und geschlossen sein konnte. Bei Duchamp verhält sich kaum etwas, wie es zunächst scheinen mag.

Michael Taylor leistet mit seinem Buch einen außerordentlichen Beitrag, um den immer weiter wachsenden Einfluss von *Étant donnés* auf die zeitgenössische Kunst aufzuzeigen, jenes Werk, das die isländische Sängerin Björk als Kunstwerk bezeichnete, das »das 20. Jahrhundert völlig verändert« habe.[10] Dennoch erweisen sich seine Ausführungen auch als enttäuschend, da sich alle im Katalog genannten Künstler von Francesco Vezzoli bis Marcel Dzama ausschließlich den rein visuellen Inhalt von Duchamps letztem Werk einzig zu ihrem eigenen Nutzen aneignen — ähnlich wie Künstler seit fast hundert Jahren Aspekte von Readymades in ihre Arbeit einfließen lassen und dies, sich auf Duchamp berufend, als eine provokative Geste ansehen. So als wäre diese einst ikonoklastische Geste nicht schon in den 1950er-Jahren zu einer standardisierten künstlerischen Vorgehensweise geworden.

Im Allgemeinen habe ich so gut wie keine Einwände gegen Taylors erhellende Forschung und den Reichtum an neuem Material, wie es sowohl in der Ausstellung als auch in der Publikation bereitgestellt wird. Ich hätte mir allerdings auch gewünscht, dass das 12-seitige Manuskript *Notes on the History of the Tableau* von Anne d'Harnoncourt und Theodor Siegl aus dem Jahre 1969, genauso wie mit den Briefen Marcel Duchamps an Maria Martins geschehen, als komplettes Quellenmaterial im Kapitel »Documentation« veröffentlicht worden wäre, anstatt ständig im fortlaufendenden Text zitiert zu werden. Jedoch wird Anne d'Harnoncourt gebührend Tribut gezollt, der großartigen langjährigen Direktorin des Philadelphia Museums of Art. Neben Teeny Duchamp und deren Tochter Jacqueline Matisse Monnier, war sie eine der drei

10 Björk in einem Interview mit Thomas Venter, »Der Look Passiert Nicht«, in: *Süddeutsche Zeitung*, 27. August 2001.

ening scholarship and wealth of new material provided both through-out the exhibition and the publication. I only would have wished for the 1969 twelve-page manuscript "Notes on the History of the Tableau" by Anne d'Harnoncourt and Theodor Siegl to have been made available entirely as source material within the catalogue's "Documentation" sec-tion—just as Duchamp's letters to Maria Martins have been—instead of it constantly being quoted within the text. While she is given due credit throughout the book, Anne d'Harnoncourt, the great late director of the Philadelphia Museum or Art, together with Teeny Duchamp and her daughter Jacqueline Matisse Monnier was one of three women who have done the most to further our understanding of Duchamp after his death. I also disagree with Taylor's assessment that André Breton "de-cided to temporarily cede leadership" of the Surrealists to Duchamp for the duration of World War II.[11] Duchamp never signed a single mani-festo and was determined to remain aloof from any movement, no mat-ter how closely associated he was with the Surrealists. Lastly I believe that likening Duchamp to Antonella da Messina's *Saint Jerome in His Studio* (c. 1475) or referring to Andrea Mantegna's *Lamentation over the Dead Christ* (c. 1480) while examining the lay-out of the torso of *Étant donnés*[12] does at best slight injustice to a declared atheist such as Duchamp. In the case of a previously unknown treasure trove of photo-graphs Duchamp himself took of *Étant donnés* and kept hidden away in a Dom Pérignon champagne box, the revelation is not so much yet an-other hint at his monastic existence ("Dom Pérignon" is the monk cred-ited with inventing champagne): The word on the box preceding "Dom Pérignon" is of course "Cuvée" (or "blend") yet another strong hint that the torso of *Étant donnés* is a composite of many different body parts from at least two women (Maria Martins and Teeny Duchamp) not meant to be anatomically correct in a mere visual context.

For the remainder of this essay please bear with me for a brief out-line of my thoughts on *Étant donnés* adding yet another layer to the many meanings of Duchamp's assemblage. Throughout his life Duchamp published handwritten notes in several editions which are meant to be examined for a better understanding of his oeuvre, most importantly *The Bride stripped Bare by Her Bachelors, Even / The Large Glass (La Mariée mise à nu par ses célibataires, même / Le Grand verre, 1915–1923)*, a highly complex and mostly abstract work on glass—just as most of his major works it is part of the collection of the Philadelphia Museum of Art—showcasing the constant longing of "nine bachelors" for an ever

11 Michael R. Taylor 2009 (see note 1) p. 43.
12 Michael R. Taylor 2009 (see note 1) p. 64, p. 97.

Frauen, die nach Duchamps Tod das Meiste zum Verständnis des Künstlers beigetragen haben. Auch stimme ich mit Taylor nicht darin überein, dass er von Andrè Breton behauptet, er habe Duchamp zeitweise die Führerschaft des Surrealismus während des Zweiten Weltkriegs übertragen.[11] Duchamp hat nie auch nur ein einziges Manifest unterschrieben und blieb entschlossen jeglichen Kunstströmungen fern, egal wie eng er im Zusammenhang mit den Surrealisten stand. Schließlich glaube ich, dass es einem erklärten Atheisten wie Duchamp gegenüber wenig gerecht wird, die Inszenierung des nackten Körpers in *Étant donnés* mit Antonella da Messinas *Sankt Jerome in seinem Atelier* (ca. 1475) oder mit Andrea Mantegnas *Klagelied über den toten Christus* (ca. 1480) in Beziehung zu setzen.[12] Im Falle des bislang unbekannten Schatzes an Fotografien, die Duchamp eigens von *Étant donnés* gemacht hat und dann in einer Dom Perignon-Champagnerkiste versteckt hielt, geht es weniger um einen Hinweis auf deren klösterliche Herkunft (»Dom Perignon« ist der Mönch, dem man die Erfindung des Champagners zuschreibt): Vielmehr ist das Wort »Cuvée« (»Verschnitt«), das auf der Kiste vor dem Wort »Dom Perignon« steht, ein deutlicher Hinweis darauf, dass der Torso in *Étant donnés* eine Komposition aus verschiedenen Körperteilen von mindestens zwei Frauen ist, nämlich Maria Martins und Teeny Duchamp, dieser also nicht als anatomisch korrekt im Sinne einer rein visuellen Lesart zu verstehen ist.

Seien Sie bitte für den Rest dieses Essays nachsichtig mit mir, wenn ich mir eine kurze Zusammenfassung meiner Gedanken zu *Étant donnés* erlaube, in der ich den Bedeutungen von Duchamps Assemblage noch eine Ebene hinzufügen möchte. Sein ganzes Leben lang hat Duchamp handgeschriebene Notizen in verschiedenen Fassungen veröffentlicht, die einem besseren Verständnis seines Œuvres dienen sollten. Hauptsächlich beziehen sich die Notizen auf sein Hauptwerk *Die Braut von ihren Junggesellen entblößt, sogar / Das Große Glas (La Mariée mise à nu par ses célibataires, même / Le Grand verre*, 1915–1923, Abb. 4), eine hoch komplexe und fast gänzlich abstrakte Glasarbeit, die wie fast alle seine größten Werke Teil der Sammlung des Philadelphia Museum of Art ist und die beständige Sehnsucht von »neun Junggesellen« nach einer in unterschiedlichen Stadien der Entkleidung befindlichen »Braut« darstellt. Noch vor der Veröffentlichung der etwa hundert Notizen zum *Großen Glas* im Jahre 1934 hat Duchamp beschlossen, einige davon zweimal herauszugeben. In beiden Fällen tragen diese den vollen Titel von *Étant donnés* und stellen so schon sehr früh die untrennbare

11 Taylor 2009 (wie Anm. 1), S. 43.
12 Ebd., S. 64, S. 97.

powerful "bride" in the state of undress. Even prior to the publication of about hundred documents relating to *The Large Glass* in 1934, Duchamp chose to twice publish a handful of them. Both times they already contain the full title of *Étant donnés*, inextricably linking *The Large Glass* to his final work from very early on. And of the posthumous notes only revealed after his death, one of those stacked in a folder titled "Inframince" (or "infrathin")—a concept of great importance to the understanding of Duchamp that roughly came to his mind at the beginning of working on *Étant donnés*—speaks of a "carcass (pseudo-geometric)."[13] The note itself bears a rough sketch of legs spread wide and angled at the knee (like an "M", Duchamp's first initial). The words "a first step" are crossed out above it so as not to give away that what we are looking at here is a rough rendering of the first state of the lower torso of his final work.

Much earlier, in late 1911, Duchamp based another drawing of his on a poem by the Symbolist writer Jules Laforgue titled "Eternal Siesta." In 1967, one year after his completion of *Étant donnés*, Duchamp created a series of etchings titled *The Lovers*, many of which contain obvious allusions to his secret work. *Eternal Siesta* may again have inspired one of them, *Après l'Amour* (1967), depicting a couple in post-coital embrace. The poem, rather morbid and sad in tone, speaks of bodies melting into one and of lying on a bed as if in a grave. A little after Duchamp's drawing of 1911 and madly in love with the wife of Francis Picabia at the time, he likens their relationship of unfulfilled longing to the couple in Andre Gide's book, *La porte étroite* (1909, published in English as *Strait is the Gate*). What is *Étant donnés*, one may ask, but the "eternal siesta" of a "pseudo-geometrical carcass" behind a "porte étroite?"

Supporting this particular reading is a drawing by Duchamp of the underside of a foot from 1946, clearly part of the family of studies for his final work. The foot is not so much an allusion to Mantegna's *Christ*, as the catalogue would have it.[14] Rather, it is a mirrored copy of a foot on the lower left corner of Ingres' *Oedipus and Sphinx* (1808), a work also referred to in Duchamp's *The Lovers* series. Besides the foot lies the upper torso of a human corpse, all skull and bones.

Furthermore, the artist Bill Copley[15] first hinted at the autumn leaves alluding to the *fall-season* and possibly the fall of the "Bride" of *The Large Glass* at the end of Duchamp's life. And after all, thanks to the publication of Duchamp's letters to Martins we now know that right

13 Paul Matisse, ed., *Marcel Duchamp, Notes* (Boston, 1983), n. p. [note 24].
14 Michael R. Taylor 2009 (see note 1), p. 97.
15 William Copley, "The New Piece," *Art in America* (July/August 1969), p. 36.

Verbindung vom *Großen Glas* zu seiner finalen Arbeit her. Eine der Notizen, die erst nach seinem Tod entdeckt wurden und sich mit vielen weiteren in einem Ordner mit der Aufschrift »Inframince« (»infradünn«) befand – ein Ideenkonstrukt, das als ein Schlüssel zum Verständnis von Duchamp hilfreich sein kann und das ihm etwa zu Beginn seiner Arbeit an *Étant donnés* in den Sinn kam –, benennt die »Isolierung eines pseudo-geometrischen [...] Gerippes«.[13] Die Notiz selbst enthält eine grobe Skizze, die weit gespreizte Beine mit angewinkelten Knien darstellt. Sie bilden ein »M« wie Duchamps erste Initiale. Die Worte »un premier pas« (»ein erster Schritt«) sind durchgestrichen, als wollte Duchamp nicht preisgeben, dass das, was wir hier sehen, eine grobe Skizze der ersten Fassung des Unterleibs für sein letztes Werk ist.

Viel früher schon, zu Beginn des Jahres 1911, bezieht Duchamp eine andere Zeichnung mit dem Titel *Ewige Siesta (Sieste eternelle)* auf ein Gedicht des symbolistischen Schriftstellers Jules Laforgue. Als er 1967, ein Jahr nach der Fertigstellung von *Étant donnés*, eine Serie von Druckgrafiken mit dem Titel *Die Liebenden (Les Amoureuses)* schuf, enthielten einige davon offensichtliche Hinweise auf seine geheime Arbeit. *Ewige Siesta* könnte wiederum die Inspiration für die Darstellung eines Paares in post-koitaler Umarmung, einer weiteren Arbeit aus dieser Serie mit dem Titel *Nach der Liebe (Aprés l'amour)*, gewesen sein. Das Gedicht erzählt in morbidem und traurigem Ton von zwei miteinander zu einer Einheit verschmelzenden Körpern, die im Bett wie in einem Grab ruhen. Kurz nach Duchamps Zeichnung von 1911 und ungemein verliebt in die Ehefrau von Francis Picabia, vergleicht er ihr Verhältnis voll unerfüllter Sehnsucht mit dem jenes Paares in André Gides Buch *La porte étroite (Die enge Pforte*, 1909). Man möchte sich fragen, was *Étant donnés* anderes ist als die »Ewige Siesta« eines »pseudo-geometrischen Gerippes« hinter einer »engen Pforte«.

Diese spezifische Lesart unterstützt eine Zeichnung von Duchamp aus dem Jahre 1946, die die Unterseite eines Fußes zeigt und offensichtlich Teil der Studien für sein letztes Werk ist. Dieser Fuß ist weniger eine Anlehnung an Mantegnas *Christus*, wie es im Katalog heißt,[14] sondern eher eine gespiegelte Kopie eines Fußes aus der unteren linken Ecke des Werks *Ödipus und Sphinx* (1808) von Ingres, eine Arbeit, auf die Duchamps *Die Liebenden*-Serie ebenfalls referiert. Neben dem Fuß liegt ein vollständig skelettierter Oberkörper.

Überdies verwies der Künstler Bill Copley als Erster darauf, dass das Herbstlaub als Anspielung auf den Verfall und vielleicht auch auf

13 Marcel Duchamp, *Notes*, hrsg. von Paul Matisse, Boston 1983, o. S. [Nr. 24].
14 Taylor 2009 (wie Anm. 1), S. 97.

in the middle of describing his progress on *Étant donnés* to her, he dwells on the year's particular season: "Autumn is quite beautiful here but all the same has a funeral air, like all beautiful autumns—something like a funeral relaxation of things."[16] With *Étant donnés*, the artist who went underground to work in secret on his last creation comes full circle.

In the end, what we are looking at through those peepholes is the surprisingly unarousing view of a naked woman with a distorted body and genitals. And this is certainly not due to problems with the casting process as the catalogue would like us to believe.[17] Duchamp was much too smart for this. Relying on his own notes as well as taking into account his preoccupation with the fourth dimension, *Étant donnés*, even as a super-natural trompe-l'oeil, was created in clear opposition to a mere visual reading. In the same way as the complex abstraction of his *Large Glass* is a break with retinal art, just as his Readymades as mass-produced objects are first and foremost provocative objects of the mind questioning preconceived notions of what constitutes art. In any case, with *Étant donnés*, porn and poetry need not be mutually exclusive. We know this since Ovid and certainly since Baudelaire in modern times. Needless to say, throughout his life Duchamp often made clear that he was only interested in a posthumous audience fifty or even a hundred years after his death. And who knows? *Étant donnés*, when first revealed in 1969 did not, as Taylor has it, "provoke a storm of controversy"[18] similar to Duchamp's *Nude Descending a Staircase* (fig. 12) of 1912 or his Readymade urinal *Fountain* (fig. 5) of 1917. Yet with anti-intellectual and hypocritical moral sentiments running high, the greatest challenges for a naked woman with wide open legs legs permanently installed in an American institution may still lie ahead. From his grave, Duchamp could certainly put our beliefs to the test once again.

16 Michael R. Taylor 2009 (see note 1), p. 409.
17 Michael R. Taylor 2009 (see note 1), p. 77.
18 Michael R. Taylor 2009 (see note 1), p. 173.

This article was first published in English in *Frieze* (November/December 2009) and was presented in its final version during the symposium "Duchamp and Art History" at the University of Bonn, Germany, January 29, 2010.

den Fall der *Braut* aus dem *Großen Glas* am Ende von Duchamps Leben zu verstehen ist.[15] Und schließlich wissen wir nun, dank der Veröffentlichung von Duchamps Briefen an Martins, dass er mitten in der Beschreibung seines Fortschritts bei *Étant donnés* näher auf eine bestimmte Jahreszeit eingeht: »Der Herbst hier ist wirklich schön, aber alles hat den Flair eines Begräbnisses, das jedem schönen Herbst innewohnt — etwas wie die begräbnishafte Entspannung aller Dinge«.[16] So schließt der Künstler, der sich zurückzog, um im Geheimen an seinem letzten großen Werk zu arbeiten, mit *Étant donnés* den Kreis.

Schlussendlich ist das, was sich dem Besucher eröffnet, wenn er durch die beiden Gucklöcher blickt, die überraschend unaufgeregte Sicht auf eine nackte Frau mit verzerrtem Körper und verzerrten Genitalien. Und das ist sicherlich nicht den Problemen zuzuschreiben, die sich bei der Abformung ergeben haben, wie der Katalog uns Glauben machen möchte.[17] Dafür war Duchamp viel zu gerissen. Vertrauen wir auf seine Notizen und berücksichtigen gleichzeitig seine Beschäftigung mit der vierten Dimension, so ist *Étant donnés* gewissermaßen als ein übernatürliches Trompe-l'œil im klaren Gegensatz zu einer rein visuellen Lesart geschaffen worden. Auf gleiche Weise stellt die komplexe Abstraktion seines *Großen Glases* einen Bruch mit der retinalen Kunst dar, und ebenso sind seine massenproduzierten Readymades in erster Linie provokante Objekte des Geistes, die gängige Auffassungen über das Wesen der Kunst in Frage stellen. Auf jeden Fall müssen Pornografie und Poesie sich nicht gegenseitig ausschließen, wie man an *Étant donnés* sehen kann. Das ist uns schon seit Ovid und aus der Moderne spätestens seit Charles Baudelaire bekannt. Es ist beinahe unnötig zu erwähnen, dass Duchamp sein Leben lang deutlich gemacht hat, nur an einem posthumen Publikum, 50 oder gar 100 Jahre nach seinem Tod, interessiert zu sein. Und wer weiß? *Étant donnés* löste, als es 1969 erstmalig enthüllt wurde, nicht, wie Taylor schreibt, »einen Sturm der Entrüstung aus«[18] wie einst der *Akt, eine Treppe hinabsteigend* (Abb. 12) aus dem Jahre 1912 oder das Readymade *Fountain* (1917, Abb. 5). Doch in Anbetracht aktueller anti-intellektueller und scheinheilig-moralischer Befindlichkeiten mag die größte Herausforderung für die Darstellung

15 William Copley, »The New Piece«, in: *Art in America*, 57, 4, July/August 1969, S. 36.
16 Taylor 2009 (wie Anm. 1), S. 409.
17 Ebd., S. 77.
18 Ebd., S. 173.

einer nackten Frau mit weit gespreizten Beinen darin liegen, dauerhaft in einer amerikanischen Kunstinstitution installiert zu bleiben. Posthum kann es durchaus noch geschehen, dass Duchamp unsere Sicht der Dinge erneut auf die Probe stellen könnte.

Aus dem Englischen von Anna Pfau

Dieser Beitrag wurde in englischer Sprache erstmals in gekürzter Form als »Pieces of the Puzzle« in: *Frieze*, November/Dezember 2009, veröffentlicht und in seiner ausgearbeiteten Version auf dem Symposium *Duchamp und die Kunstgeschichte* an der Universität Bonn am 29. Januar 2010 präsentiert.

RARITÄT AUS DEM JAHRE 1944
DUCHAMP'S GLASS VON KATHERINE S. DREIER UND ROBERTO MATTA ECHAURREN

Auf der letzten Seite der gänzlich Marcel Duchamp gewidmeten März-Ausgabe des *View*-Magazins von Charles Henri Ford aus dem Jahre 1945,[1] bei der Titelblatt, Centerfold wie auch Rückseite vom Künstler selbst gestaltet wurden (Abb. 47–48, 10), wird der aufmerksame Leser über eine Anzeige (Abb. 49) stolpern, die zur linken Seite des bekannten Doppelportraits von Duchamp (Abb. 50) platziert ist, die den selbsternannten An-Artisten im Alter von 35 sowie imaginierten 85 Jahren zeigt.

Die kleine Anzeige lenkt unser Interesse auf das damals soeben veröffentlichte Buch der Kunstmäzenin und Sammlerin Katherine S. Dreier sowie des in Chile geborenen surrealistischen Malers Roberto Matta Echaurren *Duchamp's Glass, La Marieé mise à nu par ses célibataires, même. An Analytical Reflection* (Abb. 51).[2] In einer Auflage von nur 250 Stück wurde die dünne, ringgebundene Ausgabe durch die Société Anonyme, Inc., Museum of Modern Art, in New York veröffentlicht und durch Wittenborn and Company vertrieben.

Neben André Bretons Essay *Phare de la Mariée (Leuchtturm der Braut)*, der zuerst im Dezember 1934 auf Französisch in einer Ausgabe von *Minotaure* veröffentlicht wurde,[3] ist Dreiers und Mattas Text erst der zweite (und erste englischsprachige), der Duchamps Hauptwerk, *Die Braut von ihren Junggesellen entblößt, sogar / Das Große Glas (La Mariée mise à nu par ses célibataires, même / Le Grand verre*, 1915–1923, Abb. 4) ausführlich diskutiert. Bretons Essay erschien in Buchform erst 1945 innerhalb einer revidierten und erweiterten Auflage von *Le Surréalisme et la peinture*[4] — eine Sammlung seiner theoretischen Schriften zur Malerei. Eine englische Version wurde ebenfalls erst in diesem Jahr in der zuvor genannten Ausgabe des *View*-Magazins veröffentlicht, wobei Charles Henri Ford den Text sehr wahrscheinlich selbst übersetzt hat.

Breton arbeitet zu der Zeit, zu der er an seinem ersten Essay schreibt, vor allem mit einer frühen Ausstellungsfotografie, die aufge-

1 *View*, 5, 1, März 1945.
2 Zusammen mit Man Ray und Marcel Duchamp gründete Katherine S. Dreier (1877–1952) die Société Anonyme, das erste amerikanische Museum, das sich der modernen Kunst widmet, über die sie selbst häufig schrieb. Roberto Matta Echaurren (1911–2002) kam 1939 nach New York und nachdem er über eine Reproduktion des *Übergang von der Jungfrau zur Braut (Le Passage de la Vierge à la Mariée*, 1912, Abb. 52) stolperte, vernarrte er sich buchstäblich in den älteren Künstler, der bald von Matta dachte, dass er der wohl »tiefsinnigste Maler seiner Generation« sei. *Collection of the Société Anonyme: Museum of Modern Art* 1920, Associates in Fine Arts, Yale University Art Gallery, New Haven, Connecticut 1950, S. 92.
3 *Minotaure*, Paris, 2, 6, Winter 1935. Das Titelblatt dieser Ausgabe wurde von Marcel Duchamp gestaltet.
4 André Breton, *Le Surréalisme et la peinture*, New York 1945.

RARITY FROM 1944
DUCHAMP'S GLASS BY KATHERINE S. DREIER AND ROBERTO MATTA ECHAURREN

On the last page of Charles Henri Ford's *View* magazine of March 1945,[1] an issue entirely dedicated to Marcel Duchamp, who designed the front, the centerfold and the back cover (figs. 47–48, 10), the attentive reader may come across an advertisement (fig. 49) placed left of Duchamp's famous double portrait (fig. 50) showing the "an-artist" at both 35 and the then imaginary age of 85.

The small ad draws attention to the recently published book by both the rich art patron and collector Katherine S. Dreier as well as the Chilean-born Surrealist painter Roberto Matta Echaurren: *Duchamp's Glass, La Marieé mise à nu par ses célibataires, même. An Analytical Reflection* (fig. 51).[2] The slim ring-bound volume distributed by Wittenborn and Company was published in May 1944, in an edition of only 250 copies, by the Société Anonyme, Inc., Museum of Modern Art, New York.

Besides André Breton's essay "Phare de la Mariée" ("Lighthouse of the Bride"), first published in French in an issue of *Minotaure* in December 1934,[3] Dreier's and Matta's writing is only the second text and the very first monograph to discuss Duchamp's major work *The Bride stripped Bare by Her Bachelors, Even / The Large Glass (La Mariée mise à nu par ses célibataires, même / Le Grand verre, 1915–1923, fig. 4) at length and the very first one to appear in English on the subject matter. Breton's essay appeared in book form later in 1945, within a revised and enlarged edition of *Le Surréalisme et la peinture*,[4] a collection of his theoretical writings on painting. An English version was not published until that same year, within the aforementioned issue of *View* magazine and most likely translated by Charles Henri Ford himself.

Unlike Breton when he wrote his essay, mostly working from an early exhibition photograph taken when the *Large Glass* was first shown at the Brooklyn Museum's *International Exhibition of Modern Art*[5] as well as Duchamp's notes on his *Large Glass* published in *The Bride stripped Bare by her Bachelors, Even / The Green Box (La Mariée mise à nu par ses célibataires, même / La Boîte verte, 1934, fig. 8) both

1 *View* 5, 1 (March 1945).
2 Together with Man Ray and Marcel Duchamp, Katherine S. Dreier (1877–1952), herself an artist, had founded the Société Anonyme, the first museum in America devoted to modern art, a subject on which she frequently wrote. Matta (1911–2002) came to New York in 1939 and after stumbling upon a reproduction of Duchamp's *The Passage from Virgin to Bride (Le Passage de la Vierge à la Mariée,* 1912, fig. 52) became infatuated with the older artist who soon thought of Matta to be "the most profound painter of his generation." *Collection of the Société Anonyme: Museum of Modern Art 1920,* (New Haven, Connecticut, 1950) p. 92.
3 *Minotaure* 2, 6 (Winter 1935). Cover design by Marcel Duchamp.
4 André Breton, *Le Surréalisme et la peinture* (New York, 1945).
5 Assembled by the Société Anonyme, New York, November 19, 1926–January 1, 1927; the only time it was exhibited without the cracks.

nommen wurde, als das *Große Glas* erstmals in der *International Exhi-bition of Modern Art* im Brooklyn Museum in New York gezeigt wurde,[5] und außerdem mit den Notizen Duchamps, die in *Die Braut von ihren Junggesellen entblößt, sogar / Die Grüne Schachtel* (*La Mariée mise à nu par ses célibataires, même / La Boîte verte*, 1934, Abb. 8) veröffent-licht wurden. Im Gegensatz zu ihm haben Matta und Dreier die Mög-lichkeit, das *Große Glas* im Original zu sehen.

Nach der Ausstellung im Frühjahr 1927 wird es in den Besitz Kathe-rine Dreiers überführt und in ihr Haus in West Redding, Connecticut, gebracht, wobei es beim Transport in Hunderte von Teilen zerbrach (Abb. 53). Erst über zehn Jahre später, als Duchamp im Jahre 1936 Pa-ris verlässt, um in die Vereinigten Staaten nach New York zu reisen, wird es von ihm wieder zusammengefügt. Das instandgesetzte Glas bleibt bis zum Jahre 1944 in Dreiers Wohnzimmer, bis es in ihr Haus in Milford, Connecticut, umzieht, wo es für den Zeitraum von April 1946 bis Januar 1953 vor einem Fenster aufgestellt ist. Im Juli 1957 wird es unter Duchamps Beaufsichtigung dauerhaft im Philadelphia Museum of Art installiert, wo es sich bis zum heutigen Tage befindet.

Der zweite Abschnitt der Lektüre aus *Duchamp's Glass* lautet wie folgt: »Die essentiellen Prinzipien menschlichen Bewusstseins können solange nicht erfasst werden, bis wir unsere psychologische Haltung gegenüber dem Bild als einem starrem Ding oder Objekt aufgeben — eine Sicht der Dinge, die auf dem rein äußerlich Sichtbaren beruht, was kaum etwas mit Wahrnehmung zu tun hat. Das Bild aber ist kein Ding. Es ist ein Vorgang, der erst durch den Betrachter vollendet wer-den muss. Um sich des Phänomens, das das Bild beschreibt, vollständig bewusst zu sein, müssen wir zunächst selber diesen Vorgang dynami-scher Wahrnehmung vollenden«.

In diesem Pamphlet, das auch die einzig bekannte Zusammenarbeit zwischen Dreier und Matta darstellt, wird zum ersten Mal ein entschei-dendes Konzept Duchamps eingeführt. Erst viele Jahre später, im April 1957, führt dieser die Bedeutung des Zuschauers weiter aus, in sei-nem bekannten Text *The Creative Act* (*Der kreative Akt*), ein kurzer Vortrag, den er anlässlich der American Federation of Arts Conven-tion in Houston hielt. Darin bezieht er sich auf »die beiden Pole jeder Kunstschöpfung, auf der einen Seite den Künstler, auf der anderen Seite den Zuschauer, welcher später zur Nachwelt wird«.[6] Gegen Ende des Vortrags stellt er fest, dass »der kreative Akt nicht durch den Künst-ler allein vollzogen [wird]; der Zuschauer bringt das Werk in Kontakt

5 Die Ausstellung wurde von der Société Anonyme veranstaltet und fand vom 19.11.1926–1.1.1927 statt. Dies war der einzige Zeitraum, in dem das *Große Glas* rissfrei zu sehen war.
6 Marcel Duchamp, »Der kreative Akt«, in: Marcel Duchamp. *Die Schrif-ten*, hrsg. von Serge Stauffer Zürich 1981, S. 239 f.

Matta and Dreier had the opportunity to study the *Large Glass* in the original.

Owned by Katherine Dreier and located at her home in West Redding, Connecticut, it was shipped there after its exhibition in early 1927 when it shattered into hundreds of pieces during transport (fig. 53). It was repaired by Duchamp only about ten years later when he left Paris for New York during a trip to the United States in 1936. The repaired *Glass* remained in Dreier's living room until 1944 when it is brought to her house in Milford, Connecticut, where it is placed before a window between April 1946 to January 1953. In July 1957, under the supervision of Duchamp, it is permanently installed at the Philadelphia Museum of Art where it remains to this day.

The second paragraph of *Duchamp's Glass* reads in full:

> The essential principles of human consciousness cannot be grasped until we abandon the psychological attitude of conceiving the image as a petrified thing or object; the result of emphasizing the external vision, which is rarely related to perception. The image is not a thing. It is an act which must be completed by the spectator. In order to be fully conscious of the phenomenon which the image describes, we ourselves must first of all fulfill the act of dynamic perception.

Here in this pamphlet, the only known collaboration between Dreier and Matta, a crucial concept of Duchamp is introduced for the very first time. Only years later, in April 1957, the artist himself would elaborate further on the importance of the onlooker during his well-known "The Creative Act," a brief talk given to the American Federation of Arts Convention in Houston. Within he states "the two poles of the creation of art: the artist on one hand, and on the other the spectator who later becomes the posterity."[6] He concludes that "the creative act is not performed by the artist alone. The spectator brings the work in contact with the external world by deciphering and interpreting its inner qualifications and thus adds his contribution to the creative act."[7]

In this context, it is interesting to note that in 1926, during the *Large Glass*'s exhibition in Brooklyn, the Surrealist dealer Julien Levy had apparently noted Duchamp's later dictum of the fusion of artist and spectator on a mere physical level, remarking upon his initial encounter with

6 Marcel Duchamp, "The Creative Act," in: Michel Sanouillet and Elmer Peterson, pp. 138–140 (New York 1989), p. 138.
7 Sanouillet/Peterson (see note 6), p. 140.

mit der äußeren Welt, indem er dessen innere Qualifikationen ent-
ziffert und interpretiert und damit seinen Beitrag zum kreativen Akt
hinzufügt.«[7]

In diesem Kontext ist zu bemerken, dass der Kunsthändler Julien
Levy im Jahre 1926, während der Ausstellung des *Großen Glases* in
Brooklyn, offenbar bereits Duchamps späteres Diktum dieser Verbin-
dung von Künstler und Zuschauer auf einem weniger physikalischem
Level vermerkt, indem er auf sein erstes Zusammentreffen mit diesem
Hauptwerk verweist: »Als ich dieses große Glas zum ersten Mal sah
[...], war ich nicht nur von dem Werk selbst fasziniert, sondern auch
von den zahlreichen Transformationen, die der Komposition durch ihren
zufällig entstehenden Hintergrund verliehen wurden, nämlich durch
die Zuschauer, die hinter dem Glas, das ich betrachtete, durch das
Museum liefen«.[8]

Neben den drei Fotografien des *Großen Glases* beinhaltet die 16-
seitige Ausgabe außerdem eine Schwarz-Weiß-Reproduktion von Mattas
Gemälde *The Bachelors Twenty Years After* (*Die Junggesellen zwanzig
Jahre später*, Abb. 54) aus dem Jahr 1943, das die Risse im Glas mit auf-
nimmt.

Es ist bekannt, das Katherine Dreier bereits seit den 1920er-Jahren
die Gedanken Duchamps zur modernen Kunst zu ihren Grundüber-
zeugungen machte. Und der junge Matta verehrte Duchamp und teilte
dessen Ansichten. Es ist unbedingt davon auszugehen, dass *Duchamp's
Glass* eben nicht nur von Duchamps Glas handelt, sondern dass
Duchamp als Ghostwriter gleichfalls federführend war.

Aus dem Englischen von Janina Wildfeuer

7 Ebd., 1981, S. 240.
8 Julien Levy, »Duchampiana«, in:
View, 5, 1. März 1945, S. 33–34.

Der Beitrag wurde erstmals gemeinsam mit einem Faksimile des besprochenen Buches
in englischer Sprache in: *Tout-Fait: The Marcel Duchamp Studies Online Journal* Vol. 2,
Ausgabe 4, 2002, veröffentlicht <www.toutfait.com/online_journal_details.php?postid=
1366> (20. August 2012).

this major work: "When I first saw the large glass ... I was fascinated, not merely by the work itself, but by the numerous transformations which were lent to the composition by its accidental background, by the spectators who passed through the museum behind the glass I was regarding."[8]

Besides three photographs of the *Large Glass*, a black and white reproduction of Matta's 1943 painting *The Bachelors Twenty Years After* (fig. 54) is also included in the sixteen-page volume, directly incorporating the cracks within.

It is known that ever since the early 1920s Duchamp's thoughts on modern art became Katherine Dreier's very own convictions. And the young Matta adored Duchamp, sharing his opinions. We can thus be convinced that *Duchamp's Glass* is not only about Duchamp's *Glass* but that Duchamp himself was its ghostwriter of sorts, his very own beliefs making their way onto each and every page.

8 Julien Levy, "Duchampiana," *View* 5, 1 (March 1945), pp. 33–34.

This article, together with an interactive facsimile of the publication discussed, was first published in English in: *Tout-Fait: The Marcel Duchamp Studies Online Journal* vol 2, issue 4, 2002, <www.toutfait.com/online_journal_details.php?postid=1366> (August 20, 2013).

IV
INTERVIEWS

WANTED

$2,000 REWARD

For information leading to the arrest of George W. Welch, alias Bull, alias Pickens. etcetry, etcetry. Operated Bucket Shop in New York under name HOOKE, LYON and CINQUER Height about 5 feet 9 inches. Weight about 180 pounds. Complexion medium, eyes same. Known also under name RROSE SÉLAVY

INTERVIEWS

Als der amerikanische Kunsthistoriker und Duchamp-Forscher Francis M. Naumann Anfang der 1980er-Jahre den 1998 verstorbenen New Yorker Galeristen Arne Ekstrom in dessen Lieblingsrestaurant auf der Upper East Side zu seinem turbulenten Leben inmitten bedeutender Künstler des 20. Jahrhunderts befragte und anregte, er solle doch unbedingt seine Autobiographie schreiben, erwiderte dieser ebenso knapp wie gut gelaunt: »Man sollte meiner einzig dergestalt gedenken, dass ich stets am richtigen Ort zur richtigen Zeit und dabei tadellos gekleidet war«.[1] Dieser wunderbaren Reprise eingedenk mag es manchen Künstlern allerdings weniger leicht fallen, im höheren Alter Fragen von Gesprächspartnern zu beantworten, die weniger um sie selbst als um Leben und Werk jener Künstlern kreisen, die sie selber einmal bestens gekannt haben. Was bei diesen Situationen vor Griesgrämigkeit schützt, ist der feste Glaube an das eigene Schaffen, Charme, Neugier sowie die vollständige Abwesenheit von Neid und Missgunst. Beatrice Wood, Dorothea Tanning, Charles Henri Ford, Timothy Phillips und Robert Barnes waren solche Interviewpartner, all jene, die den Autor zunächst wegen ihrer Bekanntschaft zu Duchamp interessierten.

In Augen schauen, die so vieles schon geschaut haben, Worte vernehmen über Künstler, so vertraut und persönlich, dass Gespräche es vermögen, die Zeit zu überbrücken, uns diejenigen wieder ganz und gar vor Augen zu führen, die im Leben derer, die sie kannten, solange nicht verstorben sind, wie sie sich ihrer erinnern. Das vor allem machte den Reiz der Interviews aus, sowie der tiefe Einblick in die Lebensentwürfe und das Werk der Gesprächspartner. Mit Duchamps Witwe Alexina »Teeny« Duchamp, damals 83 Jahre alt, nahmen die Interviews 1989 in Villiers-sous-Grez bei Fontainebleau südlich von Paris ihren Anfang. Mitte 1996 in Ojai, Kalifornien, dann das Beieinandersitzen über Stunden mit der damals 103-jährigen Künstlerin Beatrice Wood, die Marcel Duchamp 80 Jahre zuvor in New York kennengelernt hatte und über ihn und Francis Picabia bemerkte: »Ihre Worte waren nicht erotisch,

1 Francis M. Naumann, E-mail an den Autor vom 5. August 2012.

INTERVIEWS

In the early 1980s, the American art historian and Duchamp scholar Francis M. Naumann interviewed the New York gallery director Arne Ekstrom, who passed away in 1998, in his favorite upper East Side restaurant about his turbulent life among important artists of the twentieth century. When he suggested that he should write an autobiography, Ekstrom replied, curtly and with good humor, "All I want people to remember about me is that I was in the right place at the right time, and, when I was there, I was impeccably dressed."[1] With this wonderful response in mind, one can presume that it has not been so easy for many an artist to answer, at a certain advanced age, the questions of interviewers, in particular questions not so much directed at their own past but inquiries about the lives and work of artists they once knew. What keeps an artist being interviewed from being offended in regard to the recollections requested is, first of all, the solid belief in his or her own work, as well as charm, curiosity, and a total lack of envy or resentment. Beatrice Wood, Dorothea Tanning, Charles Henri Ford, Timothy Phillips and Robert Barnes were such interview partners, all artists whom the author spoke to at length, with an interest foremost about their relationship to Marcel Duchamp.

To look into eyes that have seen so much, to listen to words about other artists, intimate and personal, so that one may cast a bridge across time gone by, so that those long gone again appear before our eyes— as long as they are remembered they have not passed away. This is the allure that those interviews hold, as well as the more profound understanding of the life and work of the partner in the conversation. The first of such interviews took place with Duchamp's widow Alexina "Teeny" Duchamp, eighty-three years of age at the time, in 1989 in Villiers-sous-Grez south of Paris, near Fontainebleau. In 1996, in Ojai, California, hour-long interviews with the great artist Beatrice Wood, then 103, followed. Duchamp had first met her eighty years before in New York. Concerning Duchamp and Francis Picabia she remarked:

1 Francis M. Naumann, e-mail to the author, August 5, 2012.

das waren ihre Handlungen«.[2] Oder ein Gespräch mit der 92-jährigen Surrealistin Dorothea Tanning in New York 2002, in ihrem von klassischer Moderne prallvollen Apartment, darüber, warum sie die Lyrik der Malerei vorzieht, da es von allen Künsten nur die Dichtkunst sei, die das Geld noch nicht verdorben habe.[3]

In den im Folgenden veröffentlichten Interviews erfahren wir einiges sowohl über Duchamp als auch über die Gesprächspartner. Es war Timothy Phillips (1929–2004), der mit *Tout-Fait: The Marcel Duchamp Studies Online Journal* Kontakt aufnahm und immer wieder darin publizierte. So verwies er auf mögliche Anknüpfungspunkte zwischen Duchamps geometrischen Distorsionen und den Arbeiten des Mathematikers Donald Spencer. Gleichsam war er darum bemüht, Duchamp selber als Wissenschaftler und Philosoph zu etablieren, und brachte ein andermal dessen Verwendung von Farben mit Experimentalpsychologie und mnemotechnischen Methoden in Verbindung. Das Interview mit ihm fand in seiner Tappa Gallery in Toronto statt, als Timothy Phillips 70 Jahre alt war. Phillips stellte sich als Urheber »kleinerer Details unbedeutender Bilder« Salvador Dalís vor, dem er als junger Mann Anfang der 1960er-Jahre in Cadaqués assistierte. Da auch Duchamp zu dieser Zeit oft in dem nordspanischen Küstenort seine Ferien verbrachte, wusste Phillips aus eigener Erfahrung über die Bekanntschaft zwischen ihm und Dalí zu berichten.

Amerikas Ur-Avantgardist Charles Henri Ford (1913–2002) wurde im Mai 2000 in seinem New Yorker Apartment zu Duchamp befragt. Bereits im Alter von 16 Jahren hatte er die von Gertrude Stein hoch gelobte Literaturzeitschrift *Blues* publiziert, sein Magazin *View* machte später Dichter und Schriftsteller von William Carlos Williams zu Jorge Luis Borges und Albert Camus bekannt, Künstler von Giorgio de Chirico und Max Ernst bis zu Marcel Duchamp und Man Ray erlangten durch seine Zeitschrift ein breiteres Publikum. Charles Henri Fords Einfluss auf und die Bedeutung für die europäische wie die amerikanische Kunst des 20. Jahrhunderts ist nicht zu unterschätzen.[4] Von Ford, der Andy Warhols erste Filmkamera kaufen half, schwärmte Jean Cocteau: »Er ist ein Dichter in allem was er tut«, ebenso — wie gewohnt skurril — William S. Burroughs: »Als Mitglied einer spektralen Elite besitzt er einen enigmatischen wie eigentümlichen Charme. Er hat das ›Zeichen‹.«

Der amerikanische figurative Maler und ehemalige Boxer Robert Barnes (geb. 1934) verließ als 21-Jähriger Chicago, um noch als Student in den losen New Yorker Kreis von Marcel Duchamp, Max Ernst,

2 Aus einem unveröffentlichten Interview des Autors mit Wood, Juni 1996; s. Beatrice Wood, »Marcel«, in: *Marcel Duchamp. Artist of the Century*, hrsg. von Rudolf E. Kuenzli und Francis M. Naumann, Cambridge 1989, S. 12 ff.; Beatrice Wood, *I Shock Myself: The Autobiography of Beatrice Wood*, San Francisco 1992 (1988); *Beatrice Wood: Intimate Appeal: The Figurative Art of Beatrice Wood*, Ausst.-Kat. Oakland Museum, Oakland 1990; *Beatrice Wood: A Centennial Tribute*, hrsg. von Francis M. Naumann, New York 1997.
3 Thomas Girst, »Lebenswert: Der Surrealismus – ein Gespräch mit Dorothea Tanning über ihre Zeit unter den malenden Machos aus Paris und über die späte Lust an der Lyrik«, in: *Frankfurter Allgemeine Sonntagszeitung*, 14. Juli 2002, S. 18; s. Dorothea Tanning, *Birthday*, Los Angeles 1987; Dorothea Tanning, *Between Lives: An Artist and her World*, New York 2001; sowie zwei Gedichtbände *A Table of Content* (2004) und *Coming to That* (2011), St. Paul.
4 Thomas Girst, »Tee mit Amerikas Ur-Avantgardist Charles Henri Ford«, in: *Die Tageszeitung*, 30. August 2001, S. 30, sowie den Ausstellungsflyer und Pressetext zu »Alive and Kicking: The Collages of Charles Henri Ford, 1908–2002«, The Scene Gallery, New York, 31.10.–12.12.2002 (vom Autor kuratiert); s. *View: Parade of the Avant-Garde, 1940–1947*, hrsg. von Charles Henri Ford, New York 1991; Charles Henri Ford, *Water from a Bucket: A Diary, 1948–1957*, New York 2001.

"Their talk wasn't erotic, their actions were."[2] Or the conversation with the 92 year old Surrealist Dorothea Tanning in New York in 2002 in her apartment brimming with modern art, a conversation in which she explained that she preferred poetry to painting, because of all the arts, the art of writing was the only one left corrupted by money.[3]

In the interviews published here, we can gain insights not only about Duchamp but about the interview partners as well. It was Timothy Phillips (1929–2004) who initiated contact with *Tout-Fait: The Marcel Duchamp Studies Online Journal* and frequently published there. It was he who proposed links between Duchamp's geometrical distortions and the work of the mathematician Donald Spencer. At the same time, he was concerned with establishing Duchamp as a scientist and philosopher, and, yet another time, brought Duchamp's utilization of colors into connection with experimental psychology and mnemo-technical methodology. The interview took place in his Tappa Gallery in Toronto when Timothy Phillips was seventy years old. Phillips introduced himself as the creator of "minor parts of lesser pictures" by Salvador Dalí, whom he had assisted as a young man at the beginning of the 1960s in Cadaqués. Because Duchamp at this time had also spent his vacations in this coastal village of Northern Spain, Phillips could recount from his own experience the acquaintance of Duchamp with Dalí. Together with Rhonda Roland Shearer, America's avant-gardist Charles Henri Ford (1913–2002), was interviewed in May 2000 in his New York apartment. Already at the age of sixteen, he had been the publisher of the literary journal *Blues*, highly praised by Gertrude Stein. His magazine *View* was later to make known poets and authors from William Carlos Williams to Jorge Luis Borges and Albert Camus. Artists from Giorgio de Chirico and Max Ernst to Marcel Duchamp acquired a large audience through this publication. Charles Henri Ford's influence on and his importance for European as well as American art of the twentieth century is not to be underestimated.[4] Jean Cocteau went over his head to praise Ford, who would later assist Andy Warhol in purchasing his first camera: "He is a poet in everything he does." And William S. Burroughs, odd as always, assessed Ford as follows: "As a member of a spectral elite he possesses an enigmatic as well as a unique charm. He has the 'sign'."

The American figurative painter and former boxer Robert Barnes (*1934) left Chicago at age twenty-one, then still a student, in order to join the loose New York-based artist's circle that included Marcel Duchamp, Max Ernst, Roberto Matta Echaurren, Hans Richter, Julien

2 From an unpublished interview of the author with Wood, June, 1996; also see Beatrice Wood, "Marcel," in Rudolf E. Kuenzil and Francis M. Naumann, eds., *Marcel Duchamp. Artist of the Century* (Cambridge, 1989), pp. 12–17; Beatrice Wood, *I Shock Myself: The Autobiography of Beatrice Wood* (San Francisco, 1992 [1988]); *Beatrice Wood: Intimate Appeal: The Figurative Art of Beatrice Wood,* exh. cat Oakland Museum (Oakland, 1990); Francis M. Naumann, ed., *Beatrice Wood: A Centennial Tribute* (New York, 1997).

3 Thomas Girst, "Lebenswert: Der Surrealismus – ein Gespräch mit Dorothea Tanning über ihre Zeit unter den malenden Machos aus Paris und über die späte Lust an der Lyrik," *Frankfurter Allgemeine Sonntagszeitung*, June 14, 2002, p. 18; see Dorothea Tanning, *Birthday* (Los Angeles, 1987); Dorothea Tanning, *Between Lives: An Artist and her World* (New York, 2001); as well as two volumes of poetry *A Table of Content* (2004) and *Coming to That* (2011) (St. Paul).

4 See Thomas Girst, "Tee mit Amerikas Ur-Avantgardist Charles Henri Ford," *Die Tageszeitung*, August 20, 2001, as well as to the exhibition flyer and press text for "Alive and Kicking: The Collages of Charles Henri Ford, 1908–2002," The Scene Gallery, New York, October 31–December 12, 2002 (curated by the author); see Charles Henri Ford, ed., *View: Parade of the Avant-Garde, 1940–47* (New York, 1991); Charles Henri Ford, *Water from a Bucket: A Diary, 1948–1957* (New York, 2001).

Roberto Matta Echaurren, Hans Richter, Julien Levy und Bill Copley aufgenommen zu werden. Es ist wenig professionell, wenn Barnes' Interview in der Duchamp-Forschung später als »zweifelhafte Darstellung« abgetan wurde, gemeinsam mit dem unhaltbaren Vorwurf, er hätte zu »Unrecht behauptet, Duchamps Assistent gewesen zu sein«, um dem »Mythos der Nackten aus Schweinehaut« Vorschub zu leisten.[5] Dass Duchamps weibliche Figur der Assemblage seines Spätwerks *Étant donnés* in ihrem Endzustand nicht aus gegerbter Schweinehaut besteht, bedeutet schließlich nicht, dass dieser zu Beginn nicht auch mit diesem Material experimentierte. Den Reiz des Neuen solle man nicht mit einer tatsächlichen Erfindung verwechseln, sagt Robert Barnes in seinem Interview. Für ihn blieb Duchamp ein Erfinder, bei allem, was er tat. Oder, wie es der anlässlich zur Preisverleihung des Prix Marcel Duchamp interviewte Schweizer Künstler Thomas Hirschhorn formulierte: »Er hat keine Kompromisse gemacht. Er war der intelligenteste Künstler seines Jahrhunderts«.

5 *Marcel Duchamp: Étant donnés*, hrsg. von Michael R. Taylor, Ausst.-Kat. Philadelphia Museum of Art, Philadelphia 2009, S. 188, Anm. 242 [Katalog zur Ausstellung *Marcel Duchamp: Étant donnés*, 15. August–29. November 2009].

Levy and Bill Copley. It is not particularly professional to reject Barnes's interview within Duchamp research as "a dubious account," along with making the unfounded assertion that Barnes "falsely claimed to have been Duchamp's studio assistant" in order to propagate the "myth of the pigskin nude."[5] That Duchamp's female figure in the assemblage of his late work *Étant donnés* in her final realization was not made of pigskin does not mean that at the beginning of working on the assemblage no experiments were undertaken using this material. Robert Barnes says in his interview that one should not mistake novelty for invention. In his opinion, Duchamp was a true inventor in everything he did. Or, in the words of the Swiss artist Thomas Hirschhorn interviewed on the occasion of his having been awarded the Prix Marcel Duchamp, "He made no compromises. He was the most intelligent artist of his century."

Transl. Harriett Watts

5 Michael R. Taylor, *Marcel Duchamp: Étants donnés*, exh. cat Philadelphia Museum of Art (Philadelphia, 2009), p. 188, note 242 [Exhibition catalogue accompanying *Marcel Duchamp. Étants donnés*, August 15–November 29].

»ZWEI SEELEN AUF EINER WELLENLÄNGE« TIMOTHY PHILLIPS ÜBER SALVADOR DALÍ UND MARCEL DUCHAMP

Wir erfuhren das erste Mal von Timothy Phillips (1929–2005) als er einen Leserbrief als Antwort auf Sarah Boxers Artikel »A Self-Made Man. The Art World is Upset by Evidence that Marcel Duchamp Manufactures the Readymades he Claimed to have Found« an die kanadische *National Post* schrieb.[1] Der Brief wurde durch einen der Zeitungsredakteure an uns weitergeleitet. Aus diesem ersten Schreiben ging eine Korrespondenz mit Phillips hervor, und es wurde schnell offensichtlich, dass er an Duchamps Neugier gegenüber der Mathematik sehr interessiert war. Wir erfuhren zudem, dass er als Assistent Salvador Dalís gearbeitet hatte, um für diesen »kleinere Details unbedeutender Bilder« zu malen. Diese Assistenz kam 1949 zustande, als Phillips Mutter sich von Dalí porträtieren ließ, Phillips diese begleitete und seine Ausgabe von Dalís *Fünfzig magischen Geheimnisse* für ein Autogramm mitbrachte.

Möglicherweise vom Aussehen des jungen Mannes und von seinem Interesse an der Mathematik fasziniert, lud Dalí Phillips zu sich in sein Haus in Port Lligat, Cadaqués, ein. Phillips begann, seine Sommer dort zu verbringen und mit Dalí – der später in einem Brief bemerken würde, dass ein Engel Phillips auf seinen Weg gesandt hatte – zu arbeiten (Abb. 55). In der Kunstwelt des Cadaqués der damaligen Zeit traf der junge Kanadier unter anderem auf Man Ray und Marcel Duchamp.

Als aktiver Maler unterhält Phillips die Tappa Galerie in Toronto sowie die Timothy Phillips Art Foundation. Heute tief religiös, besucht er zweimal in der Woche einen Gottesdienst. In der Korrespondenz, die sich auf den Leserbrief hin ergab, lässt er uns glücklich an seinen Erinnerungen an diesen sehr anderen Lebensstil der 1950er- und 1960er-Jahre teilhaben: »Ermutigt durch das Beispiel des berühmten Meisters [Dalí] handelte ich auf immer eigenartigere Weise. Am Anfang sagte Dalí (auf ›Dalínesisch‹): ›Du bist nicht verrückt genug‹. Als ich mich von ihm trennte, erklärte er: ›Du bist zu verrückt!‹ In der Zwischenzeit war meine offenkundige Verrücktheit weiter vorangeschritten als seine Beherrschung der englischen Sprache. Schließlich erwarb mein

1 *National Post*, 15. März 1999, Wiederabdruck in der *National Post* mit Erlaubnis der *New York Times*.

"TWO MINDS ON A SINGLE WAVELENGTH" TIMOTHY PHILLIPS ON SALVADOR DALÍ AND MARCEL DUCHAMP

We first learned of Timothy Phillips (1929–2005) when he wrote a letter to the editor in Canada's *National Post* responding to Sarah Boxer's article "A Self-Made Man. The Art World is Upset by Evidence that Marcel Duchamp Manufactured the Readymades he Claimed to have Found."[1] The letter was forwarded to us by one of the paper's editors. From this initial writing, a correspondence with Phillips ensued and it soon became apparent that he was highly interested in one of Duchamp's very own fascinations: mathematics. We also became aware that he had worked as an assistant for Salvador Dalí, executing "minor parts of lesser pictures." The assistantship came about in 1949 when Phillips' mother had her portrait painted by Dalí and Phillips went along, bringing his copy of 50 *Secrets of Magic Craftsmanship* for an autograph.

Perhaps intrigued by the young man's looks and interest in mathematics, Dalí invited Phillips to his house in Port Lligat, Cadaqués, and Phillips started to spend his summers working with Dalí (who wrote later that an angel had sent Phillips across his path) (fig. 55). In the art world of Cadaqués at that time, the young Canadian met, among others, Man Ray and Marcel Duchamp.

An active painter, Phillips maintains the Toronto-based Tappa Gallery as well as the Timothy Phillips Art Foundation. Now deeply religious, he attends services twice a week. In the correspondence that came about his letter to the editor, he happily shared memories of his very different lifestyle of the 1950s and 1960s:

> Emboldened by the example of the renowned master [Dalí], I proceeded to act in ever stranger ways. In the beginning Dalí said (in 'Dalínese'): "You is not enough crazy." When I parted company from him, he declared: "You is too much crazy!" In the interval, my apparent insanity had progressed more than his command of English. Eventually, my wealthy step-father purchased for me and my newly

1 *National Post*, March 15, 1999. Reprinted in the Post with permission of *The New York Times*.

wohlhabender Stiefvater für mich und meine — katastrophalerweise — frisch angetraute Frau ein ehemaliges Kloster auf einer Bergspitze. Dort nahm ich Mescalin und enorme Mengen von Alkohol (um vom Sex gar nicht erst zu sprechen!) zu mir und bestätigte so Dalís gewitzte Einschätzung meines damaligen Seelenzustandes«.

Wir mussten ihn treffen!

THOMAS GIRST Sie scheinen eine ziemlich wilde Zeit gehabt zu haben in Cadaqués in den 1950er- und 1960er-Jahren.

THOMAS GIRST Das ist leider wahr.

THOMAS GIRST Aber sie lebten in einem Kloster.

TIMOTHY PHILLIPS Ich fing mit einer Fischerhütte an, die ich gemietet hatte, und verliebte mich dann in ein Mädchen von dort. Sie war die Tochter eines englischen Exilanten. Im Kloster zu wohnen bedeutete für mich, sehr einfach zu leben, aber wir blieben ein paar Sommer lang dort. Dann lief sie mit Jonathan Guinness davon, von dem sich dann aber herausstellte, dass er eine zweite Frau hatte, die auf dem Land wohnte. Naja, sie ging dorthin, wo das Geld war, und ich war wieder einmal am Boden zerstört. Das war dann die Zeit, in der ich religiös wurde. Bevor ich verheiratet war, arbeitete ich mit Dalí an mathematischen Berechnungen. Ich war außerdem an kleineren Details unbedeutender Bilder beteiligt, und er lobte mein Verständnis für Farbgebung. Es ist sehr schwer, jemandem, der nicht malt, zu erklären, was Farbgebung ist. Gemeinhin ist Farbgebung das, was man in einem Bild sieht, wenn man davon ein Schwarz-Weiß-Foto macht. Wenn darauf alles blass ist und man nichts voneinander unterscheiden kann, wenn alles von der tatsächlichen Farbe abhängt, dann gibt es eben keine Farbgebung. Wenn es aber in Farbe ist, dann sind es 50 % Vollton, 25 % helle Töne und 25 % dunkle Töne. Und es gibt ein Muster von vielen verschiedenen Tönen. Anscheinend geht das Verständnis für Farbgebung aber verloren. Früher wurde sie sogar in Schulen unterrichtet. Dalí sagte also zu mir, dass ich den Sinn eines Velázquez dafür hätte, eine große Übertreibung, aber ich versuchte, dem alle Ehre zu machen, und in vielen Bildern gelang mir dies nicht.

THOMAS GIRST Kennen Sie Puignau, den Unternehmer und Bürgermeister? Duchamp war er wichtig.

TIMOTHY PHILLIPS Puignau! Ja, natürlich kenne ich ihn. Er ist ein toller Mensch!

married—and disastrously so—wife, a mountaintop former monastery. There I took mescalin and vast quantities of alcohol (not to mention sex!), confirming to the letter Dalí's shrewd estimate of my then mental state.

We had to meet him!

THOMAS GIRST You seem to have had a pretty wild time while living in Cadaqués during the 1950s and 1960s.

TIMOTHY PHILLIPS That's unfortunately true.

THOMAS GIRST But you lived in a monastery.

TIMOTHY PHILLIPS First of all, I started in a fisherman's hut which I rented and then I fell in love with a local girl. She was the daughter of an English expatriate. Staying in the monastery meant very primitive living but we stayed there for a couple of summers. Then she ran off with Jonathan Guinness who secretly turned out to have a second wife that he kept in the countryside. Well, she went where the money was and I fell in one of my down periods. That's when I became religious. I was working for Dalí before I was married, doing mathematical calculations. I also did very minor parts of lesser pictures and he complimented my sense of tone. It is very difficult to explain to anybody who doesn't paint what tone is. Generally, tone is what you see in a painting when you take a black-and-white photograph. If it's all pale and you can't distinguish things, if it all depends on color it is not in tone. If it is in tone, it'll be 50 % mid-tone, 25 % light tone and 25 % dark. And it will have a pattern of masses of tone. Apparently, tone is becoming lost. It used to be taught in schools. So Dalí said to me that I had the total sense of a Velázquez, a big exaggeration, but I've tried to live up to it and in a lot of pictures I haven't.

THOMAS GIRST Did you know Puignau, the contractor and mayor? He was important to Duchamp.

TIMOTHY PHILLIPS Puignau! Yes, I certainly know him. He is a great guy!

THOMAS GIRST He arranged the wooden door for Duchamp's *Given* (figs. 14, 15) to be shipped to New York. He also got the bricks for Duchamp's last major work and helped him find a summer home, later installing a big chimney designed by Duchamp.

TIMOTHY PHILLIPS How wonderful!

THOMAS GIRST Er half, die hölzerne Tür für Duchamps *Étant donnés* (Abb. 14, 15) nach New York zu überführen. Er besorgte auch die Ziegelsteine für Duchamps letzte große Arbeit und half ihm, eine Bleibe für den Sommer zu finden, in der später ein großer, von Duchamp gestalteter Kamin erbaut wurde.

TIMOTHY PHILLIPS Wie schön!

THOMAS GIRST Duchamp erstellte sogar 1968 ein Porträt von ihm. Eine kleine Zeichnung (Abb. 56).

TIMOTHY PHILLIPS Oh, das muss ich sehen!

THOMAS GIRST War er auch ein Freund von Dalí?

TIMOTHY PHILLIPS Ja, war er tatsächlich! Er war ein sehr intelligenter Mann. Niemand konnte ein Freund Dalís sein, ohne entweder Talent zu haben oder intelligent zu sein oder beides.

THOMAS GIRST Man sagt, dass Dalí nicht der Exhibitionist war, den er sonst immer gab, sobald er mit Duchamp zusammen war.

TIMOTHY PHILLIPS Dalí war nie Exhibitionist, das war er nur für die Öffentlichkeit. Dalí war der bescheidenste Mensch, den ich je in meinem Leben kennengelernt habe. Er war nur an dem interessiert, was er lernen, was er aufnehmen konnte. Ein außergewöhnlicher Mann! Duchamp war auch ein sehr bescheidener Mensch und so gerissen und intelligent. Er war ein Schachspieler, seine Züge gab er nicht preis. Ich glaube nicht, dass Dalí Duchamp zu schätzen wusste, bis er schließlich begann, Mathematik und Metaphysik zu studieren. Zuallererst hatte Dalí dieses Konzept der freudschen Analyse, aber dann wuchs er darüber hinaus und bemerkte nicht nur geometrische Formate in der Malerei, sondern auch die Dynamik der Mathematik und Geometrie, die alles untermauerte. Ein kleines Gespräch mit Duchamp hätte Dalí gezeigt, wo die tatsächliche Wahrheit der Dinge liegt, und er hätte dann dieses freudsche Konzept aufgeben und noch viel tiefer gehen können, was er dann ja auch tat. Seine Malereien wurden zunehmend mathematischer und dynamischer.

THOMAS GIRST Er zeigte auch großes Interesse an der DNA.

TIMOTHY PHILLIPS Ja, er war ein verkannter Wissenschaftler, der fasziniert war von zeitgenössischer Wissenschaft und all ihren Disziplinen, vor allem von der Biologie und Physik.

THOMAS GIRST Als junger Mann informierte sich Duchamp über mathematische Traktate, vor allem in der Zeit, als er in der Saint-Geneviève-Bibliothek in Paris arbeitete.

THOMAS GIRST Duchamp even did a portrait of him in 1968. A little drawing (fig. 56).

TIMOTHY PHILLIPS Oh, I have to see it.

THOMAS GIRST Was he friends with Dalí as well?

TIMOTHY PHILLIPS Oh yeah, was he ever! He was a very intelligent man. No one could be friends with Dalí without having either talent or intelligence or both.

THOMAS GIRST It is said that when Dalí was with Duchamp, Dalí wasn't the exhibitionist he used to be.

TIMOTHY PHILLIPS Dalí was never an exhibitionist, that was for the public. Dalí was the humblest man I've ever known in my life. Only interested in what he could learn, what he could absorb. A remarkable man! Duchamp was a very humble man too and so sharp and intelligent. He was a chess player, he didn't advertise his moves. I don't think that Dalí appreciated Duchamp until he began to deeply study mathematics and metaphysics. First of all, Dalí had this concept of Freudian analysis but then he outgrew it and became aware of not only geometrical format in painting, but the dynamic of mathematics and geometry which underpinned everything. So a little talk with Duchamp would show Dalí just where the real truth of things laid and he could then abandon these Freudian concepts and go to something far deeper, which he did. His paintings became progressively more mathematical and dynamic.

THOMAS GIRST He also showed a big interest in DNA.

TIMOTHY PHILLIPS Yes, he was a *scientist manqué* fascinated with contemporary science and all its branches, particularly biology and physics.

THOMAS GIRST As a young man, Duchamp read up on mathematical treatises, especially at the time he was working at the library Saint-Geneviève in Paris.

TIMOTHY PHILLIPS He did, he saturated himself in that, and I also noticed that he knew Apollinaire who was unbelievably intelligent.

THOMAS GIRST He even tried to outdo de Sade by writing *Eleven Thousand Rods* a more pornographic book than the old prisoner could have had imagined.

TIMOTHY PHILLIPS I do not know one major creative mind that did not have a pornographic streak, not one!

THOMAS GIRST Can you elaborate upon when you first met Duchamp? He and Man Ray had come up to your monastery?

TIMOTHY PHILLIPS Das tat er, er vertiefte sich völlig darin, und ich stellte auch fest, dass er Apollinaire kannte, der unheimlich intelligent war.

THOMAS GIRST Er versuchte sogar, de Sade zu überbieten, indem er mit seinen *Elftausend Ruten* ein noch pornografischeres Buch schrieb, als es sich der alte Gefangene nur hätte vorstellen können.

TIMOTHY PHILLIPS Ich kenne nicht einen bedeutenden kreativen Kopf, der nicht auch eine pornografischen Ader hätte, nicht einen einzigen!

THOMAS GIRST Können Sie ausführen, wann Sie Duchamp das erste Mal getroffen haben? Er und Man Ray sind in Ihr Kloster gekommen?

TIMOTHY PHILLIPS Meine Frau hatte sie eingeladen. Sie hatte eine bemerkenswerte Fähigkeit, Menschen zu treffen und mit ihnen Kontakte zu knüpfen, und sie war unglaublich hübsch. Es war also nicht schwierig für sie, dieses berühmte Paar einzuladen. Ich wusste, dass Duchamp ein fantastisches Gespür für die Perspektive hatte und einen messerscharfen Intellekt, aber ich dachte doch, dass er ein großer Schalk der modernen Kunst war.

THOMAS GIRST Wann änderte sich diese Einstellung für Sie?

TIMOTHY PHILLIPS Naja, ich sprach mit ihm, als ich an einer Aktstudie arbeitete, und er beglückwünschte mich zu der perspektivischen Verkürzung (Abb. 57). Er sprach davon, wie schwierig solche Verkürzungen sind, und ich wusste, dass er eine sehr ernst zu nehmende Person war. Seine allgemeine Konversation zeigte schon seine sehr hohe Intelligenz, und mir wurde klar, dass er kein Schalk war. Er sagte zu mir: »Mein Ziel ist es, die Staffelei-Malerei zu zerstören«, und ich dachte: »Aber das ist doch das, was ich mache, warum willst du es zerstören?« Ich glaube, was er wollte, war, die Banalität und das Mechanische, das als Malerei angesehen wurde, zu zerstören und die Schönheit der »grauen Materie« einzuführen, um der Malerei ein bisschen mehr Intelligenz zu verleihen.

THOMAS GIRST Ich dachte, der Begriff »graue Materie« kam erst später in Duchamps Leben auf. Sprach er mit Ihnen über die »graue Materie« in Cadaqués?

TIMOTHY PHILLIPS Nein, das hat er nie getan, weil er es nicht zu sehr vertiefen wollte. Ich wusste nicht einmal, dass er zu der Zeit bereits ein meisterhafter Schachspieler war. Ich wusste eigentlich kaum etwas über ihn oder Man Ray. Ich wusste nur, dass sie berühmte Männer waren. Ich fand es gut, dass Duchamp sich über die ganze moderne Bewegung lustig machte, weil ich sie nicht mochte.

THOMAS GIRST Haben Sie irgendeine Erinnerung daran, wie Man Ray und Duchamp zusammen waren?

TIMOTHY PHILLIPS My wife invited them. She had a remarkable ability to meet people and socialize and she was incredibly pretty. So it was no difficulty for her to have this famous pair invited. I knew that Duchamp had a fantastic grasp of perspective and a razor sharp intellect, but I thought he was the supreme joker of modern art.

THOMAS GIRST When did that change for you?

TIMOTHY PHILLIPS Well, I spoke to him while I was working on a study of a nude and he complimented me on the foreshortening (fig. 57). He said how difficult foreshortenings were and I knew this was a very serious person. Just his general conversation showed a very high intelligence and I became aware that he was no joker. He said to me: "My idea is to destroy easel painting" and I thought "But this is what I am doing, why do you want to destroy it?" I believe what he wanted was to destroy the banality and the mechanicalness of what passes for painting and to introduce the beauty of "grey matter," add a bit of intelligence into painting.

THOMAS GIRST I thought the term "grey matter" did not come up with Duchamp until later in his life. Did he mention "grey matter" to you in Cadaqués?

TIMOTHY PHILLIPS No, he never did because he wouldn't go into it very much. I didn't even know he was a master chess player at that time. I did not know nearly enough about him or Man Ray. I just knew that these were famous men. I approved of Duchamp making fun of the whole modern movement because I did not like it.

THOMAS GIRST Do you have any memory of how Man Ray and Duchamp were together?

TIMOTHY PHILLIPS Well yeah, they were terrific. Man Ray, I think it was a joke, said to me, "I intend to paint a picture of such a nature that everyone of the spectators will drop dead," and I said to him: "Mr. Ray, have you paid up your insurance premiums?"

THOMAS GIRST You must have also met Teeny, Duchamp's wife?

TIMOTHY PHILLIPS Yes, she was lovely!

THOMAS GIRST Teeny and Gala [Dalí's wife] didn't get along…

TIMOTHY PHILLIPS No, I am afraid not, they wouldn't. Gala had a commercial streak. I am sure that came as a result of her childhood in Russia and her life as an ex-patriot in Paris. She became, well, not only an entrepreneur but a total opportunist. Regretfully, it spoiled the character of an otherwise wonderfully civilized woman, that's too bad. And also of course, she was a nymphomaniac and Dalí alone couldn't

TIMOTHY PHILLIPS Ja also, sie waren fantastisch. Man Ray sagte zu mir, ich dachte, es sei ein Scherz: »Ich plane, ein Bild dergestalt zu malen, dass jeder Betrachter tot umfällt«, und ich sagte zu ihm: »Mr. Ray, haben Sie schon Ihre Versicherungsbeiträge gezahlt?«

THOMAS GIRST Sie müssen auch Teeny, Duchamps Frau, kennen gelernt haben?

TIMOTHY PHILLIPS Ja, sie war entzückend!

THOMAS GIRST Teeny und Gala [Dalís Frau] kamen nicht miteinander aus …

TIMOTHY PHILLIPS Nein, ich fürchte nicht. Gala hatte eine geschäftliche Ader. Ich bin mir sicher, dass das eine Folge ihrer Kindheit in Russland und ihres Lebens als Exilantin in Paris war. Sie wurde, nun ja, nicht nur eine Unternehmerin, sondern auch eine totale Opportunistin. Bedauerlicherweise ruinierte dies den Charakter einer ansonsten wundervoll zivilisierten Frau, das ist schade. Und sie war natürlich auch eine Nymphomanin, und Dalí alleine konnte sie sexuell nicht so befriedigen, wie es Bootsmänner oder junge Schauspieler oder irgendwer anders getan hätte. Schließlich wurde Dalí depressiv und schlug sie im Hotel Meurice. Sie beendeten die Beziehung, und das war das Ende für Dalí, weil sie für alles Geschäftliche zuständig gewesen war.

THOMAS GIRST Wie haben sie ihre Sommer gemeinsam verbracht?

TIMOTHY PHILLIPS Nun ja, er malte vom frühen Morgen an bis zum Einbruch der Dunkelheit, nach dem Abendessen machte er das Licht an und malte bei künstlichem Licht weiter. Gelegentlich fuhr er mit Gala für eine kleine Exkursion in einem gelben Fischerboot aus, und oft war ich dabei. Wir fuhren zu diesen Inseln abseits des Cap Creus.

THOMAS GIRST Wo man diese Steinformationen sehen kann, die man manchmal in Dalís Malereien findet?

TIMOTHY PHILLIPS Ja, wundervolle Steinformationen!

THOMAS GIRST Und Gala las ihm vor, während er malte?

TIMOTHY PHILLIPS Ja, sie las ihm die pornografischsten Werke vor, die sie finden konnte: Marquis de Sade und auch Rabelais.

THOMAS GIRST Wissen Sie, dass jemand einst mit Gala zusammen L.H.O.O.Q. für eine surrealistische Ausstellungen in den 1960ern nachstellte – L.H.O.O.Q., Comme d'Habitude (Abb. 58)?

TIMOTHY PHILLIPS Es ist höchste Ironie, Gala einen Schnäuzer zu verpassen. Übrigens lag viel Spannung zwischen Gala und Dalí. Er wusste, dass sie eine Nymphomanin war und ihn sexuell betrog, so oft sie konnte. Dalí und Gala führten zu der Zeit eine unglückliche Beziehung,

satisfy her sexually, so boatmen or young actors or anything else would do. Eventually, Dalí got fed up and he slugged her in the Hotel Meurice. They broke up and that was the end for Dalí because she did all the business.

THOMAS GIRST How did they spend their summers together?

TIMOTHY PHILLIPS Well, he would paint from early morning until nightfall, then after supper he'd turn on the lights and painted by artificial light. Occasionally, he'd go out on a little excursion in a yellow fishing boat with Gala and I would often come along. We'd go to those islands off Cap Creus.

THOMAS GIRST Where you can see those rock formations sometimes found in Dalí's paintings?

TIMOTHY PHILLIPS Yes, wonderful rock formations!

THOMAS GIRST And Gala would read to him while he was painting?

TIMOTHY PHILLIPS Yes, she would read to him the most pornographic works that she could find: Marquis de Sade and also Rabelais.

THOMAS GIRST Do you know that someone once did the *L.H.O.O.Q.* with Gala for a Surrealist exhibition in the 1960s—the *L.H.O.O.Q., Comme D'Habitude* (fig. 58)?

TIMOTHY PHILLIPS This is a supreme piece of irony to put the moustache on Gala. Incidentally, there was a lot of tension between Gala and Dalí. He knew that she was a nympho and that she betrayed him sexually every time she could. Dalí and Gala were a very unhappy union at the time, projecting to the public something they weren't. But she had an amazing eye!

THOMAS GIRST For his art or for young men?

TIMOTHY PHILLIPS Both! (laughs.) Regarding Duchamp and Dalí, she didn't like Dalí giving too much credit to anyone. Her idea was that Dalí should be some kind of a demigod, a Renaissance man who simply absorbed everything osmotically and gave it back in his own way. The fact that he would then commune with Duchamp I think disturbed her a little bit. The idea that anyone could influence Dalí was alien to her.

THOMAS GIRST So when you met him was he still practicing his paranoic-critical method?

TIMOTHY PHILLIPS The paranoic-critical method was with him from the time he discovered it until his death. It was his basic method of creation. And it was really his way to liberate the right hemisphere of the brain because what hinders the sane person is the critique of the left

sie gaben in der Öffentlichkeit vor, etwas zu sein, was sie nicht waren. Aber sie hatte ein verblüffendes Auge!

THOMAS GIRST Für seine Kunst oder für junge Männer?

TIMOTHY PHILLIPS Beides! (lacht.) Was Duchamp und Dalí anging, so mochte sie es nicht, dass Dalí manchen Menschen so viel Anerkennung zollte. Ihrer Meinung nach sollte Dalí so eine Art Halbgott sein, ein Mann der Renaissance, der einfach alles osmotisch aufsog und in seiner eigenen Art und Weise wieder hervor brachte. Die Tatsache, dass er dann mit Duchamp so vertraut war, glaube ich, störte sie ein wenig. Der Gedanke, dass überhaupt irgendjemand Dalí beeinflussen konnte, war ihr fremd.

THOMAS GIRST Als Sie ihn also kennenlernten, praktizierte er immer noch seine paranoid-kritische Methode?

TIMOTHY PHILLIPS Diese paranoid-kritische Methode begleitete ihn von dem Moment, in dem er sie erfand, bis zu seinem Tod. Es war seine grundsätzliche Methode der Kreation. Und es war wirklich sein Weg, die rechte Hemisphäre des Gehirns freizusetzen, weil das, was den vernünftigen Menschen hindert, die Kritik der linken Hemisphäre ist. Sie ist kritisch und linear, aber wenn man die rechte Seite des Gehirns freisetzen kann, kann man diese wundervollen Einsichten haben, die frei jeglicher einschränkender Logik sind. Sie haben ihre eigenen Logiken. Es gibt so viele verschiedene Logiken — irrationale oder nicht-irrationale und hyperrationale Logiken. Sie existieren alle in der Mathematik, und das war Dalís Weg, mit dem Überrationalen in Verbindung zu treten.

THOMAS GIRST Und zugleich in das Unterbewusste einzutauchen.

TIMOTHY PHILLIPS Aber ich glaube, Duchamp zeigte ihm, dass es da eine mathematische Basis für all dies gibt. Es faszinierte Dalí sehr, zu sehen, dass Duchamp mit diesen Dingen umgehen konnte. Er verstand das ganze Feld der fortgeschrittenen Mathematik.

THOMAS GIRST Also gegenseitiger Respekt voreinander.

TIMOTHY PHILLIPS Ja, gegenseitiger Respekt. Viel gegenseitige Bewunderung unter den beiden Genies. Sie waren zwei Seelen auf einer Wellenlänge.

THOMAS GIRST Und in einem der Gemälde Dalís reicht Dalí Duchamp die Krone und macht ihn zum König.

TIMOTHY PHILLIPS Ja, das ist *Salvador Dalí malt Gala bei der Apotheose des Dollar*. Auf der linken Seite ist Marcel Duchamp als Ludwig XIV. verkleidet zu erkennen hinter einem Vorgang im Stile Vermeers,

hemisphere. It is critical and linear, but if you can liberate the right side of the brain you can have these wonderful insights, which are free of limiting logic. They have their own logics. There are so many different logics—irrational or non-rational and hyper-rational logics. They're all in mathematics, so that is Dalí's method of contacting the super-rational.

THOMAS GIRST And delving into the subconscious at the same time.

TIMOTHY PHILLIPS But I think Duchamp showed him that there was a mathematical basis for all this. It clearly fascinated Dalí to see that Duchamp could handle these things. He understood the whole field of advanced mathematics.

THOMAS GIRST Hence their mutual respect.

TIMOTHY PHILLIPS Yes, mutual respect. A lot of mutual admiration between two geniuses. They were two minds on a single wavelength.

THOMAS GIRST And in one of Dalí's paintings, Dalí hands the crown to Duchamp, turning him into a king.

TIMOTHY PHILLIPS Yes, it is *Salvador Dalí in the Act of Painting Gala in the Apotheosis of the Dollar, in which One may also Perceive to the Left Marcel Duchamp Disguised as Louis XIV, behind a Curtain in the Style of Vermeer, which is but the Invisible Monument Face of the Hermes of Praxiteles* (fig. 59) which he did three years after I broke off contact in 1962. There are so many references in the title alone. To begin with, you have the helix and its reflection.

THOMAS GIRST In the background you also find allusions to Duchamp's *Nude Descending a Staircase* of 1912 (fig. 12).

TIMOTHY PHILLIPS An incredibly complex painting with the Velázquez door and the Vermeer curtain. I believe that Dalí acknowledged Duchamp as the major mind force in modern art. For me, everything else is an effervescence of superior talent, but without real significance. Besides Klee, Dalí and Duchamp, I can't really think of many of the others as anything except being exceptional talents. Klee was a man who I think understood the insane, children and the symbolism of these minds which might in certain ways be far superior to normal minds. There might in fact be no such thing as insanity, because you can't define sanity. And Klee's exploration of the insane I think went deeper than Dalí's. At the time, I thought the value of Dalí was in his superb technique. Now I think that his technique was cumbersome although he achieved miracles.

THOMAS GIRST But Dalí as a person must have been much more insane than Klee!

der nichts anderes als das unsichtbare aber monumentale Gesicht des *Hermes von Praxiteles* ist (Abb. 59), das er 1962, drei Jahre, nachdem ich den Kontakt abgebrochen hatte, fertigstellte. Es gibt allein im Titel so viele Referenzen. Fangen wir mit der Helix und ihrer Reflektion an.

THOMAS GIRST Im Hintergrund findet man auch Anspielungen auf Duchamps *Akt, eine Treppe herabsteigend* aus dem Jahre 1912 (Abb. 12).

TIMOTHY PHILLIPS Ein unheimlich komplexes Bild mit der Velázquez-Tür und dem Vermeer-Vorhang; ich glaube, dass Dalí Duchamp als größte Geisteskraft der modernen Kunst anerkannte. Alles andere ist für mich ein Aufbrausen ausgezeichneter Talente, aber ohne wirkliche Bedeutung. Neben Klee, Dalí und Duchamp halte ich von den meisten anderen nicht allzu viel mit der Ausnahme, dass sie außergewöhnliche Talente sind. Klee war ein Mensch, von dem ich glaube, dass er die Wahnwitzigen, die Kinder und den Symbolismus dieser Denkweisen verstand, die in verschiedener Hinsicht den normalen Denkweisen weit überlegen sind. Es mag tatsächlich so etwas wie Wahnwitz gar nicht geben, weil man den gesunden Verstand nicht definieren kann. Und Klees Erforschung des Wahnwitzigen ging tiefer als Dalís, glaube ich. Zu der Zeit dachte ich, dass der Wert Dalís in seiner ausgezeichneten Technik lag. Jetzt glaube ich, dass seine Technik umständlich war, wenn er auch Wunder damit erzielte.

THOMAS GIRST Aber Dalí als Person muss viel wahnwitziger gewesen sein als Klee!

TIMOTHY PHILLIPS Klee war Schweizer! Was erwarten Sie von einem Schweizer?

THOMAS GIRST Nicht zu viel von dem, was Dalí war, mit seinen großen Augen ...

TIMOTHY PHILLIPS Das war etwas, was er lediglich inszenierte. Dalí war ganz und gar nicht wahnwitzig, einer der vernünftigsten Menschen, die ich in meinem Leben je getroffen habe. Mein Gott, war er vernünftig [lacht]!

Aus dem Englischen von Janina Wildfeuer

Das Interview wurde am 20. Juni 1999 in Timothy Phillips Tappa Galerie in Toronto geführt. Es ist in voller Länge als digitale Videoaufzeichnung erhalten, gefilmt von Friederike N. Gauss, ASRL Archiv, New York Y. Der Beitrag wurde in englischer Sprache erstmals in: *Tout-Fait: The Marcel Duchamp Studies Online Journal* Vol. 1, Ausg. 1, 1999, veröffentlicht <www.toutfait.com/online_journal_details.php?postid=795> (20.8.2012).

TIMOTHY PHILLIPS Klee was Swiss! What do you expect of a Swiss?
THOMAS GIRST Not too much of what Dalí was, with his staring eyes...
TIMOTHY PHILLIPS That was something he just put on. Dalí wasn't insane at all, one of the sanest men I've ever met in my life. My god was he sane (laughs.)!

The interview was conducted at Timothy Phillips's Tappa Gallery in downtown Toronto, June 20, 1999. It is preserved in full on a digital videotape, ASRL archive, New York (filmed by Friederike N. Gauss). This article was first published in English in: *Tout-Fait: The Marcel Duchamp Studies Online Journal* vol 1, issue 1, 1999, <www.toutfait.com/online_journal_details.php?postid=795> (August 20, 2012).

VON BLUES ZU HAIKUS
EIN INTERVIEW MIT CHARLES HENRI FORD

Neben seiner Tätigkeit als surrealistischer Schriftsteller, Fotograf und Schöpfer von Kunstobjekten gab Charles Henri Ford (1913–2002) Avantgarde-Magazine wie *Blues* und *View* heraus. Wie Alan Jones im *Arts Magazine* schreibt, »öffnete Ford die Seiten seiner ›Zeitung für Poeten‹ für den Schwarm europäischer Surrealisten (Max Ernst, Yves Tanguy, André Beton, Marcel Duchamp) und die wiederkehrenden Söhne und Töchter, die alle aus Europa nach New York zurückflüchteten. Indem es die Welten von Literatur und Kunst verband, wuchs *View* schnell zu einem Kunstmagazin jener Art heran, wie es die Vereinigten Staaten noch nie gesehen hatten«.

Zusammen mit Parker Tyler verfasste Charles Henri Ford den omni-sexuellen Roman *The Young and the Evil*, der 1933 in Paris veröffentlicht wurde und in den USA und in England 50 Jahre lang verboten war. Seine Ambitionen als Autor und Herausgeber brachten ihn in Kontakt mit Autoren wie William Carlos Williams, Wallace Stevens, Jean Cocteau und besonders Djuna Barnes, für die er *Nightwood* in Marokko abtippte, während er Paul und Jane Bowles besuchte. Ford wurde ein früher Förderer der Pop-Art und hatte großen Einfluss auf Andy Warhol und seinen Kreis. Aktiv wie stets zeigte er erst kürzlich seine Plakatentwürfe in der Ubu Galerie in New York und bereitet zudem eine Veröffentlichung seiner jüngsten Sammlung von Haikus vor.

Am 2. Mai 2000 trafen wir in seinem New Yorker Apartment einen munteren Ford sowie seine enge Freundin, die Performance-Künstlerin Penny Arcade an, um mit ihm unter anderem über eine Ausgabe des *View*-Magazins aus dem Jahre 1945 zu diskutieren (Abb. 47), die Marcel Duchamp gewidmet war und Fords Gedicht über diesen, *Flag of Ecstasy*, beinhaltete. Wir brachten unsere Kopien des *View*-Magazins mit, um ihn über bestimmte Besonderheiten darin zu befragen.

Das Interview wurde gemeinsam mit Rhonda Roland Shearer geführt, der Direktorin des Art Science Research Laboratory, New York.

FROM BLUES TO HAIKUS
AN INTERVIEW WITH CHARLES HENRI FORD

In addition to writing Surrealist literature, being a photographer and creating art objects, Charles Henri Ford (1913–2002) published such avant-garde magazines as *Blues* and *View*. As Alan Jones wrote in *Arts Magazine:*

Ford opened the pages of his 'newspaper for poets' to the swarm of European Surrealists (Max Ernst, Yves Tanguy, André Breton, Marcel Duchamp) and the returning native sons and daughters all fleeing Europe for New York. Bridging the worlds of literature and art, *View* rapidly grew into an art magazine the likes of which the United States had never seen.

Charles Henri Ford, together with Parker Tyler, authored the omnisexual novel *The Young and the Evil*, published in Paris in 1933 and banned in the United States and England for fifty years. His ambitions as a writer and editor brought him in contact with authors like William Carlos Williams, Wallace Stevens, Jean Cocteau and especially Djuna Barnes, for whom he typed up *Nightwood* in Morocco while visiting Paul and Jane Bowles. Ford became an early supporter of Pop Art and a crucial influence on Andy Warhol and his circle. Active as ever, he has recently shown his poster designs at the Ubu Gallery, New York and is preparing a publication of his latest collection of haikus.

On May 2, 2000, we met with a lively Ford, and his close friend, performance artist Penny Arcade, in Ford's New York apartment to discuss, among other topics, a 1945 issue of *View* magazine devoted to Marcel Duchamp (fig. 47), which contained Ford's poem about the artist, "Flag of Ecstasy." We brought our copies of *View* to ask him about several curiosities.

The interview was conducted together with Rhonda Roland Shearer, director of the Art Science Research Laboratory, New York.

RHONDA ROLAND SHEARER Wissen Sie, wer die Fotografie von Marcel Duchamp im Alter von 85 Jahren gemacht hat (Abb. 50), die am Ende der Marcel Duchamp-Ausgabe des *View*-Magazins vom März 1945 zu sehen ist?

CHARLES HENRI FORD Wissen Sie, das war ein Versehen, niemand wusste davon. Das auf der linken Seite, das Duchamp 1922 zeigt, ist von Stieglitz, oder?

RHONDA ROLAND SHEARER Ja, so steht das da, aber es wird nicht gesagt, wer das andere Foto gemacht hat.

CHARLES HENRI FORD Das ist richtig.

RHONDA ROLAND SHEARER Einige sagen, es war ein Double, jemand, der aussieht wie Duchamp. Aber ich glaube, dass es Duchamp ist, und Sie wissen, dass das so ist.

CHARLES HENRI FORD Oh ja, natürlich ist er es. Andernfalls wäre es nicht, würde es ...

RHONDA ROLAND SHEARER ... nichts bedeuten?

CHARLES HENRI FORD Es würde nicht funktionieren. Duchamp wurde sehr stark geschminkt um alt auszusehen.

RHONDA ROLAND SHEARER Aber erinnern Sie sich gar nicht, wer dieses Foto gemacht hat?

CHARLES HENRI FORD Vielleicht wusste ich das nie.

RHONDA ROLAND SHEARER Seite 4 des *View*-Magazins gibt Ihr Gedicht *Flag of Ecstasy* wieder, eine Hommage an Duchamp, das ein Detail aus Man Rays *Dust Breeding,* das den unteren Teil des *Großen Glases* zeigt, überlagert. Wie kam es dazu, *Dust Breeding* mit Ihrem Gedicht darauf?

CHARLES HENRI FORD Nun ja, es ist etwas, was der Drucker hinein kopierte.

RHONDA ROLAND SHEARER Suchten Sie es für Ihr Gedicht aus oder war es Parker Tyler, der für die Typografie von *Poems for Painters* (Abb. 60) zuständig war, das im selben Jahr veröffentlicht wurde und auch *Flag of Ecstasy* beinhaltete?

CHARLES HENRI FORD Ich erinnere mich nicht ... Das ist Schnee von gestern, ich kann mich nicht erinnern.

RHONDA ROLAND SHEARER Es ist ein fabelhaftes Gedicht.

THOMAS GIRST Ihr Gedicht über Duchamp ist ganz wunderbar.

CHARLES HENRI FORD Mögen Sie es?

THOMAS GIRST Oh ja, das tue ich.

RHONDA ROLAND SHEARER Do you know who took the photograph Duchamp at the Age of eighty-five (fig. 50) that was published in the back of *View's* Duchamp issue of March 1945?

CHARLES HENRI FORD You see that was an oversight, one never knew. The one to its left, showing Duchamp in 1922 is Stieglitz, isn't it?

RHONDA ROLAND SHEARER Yes that's what it says but it doesn't say who took the other one.

CHARLES HENRI FORD That's right.

RHONDA ROLAND SHEARER Some people said that this was a double, somebody that looked like Duchamp. But I think it's Duchamp, and you know it is.

CHARLES HENRI FORD Oh yeah, of course it is. Otherwise it wouldn't be, it wouldn't …

RHONDA ROLAND SHEARER … mean anything?

CHARLES HENRI FORD … it wouldn't work. Duchamp was heavily made up to look old.

RHONDA ROLAND SHEARER But you don't remember who took the photograph?

CHARLES HENRI FORD Maybe I never even knew.

RHONDA ROLAND SHEARER Page four of *View* magazine reproduces your poem "Flag of Ecstasy," an homage to Duchamp, superimposed on a detail of Man Ray's *Dust Breeding,* showing the lower part of the *Large Glass.* How did this come about, *Dust Breeding* with your poem on it?

CHARLES HENRI FORD Well, it's something that the printer superimposed.

RHONDA ROLAND SHEARER Did you pick it out for your poem or did Parker Tyler who did the typography of your *Poems for Painters* (fig. 60), published in the same year and also reproducing "Flag of Ecstasy"?

CHARLES HENRI FORD I don't remember … so much water under the bridge, I can't remember.

RHONDA ROLAND SHEARER It's a fabulous poem.

THOMAS GIRST Your poem on Duchamp is a great one.

CHARLES HENRI FORD You like it?

THOMAS GIRST Yes, I do.

RHONDA ROLAND SHEARER Could you read it for us? Do you read your poetry still?

CHARLES HENRI FORD Why, yes.

RHONDA ROLAND SHEARER Können Sie es uns vorlesen? Lesen Sie noch immer Ihre Gedichte vor?
CHARLES HENRI FORD Warum nicht. Ja.

»Over the towers of autoerotic honey
Over the dungeons of homicidal drives
Over the pleasure of invading sleep
Over the sorrows of invading a woman
Over the voix celeste
Over vomito negro
Over the unendurable sensation of madness
Over the insatiable sense of sin
Over the spirit of uprisings
Over the bodies of tragediennes
Over tarantism: »melancholy stupor and an uncontrollable
 desire to dance«
Over all
Over ambivalent virginity
Over unfathomable succubi
Over the tormentors of Negresses
Over openhearted sans-culottes
Over a stactometer for the tears of France
Over unmanageable hermaphrodites
Over the rattlesnake sexlessness of art-lovers
Over the shithouse enigmas of art-haters
Over the son's lascivious serum
Over the sewage of the moon
Over the saints of debauchery
Over criminals made of gold
Over the princes of delirium
Over the paupers of peace
Over signs foretelling the end of the world
Over signs foretelling the beginning of a world
Like one of those tender strips of flesh
On either side of the vertebral column
Marcel, wave!«

PENNY ARCADE Fantastisch.

Over the towers of autoerotic honey
Over the dungeons of homicidal drives
Over the pleasure of invading sleep
Over the sorrows of invading a woman
Over the voix celeste
Over vomito negro
Over the unendurable sensation of madness
Over the insatiable sense of sin
Over the spirit of uprisings
Over the bodies of tragediennes
Over tarantism: "melancholy stupor and an uncontrollable
 desire to dance"
Over all
Over ambivalent virginity
Over unfathomable succubi
Over the tormentors of Negresses
Over openhearted sans-culottes
Over a stactometer for the tears of France
Over unmanageable hermaphrodites
Over the rattlesnake sexlessness of art-lovers
Over the shithouse enigmas of art-haters
Over the son's lascivious serum
Over the sewage of the moon
Over the saints of debauchery
Over criminals made of gold
Over the princes of delirium
Over the paupers of peace
Over signs foretelling the end of the world
Over signs foretelling the beginning of a world
Like one of those tender strips of flesh
On either side of the vertebral column
Marcel, wave!

PENNY ARCADE Marvelous.
RHONDA ROLAND SHEARER Great, wonderful, beautiful. Thank you
CHARLES HENRI FORD I'm out of practice, I don't read. People ask
me to read and I don't usually read. But you win.
RHONDA ROLAND SHEARER I thank you, we love your work. Tell
us about the Frederick J. Kiesler fold out in *View's* Duchamp number

RHONDA ROLAND SHEARER Großartig. Wundervoll. Sehr schön. Vielen Dank.

CHARLES HENRI FORD Ich bin aus der Übung, ich lese nicht vor. Die Menschen wollen von mir, dass ich vorlese, und ich tue es gewöhnlich nicht. Aber Sie haben gewonnen.

RHONDA ROLAND SHEARER Ich danke Ihnen. Wir lieben Ihre Arbeiten. Erzählen Sie uns etwas über den Friedrich J. Kiesler-Centerfold in der Duchamp-Ausgabe von *View* (Abb. 48). Sie sagten, es war sehr teuer, diesen herzustellen. Er ist wunderschön. Mögen Sie ihn?

CHARLES HENRI FORD Ja, sicher. Er hat eine Menge Geld gekostet. Ich glaube, das hat unser Budget gesprengt.

RHONDA ROLAND SHEARER Woran erinnern Sie sich dabei in Bezug auf Duchamp und Kiesler? Haben sie Sie genötigt, ihn zu produzieren?

CHARLES HENRI FORD Nein, sie haben ihn einfach eingereicht.

RHONDA ROLAND SHEARER Ja, und Sie mochten ihn einfach und mussten ihn produzieren.

CHARLES HENRI FORD Ja, ich dachte, dass ich bereit bin, alles zu riskieren.

RHONDA ROLAND SHEARER Ja, das ist es doch, worum es bei Kunst geht, oder? Wer ist Peter Lindamood, der im März 1945 *I Cover the Cover* als Einleitung zum *View*-Magazin schrieb? Ist das nur ein Pseudonym?

CHARLES HENRI FORD Nein, Peter Lindamood war aus Mississippi, er war Unteroffizier beim Militär und so weiter.

PENNY ARCADE War er ein Freund aus Mississippi?

CHARLES HENRI FORD Ja, war er. Ja. Er war für eine spezielle italienische Ausgabe zuständig, oder?

PENNY ARCADE Ich weiß es nicht.

RHONDA ROLAND SHEARER Er schien sehr eifrig an der Duchamp-Ausgabe zu arbeiten, sagt man. Man sagt, dass er hörte, dass Duchamp mit einigen Problemen zu kämpfen hatte, um diesen Spezialeffekt für das Titelblatt zu machen und es scheint so, dass bei der Titelblattgestaltung jede Menge Tricks angewandt wurden. Erinnern Sie sich?

CHARLES HENRI FORD Nein.

RHONDA ROLAND SHEARER Aber es ist sehr schön.

CHARLES HENRI FORD Ja, das ist es.

RHONDA ROLAND SHEARER Ein anderes Coverdesign Duchamps für die *View*-Ausgabe *Young Cherry Trees Secured Against Hares* (1946), André Bretons gesammelte Gedichte, zeigt das Gesicht des Surrealis-

(fig. 48). You said that was very expensive to do. It's beautiful. Do you like it?

CHARLES HENRI FORD Yes, sure. It cost a lot of money. I think it broke our budget.

RHONDA ROLAND SHEARER So what do you remember in terms of Duchamp and Kiesler doing this? Were they pushing you to, saying it had to be done?

CHARLES HENRI FORD No, they just turned it in.

RHONDA ROLAND SHEARER Yup, and you just liked it and had to do it.

CHARLES HENRI FORD Yeah, I thought that I would risk all.

RHONDA ROLAND SHEARER Yeah, that's what art is about, isn't it? Who is Peter Lindamood who wrote the "I Cover the Cover" as an introduction to the *View* magazine of March 1945? Is that just a pseudonym?

CHARLES HENRI FORD No. Peter Lindamood was from Mississippi, he was a corporal in the military and so on.

PENNY ARCADE Was he a friend of yours from Mississippi?

CHARLES HENRI FORD Yes he was, yes. He edited a special Italian number, didn't he?

PENNY ARCADE I don't know.

RHONDA ROLAND SHEARER And so he apparently worked very hard on the Duchamp issue, it says. What he talks about is that he heard that Duchamp went through a lot of trouble to make this special effect for the cover and apparently there's all sorts of levels of trick photography in making this cover. Do you recall?

CHARLES HENRI FORD No.

RHONDA ROLAND SHEARER But it's beautiful.

CHARLES HENRI FORD Yes it is.

RHONDA ROLAND SHEARER Another of Duchamp's covers for *View* Editions, *Young Cherry Trees Secured Against Hares* (1946), André Breton's collected poems, shows the Surrealist's face through a cut-out, thus posing as the Statue of Liberty (fig. 61). Did you ask Duchamp to make this cover?

CHARLES HENRI FORD Yes. Duchamp always liked to be surprising and Breton of course was noted for not cherishing homosexuals. That's why André Breton was put in drag.

THOMAS GIRST Breton supposedly liked the cover.

ten in einem Cut Out, wie er als Freiheitsstatue posiert (Abb. 61). Haben Sie Duchamp gefragt, ob er dieses Titelblatt für Sie gestaltet?

CHARLES HENRI FORD Ja. Duchamp mochte es immer zu überraschen, und Breton war natürlich dafür bekannt, Homosexuelle nicht zu schätzen. Das ist der Grund, warum André Breton in Frauenkleidern zu sehen war.

THOMAS GIRST Breton mochte das Titelblatt angeblich.

CHARLES HENRI FORD Er mochte jede Aufmerksamkeit, die ihm entgegengebracht wurde. Niemand hat seine Gedichte in Amerika veröffentlicht.

THOMAS GIRST Es war die einzige übersetzte Ausgabe seiner Gedichte, die aus seiner Zeit in New York hervorging.

CHARLES HENRI FORD Und dann rückte er noch mit einer anderen Ausgabe heraus, und sie haben sein Titelblatt irgendwie nicht genommen. Aber das ist alles Schnee von gestern ... was ich in den letzten Jahren getan habe, ist dort anzufangen, wo Matisse aufgehört hat, Cut-Outs und sowas herstellen, aber das war bei ihm alles begrenzt auf das weibliche Geschlecht. Ich fing damit an, um seine Vernachlässigung aufzuholen. Ich zeige Ihnen ein Beispiel.

RHONDA ROLAND SHEARER Sie sind ursprünglich aus Mississippi?

CHARLES HENRI FORD Geboren in Mississippi, aufgewachsen in Tennessee. If you don't like my peaches, don't you shake my tree.

THOMAS GIRST Von Columbus in Mississippi aus begannen Sie 1929 mit der Herausgabe von *Blues*, einem kurzlebigen Gedicht-Magazin, das Gertrude Stein einst als »das jüngste und frischeste aller kleinen Magazine, die starben, um die Lyrik zu befreien«, bezeichnete. Sie waren erst 16 Jahre alt, als die erste Ausgabe herauskam.

CHARLES HENRI FORD Und jetzt bin ich 87, ungefähr so alt wie Balthus und Cartier-Bresson.

THOMAS GIRST Und Balthus geht es immer noch genauso gut wie Ihnen.

PENNY ARCADE Kennen Sie Balthus?

CHARLES HENRI FORD Ich habe ihn mal getroffen.

THOMAS GIRST Er ist sehr zurückgezogen, Balthus. Er lebt in einem kleinen Dorf in der Schweiz, in Rossinière, in einem kleinen Schloss mit einer wunderschönen Frau, die vielleicht vierzig Jahre jünger ist als er.

PENNY ARCADE Faszinierend ... wir sollten Balthus eine Nachricht schicken, »Charles Henri Ford lässt grüßen. Immer noch unter den Lebenden ... «

CHARLES HENRI FORD He liked any attention that was paid to him. I mean nobody was publishing his poetry in America.

THOMAS GIRST That was the only translated volume of poetry resulting from his time in New York.

CHARLES HENRI FORD And then he came out with another edition too and they didn't use his cover somehow. But it's all water under the bridge ... what I've been doing for the past few years is taking up where Matisse left off, doing cut outs and things but it was limited to the female sex so I've been making up for his neglect. I'll show you an example.

RHONDA ROLAND SHEARER Originally you're from Mississippi?

CHARLES HENRI FORD Born in Mississippi, raised in Tennessee, if you don't like my peaches, don't you shake my tree.

THOMAS GIRST From Columbus, Mississippi you started *Blues* in 1929, the short-lived poetry magazine which Gertrude Stein once praised as "the youngest and freshest of all the little magazines which have died to make verse free." You were only sixteen when its first issue came out.

CHARLES HENRI FORD Now I'm 87, about the same as Balthus and Cartier-Bresson.

THOMAS GIRST And Balthus is still doing as well as you are.

PENNY ARCADE Did you know Balthus?

CHARLES HENRI FORD I met him, once.

THOMAS GIRST He's very reclusive, Balthus. He lives in a tiny village in Switzerland, Rossinière, in a little chateau, with a beautiful wife maybe forty years his minor.

PENNY ARCADE Fascinating ... we should send a message to Balthus, "Charles Henri Ford says 'Hi.' Still alive..."

THOMAS GIRST "...we're still standing, alive and kicking."

RHONDA ROLAND SHEARER Did you know the librarian at the Morgan library, her name was Belle Greene?

CHARLES HENRI FORD No.

RHONDA ROLAND SHEARER She was the woman that put the library together for Morgan. And she knew a lot of the artists, she posed nude for a lot of them and actually wrote an article in 291 and was hanging out with Stieglitz. I don't know if you ran into her.

CHARLES HENRI FORD No. If she ran into me, I didn't feel it. [An air of flirtation ensues.] Penny looks always surprised when she's not at all surprised.

THOMAS GIRST »Wir sind immer noch da, gesund und munter.«

RHONDA ROLAND SHEARER Kannten Sie die Bibliothekarin in der Morgan-Bibliothek, ihr Name war Belle Grenne?

CHARLES HENRI FORD Nein.

RHONDA ROLAND SHEARER Sie war diejenige, die die Bibliothek für Morgan zusammengestellt hat. Und sie wusste sehr viel über die Künstler, sie posierte oft nackt für sie und schrieb sogar einen Artikel in *291* und ging mit Stieglitz aus. Ich weiß nicht, ob Sie ihr mal über den Weg gelaufen sind.

CHARLES HENRI FORD Nein. Wenn sie mir über den Weg gelaufen ist, habe ich es nicht mitbekommen [er flirtet]. Penny schaut immer überrascht, wenn sie überhaupt nicht überrascht ist.

PENNY ARCADE Ich bin überhaupt nicht überrascht. Das ist Deine verborgene Bisexualität.

CHARLES HENRI FORD Nicht nur verborgen, sie wird auch gelebt.

RHONDA ROLAND SHEARER Wirklich?

PENNY ARCADE Oh ja. Sie können sich da einreihen in eine Liste von Frauen wie Frida Kahlo.

RHONDA ROLAND SHEARER Heißt das, ich hätte eine Chance?

CHARLES HENRI FORD Ehm?

PENNY ARCADE Er will Sie nicht verstehen.

RHONDA ROLAND SHEARER Er gibt vor, es nicht zu tun. Heißt das, ich hätte eine Chance?

CHARLES HENRI FORD Oh ja.

THOMAS GIRST Ihr Eintrag im *Dictionary of Literary Biography* erwähnt ihre Einreichung eines poetischen Prosastücks für *Readies for Bob Brown's Machine*. Ihr Beitrag aus dem Jahre 1931 war gedacht als Vorlesemaschine, die es Lesern ermöglichte, durch Bänder und eine Kurbel die Wörter vor ihren Augen herfahren zu lassen. Die stromlinienförmigen Sätze sollten so weitab konventioneller Bücher sein wie Tonfilme es von der Bühne sind. Sie beseitigten einfach jegliche Interpunktion und alle Großbuchstaben.

CHARLES HENRI FORD e. e. cummings hat das auch gemacht.

PENNY ARCADE Eines der Dinge, die wirklich ungewöhnlich an Charles sind, ist, dass er andere Künstler anerkennt. Ich sagte einmal zu Charles: »Eines der Dinge, die ich wirklich an Dir liebe, ist dass Du andere Künstler unterstützt« Und Du sagtest: »Ich unterstütze keine anderen Künstler«, und ich sagte: »Aber Du hast andere Autoren veröffentlicht, andere Dichter unterstützt«, und Du sagtest: »Ich habe keine anderen

PENNY ARCADE Not at all surprised. It's your latent bisexuality.

CHARLES HENRI FORD Not only latent, it was executed.

RHONDA ROLAND SHEARER Really?

PENNY ARCADE Oh, yes. You can join the ranks of women like Frida Kahlo.

RHONDA ROLAND SHEARER So does this mean that I have a chance?

CHARLES HENRI FORD Huh?

PENNY ARCADE He doesn't want to understand you.

RHONDA ROLAND SHEARER He pretends he doesn't. Does this mean I have a chance?

CHARLES HENRI FORD Oh. Yeah.

THOMAS GIRST Your entry for the *Dictionary of Literary Biography* mentions your submission of a poetic prose piece to *Readies for Bob Brown's Machine*. Your contribution of 1931 was intended for a Reading Machine that allowed readers to speed the words past their eyes via reels and a crank. The streamlined sentences should be as far away from conventional books as sound motion pictures were from the stage. You simply eliminated all punctuation and capital letters.

CHARLES HENRI FORD e. e. cummings did that too.

PENNY ARCADE One of the things that's unusual about Charles is that he actually acknowledges other artists. Once I said to Charles, "One of the things that I really love about you is that you promote other artists." And you said, "I don't promote other artists," and I said, "But you published other writers, you promoted other writers," and you said, "I wasn't promoting other artists, I was exercising my taste."

THOMAS GIRST And you still write poetry, right? You write haikus.

CHARLES HENRI FORD Only haikus… I have a thousand page book, I think, of haikus and a friend of mine is going to make a typescript for that book.

THOMAS GIRST Do you write them daily, haikus?

CHARLES HENRI FORD Yeah, I guess so, but I don't make a point of it. If they come to me, I have to write them down quick, otherwise they fly out of my head.

RHONDA ROLAND SHEARER Would you read a couple?

CHARLES HENRI FORD
"Good with the bad
Charles is ready when you are
Good with the bad, what does that mean?"

Künstler unterstützt, ich habe lediglich meinen Geschmack ausgeübt«.

THOMAS GIRST Und Sie schreiben auch immer noch Gedichte, richtig? Sie schreiben Haikus.

CHARLES HENRI FORD Nur Haikus ... Ich habe ein Tausend-Seiten-Buch, glaube ich, mit Haikus, und ein Freund von mir wird ein Manuskript daraus machen.

THOMAS GIRST Schreiben Sie täglich Haikus?

CHARLES HENRI FORD Ja, ich glaube schon, aber ich lege keinen Wert darauf. Wenn sie mir in den Sinn kommen, muss ich sie schnell aufschreiben, sonst verschwinden sie wieder aus meinem Kopf.

RHONDA ROLAND SHEARER Würden Sie uns ein paar vorlesen?

CHARLES HENRI FORD
»Good with the bad
Charles is ready when you are
Good with the bad, what does that mean?«

Unglaublich, jemand wird das alles abtippen, um daraus ein großes Buch zu machen.

»Let the other people be homosexual,
As for him,
He's not that queer«

RHONDA ROLAND SHEARER Was ist mit diesem hier?

CHARLES HENRI FORD
»To my unexpected
Nude niece: ›Get out of here,
You look like a bum!‹«

THOMAS GIRST Im Jahre 1926 hat Duchamp etwas Sehnsuchtvolleres zum Thema Nichte veröffentlicht: »My knees are cold because my niece is cold«.

CHARLES HENRI FORD Oh ja.

THOMAS GIRST Ich habe noch eine andere Frage über ihn an Sie.

CHARLES HENRI FORD Ok, lassen Sie mich sehen, ob ich eine Antwort darauf weiß.

THOMAS GIRST In den letzten Jahren haben Duchamps Schüler wie Amelia Jones und Jerold Seigel über Duchamps mögliche Bi- oder verborgene Homosexualität diskutiert — eine Behauptung, die lediglich

Unbelievable! Somebody's going to type up all of those for a big book.

"Let the other people be homosexual,
As for him,
He's not that queer"

RHONDA ROLAND SHEARER How about this one?

CHARLES HENRI FORD
"To my unexpected
Nude niece: 'Get out of here,
You look like a bum!'"

THOMAS GIRST In 1924 Duchamp published something more longingly on the themes of nieces: "My knees are cold because my niece is cold."
CHARLES HENRI FORD Oh yeah.
THOMAS GIRST I actually have another question about him for you.
CHARLES HENRI FORD Well, let's see if I know the answer.
THOMAS GIRST In recent years, Duchamp scholars like Amelia Jones and Jerold Seigel have discussed Duchamp's possible bi- or latent homosexuality, a claim that seems solely supported by Duchamp in drag as *Rrose Sélavy* and other androgynous themes running through his oeuvre. Bisexual? Marcel?
CHARLES HENRI FORD Well I guess no holds were barred.
THOMAS GIRST Mm-hm.
CHARLES HENRI FORD Yeah, he's really a real actor.

After the conversation, Charles Henri Ford reads more of his haikus:

"Weeping and wailing
And grinding of teeth … you don't
Have to go below"

"I don't know if I've
Settled down or not but I'm
Not moving for now"

durch Duchamp in Frauenkleidern als *Rrose Sélavy* und andere andro-
gyne Themen in seinem Werk gestützt werden können. Bisexuell?
Marcel?

CHARLES HENRI FORD Nun. Alles ist erlaubt.

THOMAS GIRST Mm-hm.

CHARLES HENRI FORD Ja, er ist nun mal ein wirklicher Schauspieler.

Nach Ende des Gesprächs verliest Charles Henri Ford vier weitere
Haikus:

»Weeping and wailing
And grinding of teeth ... you don't
Have to go below«

»I don't know if I've
Settled down or not but I'm
Not moving for now«

»You haven't changed she
Said I thought I looked a
Little better I said«

»If it's worth reading
Once it's worth reading twice so
You know where to start«

Wir danken Penny Arcade und Indra Tamang, Fords langjährigem persönlichen Assis-
tenten und regelmäßigen Mitarbeiter, die dieses Interview möglich gemacht haben.
Für weitere Informationen zum *View*-Magazin: *View: Parade of Avant-Garde 1940–1947*
(mit einem Vorwort von Paul Bowles), hrsg. von Charles Henri Ford, New York 1991.

Das Interview wurde am 2. Mai 2000 in Charles Henri Fords Apartment in New York
geführt. Es ist in Teilen als digitale Videoaufnahme, gefilmt von Martin Samsel, erhal-
ten und im Ganzen als Audiokassette verfügbar, ASRL Archiv, New York.

Der Beitrag wurde in englischer Sprache erstmals in: *Tout-Fait: The Marcel Duchamp
Studies Online Journal* Vol. 1, Ausgabe 2, 2000, veröffentlicht <www.toutfait.com/
online_journal_details.php?postid=1209> (20. August 2012).

Aus dem Englischen von Janina Wildfeuer

"You haven't changed she
Said I thought I looked a
Little better I said"

"If it's worth reading
Once it's worth reading twice so
You know where to start"

We are grateful to Penny Arcade and Indra Tamang, Ford's longtime personal assistant and frequent collaborator, for making this interview possible. For more information on *View*, we recommend Charles Henri Ford, ed., *View: Parade of the Avant-Garde, 1940–1947* (with a preface by Paul Bowles), (New York, 1991).

The interview was conducted at Charles Henri Ford's New York apartment on May 2, 2000. It is preserved in part as a digital videotape (filmed by Martin Samsel) and available in full on audiocassette, ASRL archive, New York.

This article was first published in English in: *Tout-Fait: The Marcel Duchamp Studies Online Journal* vol 1, issue 2, 2000, <www.toutfait.com/online_journal_details.php?postid=1209> (August 20, 2012).

Interviews

»EIN GANZ NORMALER TYP«
EIN INTERVIEW MIT ROBERT BARNES ÜBER
MARCEL DUCHAMP UND *ÉTANT DONNÉS*

Der amerikanische Maler Robert Barnes (geb. 1934), der erst kürzlich zum Mitglied der American Academy of Design gewählt wurde, ist vor allem Privatperson und macht sich nicht viel aus öffentlicher Aufmerksamkeit (Abb. 63). Es bedurfte vieler Anrufe und Briefe, bis er endlich einem längeren Interview in seinem Studio in Bloomington, Indiana, zustimmte, das am 27. Januar 2001 stattfand. Außer einer kurzen Buchbesprechung zu Calvin Tomkins Biographie über Marcel Duchamp, *Duchamp: A Biography,* die in dem in Großbritannien publizierten *The Art Magazine* bei Blackwell im Jahre 1997 erschien, hatte er zuvor noch nie über seine engen Beziehungen zu Duchamp und anderen Surrealisten in New York in den 1950er-Jahren gesprochen. Obwohl er es ablehnt, als »Duchamp's last assistant« bezeichnet zu werden, gibt er zu, dass er es war, den Duchamp gebeten hatte, die Schweinehaut für *Étant donnés* in Trenton, New Jersey, abzuholen.[1] Das folgende Interview wirft daher neues Licht auf die Produktion des letzten großen Werkes Duchamps sowie seine Edition der Readymades im Jahre 1964 und deckt bisher unbekannte Facetten Duchamps sowie jener Menschen auf, die ihn zu dieser Zeit kannten.

THOMAS GIRST Es gibt viele Fragen, die ich Ihnen stellen möchte — über Sie und Ihre Kunst und die Menschen, die Sie kennen. Lassen Sie uns einfach mit *Étant donnés* (1946–1966, Abb. 14, 15) anfangen, Duchamps letztes Meisterwerk, an dem er vermutlich heimlich zwischen den Jahren 1946 und 1966 gearbeitet hat. Sie kannten dieses Werk offensichtlich schon, bevor es posthum 1969 im Philadelphia Museum of Art gezeigt wurde?

ROBERT BARNES Viele Leute kannten es schon. Ich weiß nicht, was das große Geheimnis daran ist. Ich bin mir sicher, dass Matta[2] davon wusste. Und wenn Matta es kannte, wusste jeder davon. Matta war ein größeres Plappermaul als ich. Aber, wissen Sie, viele Geheimnisse um Duchamp und all die Legenden und Geschichten, die sich um ihn herum

1 Der Kunsthistoriker Herbert Molderings zweifelte daran, dass — basierend auf seiner jüngsten Forschung mit Spezialisten — das Material, das für den Torso von *Étant donnés* verwendet wurde, wirklich Schweinehaut sei. Nur eine Untersuchung des Materials, das tatsächlich für den Torso gebraucht wurde, durchgeführt vom Philadelphia Museum of Art, könnte diese Thematik ein für alle Mal klären. [Nachtrag: Seit Erscheinen des Interviews konnte das von Duchamp für die Außenschicht seines Mannequins in *Étant donnés* verwendete Material als Vellum bzw. Kalbshaut definiert werden, siehe: Michael R. Taylor, »Consulting the Manual: Word and Image in Marcel Duchamp's *Étant donnés*«, in: *Elective Affinities. Testing Word and Image Relationships,* Amsterdam 2009, S. 31 ff., siehe auch *Marcel Duchamp: Étant donnés,* hrsg. von Michael R. Taylor, Ausst.-Kat. Philadelphia Museum of Art, Yale 2009]. In einem Telefongespräch vom 24. Januar 2002 nahm der Künstler auf das, was er im Interview sagte, erneut Bezug und erinnerte sich zudem, die Schweinehaut an einem Kai von einem Metzger in weißer Schürze abgeholt zu haben. Er habe ein großes Fass abgeholt, das mit Wasser oder Lauge gefüllt war und das er bei Lieferung unten an der Treppe zu Duchamps Apartment stehen gelassen habe, weil es zu schwer für beide Männer war und nicht nach oben getragen werden konnte.
2 Der chilenische Surrealist und Maler Robert Matta Echaurren (1911–2002) hatte Marcel Duchamp noch vor seiner Ankunft in New York 1939 getroffen und bewundert. Für weitere Informationen über Matta und seine Beziehung zu Duchamp, siehe den Aufsatz »Rarität aus dem Jahre 1944. *Duchamp's Glass* von Katherine S. Dreier und Roberto Matta Echaurren« im Kapitel »Ansichten und Durchsichten« des vorliegenden Bandes, S. 184–188.

"A VERY NORMAL GUY"
AN INTERVIEW WITH ROBERT BARNES ON
MARCEL DUCHAMP AND *ÉTANT DONNÉS*

1 Art Historian Herbert Molderings, with whom I have discussed this matter prior to the publication of this interview, expressed some doubt that—based on his recent research with specialists—the material used for the torso of *Étant donnés* could actually be pigskin. Only an examination of the material used for the *Étant donnés* torso, conducted by the Philadelphia Museum of Art, could once and for all clarify this matter. [Addendum: Since the publication of this article, the material applied by Duchamp for the outer layer of his mannequin used in *Étant donnés* could be determined as vellum or calfskin, see: Michael R. Taylor, "Consulting the Manual: Word and Image in Marcel Duchamp's Étant donnés," in *Elective Affinities. Testing Word and Image Relationships* (Amsterdam, 2009), pp. 31–45. p. 32; see also Michael Taylor, *Marcel Duchamp: Étant donnés* (Yale, 2009).] In a follow-up conversation with Robert Barnes (via phone on January 14, 2002), the artist, in addition to what he had said in the initial interview, recalled to have picked up the pigskin at a dock from a butcher dressed in a white apron. He picked up one big barrel, filled with water or brine which, upon delivery, was left at the base of the staircase leading up to Duchamp's apartment since it was too heavy for both men to carry upstairs.
2 Chilean Surrealist painter Roberto Matta Echaurren (1911–2002) had met and admired Duchamp even before his arrival in New York in 1939. For more information on Matta and his relationship to Duchamp, see "Rarity from 1944. *Duchamp's Glass* by Katherine S. Dreier and Roberto Matta Echaurren," chapter "Views and Reviews," pp. 185–189.

The American painter Robert Barnes (*1934), recently elected member of the American Academy of Design, is a very private person and does not care much for publicity (fig. 63). It was only after many phone calls and letters that he finally agreed to a lengthy interview in his studio in Bloomington, Indiana, on January 27, 2001. Besides a brief book review of Calvin Tomkin's biography of Marcel Duchamp, *Duchamp: A Biography* (New York, 1996), published in Blackwell's Britain-based *The Art Magazine* in 1997, he had never before spoken about his close encounters with Duchamp and other Surrealists in New York during the 1950s. Though refusing to be called "Duchamp's last assistant" he admits that it was he whom Duchamp had asked to pick up the pig skin for *Étant donnés* in Trenton, New Jersey.[1] The following interview, therefore, sheds some new light on the production of Duchamp's final major work as well as his edition of Readymades in 1964, and reveals heretofore unknown facets about Duchamp, and those who knew him at the time.

THOMAS GIRST There are a lot of questions that I want to ask you—about you and your art and the people you knew. Let's just start with *Étant donnés* (1946–1966, figs. 14, 15), Duchamp's final masterpiece that he supposedly worked on in secret between 1946 and 1966. You apparently knew about the piece before it was posthumously revealed at the Philadelphia Museum of Art in 1969?

ROBERT BARNES Lots of people knew about it. I don't know what this great mystery is. I am sure that Matta[2] knew about it. And if Matta knew about it, everyone in the world knew about it. Matta was a bigger blabbermouth than I was. But, you know, a lot of mystique about Duchamp and all of the legends and stories that have grown up around him were basically manufactured much later and *Étant donnés*, well you know, I think it's his masterpiece. A lot of people are critical of it. I think they are critical of it because it embarrassed them. But it is the bride fleshed out and it is the appropriate final production that Duchamp created.

ergeben haben, sind erst viel später entstanden. *Étant donnés*, das wissen Sie, ist meiner Meinung nach sein Meisterstück. Viele Menschen sehen es aber kritisch. Ich glaube, dass sie so kritisch sind, weil es sie beschämte. Aber es ist die ausgestaltete Braut und ein angemessene letztes Werk, das von Duchamp geschaffen wurde. Das Geheimnisvolle daran – um Ihnen die Wahrheit zu verraten – ist, glaube ich, gar nicht wichtig, weil alles über Marcel genauso geheim wie bekannt war, das war einfach die Art, wie er war.

THOMAS GIRST Und Sie wurden 1934 geboren?

ROBERT BARNES Ja, aber das verrate ich nicht vielen Leuten.

THOMAS GIRST Sie kamen mit 19 Jahren nach New York, sagten Sie, glaube ich.

ROBERT BARNES Nein, mit 20 irgendwas.

THOMAS GIRST Sie hatten mit 19 geheiratet. Also wurden Sie diesem Kreis von Künstlern vorgestellt durch ... wie lernten Sie sie kennen?

ROBERT BARNES Durch Matta.

THOMAS GIRST Und wie sind Sie auf ihn getroffen?

ROBERT BARNES Ich traf Matta als jungen Mann in Chicago. Das ist das Interessante an den Menschen. Man weiß, wen man kennen kann, und man weiß, wen man mögen kann, und es gibt Affinitäten, die ausgedrückt werden, ohne je dafür eine Erklärung zu haben. Das Gleiche galt für Marcel, nur dass Marcel jeden mochte. Aber Matta und ich hatten eine solche Verbundenheit, und er war gut zu mir, er war besorgt um mich. Er half mir. Es gibt eine interessante Geschichte dazu. Er war in Chicago, in einem Hotel, und er lud mich dorthin ein, und ich freute mich sehr darüber, weil er zu der Zeit mit derjenigen, von der ich glaube, dass sie seine Frau war, zusammenlebte, aber ich bin nicht sicher, ob sie das je war: Mellite, eine hinreißende Frau aus Frankreich, die ich selbst sehr liebte. Und ich freute mich sehr, ihn zu besuchen. Weil ich zu jener Zeit viel mehr an ihr interessiert war als an Matta. Als ich jung war, war ich unheimlich empfindlich gegenüber bestimmten Dingen, und ich fand es schwierig, etwas zu essen, wenn ich nervös war. Ich war einfach wie gelähmt. Was scheußlich war bei Verabredungen, weil ich nie essen konnte, wenn ich eine hatte. Und dann ging ich zu diesem Abendessen, und Matta sagte zu mir – als ich dort saß und ziemlich schlecht aussah – er sagte: »Sie haben ein Problem damit, zu essen, wenn es Ihnen nicht gut geht, oder?« und ich sagte: »Ja«, und er sagte: »Das hatte ich auch«. Heute glaube ich, dass er nie dieses Problem hatte. Ich glaube nicht, dass es Matta je schlecht ging. Er sagte: »Las-

The secrecy—to tell you the truth—I don't think is very important because everything about Marcel was secret and known, that's the way he was.

THOMAS GIRST And you were born in 1934?

ROBERT BARNES Yeah, but I don't admit it to many people.

THOMAS GIRST You came to New York when you were 19 I think you said?

ROBERT BARNES No, twenty-something.

THOMAS GIRST You had married when you were 19. So you were introduced to that circle of artists by... how did you get to know them?

ROBERT BARNES Through Matta.

THOMAS GIRST And how did you come across him?

ROBERT BARNES I met Matta when I was a young man in Chicago. It is interesting with people. You know who you can know, and you know who you can like, and there are affinities that are expressed without ever having an explanation. The same was true with Marcel, except Marcel liked everybody. But Matta and I just had an affinity and he was good to me, he was careful with me. He helped me, and there's an interesting story to indicate this. He was staying in Chicago, in some hotel, and he invited me out to his place and I was delighted to go because, at that time, he was living with what I guess was said to be his wife, but I'm not sure she ever was: Mellite, a gorgeous French woman and I was totally in love with her. And I was delighted to go. I was more interested in her than in Matta at the time. When I was a young man, I was overly sensitive to things, and I found it difficult to eat when I was nervous. I was just sort of paralyzed. It was terrible on dates, because I could never eat when I was on a date. And I went to this dinner and Matta said to me—I was sitting there looking uncomfortable—and he said "You have a problem eating, don't you, when you're uncomfortable?" and I said, "Yeah" and he said, "So did I." Now I don't think he ever did. I don't think Matta was ever uncomfortable. He said, "Let's drink this wine." And he had discovered a catch at a low price of a wine, called "Grand Echeseaux," which he dearly loved; it was his favorite wine. He bought tons of it. And after a couple of glasses, I totally relaxed. What I am telling you is that Matta had a way of making you feel comfortable and that's probably why he had nine wives because he made them feel comfortable and then uncomfortable later.

THOMAS GIRST Now that was Matta. But I have to get back to *Étant donnés*. You said you were not Marcel Duchamp's assistant but he told you to get certain things for this piece.

sen Sie uns einen Wein trinken«. Er hatte da einen guten Fang gemacht zu einem sehr niedrigen Preis, den Grand Echeseaux, den er innig mochte, es wurde sein Lieblingswein. Er kaufte Unmengen davon. Und nach ein paar Gläsern entspannte ich mich völlig. Was ich Ihnen sagen will, ist, dass Matta eine Art hatte, die es möglich machte, dass man sich wohlfühlt, und das ist vermutlich der Grund, warum er neun Ehefrauen hatte: weil er es ihnen so angenehm und erst später unbequem machte.

THOMAS GIRST Gut, das war Matta. Aber ich muss noch einmal zurückkehren zu *Étant donnés*. Sie sagten, Sie wären nicht Marcel Duchamps Assistent gewesen, aber er hatte Ihnen aufgetragen, bestimmte Dinge für dieses Werk für ihn zu besorgen.

ROBERT BARNES Ich mag diese Geschichte nicht. Lassen Sie mich Ihnen sagen, dass Matta mich zuerst Marcel vorstellte. Das ist die Geschichte. Er brachte mich in sein Apartment. Das war in den 50ern, in der Nähe von Bloomingdale's.[3]

THOMAS GIRST Da war er schon mit Teeny verheiratet.

ROBERT BARNES Ja, aber Sie wollten doch zu *Étant donnés* zurückkehren. Ich würde das nie zugeben, aber ich fuhr nach New Jersey, um die Schweinehaut zu bekommen.

THOMAS GIRST Hat er Sie darum gebeten?

ROBERT BARNES Ja. Ich wusste aber nicht, wie man einen Wagen mit Gangschaltung fuhr, und ich hatte keinen Führerschein, aber ich nahm diesen Truck, obwohl ich gar nicht wusste, wem er gehörte, wahrscheinlich irgendwelchen Händlern, und holte diese Schweinehaut ab.

THOMAS GIRST Er hatte sie bereits bestellt und brauchte bloß jemanden, der sie für ihn abholte.

ROBERT BARNES Ja, die Sache ist die: das wird jetzt Ihre ganze Forschung versauen, weil ich glaube, dass das schon seine zweite Schweinehaut war. Ich glaube, er hatte schon vorher eine. Ich weiß nicht, ob sie nur dazu da war, etwas auszubessern. Wissen Sie, als ich zur Stelle war, war *Étant donnés* schon sehr fortgeschritten, er war da schon ziemlich weit.

THOMAS GIRST Offiziell fing er 1946 daran zu arbeiten an. Unter der Signatur steht 1966.

ROBERT BARNES Das ist relativ spät. Es war da eigentlich schon fertig und stand herum, setzte Staub an. Es war eher in den 50ern, 1956.

THOMAS GIRST Wie hat er es Ihnen erstmals vorgestellt?

ROBERT BARNES Naja, ich war in seinem Apartment und er fragte mich, ob ich die Schweinehaut abholen würde, und das tat ich. Aber ich

3 Von Ende 1951 bis zum 3. April 1959 lebte Duchamp, wenn er in New York war, in einem Apartment in der 327 East 58th Street, zusammen mit seiner Frau Alexina »Teeny« Sattler, die er am 16. Januar 1954 geheiratet hatte. Das Apartment im vierten Stock ohne Fahrstuhl wurde damals immer noch von dem deutschen Surrealisten und Maler Max Ernst (1891–1976) und seiner Frau, der amerikanischen Surrealistin Dorothea Tanning (1910–2012), gemietet, die beide 1951 nach Frankreich gezogen waren.

ROBERT BARNES I am uncomfortable with that story. Let me tell you that Matta did introduce me to Marcel the first time, that's how it happened. He took me up to Duchamp's apartment. It was in the 1950s, near Bloomingdale's.[3]

THOMAS GIRST He was already married to Teeny then.

ROBERT BARNES Yeah. But you want to go back to *Étant donnés*. I would never admit this, but I went to New Jersey to get the pigskin.

THOMAS GIRST He asked you to?

ROBERT BARNES Yeah. And I didn't know how to drive a stick shift and I didn't have a driver's license but I took this truck and I don't know whose truck it was, probably some merchants, and picked up this pigskin.

THOMAS GIRST He had already ordered it and just wanted someone to pick it up for him.

ROBERT BARNES Yeah. The thing is, this is going to screw up all of your research because I think that this was his second pigskin. I think he had one before. I don't know whether it was to patch. You know when I was on the scene it was late *Étant donnés*, he was already in the process pretty much.

THOMAS GIRST Officially he started working on it in 1946, and below the signature he writes 1966.

ROBERT BARNES That's way late. It was done, sitting around, gathering dust by then. It was in the 1950s, 1956s.

THOMAS GIRST So how did he first introduce you to it?

ROBERT BARNES Well I was at his apartment and he asked me if I'd pick up the pigskin and I did. But I knew about it before then, that's the thing, everyone sort of knew about this thing and most people hated it and thought it was a waste of time. I loved it you know I thought it was his masterpiece. Although the *Large Glass* (1915–1923, fig. 4) is probably the monument but this is the masterpiece because it tested people's ability to accept Marcel. Now we accept him.

THOMAS GIRST Well a lot of people still don't.

ROBERT BARNES Well too bad.

THOMAS GIRST When you saw the piece, the door wasn't there, the door came very late.

ROBERT BARNES No. When I saw it, it was all over the place, it was in pieces. And my suspicion was that he put the skin on earlier and it cracked. He had a terrible time keeping it soft. There was a beauty shop downstairs and awful smells came out of that place it was enough to give you asthma and die just going up to Marcel's studio. And I think

3 Between late 1951 and April 3, 1959, Duchamp (when in New York), lived in an apartment on 327 East 58th Street together with his wife Alexina "Teeny" Sattler whom he married on January 16, 1954. The fourth-floor walk-up was still rented by the German Surrealist painter Max Ernst (1891–1976) and his wife, the American Surrealist artist Dorothea Tanning (1910–2012), both of whom moved to France in 1951.

wusste schon vorher davon, jeder wusste nämlich irgendwie davon, und viele Leute hassten es und dachten, dass es reine Zeitverschwendung wäre. Ich liebte es. Wissen Sie, ich dachte, dass es sein Meisterstück sei. Wenn auch *Das Große Glas* (1915–1923, Abb. 4) wahrscheinlich sein Denkmal ist, ist dies sein Meisterstück, weil es die Bewährungsprobe war, ob , ob die Menschen Marcel schlussendlich akzeptieren würden. Jetzt akzeptieren wir ihn.

THOMAS GIRST Nun ja, eine Menge Leute tun dies immer noch nicht.

ROBERT BARNES Tja, was für ein Pech.

THOMAS GIRST Als Sie das Werk sahen, war die Tür noch nicht da. Sie kam erst sehr spät dazu.

ROBERT BARNES Nein. Als ich es sah, war es überall verteilt, in Einzelteilen. Und mein Verdacht war, dass er die Haut schon früher aufgezogen hatte und sie kaputtging. Es war schrecklich schwierig, sie weich zu halten. Die Treppe runter war ein Kosmetikladen und scheußliche Gerüche kamen von dort, so sehr, dass man Asthma bekommen und sterben konnte, wenn man zu Marcels Studio hinaufging. Und ich glaube, dass er die Leute dort nach Lanolin und Weichmachern für die Haut fragte, um sie für seine Haut zu nutzen. Nicht für seine eigene Haut, sondern für die Schweinehaut. Ich glaube, die Schweinehaut, die ich abgeholt hatte — und die ich nie wirklich gesehen hatte, weil sie in der Lauge geblieben war —, sie war wohl nur zur Ausbesserung da. Wissen Sie, ob es da ausgebesserte Teile gab, als man es auseinandernahm?

THOMAS GIRST Wie Sie im *Manual of Instructions* (1966, Abb. 64) hier sehen können, kann man es an einigen Stellen auseinanderbauen. Aber wenn Sie sagen, dass es überall verteilt lag, was meinen Sie damit?

ROBERT BARNES Da waren überall Teile davon. Es war nicht schwer zu erkennen, was es war. Ich erinnere mich nicht an die einzelnen Teile. Das Ding, an das ich mich am meisten erinnere, ist dieser verdammte Flur. Alles war so typisch und so hässlich, und das Gebäude war so schrecklich, aber dieser Flur machte Sinn. Es gibt da diesen Film von Richter,[4] *8 × 8* (1966), mit einem gigantischen Schachbrett und Menschen, die darauf laufen. Und ich dachte immer, dass man in dieses Studio hineinspringen musste, fast so, wie man von einem Feld ins nächste springt.

THOMAS GIRST Von den früheren Arbeiten schließend (Abb. 31, 65) gehen manche davon aus, dass er zuerst versuchte, *Étant Donnés* als eine stehende Figur zu bauen, hat sie schon immer so gelegen?

4 Gemeint ist der in Deutschland geborene Avantgarde-Künstler und Filmemacher Hans Richter. Der Schach-Film von *8 × 8*, der in den Vereinigten Staaten gedreht wurde und in dem unter anderem Jacqueline Matisse Monnier und Marcel Duchamp mitspielen, beinhaltet auch eine Sequenz, in der letzterer als »schwarzer König« dargestellt ist. Der Flur, von dem Barnes spricht, hat ein großes Schachbrettmuster und dient noch heute der Installation von *Étant donnes* als Bodenaufsatz.

he actually asked them about lanolin and skin softeners to use on his skin. No not on his skin, on the pig's skin. My feeling is that either the pigskin that I got—which I never actually saw, it stayed in the brine—it might have been just to patch it. Do you know when they took it apart were there patched pieces?

THOMAS GIRST Well as you can see in the *Manual of Instructions* (1966, fig. 64) here, you can disassemble it at certain points. But when you say it was all over the place, what do you mean by that?

ROBERT BARNES There were pieces of it. It was not hard to see what it was. I don't remember the branches. The thing I remember most about all this is the damn floor. Well it's so appropriate and so ugly and the building was so awful, but that floor made sense. There's that movie of Richter's,[4] *8×8*, with a giant chessboard and people walking on it. And I always thought that you almost needed to hop in that studio the way you hop from one square to another.

THOMAS GIRST Judging from the preliminary works (figs. 65, 31), some argue that he first tried to construct *Étant donnés* as a standing figure, was it always lying there?

ROBERT BARNES Yeah. I don't think it ever could stand and I don't think he cared or wanted it to. He might have wanted to position it up a little bit so you had to look at the pudenda.

THOMAS GIRST What do you think in terms of this thing being anatomically correct, do you think he took life casts?

ROBERT BARNES No, he didn't give a damn about whether it was anatomically correct. In some ways—I mean if you look at it as he intended, as a voyeur, somebody peeping through a hole—it is shocking because the pussy is not right and you look at it and you say, "oh wait, no this isn't right" and you start adjusting. Marcel was smart enough to make you think that and also being hairless it was a little bit like kiddy-porn.

THOMAS GIRST But what you said with the spectator or the voyeur, looking at this and seeing, you know you have Courbet's *Origin of the World* (1866) and there you have an anatomically more or less correct pussy, whereas Duchamp's intentionally wasn't right?[5]

ROBERT BARNES Well with Courbet, you know what you're into, if I may pun a bit. In Duchamp you approach it with doubt, you're not sure you want to be there or should be there. With Courbet you know what you're thinking about, this is obviously a woman. With Duchamp you have the inaccuracies and the fact that the body is not right at all. The whole wig thing. It's all wrong but you look at it and start rearranging it

4 German-born avant-garde artist and filmmaker Hans Richter. The chess game-based story of *8×8*, shot in the United States and featuring, among others, Jacqueline Matisse Monnier and Marcel Duchamp, includes a sequence showing the latter as the "Black King." The floor which Barnes talks about is structured in a large chessboard-pattern and to this day serves as the base for the installation of *Étant donnés*.

5 After the interview, it came to my attention that Virginie Monnier—in her "Catalog of Works" published in Jean Clair's (ed.) Balthus exhibition catalogue for the late artist's major retrospective at the Palazzo Grassi, Venice, September 9, 2001–January 6, 2002 (Milan, 2001)—had described Courbet's famous painting as incorrect. Comparing it to an untitled pencil drawing by Balthus from 1963, which was obviously inspired by Courbet (fig. 62), Monnier writes: "[I]ndeed it reproduces an anatomical inaccuracy that in Courbet had caused outrage: the cleft of the vulva, as thin as a line, goes all the way to the crease of the anus, ignoring the anatomical particularities of the female body" (p. 388).

ROBERT BARNES Ja. Ich glaube nicht, dass sie je stehen konnte, und ich glaube auch nicht, dass er das so wollte. Vielleicht wollte er sie ein bisschen höher stellen, so dass man sich die Geschlechtsteile angucken muss.

THOMAS GIRST Was denken Sie bezüglich der anatomischen Korrektheit dieser Sache? Glauben Sie, dass er Abdrücke benutzt hat?

ROBERT BARNES Nein, er hat sich nicht darum geschert, ob es anatomisch korrekt war. In mancherlei Hinsicht — ich meine, schauen Sie es doch mal so an, wie er es wollte, als Voyeur, als jemand, der durch ein Loch hindurchschaut — es ist schockierend, weil die Pussy irgendwie nicht richtig ist und Sie sie ansehen und sagen: »Oh, Moment, nein, das ist nicht richtig«, und dann beginnen Sie zu justieren. Marcel war smart genug, Sie das glauben zu lassen. Es war ja auch ein bisschen wie Kinderpornografie, dieser rasierte Anblick.

THOMAS GIRST Aber was Sie sagten über den Betrachter oder Voyeur, der es anschaut und das alles sieht. Sie wissen, es gibt Courbets *Ursprung der Welt* (1866), und hier haben sie eine anatomisch mehr oder weniger korrekte Scham, während dessen Duchamp diese absichtlich inkorrekt wiedergibt?[5]

ROBERT BARNES Naja, bei Courbet wissen Sie, worauf er steht, wenn ich mal ein bisschen mit Worten spielen darf. Bei Duchamp gehen Sie das alles mit Zweifeln an, Sie sind nicht sicher, ob Sie wirklich da sein wollen oder sollten. Bei Courbet wissen Sie, worüber Sie nachdenken, das ist nun mal offensichtlich eine Frau. Bei Duchamp haben Sie diese Ungenauigkeiten und die Tatsache, dass der Körper ganz und gar nicht richtig ist. Dieses ganze Ding. Es ist alles falsch, aber Sie schauen es an und versuchen, es umzuorganisieren, und natürlich war alles, was er machte, genauso, und die Versuche, Duchamp zu erklären, sind, glaube ich, schrecklich, weil einfach alles erst einmal fremd ist. Und ich glaube, dass sogar Duchamps Erklärungen, alles, was er schrieb, irreführend waren. Absichtlich irreführend, im Nachhinein dazu gedacht, genau die Leute abzufüttern, die auch abgefüttert werden wollten.

THOMAS GIRST Warum glauben Sie, dass er absichtlich einen Torso konstruiert hat, von dem Sie sagen, dass er kein Torso, sondern eher eine entstellte Gestalt ist? Warum hat er nicht versucht — mit diesem ganzen 3D-Material — einen anatomisch korrekten Torso zu schaffen?

ROBERT BARNES Weil er kein Akademiker war. Wenn er ihn anatomisch korrekt hätte machen wollen, hätte er das tun können, aber es hätte nicht dieselbe Bedeutung gehabt.

5 Nach dem Interview wurde meine Aufmerksamkeit auf Virginie Monnier gelenkt, die in ihrem Aufsatz »Catalog of Works«, der in *Jean Clairs Balthus Exhibition catalogue for the late artist's major retrospective at the Palazzo Grassi, Venice, 9. September 2001– 6. Januar 2002* (Milan 2001) veröffentlicht wurde, Courbets berühmtes Bild als fehlerhaft beschreibt. Sie vergleicht es mit einer unbetitelten Bleistiftzeichnung von Balthus aus dem Jahre 1963, das offensichtlich durch Courbet inspiriert worden war (Abb. 62). Monnier schreibt dazu: »Tatsächlich zeigt es eine anatomische Unkorrektheit, die bei Courbet Entrüstung hervorrief: die Spalte der Schamlippen, so dünn wie eine Linie, geht bis zur Falte des Anus und ignoriert so die anatomischen Feinheiten des weiblichen Körpers« (S. 388) [Übersetzung des Autors].

and of course everything he did was like that and the attempts to explain Duchamp I think are terrible because it is alien to the point. And I think even Duchamp's explanations, all the things he wrote, were misleading. I think intentionally misleading, done after the fact, and meant to feed people who want to be fed.

THOMAS GIRST Why would you think he intentionally constructed a torso that you notice is not a torso but rather some distorted figure? Why would he not try to aim for an anatomically correct torso?

ROBERT BARNES Because he wasn't an academician. If he wanted to make it anatomically correct he could have done that and it would not have had the same impact.

THOMAS GIRST Because none of the men I know that are into women and look at this thing find it sexually arousing.

ROBERT BARNES Oh, I do.

THOMAS GIRST Oh you do?

ROBERT BARNES I think it's neat. The thought that you have is you sort of wish that women were built like that, were made like that, a little distorted, a little extra. But I'll get off that subject quickly before I get arrested. I was always amazed at how many people were embarrassed by it and obviously that was the intent of the work. I mean all of these nitwits that looked at it and said it's not worthy of Duchamp were the ones that he was out to get. And I loved it. You know I didn't see it. I never saw it put together until much later.

THOMAS GIRST But you saw it eventually. The thing is though, when it was reviewed, when it was released to the public in 1969 at the Philadelphia Museum of Art, John Canaday of the New York Times already wrote at the time that Étant donnés was "very interesting, but nothing new," maintaining that in the light of artists like Edward Kienholz, Duchamp, "this cleverest of 20th century masters looks a bit retardaire." In other words, it looked dated and surely wasn't shocking anymore.

ROBERT BARNES Because Duchamp was there before and fed into this age that had to be shocked. Étant donnés is not shocking, it's embarrassing. Big difference. You look at it and you think "I should not be thinking this or looking." And you're not shocked but I mean no one can approach this piece of work without it clobbering him. And Marcel was very subtle.

THOMAS GIRST He was very subtle. What do you think about him working with such a different media, all of the sudden coming up with this three-dimensional environment?

THOMAS GIRST Weil keiner der Männer, die ich kenne und die Frauen mögen und sich dieses Ding anschauen, es sexuell ansprechend finden.

ROBERT BARNES Oh, ich schon.

THOMAS GIRST Sie schon?

ROBERT BARNES Ich finde es hübsch. Man denkt, wünscht irgendwie, dass Frauen so gebaut sind, dass sie so geschaffen sind, ein wenig entstellt, ein wenig speziell. Aber ich lasse dieses Thema lieber, bevor ich noch verhaftet werde. Ich war immer erstaunt darüber, wie viele Leute davon peinlich berührt waren, das war doch offensichtlich genau die Absicht dieser Arbeit. Ich meine, all diese Dummköpfe, die es sich angeschaut haben und sagten, dass es nicht Duchamp würdig sei, sind genau diejenigen, auf die er es angelegt hatte. Und das liebte ich. Sie wissen, dass ich es nie gesehen habe. Ich habe es nie als Ganzes gesehen, erst viel später.

THOMAS GIRST Aber Sie haben es irgendwann doch gesehen. Die Sache ist aber, als es besprochen wurde, als es der Öffentlichkeit 1969 im Philadelphia Museum of Art vorgestellt wurde, hatte John Canaday von der *New York Times* schon geschrieben, dass *Étant donnés* »sehr interessant, aber nichts Neues« war, und er behauptete, dass Duchamp im Lichte von Künstlern wie Edward Kienholz als doch »cleverster Künstler des 20. Jahrhunderts ein bisschen this ›retardaire‹« wirke. Mit anderen Worten: Es sah altmodisch aus und war sicherlich gar nicht mehr anstößig.

ROBERT BARNES Weil Duchamp schon viel früher präsent war und dieses Jahrhundert unterhielt, das einfach schockiert werden musste. *Étant donnés* ist nicht anstößig, es ist beschämend. Das ist ein großer Unterschied. Sie sehen es an und denken: »Ich sollte das nicht denken oder sehen«. Und Sie sind auch nicht empört, aber ich glaube, niemand kann an dieses Werk herangehen, ohne dass es ihn erschlägt. Und Marcel war sehr raffiniert.

THOMAS GIRST Er war sehr raffiniert. Was halten Sie davon, dass er auf einmal mit anderen Mitteln zu arbeiten begann, und ganz plötzlich dieses dreidimensionale Environment aus dem Ärmel zog?

ROBERT BARNES Warum ist das so anders? Er hat das Ding gemacht. All seine anderen Abdrücke von Frauen führen dorthin …

THOMAS GIRST Nun ja, das ist eine Sache. Als er die Abdrücke machte …

ROBERT BARNES Ich habe nie gefragt, wer das war. Ich glaube, es war Teeny.

ROBERT BARNES Why is it so different? He made the thing. His other casts of women are all leading up to this.

THOMAS GIRST Well that is one thing. When he did the casts…

ROBERT BARNES I never asked who it was. I suppose it was Teeny.

THOMAS GIRST There are different stories about the casts.

ROBERT BARNES I guess you'll have to find the "caste" or "castette."

THOMAS GIRST Take the *Female Fig Leaf* (1950, fig. 44), for example. Richard Hamilton says that Duchamp told him he did these things by hand, whereas Duchamp scholars like Francis M. Naumann think that he actually took a live cast.

ROBERT BARNES Oh, well he would have taken a live cast because it's more fun.

THOMAS GIRST But who would that have been? Maria Martins[6] or Teeny or both?

ROBERT BARNES Probably anybody—anybody who would lend her body.

THOMAS GIRST You know Duchamp toyed with the fourth dimension in the *Large Glass*. Do you think there might also be something of that in the distorted body, by arriving—as Rhonda Roland Shearer has argued—at a higher level of representation because it is not just 3-D?

ROBERT BARNES Well if he had done it merely in 3-D, it would have been a George Segal (fig. 66). He wasn't interested in that, he's better than that. I don't know if you've noticed it. But Duchamp was magnificent. He was so smart, so intelligent, his brain was so complex and that's the best thing about it. I think you can only approach an appreciation of Duchamp and I don't think his intelligence was where people thought it was. Everyone felt that Duchamp was "scientifically pure, he could think in mathematical ways." I don't think he could add beans. I think Marcel was inventive because he was beyond science, he was beyond accuracy and figures. He was beyond all that because then he could approach us, he could manipulate us. Being around Duchamp was always— I wouldn't say challenging because he made people comfortable but the thinking was rapid and he wasn't the only one, Matta was quick, too. All of those people in the circle of Duchamp were quick.

THOMAS GIRST And you were young and in their midst.

ROBERT BARNES I was just a baby. I was a pretty kid. I didn't ever approach them with enough reverence though. I felt like I just was interested. It wasn't "oh the big artist." Because it is like anything, if you know a celebrity, you are always shocked at how human they are. The

6 Brazilian Surrealist sculptor Maria Martins (1894-1973); between ca. 1943-1948, Duchamp had an intense liaison with the wife of the Brazilian ambassador to the United States. For a detailed discussion of the early stages of *Étant donnés's* production, see "Duchamp's Window Display for André Bretons *Le Surréalisme et la peinture,*"chapter "Duchamp for Everyone," pp. 119-133.

THOMAS GIRST Es gibt verschiedene Geschichten über diese Abdrücke.

ROBERT BARNES Ich glaube, Sie müssen den Formgeber oder die Formgeberin finden.

THOMAS GIRST Nehmen Sie zum Beispiel das *Weibliche Feigenblatt* (1950, Abb. 44). Richard Hamilton sagt, dass Duchamp ihm erzählte, dass er diese Dinge von Hand gemacht habe, wobei jedoch Duchamp-Kenner, wie z. B. Francis M. Naumann, glauben, dass er tatsächlich Lebendabdrücke genommen hat.

ROBERT BARNES Oh ja, klar, er wird einen Lebendabdruck genommen haben, weil das mehr Spaß machte.

THOMAS GIRST Aber wer soll das gewesen sein? Maria Martins[6] oder Teeny oder beide?

ROBERT BARNES Vermutlich irgendwer — irgendjemand, der seinen Körper dafür hergegeben hat.

THOMAS GIRST Sie wissen, dass Duchamp im *Großen Glas* mit der vierten Dimension gespielt hat. Glauben Sie, dass davon auch etwas in dem entstellten Körper ist, zum Beispiel — wie Rhonda Roland Shearer vermutet — auf einer höheren Repräsentationsebene, weil es dreidimensional einfach nicht aufgeht?

ROBERT BARNES Nun ja, wenn er es lediglich in 3D gemacht hätte, wäre es ein George Segal (Abb. 66). Er war aber nicht interessiert daran, er ist besser. Ich weiß nicht, ob Sie das bemerkt haben. Aber Duchamp war großartig. Er war so smart, intelligent, sein Verstand war so komplex, und das ist überhaupt das Beste an ihm. Ich glaube, man sollte Duchamp einfach Anerkennung zollen und ich glaube nicht, dass seine Intelligenz so war, wie die Leute es meinten. Jeder fühlte, dass Duchamp »wissenschaftlich versiert« war, er konnte »mathematisch denken«. Ich glaube nicht, dass er Bohnen zusammenzählen konnte. Ich glaube, Marcel war erfinderisch, weil er jenseits der Wissenschaft war. Er war jenseits jeder Genauigkeit und aller Zahlen. Er war jenseits all dessen, weil er uns nur dann erreichen konnte. Er konnte uns manipulieren. Mit Duchamp zusammen zu sein, ihn um sich zu haben war immer — ich würde nicht herausfordernd sagen, weil er es den Leuten angenehm machte — aber das Denken war schneller, und er war nicht der einzige, Matta war genauso schnell. Alle diese Leute im Kreise Duchamps waren schnell.

THOMAS GIRST Und Sie waren jung und mitten unter ihnen.

ROBERT BARNES Ich war noch ein Baby. Ich war ein ziemliches Kind. Ich bin ihnen nie mit genügend Ehrfurcht begegnet. Ich war einfach interessiert. Es war nicht »Oh, der große Künstler«. Weil es ist, wie es im-

6 Die brasilianische Surrealistin und Bildhauerin Maria Martins (1894–1973); ungefähr von 1943 bis 1948 hatte Duchamp eine intensive Liaison mit der Frau des brasilianischen Botschafters in den Vereinigten Staaten. Eine detaillierte Diskussion der frühen Stadien von *Étant donnés* gibt der Aufsatz »Duchamps Schaufenster für André Bretons *Le Surréalisme et la peinture*« im Kapitel »Duchamp für Alle« im vorliegenden Band, S. 118–132.

first time I met Duchamp, I went with Matta, and Duchamp had a cold and the first thing I thought, "men of this stature don't get colds." And he was in his bathrobe eating honey out of a silver bee. Now if that wasn't so much Duchampian as Ernstian or something Richter would have thought of. But it was weird because it was so appropriate. I wonder where all the stuff from his apartment is.

THOMAS GIRST I don't know exactly, it went to the estate I guess.

ROBERT BARNES But who was left in the estate after Teeny?

THOMAS GIRST I believe Teeny's three kids, Jacqueline Matisse Monnier as well as Paul and Peter Matisse.

ROBERT BARNES What did they do with all of that?

THOMAS GIRST Some of it was donated to the Philadelphia Museum of Art, other works were donated to the Centre George Pompidou in Paris.

ROBERT BARNES Can you imagine…you know he used to have an armchair that was done in needlepoint by Miró?[7] It was all so oily because he would always lean on it. It was his favorite chair. Could you imagine sending that to the Salvation Army?

THOMAS GIRST Was it?

ROBERT BARNES I don't know. Every time when someone dies they give stuff to the Salvation Army. That reminds me of a gathering at Duchamp's place once. All the people were staring at me. It was very uncomfortable. I don't like being stared at. And Duchamp who was so sensitive, he knew that I was feeling uncomfortable. And he leaned over and he said to me "They are looking at you Robert, because you are sitting on a Brâncuşi"[8]—a little bench thing—and I started to get up and he pushed me down and said. "That's what it's for, to be sat upon. So let them look at the Brâncuşi and forget about yourself." And I did.

THOMAS GIRST Can you recall how many parts Étant donnés was?

ROBERT BARNES No, the best thing I can remember about the place was the chess-board floor. I mean that's very exciting, isn't it, for history.

THOMAS GIRST So the only time you helped him with it, was getting the pigskin? And how many times had you been to the secret studio on 210 W 14th Street?

ROBERT BARNES Oh, lots of times. I lived just down below there for a while.

THOMAS GIRST So you saw the progress that was made?

ROBERT BARNES Yeah. And at the time I was working for Carmen DiSappio who was just down the street, so…

7 Spanish Surrealist artist Joan Miró (1893–1983).
8 Romanian-born Constantin Brâncuşi (1876–1957) was one of twentieth century's leading sculptors and a close friend of Duchamp's from their early years in Paris. For some time, Duchamp became his representative, selling Brâncuşi's sculptures, mostly to affluent American collectors.

mer ist, wenn man eine Berühmtheit kennt, ist man immer erstaunt darüber, wie menschlich sie sind. Als ich Duchamp zum ersten Mal traf, war ich mit Matta unterwegs, und Duchamp hatte eine Erkältung, und das erste, was ich dachte, war, »Männer dieser Größe bekommen keine Erkältung«. Er saß da in seinem Bademantel und aß Honig aus einer silbernen Biene. Der Anblick Duchamps war einer, wie ihn sich Richter oder Ernst hätte ausmalen können. Aber es war seltsam, weil es so passend war. Ich frage mich, wo all das Zeug aus seinem Apartment hin ist.

THOMAS GIRST Ich weiß es nicht genau, ich denke, dass es an seine Erben ging.

ROBERT BARNES Aber wer ist von den Erben noch übrig nach Teeny?

THOMAS GIRST Ich glaube, Teenys drei Kinder, Jacqueline Matisse Monnier und Paul und Peter Matisse.

ROBERT BARNES Was haben sie mit all dem Zeug gemacht?

THOMAS GIRST Ein paar Dinge wurden dem Philadelphia Museum of Art gestiftet, andere Arbeiten dem Centre George Pompidou in Paris.

ROBERT BARNES Können Sie sich das vorstellen ... Sie wissen, dass er einen Sessel hatte, der aus Stickereien von Miró gemacht worden war?[7] Der war so ölig, weil er immer darauf gesessen hatte. Das war sein Lieblingssessel. Können Sie sich vorstellen, das an die Heilsarmee zu geben?

THOMAS GIRST Ist das geschehen?

ROBERT BARNES Ich weiß es nicht. Immer wenn jemand stirbt, gibt man seine Sachen der Heilsarmee. Das erinnert mich an ein Treffen in Duchamps Haus. Alle Leute haben mich angestarrt. Es war sehr unangenehm. Ich mag es nicht, angestarrt zu werden. Und Duchamp, der so einfühlsam war, wusste, dass ich mich unwohl fühlte. Und er lehnte sich zu mir und sagte: »Sie gucken dich an, Robert, weil du auf einem Brâncuşi[8] sitzt« — so eine kleine Bank — und ich stand sofort auf und er drückte mich wieder runter und sagte: »Dafür ist es da, dass man darauf sitzt. Also lass sie den Brâncuşi anschauen, und denk nicht weiter darüber nach.« Und das tat ich.

THOMAS GIRST Können Sie sich erinnern, aus wie vielen Teilen *Étant donnés* bestand?

ROBERT BARNES Nein, das einzige, woran ich mich erinnere an diesem Ort, ist der Schachbrettflur. Ich meine, das ist doch sehr aufregend für die Historie, oder?

THOMAS GIRST Das einzige Mal, dass Sie ihm halfen, war also die Schweinehaut abzuholen? Und wie oft waren Sie in seinem geheimen Studio in der 210 W 14th Street?

7 Der spanische Surrealist Joan Miró (1893–1983).
8 Der in Rumänien geborene Constantin Brâncuşi (1876–1957) ist einer der führenden Bildhauer des 20. Jahrhunderts und ein enger Freund Duchamps aus den frühen Jahren in Paris. Einige Zeit lang war Duchamp sein Agent und verkaufte Brâncuşis Skulpturen, vor allem an wohlhabende amerikanische Sammler.

THOMAS GIRST So when works like *Female Fig Leaf* came out and those things that had to do with *Étant donnés* that people could only place it with *Étant donnés* later because they did not know about it. When you saw these pieces you already knew that they had to do with this kind of work?

ROBERT BARNES The thing is that if you knew Marcel and you knew the people around them, this is a sequence that is so practical and natural, I mean these were horny people my friend. Matta was probably the horniest of all. He's probably still trying to dick everything in sight. These were people who thought about sex. I mean, it's all about sex— the gas. That's what bothered me about *Étant donnés*, what kind of light bulb is in the lamp?

THOMAS GIRST It's an electric light, though it's supposed to be a "Bec Auer," a gas burner.

ROBERT BARNES Those long things?

THOMAS GIRST Yeah the long thing, that has a green light emanating from it, under which Duchamp experimented when he did the *Chess Players* in 1911. He painted in that green light. So although with *Étant donnés* it is an electric lamp, it is supposed to be a gas lamp.

ROBERT BARNES So that is maybe where the gas came in. The gas is like what we lately have discovered as pheromones, I think, which is a sort of sex gas.

THOMAS GIRST What is sex gas?

ROBERT BARNES Gas! And with Marcel, gas is always sex gas, it will get you. Worse than mustard gas, you're done for.

THOMAS GIRST Well, after all *Étant donnés's* subtitle is "1) The Waterfall / 2) The Illuminating Gas." Do you recall having seen the painted landscape with moving waterfall used as the artwork's backdrop?

ROBERT BARNES No. I think the scene was there but I don't remember anything happening back there, it was dark. I'm embarrassed to say it, but I didn't focus on much of it then.

THOMAS GIRST But you and Duchamp saw each other often? He was at your apartment and he liked the way it was built. What's the story about that?

ROBERT BARNES Yeah, I lived on Kenmare Street. It's an architectural museum now or something. It is right across the street from the Broome Street police station. Downstairs was a tire store and there were these troll-like men who repaired tires down there and they had these vats where they would test to see if they were leaking. It was something

ROBERT BARNES Oh, viele Male. Ich habe sogar für eine Weile genau darunter gewohnt.

THOMAS GIRST Also haben Sie den Fortschritt beobachtet, den es gab?

ROBERT BARNES Ja. Zu der Zeit habe ich für Carmen DiSappio gearbeitet, nur ein paar Straßen weiter.

THOMAS GIRST Als also Arbeiten wie das *Weibliche Feigenblatt* erstmals gezeigt wurden und die Dinge, die mit *Étant donnés* zu tun hatten, die die Leute aber erst später damit in Verbindung bringen konnten, weil sie davon nicht wussten – als Sie diese Objekte gesehen haben, wussten Sie bereits, dass sie mit dieser Arbeit zu tun hatten?

ROBERT BARNES Wenn man Marcel und die Leute um ihn herum kannte, ist das alles nur ein ganz natürlicher Ablauf. Das waren spitze Leute, mein Freund. Matta war vermutlich der spitzeste von allen. Er versucht wahrscheinlich immer noch, allem in Sichtweite an die Wäsche zu gehen. Das waren Leute, die nur an Sex dachten. Ich meine, es ging alles um Sex – das Gas. Das ist es, was mich so ärgert an *Étant donnés*, was für eine Glühbirne ist in der Lampe?

THOMAS GIRST Es ist eine elektrische, auch wenn es ein »Bec Auer« sein sollte, ein Gasbrenner.

ROBERT BARNES Diese langen Dinger?

THOMAS GIRST Ja, das lange Ding, von dem ein grünes Licht ausstrahlt, unter dem Duchamp experimentierte, als er 1911 die *Schachspieler* machte. Er malte in diesem grünen Licht. Auch wenn das also in *Étant donnés* eine elektrische Lampe ist, sollte es eigentlich eine Gaslampe sein.

ROBERT BARNES Dann war das vielleicht dort, wo das Gas reinkam. Dieses Gas ist wie das, was wir kürzlich als Pheromone entdeckt haben, glaube ich, die wie eine Art Sexgas sind.

THOMAS GIRST Was ist Sexgas?

ROBERT BARNES Gas! Und bei Marcel ist Gas immer Sexgas. Es wird dich kriegen. Schlimmer als Senfgas, da bist du erledigt.

THOMAS GIRST Nun gut, schließlich lautet der Untertitel von *Étant donnés* »1. Der Wasserfall, 2. Das Leuchtgas«. Erinnern Sie sich, die gemalte Landschaft mit dem Wasserfall gesehen zu haben, wie sie als Kulisse für den Künstler diente?

ROBERT BARNES Nein. Ich glaube, es gab so eine Szene, aber ich erinnere mich an nichts, was im Hintergrund geschah; es war dunkel. Ich schäme mich, das zu sagen, aber ich habe mich damals nicht so sehr darauf konzentriert.

right out of an opera by Wagner except that the blacksmiths were vulcanizers, which is perfect. And upstairs I had my loft, which was illegal, and Marcel loved it because it was. It had a door like *Étant donnés* a shackled door, and the little place was a mess but I had put in plumbing and we would all go down to Hester Street and buy plumbing supplies. We all got glass-lined water heaters that rusted but one of the joys of the place was that we couldn't put an elbow in the tub, so it went straight. And we discovered that when you let the water out of the tub, it would explode downstairs in the tire tub. It was kind of Duchampian.

THOMAS GIRST But he came by and visited you?

ROBERT BARNES Yeah, not very often.

THOMAS GIRST You were there in the early 1950s and you stayed in New York for how long? You were already married by then and you lived with your wife who was probably young and beautiful at the same time. So were the artists that you knew fond of her as well?

ROBERT BARNES Yeah, Matta was. He wanted to steal her.

THOMAS GIRST But Duchamp wasn't hitting on her?

ROBERT BARNES I wouldn't have known if he was. She would have, but I wouldn't have. Actually my wife was, at the time, beginning to show some symptoms of mental problems, so she didn't go places. Her contact was rather limited.

THOMAS GIRST So, you were there at the time when fame started setting in for Duchamp. There were more and more people approaching him. In this regard you mentioned something about "Mr. Availability."

ROBERT BARNES I think that was Teeny's term. He was interested, I think, that was it. I don't know why anyone paid attention to me because I was really wet behind the ears. He was awfully nice to me and listened to me and I don't think I had much to say.

THOMAS GIRST But they liked to have you around.

ROBERT BARNES Yeah, I think I was decorative and I think they thought of me as maybe being someone to follow. Not follow, no, there was never any hint that I would follow anybody.

THOMAS GIRST Well you were doing figurative oil on canvas and Duchamp, probably the others too, appreciated what you were doing since everyone else had stopped doing that. You said Duchamp liked the painting that was at the Whitney, your *Judith and Holofernes* of 1959/60. Taking into account his phobia regarding oil on canvas, did he encourage you to continue in that vein?

THOMAS GIRST Aber Sie und Duchamp haben sich oft gesehen? Er war öfter in Ihrem Apartment, und er mochte die Art, wie es gebaut war. Wie ist die Geschichte dazu?

ROBERT BARNES Ja, ich lebte in der Kenmare Street. Heute ist da ein Architekturmuseum oder sowas. Es ist direkt gegenüber der Polizeistation an der Broome Street. Unten war ein Reifenladen, und da waren diese trollähnlichen Männer, die da unten Reifen reparierten und so Fässer hatten, mit denen sie testeten, ob sie undicht waren. Das hatte was von einer Oper von Wagner, nur dass die Schmiede Vulkaniseure waren, was perfekt ist. Und oben drüber hatte ich mein Loft, was eigentlich illegal war. Und Marcel liebte es, weil es illegal war. Es hatte eine Tür wie bei *Étant donnés*, mit Kettenschloss, und der kleine Raum war ein Durcheinander, aber ich hatte ein Klo dorthin gebracht, und wir gingen alle herunter zur Hester Street und kauften Sanitärzubehör. Wir bekamen Emaille-Wasserboiler, die rosteten, aber eine der Freuden an dieser Wohnung war, dass der Abfluss sich nicht biegen ließ und das Rohr gerade bleiben musste. Und wir entdeckten, dass wenn man das Wasser aus der Wanne ließ, dann explodierte es unterhalb regelrecht. Das war irgendwie wie Duchamp.

THOMAS GIRST Aber er kam vorbei und besuchte Sie?

ROBERT BARNES Ja, nicht sehr oft.

THOMAS GIRST Sie waren dort in den frühen 50ern und blieben in New York für wie lange? Sie waren damals schon verheiratet und lebten mit ihrer Frau zusammen, die wahrscheinlich jung und hübsch war. Mochten die Künstler, die Sie kannten, sie ebenso?

ROBERT BARNES Ja, Matta schon. Er wollte sie haben.

THOMAS GIRST Duchamp blieb uninteressiert?

ROBERT BARNES Ich hätte es nicht bemerkt, wenn er es getan hätte. Sie vielleicht, ich aber nicht. Tatsächlich zeigte meine Frau zu der Zeit bereits schon einige psychische Probleme, deswegen ging sie nicht viel raus. Ihr Kontakt nach draußen war eher begrenzt.

THOMAS GIRST Sie waren also dabei, als Duchamps Ruhm einsetzte. Es kamen mehr und mehr Leute, die sich ihm annäherten. In diesem Sinne sagten Sie so etwas wie »Mr. Availability«.

ROBERT BARNES Ich glaube, das war Teenys Begriff. Er war interessiert, das war es, glaube ich. Ich weiß nicht, warum alle auch mir Aufmerksamkeit schenkten, weil ich noch ziemlich grün hinter den Ohren war. Er war unheimlich nett zu mir und hörte mir zu, aber ich glaube nicht, dass ich besonders viel zu sagen hatte.

ROBERT BARNES Yeah, he was very encouraging... because Duchamp had caused this disaster in the art world. Even during his lifetime he was beginning to realize that this was really an uncomfortable and ugly situation, people who mistook novelty for invention. And I think he'd like someone who—well his whole bet was to follow what you are. I couldn't be like him, I couldn't even be like the Surrealists. I certainly enjoyed their thinking, but I couldn't go that way. I just did what I did and I still am. It makes you unpopular, maybe for a lifetime, but I'd rather do that than be popular and doubt what I am.

THOMAS GIRST So that's a quality he could appreciate.

ROBERT BARNES He could appreciate that in anybody. Well, look at the people he liked. He did not have great taste in art. He loved a guy named Leonardo Cremonini. Well Cremonini was a terrible artist. He was Italian and did those kind of long neck people with scrubby faces that didn't have features.

THOMAS GIRST Why do you think that he liked that kind of thing?

ROBERT BARNES Well he liked him. He would have him over.

THOMAS GIRST Well that's always what he said. Look at the individual and not the art.

ROBERT BARNES Well Cremonini was not likeable either. He was very conceited. Knobby heads, that was very popular in those days and everyone did that. I think maybe one of the best and the worst things Marcel offered people was a lack of discrimination. He didn't discriminate. In doing so, he made the world easier, but by opening up, eliminating, abolishing decision-making tactics in deciding what is art, I think he created a terrible disaster. Because we don't know what the hell we are doing, there are no standards. The standard now becomes fame or money, neither of which Marcel really cared about. He liked it but he did not ever pursue it. As a result, we have all of these people who want to be seen, and Marcel never wanted to be seen, he almost had to be picked out of life to be seen. I don't know what he would think if he were alive today, be amused, because he didn't discriminate. He had this idea once, it comes from a conversation we had so I don't know if it ever got said again. He wanted to know if we could decide what is art by having a vote. Have you ever heard that idea of his?

THOMAS GIRST No.

ROBERT BARNES Well he was going to have a world vote and everyone in the world would vote on what is art.

THOMAS GIRST So they would get a little questionnaire?

THOMAS GIRST Aber man mochte Sie um sich haben.

ROBERT BARNES Ja. Ich glaube, ich schmückte die Gruppe, und ich glaube, sie dachten, ich sei jemand, der ihnen folgen würde. Nicht folgen, nein, da war nie ein Hinweis darauf, dass ich irgendwem folgen würde.

THOMAS GIRST Nun ja, Sie malten gegenständlich, Öl auf Leinwand, und Duchamp und vermutlich auch die anderen schätzten, was Sie taten, weil alle anderen damit aufgehört hatten. Sie sagten, Duchamp mochte das Bild, das im Whitney Museum hing, ihr *Judith and Holofernes* von 1959/1960. Wenn man an seine Phobie gegen Öl auf Leinwand denkt, ermutigte er Sie trotzdem, diesbezüglich weiterzumachen?

ROBERT BARNES Ja, er war sehr ermutigend ... weil Duchamp dieses Desaster in der Kunstwelt verursacht hatte. Sogar noch zu Lebzeiten bemerkte er langsam, dass das wirklich eine unangenehme und schreckliche Situation war, Leute, die Neuheiten als Erfindungen ansahen. Ihm ging es vor allem darum, sich selber treu zu sein. Ich konnte nicht wie er sein, ich konnte nicht mal wie die Surrealisten sein. Ich mochte ihr Denken, klar, aber ich konnte nicht denselben Weg gehen. Ich tat lediglich, was ich tat, und so ist das noch heute. Es macht dich unbeliebt, wahrscheinlich dein Leben lang, aber ich mache lieber das, als beliebt zu sein und daran zu zweifeln, wer ich bin.

THOMAS GIRST Das ist also eine Eigenschaft, die er schätzen konnte.

ROBERT BARNES Er konnte das bei jedem schätzen. Gucken Sie sich die Leute an, die er mochte. Er hatte keinen großen Kunstgeschmack. Er liebte einen Typen namens Leonardo Cremonini. Aber Cremonini war ein schrecklicher Künstler. Er war Italiener und schuf diese Langhalsleute mit verkrüppelten Gesichtern, die keine Gesichtszüge hatten.

THOMAS GIRST Warum glauben Sie, mochte er diese Sachen?

ROBERT BARNES Er mochte ihn halt. Er lud ihn zu sich nach Hause ein.

THOMAS GIRST Das ist es, was er immer gesagt hat. Schau dir das Individuum an und nicht die Kunst.

ROBERT BARNES Cremonini war auch nicht liebenswürdig. Er war ziemlich eingebildet. Knorrige Köpfe, das war zu der Zeit ziemlich populär, und jeder tat das. Ich glaube, eines der besten und zugleich schlechtesten Dinge, die Marcel den Leuten entgegenbrachte, war der Mangel an Urteilsfähigkeit. Er benachteiligte niemanden. Und indem er das tat, machte er die Welt einfacher, aber indem er Taktiken, die darüber entschieden, was Kunst ist, abschaffte und beseitigte, glaube ich, schuf er ein schreckliches Desaster. Weil wir einfach nicht mehr wissen,

ROBERT BARNES Yeah and maybe something, pictures or something, but he thought it would be too hard to find pigmies and so he decided the only way to really get a democratic view of what art is was to have his questionnaire circulated in barber shops. In those days barbershops were not hair salons, they were just barbershops. You read dirty books and magazines and bought rubbers and it was easier than going to the drugstore. He liked those places and he thought that was probably the most democratic.

THOMAS GIRST Only men would go there though.

ROBERT BARNES Well I suppose he might have let the beauty parlors do the same thing. But that's how he'd find out what art was.

THOMAS GIRST Did anyone follow up on that?

ROBERT BARNES No, you didn't need to. The idea was good enough.

THOMAS GIRST At the time you met him, most of the Readymades were already lost, they only existed in old pictures, he made or bought a few reproductions in the 1950s, then he came out with this edition in 1964 collaborating with the Milanese dealer and scholar Arturo Schwarz. Do you have any thoughts on the 1964 edition of the Readymades?

ROBERT BARNES First of all, the Readymades were always being readymade around Marcel. I mean, things were always being put together or glued, like the spoon on the doorknob (Verrou de sûreté à la cuiller, 1957, fig. 67).[9] You don't seem to come across any mention of the antlers at the top of the stairs.

THOMAS GIRST No, what about those, what stairs?

ROBERT BARNES Well they were right at the top of the stairs of his apartment near Bloomingdale's on the East side. And that's the apartment that had the great mailbox, Duchamp, Matisse, and Ernst. Art history's mailbox, really. At the top of the stairs was a set of antlers, really at a dangerous height, so you were always afraid that somebody would come up too fast and get impaled but I think that was the purpose.

THOMAS GIRST You could hit your head?

ROBERT BARNES It was right about here [motions in front of his chin]. You sort of had to get around it. I remember another thing Duchamp had made. One time he had a way of telling what time it was with the help of mirrors. Either the clock was outdoors or indoors, I can't remember where the clock was. But he had one mirror at the clock, there's another that would reverse, and then there's another that would reverse it back.

9 Duchamp's The Locking Spoon, a Semi-Readymade involving the door of his New York apartment in 1957, is based on a modified pun first printed in Francis Picabia's 391 in July 1924.

was wir da eigentlich tun, es gibt keine Standards mehr. Der Standard heute ist Ruhm oder Geld, nichts von dem, was Marcel wirklich interessierte. Er mochte das, aber er war nie darauf aus. Im Ergebnis haben wir alle diese Leute, die gesehen werden wollen, Marcel wollte nie gesehen werden, er musste fast aus dem Leben herausgehoben werden, um gesehen zu werden. Ich weiß nicht, was er denken würde, wenn er heute noch lebte, vielleicht wäre er amüsiert, weil er selbst nicht urteilte. Er hatte einmal diese Idee, sie entstand in einem Gespräch, das wir hatten, also weiß ich nicht, ob sie je noch mal geäußert wurde. Er wollte wissen, ob wir entscheiden können, was Kunst ist, indem wir abstimmen. Haben Sie je von dieser Idee gehört?

THOMAS GIRST Nein.

ROBERT BARNES Nun ja, er wollte eine Weltabstimmung haben und jeder auf der Welt sollte abstimmen, was Kunst ist.

THOMAS GIRST Mit einem kleinen Fragebogen?

ROBERT BARNES Ja, und vielleicht mit Bildern oder sowas, aber er dachte, dass es zu schwer sein würde, Versuchspersonen zu finden, und entschied deswegen, dass der einzige Weg, um einen wirklich demokratischen Blick auf die Frage, was Kunst ist, zu erlangen, der sei, seinen Fragebogen in Friseurläden auszulegen. Zu der Zeit waren die Salons keine Friseurläden wie heute, sie waren einfach Herrensalons. Man las anrüchige Bücher und Magazine und kaufte Kondome, und das war einfacher als in eine Drogerie zu gehen. Er mochte diese Orte und dachte, dass sie möglicherweise die demokratischsten waren.

THOMAS GIRST Obwohl nur Männer dorthin gingen.

ROBERT BARNES Naja, ich nehme an, dass er das auch in Damensalons machen wollte. Aber das war der Weg, wie er herausfinden wollte, was Kunst ist.

THOMAS GIRST Schloss sich irgendjemand dem an?

ROBERT BARNES Nein, das musste man nicht. Die Idee allein war gut genug.

THOMAS GIRST Zu der Zeit, zu der Sie ihn trafen, waren viele der Readymades bereits verloren, sie existierten nur auf alten Bildern, er machte oder kaufte ein paar Reproduktionen in den 50er-Jahren, und dann brachte er 1964 diese Edition in Zusammenarbeit mit dem mailändischen Händler und Wissenschaftler Arturo Schwarz heraus. Haben Sie eine Meinung zu dieser Edition der Readymades von 1964?

ROBERT BARNES Immer gab es irgendetwas »ready-made« um Marcel. Ich meine, die Dinge wurden immer irgendwie zusammengestellt

THOMAS GIRST Well he wrote that note of a clock in profile that you can't tell the time from a *Clock in Profile* (1964). Maybe the idea with the mirrors circumvented that somehow. Did he have that installed in his apartment?

ROBERT BARNES Yes.

THOMAS GIRST Only temporarily?

ROBERT BARNES I don't remember what happened to it.

THOMAS GIRST How many mirrors?

ROBERT BARNES Three or five. It had to be an odd number.

THOMAS GIRST From a clock tower?

ROBERT BARNES No I don't think so. I don't know where the clock was. I'm old. That was forty years ago.

THOMAS GIRST But what did he do with the antlers. What was the thing with the antlers? He just had them there?

ROBERT BARNES Well it was in the hallway outside of the door.

THOMAS GIRST Were things hanging from them?

ROBERT BARNES No. It would be great to hang things from. His house was always filled with odd little things set up. They all did it. Matta did it too.

THOMAS GIRST But the Readymade-edition in 1964, why did he do that?

ROBERT BARNES I was mad about that.

THOMAS GIRST You were not in New York anymore?

ROBERT BARNES No I was away. And I said to him, "What on Earth possessed you?" Everyone thought that Arturo Schwarz initiated it as a moneymaking venture. I don't know maybe it was moneymaking. It certainly would be for Arturo.

THOMAS GIRST You went to Duchamp, you approached him, and you asked him this?

ROBERT BARNES Yeah, I said that I couldn't understand why he did it. And he explained that it was... I mean, I can make a parallel between the bride in *The Large Glass* and the bride fleshed out in *Étant donnés*. It goes full circle. The bride is not fleshed and then becomes flesh. With the Readymades, they were junk and their traversing of time brings them to commercial objects. He told me he was going to have the opening at Macy's, but I think he was joking or didn't know it, because they didn't do it.

THOMAS GIRST So when you asked him, what did he say why he did it?

oder zusammen geklebt, wie der Löffel, der an einem Türknauf befestigt ist (*Verrou de sûreté à la cuiller*, 1957, Abb. 67).[9] Sie scheinen noch nie über die Geweihe auf der Treppe gestolpert zu sein.

THOMAS GIRST Nein, was ist damit, welche Treppe?

ROBERT BARNES Nun ja, sie hingen am oberen Ende der Treppe in seinem Apartment in der Nähe von Bloomingdale's an der East Side. Das ist dieses Apartment, das diesen herrlichen Briefkasten hatte: Duchamp, Matisse und Ernst. Der Briefkasten der Kunstgeschichte, wirklich. Am oberen Ende der Treppe waren einige Geweihe auf einer wirklich gefährlichen Höhe angebracht, so dass man immer fürchten musste, dass jemand zu schnell die Treppen hochkam und davon aufgespießt wurde. Aber ich glaube, das war genau das Ziel.

THOMAS GIRST Man konnte sich seinen Kopf daran stoßen?

ROBERT BARNES Es war genau auf dieser Höhe [macht Bewegungen in Höhe seines Kinns]. Man musste sozusagen drum herum gehen. Ich erinnere mich noch an etwas anderes, das Duchamp gemacht hatte. Einmal fand er einen Weg, mithilfe von Spiegeln zu sagen, wie spät es war. Entweder war die Uhr draußen oder drinnen, ich kann mich nicht mehr daran erinnern, wo sie war. Aber er hatte einen Spiegel an der Uhr und einen, der das darin Gezeigte drehte und noch einen anderen, der es wieder zurückdrehte.

THOMAS GIRST Ja, er schrieb eine Notiz zu dieser *Uhr im Profil* (1964), von der man die Zeit nicht ablesen konnte. Vielleicht hatte diese Idee mit den Spiegeln irgendwie damit zu tun. Hatte er das in seinem Apartment installiert?

ROBERT BARNES Ja.

THOMAS GIRST Nur vorübergehend?

ROBERT BARNES Ich kann mich nicht erinnern, was damit geschah.

THOMAS GIRST Wie viele Spiegel waren das?

ROBERT BARNES Drei oder fünf. Es musste eine ungerade Zahl sein.

THOMAS GIRST Von einem Uhrenturm?

ROBERT BARNES Nein, glaube ich nicht. Ich weiß nicht, wo die Uhr genau war. Ich bin alt. Das ist vierzig Jahre her.

THOMAS GIRST Aber was hat er mit dem Geweih gemacht. Was war damit? Hatte er es einfach dort hängen?

ROBERT BARNES Ja, es hing im Flur draußen.

THOMAS GIRST Hing etwas daran?

9 Duchamps *Verrou de sûreté à la cuiller* (The Locking Spoon), ein Readymade aus dem Jahre 1957, das die Tür seines New Yorker Apartments miteinbezieht, basiert auf einem modifizierten Wortspiel, das zuerst im Juli 1924 in Francis Picabias *391* gedruckt wurde.

ROBERT BARNES That's what he told me. It was a perfect transit of the Readymade from discovery to the crassness of just being a commercial object and it is very interesting that something that was nothing becomes something by our commercial standards, and we judge by money. I mean we were discussing his urinal today. How much did you say that sold that for?

THOMAS GIRST An example of the 1964 edition (fig. 5) went for a little bit above $1.76 million in November 1999.

ROBERT BARNES That wasn't even the original. Here's a thing when an idea becomes $1.6 million.

THOMAS GIRST $ 1.76 million.

ROBERT BARNES The traversing of time, and everything in Duchamp was about the process of transit, it brought a piece of junk toilet to someone who's very wealthy or a museum's halls. But it is still worth nothing. But someone paid one point something million.

THOMAS GIRST In this case it was the Greek collector Dimitri Daskalopoulos, actually. Why would you think it is impossible for a lot of people to do research on the original ready-mades—as mass-produced objects? Scholars like Thomas Zaunschirm or William Camfield writing an entire book about *Fountain*, or Kirk Varnedoe in 1990/91, doing the *High and Low: Modern Art & Popular Culture* show at the Museum of Modern Art trying to find the original *Comb* (1916, fig. 68). Rhonda Roland Shearer is continuing to track down the original objects but you just can't find them, even in the catalogues. Why would that be?

ROBERT BARNES Because they're old junk. They're old junk that lasts, pal.

THOMAS GIRST Yeah, but the old catalogues, from the 1910s and 1920s, you should be able to find those things.

ROBERT BARNES You've got the wrong catalogues, old catalogues get thrown away. I mean art historians are bizarre. And again, I'm sure Marcel would be totally amenable to helping them create these bizarre attitudes, because it is again the transit of the thing into something else. It is transmuted and changed into something else. And certainly art history, if anything, transmutes art into something useless.

THOMAS GIRST Art history keeps artists alive and Duchamp was always more interested in the audience that came after than in his contemporaries.

ROBERT BARNES Self-glorification is what art history is about and "I have discovered this," or "This is my area." Crazy nitwits. "Duchamp

ROBERT BARNES Nein. Es wäre toll gewesen, da Sachen dranzuhängen. Sein Haus war immer voll von seltsamen Dingen, die irgendwo aufgestellt waren. Alle taten sowas. Auch Matta war so.

THOMAS GIRST Aber die Readymade-Edition von 1964, warum hat er die gemacht?

ROBERT BARNES Ich war wütend deswegen.

THOMAS GIRST Sie waren zu der Zeit nicht mehr in New York?

ROBERT BARNES Nein, ich war schon weg. Und ich sagte zu ihm: »Was in aller Welt hat dich getrieben?« Jeder dachte, dass Arturo Schwarz das initiiert hatte, um Geld daraus zu schlagen. Ich weiß nicht, vielleicht war es nur Geldmacherei. Für Arturo war das sicherlich so.

THOMAS GIRST Sie gingen zu Duchamp, sprachen ihn an und fragten ihn das?

ROBERT BARNES Ja, ich sagte, dass ich nicht verstehen konnte, warum er das tat. Und er erklärte, dass es … Ich meine, ich kann eine Parallele ziehen zwischen der Braut im *Großen Glas* und der ausgestalteten Braut in *Étant donnés*. Da schließt sich ein Kreis. Erst ist die Braut nicht ausgestaltet, dann wird sie es. Die Readymades sind Schrott, und indem sie die Zeit durchlaufen, werden sie zu kommerziellen Objekten. Er sagte mir, dass die Eröffnung dazu im Kaufhaus Macy's stattfinden würde, aber ich dachte, er würde scherzen oder es nicht besser wissen, da es dort letztlich keine Eröffnung gab.

THOMAS GIRST Als Sie ihn also fragten, was sagte er, warum er das machte?

ROBERT BARNES Das ist es, was er mir gesagt hat. Es war der perfekte Übergang des Readymade von seiner Entdeckung bis zu dieser Sottise, lediglich ein kommerzielles Objekt zu sein, und es ist sehr interessant, dass etwas, das vorher nichts war, durch unsere kommerziellen Standards zu etwas wird und wir es mit Geld bewerten. Ich meine, wir reden heute über sein Urinal. Für wieviel, sagten Sie, wurde es verkauft?

THOMAS GIRST Ein Exemplar der 1964er Edition (Abb. 5) lag im November 1999 bei etwas mehr als 1,76 Millionen Dollar.

ROBERT BARNES Und das war nicht mal das Original. Das ist so eine Sache, wenn ein Gedanke 1,6 Millionen Dollar wert wird.

THOMAS GIRST 1,76 Millionen Dollar.

ROBERT BARNES Der Verlauf der Zeit und überhaupt alles an Duchamp war ein Prozess des Übergangs, es brachte eine Schrotttoilette zu jemand sehr Wohlhabendem oder in eine Museumshalle. Aber sie

is my area." That's goofy. But Duchamp would love that. He would love to have himself be their "area." If there were any good looking ones, he'd like that too. But the whole idea of the transformation: mystery, transformation, and manipulations—those were the things that Marcel was a magician at. That's his magic.

THOMAS GIRST Paul Matisse, who assembled *Étant donnés*, in the Philadelphia Museum of Art, suggested that no one knew about the piece except Duchamp's wife, Teeny, Duchamp himself, of course, and Maria Martins.

ROBERT BARNES Well maybe it helped to sell it to people, make it more exotic.

THOMAS GIRST When Bill Copley purchased *Étant donnés* through his Cassandra Foundation,[10] he knew about it too, so it wasn't that big of a big secret. He purchased it and then gave it to the Philadelphia Museum of Art. Now, we just talked about the erotic objects that were coming out in the 1950s. When you read reviews—and those people didn't know about *Étant donnés* in the making—they were, for example, described by the *New York Times* as "bizarre artifacts," sexual objects of some sort. They didn't know what to make of them.

ROBERT BARNES The *Large Glass* was a bizarre sexual object.

THOMAS GIRST Almost everything, even the *Bottle Rack* (1914, fig. 11).

ROBERT BARNES These were the horniest people on earth in an age where we were allowed to be horny without being arrested or sued.

THOMAS GIRST I know, it's a little sad nowadays. The first thing, even before he made the *Female Fig Leaf*, the *Dart-Object*, or *Wedge of Chastity* (figs. 44-46)—which he gave to Teeny as a wedding present— before all that he had already made the wedge section of the *Wedge of Chastity*, the inner sanctum of the *Female Fig Leaf* cast, if in fact it was a cast. It's titled *Not a Shoe* (1950, fig. 17) and he gave it to Julien Levy[11] in 1950. Those two were pretty close, right?

ROBERT BARNES Yes, Levy was very much like Marcel. They were very close in character. We used to call him the "Jewish Marcel Duchamp." But he was a remarkable person in his own right. I always thought that it was sad that Julien did not make art. In the end, he did make videos. There are several of them around. I did a painting, an imaginary portrait of Alfred Stieglitz in 1966, that Julien liked and bought. It was reproduced in Julien's book *Memoir of an Art Gallery* and it was such a surprise to see it in there again. It is not a bad painting I guess. I once also did a portrait of Julien from memory that his

10 The American artist, dealer and collector William Copley (1919-1996) met Duchamp in New York in the early 1940s and became an avid supporter and friend. His Cassandra Foundation purchased *Étant donnés* and assured its transfer to the Philadelphia Museum of Art.

11 American art dealer Julien Levy (1906-1981) was the first to stage a show on Surrealism and he is generally regarded as having played an essential role in the shift of the cultural avantgarde from Paris to New York. He and Duchamp oftentimes collaborated on various shows and projects.

ist immer noch nichts wert. Aber jemand bezahlt dafür eine Million irgendwas.

THOMAS GIRST In diesem Fall war es übrigens der griechische Sammler Dimitri Daskalopoulos. Warum glauben Sie, ist es oftmals unmöglich zu den Original-Readymades als Gebrauchsgegenstände zu forschen? Wissenschaftler wie Thomas Zaunschirm oder William Camfield schreiben ganze Bücher über *Fountain*, Kirk Varnedoe kuratierte 1990/1991 die *High and Low: Modern Art & Popular Culture Show* im Museum of Modern Art und versuchte, den echten *Kamm* (1916, Abb. 68) zu finden. Rhonda Roland Shearer versucht immer noch, die Originalobjekte aufzuspüren, aber man kann sie einfach nicht finden, nicht mal in den Katalogen. Warum ist das so?

ROBERT BARNES Weil es alter Schrott ist. Es ist alter Schrott, der überdauert, mein Freund.

THOMAS GIRST Ja, aber die alten Kataloge aus den 10ern und 20ern, es muss doch möglich sein, diese Dinge zu finden.

ROBERT BARNES Man hat die falschen Kataloge. Die alten wurden alle weggeschmissen. Aber ich liebe dieses Business einfach. Kunsthistoriker sind doch bizarr. Und noch einmal: ich bin mir sicher, dass Marcel für diese bizarren Einstellungen sogar empfänglich wäre, weil es wieder dieser Übergang von einem Ding zu etwas anderem war. Es wurde verwandelt und zu etwas anderem gemacht. Und natürlich verwandelt Kunstgeschichte Kunst in etwas Unnützes, was auch sonst.

THOMAS GIRST Kunstgeschichte erhält Künstler am Leben, und Duchamp war stets interessierter an dem Publikum, das ihm folgte, als an seinen Zeitgenossen.

ROBERT BARNES Es geht um Selbstverherrlichung in der Kunstgeschichte und um »Ich habe dieses und jenes entdeckt« oder »Das ist mein Gebiet«. Verrückte Idioten. »Duchamp ist mein Gebiet.« Das ist albern. Aber Duchamp würde es lieben. Er würde es lieben, ihr »Gebiet« zu sein. Und wenn das auch noch gutaussehende Menschen wären, würde er das auch lieben. Aber dieser ganze Gedanke der Transformation... Geheimnis, Transformation und Manipulationen — das waren die Dinge, in denen Marcel ein Zauberer war. Das war seine Magie.

THOMAS GIRST Paul Matisse, der *Étant donnés* im Philadelphia Museum of Art aufbaute, vermutete, dass niemand sonst von der Arbeit wusste außer Duchamps Frau, Teeny, er selbst und Maria Martins.

ROBERT BARNES Naja, vielleicht half das, es den Leuten zu verkaufen, es noch exotischer zu machen.

wife Jean thought very accurate. It showed him with his fly open, which Julien was prone to have. He was phenomenal. Actually I had quite a falling out with Julien because he wanted me to illustrate *Jacob Again*, a book he wrote, a semi-science fiction thing. And the truth is that it wasn't very good and I couldn't illustrate it and I doodled around but Julien got impatient with me. I didn't know what to say.

THOMAS GIRST Talking about semi-science, you said there were teenage books that you and Duchamp shared a passion for.

ROBERT BARNES Oh, yeah, no one knows about that, do they? *Tom Swift and the Giant Magnet*. Tom Swift was a character, I don't know who wrote them, but they were great children's books.[12]

THOMAS GIRST So you were reading them at the time?

ROBERT BARNES No, we both knew about them. I don't know if they got translated into French or where he came across them. He probably found them in the Strand Bookstore or something.

THOMAS GIRST How did you get to talk about that?

ROBERT BARNES I don't know how. Maybe I mentioned that some of his things were like the inventions of Tom Swift. Tom Swift was a great inventor, probably much better than Marcel. Some Duchamp scholar should read Tom Swift to see if there's any correlation with anything.

THOMAS GIRST When would Duchamp have first come across the Tom Swift books?

ROBERT BARNES Well, I don't know. Tom Swift books were popular in the 1930s and 1940s and probably even the 1950s.

THOMAS GIRST Coming back to the Surrealists you knew, Max Ernst was the earliest "acquaintance." You said you ran away from home when you were 15, and you ran into him in Arizona where he resided with Dorothea Tanning between 1946 and 1953.

ROBERT BARNES In Sedona. I didn't know who the hell he was.

THOMAS GIRST You were getting rid of his trash and then you bumped into him again when you were in New York.

ROBERT BARNES Yeah. That's a real odd coincidence because I worked with a friend and we would collect trash from rich people. And Max lived in Sedona then. I wonder what happened to that place. I'm sure his son Jimmy got it and Jimmy is dead now.

THOMAS GIRST He was not rich really.

ROBERT BARNES No, but we thought he was rich. We didn't have anything. But we would go around to these homes in Sedona and offer to get rid of their garbage. And in places like that garbage is big business,

12 Mostly written by Howard Garis under the pseudonym "Victor Appleton," the highly popular children and young adult literature series of *Tom Swift's Adventures* were published in forty individual volumes by Grosset & Dunlap between 1910–1941. Every book featured a great abundance of scientific inventions. In the spirit of Jules Verne, Alfred Jarry and (to a lesser extent) Raymond Roussel, the books must certainly have held some charm for Duchamp.

THOMAS GIRST Als Bill Copley *Étant donnés* durch seine Cassandra Foundation erwarb,[10] wusste er auch davon, also war es kein so großes Geheimnis. Er erwarb das Werk und überließ es dann dem Philadelphia Museum of Art. Wir sprachen gerade von den erotischen Objekten, die in den 50ern aufkamen. Wenn man Besprechungen liest — und diese Leute wussten nichts von der Entstehung *Étant donnés* —, werden sie zum Beispiel in der *New York Times* als »skurrile Artefakte« beschrieben, als irgendwelche sexuellen Objekte. Man wusste nicht, was man daraus machen sollte.

ROBERT BARNES Das *Große Glas* war ein skurriles sexuelles Objekt.

THOMAS GIRST Nahezu alles, sogar der *Flaschentrockner* (1914, Abb. 11).

ROBERT BARNES Das waren eben die spitzesten Leute auf der Welt in einer Zeit, in der wir spitz sein durften, ohne gleich verhaftet oder angeklagt zu werden.

THOMAS GIRST Ich weiß, das ist ein bisschen traurig heutzutage. Zuerst, noch bevor er *Weibliches Feigenblatt* machte, das *Dart-Objekt* und den *Keuschheitskeil* (Abb. 44–46) — die er Teeny zur Hochzeit schenkte —, vor all dem hatte er schon den Keil des »Keuschheitskeils« geschaffen, das Allerheiligste des Abdrucks des *Weiblichen Feigenblatts*, wenn es denn tatsächlich ein Abdruck war. Es heißt *Not a Shoe* (1950, Abb. 17), und er gab es Julien Levy[11] 1950. Diese beiden waren ziemlich eng miteinander, richtig?

ROBERT BARNES Ja, Levy war Marcel sehr ähnlich. Sie waren sich sehr nah im Charakter. Wir nannten ihn den »Jewish Marcel Duchamp«. Aber er war für sich gesehen auch eine außergewöhnliche Person. Ich dachte immer, dass es traurig sei, dass Julien selbst keine Kunst schuf. Am Ende machte er Videos. Es gibt einige von ihm. Ich fertigte ein Gemälde an, ein imaginäres Porträt von Alfred Stieglitz von 1966, das Julien sehr mochte und kaufte. Es wurde in Juliens Buch *Memoir of an Art Gallery* abgedruckt und es war eine tolle Überraschung, es darin wiederzusehen. Es ist kein schlechtes Bild, glaube ich. Ich fertigte auch mal ein Porträt von Julien an, aus der Erinnerung heraus, seine Frau Jean fand es sehr treffend. Es zeigte ihn mit offenem Reißverschluss, was Julien oft geschah. Er war phänomenal. Ich hatte sogar mal einen Streit mit ihm, weil er wollte, dass ich *Jacob Again* illustrierte, ein Buch, das er schrieb, so ein halbes Science-Fiction-Ding. Tatsächlich war es nicht besonders gut, und ich konnte es nicht illustrieren und kritzelte so herum, bis Julien ungeduldig wurde. Ich wusste aber nicht, wie ich es ihm sagen sollte.

10 Der amerikanische Künstler, Händler und Sammler William Copley (1919–1996) traf Marcel Duchamp in New York in den frühen 1940er-Jahren und wurde ein begeisterter Unterstützer und Freund. Seine Cassandra Foundation erwarb *Étant donnés* und sicherte seinen Transfer ins Philadelphia Museum of Art.
11 Der amerikanische Kunsthändler Julien Levy (1906–1981) war der erste Förderer einer Ausstellung über den Surrealismus und wird allgemein als derjenige angesehen, der bei dem Transfer der Avantgarde-Bewegung von Paris nach New York eine entscheidende Rolle gespielt hatte. Er und Duchamp arbeiteten oft zusammen an verschiedenen Ausstellungen und Projekten.

you never get rid of it. And we offered to take it and dispose of it in a "clean and orderly fashion," which meant we would dump it in any place we could where no one would see it. My friend had a pick-up truck—all Navahos if they have a vehicle, have turquoise pick-up. And we loaded it up with this plaster from this guy's home, with faces on it, they were kind of interesting, and dumped them. So somewhere up there if you want to excavate, there's a whole bunch of rejected Max Ernst sculpture. I have a picture of myself sitting on his *King and Queen*-sculpture.[13] I looked like I was twelve.

THOMAS GIRST While you were down there?

ROBERT BARNES Yeah.

THOMAS GIRST Who took the picture of you, your friend?

ROBERT BARNES Yeah. Max Ernst was very shadowy. Whenever he stayed in New York, he stayed at Marcel's.

THOMAS GIRST What about Man Ray?

ROBERT BARNES I didn't like him.

THOMAS GIRST You mentioned that Duchamp once introduced you to a dealer of ethnic art.

ROBERT BARNES Yeah, Carlebach I think he was called.

THOMAS GIRST Did he take you there?

ROBERT BARNES The first time I went with him. Carlebach was a dealer in ethnic material and he had this store filled—it was what you would expect a junk shop to have—filled from floor to ceiling with all of these ju-ju's. You could buy an African sculpture for a couple hundred dollars or less.

THOMAS GIRST So Duchamp brought you there because he liked the place?

ROBERT BARNES Yes.

THOMAS GIRST Was there any literature that he recommended to you?

ROBERT BARNES Oh yeah. Dujardin and Lautréamont, they all loved Lautréamont, but I'm not going to get into that. The book that was most like Marcel, I don't know wether he loved it or not, was *À Rebours* by Huysmans, *Against the Grain*. It was so like Marcel. That's a story of art. Put too much on it and it's going to die. Actually, Marcel introduced me to French literature, Camus, Celine, he was a bad boy. And of course I never liked Beckett. Beckett is the literary equivalent of Bergman films, which at the time were very exciting, but if you saw them again, you would get very embarrassed.[14]

13 According to Dorothea Tanning, Max Ernst's sculpture *Capricorn* (1947) was first conceived as a garden sculpture "of regal but benign deities that consecrated our 'garden' and watched over its inhabitants." See Dorothea Tanning, *Birthday* (San Francisco 1986). n. p. [photo caption in mid-section between pp. 96 and 97]. Ernst himself referred to the sculpture as a family portrait, depicting Dorothea, his two dogs and himself. It was cast in bronze and first turned into an edition in 1964.

14 French writer Edouard Dujardin's (1868–1947) *Les Lauriers sont coupées*, 1888 (or *The Laurels Have Been Cut*), is often regarded to be the first novel introducing direct interior monologue; the writings of French author Isidore Ducasse (aka Comte de Lautréamont, 1846–1870) were held in high esteem by the Surrealists, who regarded his eccentric writing as a precursor to their own movement (especially his *Les Chants de Maldoror*, 1869); decadent French novelist and art critic Joris Karl Huysmans (1848–1907), *Against the Grain*, 1884; French existentialist writer Albert Camus (1913–1960); French novelist Louis Ferdinand Céline (1894–1961); Irish playwright and novelist Samuel Beckett (1906–1989), *End Game*, 1957; Swedish film and theater director Ingmar Bergman (1918–2007).

THOMAS GIRST Wenn wir über Halb-Wissenschaften reden: Sie sagten, es gab Jugendbücher, für die Duchamp und Sie eine gemeinsame Leidenschaft hatten.

ROBERT BARNES Oh ja, niemand weiß davon, oder? *Tom Swift and the Giant Magnet*, Tom Swift war eine Figur, ich weiß nicht, wer die Bücher schrieb, aber das waren tolle Kinderbücher.[12]

THOMAS GIRST Sie haben sie zu der Zeit gelesen?

ROBERT BARNES Nein, wir wussten beide davon. Ich weiß nicht, ob sie ins Französische übersetzt wurden oder wie er darauf kam. Er fand sie wahrscheinlich im New Yorker Buchladen The Strand oder so.

THOMAS GIRST Wie kam es dazu, dass Sie darüber redeten?

ROBERT BARNES Ich weiß nicht wie. Vielleicht bemerkte ich, dass einige seiner Sachen wie die Erfindungen von Tom Swift waren. Tom Swift war ein großer Erfinder, vermutlich viel besser als Marcel. Einige Duchamp-Kenner sollten Tom Swift lesen, um herauszufinden, ob es da irgendwelche Zusammenhänge gibt.

THOMAS GIRST Wann wurde Duchamp zum ersten Mal auf die Tom Swift-Bücher aufmerksam?

ROBERT BARNES Hm, das weiß ich nicht. Die Tom Swift-Bücher waren in den 30ern und 40ern und vielleicht auch 50ern ziemlich bekannt.

THOMAS GIRST Um auf die Surrealisten zurückzukommen, die Sie kennen, Max Ernst war die früheste Bekanntschaft. Sie sagten, Sie liefen von Zuhause weg, als Sie 15 waren, und Sie begegneten ihm in Arizona, als er dort mit Dorothea Tanning wohnte, in den Jahren 1946 bis 1953.

ROBERT BARNES In Sedona. Ich hatte keine Ahnung, wer er war.

THOMAS GIRST Sie entsorgten seinen Müll und trafen ihn dann wieder, als Sie in New York waren.

ROBERT BARNES Ja. Das ist ein wirklich dämlicher Zufall, weil ich mit einem Freund zusammen arbeitete und wir Müll von reichen Leuten sammelten. Und Max lebte damals in Sedona. Ich frage mich, was mit der Wohnung passierte. Ich bin mir sicher, dass sein Sohn Jimmy sie bekam, und Jimmy ist inzwischen tot.

THOMAS GIRST Er war nicht wirklich wohlhabend.

ROBERT BARNES Nein, aber wir dachten, er sei wohlhabend. Wir hatten nichts. Aber wir fuhren da in Sedona herum und boten an, den Müll abzuholen und zu entsorgen. An solchen Orten ist Müll das große Geschäft, man wird ihn nie los. Wir boten also an, ihn abzuholen und ihn »sauber und ordnungsgemäß« zu entsorgen, was bedeutete, das wir

12 Hauptsächlich von Howard Garis unter dem Pseudonym »Victor Appleton« geschrieben, wurde die erfolgreiche Jugendbuchserie der *Abenteuer des Tom Swift* in 40 Einzelausgaben von Grosset&Dunlap zwischen 1910 und 1941 veröffentlicht. Jedes Buch zeichnet sich durch eine große Fülle von wissenschaftlichen Erfindungen aus. Im Geiste Jules Vernes, Alfred Jarrys und — zu einem geringeren Maße — Raymond Roussel, müssen diese Bücher einen gewissen Charme auf Duchamp ausgeübt haben.

THOMAS GIRST So Duchamp introduced you to Beckett.

ROBERT BARNES Yeah, he mentioned it and then I read it.

THOMAS GIRST Beckett's *End Game* might in part be based on Marcel's chess game problem.[15] Do you play chess?

ROBERT BARNES Yes, I hate it. I absolutely hate it. I played with Marcel because he liked to play with people who didn't know how to play chess. You know, a chess champion is used to gambits and if he plays with someone who has no idea what they should be doing, it is almost more taxing. He liked that. I would put the pieces in positions that I thought were decorative. And of course I would surrender.

THOMAS GIRST Did he teach you?

ROBERT BARNES No, it was just a pastime. And what would happen would be that I would sacrifice so many pieces that it was very hard to get a checkmate. Everything is being sacrificed and it was just totally disorganized and I think that was something that Marcel liked.

THOMAS GIRST There is this story that he got annoyed with John Cage[16] complaining that Cage never even tried to win. So there was also something where people were good chess players and he just didn't think that they were trying hard enough to beat him.

ROBERT BARNES That was a strange relationship. Didn't Cage hate *Étant donnés*?

THOMAS GIRST I don't know about that.

ROBERT BARNES It was a weird relationship.

THOMAS GIRST But Cage owes a lot to Duchamp. It's not the other way around. But now for something completely different: Paul Swan I'm supposed to ask you about. So who was Paul Swan?

ROBERT BARNES God, if there was a Duchampian theater, it was Paul Swan. I did paintings with Paul Swan, I'll show you one later, pastels. Paul Swan was an occupant of the apartments in the Carnegie Hall when the Carnegie Hall was great and real before it was fixed and made up for the deluxe world. In Carnegie Hall there were apartments and they were slowly getting rid of people who were in these apartments because they wanted them back either for space or for rich people. But Paul Swan held on.

THOMAS GIRST How old was he?

ROBERT BARNES I'll tell you in a minute. He was very old. And in order to stay and pay the rent, Paul would have his soirées on Saturday evenings and you could go, he couldn't charge because it was his apartment but there was a donation box. And he would dance and then he would

15 In 1932, together with the chess master Vitaly Halberstadt, Marcel Duchamp co-wrote and designed a book on a highly specific endgame situation in chess, *L'Opposition et les cases conjuguées sont reconciliées* (or *Opposition and Sister Squares are Reconciled*), published in French, German and English by L'Echiquier (Edmond Lancel), Brussels.
16 American avant-garde musician John Cage (1912–1992) came under Duchamp's spell soon after Cage arrived in New York in 1942.

ihn überall dort ausschütteten, wo wir konnten und niemand es sah. Mein Freund hatte so einen Pickup-Truck — alle Navajos, die ein Fahrzeug hatten, hatten einen türkisfarbenen Pickup. Wir beluden ihn mit diesem Gipszeug von diesem Typen, mit Gesichtern drauf, die waren irgendwie interessant, und warfen sie dann weg. Wenn Sie graben wollen, irgendwo dort ist jede Menge von diesen Skulpturen von Max Ernst. Ich habe ein Bild von mir selbst, wie ich auf seiner *King and Queen*-Skulptur sitze.[13] Ich sehe darauf aus wie zwölf.

THOMAS GIRST Während Sie dort waren?

ROBERT BARNES Ja.

THOMAS GIRST Wer hat dieses Bild von Ihnen gemacht, Ihr Freund?

ROBERT BARNES Ja, Max Ernst war sehr geheimnisvoll. Immer wenn er in New York war, war er bei Marcel.

THOMAS GIRST Was ist mit Man Ray?

ROBERT BARNES Ich mochte ihn nicht.

THOMAS GIRST Sie erwähnten, dass Duchamp sie einmal einem Händler für ethnische Kunst vorstellte?

ROBERT BARNES Ja, Carlebach hieß er, glaube ich.

THOMAS GIRST Brachte er Sie zu ihm?

ROBERT BARNES Beim ersten Mal war ich mit ihm unterwegs. Carlebach war ein Händler für ethnische Materialien, und er hatte diesen Laden, gefüllt mit all dem, was man von einem Trödelladen erwartet, vom Boden bis zur Decke voll mit diesem ganzen Zeug. Man konnte eine afrikanische Skulptur für ein paar hundert Dollar oder weniger kaufen.

THOMAS GIRST Duchamp brachte Sie dorthin, weil er diesen Ort mochte?

ROBERT BARNES Ja.

THOMAS GIRST Gab es irgendwelche Literatur, die er Ihnen empfahl?

ROBERT BARNES Oh ja. Dujardin und Lautréamont, die liebten alle Lautréamont, aber darauf gehe ich hier nicht weiter ein. Das Buch, das Marcel am meisten ähnelte, ich weiß gar nicht, ob er es mochte oder nicht, war *Gegen den Strich* von Huysmans. Es war Marcel so ähnlich. Eine Geschichte über Kunst. Überlade sie, und sie stirbt. Marcel brachte mich sogar auch zur französischen Literatur, Camus, Céline, er war ein böser Junge. Und natürlich mochte ich Beckett nie. Beckett ist das literarische Äquivalent zu den Bergman-Filmen, die zu der Zeit sehr spannend waren, aber wenn man sie dann noch einmal sah, dann schämte man sich.[14]

13 Dorothea Tanning zufolge war Max Ernsts Skulptur *Capricorn* (1947) zunächst als eine Gartenskulptur »von majestätischen aber liebevollen Gottheiten, die unseren Garten segneten und über seine Bewohner wachten« gedacht. S. Dorothea Tanning, *Birthday*, San Francisco 1986, o. S. [Bildunterschrift in der Fotostrecke im Mittelteil, zw. S. 86 und S. 97]. Ernst selbst sprach über die Skulptur als ein Familienporträt, das Dorothea, seine zwei Hunde und ihn selbst darstellen sollte. Sie war in Bronze gegossen und wurde erstmals 1964 in einer Edition gefertigt.

14 *Les Lauriers sont coupés* des französischen Autors Edouard Dujardin (1868–1947) wird oft als der erste Roman gesehen, der den direkten inneren Monolog einsetzt; die Werke des französischen Autors Isidore Ducasse, auch bekannt als Comte de Lautréamont (1846–1870), wurden von den Surrealisten sehr geschätzt, weil sie seine exzentrische Art zu schreiben, vor allem sein *Les Chants de Maldoror* von 1869 als eine Vorstufe ihrer eigenen Bewegung ansahen; außerdem der dekadente französische Romanautor und Kunstkritiker Joris Karl Huysmans (1848–1907), dessen Werk *A rebours* von 1884; der französische Existentialist und Autor Albert Camus (1913–1960); der französische Romanautor Louis Ferdinand Céline (1894–1961); der irische Dramatiker und Romanautor Samuel Beckett (1906–1989) mit seinem Werk *Endspiel* von 1957; der schwedische Film- und Theaterregisseur Ingmar Bergman (1918–2007).

give a little lecture. If you timed it right, you would get in on Paul's bacchanal. And Marcel introduced me. Matta found Paul Swan, made Marcel go, and then he became a fan. And the best thing that he did was the bacchanal of the Sahara Desert in which he danced naked, virtually—he had veils, very gay. All by himself, he would do the bacchanal of the Sahara Desert losing his veils and ending up totally naked. Paul was in his late eighties at this time and then he would stand in front of the audience stark naked and would explain the reason why his body was in such great condition and why his skin was so perfect was that he bathed daily in a vat of olive oil and that everyone should do that if they want to stay as young as he is. And he was one of the first health food addicts, he and Francis Stella, they were the first ones to be fanatical about health food. The trouble is, only Paul Swan thought that he still had smooth skin that looked really young. He was really a wreck. His little thingy was all shriveled. And of course everyone would throw money into the box afterwards because it was such a marvelous event.

THOMAS GIRST So it wasn't publicly advertised? Only artists went there basically? It was only known through word of mouth?

ROBERT BARNES Yeah, basically. The thing is, he must have made a fortune because no one wanted Paul to get kicked out of Carnegie Hall. I don't know what happened. I went to Europe after that and lost track but he probably died. Oh, those performances were so superb. It made the happenings seem mundane. You know, they think they started that stuff down at Judson Church. No! Swan's soirées were a million times more exciting.

THOMAS GIRST Every week?

ROBERT BARNES I don't know. I think every week.

THOMAS GIRST How many people were there usually?

ROBERT BARNES Twenty people. I know Matta always loved to go there and a whole group would go up there.

THOMAS GIRST I have another question: You have a few works by Duchamp that he simply gave to you. That was very generous at the time. What did you think?

ROBERT BARNES He gave something to me and he would always say, "Look, if you need money sometime, you could probably sell this." We were thinking like a couple hundred dollars probably. I never sold them. I've had hard times. I'm sentimental.

THOMAS GIRST It's not about monetary value, it's about this guy giving it to you.

THOMAS GIRST Duchamp brachte Sie also zu Beckett.

ROBERT BARNES Ja, er sprach von den Büchern, und ich las sie.

THOMAS GIRST Becketts *Endspiel* basiert möglicherweise in Teilen auf Marcels Schachspielproblem.[15] Spielen Sie Schach?

ROBERT BARNES Ja, aber ich hasse es. Ich hasse es total. Ich spielte mit Marcel, weil er es mochte, mit Leuten zu spielen, die nicht wussten, wie man Schach spielt. Wissen Sie, ein Schachmeister kennt die Gambit-Eröffnungen alle, und wenn er mit jemandem spielt, der keine Ahnung davon hat, ist es fast noch anstrengender. Er mochte das. Ich stellte die Figuren auf Felder, wo sie sehr dekorativ aussahen. Und natürlich gab ich mich dann geschlagen.

THOMAS GIRST Lehrte er Sie darin?

ROBERT BARNES Nein, es war nur ein Zeitvertreib. Es war so, dass ich sehr viele Figuren opferte, so dass es sehr schwer war, ihn matt zu setzen. Alles wurde irgendwie geopfert, und es war total unorganisiert, aber ich glaube, dass Marcel das mochte.

THOMAS GIRST Es gibt die Geschichte, dass er sich über John Cage ärgerte[16] und sich beschwerte, dass Cage nie versuchte zu gewinnen. Es gab also auch Situationen mit Leuten, die gute Schachspieler waren und von denen er lediglich dachte, dass sie zu selten versuchten, ihn zu schlagen.

ROBERT BARNES Das war eine komische Beziehung. Hasste Cage nicht *Étant donnés*?

THOMAS GIRST Ich weiß davon nichts.

ROBERT BARNES Das war eine eigenartige Beziehung.

THOMAS GIRST Aber Cage hat Duchamp sehr viel zu verdanken. Es ist eben nicht andersherum. Aber jetzt zu etwas ganz anderem: Paul Swan. Darüber sollte ich mit Ihnen reden. Wer war also Paul Swan?

ROBERT BARNES Oh Gott, wenn es ein duchampsches Theater gab, dann war das Paul Swan. Ich schuf Bilder mit Paul Swan, ich zeige Sie ihnen später, Pastelle. Paul Swan war ein Besetzer der Apartments in der Carnegie Hall, als die Carnegie Hall noch groß und ursprünglich war, bevor sie für die Luxuswelt eingenommen wurde. In der Carnegie Hall waren Apartments, und man versuchte langsam, die Leute, die in diesen Apartments wohnten, loszuwerden, weil man letztere zurückhaben wollte wegen des Platzes oder für reiche Leute. Aber Paul Swan hielt durch.

THOMAS GIRST Wie alt war er?

ROBERT BARNES Moment. Er war sehr alt. Um zu bleiben und die Miete zu bezahlen, organisierte Paul samstags abends Soirées, zu de-

15 1932 schrieb und entwarf Marcel Duchamp zusammen mit dem Schachmeister Vitaly Halberstadt ein Buch über eine sehr spezifische Endsituation im Schach, *L'Oppostion et les cases conjuguées* sonst *reconciliées* (»Opposition and Sister Squares are Reconciled«; »Opposition und Schwesterfelder sind versöhnt«), das auf Französisch, Deutsch und Englisch bei L'Echiquier (Edmond Lancel, Brüssel) veröffentlicht wurde.

16 Der amerikanische Avantgarde-Musiker John Cage (1912–1992) wurde schnell in Duchamps Bann gezogen, nachdem er 1942 nach New York gekommen war.

ROBERT BARNES I'm also not a "hem of the cloak" person.

THOMAS GIRST What's that?

ROBERT BARNES Touching Marcel's hand to become empowered. You know, I did a painting about Marcel and I hate myself for it.

THOMAS GIRST I like it.

ROBERT BARNES Well I don't because I swore that I would never use Marcel in any way as a stepping-stone to anything.

THOMAS GIRST Which a lot of people did who didn't know him as well as you.

ROBERT BARNES Yeah, well if you notice, the people that really did know Marcel, don't like to talk about him. The fact that I'm doing this is really kind of weird. I shouldn't be. And in some ways it is blasphemous. But there is nothing to blaspheme if you don't turn Marcel into a God. Marcel was normal and very, very bourgeois. He was a normal guy, very normal. He smoked terrible cigars. He smoked Blackstones and he also smoked La Frederic, which is like smoking rope.

THOMAS GIRST He never did any drugs?

ROBERT BARNES No, why would he? Wine's good enough, isn't it? He's dead now, you notice? What is it on his grave? It's wonderful.

THOMAS GIRST "Besides, it's always the others that die." I like that too. We were talking before about how he gave you three or four works of his, and you didn't ask him for, he didn't want to get paid for...

ROBERT BARNES Get paid?! Marcel never got paid anything.

THOMAS GIRST Was it for the favors that you did for him or was it just because he felt a certain friendship towards you?

ROBERT BARNES That's what makes real friendship comfortable, when you don't count favors. I've counted favors, all on his side. The guy was generous. Everyone knew that and I think that probably people did take advantage of him. I'm not sure that Schwarz didn't.

THOMAS GIRST And you didn't run to him and want him to sign certain stuff.

ROBERT BARNES Oh yeah, sign.

THOMAS GIRST Well that's good, because some people did.

ROBERT BARNES "Oh, mister, can I have your autograph on my ball?"

THOMAS GIRST And he probably wouldn't have refused.

ROBERT BARNES No he wouldn't have.

THOMAS GIRST You left New York when?

ROBERT BARNES I'm not sure. I went to London to Slade School and had more contact with Matta and Copley, because Copley had a home

nen man gehen konnte. Er konnte dafür nichts nehmen, weil es ja sein Apartment war, aber es gab eine Spendenbox. Er tanzte und gab eine kleine Lesung. Wenn man zur richtigen Zeit kam, konnte man bei Pauls *Bacchanal* mitmischen. Marcel stellte mich ihm vor. Matta entdeckte Paul Swan, bewegte Marcel zum Hingehen, der so ein Fan wurde. Und das Beste, was er tat, war dieses *Bacchanal of the Sahara Desert,* wo er gewissermaßen nackt tanzte, mit Schleiern, sehr belustigend. Er tanzte dieses Bacchanal ganz für sich allein, streifte seine Schleier ab und war am Ende total nackt. Paul war zu der Zeit schon Ende 80 und stand da gänzlich nackt vor dem Publikum und erklärte, warum sein Körper in so guter Verfassung und seine Haut so perfekt sei, weil er nämlich täglich in einem Bottich mit Olivenöl badete und dass jeder das tun sollte, wenn man so jung wie er bleiben wolle. Er war einer der ersten Anhänger der Reformkost, er und Francis Stella, sie waren die ersten, die so fanatisch nach dieser Gesundheitskost waren. Das Problem ist: Nur Paul Swan selbst dachte, dass er immer noch diese weiche Haut hätte, die wirklich jung aussah. Eigentlich war er tatsächlich ein Wrack. Sein kleines Dingsda war total verschrumpelt. Und natürlich warf jeder nachher Geld in die Box, weil es so ein herrliches Ereignis war.

THOMAS GIRST Es wurde also nicht öffentlich angekündigt? Es kamen hauptsächlich Künstler? Man wusste nur durch Mundpropaganda davon?

ROBERT BARNES Ja, hauptsächlich. Die Sache ist die, er musste ein Vermögen gemacht haben, weil niemand wollte, dass Paul aus der Carnegie Hall geschmissen wurde. Ich weiß nicht mehr, was passierte. Ich ging danach nach Europa und habe seine Spur verloren, aber wahrscheinlich starb er dann. Ach, diese Aufführungen waren ausgezeichnet. Es ließ die Happenings banal erscheinen. Sie wissen, man geht davon aus, dass alles in der Judson Church begann? Mitnichten! Swans Soirées waren tausendmal spannender.

THOMAS GIRST Fanden sie jede Woche statt?

ROBERT BARNES Ich weiß nicht. Ich glaube ja.

THOMAS GIRST Wie viele Leute waren normalerweise dabei?

ROBERT BARNES 20. Ich weiß, dass Matta es liebte, dabei zu sein, und eine ganze Gruppe von Leuten war auch da.

THOMAS GIRST Ich habe eine andere Frage: Sie besitzen ein paar Arbeiten von Duchamp, die er Ihnen einfach schenkte. Das war damals sehr großzügig. Was dachten Sie darüber?

over there. I had a great dinner once at Copley's house. We ate off of Magritte plates with parts of the body painted on them and since we were guests of honor, my wife and I, my first wife, got first choice. She got the male plate and I got the female plate. Thought you might have hair in your food, kind of an interesting dinner. Matta always made things interesting.

THOMAS GIRST And Matta you were the closest with, he introduced you to everyone and he was just one wild person.

ROBERT BARNES Yeah he was a good painter too. You know, I'm not sure where Matta fits in, in the history. You know, who cares. What's interesting is that we're living in a generation of young people who are constantly preoccupied with their place in history. What the hell does it matter? Marcel never thought about that. Maybe later on when he started cataloguing stuff, he starting thinking that maybe he wanted to leave some legacy. But legacy is bullshit. But everyone now is "where's my place in history." How many times can you ask?

THOMAS GIRST Well your generation will not decide who makes it into the history books.

ROBERT BARNES No one will decide. Some lizard or something might decide in the end. But people are so worried about whether they are going to be known. Now they create money and become attached to it. I thank God I lived in the era of Marcel and those people, who weren't. Money was certainly not much of a preoccupation. It drifted across their brains, but it was definitely not much of a preoccupation. It was interesting, I did a talk on de Kooning.[17] While they were circulating that show of his and I got to the middle of the talk and I suddenly realized and said it out loud that I didn't think anyone thought they were going to make money from their work, a lot of money, and it wasn't until the 1970s that it started changing and people started clawing each other to get known, get a gallery, a good gallery, to get this and get that and the art is boring because of it. I mean how much can you be shocked by all the latest things? We have some guy cutting off pieces of his penis in a gallery, good for him.

THOMAS GIRST Well it becomes shallow and hollow and everything has been done before and done better mostly.

ROBERT BARNES I'm afraid Marcel unleashed some of that and I know he knew it and I think he was a little bit dismayed or amused; it would be both in this case.

17 Willem de Kooning (1904–1997). Born in Rotterdam, the action painter was one of the founding members of what came to be known as The New York School.

ROBERT BARNES Er gab mir etwas und sagte immer: »Sieh mal, wenn du irgendwann Geld brauchst, kannst du das hier vielleicht verkaufen«. Wir dachten an ein paar hundert Dollar vielleicht. Ich habe sie aber nie verkauft. Ich hatte schwere Zeiten. Und jetzt werde ich sentimental.

THOMAS GIRST Es geht nicht um den finanziellen Wert, sondern darum, dass er sie ihnen gegeben hat.

ROBERT BARNES Ich bin aber auch keine »hem of the cloak«-Person.

THOMAS GIRST Was ist damit gemeint?

ROBERT BARNES Marcels Hand zu nehmen, um mehr Macht zu bekommen. Sie wissen, dass ich ein Bild von Marcel malte, und ich hasse mich selbst dafür.

THOMAS GIRST Ich mag es.

ROBERT BARNES Tja, ich nicht, weil ich schwor, Marcel niemals auch nur irgendwie als Sprungbrett für irgendetwas zu nutzen.

THOMAS GIRST Was viele Leute taten, die ihn nicht so gut kannten wie Sie.

ROBERT BARNES Ja, wie Sie vielleicht festgestellt haben, mögen diese Leute, die Marcel wirklich kannten, nicht über ihn reden. Die Tatsache, dass ich das gerade tue, ist schon ein wenig seltsam. Ich sollte das nicht tun. Und irgendwie ist es blasphemisch. Aber es gibt auch nichts zu lästern, wenn man Marcel nicht in einen Gott verwandelt. Marcel war normal und sehr, sehr bürgerlich. Er war ein normaler Typ, ganz normal. Er rauchte schreckliche Zigarren, Blackstones und auch La Frederic, das ist als würde man ein Seil rauchen.

THOMAS GIRST Er nahm nie irgendwelche Drogen?

ROBERT BARNES Nein, warum sollte er? Er ist tot, haben Sie das bemerkt? Was steht auf seinem Grab? Es ist wundervoll.

THOMAS GIRST »Übrigens sterben immer die Anderen.« Ich mag das auch sehr. Wir haben vorhin darüber geredet, wie er Ihnen drei oder vier kleine Arbeiten schenkte, worum Sie ihn nicht baten, und er nicht bezahlt werden wollte.

ROBERT BARNES Bezahlt werden? Marcel wurde nie für irgendetwas bezahlt.

THOMAS GIRST War es für die Gefälligkeiten, die Sie ihm entgegenbrachten oder einfach weil er eine gewisse Freundschaft für Sie fühlte?

ROBERT BARNES Das ist es, was wahre Freundschaft ausmacht, wenn man Gefälligkeiten nicht zählt. Ich habe diese Gefälligkeiten alle gezählt, die von seiner Seite aus. Dieser Mann war großzügig. Jeder wusste das,

THOMAS GIRST Well that is what Apollinaire, who first wrote about him in 1913, said—that he was the artist who was going to reconcile people and art.[18] The people and art come together and I think in a weird way he did.

ROBERT BARNES And then you have to decide whether you want that. It sounds good but I'm not sure that's what you want. I mean I'm really kind of intrigued by the bardic tradition as the artist being a mysterious power or medium. And in a lot of ways Marcel fit that very well. The Bards could intervene in worlds and stop them and create a poem that would solve everything. Not very realistic. There is something about art not being democratic that might be good. I certainly couldn't justify it. But I'm functioning on instinct; maybe it's not good that it's available so much.

THOMAS GIRST I think it is probably something that will change again. Maybe people will get into something else and then art is just there and will survive on its own, hibernating. Look at what is happening to poetry now. Not too many people read poetry. Poetry is really in a state of hibernation. And I mean you don't really know. Two hundred years down the line poetry might be "the thing." Everyone goes there and reads that as much as art is being looked at today. That very well might happen but we don't know.

ROBERT BARNES I don't object to what's going on in contemporary art but I do think that it's kind of boring. I also think that it is so closely meshed with fashion. That fashion brand having the show at the Guggenheim, what show was that?

THOMAS GIRST The *Armani Show* at The Guggenheim, New York, in 2000/2001.

ROBERT BARNES It is totally appropriate. Since it is hard to distinguish art from fashion anyhow. It is kind of interesting that always in the kind of painting that I did, people were denigrating the idea that art imitates life. What we have now is life imitating art and it's recoiled on us a little bit, hasn't it?

THOMAS GIRST Now with your own art, what I've looked at and what I've seen in catalogues always seems to be in action, very much so.

ROBERT BARNES Figure it out. I mean, what did you do today? We kept moving.

THOMAS GIRST Futuristic approach.

18 French poet, art critic, writer and socialite Guillaume Apollinaire (1880–1918) was an early admirer of Duchamp. In his book of 1913, *Les Peintres Cubistes*, he made the statement that "[p]erhaps it will be the task of an artist as detached from aesthetic preoccupations and as intent on the energetic as Marcel Duchamp, to reconcile art and the people." Guillaume Apollinaire, *The Cubist Painters: Aesthetic Meditations* (New York, 1970), p. 48.

und ich glaube, dass die Leute daraus wohl einen Nutzen zogen. Ich bin mir nicht sicher, ob nicht auch Schwarz das tat.

THOMAS GIRST Und sie gingen nicht zu ihm hin und fragten ihn, ob er ein paar Dinge signierte.

ROBERT BARNES Oh ja klar, signieren.

THOMAS GIRST Gut so, aber einige Leuten taten das tatsächlich.

ROBERT BARNES »Oh, Herr Duchamp, können Sie mir vielleicht ein Autogramm auf meine Weichteile geben?«

THOMAS GIRST Er hätte das vielleicht gar nicht zurückgewiesen.

ROBERT BARNES Nein, hätte er nicht.

THOMAS GIRST Wann verließen Sie New York?

ROBERT BARNES Ich bin mir nicht sicher. Ich ging nach London zur Slade School und hatte mehr Kontakt mit Matta und Copley, weil Copley dort ein Haus hatte. Ich war da mal zu einem tollen Abendessen in seinem Haus. Wir aßen von Magritte-Tellern, auf denen Körperteile gemalt waren und weil wir Ehrengäste waren, meine Frau und ich — meine erste Frau —, durften wir zuerst wählen. Sie bekam den männlichen Teller und ich den weiblichen. Es sah aus, als hätte man Haare in seinem Essen, irgendwie ein interessantes Abendessen. Matta machte immer solche interessanten Dinge.

THOMAS GIRST Und mit Matta waren Sie besonders eng, er stellte Ihnen jeden vor, er war einfach ein wilder Kerl.

ROBERT BARNES Ja, er war auch ein guter Maler. Wissen Sie, ich bin nicht sicher, wo Matta in die Geschichte passt. Wen kümmert's. Was interessant ist: Wir leben in einer Generation von jungen Leuten, die ständig damit beschäftigt sind, ihren Platz in der Geschichte zu finden. Was zum Teufel ist daran wichtig? Marcel dachte nie über sowas nach. Vielleicht später, als er begann, Zeug zu katalogisieren, vielleicht dachte er dann auch darüber nach, ein Erbe zu hinterlassen. Aber so ein Erbe ist doch Blödsinn. Aber jeder heutzutage denkt »Wo ist mein Platz in der Geschichte?«. Wie oft kann man sowas fragen?

THOMAS GIRST Nun ja, Ihre Generation wird nicht entscheiden, wer es in die Geschichtsbücher schafft.

ROBERT BARNES Niemand wird das entscheiden. Irgendeine Echse oder so wird das am Ende entscheiden. Aber die Leute sind so besorgt darum, ob sie bekannt sein werden. Heute produzieren sie Geld und werden davon abhängig. Ich danke Gott dafür, dass ich im Zeitalter von Marcel und den Leuten, die nicht so waren, lebte. Geld war bestimmt nicht die Hauptbeschäftigung. Das war interessant, ich hielt einen Vor-

ROBERT BARNES Oh no, that's what Marcel knew, transience, everything is in transit and you have to watch it and watch it evolve and transit. Going to a store and watching things move and turn into junk.

THOMAS GIRST There are some historic figures that you refer to in your paintings.

ROBERT BARNES There is Joyce, Tzara, Stieglitz.[19] I really admired Tzara, he reminded me of myself when I was younger.

THOMAS GIRST Did you meet him?

ROBERT BARNES Once. It was way towards the end of his life, I think the last year of his life. I don't remember when he died, in the 1960s. And he said that he thought the last bastion of an icon class was a conservative state.

THOMAS GIRST And that's where we are?

ROBERT BARNES No I don't think that's where we are, but I think that if you want something shocking anymore, it might have to be very conservative. Maybe that's why we elected that guy with the tiny little something. Things flip back and forth. We've experienced so much license. I love license, I love not being under control. But we've experienced so much of it that it gets jaded. I mean, sex, sex is boring to kids. I always thought it was my daughters whom I should prohibit having sex and tell them that they can't do this and it's terrible so that they'd enjoy it. I thought holding hands was exciting when I was kid, now fucking is about that level, so where do you go up? Maybe killing people or something.

THOMAS GIRST That's true. There's also a big movement of women who want to stay virgins until they get married.

ROBERT BARNES Heh, try it.

THOMAS GIRST You put yourself in a very interesting position of course where people will come knock on your door.

ROBERT BARNES I have no objection to the drama and distance that people go through to get attention with their so-called works of art, except that they are getting known and I don't like it. I don't like getting known to art, particularly.

THOMAS GIRST In a way, since there are no more movements…

ROBERT BARNES Do you know what killed the movements? When someone decided to call the last movement that we heard of Neo-Geo. Even the yuppies laughed when you uttered that one, they did try Neo-romanticism after that. That was so pathetic.

THOMAS GIRST Well because there is a lot of individuality going on, I think that in order to be an artist you also have to have social skills, to

19 The Irish writer James Joyce (1882–1941), author of *Ulysses*, 1922, and *Finnegans Wake*, 1939; early Romanian Dadaist Tristan Tzara (1896–1963); Alfred Stieglitz (1864–1946), influential American photographer and promoter of photography as an independent form of art.

trag über de Kooning[17] während einer seiner Wanderausstellungen, und als ich ungefähr in der Mitte angelangt war, fiel mir plötzlich etwas ein, und ich sagte es auch laut, dass ich nicht glaubte, dass irgendwer damals davon ausging, Geld durch seine Arbeit zu verdienen, viel Geld, und es dauert bis in die 70er, bis sich das änderte und die Leute sich gegenseitig bekrallten, um bekannt zu werden, in eine Galerie zu kommen, eine gute noch dazu, um dieses und jenes zu bekommen. Kunst ist genau deswegen langweilig. Ich meine, wie sehr kann man noch von all diesen Dingen schockiert werden? Irgendein Typ schneidet in irgendeiner Galerie seinen Penis in Stücke: gut für ihn.

THOMAS GIRST Nun ja, vieles erscheint seicht und dumpf, und alles wurde irgendwie schon mal gemacht und meistens auch besser.

ROBERT BARNES Ich fürchte, Marcel hat das entfesselt, und ich weiß, dass er das wusste, und ich glaube, dass er ein wenig bestürzt oder belustigt darüber war — wahrscheinlich beides.

THOMAS GIRST Das ist genau das, was Apollinaire, der als erstes 1913 über ihn schrieb, sagt, dass er der Künstler sei, der Leute und Kunst miteinander versöhnen würde.[18] Die Menschen und die Kunst kommen zusammen, und ich glaube das ist ihm auf ganz merkwürdige Art und Weise auch gelungen.

ROBERT BARNES Und dann muss man selbst entscheiden, ob man das will. Es hört sich gut an, aber ich bin nicht sicher, ob es das ist, was sie wollen. Ich meine, ich bin wirklich fasziniert von der bardischen Tradition des Künstlers als geheimnisvolle Kraft oder Medium. Und in vielen Dingen erfüllt Marcel das sehr gut. Dichter konnten in die Welt eingreifen und sie stoppen und ein Gedicht schaffen, das alles löst. Nicht sehr realistisch. Kunst ist nicht demokratisch, und das ist irgendwie gut. Ich könnte sie gewiss nicht rechtfertigen. Aber ich funktioniere nach Instinkt, vielleicht ist es nicht gut, dass sie so sehr verfügbar ist.

THOMAS GIRST Ich glaube, das ist etwas, was sich vermutlich wieder ändern wird. Vielleicht interessieren sich die Leute für etwas anderes, und Kunst ist dann einfach da und wird ganz für sich überleben, wird überwintern. Sehen Sie sich an, was mit der Dichtung im Moment passiert. Es lesen nicht besonders viele Menschen Gedichte. Dichtung ist gerade in so einem Zustand der Überwinterung. Und ich meine, man weiß es wirklich nicht. Zweihundert Jahre weiter ist Dichtung vielleicht »das Ding«. Jeder geht hin und liest so viel, wie Kunst heute angeschaut wird. Das mag doch wirklich passieren, wir wissen es nur nicht.

17 Willem de Kooning (1904–1997). In Rotterdam geboren war der Aktionsmaler einer der Gründungsmitglieder der später bekannten New York School.
18 Der französische Poet, Kunstkritiker, Autor und Salonlöwe Guillaume Apollinaire (1880–1918) war ein früher Bewunderer Duchamps. In seinem Buch aus dem Jahre 1913, *Les peintres cubistes. Méditations esthétiques* (Paris) behauptet er: »Vielleicht wird es einem derart von ästhetischen Vorurteilen befreiten, derart um Energie bemühten Künstler wie Marcel Duchamp vorbehalten bleiben, Kunst und Volk wieder miteinander zu versöhnen«. Guillaume Apollinaire, *Die kubistischen Maler*, Zürich 1956, S. 108.

be a socializer, you know, schmoozing up to the right people and all to get exposure so that you will have a gallery show. Now it's not in the hand of artists anymore. In a way it is tough to get back from there.

ROBERT BARNES You know, Dada thought that they were anti-art. The social extremes of art is what really created an anti-art atmosphere and at a certain point it got exciting to see something that wasn't trying to bop you. But I don't know if we can go back to a state where we enter into something that is coming at us. And you know I always thought that the worst thing that happened—and I really didn't discourage my children from it—was Sesame Street. Everyone raised their hands and said "Isn't that wonderful, our children are learning the alphabet." They are being shrieked at by purple animals and then at a certain point school started to entertain the students. I mean I ran into that in college. The best professors, the ones that are really given the awards, were the ones that were very eccentric, entertainers, and that's nuts.

THOMAS GIRST The entertainment thing is very American. That you have to entertain.

ROBERT BARNES What it does is it closes you out of the act. It makes you victim of the act but it closes you out of the experience. All of your experience is sensation and you're not allowed to move in. When I'm in Italy, I love to go see some of these Renaissance paintings that you can't leave. You have to stay in those paintings; you can't just say "look I'm shocked" and then go on. No, you look and you wonder.

THOMAS GIRST That has already started with the reproduction of images in catalogues since the early twentieth century. You are conditioned. You flip through them and you can look at all of this stuff very fast and no one is really stipulated, not much is demanded of you and you are not trained to appreciate art by looking at it for a very long time.

ROBERT BARNES Well I'm not complaining. I think it's good and that if it does destroy art as a thing, art as a possession or a commodity, then that is fine. We will start at another level and find something else.

THOMAS GIRST Can you repeat the story about the turtle again that's been sitting on your lap since the beginning of our interview?

ROBERT BARNES There's a guy in Michigan. I used to buy stuffed animals, taxidermy. He's a master. I mean this turtle is beautiful, it even has mud on his back. It's just a gorgeous piece of art, this thing. And he was a master, I mean I went up there and he was stuffing a polar bear.

THOMAS GIRST You needed these for your art basically?

ROBERT BARNES Ich lehne nicht ab, was heute in der zeitgenössischen Kunst passiert, aber ich glaube, sie ist irgendwie langweilig. Ich glaube auch, dass das alles sehr mit Mode zu tun hat. Diese Modemarke, die diese Ausstellung im Guggenheim hatte, was war das für eine Show?

THOMAS GIRST Die Armani-Ausstellung im Guggenheim, New York, von Oktober 2000 bis Februar 2001.

ROBERT BARNES Das ist total zeitgemäß. Weil es so schwierig ist, Kunst von Mode zu unterscheiden. Es ist irgendwie interessant, dass Leute in der Art von Malerei, die ich verfolge, immer den Gedanken abwerten, dass Kunst das Leben imitiert. Was wir heute haben, ist das Leben, das die Kunst imitiert und das ein wenig von uns abgeprallt, oder?

THOMAS GIRST Was Ihre eigene Kunst betrifft, die ich gesehen habe und die ich in Katalogen fand, scheint diese immer in Aktion zu sein, sogar sehr.

ROBERT BARNES Kriegen Sie's raus. Ich meine: was haben Sie heute getan? Wir sind schon weiter.

THOMAS GIRST Eine futuristische Annäherung.

ROBERT BARNES Nein, das wusste Marcel, Vergänglichkeit, alles ist in Bewegung, und man muss beobachten und sehen, wie sich alles entwickelt und verändert. In einen Laden gehen und sehen, wie sich die Dinge bewegen und zu Müll werden.

THOMAS GIRST Es gibt einige historische Figuren, auf die Sie sich in ihren Malereien beziehen.

ROBERT BARNES Ja, Joyce, Tzara, Stieglitz.[19] Ich bewunderte Tzara wirklich, er erinnerte mich an mich selbst, als ich jünger war.

THOMAS GIRST Haben Sie ihn getroffen?

ROBERT BARNES Ein einziges Mal. Es war zum Ende seines Lebens hin, ich glaube, in seinem letzten Jahr. Ich erinnere mich nicht mehr daran, wann er starb, irgendwann in den 60ern. Und er sagte, dass er dachte, dass die letzte Bastion von Ikonen der konservative Zustand sei.

THOMAS GIRST Und dort sind wir nun?

ROBERT BARNES Nein. Ich glaube nicht, dass wir dort sind. Aber ich glaube, dass wenn Sie etwas irgendwie Schockierendes wollen, es sehr konservativ sein muss. Vielleicht haben wir deswegen den Typen mit dem winzig kleinen zum Präsidenten gewählt. Dinge ändern sich. Wir haben so viel Freiheit erlebt. Ich liebe sie, ich mag es, nicht unter Beobachtung zu stehen. Aber wir haben so viel davon erlebt, dass man

19 Der irische Autor James Joyce (1882–1941), Verfasser von *Ulysses* aus dem Jahre 1922 sowie *Finnegans Wake* von 1939; der frühe rumänische Dadaist Tristan Tzara (1896–1963); Alfred Stieglitz (1864–1946), ein einflussreicher amerikanische Fotograf und Wegbereiter der Fotografie als unabhängige Form der Kunst.

ROBERT BARNES Yeah I like them around. My wife paints still-lives with them in it and I just like them to be here. Maybe it's because they're not supposed to be here. Well I would call him and he would sell me things that people would pay him a deposit to do and never come back for them. So I would pay the other part of the fee and they were cheap, like thirteen, fifteen dollars. So all of the sudden I tried calling and I could not get through and finally I checked up and called information and, I guess it can be told now, this guy tells me, "we had his phone tapped for a year." Turns out he had been stuffing his animals with dope. A great way when you think of it. Who is going to suspect? If this turtle here is full of cocaine that would be very nice. I still don't think I would open it up because it is too beautiful.

THOMAS GIRST Is that the place where you got the pigskin?

ROBERT BARNES No, no this was much later.

THOMAS GIRST Do you remember the place where you got the pigskin?

ROBERT BARNES I think it was in Trenton.

THOMAS GIRST In Trenton, where supposedly the urinal for Duchamp's *Fountain* came from.

ROBERT BARNES Trenton's a great place.

THOMAS GIRST Was that a meat place?

ROBERT BARNES A butcher. I didn't know the urinal came from there. Trenton might be an art center. Did you ever think of that?

THOMAS GIRST That was where the J. L. Mott Ironwork swere, where Duchamp's urinal was supposedly made which he then signed "R. Mutt."

ROBERT BARNES You see it's an art center.

THOMAS GIRST Why go to a butcher in Trenton if there are so many in New York?

ROBERT BARNES Because no one would do it. Can you get pigskin off without wrecking it?

THOMAS GIRST No, but that butcher could?

ROBERT BARNES I guess so. I live in this country village in Italy and the guy that butchers pigs every year asked me "Roberto, I want you to help me with the slaughter tomorrow." And I said, "Vittorio, I'm a painter, not really a butcher." And he said, "I have to get up at four in the morning. I want to be with someone who is a good conversationalist. I'll show you how to kill pigs." And he did. If you knew what was inside of pigs, you wouldn't eat them. It was awful stuff. But it was interesting and that's what got me started to do paintings about the *Flaying of Marsyas*,[20] it

20 In Ovid's *Metamorphoses*, the satyr Marsyas challenged Apollo in a contest with a flute. After the muses declared his defeat, Apollo flayed him. Ever since the sculptures of the Hellenistic Period (often using the fable as a means to extol their knowledge of the human anatomy), this theme has inspired artists in all fields throughout the ages.

ganz abstumpft davon. Ich meine, Sex, Sex ist langweilig für Kinder. Ich dachte immer, ich müsste meinen Töchtern den Sex verbieten und ihnen sagen, dass sie es nicht tun sollen und es schrecklich ist, so dass sie es genießen würden. Ich dachte als Kind, Händchenhalten sei aufregend, aber zum Teufel, es war noch viel mehr, wohin geht das also? Bis zum Leute töten oder so?

THOMAS GIRST Das ist wahr. Es gibt auch eine Menge Frauen, die Jungfrau bleiben möchten, bis sie heiraten.

ROBERT BARNES Hey, versuchen Sie's.

THOMAS GIRST Sie selbst positionieren sich doch recht interessant, die Leute klopfen an Ihre Tür.

ROBERT BARNES Ich habe keinen Einwand gegen das Drama und die Distanz, die die Leute durchleben, um Aufmerksamkeit für ihre so genannten Kunstwerke zu bekommen, außer dass sie bekannt werden und ich das nicht mag. Ich mag es vor allem nicht, in der Kunst bekannt zu werden.

THOMAS GIRST Wenn es keine anderen Bewegungen gibt …

ROBERT BARNES Wissen Sie, was die Bewegungen getötet hat? Als jemand entschied, die letzte Bewegung, von der wir hörten, Neo-Geo zu nennen. Sogar die Yuppies lachten, als man davon sprach, sie versuchten sich danach an der Neuromantik. Das war so erbärmlich.

THOMAS GIRST Weil es um viel Individualismus geht, glaube ich, dass man auch soziale Kompetenzen haben muss, um ein Künstler zu sein, ein Socializer, wissen Sie, der mit den richtigen Leuten plaudert, um aufgenommen zu werden und eine Galerie-Ausstellung zu bekommen. Es liegt heute nicht mehr in den Händen des Künstlers. Es ist sicherlich schwierig, davon wieder wegzukommen.

ROBERT BARNES Wissen Sie, die Dadaisten dachten, sie seien Anti-Kunst. Die sozialen Extreme der Kunst schufen eine Anti-Kunst-Atmosphäre, und an einem gewissen Punkt wurde es spannend, etwas zu sehen, was dich nicht knufft. Aber ich weiß nicht, ob wir zurück zu einem Zustand zu gelangen vermögen, in dem wir uns dem öffnen, was uns zu erreichen sucht. Und Sie wissen, dass ich immer dachte, dass das Schlimmste, was passieren konnte — und ich wollte meine Kinder wirklich nicht davon abbringen —, die Sesamstraße war. Jeder hob seine Hand und sagte: »Ist es nicht toll, unsere Kinder lernen das Alphabet.« Sie wurden von violetten Tieren angekreischt, und an einem bestimmten Punkt begannen die Schulen dann, Studenten zu belustigen. Auch mir ist sowas passiert, allerdings erst im College. Die besten Professoren,

means the removal of the external self in the Renaissance and I always liked the idea of peeling away layers. The painting came much later so I must have had the Duchampian idea on my mind of peeling away a skin and putting it somewhere else. People used to dress and masquerade in skins sometimes, not just furs, but sometimes other people's skins. Anyway, the Italian butcher had me killing these pigs and it really is a shocking experience. Pigs are very human and it is very much like a human sacrifice. I did a lot of *Flaying of Marsyas* paintings after that. I never did a pig, but it is an act that you don't forget.

THOMAS GIRST You're not happy with Pop Art?

ROBERT BARNES Well why, I'm not unhappy either.

THOMAS GIRST While we took our stroll through the Bloomington Art Museum you looked at certain paintings and said "Oh my God."

ROBERT BARNES Well I remember I had kids books "Look at the spot!"—and then you'd look away and see a spot, so what? You know what we've done over the last hundred years? We have dissected the work of art. You have optical art, which is the visual, you have abstract expression, which was so involved with the touch, and I still love that. That's probably why I don't do other things because I love the feel of paint, very sensual, very sexual.

THOMAS GIRST Touch is something you are never allowed to do in museums.

ROBERT BARNES Museums are another story. They are mortuaries. You have Abstract Expressionism, which deals with surface, optical art, which is the effects of light and dark, of colors, you have Pop Art, which deals with subject matter. Basically the idea and sensation of the image left behind tactility and in some cases the optical effect of color. Duchamp represented the bigger idea of art as an idea or idea as the gas, and that is probably the best of the bunch. If you keep dissecting, even conceptual art is just the idea. I always think that conceptual art grew out of the academic.

THOMAS GIRST Conceptual art owes to Duchamp as well.

ROBERT BARNES Yeah but see Duchamp appealed to the academics because he was an intellectual. Not that they ever understood it or ever would or could or should. The revenge, the way academics wreck art is by explaining it. It's the most obscene thing you do. And look at the books on Marcel, thousands of books on Marcel, all of them falling over each other to explain. The best would be a book that is so absurd that it becomes another work, almost a Readymade or some absurdity.

die, denen wirklich Anerkennung zugesprochen wurde, waren die, die exzentrisch waren, die die Entertainer waren, und das ist doch verrückt.

THOMAS GIRST Diese Entertainment-Sache ist wirklich sehr amerikanisch. Dass man unterhalten muss.

ROBERT BARNES Es schließt dich aus der Handlung aus. Es macht dich zu einem Opfer dieser Handlung und schließt dich von jeder Erfahrung aus. Alle Erfahrung ist eine Empfindung, und du darfst nicht daran teilhaben. Wenn ich in Italien bin, mag ich es sehr, einige dieser Renaissance-Malereien anzuschauen, die man nicht mehr verlassen kann. Man muss in diesen Bildern bleiben. Man kann nicht einfach sagen: »Ok, ich bin schockiert«, und dann weitergehen. Nein, Sie schauen es sich an und staunen.

THOMAS GIRST Das fing bereits im frühen 20. Jahrhundert mit dem Abdruck einiger Bilder in Katalogen an. Man ist konditioniert. Man blättert sie schnell durch und kann sich all diese Dinge sehr schnell anschauen, und niemand muss sich wirklich anstrengen, es wird nichts von dir gefordert, und man ist es nicht gewohnt, Kunst zu schätzen, indem man sie lange Zeit betrachtet.

ROBERT BARNES Nun ja, ich beschwere mich nicht. Ich glaube, es ist gut, und wenn es Kunst als ein Ding, als ein Besitz oder als Ware zerstört, ist das gut. Wir werden auf einer anderen Ebene anfangen und etwas anderes finden.

THOMAS GIRST Können Sie noch einmal die Geschichte über die Schildkröte, die seit Beginn des Gesprächs auf Ihrem Schoß sitzt, wiederholen?

ROBERT BARNES Da gab es so einen Typen in Michigan. Ich kaufte gelegentlich Tiere bei ihm, Präparate. Er war ein Meister seines Fachs. Ich denke, diese Schildkröte ist wunderschön, sie hat sogar Schlamm auf dem Rücken. Es ist einfach ein großartiges Kunstwerk, dieses Ding. Und er war ein Meister, ich ging einmal zu ihm hinauf, und er stopfte gerade einen Eisbären aus.

THOMAS GIRST Brauchten Sie diese Dinge für Ihre Kunst?

ROBERT BARNES Ja, ich hab sie gerne um mich. Meine Frau malt Stillleben mit ihnen drauf, und ich mag es einfach, sie hier zu haben. Vielleicht weil sie nicht hier sein sollten. Nun ja, ich rief ihn an, und er verkaufte mir Dinge, für die Leute bereits eine Anzahlung geleistet hatten, aber nie wiederkamen. Ich zahlte ihm also den anderen Teil der Kosten, und sie waren günstig für mich, vielleicht dreizehn, vierzehn Dollar. Als ich ihn einmal anrief und ihn nicht erreichte und schließlich die

THOMAS GIRST The only thing Duchamp wasn't was political.

ROBERT BARNES I never heard him say anything—political in what way?

THOMAS GIRST Well, all of his known remarks on politics and world affairs probably do not exceed five hundred words.

ROBERT BARNES Don't you ever think that is the artist's posture?

THOMAS GIRST Well I would think that you would be a little bit more concerned about both world wars, nuclear bombs, and even the student riots in 1968.

ROBERT BARNES If you look at it, Picasso[21] was very artificial in terms of his political acts, even the communist party was so inept that he didn't like it.

THOMAS GIRST Well *Guernica* was always...

ROBERT BARNES Well I'm not sure that that was even a factor, it didn't certainly stop anything. Politics and art. Politics is always pathetic when it gets involved in art.

THOMAS GIRST Well the other way around, you just talked about being the bard, being able to stop the war.

ROBERT BARNES Well we can't do that anymore. Walking onto the battlefield is a little easier than having missiles shot at you. I think that the political posture is almost designed for the artist. It's pathetic. I like to shock people by saying that war is probably the ultimate work of art, so ultimate that, if you don't do it well, you get killed. Artists are always talking about how hard it is to be an artist or make works or how painful war is, really horrible, painful, and if you do make a mistake, you don't get a chance to erase it or wipe it off a canvas. I always think artists are such ninnies. I mean we can change everything and in a sense that is good but if you run over somebody on the street, you can't back up and have them come back to life.

THOMAS GIRST Because they're suffering so much without actually experiencing.

ROBERT BARNES There's no suffering involved in a work of art. But maybe realizing that you're stupid is suffering.

THOMAS GIRST So a lot more people are involved in the arts that probably should be doing something else.

ROBERT BARNES Well 99 percent probably. That's why they teach.

21 Pablo Picasso (1881–1973). Considered by many to be one of the twentieth century's pre-eminent artist's most important paintings, *Guernica* depicts the horrors of the German bombing of the Spanish town of Guernica on April 26, 1937. The nationalist regime of General Franco had asked the German Luftwaffe's Legion Condor to bomb the Basque town during the Spanish Civil War.

This article was first published in English in: *Tout-Fait: The Marcel Duchamp Studies Online Journal* vol 2, issue 4, 2002, <www.toutfait.com/online_journal_details.php?postid=1193> (August 20, 2012).

Auskunft fragte, sagte mir der Typ, ich glaub', das kann ich heute erzählen: »Unser Telefon wurde angezapft.« Es stellte sich heraus, dass er seine Tiere mit Drogen ausgestopft hatte. Eine tolle Sache, wenn man darüber nachdenkt. Wer sollte so etwas schon vermuten? Wenn diese Schildkröte hier voller Kokain ist, wäre das ziemlich toll. Ich glaube aber immer noch, dass ich sie nicht öffnen werde, weil sie zu schön dafür aussieht.

THOMAS GIRST Ist das auch der Ort, an dem Sie die Schweinehaut bekamen?

ROBERT BARNES Nein, nein, das war viel später.

THOMAS GIRST Erinnern Sie sich daran, wo Sie die Schweinehaut bekamen?

ROBERT BARNES Ich glaube, das war in Trenton.

THOMAS GIRST In Trenton, wo vermutlich 1917 auch das Urinal für *Fountain* herkam.

ROBERT BARNES Trenton war ein toller Ort.

THOMAS GIRST War da eine Fleischerei?

ROBERT BARNES Ein Metzger. Ich wusste nicht, dass das Urinal auch daher kam. Trenton sollte vielleicht ein Kunstzentrum sein. Haben Sie mal darüber nachgedacht?

THOMAS GIRST Vermutlich wurde Duchamps mit »R. Mutt« signiertes Urinal von J. L. Mott Ironworks in Trenton hergestellt.

ROBERT BARNES Sehen Sie, es ist ein Kunstzentrum.

THOMAS GIRST Warum zu einem Metzger in Trenton gehen, wenn es so viele davon auch in New York gibt?

ROBERT BARNES Weil das bestimmt keiner machen wollte. Können Sie Schweinehaut entfernen, ohne sie dabei kaputt zu machen?

THOMAS GIRST Nein, aber dieser Metzger konnte das?

ROBERT BARNES Denke ich mal. Ich lebe in diesem Dorf in Italien, und der Typ, der jedes Jahr die Schweine schlachtet, fragte mich: »Roberto, ich möchte, dass du mir morgen beim Schlachten hilfst«. Und ich sagte: »Vittorio, ich bin ein Maler, kein Metzger«. Und er sagte daraufhin: »Ich muss um 4 Uhr morgens aufstehen. Ich möchte dann mit jemandem zusammen sein, der ein guter Entertainer ist. Ich werde dir zeigen, wie man Schweine tötet«. Und das tat er. Wenn Sie wüssten, was in so einem Schwein drin ist, würden Sie es nicht essen. Das war schrecklich. Aber es war auch interessant und brachte mich dazu, mit dem Gemäldezyklus »Die Häutung des Marsyas« zu beginnen.[20] Es zeigt die Demontage des äußeren Selbst in der Renaissance, mir gefiel diese Idee,

20 In Ovids *Metamorphosen* fordert der Satyr Marsyas Apollo in einem Wettbewerb mit einer Flöte heraus. Nachdem die Musen seine Niederlage erklärt haben, zieht Apollo ihm die Haut ab. Seit jeher hat dieses Thema in den Skulpturen der hellenistischen Zeit – die oft Fabeln zum Vorwand nehmen, ihr Wissen über die menschliche Anatomie hervorzuheben – Künstler aller Genres inspiriert.

Schichten abzutragen, schon immer. Die Bilder entstanden erst spät, also muss ich diese duchampsche Idee, eine Haut abzutragen, schon eher gehabt und sie solange zur Seite gelegt haben. Die Leute waren es gewohnt, sich mit Häuten zu verkleiden, nicht nur Pelze, sondern manchmal auch anderer Leute Haut. Wie auch immer, der italienische Metzger ließ mich diese Schweine töten, und das war wirklich ein schockierendes Erlebnis. Schweine sind sehr menschlich, und es ist wie ein Menschenopfer, sie zu töten. Ich malte danach viele »Häutung des Marsyas«-Gemälde. Ein Schwein malte ich nie, aber das ist eine Tat, die man nicht vergisst.

THOMAS GIRST Mit Pop-Art sind Sie nicht glücklich?

ROBERT BARNES Nun ja, warum? Ich bin auch nicht unglücklich damit.

THOMAS GIRST Als wir durch das Bloomington Art Museum bummelten, sahen Sie einige solcher Bilder und sagten: »Oh, mein Gott.«

ROBERT BARNES Nun ja, ich erinnere mich, dass ich diese Kinderbücher hatte, »look at the spot« und dann schaut man weg und sieht einen Punkt, oder? Sie wissen, was wir in den letzten 100 Jahren getan haben? Die Kunst komplett seziert. Wir haben die Op-Art, die alles Visuelle ist, wir haben den Abstrakten Expressionismus, der sich so sehr mit Berührung befasst, und ich liebe das immer noch. Das ist wahrscheinlich der Grund, warum ich nichts anderes tue, weil ich das Haptische an der Farbe liebe, so sinnlich, so sexuell.

THOMAS GIRST Berührungen sind in Museen meistens verboten.

ROBERT BARNES Museen sind eine andere Geschichte. Das sind Leichenhallen. Man hat Abstrakten Expressionismus, der sich auf die Oberfläche bezieht, die Op-Art, die mit den Effekten von Licht und Dunkel und Farben spielt, man hat die Pop-Art, die sich auf den Gegenstand bezieht. Grundsätzlich blieb die Idee und Empfindung des Bildes hinter der Fühlbarkeit zurück und in einigen Fällen sogar hinter dem optischen Effekt von Farbe. Duchamp vertrat den größeren Gedanken von Kunst als einer Idee oder der Idee als Gas, und das ist vermutlich das Allerbeste von alldem. Wenn man nicht aufhört mit dem Sezieren, ist sogar Konzeptkunst nur noch ein Gedanke. Ich glaube schon immer, dass Konzeptkunst aus den Hochschulen kam.

THOMAS GIRST Die Konzeptkunst verdankt Duchamp ebenso viel.

ROBERT BARNES Ja, aber sehen Sie, er übte einen Reiz auf die Akademiker aus, weil er ein Intellektueller war. Es ist nicht so, dass sie es je verstanden oder je verstehen würden oder könnten oder sollten. Ihre Revanche ist die Art, wie sie als Akademiker die Kunst zerstören, näm-

lich indem sie sie erklären. Es ist das Obszönste, was man überhaupt machen kann. Und schauen Sie sich die Bücher über Marcel an, tausende von Büchern über Marcel, die alle übereinander herfallen, um ihn zu erklären. Das Beste wäre ein Buch, das so absurd ist, dass es eine andere Arbeit wird, fast ein Readymade oder irgendeine Absurdität.

THOMAS GIRST Das einzige, was Duchamp nicht war, war politisch zu sein.

ROBERT BARNES Ich habe ihn nie etwas sagen hören — politisch in welchem Sinne?

THOMAS GIRST Nun ja, all seine bekannten Bemerkungen zur Politik und dem Weltgeschehen umfassen vermutlich nicht mehr als 500 Worte.

ROBERT BARNES Denken Sie tatsächlich, dass das des Künstlers Haltung ist?

THOMAS GIRST Ich würde denken, dass man ja doch ein bisschen betroffener sein könnte über die beiden Weltkriege, die Atombomben oder auch die Studentenkrawalle 1968.

ROBERT BARNES Wenn Sie sich das anschauen, war Picasso[21] sehr unecht, was seine politischen Handlungen betrifft, sogar die kommunistische Partei war so unfähig, dass er sie nicht mochte.

THOMAS GIRST Aber *Guernica* war immer...

ROBERT BARNES Ich bin nicht sicher, dass das Bild jemals eine Rolle spielte, es beendete nämlich gar nichts. Politik und Kunst. Politik ist immer erbärmlich, wenn sie sich mit Kunst befasst.

THOMAS GIRST Andersherum sprachen Sie vorhin vom Dichter, der in der Lage ist, den Krieg zu beenden.

ROBERT BARNES Das können wir heute nicht mehr. Übers Schlachtfeld zu laufen ist etwas einfacher als von Raketen beschossen zu werden. Ich glaube, dass die politische Pose geradezu für den Künstler bestimmt ist. Das ist erbärmlich. Ich mag es, Menschen zu schockieren, indem ich sage, dass der Krieg vermutlich das ultimative Kunstwerk ist, so ultimativ, dass man getötet wird, wenn man es nicht richtig macht. Künstler reden immer davon, wie schwer oder schmerzhaft es ist, ein Künstler zu sein oder Arbeiten zu gestalten. Der Krieg aber ist wirklich schrecklich, schmerzhaft, und wenn man einen Fehler macht, bekommt man keine Möglichkeit, das alles ungeschehen zu machen oder es von der Leinwand zu wischen. Ich dachte schon immer, dass Künstler wahre Trottel sind. Ich meine, wir können alles verändern, und auf eine Weise ist das auch gut, aber wenn man jemanden auf der Straße überfährt,

21 Pablo Picasso (1881–1973). *Guernica* wird als eins der wichtigsten Gemälde des herausragenden Künstlers des 20. Jahrhunderts gesehen und stellt die Gräuel der Bombardierung der spanischen Stadt Guernica durch die Deutschen am 26. April 1937 dar. Das nationale Regime unter General Franco hatte die Legion Condor der deutschen Luftwaffe darum ersucht, die baskische Stadt im Spanischen Bürgerkrieg anzugreifen.

kann man nicht einfach wieder zurücksetzen und sie wieder ins Leben holen.

THOMAS GIRST Man leidet ohne tatsächliche Erfahrung.

ROBERT BARNES Es gibt bei einem Kunstwerk kein Leiden. Aber zu bemerken, dass man doof ist, ist Leid.

THOMAS GIRST Es befassen sich also eine Menge Leute mit Kunst, die besser etwas anderes tun sollten.

ROBERT BARNES Ja, wahrscheinlich 99 Prozent. Das ist der Grund, warum sie unterrichten.

Aus dem Englischen von Janina Wildfeuer

Der Beitrag wurde in englischer Sprache erstmals in: *Tout-Fait: The Marcel Duchamp Studies Online Journal* Vol. 2, Ausgabe 4, 2002, veröffentlicht <www.toutfait.com/online_journal_details.php?postid=1193> (20. August 2012).

PRIX MARCEL DUCHAMP 2000
SIEBEN FRAGEN
FÜR THOMAS HIRSCHHORN

Am 1. Dezember 2000 wurde mit Thomas Hirschhorn der Gewinner des Prix Marcel Duchamp bekanntgegeben, der in diesem Jahr erstmalig verliehen wurde. Für zeitgenössische, in Frankreich lebende Künstler bestimmt, ist die Auszeichnung mit einem Preisgeld von 200.000 FF verbunden sowie der Möglichkeit einer zweimonatigen Ausstellung im Centre Pompidou. Hirschhorns *Pole Self* wurde dort zwischen dem 28. Februar und dem 30. April 2001 gezeigt.

Hirschhorn ist derweil der Kunstwelt nicht fremd. 1957 in Bern geboren, hatte der Künstler bereits europaweit seine Werke gezeigt, als ihn Catherine David 1994 im Jeu de Paume präsentierte. Mit fünf Einzelausstellungen allein im Jahr 2001, von Zürich bis Barcelona, sowie seiner Teilnahme an internationalen Kunstschauen, etwa der Biennale von Venedig, ist auch die Nachfrage an seinen Werken stetig gewachsen.

Sein Œuvre indes ist nicht leicht zu erfassen und fast unmöglich zu vergessen. Hirschhorn verwendet alltägliche Materialien wie Silberfolie, Pappe und Klebestreifen für seine meist mehrere Räume umspannenden Installationen. Wo immer sie gezeigt wird, scheint seine Kunst zu wachsen und sich auszubreiten. Einigen Betrachtern mögen seine Environments schlichtweg hässlich, seine Werkstoffe zu billig und der Versuch, den Besucher intellektuell zu involvieren, als allzu didaktischer Eifer erscheinen. Natürlich, hier findet man nicht die unnahbar glattpolierten Oberflächen eines Jeff Koons. Der Gebrauch des Materials gründet sich vielmehr auf einer demokratisch-egalitären Vorstellung, die dem Betrachter die Nachvollziehbarkeit der Kunstproduktion möglich macht. Und Kunst ist nicht nur zum ästhetischen Wohlbefinden gedacht, sondern erfordert eine Auseinandersetzung, die Zeit bedarf, den Betrachter einbezieht und Ideen wie Vorstellungen generiert. Oft baut Hirschhorn »Altäre« oder »Kioske« im öffentlichen Raum, die er Schriftstellern und Künstlern wie Raymond Carver oder Robert Walser, Ingeborg Bachmann und Meret Oppenheim widmet. Er setzt sich mit dem Holocaust auseinander und verballhornt die Obsession seines

PRIX MARCEL DUCHAMP 2000
SEVEN QUESTIONS
FOR THOMAS HIRSCHHORN

On December 1, 2000, Thomas Hirschhorn was announced the winner of the Prix Marcel Duchamp, the first time this new award was presented. Geared towards contemporary artists living in France, the winner of the Prix Marcel Duchamp receives 200,000 FF (a little less than $ 30,000) and a two-month show at the Centre Pompidou. Hirschhorn's *Pole-Self* was exhibited there between February 28–April 30, 2001.

Hirschhorn, of course, is no stranger to the art world. Born in Berne, Switzerland, in 1957, he had been on the rise even before Catherine David showed his work at the Jeu de Paume, Paris, in 1994. And with five solo shows in 2001 alone, from Zurich to Barcelona, as well as his participation in major art events such as the Venice Biennale, the demand for his works is way up.

Hirschhorn's oeuvre is not easy to grasp and almost impossible to forget. Using everyday material such as silver foil, cardboard or duct tape, his installations incorporate entire rooms. His art seems to grow and spread wherever it is displayed. To some viewers Hirschhorn's environments appear plain ugly, his material too cheap and his eagerness to intellectually involve the visitor is seen as too didactic. To be sure, his is not the inaccessibly polished surface of a Jeff Koons. The use of material is embedded in a democratic and egalitarian notion of the viewer having the possibility to see exactly how his art is made. And art is not only for glances or aesthetic pleasantries but for spending some time with, for engaging the viewer and generating ideas. Often, Hirschhorn builds "altars" or "kiosks" in public spaces, dedicating them to writers and artists such as Raymond Carver or Robert Walser, Meret Oppenheim or Ingeborg Bachmann. He tackles the Holocaust straight-on (no niceties here) and pokes fun at his native country's obsession with the production of luxury goods. For *Pole Self* Thomas Hirschhorn transformed various rooms of the Centre George Pompidou into a library, with books attached to metal chains dangling from the ceiling. Other installations included sandbags to wrestle with as well as an

Heimatlandes mit der Produktion von Luxusgütern. Für *Pole Self* hat Thomas Hirschhorn mehrere Räume im Centre George Pompidou in eine Bibliothek umgewandelt, in der Bücher an Metallketten von der Decke baumeln. Andere Installationen beherbergen Sandsäcke zum Hineinschlagen und einen »antikapitalistischen Müllcontainer« mit Büchern über Luxus und Wohlstand.

Die Londoner Kunstkritikerin Kate Bush pries in der Dezemberausgabe von *Artforum* 2001 kürzlich die »unverwechselbare Nonästhetik« des Künstlers, »begründet auf wackligen Formen, billigem Material und einem Wirbelwind von Bildern und Worten – [...] angetrieben von einem Gefühl der Dringlichkeit und Unbegreiflichkeit angesichts einer Katastrophe, die uns unter seinem unversöhnlichem Neon keine Möglichkeit zum Versteck mehr gibt.«[1]

Als Gilles Fuchs, Präsident der Association pour la Diffusion de l'Art Français, den Prix Marcel Duchamp übergab, soll Hirschhorn diesen nach der Laudatio lediglich mit einem »Merci« auf den Lippen entgegengenommen haben. *Tout-Fait* wollte es bezüglich Hirschhorns Wertschätzung Duchamps etwas genauer wissen. Was folgt, sind dessen Antworten auf sieben Fragen, die wir an ihn gerichtet haben.

THOMAS GIRST Herzlichen Glückwunsch zum Erhalt des Prix Marcel Duchamp 2000/2001. Können Sie sich denken, warum die Wahl auf Sie gefallen ist?
THOMAS HIRSCHHORN Es ist ein Zufall, dass dieser Preis den Namen »Marcel Duchamp« trägt. Es ist ein Zufall, dass mir der Preis zugesprochen wurde

THOMAS GIRST Gibt es ganz spezifische Projekte, für die Sie Ihr Preisgeld verwenden?
THOMAS HIRSCHHORN Ich habe das Preisgeld für die Produktion der Arbeit *Pole Self* verwendet.

THOMAS GIRST Duchamp hat sich stets kritisch Preisen und Jurys gegenüber geäußert, obschon er Auszeichnungen, nicht wie Breton, durchaus entgegennahm. 1946 wählte Duchamp gemeinsam mit Alfred H. Barr und Sidney Janis Max Ernsts *The Temptation of St. Anthony* als Gewinner eines Wettbewerbs unter einer Anzahl von Gemälden, die sich alle mit dem gleichen Thema auseinandersetzten. Duchamp bemerkte zu seiner Erfahrung als Juror: »Juroren neigen dazu, falsch

1 Kate Bush, »Best of 2001«, in: *Artforum*, Dezember 2001 [Übersetzung des Autors].

"anticapitalist trash heap" in which books on luxury and wealth could be found.

Most recently, in *Artforum*'s December issue of 2001, London-based art critic Kate Bush praised Hirschhorn's "distinctive nonaesthetic—based on rickety form, cheap materials, and a blizzard of images and words ... powered by a sense of urgency and incomprehension in the face of catastrophe that leaves us, under his unforgiving neon, nowhere to hide."[1]

When awarded the Prix Marcel Duchamp presented by Gilles Fuchs, the president of the Association pour la Diffusion Internationale de l'Art Français, a simple "Merci" is reported to be all Thomas Hirschhorn said during the ceremony. *Tout-Fait* wanted to know a little bit more regarding the artist and his appreciation of Marcel Duchamp. What follows are Hirschhorn's answers to seven questions we were eager to ask him.

THOMAS GIRST Congratulations on the Prix Duchamp 2000/2001. Any idea about why it was you who received it?

THOMAS HIRSCHHORN It is by chance that the price bears Marcel Duchamp's name. It is by chance that the price was given to me.

THOMAS GIRST Are there any specific projects you have used your grant for?

THOMAS HIRSCHHORN I have used the money for the production of the work *Pole Self.*

THOMAS GIRST Duchamp seemed to despise the very idea of a jury although unlike Breton, he did not refuse awards. In 1946, together with Alfred H. Barr and Sidney Janis, Duchamp chose Max Ernsts *The Temptation of St. Anthony* from a number of submissions on the same subject to be the winning entry of a competition. Regarding his experience as a juror, Duchamp said: "Jurors are always apt to be wrong ... even the conviction of having been fair does not change any doubts on the right to judge at all."[2]

THOMAS HIRSCHHORN Receiving an award engages the giver more than it does the laureate. I on the other hand am engaged towards my work and to my work alone.

1 Kate Bush, "Best of 2001," *Artforum* (December 2001).
2 Marcel Duchamp, in: *The Temptation of St. Anthony* (Washington, D.C. 1946), p. 3.

zu liegen [...] selbst die Überzeugung gerecht zu sein mindert nicht die Zweifel am Recht daran, überhaupt etwas zu beurteilen«.[2]

THOMAS HIRSCHHORN Einen Preis zu erhalten, engagiert nicht den Preisträger sondern den, der den Preis vergibt. Ich hingegen bin gegenüber meiner Arbeit engagiert und nur ihr gegenüber.

THOMAS GIRST Welchen Einfluss, wenn überhaupt, hat Duchamp auf Ihre Kunst?

THOMAS HIRSCHHORN Die Beiträge Duchamps zur Ausstellung *Exposition Internationale du Surréalisme* (Abb. 69) in Paris und zu *First Papers of Surrealism* (Abb. 70) in New York haben mich begeistert. Was mich beeindruckt, ist sein Verständnis der Rolle des Künstlers. Marcel Duchamp war frei mit dem Eigenen.

THOMAS GIRST Erinnern Sie sich an das erste Mal, als Sie mit Duchamps Werk konfrontiert wurden?

THOMAS HIRSCHHORN Das war in der Kunstgewerbeschule Zürich (heute Schule für Gestaltung) im Kunstgeschichteunterricht. Wir diskutierten das Bild *The Passage from Virgin to Bride* (1912, Abb. 52), die Arbeiten, die er danach machte wie den *Chocolate Grinder* (1913, Abb. 71) oder das großartige Werk *The Large Glass* (1915–1923, Abb. 4) und die Readymades. Dann las ich das für mich sehr wichtige Buch von Thierry de Duve *Nominalisme Pictural*. Später sah ich im Philadelphia Museum of Art die wunderschöne Louise und Walter Arensberg Collection.

THOMAS GIRST Sie haben einmal gesagt: »Was mich interessiert, ist das Zu-viel-Tun, das Leisten einer Über-Arbeit, wie beim Licht.« Ist diese Bemerkung mit Duchamps Notizen zu Inframince vergleichbar?[3] Darin bekundet er unter anderem sein Interesse an der Wärme von Stühlen, nachdem man auf ihnen gesessen hat, die Extra-Energie, die man auf das Herabdrücken eines Lichtschalters, etcetera, verwendet.

THOMAS HIRSCHHORN Das kann man nicht vergleichen. Mich interessiert das »zuviel«, zuviel-tun, zuviel-geben, sich ausgeben, Kraft verschwenden. Verschwendung als Werkzeug oder Waffe.

THOMAS GIRST In Ihren Arbeiten meine ich ständig, den inhärenten Unwillen zu erkennen, überhaupt etwas im gegebenen Kunstweltkontext auszustellen. Ihre Installation im Guggenheim Shop vor einigen Jahren

2 Marcel Duchamp in: *The Temptation of St. Anthony*, Washington, D.C. 1946, S. 3 [Übersetzung des Autors].
3 Erstmals posthum publiziert in Marcel Duchamp, *Notes*, hrsg. von Paul Matisse, Paris 1980, o. S. [Nr. 1–46].

THOMAS GIRST To what extent, if at all, has Duchamp influenced your work?

THOMAS HIRSCHHORN I enthusiastically embraced Duchamp's contributions to the Paris exhibition *Internationale du Surréalisme* (fig. 69) as well as the show in New York, *First Papers of Surrealism* (fig. 70). What fascinates me is his understanding of being an artist. Marcel Duchamp was free with his own.

THOMAS GIRST Do you remember the first time you became aware of Duchamp's art?

THOMAS HIRSCHHORN This was at the Kunstgewerbeschule (School of Applied Arts) in Zurich during art history class. We discussed *The Passage from Virgin to Bride* (1912, fig. 52), works he did back then, like *The Chocolate Grinder* (1913, fig. 71), or this magnificent *Large Glass* (1915–1923, fig. 4) as well as the Readymades. Then I read the book *Pictorial Nominalism* by Thierry de Duve, which was very important to me. Later I saw the wonderful collection of Louise and Walter Arensberg at the Philadelphia Museum of Art.

THOMAS GIRST You once said that what you are interested in is the "doing-too-much, the provision of extra-work, as is the case with light." Is this statement comparable to Duchamp's notes about Inframince,[3] in which he makes known his interest in the warmth of chairs, after sitting on them, the extra-energy used when pushing down a light-switch, etc.

THOMAS HIRSCHHORN One cannot compare the two. I'm interested in the "too much," doing too much, giving too much, putting too much of an effort into something. Wastefulness as tool or weapon.

THOMAS GIRST Within your works, I sometimes sense the inherent unwillingness to even do as much as to exhibit within the given context of the artworld. Your installation for the Guggenheim Museum Store in Soho was such a total refusal without having to say "no." In the beginning Duchamp did not exhibit his Readymades and often refused to participate in exhibitions. Are your new works in the classic size of large oil on canvas (with picture frame to hang from a wall) a first compromise regarding the possibility of displaying your work (i. e., within the apartments of collectors), comparable to Duchamp's later editions of the Readymades?

3 A concept first published posthumously in Paul Matisse, ed., *Marcel Duchamp, Notes* (Boston, 1980), n. p. [notes 1–46].

war so eine Totalverweigerung, ohne dabei »Nein« zu sagen. Duchamp stellte seine Readymades zu Beginn nicht aus und weigerte sich oft, an Ausstellungen teilzunehmen. Sind Ihre neuen Arbeiten, die ich erstmalig auf der *Armory Show* 2001 sah, im klassischen Öl-auf-Leinwand Grossformat — mit Rahmen, zum an die Wand hängen — ein erster Kompromiss hinsichtlich der Vorführbarkeit Ihrer Werke — in Wohnungen von Sammlern z. B. —, ähnlich wie Duchamps spätere Editionen der Readymades?

THOMAS HIRSCHHORN Duchamp hat keine Kompromisse gemacht. Er war der intelligenteste Künstler seines Jahrhunderts.

Das Interview wurde vom Autor via E-Mail und Fax geführt. Thomas Hirschhorns Antwortschreiben ging ASRL am 20. September 2001 in Form zweier handgeschriebener Seiten, exklusive Deckblatt, zu. Frau Petra Gördüren, Galerie Arndt&Partner, Berlin, sei für die Herstellung des Kontakts und Frau Sophie Pulicani, Atelier Thomas Hirschhorn, Paris, für die Zusendung der Abbildungen gedankt.

Der Beitrag wurde gleichzeitig in englischer und deutscher Sprache erstmals in: *Tout-Fait: The Marcel Duchamp Studies Online Journal* Vol. 2, Ausgabe 4, 2002, veröffentlicht <www.toutfait.com/online_journal_details.php?postid=1450> (20. August 2012).

THOMAS HIRSCHHORN Duchamp never made any compromises. He
was the most intelligent artist of his century.

Transl. Thomas Girst

The interview was conducted by the author via e-mail and fax. Thomas Hirschhorn's
answers were sent to ASRL on September 20, 2001, consisting of two handwritten
pages, excl. the cover page. Many thanks to both Ms. Petra Gördüren of Arndt &
Partner, Berlin, for establishing contact, as well as to Ms. Sophie Pulicani, studio
Thomas Hirschhorn, Paris, for making the images available.

This article was first published simultaneously in both English and German in:
Tout-Fait: The Marcel Duchamp Studies Online Journal vol 2, issue 4, 2002,
<www.toutfait.com/online_journal_details.php?postid=1413> (August 20, 2012).

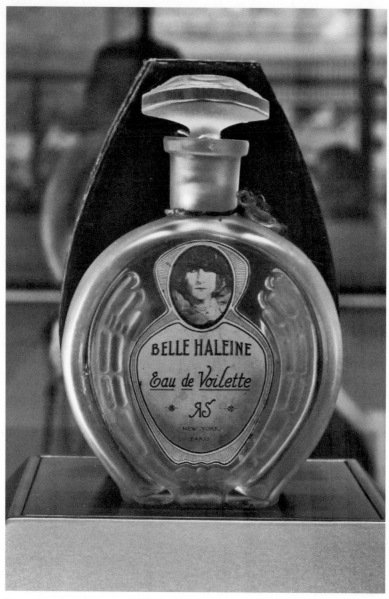

1
Marcel Duchamp, *Belle Haleine:*
Eau de Voilette, 1921, Parfumflakon
von Rigaud mit von Marcel Duchamp
und Man Ray gestaltetem Etikett,
15,2 cm, Privatsammlung, ausgestellt in
der Neuen Nationalgalerie Berlin,
27.–30. Januar 2011

Marcel Duchamp, *Belle Haleine:*
Eau de Voilette, 1921, Rigaud perfume
bottle with label created by Marcel
Duchamp and Man Ray, 15.2 cm,
private collection, on exhibition at
Neue Nationalgalerie Berlin, January
27–30, 2011

2
Marcel Duchamp, Titelseite für *New York Dada*, 1921, Offset-Lithografie, 36,8 × 25,5 cm, Philadelphia Museum of Art

Marcel Duchamp, Cover for *New York Dada*, 1921, offset lithograph, 36.8 × 25.5 cm, Philadelphia Museum of Art

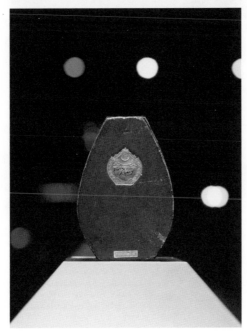

3
Marcel Duchamp, *Belle Haleine: Eau de Voilette*, 1921, ovale, violette Schachtel. Mit goldenem Etikett mit Signatur: »Rrose / Sélavy / 1921« (signiert nach 1945), Privatsammlung

Marcel Duchamp, *Belle Haleine: Eau de Voilette*, 1921, oval, violet-color, cardboard box, inscribed on gold label: "Rrose / Sélavy / 1921" (signed after 1945), private collection

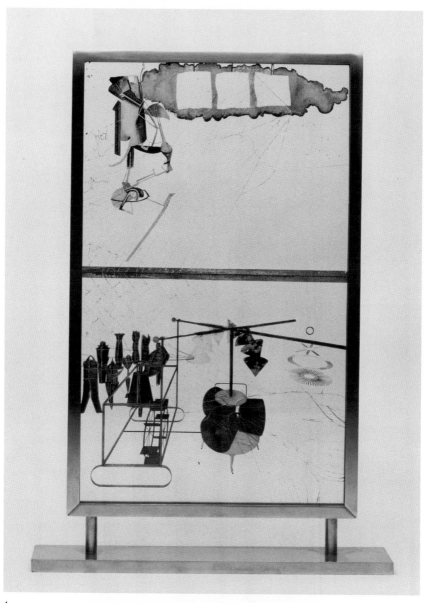

4

Marcel Duchamp, *Die Braut von ihren Junggesellen entblößt, sogar / Das Große Glas*, 1938/39, Kollotypie und Pochoir auf 0,6 mm Zelluloid, Miniaturreproduktion, 26,2 × 22,9 cm, Staatliches Museum Schwerin — Kunstsammlungen, Schlösser und Gärten

Marcel Duchamp, *The Bride stripped Bare by Her Bachelors, Even / The Large Glass*, 1938/39, collotype and pochoir on 0,6 mm celluloid, miniature reproduction, 26.2 × 22.9 cm, Staatliches Museum Schwerin — Kunstsammlungen, Schlösser und Gärten

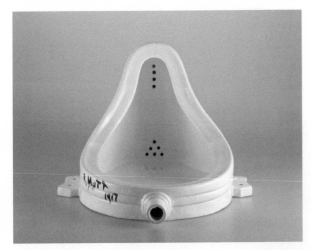

5
Marcel Duchamp, *Fountain*, 1917/1964,
Keramik, 36 × 48 × 61 cm, The Israel
Museum: Vera & Arturo Schwarz
Collection of Dada and Surrealist Art

Marcel Duchamp, *Fountain*,
1917/1964, ceramic, 36 × 48 × 61 cm,
The Israel Museum: Vera & Arturo
Schwarz Collection of Dada and
Surrealist Art

6
Marcel Duchamp, *Fahrrad-Rad*,
1913/1964, Fahrradreifen und
Gabel, umgedreht auf einem weiß
lackierten Küchenstuhl montiert,
126,5 cm hoch, Hessisches Landes-
museum Darmstadt

Marcel Duchamp, *Bicycle Wheel*,
1913/1964, bicycle wheel and
fork mounted upside down on
a kitchen stool painted white,
126.5 cm high, Hessisches Landes-
museum Darmstadt

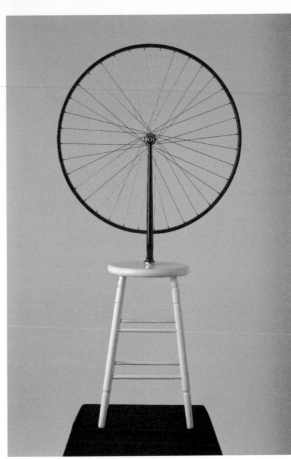

7
Besucher vor der Ausstellungs-
vitrine von *Belle Haleine*,
Neue Nationalgalerie, Berlin, 2011

Visitors in front of the showcase
of *Belle Haleine*, Neue National-
galerie, Berlin 2011

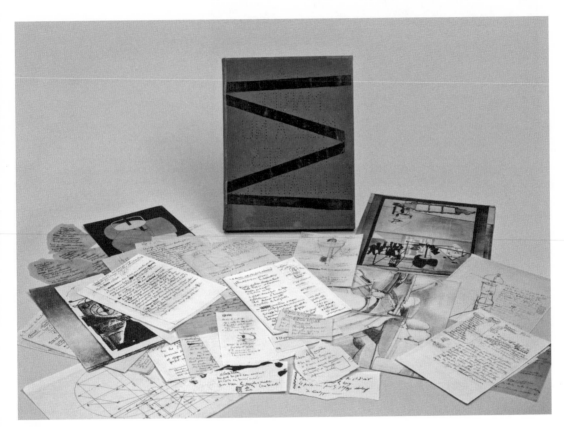

8

Marcel Duchamp, *Die Braut von ihren Junggesellen entblößt, sogar / Die Grüne Schachtel*, 1934, grüne Pappschachtel, gefüttert mit grünem Velourspapier, 93 faksimilierte Blätter, 33,2 × 28 × 2,5 cm, Staatliches Museum Schwerin — Kunstsammlungen, Schlösser und Gärten

Marcel Duchamp, *The Bride stripped Bare by her Bachelors, Even / The Green Box*, 1934, green-flocked cardboard box, 93 facsimiles, 33.2 × 28 × 2.5 cm, Staatliches Museum Schwerin — Kunstsammlungen, Schlösser und Gärten

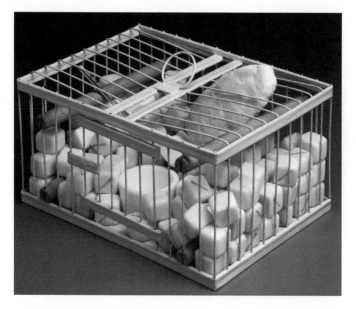

9
Marcel Duchamp, *Why not Sneeze Rrose Sélavy?* 1921/1963, Replik von Ulf Linde, 152 Marmorwürfel in der Form von Zuckerstückchen, Thermometer und Sepiaschale in einem kleinen Vogelkäfig, 11,4 × 22 × 16 cm, Moderna Museet Stockholm: Schenkung des Moderna Museets Vänner

Marcel Duchamp, *Why not Sneeze Rrose Sélavy?* 1921/1963, replica made by Ulf Linde, 152 marble cubes in the shape of sugar lumps, a thermometer, and a cuttlebone in a small birdcage, 11.4 × 22 × 16 cm, Moderna Museet Stockholm: Gift of Moderna Museets Vänner

10
Marcel Duchamp, Umschlag für *View* (Rückseite), März 1945, 30,5 × 23 cm, 54 S., Staatliches Museum Schwerin — Kunstsammlungen, Schlösser und Gärten

Marcel Duchamp, Cover for *View* (verso), March 1945, 30.5 × 23 cm, 54 pp., Staatliches Museum Schwerin — Kunstsammlungen, Schlösser und Gärten

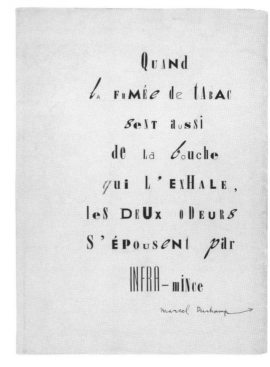

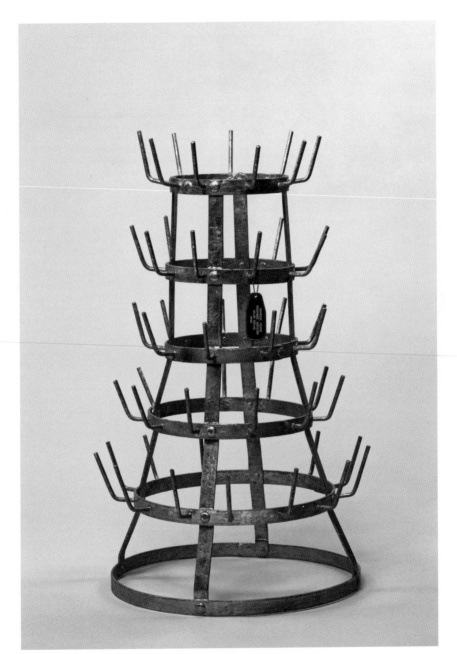

11

Pierre Granoux, *Flaschentrockner*,
1914/2012, Replik, feuerverzinktes
Eisen, 64,2 × 37,7 × 37,7 cm, Staatliches
Museum Schwerin — Kunstsamm-
lungen, Schlösser und Gärten

Pierre Granoux, *Bottle Dryer*,
1914/2012, replica, galvanized iron,
64.2 × 37.7 × 37.7 cm, Staatliches
Museum Schwerin — Kunstsamm-
lungen, Schlösser und Gärten

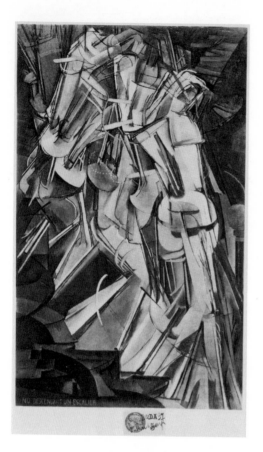

12
Marcel Duchamp, *Akt, eine Treppe herabsteigend, Nr. 2*, 1937, farbige Kollotypie und Pochoir auf Papier, 35 × 19,8 cm, Staatliches Museum Schwerin – Kunstsammlungen, Schlösser und Gärten

Marcel Duchamp, *Nude Descending a Staircase, No. 2*, 1937, colored collotype and pochoir on paper, 35 × 19.8 cm, Staatliches Museum Schwerin – Kunstsammlungen, Schlösser und Gärten

13
Marcel Duchamp, *Von oder durch Marcel Duchamp oder Rrose Sélavy / Die Schachtel im Koffer*, 1941, Pappschachtel mit Miniaturrepliken und Farbreproduktionen der Werke Marcel Duchamps, 39 × 35 × 8 cm, Staatliches Museum Schwerin – Kunstsammlungen, Schlösser und Gärten

Marcel Duchamp, *From or by Marcel Duchamp or Rrose Sélavy / The Box in a Valise*, 1941, miniature replicas and color reproductions of works by Marcel Duchamp contained in a cardboard box, 39 × 35 × 8 cm, Staatliches Museum Schwerin – Kunstsammlungen, Schlösser und Gärten

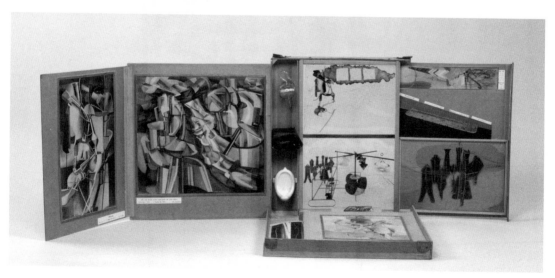

14
Marcel Duchamp, *Étant donnés:*
1° la chute d'eau, 2° le gaz d'éclairage
(Gegeben Sei: 1. Der Wasserfall /
2. Das Leuchtgas), 1946–66, Assemblage,
Außenansicht, 242,6 × 177,8 × 124,5 cm,
Philadelphia Museum of Art: Schenkung
der Cassandra Foundation

Marcel Duchamp, *Étant donnés:*
1° la chute d'eau, 2° le gaz d'éclairage
(Given: 1. The Waterfall, 2. The Illu-
minating Gas), 1946–66, assemblage,
exterior, 242.6 × 177.8 × 124.5 cm,
Philadelphia Museum of Art:
Gift of the Cassandra Foundation

15
Marcel Duchamp, *Étant donnés:*
1° la chute d'eau, 2° le gaz d'éclairage
(Gegeben Sei: 1. Der Wasserfall /
2. Das Leuchtgas) 1946–66, Assemblage,
Blick nach innen, 242,6 × 177,8 × 124,5 cm,
Philadelphia Museum of Art: Schenkung
der Cassandra Foundation

Marcel Duchamp, *Étant donnés:*
1° la chute d'eau, 2° le gaz d'éclairage
(Given: 1. The Waterfall, 2. The Illu-
minating Gas), 1946–66, assemblage,
interior view, 242.6 × 177.8 × 124.5 cm,
Philadelphia Museum of Art:
Gift of the Cassandra Foundation

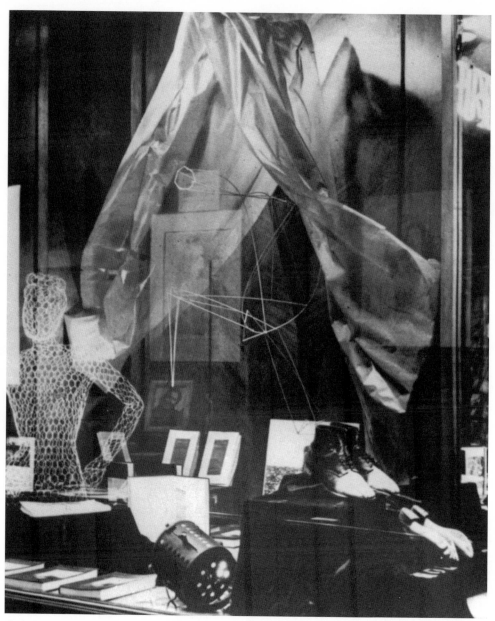

16

Marcel Duchamp, Schaufenster für
André Bretons *Le Surréalisme et
la peinture* von André Breton, 1945,
Foto: Privatsammlung

Marcel Duchamp, Window Display
for *Le Surréalisme et la peinture*
by André Breton, 1945, photograph:
private collection

17
Marcel Duchamp, *Not a Shoe*, 1950,
galvanisierter Gips, 7 × 5 × 2,5 cm,
Centre Georges Pompidou, Paris

**Marcel Duchamp, *Not a Shoe*, 1950,
galvanized plaster, 7 × 5 × 2.5 cm,
Centre Georges Pompidou, Paris**

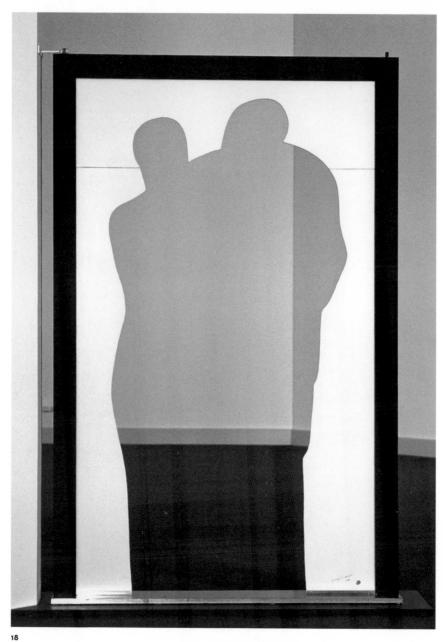

18

Marcel Duchamp, *Door for Gradiva*,
1937/1968, Plexiglas-Replik,
198 × 132 cm, Hessisches Landes-
museum Darmstadt

Marcel Duchamp, *Door for Gradiva*,
1937/1968, plexiglass replica,
198 × 132 cm, Hessisches Landes-
museum Darmstadt

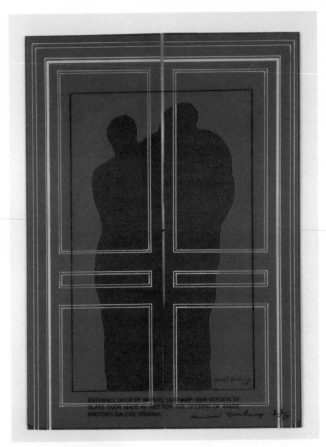

19

Ankündigung der Ausstellung *Türen*,
1968, Miniaturreplik aus Plexiglas,
Faltblatt, Karton, 28 × 19,5 cm (Replik),
55,9 × 39 cm (Faltblatt), 28 × 19,7 cm
(Karton), Staatliches Museum Schwe-
rin — Kunstsammlungen, Schlösser
und Gärten

Announcement for the exhibition
Doors, 1968, miniature plexiglass
replica, folded paper, cardboard box,
28 × 19.5 cm (replica), 55.9 × 39 cm
(folded paper), 28 × 19.7 cm (card-
board box), Staatliches Museum
Schwerin — Kunstsammlungen,
Schlösser und Gärten

20

Gipsabdruck von *Gradiva* im Londoner
Arbeitszimmer Sigmund Freuds nach
dem antiken Original in den Vatikani-
schen Museen (ca. 2. Jh. v. Chr.), Freud
Museum, London

**Plaster Cast of *Gradiva* in Sigmund
Freud's study room in London, after
the antique original in the Vatican
Museums (approx. B.C. 200), Freud
Museum, London**

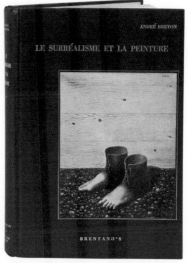

21

Marcel Duchamp, Umschlaggestaltung
für André Breton, *Le Surréalisme
et la peinture*, New York, 1945, mit
einer Abbildung von René Magrittes
Das rote Modell (1935)

**Marcel Duchamp, Cover for André
Breton, *Le Surréalisme et la peinture*,
New York, 1945, including an image
of René Magritte's *The Red Model*
(1935)**

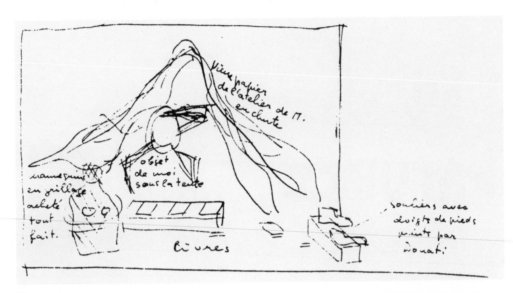

22
Isabelle Waldberg, Zeichnung von
Duchamps Schaufenstergestaltung
für André Bretons *Le Surréalisme
et la peinture* in einem Brief an
Patrick Waldberg vom 10. Novem-
ber 1945, in: Patrick Waldberg,
Isabelle Waldberg, *Un Amour Acé-
phale. Correspondance 1940-1949*,
Paris 1992, S. 331

**Isabelle Waldberg, Drawing of
Duchamp's Window Display for
André Breton's *Le Surréalisme
et la peinture*, 1945 in a letter to
Patrick Waldberg from Novem-
ber 10, 1945, in Patrick Waldberg,
Isabelle Waldberg, *Un Amour
Acéphale: Correspondance
1940-1949* (Paris, 1992), p. 331**

23
Marcel Duchamp, »Schaufenster
für André Bretons *Le Surréalisme
et la peinture*«, in: *La Victoire*,
24. November 1945

**Marcel Duchamp, "Window Dis-
play for André Breton's *Le Surréa-
lisme et la peinture*," *La Victoire*,
November 24, 1945**

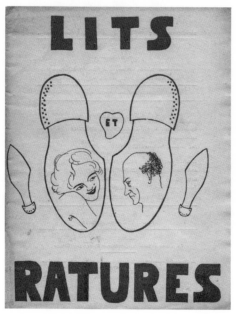

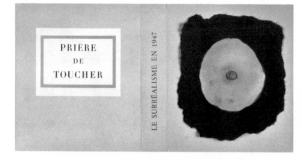

24
Francis Picabia, Umschlaggestaltung
für *Littérature* 7, Dezember 1922)

Francis Picabia, Cover for
***Littérature* 7, December, 1922)**

25
Marcel Duchamp, Umschlag des Kata-
logs *Le Surréalisme en 1947*, Deluxe-
Ausgabe, Karton, Collage bestehend
aus Samt und Schaumgummibrust,
25 × 22,8 cm, Staatliches Museum
Schwerin – Kunstsammlungen,
Schlösser und Gärten

**Marcel Duchamp, Cover for *Le Sur-
réalisme en 1947*, deluxe edition,
cardboard, collage of velvet and
foam-rubber breast, 25 × 22.8 cm,
Staatliches Museum Schwerin –
Kunstsammlungen, Schlösser und
Gärten**

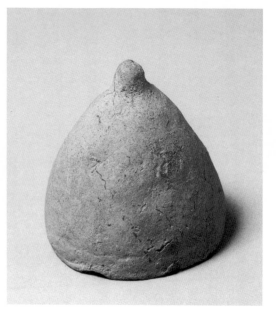

26
Votiv in Form einer weiblichen Brust,
2. Jh. v. Chr., 7,2 cm hoch, Durchmesser
7,5 cm, Medelhavsmuseet, Stockholm

**Votive sculpture, female breast,
terracotta, (B.C. 200), 7.2 cm high,
7.5 cm in diameter, Medelhavs-
museet, Stockholm**

JINDRICH STYRSKY :
Le gilet de Majakovsky 1939

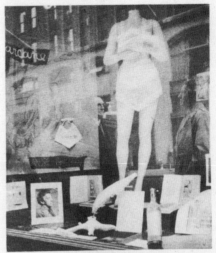

**Vitrine de librairie pour
ARCANE 17**
(Arrangement de Marcel Duchamp)

**Vitrine de librairie pour
LE SURREALISME ET LA PEINTURE**
(Arrangement de Marcel
Duchamp et Enrico Donati)

WILHELM FREDDIE :
Pro patria

27
Le Surréalisme en 1947, Plate XLI, 1947,
Staatliches Museum Schwerin – Kunst-
sammlungen, Schlösser und Gärten

Le Surréalisme en 1947, Plate XLI, 1947,
Staatliches Museum Schwerin – Kunst-
sammlungen, Schlösser und Gärten

28
Marcel Duchamp, Umschlaggestal-
tung für *VVV Almanac*, März 1943,
Nr. 2–3, (Rückseite), 144 S., Staatliches
Museum Schwerin – Kunstsamm-
lungen, Schlösser und Gärten

**Marcel Duchamp, Cover for *VVV
Almanac*, March 1943, No. 2–3,
(verso), 144 pp., Staatliches Museum
Schwerin – Kunstsammlungen,
Schlösser und Gärten**

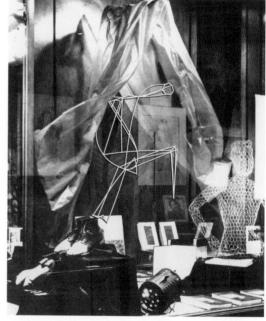

29
Marcel Duchamp, Schaufenster
für André Bretons *Le Surréalisme
et la peinture*, 1945, darüber
eine Computergrafik (2001) der
Skulptur von Isabelle Waldberg
für Duchamps Schaufenster von
Robert Slawinski, Art Science
Research Laboratory, New York

**Marcel Duchamp, Window
Display for André Bretons
Le Surréalisme et la peinture,
1945, above, computer graphics
(2001) of the sculpture of
Isabelle Waldberg, designed
for Duchamp's window display
by Robert Slawinski, Art
Science Research Laboratory,
New York**

30
Marcel Duchamp, Schaufenster
für André Bretons *Le Surréalisme
et la peinture*, 1945, darüber eine
Computergrafik (2001) der auf
ihrer Längsachse um 180 Grad
gewendeten Skulptur von Isabelle
Waldberg für Duchamps Schau-
fenster von Robert Slawinski,
Art Science Research Laboratory,
New York

**Marcel Duchamp, Window
Display for André Bretons
Le Surréalisme et la peinture,
1945, above, computer graph-
ics (2001) of the sculpture
of Isabelle Waldberg, turned
180 degrees along its longitudinal
axis, designed for Duchamp's
window display by Robert
Slawinski, Art Science Research
Laboratory, New York**

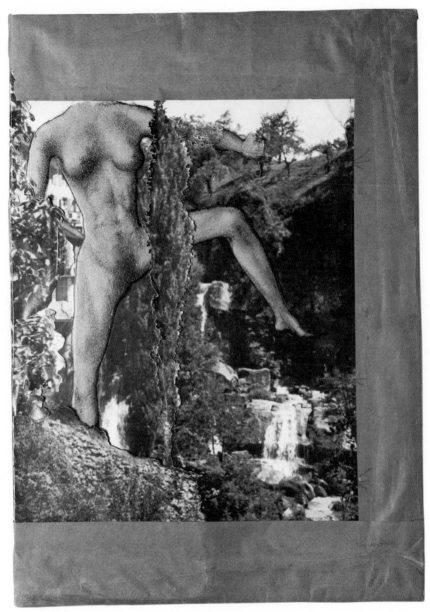

31
Marcel Duchamp, *Untitled* (photo-
collage landscape study for
Étant donnés), 1946, strukturiertes
Wachs, Bleistift und Tine auf
gegerbtem Papier und geschnittene
Silbergelatine-Fotografien, auf
eine Platte montiert, 43,2 × 31,1 cm,
Privatsammlung

Marcel Duchamp, *Untitled* (photo-
collage landscape study for
Étant donnés), 1946, textured wax,
pencil and ink on tan paper and
cut gelatin-silver photographs,
mounted on board, 43.2 × 31.1 cm,
private collection

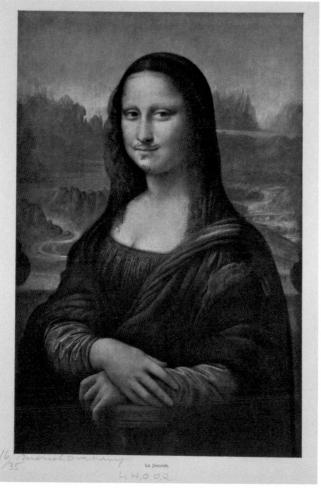

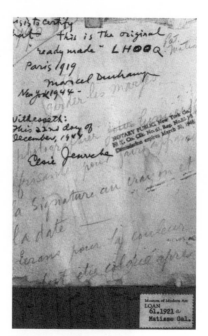

32
Marcel Duchamp, *L.H.O.O.Q.*,
1919/1965, Bleistift, weiße Gouache
auf farbigem Druck des Gemäldes
Mona Lisa von Leonardo da Vinci,
30,1 × 23 cm, Staatliches Museum
Schwerin – Kunstsammlungen,
Schlösser und Gärten

Marcel Duchamp, *L.H.O.O.Q.*,
1919/1965, pencil, white gouache on
reproduction of the *Mona Lisa* by
Leonardo, 30.1 × 23 cm, Staatliches
Museum Schwerin – Kunstsamm-
lungen, Schlösser und Gärten

33
Marcel Duchamp, *L.H.O.O.Q.*, 1919,
Inschrift auf der Rückseite: L.H.O.O.Q.,
Elsie Jenriche, mit Stempel der
Notarin, 1944, Privatsammlung

Marcel Duchamp, *L.H.O.O.Q.*, 1919,
Inscribed verso: L.H.O.O.Q., Elsie
Jenriche, witnessed by a notary,
1944, private collection

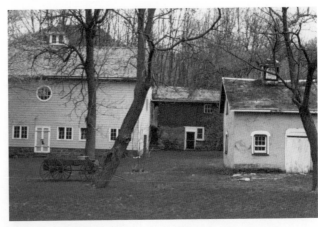

Kurt Seligmanns Farm in Sugar Loaf, New York, 26. April 2000, Art Science Research Laboratory, New York

Kurt Seligmann's farmhouse in Sugar Loaf, New York, April 26, 2000, Art Science Research Laboratory, New York

35
Marcel Duchamp, Umschlaggestaltung für *First Papers of Surrealism*, 1942, (Vorderseite), 52 S., Staatliches Museum Schwerin – Kunstsammlungen, Schlösser und Gärten

Marcel Duchamp, Cover for *First Papers of Surrealism*, 1942 (recto), 52 pp., Staatliches Museum Schwerin – Kunstsammlungen, Schlösser und Gärten

313

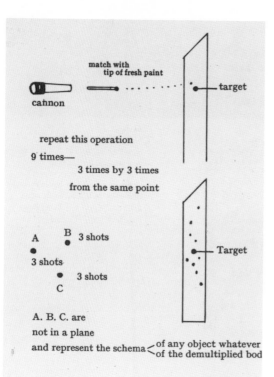

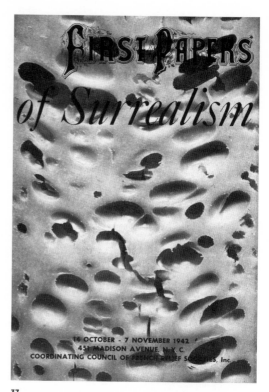

36

The Bride Stripped Bare by her Bachelors, Even. A typographic version by Richard Hamilton of Marcel Duchamp's Green Box, Edition Hansjörg Mayer, Stuttgart, London, Reykjavik 1976, o. S., Staatliches Museum Schwerin — Kunstsammlungen, Schlösser und Gärten

The Bride Stripped Bare by her Bachelors, Even. A typographic version by Richard Hamilton of Marcel Duchamp's Green Box, Edition Hansjörg Mayer (Stuttgart, London, Reykjavik, 1976), n. p., Staatliches Museum Schwerin — Kunstsammlungen, Schlösser und Gärten

37

Marcel Duchamp, Umschlaggestaltung für *First Papers of Surrealism,* 1942, (Rückseite), 52 S., Staatliches Museum Schwerin — Kunstsammlungen, Schlösser und Gärten

Marcel Duchamp, Cover for *First Papers of Surrealism,* 1942, (verso), 52 pp., Staatliches Museum Schwerin — Kunstsammlungen, Schlösser und Gärten

PRINTED AND PUBLISHED IN PARIS, FRANCE, SEPTEMBER 1932

SEPTEMBER
1932

THIS QUARTER

ANDRÉ
BRETON
LUIS BUÑUEL
RENÉ CHAR
GIORGIO DI CHIRICO
RENÉ CREVEL
SALVADOR DALI
MARCEL DUCHAMP
PAUL ELUARD

SURREALIST
NUMBER

MAX ERNST · VALENTINE HUGO
GRETA KNUTSON · MAN RAY
BENJAMIN PÉRET
YVES TANGUY
TRISTAN
TZARA

PUBLISHED AND EDITED BY EDWARD W. TITUS
AT 4 RUE DELAMBRE, MONTPARNASSE, PARIS

PUBLISHERS FOR GREAT BRITAIN & DOMINIONS :
WILLIAM HEINEMANN, LTD., LONDON, W. C. I.
PUBLISHERS FOR U. S. A. & CANADA : RAY LONG & RICHARD R. SMITH INC., NEW YORK

MARCEL DUCHAMP

sequence [of a set] of small happenings appearing to
necessitate one another under causal laws, *in order to
extract the sign of relationship between*, on the one
hand, this *position of Rest* (capable of all eccentrici-
ties), on the other, a *choice of Possibilities* avail-
able under these laws and at the same time deter-
mining them.

Or :

we shall determine the conditions under which may
best be demonstrated [the] super-rapid position of
Rest [the snapshot exposure] (= allegorical appear-
ance) of a set ... &c.

Or :

Given, in the dark, (1) the waterfall
(2) the lighting gas,
we shall determine [2] (the conditions for) the super-
rapid exposure (= allegorical appearance [3] of several
collisions [acts of violence] appearing strictly to suc-
ceed one another—in accordance with certain causal
laws [4]—*in order to extract the sign of relationship*
between this snapshot exposure (capable of all eccen-
tricities) *on the one hand* and the choice of the pos-
sibilities available under these laws *on the other*.

Algebraic Comparison :

a a being the demonstration
b b ,, ,, possibilities
the ratio $\dfrac{a}{b}$ — is in no way given by a number c

[2] This has "*we shall consider*" written over it.
[3] This has "*allegorical reproduction*" written over it.
[4] There is a ring round these six words, and the note, "*unneces-
sary.*"

— 190 —

38
Umschlag von *This Quarter*,
herausgegeben von Edward
W. Titus, Paris, September
1932, 212 S.

**Cover from *This Quarter*,
edited by Edward W. Titus,
Paris (September 1932),
212 pp.**

39
Englische Übersetzung von
Marcel Duchamps Notiz
(»Preface«) aus *Die Braut
von ihren Junggesellen
entblößt, sogar / Die
Grüne Schachtel*, 1934, von
Jacob Bronowski, in: *This
Quarter*, herausgegeben
von Edward W. Titus, Paris,
September 1932, 212 S.,
S. 13

**English translation of
Marcel Duchamp's note
("Preface") from *The
Bride stripped Bare by
her Bachelors, Even /
The Green Box*, 1934,
by Jacob Bronowski, in
This Quarter, edited by
Edward W. Titus, Paris
(September 1932), 212 pp.,
p. 13**

40

Notiz (»Preface«) aus *Die Braut von ihren Junggesellen entblößt, sogar / Die Grüne Schachtel*, 1934, Staatliches Museum Schwerin – Kunstsammlungen, Schlösser und Gärten

Note ("Preface") taken from *The Bride stripped Bare by her Bachelors, Even / The Green Box*, 1934, Staatliches Museum Schwerin – Kunstsammlungen, Schlösser und Gärten

41

Notiz (»Preface«) aus *The Bride stripped Bare by her Bachelors, Even*. A typographic version by Richard Hamilton of Marcel Duchamp's Green Box. Edition Hansjörg Mayer, Stuttgart, London, Reykjavik 1976, o. S., Staatliches Museum Schwerin – Kunstsammlungen, Schlösser und Gärten

Note ("Preface") taken from *The Bride Stripped Bare by her Bachelors, Even*. A typographic version by Richard Hamilton of Marcel Duchamp's Green Box. Edition Hansjörg Mayer (Stuttgart, London, Reykjavik, 1976), n. p., Staatliches Museum Schwerin – Kunstsammlungen, Schlösser und Gärten

42
Bourdalou, Meißen um 1740, Porzellan,
Sammlung Ludwig, Bamberg

Bourdalou, Meissen by around 1740,
porcelain, Sammlung Ludwig, Bamberg

43
Marcel Duchamp, *Gestaltung für
Dada 1916–1923*, 1953, Druck auf
Zellstoffpapier, 96,5 × 63,5 cm, Staat-
liches Museum Schwerin – Kunst-
sammlungen, Schlösser und Gärten,
Siehe auch S. 162–164

**Marcel Duchamp, *Design for Dada
1916–1923*, 1953, print on tissue
paper, 96.5 × 63.5 cm, Staatliches
Museum Schwerin – Kunstsamm-
lungen, Schlösser und Gärten,
See also pp. 162–163, 165**

44
Marcel Duchamp, *Weibliches Feigen-
blatt*, 1950/1951, galvanisierter Gips,
9 × 14 × 12,5 cm, Staatliches Museum
Schwerin – Kunstsammlungen,
Schlösser und Gärten

Marcel Duchamp, *Female Fig Leave*,
1950/1951, galvanized plaster,
9 × 14 × 12.5 cm, Staatliches Museum
Schwerin – Kunstsammlungen,
Schlösser und Gärten

45
Marcel Duchamp, *Keuschheitskeil*,
1954/1963, Replik, Guss in Bronze und
Dentalkunststoff, 5,6 × 8,5 × 4,2 cm,
Staatliches Museum Schwerin –
Kunstsammlungen, Schlösser und
Gärten

Marcel Duchamp, *Wedge of Chastity*,
1954/1963, replica, bronze and
dental plastic, 5.6 × 8.5 × 4.2 cm,
Staatliches Museum Schwerin –
Kunstsammlungen, Schlösser und
Gärten

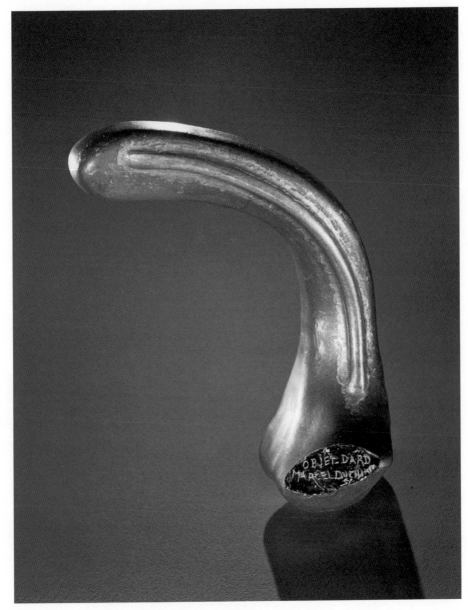

46
Marcel Duchamp, *Objet Dard*
(Dart Objekt), 1951, galvanisierter
Gips, 7,5 × 20,1 × 6 cm, Privatsammlung

Marcel Duchamp, *Objet Dard (Dart*
Object)*, 1951, galvanized plaster
with inlaid lead rib, 7.5 × 20.1 × 6 cm,
private collection

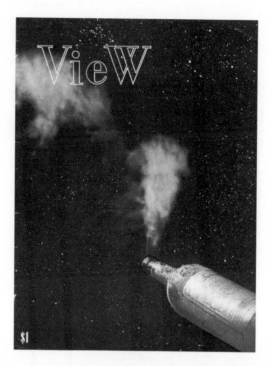

47
Marcel Duchamp, Umschlag für
View (Rückseite), März 1945, 54 S.,
30,5 × 23 cm, Staatliches Museum
Schwerin – Kunstsammlungen,
Schlösser und Gärten

**Marcel Duchamp, Cover for *View*
(verso), March 1945, 54 pp.,
30.5 × 23 cm, Staatliches Museum
Schwerin – Kunstsammlungen,
Schlösser und Gärten**

48
Friedrich Kiesler, Triptychon in *View*:
*Les Larves d'Imagie. D'Henri Robert
Marcel Duchamp*, März 1945, 54 S.,
30,5 × 23 cm, Staatliches Museum
Schwerin – Kunstsammlungen,
Schlösser und Gärten

**Friedrich Kiesler, Triptych in *View*:
*Les Larves d'Imagie. D'Henri Robert
Marcel Duchamp*, March 1945, 54 pp.,
30.5 × 23 cm, Staatliches Museum
Schwerin – Kunstsammlungen,
Schlösser und Gärten**

D
La An
mariée **U** analytical
mise à nu **C** reflection
par ses **H** by
célibataires, K. S. Dreier
même. **A** and Matta
250 copies **M** 5 ill. $1.75
Wittenborn **P** 38 East 57 St.
& Co. **,** N. Y. 22
Books on the Catalog on
Fine Arts **S** request.

GLASS

49
Marcel Duchamp, Anzeige in
View, März 1945, 54 S., Staat-
liches Museum Schwerin –
Kunstsammlungen, Schlösser
und Gärten

Marcel Duchamp, Advertise-
ment in *View*, March 1945,
54 pp., Staatliches Museum
Schwerin – Kunstsammlungen,
Schlösser und Gärten

1922 STIEGLITZ

MARCEL DUCHAMP AT
THE AGE OF 35

1972

MARCEL DUCHAMP AT
THE AGE OF 85

50
Marcel Duchamp im Alter von
35 und 85 Jahren, in *View*,
März 1945, 54 S., Staatliches
Museum Schwerin – Kunst-
sammlungen, Schlösser und
Gärten

**Marcel Duchamp at the
age of 35 and 85, in *View*,
March 1945, 54 pp., Staatli-
ches Museum Schwerin –
Kunstsammlungen, Schlösser
und Gärten**

51
Seite aus *Duchamp's Glass, La Mariée
mise à nu par ses célibataires, même:
An Analytical Reflection*, 1944, von
Katherine S. Dreier und Roberto Matta
Echaurren, Art Science Research
Laboratory, New York

**Page from *Duchamp's Glass, La Mariée
mise à nu par ses célibataires, même:
An Analytical Reflection*, 1944, by
Katherine S. Dreier and Matta Echaur-
ren, Art Science Research Laboratory,
New York**

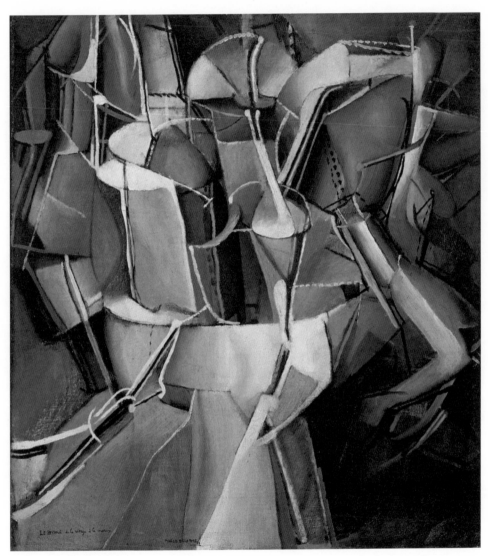

52
Marcel Duchamp, *Der Übergang
von der Jungfrau zur Braut*, 1912,
Öl auf Leinwand, 59,4 × 54 cm,
Museum of Modern Art, New York

Marcel Duchamp, *The Passage from
Virgin to Bride*, 1912, oil on canvas,
59.4 × 54 cm, Museum of Modern Art,
New York

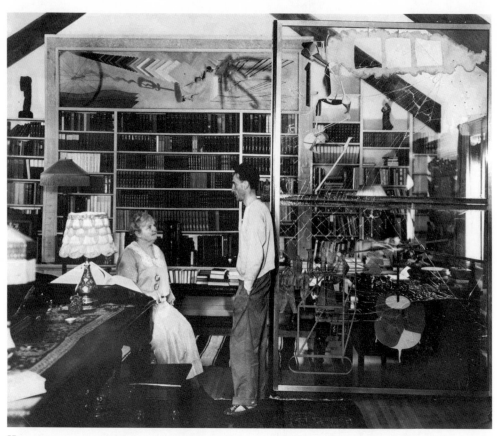

53

Fotografie von Katherine S. Dreier
und Marcel Duchamp in Dreiers Haus
in West Redding, Connecticut, 1936,
The Beinecke Rare Book and
Manuscript Library, Yale University

Photograph of Katherine S. Dreier
and Marcel Duchamp at her home
in West Redding, Connecticut, 1936,
The Beinecke Rare Book and
Manuscript Library, Yale University

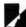

54
Roberto Matta Echaurren,
*The Bachelors Twenty Years After
(Die Junggesellen zwanzig Jahre spä-
ter)*, Öl auf Leinwand, 96,5 × 127 cm,
1943, Philadelphia Museum of Art

Roberto Matta Echaurren,
The Bachelors Twenty Years After,
oil on canvas, 96.5 × 127 cm, 1943,
Philadelphia Museum of Art

55
Salvador Dalí und Timothy
Phillips, frühe 1960er-Jahre,
Art Science Research Labo-
ratory, New York

**Salvador Dalí with Timothy
Phillips, early 1960s, Art
Science Research Laboratory,
New York**

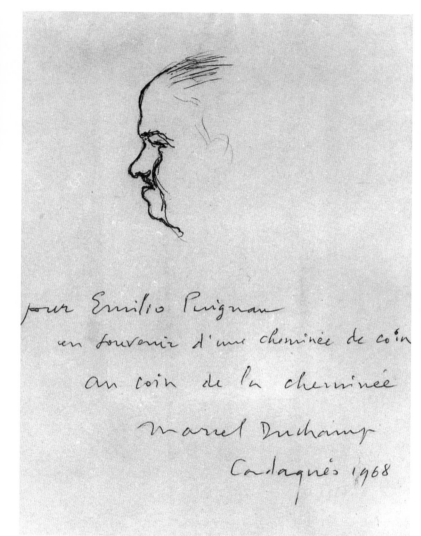

56
Marcel Duchamp, The Mayor of
Cadaqués, 1968, Kohle auf Papier,
26 × 19 cm, Collection Emilio Puignau,
Cadaqués

**Marcel Duchamp, The Mayor of
Cadaqués, 1968, charcoal on paper,
26 × 19 cm, Collection Emilio Puignau,
Cadaqués**

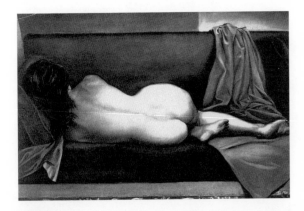

57
Timothy Phillips,
Untitled (Nude after
Velázquez), späte
1950er-Jahre, Art
Science Research
Laboratory, New York

Timothy Phillips,
***Untitled* (Nude after**
Velázquez), late 1950s,
Art Science Research
Laboratory, New York

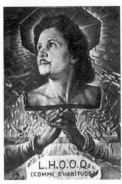

58
L.H.O.O.Q., Comme d'habitude,
1961, Ausstellungsplakat, Art
Science Research Laboratory,
New York

L.H.O.O.Q., Comme d'habitude,
1961, exhibition poster, Art
Science Research Laboratory,
New York

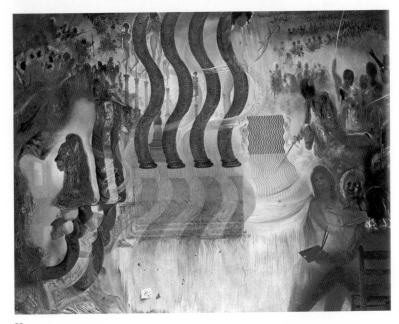

59
Salvador Dalí, *Salvador Dalí malt Gala bei
der Apotheose des Dollar. Auf der linken
Seite ist Marcel Duchamp als Ludwig XIV.
verkleidet zu erkennen hinter einem
Vorgang im Stile Vermeers, der nichts an-
deres als das unsichtbare, aber monumen-
tale Gesicht des Hermes von Praxiteles
ist,* 1965, Öl auf Leinwand, 400 × 498 cm,
Peter Moore Collection, Cadaqués

Salvador Dalí, *Salvador Dalí in the Act of
Painting Gala in the Apotheosis of the
Dollar, in which One may also Perceive to
the Left Marcel Duchamp Disguised as
Louis XIV, behind a Curtain in the Style
of Vermeer, which is but the Invisible Mon-
ument Face of the Hermes of Praxiteles,*
1965, oil on canvas, 400 × 498 cm, Peter
Moore Collection, Cadaqués

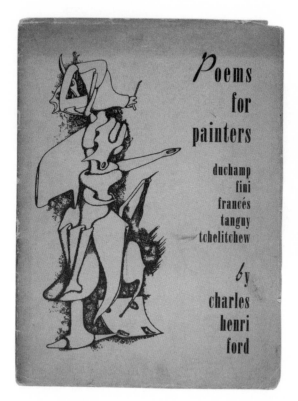

63

Robert Barnes in der Marcel Duchamp-
Ausstellung des Indiana University Art
Museum, Bloomington, Januar 2001,
Foto: Thomas Girst

Robert Barnes visiting the Marcel
Duchamp collection of the Indiana
University Art Museum, Bloomington,
January 2001, photograph: Thomas
Girst

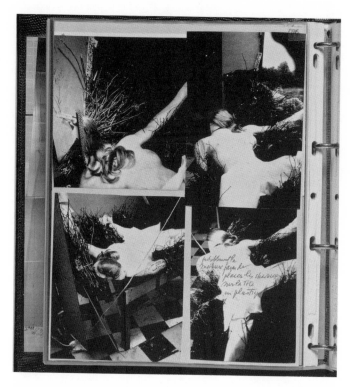

64
Marcel Duchamp, Eine Seite aus
Manual of Instructions for the Assem-
bly of Étant donnés: 1° la chute d'eau,
2° le gaz d'éclairage, 1966, Philadel-
phia Museum of Art, 1987 (englische
Ausgabe 2009), o. S.

Marcel Duchamp, One page of
Manual of Instructions for the Assem-
bly of Étant donnés: 1° la chute d'eau,
***2° le gaz d'éclairage*, 1966, Philadel-**
phia Museum of Art, 1987 (English
version 2009), n. p.

65
Marcel Duchamp, *Étant donnés: Maria,*
la chute d'eau et la gaz d'éclairage
(Gegeben sei: Maria, der Wasserfall
und das Leuchtgas), 1947, pencil on
paper, 40 × 29 cm, Moderna Museet
Stockholm

Marcel Duchamp, *Étant donnés: Maria,*
la chute d'eau et la gaz d'éclairage
(Given: Maria, the Waterfall and the
Illuminating Gas), 1947, pencil on
paper, 40 × 29 cm, Moderna Museet
Stockholm

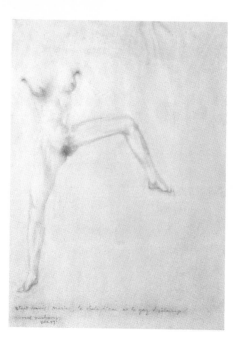
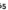

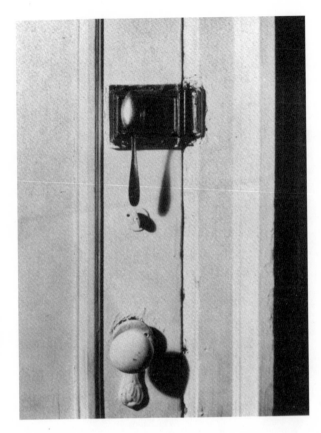

67
Marcel Duchamp,
Verrou de sûreté à la cuiller (The Locking Spoon), 1957, Metall-löffel an einem Tür-schloss befestigt, 14 cm hoch, Ort unbekannt

Marcel Duchamp,
Verrou de sûreté à la cuiller (The Locking Spoon), 1957, metal spoon affixed to a door lock, 14 cm high, pres-ent location unknown

66
George Segal,
Caressing Hands, o. J.,
Gips, George and
Helen Segal Foundation

George Segal,
Caressing Hands, n. d.,
plaster, George and
Helen Segal Foundation

68
Marcel Duchamp, *Kamm*,
1916/1964, Stahlkamm,
16,6 × 3 cm, Staatliches
Museum Schwerin –
Kunstsammlungen,
Schlösser und Gärten

Marcel Duchamp, *Comb*,
1916/1964, steel comb,
16.6 × 3 cm, Staatliches
Museum Schwerin –
Kunstsammlungen,
Schlösser und Gärten

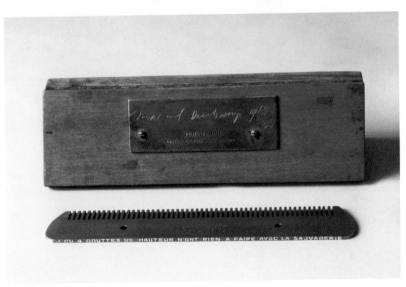

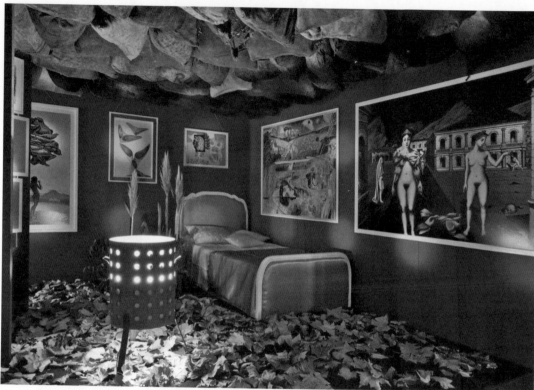

69

Marcel Duchamp, *Twelve Hundred Coal Bags Suspended from the Ceiling over a Stove*, 1938, Reenactment des Environments für die Ausstellung *Exposition Internationale du Surréalisme* (Paris), anlässlich der Ausstellung *Gegen Jede Vernunft. Surrealismus Paris-Prag*, 14.11.2009–14.02.2010, Wilhelm-Hack-Museum, Ludwigshafen

Marcel Duchamp, *Twelve Hundred Coal Bags Suspended from the Ceiling over a Stove*, 1938, Reenactment of the environment for *Exposition Internationale du Surréalisme* (Paris), during the exhibition *Gegen Jede Vernunft. Surrealismus Paris-Prag*, November 14, 2009–February 14, 2010, Wilhelm-Hack-Museum, Ludwigshafen

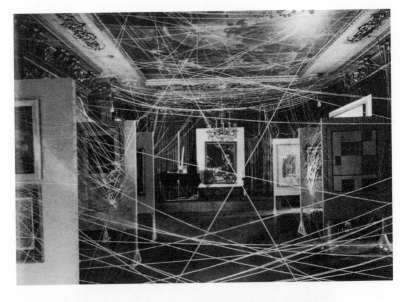

70
Marcel Duchamp, *Sixteen Miles of String*, 1942, Installation in der Ausstellung *First Papers of Surrealism*, New York, kuratiert von André Breton and Marcel Duchamp

Marcel Duchamp, *Sixteen Miles of String*, 1942, Installation in the exhibition *First Papers of Surrealism*, New York, curated by André Breton and Marcel Duchamp

71
Marcel Duchamp, *Schokoladenreibe, No. 2*, 1913, Öl, Graphit und Faden auf Leinwand, 65,4 × 54,3 cm, Philadelphia Museum of Art: The Louise and Walter Arensberg Collection

Marcel Duchamp, *Chocolate Grinder, No. 2*, 1914, Oil, graphite, and thread on canvas, 65.4 × 54.3 cm, Philadelphia Museum of Art: The Louise and Walter Arensberg Collection

ZUM AUTOR

Thomas Girst, geboren 1971, Studium der Kunstgeschichte, Amerikanistik und neueren deutschen Literatur in Hamburg und New York, Promotion (*Art, Literature and the Japanese American Internment Experience*). Kulturkorrespondent der *Tageszeitung*, Autor, Herausgeber u. a. von *Die Aussenseite des Elementes* (1991–2003). Als Forschungsleiter des Art Science Research Laboratory unter Harvardprofessor Stephen Jay Gould und Rhonda Roland Shearer, New York, war Girst u. a. Chefredakteur von *Tout-Fait: The Marcel Duchamp Studies Online Journal* (1998–2003). Seit 2003 Leiter des Kulturengagements der BMW Group. Dozent an der Ludwig-Maximilians-Universität, München, Lehraufträge an der Akademie der Bildenden Künste München und der Zürcher Hochschule für Angewandte Wissenschaften. Kurator u. a. von *Marcel Duchamp in München 1912*, Mitherausgabe des gleichnamigen Katalogs. 2014 erscheint *The Duchamp Dictionary* bei Thames and Hudson.

DANK

Jacqueline Matisse Monnier und Antoine Monnier für das große Interesse und die jahrzehntelange Herzlichkeit der Association Marcel Duchamp. Paul B. Franklin für sein enzyklopädisches Wissen und seine Hilfsbereitschaft. Dirk Blübaum als Direktor des Staatlichen Museum Schwerin für seine Vision. Gerhard Graulich und Kornelia Röder für den steten Austausch. Annette Kulenkampff für ihre Professionalität. Francis M. Naumann für seine Freundschaft. Friederike, Balthazar, Konstantin und Helena für ihre mir mit dem Herzen zugewandte Nachsicht. Katharina Uhl, ohne die es dieses Buch nicht geben würde.

The Indefinite Duchamp ist Jens Kiefer gewidmet.

ABOUT THE AUTHOR

Thomas Girst, b. 1971, studied art history, American Studies and German literature at Hamburg and New York University, PhD *(Art, Literature and the Japanese American Internment Experience)*. Cultural correspondent for the *Tageszeitung*, author, and founding editor of *Die Aussenseite des Elementes* (1991–2003). As research manager of the Art Science Research Laboratory under the directorship of Harvard professor Stephen Jay Gould, Girst also was editor-in-chief of *Tout-Fait: The Marcel Duchamp Studies Online Journal* (1998–2003). Since 2003, he is Head of Cultural Engagement at the BMW Group. He lectures at the Ludwig-Maximilians-University in Munich, the Academy of Fine Arts Munich as well as at the University of Applied Sciences in Zurich. In 2012, he curated *Marcel Duchamp in Munich 1912* whose catalogue he co-edited. He is the author of *The Duchamp Dictionary*, to be published in 2014 by Thames and Hudson.

ACKNOWLEDGMENTS

Jacqueline Matisse Monnier and Antoine Monnier for their ceaseless interest and the decade-long cordiality of the Association Marcel Duchamp. Paul B. Franklin for his encyclopedic knowledge and his helpfulness. Dirk Blübaum, director of the State Museum Schwerin, for his vision. Gerhard Graulich and Kornelia Röder for the constant exchange of ideas. Annette Kulenkampff for her professionalism. Francis M. Naumann for his friendship. Friederike, Balthazar, Konstantin and Helena Girst for their loving lenience. Katharina Uhl, as this book would not exist without her.

The Indefinite Duchamp is dedicated to Jens Kiefer.

The Indefinite Duchamp
Thomas Girst
Poiesis. Schriftenreihe des Duchamp-Forschungs-
zentrums Schwerin, Staatliches Museum Schwerin –
Kunstsammlungen, Schlösser und Gärten

Herausgeber Band 2 **Editor volume 2**
Katharina Uhl

Redaktion und Lektorat **Editing and Copyediting**
Katharina Uhl

Übersetzungen **Translations**
Amy Fulconbridge, Harriett Watts, Janina Wildfeuer
(Deutsch–Englisch **German–English**)
Anna Pfau, Janina Wildfeuer
(Englisch–Deutsch **English–German**)

Grafische Gestaltung und Satz
Graphic design and typesetting
Atelier Sternstein, Stuttgart | J. Sternstein, M. Witthoeft

Schrift **Typeface**
Neutraface Text

Reproduktionen **Reproductions**
Weyhing digital, Ostfildern

Verlagsherstellung **Production**
Heidrun Zimmermann

Papier **Paper**
Alster Werkdruck, 100 g/m²

Druck **Printing**
Offizin Scheufele, Stuttgart

Buchbinderei **Binding**
Litges & Dopf Buchbinderei GmbH, Heppenheim

Fotonachweis **Credits**
ASRL (Art Science Research Laboratory):
S. **pp.** 310, 313, 322, 326, 327
Centre Georges Pompidou, Paris (bpk – Bildagentur für
Kunst, Kultur und Geschichte): S. **p.** 303
Freud Museum, London: S. **p.** 306
Hessisches Landesmuseum Darmstadt (Wolfgang
Fuhrmannek): S. **pp.** 295, 304
The Israel Museum: The Bridgeman Art Library:
S. **pp.** 293, 295
Medelhavsmuseet, Stockholm (Ove Kaneberg): S. **p.** 308
Moderna Museet, Stockholm: S. **pp.** 298, 330
Museum of Modern Art, New York (Scala, Florenz): S. **p.** 323
Neue Nationalgalerie Berlin (Friedhelm Denkeler, Roman
März): S. **pp.** 293 (M), 292, 296 (D)
Philadelphia Museum of Art: S. **pp.** 301, 325, 333
Sammlung Ludwig Bamberg: S. **p.** 317
The George and Helen Segal Foundation (Donald Lokuta):
S. **p.** 331
Staatliches Museum Schwerin (Gabriele Bröcker):
S. **pp.** 294, 297, 298, 299, 300, 305, 308, 310, 311, 313, 314,
317, 318, 320, 321, 322, 328, 330, 331
Wilhelm-Hack-Museum, Ludwigshafen am Rhein: S. **p.** 332

Erschienen im **Published by**
Hatje Cantz Verlag
Zeppelinstrasse 32
73760 Ostfildern
Deutschland / Germany
Tel. +49 711 4405-200
Fax +49 711 4405-220
www.hatjecantz.de

Hatje Cantz books are available internationally at
selected bookstores. For more information about our
distribution partners please visit our homepage at
www.hatjecantz.com

ISBN 978-3-7757-3414-1

Printed in Germany